Visual Sense

SENSORY FORMATIONS

Series Editor: David Howes

ISSN: 1741–4725

- What is the world like to cultures that privilege touch or smell over sight or hearing?
- Do men's and women's sensory experiences differ?
- What lies beyond the aesthetic gaze?
- Who says money has no smell?
- How has the proliferation of 'taste cultures' resulted in new forms of social discrimination?
- How is the sixth sense to be defined?
- What is the future of the senses in cyberspace?

From the Ancient Greeks to medieval mystics and eighteenth-century empiricists, Karl Marx to Marshall McLuhan, the senses have been the subject of dramatic proclamations. Senses are sources of pleasure and pain, knowledge and power. Sites of intense personal experience, they are also fields of extensive cultural elaboration. Yet surprisingly, it is only recently that scholars in the humanities and social sciences have turned their full attention to sensory experience and expression as a subject for enquiry.

This path-breaking series aims to show how the 'sensual revolution' has supplanted both the linguistic and the pictorial turns in the human sciences to generate a new field—*sensual culture,* where all manner of disciplines converge. Its objective is to enhance our understanding of the role of the senses in history, culture and aesthetics, by redressing an imbalance: the hegemony of vision and privileging of discourse in contemporary theory and cultural studies must be overthrown in order to reveal the role all senses play in mediating cultural experience. The extraordinary richness and diversity of the social and material worlds, as constituted through touch, taste, smell, hearing, sight and, provocatively, the sixth sense, are addressed in the volumes of this series as follows:[1]

Empire of the Senses: The Sensual Culture Reader (Ed. David Howes) documents the sensual revolution in the humanities and social sciences, and reclaims sensation as a domain for cultural inquiry.

The Auditory Culture Reader (Eds Michael Bull & Les Back) articulates a strategy of 'deep listening'—a powerful new methodology for making sense of the social.

The Smell Culture Reader (Ed. Jim Drobnick) foregrounds the most marginalized, and potentially subversive, sense of modernity, in addition to sampling how diverse cultures scent the universe.

The Book of Touch (Ed. Constance Classen) maps the tactile contours of culture, exploring the powerful and often inarticulate world of touch, the most basic of our senses.

The Taste Culture Reader (Ed. Carolyn Korsmeyer) serves up a savoury stew of cultural analysis, blending together the multiple senses of the term 'taste'.

Visual Sense: A Cultural Reader (Eds Elizabeth Edwards & Kaushik Bhaumik) explores and interrogates the multiplicity of scopic regimes within and without the Western tradition.

The Sixth Sense Reader (Ed. David Howes) asks: What lies beyond the bounds of sense? Is the sixth sense ESP, electromagnetic sensitivity, intuition, revelation, gut instinct or simply unfathomable?

1. Full publication details are available from the publishers, Berg, 1st Floor, Angel Court, 81 St Clements Street, Oxford OX4 1AW, UK; or consult http://www.bergpublishers.com.

Visual Sense
A Cultural Reader

**Edited by Elizabeth Edwards
and Kaushik Bhaumik**

Oxford • New York

First published in 2008 by
Berg
Editorial offices:
1st Floor, Angel Court, 81 St Clements Street, Oxford, OX4 1AW, UK
175 Fifth Avenue, New York, NY 10010, USA

Berg is the imprint of Oxford International Publishers Ltd.

Library of Congress Cataloguing-in-Publication Data

A catalogue record for this book is available from the Library of Congress.

British Library Cataloguing-in-Publication Data

A catalogue record for this book is available from the British Library.

ISBN 978 1 84520 740 3 (Cloth)
ISBN 978 1 84520 741 0 (Paper)

Typeset by Apex CoVantage
Printed in the United Kingdom by Biddles Ltd, King's Lynn

www.bergpublishers.com

Contents

PART 4. CREATING

PART 5. RUPTURES

PART 6. EXTENSIONS

Illustrations

Acknowledgements

There are many people involved in the making of a volume of this complexity. All our contributors have been unfailingly supportive; without them the volume could not have happened. Suzannah Biernoff, Barry Flood, David Morgan, Jan-Eric Olsén, and Karen Strassler, especially, have been supportive beyond the call of duty. We are also most grateful to Liam Buckley, Karen Strassler, Chris Pinney, Roslyn Poígant, *Uppsala Nya Tiding, Durant Daily Democrat, Herald-Palladium,* Berliner Gesellschaft für Anthropologie, Ethnologie und Urgeschichte and the Master and Fellows of St John's College, Cambridge, for permission to use their photographs. Anne Fricker and Andrew Manning of the MATAR Research Centre, and Patrick Sutherland, all at University of the Arts London, and Mohini Chandra and Gulammohammed Sheikh came to the rescue with cover and editorial images—we are blessed to have such generous colleagues, and we are grateful for their permission to use their photographs. We are grateful to Charles Gagnon for his translations of French. Eve Waring, Amy Hellerman and Angela Higuera have eased our lives greatly. At Berg Hannah Shakespeare, Helen Swain, Ian Critchley and Ken Bruce remained cheerful and supportive through thick and thin, and thanks to Julia Rosen and Barbara Walsh for their careful copy-editing.

We must thank also the senior administration of Concordia University, Montreal, for their generous financial support of the *Sensory Formations* series, including this volume, and University of the Arts London (LCC Research Committee) for further financial support.

We are also grateful to all the copyright holders who responded generously to our pleas of poverty.

Many friends and colleagues, and the two anonymous readers, discussed ideas and suggested pieces to us. Even if their suggestions didn't make the final cut, they influenced our thinking and informed our decisions: Susanne Bauer, Joshua Bell, Jeremy Coote, Janice Hart, Mike O'Hanlon, Chris Morton, Chris Pinney, Simon Schaffer and Anne Secord.

Last but far from least is David Howes, the series editor, whose patience, advice, kindness and saintly fortitude has been wondrous.

We see the things themselves, the world is what we see: formulae of this kind express a faith common to the natural man and the philosopher— the moment he opens his eyes; they refer to a deep-seated set of mute 'opinions' implicated in our lives. But what is strange about this faith is that if we seek to articulate it into theses or statement, if we ask ourselves what is this we, what seeing is, and what things or world is, we enter into a labyrinth of difficulties and contradictions.

Maurice Merleau-Ponty, *The Visible and Invisible*

I fell asleep thinking of him,
And he came to me.
If I had known it was only a dream
I would never have awakened.

Ono no Komachi, ninth-century Japanese poet

Part 1. Introduction

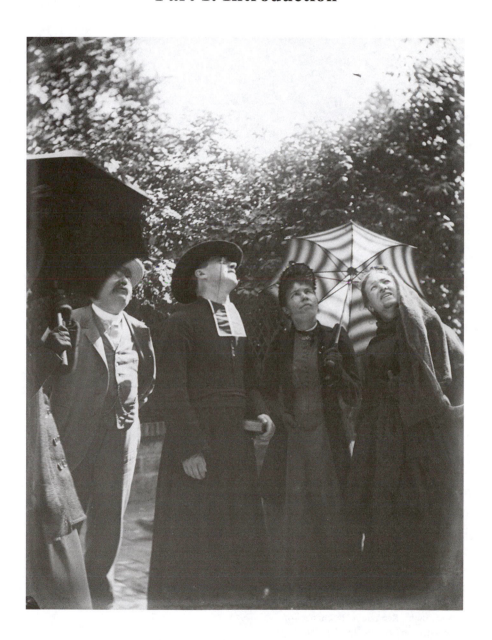

Figure 1 (overleaf) *Looking Up.* Photographer:
Samuel Butler. Reproduced by courtesy of
the Master and Fellows of St John's College,
Cambridge.

–1.1–

Visual Sense and Cultures of Sight
An Introduction
Elizabeth Edwards and Kaushik Bhaumik

Sensory Approaches

The enormous expansion of visual studies and visual culture in recent decades has made itself felt in almost every field of academic enquiry. It has spawned a mass of literature, conferences, student courses and specialist journals such as *The Journal of Visual Culture* and *Visual Studies* and all the while infiltrating others. In order to digest this amorphous and sprawling field for the student, a number of Readers have emerged. Some are general in their approach (e.g. Evans and Hall, 1999; Mirzoeff, 2002); others have a specific focus, for instance, feminism and visual culture (Jones, 2003), religion and art (Plate, 2002) or visual culture of the nineteenth century (Schwartz and Pryzyblyski, 2004).

At one level *Visual Sense* is another contribution to this literature, but importantly it is also something very different. It takes as its starting point vision as neither an abstracted form nor simply a set of ideologically determined social practices, although, of course, it can be these things. Nor does it separate and intellectualise vision, defining it through philosophy or theories of perception, for example, or analysing it in isolated apprehension of its object—such as race or gender. Instead it explores vision and sight as something sensorially integrated, embodied and experienced. The reader is concerned not only with the question 'What are the uses of the visual or visuality?' but also how the visual is *felt*—emotionally and physically as well as intellectually at the interface 'between vision and language, vision and audition, and vision and the invisible, between the seen and the overlooked' (Mitchell, 2003: 250).

The spirit of the Sensory Formations series gives the perfect context for such an exploration, one which is both a counterpoint to existing approaches to visual culture and its canon and at the same time mindful of its rich legacy. It presents pieces which, in multiple ways, address embodied vision: vision that leaks into other sensory modes. For in going back to examining what people do with the visual, and how the visual field is created through use, in a very visceral sense, one can begin to extend the range of meanings generated by visual activity.

Another key and fundamental difference distinguishes this collection of Readings from other visual culture Readers. The classic Reader tends to condense an extant field, presenting a canon of Readings brought together to reproduce that canon in easily accessible form. Whilst such intentions are, of course, admirable and the results useful, this volume again takes a different approach. This Reader assembles an eclectic, interdisciplinary selection of Readings that constitute a beginning, an opening up, of a newly figured field for thinking about the visual. It sets no defining parameters for this new field but rather suggests multiple and overlapping possibilities by encouraging visually attuned Readings over a wide range of subjects and methodologies: 'If one reads in the right way the words will unfold in us a real, visible world' (Novalis, quoted in Kittler, 1999: 9), that is, visually experienced and felt worlds. The Readings are drawn from history, art history, anthropology, literary studies, cultural studies, philosophy, theology and history of science. However, it must be stressed that the interdisciplinary resides not only in the subject matter of the Readings, nor indeed in the labels attached by certain scholars. It also resides, crucially, in the methodologies applied, for the different disciplines bring slightly different conceptual and analytical textures to the sensory and its object.[1] The juxtaposition of Readings from various disciplines points to both epistemological overlaps and differences to be found, depending on the questions brought to the object of study, different shapes of focus, and different framings of objectivity and subjectivity over a range of approaches from arts practice to science.

The Readings are intended, first and foremost, to inspire students with the potential of such a reimagined field. It is one which acknowledges, but also moves beyond, models of vision in which images (in the broadest sense) are held simply to reflect a set of cultural and political ideologies held by the makers and readers of those images, or understood through the meta-theories of Western modernity and postmodernity, such as semiotics or the psychoanalytical. It also hopes to suggest an alternatively nuanced reading of classic texts, such as those presented here from Bachelard on daydream, Merleau-Ponty on the sensory density of vision and Nochlin on Camille Pissarro. At the same time it intends to imbue new ones, such as those from Thomas on Marie-Antoinette, Harris on contemporary art in Tibet and Wilson on romantic responses to ice, with a sense of the embodied visual and synaesthetic quality. As such the Reader provides students with some firm examples on which to build their ideas, whatever their perspective.

Following on from this position, another key departure in this Reader is the emphasis on different cultural systems and thus different cultural uses of vision, with examples from Tibet, West Africa, Andean South America, India, Mexico, Japan and Australia, for instance. The importance of vision in many cultures and its complex relation with the social and sensory body is amply demonstrated through the ethnographic record. We have chosen pieces which articulate precisely a dynamic non-Western visuality, operating within the broader socio-sensory environment. On one hand this reflects our own intellectual backgrounds in anthropology and cross-cultural

history, which have sensitised us to the relative position of vision and sight in alternative hierarchies and interrelations of the senses. On the other it responds to, and builds on, the increasing challenges being made to the idea of the supremacy of vision which has informed so many critiques.

A growing body of work on the senses cross-culturally in recent years has destabilised the Western five-sense model in general and assumptions about the nature of occularcentrism in particular. In this model, sight in particular, along with hearing, has been understood as representing the rational and 'nonsensual', according with an objective reality, whereas touch, smell and taste stand for the lower 'irrational', visceral and sensory, lacking a mechanistic and rational connection with the world (see Classen, 1993). However, as a number of Readings suggest, such as those by Renne and Faris Thompson on West African examples and even that by Thomas on revolutionary France, vision is not necessarily rational but can also be associated with fracture, chaos or danger, linked to witchcraft, sorcery or the 'evil eye'.

However, it is important that these positions not be read as an essentialising opposition of Western/non-Western, rational/irrational. Rather, they demonstrate fluid and shifting models for looking at the world. The crucial question which runs throughout the Reader is, as Ingold has argued, not what cultures perceive but how they perceive, how they use sight in relation to other sensory modes and how they might be understood in ways which do not necessarily privilege the visual. As he argues, 'It will no longer do to identify cultural variations with alternative worldview, as though everyone perceived their surroundings in the same way (visually, by viewing it) but saw different things on account of their drawing of different models for organising the data of perception into representations' (2000: 250). Instead it is necessary to look at the different sensory modes, including vision, through which the world is presented to the mind, a fully synaesthetic and entwined integration of sensory modes to create the inner sensibility of human experience of which vision is integral (Csordas, 1994: 4).

An Emerging Field

The aim of this introduction is not to attempt an exhaustive summary or a detailed discussion of this vast field. This would be a book in itself. The intention instead is to give a broad overview of the issues that concerned us as we made selections for the volume, and to provide some compass points for engaging with the readings, by way of key themes and the position of such approaches in relation to visual studies on one hand and anthropology of the senses on the other.

Mirzoeff points out in the introduction to his important *Visual Culture Reader* (2002) that the word *culture* in visual culture explicitly refers to the politics of visual practice, a relentless pointing out of the constructed nature of vision, its elisions and fantastic creations. Emerging from this position has been a critical exploration

of the social, political and economic constitution of vision in which the boundaries and operations of scopic regimes have been interrogated and deconstructed (e.g. Jay, 1988; Jenks, 1995).

This approach has enormously enriched the studies of the visual. The deconstructive turn aimed to understand visual practices through the assumptions which shaped them and to which they themselves were integral. It was enabled not only by theoretical developments in literary and cultural studies, but also through perspectives coming in from obvious disciplines such as art history and film studies as well from more or less obvious ones such as archaeology and biology, and from not so obvious ones such as economics and law. This highly contextualised approach has extended the discursive space of the visual itself to include that which had been culturally 'invisible' in the disciplinary discourses of the visual (for example Elkins, 1999).[2] It has spawned a depth of research into an almost infinite array of cultures and aspects of 'visual production' from cityscapes or photo booths (Boyer, 1994; Chalfen, 2001) and from the prehistoric to twenty-first-century New Media, in imaginative and very often entertaining ways. The new Visual Studies was both the realisation and product of this 'pictorial turn', as Mitchell termed it (1994: 11–34), and enabled interdisciplinary perspectives, appropriating ideas and eclectic methodologies from art history, anthropology, cultural studies and psychology, for instance.

However, there is a danger that the position outlined above tends to reify and isolate visual practice, reproducing its Western privileging in the sensory hierarchy. In recent years there has been an increasing exploration of alternative approaches. Concerns and responses have taken two forms. In visual studies increasing attention has been paid to the broader sensory role of vision. In anthropology a methodological and theoretical attention to a critical engagement with differently figured sensory hierarchies and registers has emerged and has suggested the potential of such approaches for enriching cultural understandings.

Of course, as the preceding discussion suggests, such ideas do not appear in a vacuum. Wider formative murmurings have been occurring in contemporary scholarship for some time. Nor, of course, are these debates new in themselves. The nature of sensory experience, and the place of vision, has engaged philosophers since the classical period in Western Europe (for a summary see Classen, 1993). Twentieth-century theorists also foundational to visual and media studies, such as Walter Ong and Marshall McLuhan, constantly argued for the integrated sensory nature of 'visual media' both explicitly and implicitly (see Howes, 2003: 14–16). Even though they privilege the visual in various forms and dichotomous models such as ear/eye/oral/literate, Ong in particular is attuned to the ways in which different cultures 'relate their various conceptual apparatus to the various senses' (Ong, 1991: 26).

Recent debates on the nature of visual culture and visual studies have, however, indicated a quickening of the pace and shift in the direction of a wider sensory understanding of the visual (see, for example, Bal, 2003), and responses (Bryson et al.,

2003; Mitchell, 2005a,b). Bal had pointed out, for instance, the absurdity of an essentialised or pure form of 'the visual':

> The act of looking is profoundly 'impure' ... this impure quality is also ... applicable to other sense-based activities: listening, reading, tasting, smelling. This impurity makes such activities mutually permeable, so that listening and reading can also have visuality to them. (Bal, 2003: 9)

Likewise, Mitchell has argued that there are no 'visual media' as such, that 'all media are, from the standpoint of sensory modality, "mixed media"' (2005a: 257).

He has recently described visual experience as 'braided', in that 'one sensory channel or semiotic function is woven together with another more or less seamlessly' (2005a: 262). A similar position has been argued by anthropologist Webb Keene, who describes the 'bundling' of sensory and material affects in which an object is defined through the co-presence of the visual with other qualities—such as texture, weight or size (2005: 188). In these models, one sensation is often integrally related to and followed by another to form continuous patterns of experience, representing a dense social embedding, as an object—whether the gaslit city, photographs or hairstyles—read over multiple sensory qualities. In many ways this echoes Merleau-Ponty's description of the seer: '[I]immersed in the visible by his body the seer does not appropriate what he sees, he merely approaches it by looking, he opens himself to the world' (quoted in Ingold, 2000: 264). This position is not, of course, a rejection of discourse of visual culture, for vision nonetheless 'retains its sensory dominance through myriad scattered reflections' (Howes, 2003: xii), but aims to cohere, extend and reintegrate the sensory within visual discourse.

Whilst these debates might be seen as constituting another 'turn', a 'phenomenological turn' or 'sensory turn', they have seldom moved beyond the abstract and seldom address exactly how it is that vision was culturally embodied and experienced. Consequently, mindful of the need for 'ethnographic demonstration' of sensory arguments, in this volume we have resisted a retreat into a 'pure phenomenology' such as that of the philosopher Husserl's *Lebenswelt* or Merleau-Ponty's 'Being-in-the world'. Rather the phenomenological here is interpreted in a more applied sense, which, as the anthropologist Michael Jackson argues, 'prepares the ground for detailed descriptions of how people immediately experience space and time, and the world in which they live' (1996: 12), a domain of knowledge inseparable from the world in which people actually live and act.

This anthropological phenomenology can be seen as coming together with a well-established strand of anthropology of the senses rather than visual studies. While this second strand was contemporary with, and related to, critiques of visualism in other disciplines (e.g. Crary, 1990; Jay, 1993), it was also related to a shift away from, or at least the profound self-consciousness of, the visualism of anthropology (see Fabian,

1983: 106–9) and that awareness that different world views were premised on different sensory hierarchies and registers. In this environment the ideas of the visual sense as integral to broader sensory experience were most cogently developed and, importantly, ethnographically grounded. As early as 1991, Howes's seminal collection of essays, one of which (Classen) is extracted in this volume, argued the necessity of understanding

> how the patterning of sense experience varies from one culture to the next in accordance with the meaning and emphasis attached to each of the modalities of perception. It was also concerned with tracing the influence such variations have on forms of social organisation, conceptions of self and cosmos, the regulation of emotions, and other domains of cultural expression. (Howes, 1991: 1)

The impact of such a position on thinking about visual sense within a range of culturally constituted sensory modalities is clear. Further, the heuristic necessity of such a position was put plainly by another anthropologist, Paul Stoller, who worked with Songhay in Niger and whose ethnography constitutes one of the most important contributions of sensorial anthropology (Howes, 1991: 8–11). He referred to 'the sensual turn' as an essential counterbalance, and indeed an escape from the visually bounded 'sedimented certainties of cultural empiricism' (Stoller, 1989: 38). In this approach, the sensual and methodological sensitivity to the sensual, the possibility of the synaesthetic, becomes central to cultural understanding.

This Reader presents material which could be seen to enrich those debates. The concern is with categories of cultural experience which work through and mobilise vision in specific ways across time and space—the experience of the street, revolt, celebrity and science, for instance. All are active in the creation of knowledge and integral to the processes of seeing, thinking and knowing. If this constitutes a 'sensory turn', it is integrally related to emotion, which has been increasingly explored in recent years (see, e.g. Harkin, 2003; Milton and Svašek, 2005; Reddy, 2001). Questions of sentiment, anger, longing, love and excitement, for instance, entangled with the sensory, permeate the Readings here (e.g. Buckley, Edwards, Thomas and Morgan).

We aim to point to ways in which a differently configured approach to sight and vision can help us understand other forms of 'being in the world', and the way in which daily practices of seeing, meaning and thought are 'made up of ideas, emotions, sensory responses and pictures in our imagination' (MacDougall, 2006: 1–2). The Readings are pieces that wallow in the impurities of imagination, emotion, ideas and vision. Even if at first glance they do not appear to be about vision, they are, at the same time, about the feeling of vision at a profound level.

Seeing Things

Resonating through these debates is the relation with the apprehended world, for sensory faculties exist in relation to the sensory objects they produce. All the pieces

here have objects of the social world as the focus of vision in some form, whether an ordering of the natural worlds (Daston) or the engagement with the material and embodied performances of spirit worlds (Morphy and Faris Thompson). This is not the place to reiterate the discussions from Plato onward on the ambiguous relations between vision, representation and reality (see, e.g. Brennan and Jay, 1996; see also debates in Elkins, 2007), although those debates inform all these Readings. What is significant here, as we have argued, is the multi-sensory mediation in that world. A key influence in developing a sensory approach to 'seen things', and certainly one of our influences in selecting the pieces, has been that of material culture studies in anthropology, for despite its highly theorised models, anthropology has always encountered what Csordas has termed 'the existential ground of culture and self' (1994: 6).[3]

Of particular influence in thinking about the apprehension of objects and the material world has been Alfred Gell's work on anthropological theories of art. Although he does not address it as such, his arguments on affect and enchantment by implication engage the sensory, and indeed the emotional, for social effects are sensory effects. He argues that things have agency in that they elicit both effect and affect. This in its turn both constitutes and is constituted by social relations as things, play a 'practical mediating role ... in the social processes' (Gell, 1998: 60). This is a process which whether applied to cinema, photographs or architecture, as the Readings here demonstrate (e.g. Stone, Tsivian and Pinney), might be understood as sensory in that these material encounters demand embodied responses and emotional affect.

In art history a similarly shaped position has been expressed most recently in the work of Hans Belting. As part of his broader *Bild-Anthropologie* project he shifts Mitchell's (1986) iconological trio of image, text and ideology to image, medium and body as a way 'to grasp images in their rich spectrum of meanings and purposes' (2005: 302) through material and embodied apprehension and affect. What is being argued here again is that the material world both constitutes and is constituted through the sensory, and shapes perceptions of it and responses to it. The visually apprehended world is constituted as a relation between the social object as agent and the body as the perceiving, sensorially engaged body on which meaning ultimately depends. It creates what another anthropologist, Michael Taussig, has described as 'visceral quality ... uniting viewer and the viewed' (1993: 24)[4] as a process of incorporation through which the body is central to the perceptual forms of the experienced world which are generated.

Related to the debate about the visual and sensory response to things are more general recent concerns about the 'decarnalisation' of objects, which is effectively a de-sensing of objects. The analysis of material objects—city streets, domestic environments, icebergs or shoes, all of which feature in the Readings here—have arguably too often been premised solely on the visual and its linguistic translation.[5] Cultural historian Barbara Stafford has, for instance, drawn attention to the way in which the Saussurean 'linguistic turn' of textualism (which has impacted on so much

visual theory)[6] has 'emptied the mind of its body, obliterating the interdependence of physiological functions and thinking' (1997: 5). This position reflects the values attached to Western understandings of the hierarchy of the senses in which, as we have already suggested, seeing stands for the production of rational knowledge.

From such a critical concern with performative embodiment and the problem of decarnalisation within the everyday usage of visual images, anthropologist Christopher Pinney has developed the term 'corpothetics' as 'the sensory embrace of images, the bodily engagement that most people ... have with artworks' (2001: 158). This he sees as 'a critique of conventional approaches to aesthetics and [an argument] for a notion of corpothetics—embodied corporeal aesthetics—as opposed to "disinterested" representation which over-cerebralizes and textualizes the image' (Pinney, 2004: 8).[7] Anthropology has resonated with the destabilisation or refiguring of the dynamics of vision, and material cultural studies has effectively, in part, worked to 'recarnalise objects' and the visual world. Some examples are included in this volume, for instance, Readings by Classen, Buckley and Ingold. Indeed. Taussig, in a pleasing refraction, has argued the tactility of vision and the necessity of rethinking the term vision in relation to other sensory modalities in a way which questions their assumed categorisation—we are 'stimulated into rethinking what "vision" means as this very term decomposes before our eyes' (1993: 26). Most recently visual anthropologist David MacDougall has explored the relationship between filmic images and sensory apprehension, arguing that 'we tend to forget how cursory looking can be. To look carefully requires strength, calmness, and affection. The affection cannot be in the abstract: it must be an affection of the senses' (2006: 7).

A further noteworthy reworking of the boundaries between people and things, vision and the haptic, is to be found in neurophysiology, where a body of work, namely, situated cognition theory, holds that skin is an arbitrary boundary and things are part of the mind. Although the Reader intentionally does not reach into the scientific, beyond the cultural practices of science, it is worth noting. Here the mind is not so much a series of language-like data structures and symbol manipulations but, echoing Jackson's anthropological phenomenology, 'the tuning of basic responses to a real world that enables an embodied organism to sense, act, and survive in a coupling of organisms and the world which is at the root of daily action' (1996: 4). In this understanding of the human mind as 'wild cognition', people are 'hard-wired' as environmentally embedded and embodied agents, 'beings that move and that act upon and thus within their worlds' in an ongoing engagement with the sensorially perceived world (1997: 7). To quote Clark's provocative description, 'Mind is a leaky organ: forever escaping its "natural' confines and mingling shamelessly with body and with world' (1997: 53). Thus vision, in this Reader, escapes its traditional confines and is manifested as a leaky organ, in that we see not with our eyes but with our whole body (Marks, 2000: 148–9).[8]

All these positions suggest a critical mass, emerging within anthropology and elsewhere, which links the ambiguities of visual experience within a broader sensory

domain and the state of 'being-in-the-world'. Thus the uses of vision in the way in which we are addressing them here constitute a perceptual tool to work through life—individual life, collective life and social life. Because the visual is seen as essential for life in a foundational sense, if looked for it is to be found everywhere, explicitly in embodied states and material defined as visual such as maps and pictures, as well as implicitly in, for example, the metaphors of language, in the emotive spaces created by writing styles, as offered here by Field on Japanese poetry, or the 'city inside our heads' created by use of urban layouts such as those discussed by Stone in this volume. Yet, at the very moment of delineating something visually 'out there', visual faculties are used toward some other purpose. They become a deep reflex of self-understanding, an agent of pleasure and creativity or, more directly, as a tool for fulfilling goals and objectives. Social beings are constantly in the visual, not unlike Merleau-Ponty's well-known concept of 'double-sensation' (of touching and being touched; 1958: 106), with no difference between visual entanglement and the navigation and clarification of the visual entanglement.

The embodied position taken here is not to depoliticise vision, or indeed the body, nor to strip it of its ideological instrumentality. These elements, as again the Readings demonstrate, remain active within with their multifarious entanglements.[9] The visual and its sociopolitical performances are to be found throughout the Readings. They permeate simple everyday tasks, like arranging furniture, as well as complex ones like building empires or creating a film industry. Yet significantly, such visual activities are contingent on one another. An example is furnished by Buckley's essay, which shows how the sensory performance of elegance in Gambia is integrally related to the concept of the individual in the modern nation state. Likewise, as Biernoff, Barasch and Klima's essays demonstrate, individual visual experiences, often of a transcendent nature, are closely related to the negotiation of religious authority. Thus, as the Readings suggest, not only is the visual complex in terms of the web of meanings in which it is entangled, but this complexity is generated by the very fact that the visual (or, indeed, consciousness of its absence) is embedded in almost every conceivable human activity and in every imagining. For instance, the visual is used explicitly when one reads a novel, but also implicitly as the reader simultaneously feels his way through the world made up of entanglements—material, emotional, conceptual or sensual—described in the novel. The sensual, encompassing thickness of language (Bryson, 1981: 3) permeates this volume as demonstrated in the Readings by Field on Japanese poetry, Nead on the literary expression of gas-lit in London and Wilson in ice.

It follows from this, as Bal, Mitchell and Howes have argued from their different disciplinary positions, that there is indeed no pure visual object as such but only uses of embodied and sensorially engaged sight. As we have suggested, we have set out to explore this through pieces that would not necessarily be conventionally thought of as being explicitly visual. Indeed, this approach might be seen as responding to Bal's question, '[W]hat happens when people look, and what emerges from that act?'

(2003: 9). Our response is that as they look they 'feel' sensations, qualities, affects and emotions which emerge from looking and seeing but cannot be reduced to it.

The Arrangement of the Reader

This Reader is the last in the Sensory Formations series, and, as will be patently clear, it addresses the key sense as defined by the Aristotelian classification of the senses: vision or sight.[10] As we have already suggested, the volume is a starting point for thinking about the visual sense, not merely an end point teaching manual, although, of course, it has that function, too.

The Readings encompass an eclectic range in order to describe qualities of seeing, all of which, in different ways, imply bodily relations. When we were planning the volume and selecting material from a vast array of possibilities, we considered the way in which the experience of vision was articulated in English.[11] The richness of vocabulary revealed different sets of embodied relations with the act of seeing: staring, gazing, concentrating, attending, observing, glancing, glimpsing, peeking, squinting, surveying, regarding, gawping, leering, spectating and on and on. Then there were the words for the lack, disruption, or aversion of vision. Emerging from this revealing and entertaining exercise were the categories which form the sections of this book, all of which are essentially about *qualities* of sight within specific cultural contexts, ways of doing things with visual sense.

We have chosen pieces which represent both a wide disciplinary spread and a wide geographical or cultural spread, and which, in some way, could be understood as extending the visual into other sensory modalities, or informing the visual through those modalities. A further important consideration was that a majority of the pieces were ethnographically grounded, giving experiential shape to theoretical issues. All, however, have theoretical contributions to make, either implicitly or explicitly, in relation to materiality (e.g. Pinney), phenomenological Readings (e.g. Klima), or sensory and emotional approaches to vision in history or anthropology, for instance.

The structure of the volume is intended to bring to the fore different qualities of vision and visual experience. We start with the idea of *Labyrinth,* which explores the complexity, density and occasionally the impenetrable in vision. *Orderings,* the second section, perhaps resonates most closely with the classic concerns of visual culture, the role of the ideological and social field in constructing visual practices. *Creating* follows, picking up the themes of the previous section but reversing them, exploring the role of visual imaginings in constructing the social field. *Ruptures,* as the title suggests, explores visual sense as a point of fracture, conscious and unconscious. The final section, *Extensions,* explores the opening up of the visual field in new sensorial relations, from digital surgery to the daydream, a fluid interplay between rationality and irrationality. Within these larger categories of visual quality and action we have tried to be comprehensive in a very broad and generalised manner about the categories of seeing/seen and showing/shown, using such concepts

as the everyday, spectacle, detecting and renunciation. A short introduction to each section outlines its conceptual parameters, the objectives of the Readings within it, relations between the Readings and their relation with the key themes outlined in this introduction.

The sections should not be understood as fixed or containing, however. They overlap, further complicating visual experience. Like vision itself, they are impure. For example, one might see the desire of spectacle in the daydream, the constructive in the rubble of revolution, and the creative in the spiritual density and brilliance of utopian painting. So, for instance, the art of Gongkar Gyatso, the subject of Harris's essay, although placed in the section on *Rupture,* has much to do with contesting the meanings of the sacrality attributed to Tibetan culture and with creative imaginings; the everyday experience of weather, as discussed by Ingold, has do to with the transcendence of light; and blindness, discussed by Barasch, is associated with extension into the divine realm.

Nonetheless, there is broad narrative shape to the volume. It starts with *Labyrinth* as a metaphor for the density of vision, a density so great that it can be blinding, that is, it can restrict vision, either metaphorically or literally. The volume ends on the lightness and openness of the reverie or daydream—an extension of the vision into the realm of the imagination, existing in the embodied brain. In between lie cultural and visual practices which attempt to move human experience from the impenetrable labyrinth toward clarity, inflected as they are with the social, political and ideological. This position variously and slowly clarifies in the sections that follow, as strategies are used to order, control or apply vision in a multitude of ways. All are saturated with other sensory modes where, for instance touch, orality or the haptic imagination merge seamlessly in the braided qualities of visual experience which we discussed earlier.

For this reason we want readers to read the pieces 'against the grain', as Benjamin famously recommended of history (1992: 248)—that is, read against the obvious and direct meaning—so that the visual and sight emerge where one least expects to find them. We have tried to suggest, through the structure of the Reader, that the visual is not stretched between two impossible polarities, represented through the metaphors of the labyrinth and the daydream, but rather that diverse contexts are brought into play in the ceaselessly dynamic loop between action and constructs, between cultural blindness and relative enlightenment.

There is, of course, as we have suggested, an embarrassment of riches of material on the visual at our disposal. Once one starts reading against that grain especially, the range and number of visual texts expand almost infinitely. In the end we have chosen pieces that not only fulfilled our intellectual objectives but also made us excited and enabled us to *feel* the sense of vision. Some of the Readings will not appear, at least to the casual reader, to be first and foremost about vision. But by placing them in the context of the sensorially and visually attuned, and encouraging that reading against the grain, the Reader aims to give a sense of the potential and excitement of sensory visual thinking. It presents sight as part of an experiential whole where things are literally made 'sensible, as making sense … immersed in a world and in an activity

of visual being' (Sobchack, 1992: 8), and which permeates human sensory experiences, fundamental to their 'being-in-the-world'.

Notes

1. For instance, Marie-Antoinette's hairstyles, as discussed here by Chantal Thomas, might for an historian be a symbolic object constituting an historical event, whereas an anthropologist, perhaps following Mary Douglas's *Purity and Danger,* might see visceral disgust as key in shaping the narrative. The object is shown as open to a number of sensory readings.
2. For an analytical summary of those debates, along with the 1996 'Visual Culture Questionnaire' in the journal *October* and interviews with some of the protagonists, see Dikovitskaya (2005).
3. Similar affective studies have been undertaken in art history, for instance, Holly's (1996) Lacanian reading of the affective quality of renaissance painting such as altarpieces.
4. Taussig here is drawing on Walter Benjamin's work on mimesis.
5. For a discussion of material culture and the senses more generally, see E. Edwards, C. Gosden and R. Phillips (eds), *Sensible Objects,* Oxford: Berg, 2006, and essays therein.
6. For a useful exploration in relation to photography, see Elkins (2007).
7. See also Pinney in this volume.
8. See also Marks in this volume.
9. There is, of course, a very substantial literature on the political construction of the body which is beyond the scope of this essay.
10. The arrangement also aligns the Reader with the other volumes in the Sensory Formations series—touch, hearing, smell and taste. There is also a volume of the sixth sense.
11. We also undertook this exercise, with less expertise, in French and German.

References

Bal, Mieke (2003), 'Visual Essentialism and the Object of Visual Culture', *Journal of Visual Culture,* 2(1): 5–32.
Belting, Hans (2005), 'Image, Medium, Body: A New Approach to Iconology', *Critical Inquiry,* 31(2): 302–19.
Benjamin, Walter (1992), 'Thesis on the Philosophy of History', in H. Arendt, ed., *Illuminations,* London: Fontana.
Boyer, M. Christine (1994), *City of Collective Memory,* Cambridge, MA: MIT Press.
Brennan, Teresa, and Jay, Martin, eds (1996), *Vision in Context: Historical and Contemporary Perspectives on Sight,* New York: Routledge.

Bryson, Norman (1981), *Word and Image: French Painting of the Ancien Régime,* Cambridge: Cambridge University Press.

Bryson, Norman, et al. (2003), 'Responses to Mieke Bal's "Visual Essentialism and the Object of Visual Culture", *Journal of Visual Culture,* 2(2): 229–68.

Chalfen, Richard (2001), 'Print Club Photography in Japan'. *Visual Sociology,* 16(1): 55–73.

Clark, Andy (1997), *Being There: Putting Brain and World Together Again,* Cambridge, MA: MIT Press.

Classen, Constance (1993), *Worlds of Sense: Exploring the Senses in History and Across Cultures,* London: Routledge.

Crary, Jonathan (1990), *The Techniques of the Observer,* Cambridge, MA: MIT Press.

Csordas, T. J. (1994), 'Introduction: The Body as Representation and Being-in-the-World', in Csordas, T. J., ed., *Embodiment and Experience,* Cambridge: Cambridge University Press.

Dikovitskaya, Margaret (2005), *Visual Culture: The Study of Visual Culture after the Visual Turn,* Cambridge, MA: MIT Press.

Edwards, E., Gosden C., and Phillips, R., eds (2006), *Sensible Objects,* Oxford: Berg.

Elkins, James (1999), *The Domain of Images,* Ithaca, NY: Cornell University Press.

———, ed. (2007), *Photography Theory,* London: Routledge.

Evans, Jessica, and Hall, Stuart, eds (1999), *Visual Culture: The Reader,* London: Sage.

Fabian, Johannes (1983), *Time and the Other: How Anthropology Makes Its Object,* New York: Columbia University Press.

Gell, Alfred (1998), *Art and Agency: An Anthropological Theory,* Oxford: Clarendon Press.

Harkin, Michael E. (2003), 'Feeling and Thinking: Towards an Ethno-history of the Emotions', *Ethnohistory,* 50: 261–84.

Holly, Michael Anne (1996), *Past Looking: Historical Imagination and the Rhetoric of the Image,* Ithaca, NY: Cornell University Press.

Howes, David (2003), *Sensual Relations: Engaging the Senses in Culture and Social Theory,* Ann Arbor: University of Michigan Press.

——— (1991), 'To Summon All the Senses', in D. Howes, ed., *The Varieties of Sensory Experience,* Toronto: University of Toronto Press.

Ingold, Tim (2000), *The Perception of the Environment: Essays on Livelihood, Dwelling and Skill,* London: Routledge.

Jackson, Michael, ed. (1996), *Things as They Are: New Directions in Phenomenological Anthropology,* Bloomington: Indiana University Press.

Jay, Martin (1988), 'Scopic Regimes of Modernity', in Hal Forster, ed., *Vision and Visuality,* Seattle: Bay Press.

——— (1993), *Downcast Eyes,* Berkeley: University of California Press.

Jenks, Chris, ed. (1995), *Visual Culture,* London: Routledge.

Jones, Amelia, ed. (2003), *The Feminism and Visual Culture Reader,* London: Routledge.

Keene, Webb (2005), 'Signs Are Not the Garb of Meaning: On the Social Analysis of Material Things', in D. Miller, ed., *Materiality,* Durham, NC: Duke University Press.

Kittler, F. (1999), *Gramophone, Film, Typewriter,* translated and with intro by Geoffrey Winthrop-Young and Michael Wutz, Stanford, CA: Stanford University Press.

MacDougall, David (2006), *The Corporeal Image: Film Ethnography and the Senses,* Princeton, NJ: Princeton University Press.

Marks, Laura E. (2000), *The Skin of the Film: Intercultural Cinema, Embodiment and the Senses,* Durham, NC: Duke University Press.

Merleau-Ponty, M. (1958), *Phenomenology of Perception,* tr. Colin Smith, London: Routledge.

Milton, Kate, and M. Svašek, eds (2005), *Mixed Emotions: Anthropological Studies of Feeling,* Oxford: Berg.

Mirzoeff, Nicholas, ed. (2002), *The Visual Culture Reader,* 2nd edn, London: Routledge.

Mitchell, W.J.T. (1986), *Iconology: Image, Text, Ideology,* Chicago: Chicago University Press.

———(1994), *Picture Theory: Essays on Verbal and Visual Representation,* Chicago: Chicago University Press.

———(2003), 'The Obscure Object of Visual Culture: A Response to Meike Bal', *Journal of Visual Culture,* 2(2): 249–52.

———(2005a), 'There Are No Visual Media', *Journal of Visual Culture,* 4(2), 257–66.

———(2005b), *What Do Pictures Want?: The Lives and Loves of Images,* Chicago: University of Chicago Press.

Ong, Walter (1991), 'The Shifting Sensorium', in D. Howes, ed., *The Varieties of Sensory Experience,* Toronto: University of Toronto Press.

Pinney, Christopher (2001), 'Piercing the Skin of the Idol', in C. Pinney and N. Thomas, eds, *Beyond Aesthetics,* Oxford: Berg.

———(2004), *Photos of the Gods,* London: Reaktion.

Plate, S. Brent (2002), *Religion Art and Visual Culture: A Cross-Cultural Reader,* New York: Palgrave.

Reddy, William M. (2001), *The Navigation of Feeling: A Framework for the History of Emotions,* Cambridge: Cambridge University Press.

Schwartz, V. R., and J. M. Pryzyblyski, eds (2004), *The Nineteenth-Century Visual Culture Reader,* New York: Routledge.

Sobchack, V. (1992), *The Address of the Eye: A Phenomenology of Film Experience,* Princeton, NJ: Princeton University Press.

Stafford, Barbara Maria (1997), *Good Looking: Essays on the Virtue of Image,* Cambridge, MA: MIT Press.

Stoller, Paul (1989), *The Taste of Ethnographic Things,* Philadelphia: University of Pennsylvania Press.

Taussig, Michael (1993), *Mimesis and Alterity: A Particular History of the Senses,* New York: Routledge.

Part 2. Labyrinth

Figure 2 (overleaf) Repulped paper printed with gold Indigo Electro Ink at × 500 magnification. Photographer: Anna Fricker. Reproduced by courtesy of the MATAR Research Centre, University of the Arts London.

This exploration of visual sense begins with the idea of sight as a dense experience, physiologically, intellectually and experientially. The Readings are gathered around the motif of the labyrinth, a tangled and at times seemingly dense and impenetrable mass of ideas and things, material and spiritual, which can baffle with its immensity, complexity and sensory ambiguity. Visually ambiguous encounters encompass a wide range of confrontations, from entire worlds that confuse the visual sense with their complexity to singular objects that threaten to overwhelm the visual faculties through their power or brilliance. Sight here, then, becomes both an experience of this world and a guide through it.

Whatever the nature of such encounters, the moment of sensory confusion is the point at which the visual suddenly becomes a labyrinth of possible meanings of which sense needs to be made. All the Readings in this section point to various ways in which human beings make sense of this labyrinth at the interface of meaning and failure of sensory cognition. They present, for instance, examples of the world's complexity not making sense and responses to that experience or condition. The source of visual confusion is engaged with here and captured by the powers of the human imagination or the intuitive faculties rather than by modes of empirical analysis as the labyrinth made comprehensible through various modes of myth making—fantasy, attribution of extraordinary qualities, litigation or outright veiling of that which eludes satisfactory capture by the visual sense.

The section is introduced by an extract from philosopher Maurice Merleau-Ponty's classic on the phenomenology of visual meditations on the deep textural and tactile qualities of seeing the physical world. It gently introduces the idea of the formal complexities of the visual sense which, for him, is an entanglement of the sensory and the material labyrinth that is the world. It is in the complexity of this entanglement that sensory ambiguity lies, for it may in turn give rise to various myths or cultural assumptions about the visual object as a way of normalising the anomalous or incomprehensible. An illustration here of such myth making is Alain Grosrichard's perceptive psychoanalytic deconstruction of European myths about the complex political economy which underpinned and enabled the organisation of the Ottoman harem. The very labyrinthine quality of the spatial, human and sensory relational dynamics that was the Ottoman harem baffled European understandings of power. It resulted in simplifications and misreadings that allowed Europeans to construct, for example, essentialising images that became lasting and stereotypical Western myths about the Orient, such as the sultan as a despotic ruler.

Following these essays are two pieces that focus on the early Christian world. As such they go back, as it were, to key sites and moments in the construction of Western cultural formations of vision and sight. Both cultural historian Suzannah Biernoff's

study of philosophical debates in the European Middle Ages, which dynamically engaged with the nature of the material and physical body, and Moshe Barasch's piece on the blind in the early Christian world engage with the idea of the extraordinary powers attributed to human sight. While embodied intensity is key to Biernoff's essay on the centrality of sight in debates on understanding and perceiving the divine nature of the human body, Barasch's piece tells us how the blind in early Christianity were attributed with extraordinary powers of insight that were integral to this world's understanding of the divinity of Christ. The valorisation of the absence of vision presented by Barasch's analysis reflects on the divine qualities attributed to sight itself in Christian culture, a theme which unites it with Biernoff's essay. These pieces function also as generalized meditations on the intensity generated by the human mind as it comes to terms with the power the complexity of the material world exercises on the sensory faculties.

If the preceding essays celebrate the extraordinary power of sight in making sense of an opaque world, the four essays that follow present different ways in which human beings have sought to tame the visually overwhelming. They address strong sights that cannot be accessed readily—objects that are too dazzling and powerful for the human intellect and sensorium. Patrice Caldwell's historical overview of the practice of veiling in the Mediterranean gives the lie to contemporary popular assumptions of its being intrinsically related to Islam. Instead, she argues, that practice appears to have arisen from a shared universe of ideas about sacred femininity. These were centered on goddess cults and mysteries, all of which involved veiling as a way of addressing visual intensity. All have, over time, mutated to various contemporary forms of veiling. The theme of the qualities and intensities of seeing is continued in the extract from anthropologist Alan Klima. He explores the ways in which density and intensity of seeing, focused on the decomposing corpse, are internalised in Thai Buddhism. This highly dense and visceral seeing becomes a contemplation of the nature of the unstable and equally visceral nature of the living body in ways that have implications for phenomenological Readings of the experience. A similar quality of intensity is demonstrated by another anthropologist, Howard Morphy. In an extract from his study of the symbolic and spiritual meaning of Yolngu art from Arnhem Land, Australia, he demonstrates the sacred significance of the intense visual quality of a concentrated and unique brilliance achieved through the material qualities of paint and design in ritual paintings. Also key in this example is the intensity of the creative, a theme picked up again by Readings in the *Creating* section. Susan Stewart's essay examines intensity through the consideration of the grotesque. It explores the density of exaggeration as it is expressed through the notion of the visually grotesque. This trope transforms, distances and inverts norms of making sense of the seen, something that Klima explores too but from the opposite direction, where the grotesque and disturbing are internalized, not distanced. In this it articulates the relation of self and other, a recurring theme through this section of *Labyrinth*.

Rounding off the section is Jane Gaines's postmodern play on the theme of the double. It focuses on a lengthy litigation over copyrights to poses struck by a Jacqueline Onassis lookalike. Recalling an historical photograph of Jackie O, the poses were used in an advertisement. What is significant for our contexts here is that the debate alerts one to the way in which the visual properties of an object can at once be fixed by a realist medium of visual reproduction such as photography and yet can be put under playful doubt by the lookalike, causing enormous cultural trouble. The lookalike threatens to put a settled case of visual clarity onto the edge of the confusion of the visual labyrinth signaled by Jackie's double. Like the reading on veiling by Caldwell, but with very different effect, this essay reveals cultural assumptions about density of visibility and nonvisibility.

While density in many cases lies at the boundaries and extremes of vision, such as blindness or incomprehensibility, all the essays can be read as engaging with a vision which is variously embodied, multi-sensory and even visceral. The elements of intensity and experience which emerge in these Readings are not necessarily confined to the sensory intensity of labyrinth but instead resonate through the other sections of the Reader. For instance, *Ordering* might also be understood as a response to the *Labyrinth,* as might *Creativity.* Consequently they should be read in conjunction with them.

The Intertwining—The Chasm
Maurice Merleau-Ponty

The visible about us seems to rest in itself. It is as though our vision were formed in the heart of the visible, or as though there were between it and us an intimacy as close as between the sea and the strand. And yet it is not possible that we blend into it, nor that it passes into us, for then the vision would vanish at the moment of formation, by disappearance of the seer or of the visible. What there is then are not things first identical with themselves, which would then offer themselves to the seer, nor is there a seer who is first empty and who, afterward, would open himself to them—but something to which we could not be closer than by palpating it with our look, things we could not dream of seeing "all naked" because the gaze itself envelops them, clothes them with its own flesh. Whence does it happen that in so doing it leaves them in their place, that the vision we acquire of them seems to us to come from them, and that to be seen is for them but a degradation of their eminent being? What is this talisman of color, this singular virtue of the visible that makes it, held at the end of the gaze, nonetheless much more than a correlative of my vision, such that it imposes my vision upon me as a continuation of its own sovereign existence? How does it happen that my look, enveloping them, does not hide them, and, finally, that, veiling them, it unveils them?[1]

We must first understand that this red under my eyes is not, as is always said, a *quale,* a pellicle of being without thickness, a message at the same time indecipherable and evident, which one has or has not received, but of which, if one has received it, one knows all there is to know, and of which in the end there is nothing to say. It requires a focusing, however brief; it emerges from a less precise, more general redness, in which my gaze was caught, into which it sank, before—as we put it so aptly—*fixing* it. And, now that I have fixed it, if my eyes penetrate into it, into its fixed structure, or if they start to wander round about again, the *quale* resumes its atmospheric existence. Its precise form is bound up with a certain wooly, metallic, or porous [?] configuration or texture, and the *quale* itself counts for very little compared with these participations. Claudel has a phrase saying that a certain blue of the sea is so blue that only blood would be more red. The color is yet a variant in another dimension of variation, that of its relations with the surroundings: this red is what it is only by connecting up from its place with other reds about it, with which it forms a constellation, or with other colors it dominates or that dominate it, that it attracts

or that attract it, that it repels or that repel it. In short, it is a certain node in the woof of the simultaneous and the successive. It is a concretion of visibility, it is not an atom. The red dress a fortiori holds with all its fibers onto the fabric of the visible, and thereby onto a fabric of invisible being. A punctuation in the field of red things, which includes the tiles of rooftops, the flags of gatekeepers and of the Revolution, certain terrains near Aix or in Madagascar, it is also a punctuation in the field of red garments, which includes, along with the dresses of women, robes of professors, bishops, and advocate generals, and also in the field of adornments and that of uniforms. And its red literally is not the same as it appears in one constellation or in the other, as the pure essence of the Revolution of 1917 precipitates in it, or that of the eternal feminine, or that of the public prosecutor, or that of the gypsies dressed like hussars who reigned twenty-five years ago over an inn on the Champs-Elysées. A certain red is also a fossil drawn up from the depths of imaginary worlds. If we took all these participations into account, we would recognize that a naked color, and in general a visible, is not a chunk of absolutely hard, indivisible being, offered all naked to a vision which could be only total or null, but is rather a sort of straits between exterior horizons and interior horizons ever gaping open, something that comes to touch lightly and makes diverse regions of the colored or visible world resound at the distances, a certain differentiation, an ephemeral modulation of this world—less a color or a thing, therefore, than a difference between things and colors, a momentary crystallization of colored being or of visibility. Between the alleged colors and visibles, we would find anew the tissue that lines them, sustains them, nourishes them, and which for its part is not a thing, but a possibility, a latency, and a *flesh* of things.

If we turn now to the seer, we will find that this is no analogy or vague comparison and must be taken literally. The look, we said, envelops, palpates, espouses the visible things. As though it were in a relation of pre-established harmony with them, as though it knew them before knowing them, it moves in its own way with its abrupt and imperious style, and yet the views taken are not desultory—I do not look at a chaos, but at things—so that finally one cannot say if it is the look or if it is the things that command. What is this prepossession of the visible, this art of interrogating it according to its own wishes, this inspired exegesis? We would perhaps find the answer in the tactile palpation where the questioner and the questioned are closer, and of which, after all, the palpation of the eye is a remarkable variant. How does it happen that I give to my hands, in particular, that degree, that rate, and that direction of movement that are capable of making me feel the textures of the sleek and the rough? Between the exploration and what it will teach me, between my movements and what I touch, there must exist some relationship by principle, some kinship, according to which they are not only, like the pseudopods of the amoeba, vague and ephemeral deformations of the corporeal space, but the initiation to and the opening upon a tactile world. This can happen only if my hand, while it is felt from within, is also accessible from without, itself tangible, for my other hand, for

example, if it takes its place among the things it touches, is in a sense one of them, opens finally upon a tangible being of which it is also a part. Through this criss-crossing within it of the touching and the tangible, its own movements incorporate themselves into the universe they interrogate, are recorded on the same map as it; the two systems are applied upon one another, as the two halves of an orange. It is no different for the vision—except, it is said, that here the exploration and the information it gathers do not belong "to the same sense." But this delimitation of the senses is crude. Already in the "touch" we have just found three distinct experiences which subtend one another, three dimensions which overlap but are distinct: a touching of the sleek and of the rough, a touching of the things—a passive sentiment of the body and of its space—and finally a veritable touching of the touch, when my right hand touches my left hand while it is palpating the things, where the "touching subject" passes over to the rank of the touched, descends into the things, such that the touch is formed in the midst of the world and as it were in the things. Between the massive sentiment I have of the sack in which I am enclosed, and the control from without that my hand exercises over my hand, there is as much difference as between the movements of my eyes and the changes they produce in the visible. And as, conversely, every experience of the visible has always been given to me within the context of the movements of the look, the visible spectacle belongs to the touch neither more nor less than do the "tactile qualities." We must habituate ourselves to think that every visible is cut out in the tangible, every tactile being in some manner promised to visibility, and that there is encroachment, infringement, not only between the touched and the touching, but also between the tangible and the visible, which is encrusted in it, as, conversely, the tangible itself is not a nothingness of visibility, is not without visual existence. Since the same body sees and touches, visible and tangible belong to the same world. It is a marvel too little noticed that every movement of my eyes—even more, every displacement of my body—has its place in the same visible universe that I itemize and explore with them, as, conversely, every vision takes place somewhere in the tactile space. There is double and crossed situating of the visible in the tangible and of the tangible in the visible; the two maps are complete, and yet they do not merge into one. The two parts are total parts and yet are not superposable.

Hence, without even entering into the implications proper to the seer and the visible, we know that, since vision is a palpation with the look, it must also be inscribed in the order of being that it discloses to us; he who looks must not himself be foreign to the world that he looks at. As soon as I see, it is necessary that the vision (as is so well indicated by the double meaning of the word) be doubled with a complementary vision or with another vision: myself seen from without, such as another would see me, installed in the midst of the visible, occupied in considering it from a certain spot. For the moment we shall not examine how far this identity of the seer and the visible goes, if we have a complete experience of it, or if there is something missing, and what it is. It suffices for us for the moment to note that he who sees cannot

possess the visible unless he is possessed by it, unless he *is of it,** unless, by principle, according to what is required by the articulation of the look with the things, he is one of the visibles, capable, by a singular reversal, of seeing them—he who is one of them.†

We understand then why we see the things themselves, in their places, where they are, according to their being which is indeed more than their being-perceived—and why at the same time we are separated from them by all the thickness of the look and of the body; it is that this distance is not the contrary of this proximity, it is deeply consonant with it, it is synonymous with it. It is that the thickness of flesh between the seer and the thing is constitutive for the thing of its visibility as for the seer of his corporeity; it is not an obstacle between them, it is their means of communication. It is for the same reason that I am at the heart of the visible and that I am far from it: because it has thickness and is thereby naturally destined to be seen by a body. What is indefinable in the *quale,* in the color, is nothing else than a brief, peremptory manner of giving in one sole something, in one sole tone of being, visions past, visions to come, by whole clusters. I who see have my own depth also, being backed up by this same visible which I see and which, I know very well, closes in behind me. The thickness of the body, far from rivaling that of the world, is on the contrary the sole means I have to go unto the heart of the things, by making myself a world and by making them flesh.

Notes

1. EDITOR: Here in the course of the text itself, these lines are inserted: "it is that the look is itself incorporation of the seer into the visible, quest for itself, which *is of it,* within the visible—it is that the visible of the world is not an envelope of *quale,* but what is between the qualia, a connective tissue of exterior and interior horizons—it is as flesh offered to flesh that the visible has its aseity, and that it is mine—The flesh as *Sichtigkeit* and generality. → whence vision is question and response.... The openness through flesh: the two leaves of my body and the leaves of the visible world.... It is between these intercalated leaves that there is visibility.... My body model of the things and the things model of my body: the body bound to the world through all its parts, up against it → all this means: the world, the flesh not as fact or sum of facts, but as the locus of an inscription of truth: the false crossed out, not nullified."

* The *Uerpräsentierbarkeit* is the flesh.
† The visible is not a tangible zero, the tangible is not a zero of visibility (relation of encroachment).

–2.3–

Labyrinthine Complexities: The Ottoman Harem as Seen by Western Orientalists
Alain Grosrichard

The Eye of Asia

The Turk had been a vague source of terror ever since the Crusades. But with the taking of Byzantium on 2 April 1453 by Mehmet II, the Ottoman Empire set itself down at the gates of Europe, to which it would be a constant military threat for more than two centuries. For the sixteenth-century European he would be a fearsome—not to say hated—though respected enemy; he was feared for a power that derived from the courage and discipline of his armies and the burning faith that drove them. One is struck by this strong and effective regime in which political, military and religious powers were combined in the hands of a single man, the Great Lord, of whom the first Western ambassadors have sketched portraits to fire the imagination.[1] Even those who pronounce themselves horrified by a religion of which little is known, whose traditions, partly inherited from Byzantium, emerge with the most caricatured features, can still admire the tolerance which reigns in those countries conquered by the Turks at a time when Europe was tom by religious wars.[2]

'This Aesopian Crow...'

From the seventeenth century onwards, however, things change. The external threat remains, but it is judged differently; journeys to the Levant are made more frequently, the sojourns are longer and the accounts of them which appear are increasingly numerous and better informed. Progress is made in learning the history and geography of this empire[3] and the customs of its inhabitants. Efforts are also made to understand the nature of the political regime and the sources of a power which until then had been encountered only through its external manifestations.

It is, though, a regime already in decline, and threatened from within, which travellers are in the process of discovering. While the Ottoman sultans of the sixteenth century took an active lead in the affairs of the Empire, those who were to follow them would on the whole become detached from it and would not venture from their palaces, where they would remain under the sway of women or favourites. Bloody

revolts multiplied; in the course of the seventeenth century, four sultans would be deposed or assassinated. Mantran notes[4] that between January 1644 and September 1656 seventeen grand viziers would succeed one another, with only one of them dying a natural death.

At one and the same time, without ceasing to be feared, Ottoman might became an enigma. 'It is a torrent, threatening us unceasingly, which has far overflowed and is making ready to flood the whole of Europe, as it has done the greater part of Asia …', wrote Jean Coppin in 1665.[5] In his eyes, such savagery was justification for a new crusade, which was long overdue. Like Pierre l'Ermite before him, he addressed himself to 'all the rulers of Christendom':

> How can you suffer with untroubled spirit that a brutal and barbarous nation should insolently sully with its abominations a land honoured with the sacred relics of the son of God? … Providence has allowed Turks to heap victory upon victory only in order to awaken your zeal, and the same justice which has punished the sins of Christendom with the laying waste of so many Provinces is not insensible to the voice of their iniquity which cries out unceasingly before it, and can scarce any longer delay the dreadful punishments which are merited by so many vices and impieties.[6]

In his eyes, victory is certain if the Christian princes will agree to unite and readily heed the plan of war which he is offering them. For the vaunted Ottoman might is moribund: 'it lays itself open to ruin through the vastness of its territories and the extreme nature of its tyranny'. Referring to the sultan, La Boullaye le Gouz had already written: 'the Christian princes could easily pluck this Aesopian crow, were they but willing to recognize its flaws'.[7] It seems, therefore, that the Ottoman regime maintains itself only by a miracle. It is a challenge to political reason, and its existence can be explained only as something decreed by Providence, whose will it was both to punish the Christians for their divisions and to give them the opportunity to redeem themselves by annihilating this monster. This is a theme also taken up by Ricaut at the beginning of his *Histoire de l'état présent de l'Empire Ottoman,* which would be one of Montesquieu's major sources:

> When I look closely at the constitution of the government of the Turks, and I see a power that is utterly absolute in an Emperor who is without reason, virtue or merit, whose commandments, however unjust they be, are Laws; whose actions, although suspect, are exemplary; and whose judgements, especially in affairs of State, are decisions which cannot be opposed. When I consider further that among them there is so little reward for virtue, and so much impunity for vices, from which profit is rendered to the Prince; in what manner men are suddenly elevated by the flattery, the whim and the mere favour of the Sultan to the greatest, most notable and most honourable offices of the Empire, with neither birth, nor merit, nor any experiences of the affairs of the world. When I consider how short a time they remain in such eminent offices, how the Prince has them put to death in the blink of an eye; how eagerly and urgently they hasten to acquire riches, more than any of the peoples of the world, while knowing that their riches are their chains, and

that they finally must be the cause of their ruin and their downfall ..., I cannot but attribute its steadfast endurance within and the fortunate successes of its arms without more to some supernatural cause than to the wisdom of those who govern it; as if God, who does all things for the best, had aroused, raised up and upheld this mighty nation for the good of his Church and to punish the Christians for their sins and their vices.[8]

When we read this page we can tell just how much the European observer of the second half of the seventeenth century saw the Ottoman regime as having become the overriding image of political monstrosity. *Despotism*—to give this monstrosity the name which it would bear henceforth—truly is a monster in so far as, being explicable only as some transcendental plan of Providence, it stands simultaneously as the threat of punishment and as a call to order (this being, moreover, in keeping with the interpretation of monstrosity offered by a long theological tradition). But the threat it contains, for all that it is geographically close and chronologically imminent, still remains an external one. It is a threat of aggression, not of subversion. And there are ready arguments, as old as the West itself, to provide reassurance on this point. Ricaut himself writes: 'One need not be surprised that [the Turks] are happy in servitude and that they live gladly under tyranny, since for them this is as natural as it is for a body to live and to be nourished on the food to which it has been accustomed since childhood.'[9] Since it is therefore from a natural necessity that people in those parts have given themselves over to servitude, the same natural necessity which has created different conditions in Europe will preclude things from being the same among us.

'The Spy at Court ...'

Very quickly, however, this external threat will appear as if it were also, and even primarily, an internal one. The security that Europe found for itself in the monstrosity of Asiatic despotism gives way to an increasingly insistent anxiety about the nature and future of the monarchy—that political power to which it had laid claim as its own; the proliferating travels of ambassadors, merchants and missionaries, and the accounts of these which they published, enabled the accumulation of varied but concurring information about Oriental regimes, and attempts were made to understand them by seeking to find in them disguised or denatured versions of politico-social structures familiar in Europe. Tavernier writes, for example:

In the State of Persia we can identify, as in almost all the states of Europe, three distinct bodies or ranks. The first is that of the sword, which corresponds to the nobility and includes the house of the King, the Khans or provincial governors and all of the army command. The second is that of the pen, which embraces those who are concerned with the law and the courts, and the third is like our Third Estate, made up of Merchants, Artisans and Labourers.[10]

Bernier and Chardin do likewise, looking for equivalents in terms and in functions, striving always for understanding by comparing the unknown with the known, and foreign conduct with familiar rules. These are ethnocentric prejudices, but they endow the differences which are brought out by analogies (statutes regarding property and the family, the role of priests, sexual relations, etc.) with the significance of possible perversions, and therefore of internal threats to the political and social system which is the point of reference.

These threats seem the more stark the more the European monarchies—the French monarchy very much so—indicate a tendency to absolutism, centralization and arbitrary rule. This is a reverse movement from the earlier one, this time impelling the example of the regimes of Asia as a reference to draw analogies with the actual state of monarchies, and to draw conclusions on the fate in store for them. As if, by learning to decipher the structures of an impossible power from the outside, Europeans were discovering that they had equipped themselves with the best key for interpreting their own present. An endoscopic fantasy, in a sense, one in which novels and drama would find an inexhaustible source.[11] The opening up of the seraglio, with its violent or unnatural amours, its mutes and eunuchs, its blind princes and veiled sultanas—a space in which pleasure and death are experienced within a time made up only of disconnected moments without duration, a master who is ever absent and everywhere present, and above all that language of silence, absurd yet supremely effective, consisting of signs which refer only to themselves: this is the stripping bare (a nudity of dream or delirium) of what the whole century fears and, perhaps, secretly desires.

It might be said that the same goes for travels among the savages of the New World, and Bougainville would also provide Diderot with the stuff of dreams. Certainly—and we shall see later how the West Indies manage eventually to meet the East Indies in the imagination. But there is at least one point where this symmetry fails: it is that we can see ourselves in the Turk or the Persian, and they can see themselves in us. But the Savage disappears, and as for us, we can no longer find ourselves upon his island.

Thus, while the despotic Orient is indeed the *Other* held up for us to see, it is also the one that *regards* us, in every sense of that word. Ever since the envoy from the Sublime Porte visited Louis XIV in 1669, the gaze of the Oriental has haunted France and Paris.[12] And this vast literary output (which keeps on growing up until the middle of the eighteenth century) is not just the mere result of fashion (or at least, it demands explanation). From the 'Turkish spy'[13] to the 'Chinese spy',[14] how many spying eyes have been imagined in order to strip us of our own secrets! Have we inquired deeply enough into the strange and complex relation that is at the root of this literature's success? An entire century took pleasure in making itself seen through what it burned to go and see; in revealing to itself the truth about its princes, its obeisances, its way of making love—in short, all its madness—through the artifice of a gaze which, it tells itself, is foreign. This gaze, which to me is other, knows more about me than I do myself. And when I attempt to go and look behind what I believe

to be the point from which, over there in that other world, it looks at me, it is myself and our world that I find in the end.

. . .

The Two Definitions of Despotic Power

Putting Out Eyes

A despotic government offers itself, as it were, at first sight.[15] If we want an accurate idea of the function of the gaze in the economy of despotic power, we need only comprehend this definition by Montesquieu in all its meanings, first of all in the strictest meaning: the despot puts out eyes:

> There is a very specific thing in Persian Law, which is that the law of the State directs that no blind man should be raised to the throne. Although there are those who maintain that this law should be understood in a moral sense, it has been used to uphold the prevailing custom in Persia of blinding male children of royal blood.[16]

Therefore, to be master is to see. The despot can be stupid, mad, ignorant, drunk or diseased, but what does it matter so long as he sees. Not seeing means being condemned to obey. Under the despotic regime, where obedience is always 'blind', the blind man is the emblematic figure of the subject.

Xenophon said of Cyrus: 'The good ruler he regarded as a law with eyes for men, because he is able not only to give commandments but also to see the transgressor and punish him',[17] and he recounts how the King of Persia established the policing of his realm by multiplying spies throughout its length and breadth.[18] Things do not seem to have changed at all since then. Tavernier notes that the 'superintendent of all the King's property' is called the *Nazar,* which means the 'Seer'. In the Persia crossed by Paul Lucas or Chardin, everywhere they feel 'the eyes of the King' directed upon them; this is the phrase the Persian language uses to designate spies. But it is not merely a question of spies; wherever one is in the despotic space, one can never know whether it is the eye of the master himself that watches. In Turkey, according to Gedoyn, the Great Lord can be present at ordinary meetings of the Divan, 'through a trellised window looking into the room, by which means he holds his officers in a state of fear and stricture, always with the suspicion that their master is present at their deliberations'.[19] But it is in his power to watch anyone anywhere—for example, by assuming the guise of an anonymous passer-by in a Constantinople street. Thévenot tells us:

> Sometimes he would go to a baker's, where he would buy bread; and sometimes to a butcher's, where he would buy a piece of meat; and one day, when a butcher had tried to sell him meat above the price that he had set, he signalled to his executioner, who cut off the butcher's head straight away.[20]

Oriental despotism is the empire of the gaze which is simultaneously everywhere and nowhere, unique and without number.

The gaze as master, in the first place because he is the master of the gaze. From his seraglio, Amurat would watch what was happening outside 'with an excellent telescope which had been the gift of the Venetians; and one day when he was engaged upon this, as was his custom, he saw in Pera a man who was also looking through a telescope at the sultans who, at that moment, were walking in the garden'.[21] Whereupon he sent his mutes to kill him and hang him from his far-off window, in offering to the gladdened eye of the sultan. The blinding of royal children in the seraglio at Ispahan is the exemplary illustration of this mastery of the gaze; it is precise but simple work, demanding not so much the skill of the goldsmith or the surgeon as the care of the zealous servant preparing some delicacy for his master. And it is not the eye—the organ and the envelope of sight—which he brings him, but the pupil: the gaze itself. This is mastery attained, probably the master's crowning *jouissance,* for he can gaze upon the gaze itself as he holds it in his hands.

True service, therefore, means showing the master that he holds the monopoly of the gaze. In the early seventeenth century, Michel Baudier made the point that in the seraglio at Constantinople—'now the principal seat of the arrogance of Princes'— any man who dares to lift his eyes and gaze upon the visage [of the Great Lord] is guilty of a great crime, so that all the bashaws of the Court, with the exception of the Vizier, the Mufti and the doctor, have their hands joined and their eyes lowered as they make their way to revere, or rather to adore him; and in this posture, bowing deeply to the ground, they greet him without setting eyes upon him, although he is before them.[22]

The same thing was repeated by Du Vignau, at the end of the century: the Turks 'take care never to fix their eyes upon those of His Highness, nor even anywhere close to his face.... They must not be so bold as to look upon him, and it is enough that they be looked at.[23] The same goes for Siam: 'If the King should appear, all doors and windows must be closed, and all the people prostrate themselves upon the ground without daring to cast their eyes upon him.'[24]

With this power over the gaze, the master can and does make play with it. Although he is all-seeing but invisible, he does show himself. But the appearance of the despot always comes down to a matter of theatrical staging.[25] Cyrus knew that grandeur is a thing of artifice and optical illusion when he adopted Median dress:

for he thought that if anyone had any personal defect, that dress would help to conceal it, and that it made the wearer look very tall and very handsome. For they have shoes of such a form that without being detected the wearer can easily put something into the soles so as to make him look taller than he is. He encouraged also the fashion of penciling the eyes, that they might seem more lustrous than they are, and of using cosmetics to make the complexion look better than nature made it.[26]

As for the Great Mogul, he gives audience on certain days:

> The King sitts in a little gallery over head; ambassidors, the great men and strangers of
> qualety within the inmost rayle under him, raysed from the ground, covered with cano-
> pyes of velvet and silke … the meaner men representing gentry within the first rayle, the
> people without in a base court, and soe that all may see the King. This sitting out hath soe
> much affinitye with a theatre.[27]

This calculated representation of the despot has, moreover, a solemnity and reg-
ularity which makes it akin to some astronomical phenomenon.[28] In Ethiopia, the
despot shows himself only four times a year, and that veiled. According to Gaultier
Schouten, the king of Arraka appeared only every five years, at the full moon of
the last month in that year. And Thomas Roe describes the appearance of the Great
Mogul twice a day at a window of his palace overlooking a great square where the
people would assemble to see him: 'For, as all his subjects are slaves, so is he in a
kynd of reciprocall bondage, for he is tyed to observe these howres and customes
so precisely that, if hee were unseene one day and noe sufficient reason rendred, the
people would mutinie.'[29] The despot bends to laws as strict as those of nature. But
nature itself seems to obey him in return—as in Japan, where, before the motionless
Dairi, 'his smallest movements and gestures were observed and from them predic-
tions would be made of whether the day would be a happy or an unhappy one; ac-
cording to the season and according to the circumstances of the time, his movements
were also regarded as presaging plenty or barrenness, peace or war',[30] or again as in
Siam, where the king can lower the waters of the river with one look.[31]

Chardin writes: 'the Kings in Persia and the rest of the Orient are kings for dis-
play'. But they are so, one might say, *through* display. Whether he appears, at regular
intervals, framed by a window, or hides; whether it is obligatory to show oneself to
him when he emerges, or instead prostrate oneself out of sight—the despot tends
always to be constituted as a pure 'being of the gaze', simultaneously peripheral
and central, enclosing and enclosed, since he is this gaze which is imagined to look
upon everyone else, and this unique gaze which, from the centre of the Palace, is cast
down upon the City, the Empire and the World.

Despotic power is therefore characterized by what is 'at first sight'—in every
sense, if we are willing to go along with the semantic game for which Montesquieu's
definition provides the opportunity. But there is a second definition which we find
in Montesquieu, one which emphasizes another, equally characteristic feature of this
kind of power.

'The Will of a Billiard Ball'

'When once the prince's will is made known, it ought infallibly to produce its ef-
fect,'[32] writes Montesquieu, 'just as one billiard ball hitting another must produce its

effect'—a new metaphor, deliberately borrowed from a Cartesian universe, and one whose pertinence we ought now to value.

As the empire of the gaze, it is not surprising that despotism is also the empire of signs. As Rousseau wrote: 'The most vigorous speech is that in which the Sign has said everything before a single word is spoken. Tarquin, Thrasybulus lopping off the heads of the poppies ...'.[33] But there is an even more vigorous form of speech, where the sign itself is exhausted in the very materiality of the signifier. 'Alexander putting his ring to his favourite's mouth'—here is the true language of the Absolute Master: the one where the sign has said everything, without it even being necessary, or even possible, to follow it with spoken words that would interpret it. Not because its meaning is clear, but because it has no meaning. Using the language of 'signs', even to signify death, is to allow the existence of an interpreter, who might betray, even in explaining the order, thereby legitimating it, and causing the master to seem dependent on something other than himself (truth, law) and subject at least to reason: 'In a despotic government, it is equally pernicious whether they reason well or ill; their reasoning is alone sufficient to shock the principle of that government.'[34] It seems that the more arbitrary an order is, the more it is obeyed, as if the only thing that mattered was its materiality as signifier, stripped of all other reference but itself: 'As soon as the Prince commands, everything he says is done straight away, and even when he knows not what he does nor what he says, as when he is drunk.'[35] Which is to say that the despot's very person matters little; obedience is given less to this person than to the signifier of his will. There is no doubt that the despot is master of the signifier, as he is of the gaze, and he is master through the signifier, as he is through the gaze. But we have to go further. A moment ago the master merged with the gaze itself; now he merges with the signifier.

We said earlier that obedience to the despot is 'blind'. Despotic states need vast desert plains: transparent space without obstacles, without secrets, open on every side to the gaze. Let us add that this space is a silent desert. Noise is an obstacle to the power of the signifier, which can circulate well—without interference—only in silence. Obviously, there is little difficulty in establishing this silence in those vast deserts. What is striking, though, is that it holds equal sway in the city. According to the majority of the travellers, Constantinople is the biggest city in Europe, even more populous, they say, than Paris.[36] Yet Tournefort states: 'there is more noise made in a single day in a Paris marketplace than in a whole year in the entire city of Constantinople'.[37] Enter the first courtyard of the seraglio, where a crowd presses close: 'You could hear a pin drop, so to speak, and if someone broke the silence with a voice just slightly raised ... he would be beaten with sticks straight away by the officers on patrol; it seems that even the horses know their place....'[38]

Although his ears, like his eyes, are imagined to be everywhere, the despot is not spoken to, and words are always and only addressed to the one among his servants who has the privilege of passing on the message.[39] Whatever the content or meaning of the message, it is not that what might be said would be likely to displease. The

prohibition has nothing to do with the meaning, but with the very employment of speech. Taking the initiative, even in order to tell the master that one loves him or one is his slave, would already constitute revolt, since the subject is therefore flaunting his claim to dispose likewise of the signifier. As Usbek wrote, in despotism: 'there is never a minor rebellion, nothing between protest and insurrection'.[40]

As for the despot himself, when he opens his mouth it is to make his voice heard, but never with meaning. Since it has no reference to anything other than itself, the word of the despot is not meant to be understood, verified or legitimated; with every instance it creates a new truth, just as it posits a new law, as valid for nature as for his subjects. When the sultan sails out on the sea in his ceremonial vessel:

> he savours long and deep the flattering pleasure of seeing a multitudinous people that obeys his voice, and this awesome element subordinate to his laws and, it would seem, holding back the fury of its waves, so that its calm surface might express the respect due to his might.[41]

This is why no dialogue is introduced between the despot and his subjects; there are no misunderstandings to be clarified, no consequent meanings to interpret, no time for understanding. Thus no answer is ever given to the despot; he is *echoed*. Each word he releases comes back to him, multiplied and magnified by a thousand mouths. The answer is always there already in the proposition put forward, however absurd it may be—precisely because it is absurd: 'If the King says at noon that it is night, it must be said that the Moon and the Stars are up in the sky.'[42]

The voice of the master can stupefy to this degree only because he is sparing of it.[43] It resonates as the gaze makes itself visible—in flashes, between two silences. The shorter the flash, the better it works. The outcome is that in order to make himself heard, the best thing of all is for the despot never even to open his mouth: 'To be a good Sultan, one must never speak, but by one's extraordinary gravity, make men tremble with a blink of an eye.'[44] By its fleeting interruption of the gaze which is fixed upon you, the blink of an eye, which sends death, is probably the master signifier in its pure state.

The Flying Letter

But in the despotic world, absolute power is exercised usually by means of the graphic signifier: 'The Ottoman kings convey their commands almost always in writing, and the style which they use in writing is very particularly theirs', observed Baudier.[45] Chardin points out that in Persia the king is always accompanied by his 'chief scribe' (the *Douader*), who goes around with a roll of paper on his person, ready to 'write down straight away everything which the King tells him to'.[46] The fact is that in Muslim Asia the respect given to the letter *per se* is extreme. All the more so when the letter is guaranteed as issuing from the king by the mark of the Great

Seal—which in Persia is hidden in a casket within the seraglio, with the queen mother as its titular custodian. And the Persians considered it 'a great impudence, and indeed disrespect, to touch the King's Letters. They enclose these letters of their King in pearl-embroidered bags or in some other way, for fear that hands will touch them.'[47]

Later, we shall consider the reasons which authors of the period give to explain this extraordinary power of the written word in the Ottoman and Persian regimes.[48] For now, let us merely stress the wonderful effects of these written orders [*Hatchérif*] which, says Du Vignau: 'were the principal means for preserving Ottoman authority, since a sheet of paper with five or six lines on it written in the hand of His Highness, does more than could substantial armies'.[49] It is as if the signifier itself flies, strikes and kills by being materialized in the letter. It is at one and the same time the sentence, the axe and the executioner. Unleashed from a single central spot and carried by a messenger whose prototype is a mute from the Grand Seraglio, it ploughs a soundless and unimpeded furrow to reach an unfailing target which the whim of the master has set for it. For example, the death of a pasha is decided: 'A messenger arrives and shows him the order he has to bring the man's head; the latter takes this order from the Great Lord, kisses it, places it upon his head as a sign of the respect he bears for the order, makes his ablutions and says his prayers, after which he freely lays down his head.'[50] All efficacity is thus concentrated into nothing more than the material of the sign, to the point where a blank sheet of paper can be all that is needed to prompt obedience. During a revolt of the ispahis at Andrinopolis, Du Vignau records, Suleiman Aga, chief of the janissaries, 'went in the midst of the rebels, escorted only by ten janissaries, with a paper in his hand, on which nothing was written. Seizing the leader of the rebels by the neck, and showing him the paper, he said: "The Emperor commands." '[51]

But the letter can annihilate in this way because it has the power to create. In the despotic state, where all are equally nothing before the unique One who is and has everything, no grandeur of birth or merit is attached to the person. Elevation or downfall, existence itself and its obliteration, are always the effect of the signifier: 'There is no protection from the extravagances of the whim of Despots, neither in probity, nor in zeal, nor in services rendered; the passage of an idle thought, marked by a movement of the mouth or a signalling of the eyes'[52]—or, more usually, by a letter—makes and unmakes viziers and pashas, or raises a humble cook to the highest office. The only greatness is the ephemeral one conferred by *hic et nunc,* momentary preference. As Montesquieu would observe: 'if those who are not actually employed were still invested with privileges and titles, the consequence must be that there would be men in the state who might be said to be great of themselves; a thing directly opposite to the nature of this government'.[53] In other words, all the value—and the only value—that individuals have depends upon how the seal of the master is marked upon them. It needs only this simple seal to be taken away again for the subject it rendered powerful to be immediately obliterated: 'Once the death sentence has been issued by the Prince against whomsoever it be, the Turks no longer accord him any

station and when they speak of him they treat him like a dog.'[54] Charles XII told an unyielding senate in Sweden that he would send one of his boots to command them, Montesquieu records, adding: 'This boot would have governed like a despotic prince.'[55] He meant that despotic power is not shared. Nor is it delegated. To say that 'in a despotic government the power is communicated entire to the person entrusted with it'[56] is to say that it is *transmitted:* the language of the physician rather than of politics, referring not so much to a society of men jealous of their freedom as to a mechanical world peopled by machine-animals and governed only by the laws of shock. But if this power can thus be transmitted entire, without loss or friction, without the resistance of 'intermediary bodies' (like the nobility in a monarchical regime), it is because it resides always and entirely within a signifier which passes silently from hand to hand: 'The Vizier himself is the despotic prince; and each particular officer is the Vizier.'[57] But this complete transmission of power is possible only because each man is nothing in himself, and can be merged with the signifier with which the master desires to mark him and make him serve as a neutral and transitory aid. How, then, is a vizier created in the Turkey that was visited by Ricaut?

> No other ceremony is carried out that I know of ... but that of placing in his hands the seal of the Great Lord, on which the Emperor's name is inscribed and which he carries always on his person. By virtue of this seal he is invested with all the power of the Empire, and can, without formality, remove every obstacle standing in the way of his free administration.[58]

It is therefore 'in the name of the despot' that the vizier commands. 'In the name of the despot' here means strictly *through his name,* which is itself reduced to the interlaced letters inscribed on his seal.[59] This name is what allows the prince's will 'infallibly to produce its effect just as one billiard ball hitting another must produce its effect'. It slips at lightning speed along the chain which, from despot to vizier and from vizier down to the lowest of subordinates, links the centre of the Empire to its periphery. The metaphor of the billiard ball evokes the *immediacy* of the order's transmission, which means that a part of its effect is almost instantaneous, but also that what is written 'in the name of the despot' is never a *means* of saying something to someone. There probably is a message, for there is a messenger. But the message is merged here with the code, and is itself the code. In the despotic world, what circulates is a name, and what is communicated is movement, never meaning. And the laws of this world are those of shock, which delivers life or death. So that we can echo Montesquieu in saying that despotic power is exercised entire, like the power of a name: 'The inhabitants of those countries need only the name of a prince to govern them.'[60] The despot's name is itself the despot.

A world of deserts and silence, sufficiently resembling the one Descartes fashioned for himself in the Second Meditation, the better to tear himself away from it; a creation which is not 'continued' by a God whose constancy would be a proof of

benevolence, and would allow men to transform nature by dominating it, to enrich themselves and prosper—but a creation called into question at every moment by a capricious and perverse Evil Genius. Truths that are created, but with nothing to assure them, absurd and contradictory truths that are never the same, yet stand as law. And nowhere are there men ('others'), but 'hats and coats'[61] covering automata which the master's name can animate or paralyse. In other words, a world from which any kind of truly subjective relation seems to be absent, one reduced to the blind efficacity of a name—of a letter—animated by a descending centrifugal movement, and governed only by the impulse of efficient causality.

The essential feature of despotic power is a name as efficient cause—this is how we might characterize it at its most schematic if we were to rely on the travellers' accounts. But also, in a movement that is exactly the opposite of this, introducing another feature of power which this time assumes all too human relations: a gaze as final cause.

Notes

1. See, among others, A. Geufroy, *Brière Description de la cour du Grand Turc,* Paris 1543; or J. Gassot, *Le Discours du Voyage de Venise à Constantinople,* Paris 1550, who take a very severe view of the regime. More admiring descriptions of the Sultan are given by P. du Fresne-Canaye (*Le Voyage au Levant,* 1573, reprinted H. Hauser, Paris 1897) and Ogier Ghislain de Busbec, the Flemish Papal legate (*Turcicae legationis epistolae quatuor,* Paris 1581).

2. See P. du Fresne-Canaye, who was a Huguenot. Among those who defended the Turk in one way or another during the sixteenth century, along with Montaigne, we can mention Bodin, R. de Lussinge, P. Charron or Guillaume Postel (*De la République des Turcs, et, là où l'occasion s'offrira, des mœurs et lois de tous les Muhamedistes,* Cosmopolite, Poitiers 1560). Postel speaks very admiringly about the education of the young princes (I, pp. 30–37), and he is one of the few in his day to present the Muslim religion in a relatively positive light.

3. On these last points, see, among others, articles by R Derathé ('Les philosophes et le despotisme', in *Utopies et Institutions au XVII siècle*), and S. Stelling-Michaud: 'Le Mythe du despotisme oriental', *Schweitzer Beiträge zur allgemeinin Geschichte,* 18–19 (1960–61).

4. *La Vie quotidienne à Constantinople au temps de Soliman le Magnifique et de ses successeurs,* Hachette, 1965, p. 89.

5. P. Jean Coppin, *Le Bouclier de l'Europe ou la Guerre sainte,* written in 1665, published in 1686 (Lyon, Le Puy), p. 7.

6. Ibid., p. 4.

7. *Voyages et Observations du sieur de La Boullaye le Gouz, gentilhomme angevin,* Paris 1653.

8. Ricaut, *Histoire de l'état présent de l'Empire Ottoman* (London 1669), French trans., Amsterdam 1670, pp. 2, 3. This is one of the sources for Racine's *Bajazet.*

9. Ibid., p. 5.

10. Tavernier, 'Voyage en Perse', in *Voyages dans L'Indoustan ...*, 1665, vol. I, Book V, ch. 14, p. 646.

11. The copious literature on this question was catalogued and commented on by P. Martino (*L'Orient dans la littérature française au XVIIe et au XVIIIe siècle*), Hachette, 1906; M.-L. Dufrenoy (*L'Orient romanesque en France, 1704–1779,* Montreal, Beauchemin 1946); C.-D. Rouillard (*The Turks in French History, Thought and Literature,* Paris 1942).

12. 1669, the Embassy of Suleiman Muta Ferraca; 1684 and 1686, visit of ambassadors from Siam; 1715, the visit of Mehemet Riza Beg, 'ambassador' of Persia, which was a topic on everyone's lips (see M. Herbette, *Une ambassade persane sous Louis XIV;* Paris 1907); Saint-Simon describes this visit in his *Mémoires,* Hachette, 1857, p. 292).

13. In 1684, Giovanni Paolo Marana began the publication, in French, of *L'Espion du Grand Seigneur, et les relations secrètes envoyées au Divan de Constantinople, découvert à Paris pendant le règne de Louis le Grand.* This work was such a success that it was repeatedly reprinted up until 1756, with the title *L'Espion dans les cours des princes chrétiens, ou l'on voit les découvertes qu'il a faites dans toutes les cours, avec une dissertation curieuse de leur lorce, politique et religion.* Below its title, the Dutch publishers of the Persian Letters added: 'In the vein of *L'Espion dans les cours*'. See Martino, *L'Orient ...*, p. 284.

14. See, for example, Guerineau de Saint-Peravi, *L'Optique, ou le Chinois à Memphis,* Paris 1763.

15. Montesquieu, *Mes Pensées,* no. 1794, *Complete Works,* Pléiade, vol. I, p. 1429. Montesquieu kept to this formulation, which is to be found elsewhere in the Pensées (no. 1794), and in *The Spirit of Laws.*

16. Chardin, *Voyages,* vol. II, p. 214: 'The right of succession belongs to the oldest son, unless he is blind. But the king usually has the sceptre handed on to the one of his choosing, by blinding his eldest sons.'

17. Xenophon, *Cyropaedia,* trans. Walter Miller (2 vols), Loeb Classical Library, London: Heinemann, Cambridge, MA: Harvard University Press, 1914 (reprinted 1968), p. 317.

18. Ibid., III, ch. 2.

19. *Journal et Correspondance* de Gedoyn 'le Turc' (1623–25), Paris, 1909, p. 127.

20. G. Thévenot, *Voyages ... en Asie et en Afrique,* Paris 1989. See also Ricaut, *Histoire,* ch. 11, French translation, p. 89.

21. Jean Dumont, Baron de Carlscroon, *Nouveau Voyage du Levant ...*, The Hague 1694, letter XIII, p. 194.

22. Baudier, *Histoire génerale du sérail el de La cour du Grand Seigneur, empereur des Turcs* (1623), 2nd edn, 1626, p. 37.

23. Du Vignau, *l'État present de La puissance ottomane,* 1687, p. 21.

24. Tavernier, *Voyages,* vol. II, p. 486.

25. See, for example, the pages in Antoine Galland's *Journal,* Constantinople (1672–73), on the emergence of the Great Lord, whose brilliance defies imagination: 'If only Mademoiselle de Scudéry had been able to create something like this in her imagination, [etc.] (journal, ed. Schefer, 1881, vol. I, p. 122).

26. Xenophon, *Cyropaedia,* VIII, ch. 1, p. 325.

27. *The Embassy of Sir Thomas Roe to India 1615–49 as Narrated in His Journal and Correspondence,* Oxford University Press, 1926 edn, ed. William Foster, p. 87.

28. N.-A. Boulanger, *Recherches.* In a note he adds: 'There is scarcely a sovereign in Europe who, unwittingly, does not still affect to appear with this ceremonial regularity in the manner of the Orient' (section XVII).

29. Roe, *Embassy.* In the *Lettre à M. Chapelin* which follows his *Voyages dans l'Indoustan,* Bernier describes the terror with which the people of Delhi were gripped during an eclipse of the sun in 1666.

30. *Cérémonies religieuses,* vol. VI (quoted by Boulanger, *Recherches,* section XIII).

31. Tavernier, *Voyages,* vol. II, Book II ('Voyage des Indes'), ch. XVIII, p. 488.

32. *Spirit of Laws,* Book III, ch. 10.

33. Rousseau, *The First and Second Discourses and Essay on the Origin of Languages,* trans. Victor Gourevitch, Harper & Row, New York 1986, p. 241.

34. Montesquieu, *Spirit of Laws,* Book XIX, ch. 27.

35. Chardin, *Voyages,* p. 211.

36. In 1615, George Sandys (*Sandys Travels . . .*) speaks of a population of 700,000; in 1640, the Venetian *Bailo* Alvise Contarini speaks of a million. On this question, see Robert Mantran, *Istanbul dans la secunde moitié du XVIIe siècle* (A. Maisonneuve, 1962), p. 44.

37. Tournefort, *Relation d'un voyage du Levant,* Paris 1717, vol. II, letter 13, p. 35.

38. Ibid., vol. I, letter 12, p. 465.

39. There are a few little Indian kinglets, writes Baudier, who only ever speak to one man: 'And that man receives any request made to the king through the mouth of fifty individuals who speak it one to the other, until it reaches him' (Baudier, *Histoire générale,* p. 38).

40. Persian Letters, letter 80.

41. Guer, *Mœurs et Usages des Turcs,* Paris 1746, vol. II, Book lV, p. 17.

42. Bernier, *Voyages au Cachemire . . .,* 1655, vol. II, p. 45: 'Letter to Mons. de la Mothe Le Vayer containing the description of Delhi and Agra, capital cities of the empire of the Great Mogul': 'The king cannot say one word, however unwarranted, but it is forthwith taken up, and certain of his highest-ranking Omerhs raise their hands aloft, as if to receive heaven's benediction, straight away crying: "Karamat, Karamat! A Wonder, he spoke a Wonder!" '

43. Tavernier thus describes the 'audience' of the ambassadors at Constantinople: 'Everything took place in great silence, and the Great Lord answered nothing, leaving it to the charge of the Grand Vizier to say a few words as leave taking to the ambassador, who retired with a deep bow, without showing his face and without turning his back until he was out of the room' (*Voyages,* ch. 6, p. 453).
44. Baudier, *Histoire générale,* p. 37.
45. Baudier adds: 'Scarcely in all of history shall one find a single example of Monarchy or Republic in which the highest have commanded so imperiously and have been obeyed so promptly, as are the Turks; their letters exude only threats, and speak no other language but that of cruelty' (ibid., p. 14).
46. Chardin, *Voyages,* vol. II, ch. 7, p. 261.
47. Ibid.
48. A 'grammarian' like De Brosses saw in them the distinctive features of the 'Oriental' (which is to say Semitic) languages; by effectively omitting the vowels from their writing, the ancient Orientals indicated that these languages are 'languages for the eyes', while ours are, rather, 'languages for the ear' (*Traité de la formation mécanique des langues,* 1765, vol. II, p. 48, quoted by G. Genette in *Mimologiques,* Seuil,. 1976, p. 90).
49. Du Vignau, *l'État présent,* p. 90.
50. Thévenot, *Voyages,* ch. 35. This same scene is described in unvarying terms by almost all the authors.
51. Du Vignau, *l'État présent,* p. 84.
52. Chardin, *Voyages,* vol. II, ch. 7, p. 261: 'The Great Lord [in Turkey] is a long way from being absolute in the manner of the King of the Persians', he adds. This does not seem to be Ricaut's perception: 'It is neither virtue, nor merit, nor nobility of blood which makes the Bacha, it is only the favour of the Sultan, who can without ado create one from the least of his soldiers' (*Histoire,* ch. 16, p. 127), or that of Dumont, Baron de Carlscroon: 'Disregarding the pashas of long standing, [the Great Lord] sometimes takes a mere *chiaous,* or even a cook, as has been seen, and in a single day raises him to the dignity of Grand Vizier' (*Nouveau Voyage,* letter XIX, p. 274).
53. Montesquieu, *Spirit of Laws,* Book V, ch. 16. See also ch. 19: 'In despotic governments ... they indiscriminately make a prince a scullion, and a scullion a prince.'
54. Tavernier, *Nouvelle Relation de l'intérieur du sérial du Grand Seigneur,* 1712, ch. 15, p. 493. Similarly in Persia, where reversals of fortune are always 'prodigious and terrifying', 'for in an instant a man will find himself so entirely bereft that he has nothing left to him' (Chardin).
55. Montesquieu, *Spirit of Laws,* Book V, ch. 14.
56. Ibid., ch. 16.
57. Ibid.
58. Ricaut, *Histoire,* p. 81.

59. There is never any *image* on this seal, stresses Baudier (*Histoire générale,* pp. 178–9): 'Nowhere do we read that any Turkish emperor had for his weapons and seal anything other than Arabic characters and words; moreover, these men whose words are not cast to the wind, like those of several other Princes, but engraved, have … subjugated the Empire of Constantinople, ravished that of Trebizond, conquered Egypt, pacified Palestine, Damascus, Pamphylia, Cilicia, Caramania.'

60. Montesquieu, *Spirit of Laws,* Book V, ch. 19. This omnipotent character of the name, which has become independent of the man who bears it, is a characteristic feature of despotism; monarchy is lost and the king becomes a despot whenever 'his ministers make use of his name to do all things' (see *Dossier de l'Esprit des lois,* p. 997).

61. Or rather, plumes and tunics, which are a part of the panoply of signifiers available to the Master for elevating or annihilating one or other of his subjects.

−2.4−

The Blind in the Early Christian World
Mosche Barasch

Among the many elements that early Christianity inherited from previous ages were concepts of the nature and origin of blindness, as well as attitudes to the blind. It was part of those beliefs, common also among early Christians, that blindness is a punishment for sin. Sometimes this punishment could be effected by miraculous means, as in the Acts of the Apostles (13:8–11). While Paul was preaching, Elymas the magician sought "to turn away the deputy from the faith," so Paul "set his eyes on him" and said "behold, the hand of the Lord is upon thee, and thou shalt be blind, not seeing the sun for a season. And immediately there fell on him a mist and a darkness; and he went about seeking some to lead him by the hand."

Because blindness was somehow, even if only vaguely, connected with guilt, it could also be seen as joined to emotional states that were sins and vices. The coupling of blindness and vice often appears in the writings of the Fathers of the Early Church, and one cannot always say whether it is meant as a metaphor or taken more literally. St. Ambrose, the fourth-century bishop of Milan, for example, understands blindness as a manifestation of passion.[1] Another late fourth-century Father of the Early Church, Jerome, equates blindness with *arrogantia*.[2] At about the same time, still another Father of the Latin Church, Arnobius, linked blindness with insanity (furor), reviving the ancient affinity of losing one's eyesight to losing one's mind in a Christian version of the Greek concept of ate. He also perceives a connection between blindness and dementia.[3] In the early fifth century, when the period we call early Christian was drawing to an end, Augustine speaks of "blindness" as of a more or less metaphorical synonym of *furor* and *dementia*.[4]

. . .

The Healing of the Blind

In these contexts careful attention should be paid to the scene of the Healing of the Blind. It is well known that the range of themes that appear in early Christian imagery is rather restricted, particularly as compared to contemporary pagan imagery in late antiquity. The very selection of a subject for literary description or pictorial depiction is therefore of significance. This can best be observed in the painted or

carved images, perhaps because the subject matter is so narrowly limited. The theme of almost every early Christian image reflects a profound belief or a basic emotional need that was central to, and dominated the spiritual world of, the new religion. The fact that in the repertory of the earliest Christian images the Healing of the Blind is important therefore deserves careful attention. While there are only a few paintings in early Christian catacombs, a catacomb such as that of Domitilla may have several representations of the Healing of the Blind. The location on the catacomb wall or on the front panel of a Christian sarcophagus where the Healing of the Blind is represented is also significant. It is the site that ensures better visibility in an environment where decorations are not easily perceived. But the location in itself indicates that the scene has a central symbolic meaning. Obviously the Healing of the Blind had a particular appeal for early Christian audiences.

In the original Hebrew Bible, or the Old Testament in Christian terminology, the restoring of sight to the blind is perceived as the ultimate miracle, an event that goes beyond what is thinkable in the terrestrial world and in our present life. So utterly utopian appeared the healing of the blind that it was understood as a distinctive mark of the messianic age. 'And in that day," says Isaiah, "shall the deaf hear the words of the book, and the eyes of the blind shall see out of obscurity, and out of darkness" (Isaiah 29:18). Later, when the prophet describes that utopian state of bliss, he says: "Then the eyes of the blind shall be opened" (35:5). The transplantation of healing the blind into the messianic age may perhaps help us understand that the returning of sight to those who have lost it plays only a minor role in the Old Testament narratives.

As in the Hebrew Bible, in the culture of the late stages of the Hellenistic age, especially in Near Eastern countries, the healing of the blind remained an utterly miraculous act, even though it was perhaps more common in the imagination of the time. Eloquent testimony to this development of beliefs may be found in the Book of Tobit, a charming piece of religious fiction. In this apocryphal story, composed as early as the second century B.C., the whole narrative is framed by the action undertaken in order to return eyesight to a blind old man. As we know, in Tobit the miraculous healing is achieved by seemingly "natural" means, by sprinkling a medication made of the gall and liver of a fish on Tobit's eyes. The natural components of the medication, however, do not diminish the mysterious, miraculous nature of the event. The knowledge that these particular substances will have a healing effect is revealed to Tobit's son by an angel. Whatever else the story of Tobit may attest to, it shows that by the time it was composed the healing of the blind was no longer perceived as so utterly utopian that even as a miracle it could not be imagined as taking place.

No other apocryphal text presents the healing of a blind person in such explicit, narrative way as the Book of Tobit. But implicit evocations of the same miracle are also found in other apocryphal writings, though sometimes put in a negative form. Thus in what is known as the "Letter of Jeremiah," now a part of the apocryphal Book of Baruch,[5] it is said of the idols against whom the prophet preaches that "They cannot save a man from death, nor rescue the weak from the strong. They cannot restore

a blind man's sight, they cannot deliver a man who is in distress" (6:35–36). Such statements show, even if they do not explicitly state, that the restoring of sight to a blind man, though it remains miraculous, was considered feasible within the reality of our present world. The healing of the blind does not have to be postponed till the Messianic age.

In the pagan traditions of antiquity, especially in the later stages of the period, the idea of healing the blind arises in various forms. Thus it is explicitly told of Isis, one of the divine figures endowed with healing powers, that she restored sight to the blind. Many sick people came to her shrine to seek relief, and among them, Diodorus Siculus relates, those "who have been despaired of by their physicians because of the difficult nature of their malady [and] are restored to health by her [Isis], while numbers who have altogether lost the use of their eyes or of some other parts of their body, whenever they turn for help to this goddess are restored to their previous condition."[6]

The belief in the supernatural healing powers with which some elect people are endowed, however vaguely this endowing may be defined, also includes the restoration of sight to those who have lost it. The ruler in whom a god has invested his powers can perform the miracle of healing the blind. Tacitus tells that Vespasian, in the presence of a crowd, healed the eyes of a blind man by moistening them with his spittle.[7]

Less miraculous ways of restoring sight to the blind were also sought. To adduce a single example I shall mention the belief that the serpent, as a symbolic image of sharp sight, can provide a medication for the restoring of sight. Since the serpent was believed to be able to rejuvenate its sharp eyes, and therefore symbolized the sun,[8] the substance of its body is also endowed with particular healing power.[9]

What matters in our context are not the specific details of these stories, but the very fact that the possibility of healing the blind, however slight, was perceived as something thinkable within our reality. In the New Testament the stories of the miraculous healing of the blind play a central part in manifesting Christ's supernatural powers. The methods by which he restored sight to the blind vary. Sometimes the miracle is performed by word of mouth alone, as when Christ says to the blind man: "Go thy way; thy faith hath made thee whole" (Mark 10:46ff.). On another occasion, a bodily contact is imagined in the healing of two blind men: Christ touches their eyes, and by this touch sight is restored to them (Matt. 9:27–30). Finally, an even more material contact is reported: this time a medicine is applied to the eyes of the blind man, a mixture of spittle and clay, prepared by Christ himself (John 9:6–7). We are not concerned here with the healing methods reported. Whatever the variations, the same basic concept underlies all these stories. In our present context it is of crucial consequence that the Healing of the Blind can take place in our terrestrial world, the world of the present, not of a coming utopian age. Christ's ability to perform the miracle may carry some connotation of the Messianic age to come, but his acts of healing take place in a pre-Messianic reality.

In the visual imagery of early Christianity, as recorded in paintings and sculptures, the theme of healing the blind acquired major significance and became one of the central subjects. What the painted and carved images of the Healing of the Blind suggest does not contradict, or radically diverge from, the ideas of such miraculous healing as related in the New Testament stories. But the images emphasize one particular aspect of the motif, an aspect that is less prominent in the texts. This is the conceptual context of the miracle as well as the specific, material object on which the Healing of the Blind is represented that endow the individual scene of restoring the sight with its specific meaning.

In early Christian art, pictorial representations of the Healing of the Blind are found in places and on objects that are highly charged, in emotion as well as in dogmatic beliefs. With a rare exception, these places and objects have an immediate connection with the service for the dead.[10] They are mainly the walls of catacombs or the frontal panels of sarcophagi. The earliest representations of the Healing of the Blind that have come down to us are those painted on catacomb walls in Rome. Even if some of the originals are lost, we have a fairly good idea, derived from drawings made by scholars in early modern times, of what they looked like, even if only in general outline. In trying to understand these early paintings we have to keep in mind that the Christian catacomb is not a neutral space, its walls are not the unobtrusive background provided by the walls of a museum. The catacomb not only is a space highly charged with emotion, but it also provides a distinct conceptual, religious context for whatever can be seen within it. The images and objects perceived here are endowed with an articulate meaning and carry connotations that point in one direction. This emotional and religious context is the craving for salvation, or, in the formulation of Charles Rufus Morey, the "deliverance from death (*vivas in Domino*), deliverance from sin and the misery thereof (*in pace*)."[11] In a catacomb, the Healing of the Blind is not a medical action; it is not even simply a miracle. Here it necessarily acquires the connotation of salvation. The blind person to whom sight is restored is an image of the transition from bondage to salvation. In particular, the healing becomes an image of the transition from death to eternal life.

. . .

To grasp an early Christian spectator's understanding of a representation of the Healing of the Blind we should also recall that throughout antiquity the hand was known as a healing agent; it alleviated pain. Probably the best formulation of this belief was the "mellow hand" that reduced the pains of childbirth.[12] But in general the hand, particularly the touching hand, was considered throughout antiquity as healing severe illness and distress. One recalls the lines in Aeschylus's *Prometheus Bound* spoken to Io, who suffers madness (846–50):

> There is a city, furthest in the world,
> Canobos, near the mouth and issuing point

of the Nile: there Zeus shall make you
sound of mind
touching you with a hand that brings no
fear
and through that touch alone shall come
your healing.

The miracle-working power of the healing hand is not restricted to Zeus. It is best known of Asclepius. Where a mortal physician depends on surgery, Asclepius heals by the mere movement of his hand. Such beliefs are specifically attested for the blind. Thus a blind man dreamt that Asclepius appeared to him and with his fingers opened his eyes. The next morning he got up, having his eyesight fully restored.[13] This kind of miracle penetrated into Christian imagination. St. Eligius healed a blind woman by the mere movement of his hand.[14] Gregory of Tours tells of a girl punished by being blinded who regained her eyesight in a similar way.[15]

In representing the bodily contact between the healer and the healed, focused in the gesture of Christ touching the eyes of the blind, artists also created a powerful pictorial device that guides the spectator's attention to the central point. It is both the eye of the blind and the point where the divine and the human meet.

This compositional pattern—Christ touching the eye of the blind—was retained for centuries and was employed in both static, emblematic images and dynamic, narrative representations. A good example of the first category is an early-fourth-century sarcophagus, produced in Rome ca. 315. Here Christ healing the blind is placed between two symbolic scenes that have no narrative connection with the miracle portrayed: the Adoration of the Magi to the left and Daniel in the Lions' Den to the right. The blind person being healed is a small figure. Christ touches his eye, and this action is the center of the narrative. It is hard to say, though, whether he does so with his index finger only or with two fingers.[16] If two fingers are shown stretched out, the artist may have combined two actions—the pointing or touching as well as the blessing. In the representation of Christ healing the blind in a mosaic in S. Apollinare Nuovo, the blind man is as tall as Christ himself, he stands upright, holding in his hand the staff that identifies him as blind. That he wears a priest's garment may perhaps indicate that the healing is an opening of the blind one's eyes to the "true belief" that is Christianity.[17]

It is obvious that the Healing of the Blind was one of the central scenes in early Christian art, and the original audiences, the early Christian believers, may have understood this intuitively. The modern student, however, must ask what the reasons were for the forceful emergence of the scene, and what made it one of the core mental images of Christianity in the early period of its crystallization. A change in the central imagery of a great religious movement cannot be an isolated phenomenon. It necessarily grows from profound, if hidden, roots of the new belief, and sometimes it reflects the character of the new religion more sharply than both patrons and artists

consciously intended, or even were aware of. What, then, was it that produced, and was reflected in, the theme of the blind miraculously healed by the redeemer?

Some aspects both of the religions of salvation, that is, religions that make salvation of the individual soul and of mankind the centerpiece of their message,[18] and of the connotations of blindness should here be recalled, even if only in broad outline. First, it is a characteristic feature of all religions of salvation that they are fascinated with sudden change, with an unprepared (or seemingly unprepared) radical inversion. Such changes play a central part in their spiritual world. Moreover, these abrupt changes are usually polar inversions, an instant move from the condition of deepest distress to that of highest bliss. In these religions, we should keep in mind, salvation was never imagined as a continuous process, a gradual liberation from the suffering from which one longed to be redeemed. On the contrary, redemption has always been viewed as a sudden event, unprepared and precisely for this reason also miraculous. In Christianity this particular character of salvation becomes markedly manifest. The most radical inversion imaginable, the revival of the dead, became a central dogma in Christian belief, and for centuries it also remained a central theme in Christian art. In its sheer improbability, the miracle of healing the blind, of giving back sight to those who have lost it, has a certain affinity to the ultimate miracle of the revival of the dead. Because of this polar inversion, one understands how Christianity, totally oriented toward redemption, was mentally and emotionally prepared to make the healing of the blind a central image.

The other aspect that should be considered here has something to do with the symbolic nature of blindness and seeing. In the writings of the Fathers of the Early Church, both Greek and Latin, the state of a person (whether Jewish or gentile) before his or her conversion is described as a condition of blindness and darkness; the state after the conversion is one of seeing and light. A single witness to this use of the terms will suffice. An important thinker of the early Latin Church, Tertullian, opens his short treatise *On Baptism* with a sentence about the "happy sacrament" of baptism, and says that its water washes away from us "the faults of the former blindness" and makes us free for the eternal life.[19]

In the language of metaphors that prevailed in the early Christian world the terms "blindness" and "darkness" (and often also "ignorance") are frequently considered as synonyms and are used interchangeably. These metaphors describe the nature of a believer's life before his conversion. Conversion is an illumination. Already in the New Testament, the act of conversion to Christianity is described as an enlightening (Heb. 6:4), and from this it naturally follows that our life preceding conversion was spent in ignorance, darkness, and blindness. The sins committed before our conversion, that is, before the moment of true "illumination," while we still lived in "darkness" and "blindness," are more easily forgiven than those committed after our minds have been illumined. These metaphors, making blindness a hallmark of false beliefs, were widely known and applied; they were also common in the thought and language of the various regions and trends of Christianity in late antiquity. Christian

audiences in both the eastern and western part of the Roman Empire were familiar with these mental pictures and with the connotations they evoked.

These connotations, of course, also shaped the meaning of the Healing of the Blind and the way Christian audiences understood representations of the scene and reacted to them. The Healing of the Blind is not only an image of salvation from darkness to light; it is also specifically the message that conversion to Christianity, the religion of salvation, assures redemption, bliss, and eternal life. It is these connotations that explain the emergence and significance of the scene in early Christian imagery.

Notes

1. Ambrose, *Cain and Abel* 2.416.
2. St Jerome, Epistle 97:19.
3. Arnobius, *Adversus nationes Libri VII (Against the Heathen)* 7.29.
4. "Or will some one carry so wonderful a blindness to the extent of wildly attempting, in the face of evident truth, to contend that …" I quote from Saint Augustine. *The City of God,* trans Marcus Dods (New York: Modern Library, 1950), p. 20.
5. The "Letter of Jeremiah" was probably composed in the first century B.C. and is thus close in time to the New Testament.
6. Diodorus Siculus, *Library* 1.25.3.
7. Tacitus, *Histories* 4.81. This story is also mentioned by Suetonius, *Lives,* Vespasian 7.
8. See Aelian, *The Characteristics of Animals* 9.15, and Macrobius, *The Saturnalia* 1.20.2–3.
9. Otto Weinreich, "Antike Heilungswunder: Untersuchungen zum Wunderlauben der Griechen und Römer." *Religionsgeschichtliche Versuche und Vorarbeiten* 8, no. 1 (Gisen, 1909): 107f.
10. The exception I have in mind is an ivory pyxis in the Museo Sacro in Rome. It was a physician's medicine box, and on its lid the Healing of the Blind is carved. See Charles Rufus Morey, *Early Christian Art* (Princeton: Princeton University Press, 1942) fig. 91 and pp. 94ff; Andre Grabar, *Christian Iconography: A study of its origins* (Princeton: Princeton University Press, 1968), fig. 246 and p. 97. The fine carving technique and the fully developed style suggest that the precious object was produced in the early sixth century.
11. Morey, *Early Christian Art,* p. 62.
12. See Weinreich, "Antike Heilungswunder," pp. 14ff. One of the most famous references in ancient literature is found in Ovid's *Metamorphoses,* 10.510ff, where Lucina touches Leto, who is in labor pains.
13. Weinreich, "Antike Heilungswunder" p. 30.
14. See *Vita S. Eligii* 2.51. (Migne, *Patrologia Latina,* vol. 87, col. 570A)

15. Gregory of Tours, *In gloria martyrum.*
16. Schiller, *Iconography of Christian Art* (London: Lund and Humphries, 1971), fig. 246. Schiller gives a list of many other examples without however dividing between emblematic and narrative representations.
17. Ibid., fig. 430.
18. I should stress here that I do not use the concept of religion of salvation in a strict terminological sense. For the history of defining the concept, see Hans G. Kippnberg, *Die Entdeckung der Religionsgeschichte: Religionswissenschaft und Moderne* (Munich: Verlag C.H. Beck, 1997), pp. 172ff, 239ff.
19. The reading according to a restored manuscript. The restored version reads: "De sacramento aquae nostrae, qua ablutis delictis pristinae caecitatis in vitam aeternam liberamur." See Franz Joseph Dölger, "Die Sünde in Blindheit und Unwissenheit: Ein Beitrag zu Tertullian *De baptismo,*" in Dölger, *Antike und Christentumn: Kultur-und religionsgeschichtliche Studien,* 2nd ed. II (Münster: Aschendorf, 1974), pp. 171–74.

–2.5–

Seeing and Feeling in the Middle Ages
Suzannah Biernoff

In the fourteenth century William of Ockham claimed that the intellect was capable of grasping its objects intuitively, at a distance. By dispensing with the theory of species, and the Aristotelian principle of physical causation, he effectively 'denied the need for sensation'.[1] I begin with Ockham's intervention because it foregrounds the ambiguous status of sight, in the Middle Ages as well as today. His theory of intuition (by this Ockham meant an act of the mind, independent of the body) also provides a more immediate counterpoint to Roger Bacon's emphasis on the *physical interaction* between object and sense organ. Fundamentally, for Bacon, sight is a change in the sensitive humours and membranes of the eye; and as such, it is accompanied by a certain amount of pain. Here is his description of the effect of intromitted species on the lens:

> [The anterior glacialis] must be somewhat thick, in order that it may experience a feeling from the impressions [species] that is a kind of pain. For we observe that strong lights and colour narrow vision and injure it, and inflict pain ... Therefore vision always experiences a feeling that is a kind of pain ...[2]

This image of responsive, mutable biological matter is a long way from Bacon's geometrical articulation of the eye as an instrument for seeing. Indeed, it is closer to the contemporary literary tropes of ocular penetration or wounding. Central to both discourses of vision—amatory and scientific—is the idea that we are altered by the things we look at; that the objects of our gaze 'move' us physically and emotionally. It is significant—and further evidence of the complex relationship between carnal vision and the optical gaze—that this movement or alteration is denoted by the term 'passion' (*passio*).

Passion—defined as any violent physical or emotional change—was a characteristic of the fleshy body. A 'passion' was something one underwent or endured; a process of transformation. As such, the action of species 'is called "passion" because the medium and sense, in receiving species, undergo a transmutation in their substance ...'[3] Moreover, just as 'passion' in current English usage suggests a state in which the line between pain and pleasure is indistinct, so too sensation is for Bacon a source of pleasure or delight as well as a kind of suffering. He notes that

'although in sense there is some suffering and injury ... nevertheless there is simultaneously a pleasure that prevails over the suffering and injury ...'[4]

The potential of sight to cause physiological change is a recurring motif in medieval theology as well as folklore, the obvious example being the evil eye ... [F]or Bacon the sight of any object, living or inanimate, would precipitate a 'transmutation' in the viewer. There was nothing novel in this: Augustine had cited a number of phenomena illustrating our extraordinary responsiveness to the visible world. These range from the predictable—the chameleon's ability to assume the colours of its surroundings—to the bizarre. For instance, he reports that the tender and malleable flesh of foetuses will 'follow the inclination of their mothers' soul, and the phantasy which arose in it [the soul] through the body upon which it looked with passion'.[5] Bacon's more prosaic explanation is that:

> before the action, the recipient [medium or sense organ] is of itself dissimilar to the agent, and through the action it becomes similar ... and when the agent acts on the recipient, it at once assimilates the latter to itself and makes the recipient to be such as the agent is in actuality ...[6]

This is not an account of a mental event. Following Aristotle, Bacon insists that sensation occurs in the bodily organs of sense: the eyes, the nerves of the skin and surrounding flesh, the internal organs of the brain. It bears repeating that we are not, therefore, dealing with a duality of mind and body; nor a mind-body 'problem'. The images of the visible world reproduced in the eyes and brain are, for Bacon as for Aristotle, *material* images. The separable intellect may be able to grasp pure abstractions, but the sensitive soul is embodied; its perceptions and emotions enmattered.[7]

The comment is often made that sight, more than any other sense, requires or imposes a distance between subject and object, and that this *physical* distance corresponds to the *emotional* distance of detached intellectual scrutiny.[8] As the feminist theorist Elizabeth Grosz puts it:

> Of all the senses, vision remains the one which most readily confirms the separation of subject from object. Vision performs a distancing function, leaving the looker unimplicated in or uncontaminated by its object. With all of the other senses, there is contiguity between subject and object, if not an internalization and incorporation of the object by the subject.[9]

Vision, Grosz implies, is inherently distancing: it is because of this perceptual fact that ocular metaphors lend themselves so readily to discourses of knowledge that emphasise objectivity and dispassionate observation, that privilege the overview and aim to put things 'in perspective'. There is also a suggestion here that sight—unlike the other senses—is somehow disembodied. In contrast to touch, taste, hearing and smell, we tend not to think of sight as a *sensation*. It's as though vision isn't *felt* or experienced in the way that the other senses are. So, for example, in Lacanian theory,

sight is aligned with the visible or specular self (the mirror-image), while the other senses are taken to constitute the 'felt' self. [10] This rather odd distinction (if you think about it) between sight and all the other senses—between seeing and feeling—is consistent with a pervasive association between seeing and knowing in much of Western thought and culture.[11] The corporeality of sight is repressed and vision is imagined either as an intellectual act—the disembodied gaze of the 'mind's eye'—or as a mechanical process akin to a camera.

The polarisation of seeing and feeling does not work in an Aristotelian or Baconian context. Seeing *is* feeling in every sense: a physical 'touch', a sensation of pleasure and pain, an emotion 'expressed in matter'.[12] It is also a movement. Sight, for Bacon and his contemporaries, involved an extension of the sensitive soul (or, in a different context, the flesh) beyond the body's visible limits. According to this interpretation of extramission, sight is not only the most spatialised of the senses; it is a form of motility.[13] If we read descriptions of the roaming, grasping, probing or penetrating eye as literal rather than metaphorical, then medieval vision had a kinaesthetic dimension. It involved a sensation of movement (from the Greek *kineo,* 'move' and *aisthesis,* 'sensation').

The theory of extramission is implicit in the idea that sight is a way of moving around in the world. But intromission was also understood as a kind of movement or alteration of the viewer: Bacon's word was 'transmutation'. When we talk of being 'moved' by something, we are using a figure of speech that derives ultimately from the Aristotelian precept that sensation is a 'qualitative alteration (*alloiosis*)'.[14] To perceive or sense (there is no distinction between sensation and perception for Aristotle or Bacon) is to be materially altered.[15] An alteration is not, of course, a movement (*kinesis*) from one place to another. Instead, the term refers to the actualisation of a potential in matter. It is a precondition of sensation that the sentient soul is 'potentially like what the perceived object is actually ...'[16] Even when dormant our bodily senses must have the capacity and proclivity for sensation, in the same way that fuel is combustible but 'never ignites itself spontaneously'.[17]

Potentiality is an actively receptive state of being: visible species are reproduced through transparent substances and through the sense organs because they are 'brought forth out of the *active potency* of matter' (emphasis added).[18] While the agent 'informs' or impresses itself upon latent matter, the potentiality of that matter actively draws forth the species from an adjacent medium. So the receptive humours of the eye elicit species from the surrounding air; the organ of the imagination draws forms from the common sense, and so on throughout the perceptual continuum ... What is important here is that the idea that we are 'moved', altered or affected by things in our sensory world presupposes a capacity and desire to be moved or affected.

As a condition of latent matter, potentiality is for Bacon a pre-requisite for any perceptual or cognitive act. But there was another, quite different sense in which potential was realised in perception. Plotinus had written of 'percipients and things perceived' as 'members of one living being'[19] From a Neoplatonic point of view,

perception depended not on the active potency of matter—or indeed on any causal relationship between agents and recipients—but on a psychological disposition of the subject: a sympathy with one's objects (the term Plotinus uses is *sympatheia*).[20] The source of this inborn affinity, and a precondition of perception, is the original creative principle in which all things participate: the 'One', the 'Intellect' or 'Soul'. Every act of sense-perception, every thought was thus a recognition or remembrance of a pre-existing, inborn reality. Each sensation carried an intimation of this 'organic unity' of being; a sense that 'our eyes are parts of the same organism as the objects of vision'.[21]

While the abstractive, geometrical tradition embraced by Bacon and his contemporaries seems to confirm current suspicions about Western ocularcentrism, other aspects of medieval vision are not so easily accommodated. We find, in these historical sources, two divergent visual worlds: one characterised by the sharp delineation and separation of seer and seen; the other by bodily interaction and affinity. The coexistence of different visual worlds in the Middle Ages suggests that there is more than one history of vision; and more than one kind of spectator. What we are dealing with is not only a complex (and often contradictory) history of the visual sense, but also a history of the 'self' that emerges and is defined in different perceptual environments.

In his account of the mirror stage, Lacan notes that 'the formation of the I' is often represented in dreams as a fortress.[22] A comparison of his edifice with the same topos in medieval literature reveals a telling discrepancy. The allegory of the castle is used in amatory and devotional literature—for example the *Romance of the Rose* and the *Ancrene Wisse*—to signify the permeability of the body/self. [23] Time and again the reader's attention is directed to windows, doors, gateways: architectural openings representing the five bodily senses. Sight in particular was the 'window' through which the world flowed in, and the soul slipped out. In these medieval texts, the allegory of the castle or fortress serves—however paradoxically—to dramatise and amplify the interpenetration of self and world; a meeting that is often erotically charged.

Lacan's imaginary edifice, on the other hand, is isolated and impregnable. His castle stands alone, 'lofty, remote;' and the dream-subject 'flounders' in the surrounding wasteland of 'marshes and rubbish-tips'.[24] If we read these renditions of the same trope as commentaries on the visually mediated relationship between self and world, they do indeed suggest different experiences, and divergent symbolic economies. For Lacan, the mirror locks the child within its binary logic: the world and others are reduced to a version of the self through absolute identification or alienation.[25] The 'spell' is not broken until the resolution of the Oedipus complex. Only then, through the interpolation of the father's authority and language into the dyadic bond of self and (m)other, does the child make a more or less successful transition from the visual domain of the Imaginary to the Symbolic order structured like a language.[26]

Stripped to its structural bones, the narrative of the Mirror Stage and Oedipus complex configures human subjectivity in terms of a scopic dualism on the one hand,

and on the other, linguistic mediation provided by the word of a third party: the father. Yet when we turn to medieval theories of sight we find mediation internal to visual relationships. For Bacon, sight constitutes a fluid and ambiguous zone; an intermediary between the external world and the internal faculties of the sensitive soul. And instead of an agonistic oscillation between difference and sameness, vision entailed an assimilation of the viewer to his or her object.

To understand the lived experience and symbolic range of medieval vision, we clearly need to rethink the relationship between viewing subjects and visible objects.

Notes

1. K. H. Tachau, 'The problem of the *Species in Medio* at Oxford in the generation after Ockham', *Mediaeval Studies,* 44, (1982) 443.
2. Roger Bacon, *Opus Majus of Roger Bacon,* Trans R. Burke. 2 vols (New York: Russell, 1962), 2: 445–6 (5.1.4.2).
3. Roger Bacon, *Roger Bacon's Philosophy of Nature: a critical edition with English Translation, Introduction and Notes of* De multiplicatione specierum *and* De speculis comburentibus by D. C. Lindberg (Oxford: Clarendon Press, 1983), 7 (1.1).
4. Bacon, *De multiplicatione specierum,* 19–21 (1.). His source is Aristotle, *On the Soul,* 2.2.413b.
5. St. Augustine, *The Trinity,* trans. S. McKenna. Fathers of the Church 45. (Washington DC: Catholic University of America Press, 1963), 322 (11.2.5). Augustine claims that 'numerous examples' of the phenomenon can be found in nature, and recalls the story (Gen. 30.37–41) in which Jacob places wooden rods of different hues in his watering troughs so that the offspring of his sheep and goats will be coloured accordingly.
6. Bacon, *De multiplicatione specierum,* 7 (1.1). For Aristotle's explanation of this process, see *On the Soul,* 2.5.416b, 418a.
7. H. Putman and M. C. Nussbaum, 'Changing Aristotle's Mind', *Words and Mind,* ed. J. Conant (Cambridge, MA: Harvard University Press, 1994), 32–42. For Aristotle's theory of perception and emotion as bodily functions, see: *On the Soul,* 403a25-b27; 427a27.
8. See, for example, G. N. A. Vesey's definition of 'vision' in *The Encyclopedia of Philosophy,* ed. P. Edwards, 8 vols (New York: Macmillan, 1967), 8: 252: 'We can imagine a disembodied mind having visual experiences but not tactile ones. Sight does not require our being part of the material world in the way in which feeling by touching does.'
9. E. Grosz, *Jacques Lacan: A Feminist Introduction* (London: Routledge, 1990), 38. Grosz makes this observation in the context of a discussion of Lacan's 'mirror stage'. The recurrence of this theme in contemporary French thought is treated

at length by Martin Jay in *Downcast Eyes* (Berkeley: University of California Press, 1994).

10. For Lacan's account of the mirror stage, see J. Lacan, 'The Mirror Stage as Formative of the Function of the I as Revealed in Psychoanalytic Experience' (1949), *Écrits: A Selection,* trans. Alan Sheridan (London: Tavistock, 1977), 1–7.

11. Most Indo-European terms for mental activity derive from words for vision or the visible. Stephen A. Tyler, "The Vision Quest in the West, or What the Mind's Eye Sees," *Journal of Anthropological Research* 40 (1984): 27. See also Jay, *Downcast Eyes,* 1.

12. Aristotle, *On the Soul,* 1.1.403a25: 'the affections of the soul are enmattered accounts [or proportions]'. Bacon is working on the same principle when he says 'there must be something more active and productive of change in the sentient body than light and color, because it not only causes apprehension but also a state of fear or love or flight or delay.' Bacon, *Opus majus,* 2:425 (5.1.1.4).

13. Bacon maintained that vision was both passive and active: we passively receive the species of objects (intromission), but at the same time our eyes are channels for a radiant power of vision (extramission).

14. Aristotle, *On the Soul,* 2.4.415b.

15. Thomas Slakey argues that in *On the Soul* Aristotle presents perception as 'simply the movement which occurs in the sense-organs, not some psychic process in addition to the movement in the organs'. In other words, Aristotle understands perception as a bodily process, not as a mental 'interpretation' of a physiological alteration of the sense organ. 'Aristotle on Sense-perception', *Aristotle's De Anima in Focus,* ed. M. Durrant (London: Routledge, 1993, 77.

16. Aristotle, *On the Soul,* 2.5.418a.

17. Aristotle, *On the Soul,* 2.5.417a.

18. Bacon, *De multiplicatione specierum,* 191 (3.2). See also 47 (1.3) in the same text.

19. Plotinus, *Enneads,* trans S. McKenna, 4th ed. (London: Faber, 1969), 337 (4.5.8).

20. Plotinus rejects Aristotle's claim that the medium performs a necessary, causal function in vision. *Enneads,* 328–38 (4.5). For a commentary on the text, see: E. K. Emilsson, *Plotinus on Sense-Perception: a Philosophical Study* (Cambridge: Cambridge University Press, 1988), especially chapters 3 and 4: 'The relation between the eye and the object of vision' and 'Sensory affection'.

21. This is Emilsson's interpretation of Plotinus's concept of *sympatheia, Plotinus on Sense Perception,* 59.

22. J. Lacan, 'The Mirror Stage as Formative of the Foundation of the *I* as Revealed in Psychoanalytic Experience.' *Écrits: a Selection,* Trans. A. Sheridan (London: Tavistock, 1977), 5.

23. I would therefore disagree with Pouchelle's emphasis on corporeal, architectural and symbolic closure. In her view, 'All "spaces"—the cosmos, Paradise,

syllogistic reasoning, the body—were at that time [in the Middle Ages] closed.' *Body and Surgery in the Middle Ages,* trans R. Morris (Cambridge: Polity, 1990), 125. She does, however, mention the symbolic significance of the sense as 'breaks in the wholeness of the body' (149).

24. Lacan, 'Mirror Stage', 5.
25. J. Gallop, *Reading Lacan* (Ithaca, NY: Cornell University Press, 1985), 60–1.
26. See the entries for 'Imaginary' and 'Symbolic' in J. Laplanche and J-B Pontalis, *The Language of Psycho-Analysis,* trans. D. Nicholson-Smith (London: Hogarth/Institute of Psycho-Analysis, 1973), 439–40.

–2.6–

The Light of Wangarr
Howard Morphy

In relation to *Wangarr,* the spiritual power of the ancestral being and world creating force, the sacred likanbuy paintings[1] of the Yolngu of Arnhem Land, Australia, have a property of a different order, *bir'yun,* that they do not share with Yolngu paintings of other categories. *Bir'yun* can be termed an aesthetic property since it operates independently of the specific meanings encoded in a painting, though as we shall see it interacts with them. *Bir'yun* is a particular visual effect resulting from aspects of the form of likanbuy paintings. Donald Thomson writes[2] that the mundane or secular meaning of *bir'yun* refers to intense sources and refractions of light: to the sun's rays and to light sparkling in bubbling fresh water:

Gong ngayi walu bir'yun-bir'yun, marrtji
fingers his sun scintillate go
The sun's rays scintillate

As applied to paintings, *"bir'yun* is the flash of light—the sensation of light that one gets and carries away in one's mind's eye, from a glance at the *likanbuy miny'tji"*.[3] The bir'yun of a painting is the visual effect of the fine cross-hatched lines that cover the surface of a sacred painting: "it is the sensation of light, the uplift of looking at this carefully carried out work. They see in it a likeness to the *wangarr*".[4] Thus bir'yun is the shimmering effect of finely cross-hatched paintings which project a brightness that is seen as emanating from the wangarr being itself: this brightness is one of the things that endows the painting with the ancestral power. I have argued elsewhere[5] that bir'yun is an example of what Munn refers to as "qualisign", a quality that operates as a sign.[6] The sensations of brightly shining light and lightness are both associated with ancestral power. In ritual, in addition to cross-hatched painting, naturally shiny substances such as fat, blood, wax, and feathers are used extensively to decorate objects and people. Highly shiny materials are thought to be ancestrally powerful, and lightning and rainbows are both considered manifestations of ancestral beings. Moreover, Yolngu who have experienced ancestral intervention sometimes refer to it as a flash of light or a bright light filling the head.[7] This suggests that brilliance, shininess, is a qualisign that people learn to interpret as ancestral power and which indeed becomes one of the ways in which

they experience that power; the brilliance of paintings is this itself felt as a manifestation of ancestral power.

Thomson states that this brilliance is one of the reasons why a likanbuy painting is either wholly or partly obscured when a person painted with one goes into the main camp. The painting is obscured by smearing the cross-hatched infill, thus reducing the fineness and separateness of the cross-hatched lines to a smudge of pigment. Although some aspects of the form of the painting are discernable, it has lost its brilliance (bir'yun), and through losing this has lost some of its ancestral power, "its likeness to the wangarr."

In this form the painting becomes safe, the danger of the design is reduced, and women and children can come into contact with it. The danger of bir'yun is also given as the reason for denying women access to certain places and certain sacred objects. The corollary of this protection, however, is that men keep some of the most powerful manifestations of ancestral power to themselves and deny the women the opportunity to experience that power to the extent men are able to.

The concept of bir'yun also explains one of the main differences between likanbuy paintings and bulgu paintings (both of which consist largely of clan designs). Bulgu paintings, which occur in open contexts, are not *bir'yunhamirri,* "having bir'yun," whereas likanbuy paintings are. One of Thomson's informants described bulgu paintings as being *mali nhanngu likanbuy miny 'tji,* "shades of likanbuy painting," whereas likanbuy paintings can be described as *mali wangarr,* "shades of the wangarr." Bulgu paintings are a subordinate category of paintings to likanbuy, one stage further removed from the wangarr ancestors, reinforcing the distinction between closed contexts, which are closest to the source of ancestral power, and open contexts, which are farthest away.

All clan paintings, both Dhuwa and Yirritja,[8] are said to possess bir'yun.[9] However, depending on the clan and wangarr ancestor concerned, the bir'yun itself may have different connotations. For example, Thomson records that the bir'yun of a Gupapuyngu *birrkurda* (wild honey) design expressed *gapu raypiny,* "the light of fresh water," and the light of eucalypts in flower; *ngoy ngamathirri, ngoy kitkitthun.* "[the light makes] the heart go happy, [makes] it smile." The wangarr *birrkurda* is associated with fresh water and eucalypts in flower (the source of pollen for the bees), and both the meanings are encoded in the design. The visual effect of the painting, its bir'yun, is thus integrated with the semantic aspects of the painting, enabling it to express characteristic properties of the wangarr being that it represents.

In the majority of cases, as above, bir'yun is described as expressing positive emotions: *wakul,* "joyfulness," *ngamathirri,* "happiness," and so on. However, Thomson gives one detailed example in which bir'yun expresses negative emotions. It concerns the shark in Djambarrpuyngu country before it reached Wurlwurlwuy in the country of the Djapu clan. The painting Thomson was concerned with was an entirely geometric painting representing wells and watercourses created by the shark after it had been speared by the hunters. In this case Thomson records that the bir'yun of the

painting is also referred to by a more specific term, *djawarul*. *Djawarul* is the proper name of a sacred well (*mangutji*) created by the wangarr shark that was speared by the ancestral being Marrayanara. *Djawarul* refers to the "flash of anger in the shark's eye—the blaze of the eye of the shark killed by stealth." The spirit of the wangarr shark is dangerous (*mardakarritj*) and was described as *miringu maarr,* "the power of vengeance."

The power of wangarr is always morally positive. It cannot be used by sorcerers. It can, however, be used by clan members out to avenge the death of one of their number, whether killed violently or by sorcery. It can also be used against those who violate a religious taboo or infringe the rights of women.

Notes

1. *Likanbuy* paintings are those of the most sacred and restricted form, used on *rangga* (sacred objects). They have a complex componential structure of clan designs and other geometric elements. The entire painting is infilled with cross-hatching, with the exception of certain elements of the clan design.
2. Donald Thomson, *Field Notes* 5.8.1937.
3. Ibid 4.8.1937.
4. Ibid 4.8.1937.
5. Howard Morphy, 'From dull to brilliant: the aesthetics of spiritual power among the Yolgnu.' *Man* 1989 (1): 21–40.
6. Nancy Munn, *The Fame of Gawa,* (Cambridge: Cambridge University Press, 1986).
7. See W. Chaseling, *Yuengor,* London: Epworth Press 1957, 168.
8. Dhuwa and Yirritja are the two exogamous patrilineal moieties of Yolngu society. Individuals belong to the moiety of their father and marry a person of their mother's moiety. See Howard Morphy, *Ancestral Connections,* 43–45.
9. Thomson *Field Notes* 4.8.1937.

–2.7–

Corpore Obscuro: Meditation on the Dead in Thailand
Alan Klima

Objects, reflecting light, press outward from themselves, leaving their imprints on photographic negatives like footprints in the sand. Or, as André Bazin said of the ontology of the photographic image, like the face of a corpse on a death mask.[1] And so is it with Buddhist meditation on death among the nuns and monks in the central Thai monastery of Toong Samakhi Dhamm Temple (Wat Toong). In fact, corpses are of the greatest worth for impressing upon the mind an eidetic reminder of mortality, almost as though one's mind were light-sensitive paper. To make that impression, nuns and monks retire to intensive, sometimes lifelong meditation on the corpse. Although seemingly morbid, this attention to the body in death is integral to the Buddhist soteriological path, as the nuns and monks of Wat Toong understand it. The body must fall apart and die, as universal law, but that one must also fall apart emotionally along with it is not written in stone, as it were. The organizing trope in Thai Buddhism of dukkha, "suffering," necessarily demands an intimate confrontation with the painful and disappointing tendency of the body to fall apart and die. It is the practitioners' belief that only by coming to terms with this truth can one ever escape from being emotionally subject to it. And yet, it seems as if they have as much difficulty as anyone else in trying to realize the significance of the one thing humans seem most adept at avoiding—but that is necessary, as they explain, for marking a relatively systematic route toward an awareness of death. They take aim, as it were, by means of vision and imagination.

Techniques for harnessing vision for this purpose are ancient, as far as texts can tell us, and yet are also fairly well represented in contemporary Thailand in temples such as Wat Toong. To enter into an atmosphere infused with death, nuns and monks avoid the diversions of everyday life; they sometimes live in cremation and burial grounds, sometimes alone in the forest, sometimes in a reclusive monastery, and all the while dedicate their life to training mental attention systematically, eventually cultivating a pronounced ability to visualize. Most important in this cultivation of vision is the instruction to spend as much time as possible around a cadaver. There the meditators should clearly inspect every detail of it, and use the detail to commit it to eidetic memory. The corpse should be stared at over and over, with particular attention to its most gruesome details. Buddhaghosa, in the text the *Visuddhimagga,*

lists ten such details or aspects worth impressing on the mind: the bloated, the livid, the festering, the cut up, the gnawed, the scattered, the hacked and scattered, the bleeding, the worm-infested, the skeleton. The text goes on to describe further each aspect of decomposition in the most lurid and prurient detail; it almost seems deliberately in bad taste. The livid, for instance, is "reddish-colored where flesh is prominent, whitish-colored in places where pus has collected, but mostly blue-black." The festering "is trickling with pus in broken places." The gnawed "has been chewed here and there in various ways by dogs, jackals, etc." The scattered "is strewed here and there in this way: 'Here a hand, there a foot, there the head.'" The hacked and scattered is "scattered ... after it has been hacked with a knife in a crowsfoot pattern on every limb." The bleeding "sprinkles, scatters, blood and it trickles here and there ... smeared with trickling blood." The worm-infested is "full of maggots."[2]

Here the corpse in its gory, abject, and repulsive state is the most desirable aesthetic. Once thoroughly immersed in this aesthetic of gore, meditators perform the crucial next step of imagining themselves as such a corpse, applying the visualization to their own body as if it were in a state of exposed internal organs and repulsive detail. The sensationally hideous aspect of such images can affect a meditator deeply, and suddenly. But it is not only physical corpses that are used as sources of the abject detail. Given that fiasco of British tabloid journalists depicting "cannibalism" at the temple, the meditators now generally avoid using real corpses, in accordance with their promise to Thai authorities not to appear too dark in the eyes of the world. This is the way to best serve the national image. Instead they use, as in many other Buddhist temples in Thailand, photographs of corpses for their meditation; these are usually culled from hospital autopsy procedures.

How great a loss is this? Would the "real presence" of a corpse be essential to impressing upon the mind the details of corporeal mortality? Is the physical presence of the cadaver different in nature from the two-dimensional "mere reproduction" of the body in death?

In fact, not only is photography employed by Buddhist nuns and monks to produce visions of death, but so too is a variety of material tools and visual aids drawn from biomedical anatomy instruction. These are precisely the artifacts of Western science that are said to divest our being of its holistic nature and narrowly hypostatize it in the objectified, medicalized form of "the body." In fact, Michel Foucault has argued that the techniques of seeing formed in autopsy are the source not only of clinical knowledge but of the entire disciplinary matrix upon which modern power rests. "Medicine becomes modern with the corpse," he wrote in *The Birth of the Clinic*. "It will no doubt remain a decisive fact about our culture that its first scientific discourse concerning the individual had to pass through this stage of death."[3]

Thai Buddhist meditators acquire for their purposes both autopsy photographs and the Western medical anatomy representations that are used by Thai doctors. *Gray's Anatomy* cutouts and plastic statues are common Buddhist paraphernalia, even at temples that do not practice corpse meditation. The practice of medical autopsy, and especially the clinical photographic record of it, are images and frames that have

been taken over by Buddhists and used in new ways. Monks and nuns regularly visit hospital autopsy rooms, and many temples have autopsy photographs on display for the public, sometimes with captions under, say, a mutilated face, that read "I was once like you. You will one day be like me!" And meditators use autopsy photographs and biomedical anatomy representations in the formal practice of asubha kammatthāna, to enter into their modes for the intimate observance of mortality.

Such photography of abject bodily dismemberment can be directly incorporated into the practice of meditation, and in Wat Toong is often pivotal to its effectiveness. The first step in the process, however, involves cultivating the basic ability to concentrate on an object of mental attention, regardless of its content. Samādhi, concentration, is usually built up through the technique of mindfulness of the breath. This may require hours, days, or weeks of sitting with the mind focused on the sensation of the breath at one point, most commonly where it passes the nostrils. One focuses on that point alone, constantly returning to it when distracted, until one builds up enough momentum in concentration to hold to the one point easily. With the ability to focus the mind to near one-pointedness based on attention to tactile sensation, meditators then transfer concentration to vision of a physical meditation object: the photograph of a corpse. Meditators impress the physical sight of the autopsy photograph on their minds by concentrating first on the outer sight, with special attention to the graphic details. They then attempt to reconstruct the image within "inner seeing" (*hen pai nai*) or "inner looking" (*maung pai nai*). In Thai Buddhism, what is referred to in English as the "mind's eye" would fall within the rubric of the mind as the sixth differentiated sense organ, in addition to the Euro-American five. In this conception, the mind as a sense organ has as its objects the appearance of any phenomena that do not have material contact as a condition of their immediate possibility: in other words, inner picturing, monologue, intentions, thoughts. The advantage in Thai meditation of this six-sense perceptual model is that it does not privilege the mind as a separate receptor of the five senses, but treats it as a sense like any other, which, as will become clear later, is central to the theoretical orientation of meditation.

This meditation is hard practical work, and different from simply making theoretical declarations that there is no inner or outer, that dualism is false, or that there are people who do not distinguish body and mind. The hard work consists in taking the abject object inward, since the abject at first may indeed appear to be what Kristeva describes as having only one quality of an object, "that of being opposed to *I*."[4] One begins with roving back and forth between the physical image and the mental image, each time staring, concentrating, trying to be more and more accurate in the inner visualization, and then comparing it with the outer, physical sight of the object, developing a closer and closer match. If one is a cultural other who does not distinguish between inner mind and outer world (*lok pai nai / lok pai naug*), then of course this cannot be practiced. But in Thailand this technique, which is also called "touring the cemetery within" (*bai teio ba cha pai nai*), is possible both to conceive of and to perform. The exercise itself can bring the mind to a fairly concentrated degree of samādhi, so that a clear and detailed image of a body part or an entire corpse is impressed on the mind's eye.

The practitioners can then work on that image alone, in the absence of the physical object, and focus on it just as one would focus on the breath as a meditation object. The point is to be able to cull from the material world a reproduction in the realm of inner vision, which one can work in formal sitting meditation without need of any physical sign. One calls the mental image to mind over and over, hour after hour, day after day, week after week.

There are three patterns of experience in samādhi that meditators report one might pass through, with enough continuous effort. The first is called "momentary concentration" (*kannika samādhi*), when concentration becomes focused but only in temporary spurts. In the initial momentary concentration, one gets what could be characterized as merely an unusually clear version of ordinary inner picturing. The second is "threshold concentration" (*upajhāna samādhi*), which is on the verge of absorption. Threshold concentration is deeper and lasts longer than momentary concentration, and it is in threshold concentration that the mind may start to see clear and whole inner mental images. At threshold samādhi, the inner visualization is of another order. It has its own momentum and appears seemingly without volition, popping up more or less clear, detailed, and complete so that it can be taken as an object of meditation, which is to say, as something already "there" that one can focus on. The third kind of samādhi is called "attainment concentration" (*āpāna samādhi*). In this case, absorption has occurred and the image has become absolutely stark and clear; it becomes the only thing present, so that there is no longer any reference point outside this absorption from which the image can be said to be "out" or "in," or even "there" in the usual sense of the terms. Through continuous practice, one's samādhi builds up toward absorption in the image, until the immaterial image-object itself is taken in so deeply that it is not much like an object anymore, and it snatches one into a spiraling descent, heading straight into its repulsiveness, until one is dwelling right in the heart of an image of death. In all this, it is the graphic and gory aspect, the foul and repulsive detail that carries the greatest eidetic-mnemonic power.

The bodily details "stick to the heart," *did chai,* as the nuns of Wat Toong say. Mae-Chi Liem has regular experiences of seeing into her body: "It cracks open, divides, and separates. This body opens up for you to see. You see bodily ooze, clear ooze like in the brain; thick, filmy ooze and clear ooze. The body splits open into intestines, intestines the size of your wrist, *na.* Liver, kidneys, intestines, the stomach, you can see it all."

. . .

It may seem counterintuitive that this experience is so valued and desired. As Stephen Collins writes of asubha meditation in Sri Lankan Theravāda Buddhism, the contemplation of the negative and averse characteristics of the body is often balanced by practice ideals of positive and cheerful comportment.[5] Over the course of studying in Wat Toong, I came to know several practitioners for whom such a balance of emotional forces was obviously necessary, but more for whom this was not necessary and who expressed suspicion of such emotional needs. Rather, as Collins also

discerns, the demonstration of positive external signs of contentment may be both a necessary social exchange in presenting the value of Buddhism to the rest of society, and perhaps also an actual effect of the beneficial practices of this form of meditation.[6] Mentioning the "positive side" of Buddhism can also assuage the concerns of academic readers who might receive undesired impressions about Buddhists because they do not share the same values. On the other hand, there can be no doubt that this meditation on seemingly morbid subjects can become, in fact, morbid. An early Buddhist text in the disciplinary rules for nuns and monks tells of the occasion when Buddha came up with the rule forbidding suicide, after a group of monks became so despondent after contemplating corpses that they took their own lives, or had others kill them, en masse.[7] I have witnessed people go into nervous breakdowns, for lack of better words, during the practice of Buddhist corpse meditation, including what clinicians might identify as psychotic hallucinations and fantasies. At the temple there is a short but significant history of the meditators whose "minds cracked" (*sati taeg*), as they term it, at the sight of meditation imagery; most of them never recovered.

· · ·

This consciousness of the body is to be carefully maintained, cultivated, and guarded with mindfulness and equanimity (which I was subsequently unable to do). The initial breakthrough is what meditators call, in Thai, *dai kammatharn,* to "get a meditation tool." The meditation tool can be cared for by mindful attendance to the point that it is vividly present in everyday life, and so also easily reentered into during formal sitting, returning the meditator to the intimate clarity of jhāna. Once this abject imagery has "stuck to the heart" (*did chai*), meditators at Wat Toong go around in their day-to-day life intensely aware of, say, their skeleton, their skin hairs, or their heart, actually seeing it inwardly all the time, and they build this awareness over long periods of time until it induces and provokes them to touch the charnel ground within, and brush against an insight into their existence. We all know, of course, that there are bones in our bodies, that the body is a delicate and impermanent construction, that it will definitely wear out, get sick, be painful, and finally die. But this kind of knowing or consciousness is usually an objectified form of knowledge. We know the body as an *object* that will fall apart. It is possible to make the intellectual association that this falling apart pertains to "me." But the immediate consciousness of the truth of the body is much more rare and precious, and glimmers of it usually come only under extremely unfortunate circumstances, circumstances that can sometimes be too overwhelming and upsetting to support the instruction of inspection, such as with serious pain and illness, childbirth, fatal diagnosis, or as we die. To know the body not as an object linked in a string of thoughts to a hypothetical "me," but as, say, a heap of bones, an intricate jalopy of a skeleton clunking along, is to glimpse a very powerful form for contemplating death and impermanence.

· · ·

For their soteriological purposes, the nuns and monks of Wat Toong seek out the *salod chai,* letdown, of repulsiveness. But the "truth" of these images is ultimately

not located in the image. It is the graphic, gory detail that "sticks to the heart" (*did chai*), and toward which this Buddhist pedagogy of visual images, and often also this Buddhist use of photography, leads; ultimately, however, the image realm of charnel ground may not be the realm of the physical eye, an organ that contacts things in an outer visual field. And yet asubha kammatthāna can have a connection to mechanically reproduced visual objects, which do operate that way. In the most absorbing photographic, video, and cinematic perception, of course, outer physical sight is the primary mode of contact, and in that sense the material body of the viewers themselves are not ordinarily the object of attention. But this is not a truth inherent to the "nature" of such visual media. Photographic images of death, corpses, and the repulsiveness of the body can be exchanged in a constant relation to eidetic visions of the body. And though they do not consist of matter, nevertheless these asubha images lead to an intimate awareness, a seeing of the body in the body, a reproduction in which, ultimately, a copy of a body can be retransformed and restored into an original—into a body once again.

"I look deeply into the parts of the being," Mae-Chi Sa-ad says. "What do I see? I see from the scalp to the skull, all the way down. And then I contemplate, *na*. I contemplate the mind, let the mind stay put with the mind, let the mind *phicarana-aaa* [contemplate] *lo-ooong* [sink down, down] to the feet. Go down and up, up and down ... see my body, watch to see what this body really is for sure ... In my tummy," she laughs, "what kinds of things are in there? I look throughout my parts. If the mind is calm or the mind is distracted, I simply make note of it, that's all. If the mind is quiet, the mind is buoyant. No pain or stiffness. When sitting, it's like ... it's not as though our body is a body of ours."

Notes

1. André Bazin, *What Is Cinema?*, Vol. 1 (Berkeley/Los Angeles: University of California Press, 1968), p. 12.
2. Buddhaghosa, *The Path of Purification* (*Visuddhimagga*), 185–86.
3. Michel Foucault, *The Birth of the Clinic*, p. 197, cited in Jean Baudrillard, "Political Economy and Death," in *Symbolic Exchange and Death*, translated by Iain Hamilton Grant (Thousand Oaks, Calif.: Sage Publications, 1993), p. 183.
4. Julia Kristeva, *Powers of Horror: An Essay in Abjection* (New York: Columbia University Press, 1982), p. 1.
5. Stephen Collins, "The Body in Theravada Buddhist Monasticism," in *Religion and the Body*, edited by S. Coakley (Cambridge: Cambridge University Press, 1996), pp. 195–96.
6. Ibid., 201–2.
7. Ibid., 195.

—2.8—

The Imaginary Body: The Grotesque
Susan Stewart

The body presents the paradox of contained and container at once. Thus our attention is continually focused upon the boundaries or limits of the body; known from an exterior, the limits of the body as object; known from the interior, limits its extension into space.

...

We want to know what is the body and what is not, and it is in the domain of ritual and the carnival grotesque that we see this boundary confused and ultimately redefined. Bakhtin has characterized the grotesque body as a "body in the act of becoming." The grotesque body undergoes hyperbolization of the bowels, the genital organs, the mouth, and the anus. "All these convexities and orifices have a common characteristic: it is within them that the confines between bodies and between the body and the world are overcome: there is an interchange and an interorientation."[1] The grotesque body, as a form of the gigantic, is a body of parts. The productive and reproductive organs which are its focus come to live an independent life of their own. The parading of the grotesque is often the isolation and display of the exaggerated part—the mummer hidden by his huge, balloon-filled breasts, or, on a less formal level, the high-school boy substituting a "moon" in the car window for that symbol of balance, proportion, and depth, the face. This scattering and redistribution of bodily parts is the antithesis of the body as a functional tool and of the body as still life, the classical nude. In medieval rhetoric, for example, we find the convention of description specifying that the body should be viewed from head to foot. But the grotesque presents a jumbling of this order, a dismantling and re-presentation of the body according to criteria of production rather than verticality.[2]

...

The grotesque body can thus be effected by the exaggeration of its internal elements, the turning of the "inside out," the display of orifices and gaps upon the exterior of the body. But in addition to this interpenetration of the exterior and interior of the body, an exchange of sexuality and an exchange between animal and human also can be used to effect the grotesque, and its corresponding sense of interchange and disorder. Natalie Zemon Davis, writing about early modern Europe, notes:

The ritual and/or magical functions of sexual inversion were filled in almost all cases by males disguised as grotesque cavorting females. In sections of Germany and Austria, at carnival time male runners, half of these masked as females, half as male, jumped and leaped through the streets. In France it was on St. Stephen's Day or New Year's Day that men dressed as wild beasts or as women and jumped and danced in public (or at least such was the case in the Middle Ages). The saturnalian Feast of Fools, which decorous doctors of theology and prelates were trying to ban from the French cathedrals in the fifteenth and sixteenth centuries, involved both young clerics and laymen, some of them disguised as females, who made wanton and loose gestures.[3]

. . .

In anthropological and historical studies considerable attention has been focused on the ways in which such symbolic inversions present the world upside down, the categories and hierarchical arrangement of culture in a recognizable disorder. Theories of inversion have explained these symbolic phenomena as reaffirmations of cultural categories through learning, as mechanisms for change and revolution, and as "safety valves" for an otherwise turbulent populace. Many of these conclusions are based upon cross-cultural studies of trickster characters, for Trickster continually violates the boundary between nature and culture; he is part animal, part human (often a "talking" animal such as the crow or coyote, or a producer such as the spider), part man and part woman (often coupling with either sex indiscriminately), and a violator of cultural taboos (often eating the food that is specific to other animal groups, or eating what should not be food at all). Yet Trickster is also a spirit of creativity, a refuser of rigid systems, and thus is both credited with founding culture and accused of violating the norms of culture. For example, at the conclusion of the Winnebago trickster myth that forms the basis for Paul Radin's classic study of the trickster, Trickster unleashes the Mississippi, allowing it to flood the land, and thereby makes agriculture possible.[4]

It seems clear that the function of such exaggeration in physiology and gesture must be linked to the particular historical context in which it appears. The laity's appropriation of the Feast of Fools and the gigantic in the Renaissance made the carnival grotesque symbolic of a "second life" of the masses, a life of antiorder and vernacular authority as opposed to the official doctrines of religious and state institutions. Such a split perhaps made these forms of festive disorder all the more likely to be taken up in the spirit of revolt when class conflicts arose. And yet rituals of inversion which are clearly framed and circumscribed by religious or state authority (for example, the liminal stages of official puberty rites such as confirmation ceremonies), or phenomena of inversion which are imposed vertically from outside the popular classes (for example, the TV parody show), are far less likely to result in permanent change; these officially sanctioned forms would seem to function more to reaffirm cultural categories by forcing participants to articulate such categories from their opposites.

Furthermore, we must also consider these images of the grotesque body precisely as images or representations. Like any art form, they effect a representation and

transformation of their subject. Yet to make from the body a work of art involves the creation of a supplement or extension. The work of art as costume, mask, and disguise differs significantly from the work of art as external object. The body is paraded, put on display, in time as well as in space; most often those contexts in which it appears are structured so that there is little or no division between participants and audience. The distance between the artwork, the artist, and the audience is thereby collapsed doubly; the body is the work, and there is reciprocity between individuals/works rather than unilinear distance between work and observer. The mask and costume are, like the face, apprehended in what Philip Fisher has called "democratic space,"[5] the space immediately in front of our line of perception rather than the space above us, occupied by an authoritative and transcendent architecture; or the space at our feet to which we condescend; or the space directly behind us, invisible and threatening. But it is not simply the fact that this space can be directly confronted which makes it democratic; its democracy, its reciprocity, depends upon its public quality. It is just beyond the space that each culture variously determines as the private and just within the space that a culturally determined perception defines as remote. It is space occupied by the other, the space of dialogue. Thus the mask, the costume, and the disguise find their proper context in carnival and festivity, where there is little specialization of roles and where hierarchy is overturned. Even in ritual uses of mask and disguise, where specialization does occur (say, for example, kachina clowns at Hopi ceremonial feasts), the performer must engage in face-to-face communication with the audience.

While the grotesque body of carnival engages in this structure of democratic reciprocity, the spectacle of the grotesque involves a distancing of the object and a corresponding "aestheticization" of it. In carnival the grotesque is an exaggeration and celebration of the productive and reproductive capacities of the body, of the natural in its most sensual dimensions. But in spectacle the grotesque appears not in parts but in a whole that is an aberration. The participant in carnival is swept up in the events carnival presents and he or she thereby experiences the possibility of misrule and can thereby envision it as a new order. In contrast, the viewer of the spectacle is absolutely aware of the distance between self and spectacle. The spectacle exists in an outside at both its origin and ending. There is no question that there is a gap between the object and its viewer. The spectacle functions to avoid contamination: "Stand back, ladies and gentlemen, what you are about to see will shock and amaze you." And at the same time, the spectacle assumes a singular direction. In contrast to the reciprocal gaze of carnival and festival, the spectacle assumes that the object is blinded; only the audience sees.

The history of the aberrations of the physical body cannot be separated from this structure of the spectacle. The etymology of the term monster is related to *moneo,* "to warn," and *monstro,* "to show forth".[6] From Hellenistic times through the Middle Ages and the Renaissance, dwarfs, midgets, and occasionally gigantic figures were kept as accouterments of court life, as entertainers and pets. In the eighteenth century

such figures were put on display in public taverns, and notices posted in local papers or handbills served to advertise them. Gulliver's fate in Brobdingnag (inversely) recapitulates this history: he is first kept in a box and exhibited on market days and in taverns; later he is rescued by an invitation to serve at court. The Queen, who "was however surprised at so much wit and good Sense in so diminutive an Animal," takes him on as a human pet or doll.[7]

In his book *Giants and Dwarfs,* Edward Wood records a handbill advertising a dwarf couple exhibited in "1712 at the Duke of Malborough's Head, over against Salisbury-Court, Fleet-street," and also "a collection of strange and wonderful creatures from most parts of the world, all alive, over against the Mews Gate, at Charing-cross, by her Majesty's permission." The handbill for this exhibition reads:

> The first being a little Black Man being about 3 foot high, and 32 years of age, straight and proportionable every way, who is distinguished by the name of the Black Prince, and has been shewn before most kings and princes in Christendom. The next being his wife, the Little Woman, not 3 foot high, and 30 years of age, straight and proportionable as any woman in the land, which is commonly called the Fairy Queen, she gives a general satisfaction to all that sees her, by diverting them with dancing, being big with child. Likewise their little Turkey horse, being but 2 foot odd inches high, and above 12 years of age, that shews several diverting and surprising actions, at the word of command. The least man, woman, and horse, that ever was seen in the world alive; the horse being kept in a box.[8]

Here we have the tragedy of a public miniature: the prince as a mirror of the princes of Christendom, yet made diminutive, conquered, as the cultural other; his wife, monstrously "big with child"; and his horse, miraculously diverting, are the promise of repetition and animation—toys come to a life that is of necessity a death as the box offers a coffin's promise of eternity. Similarly, in his study *Freaks,* Leslie Fiedler records that "giants have, ironically, bafflingly (how hard it is for us to sympathize with them!), played the role of victims rather than victimizers. Before they became side show attractions, they were used chiefly as soldiers—parade ground attractions placed conspicuously in the front ranks—and porters, lofty enough to impress visitors at the gates of kings."[9] The fate of other types of "freaks," as chronicled by Fiedler—bearded ladies, wild men, feral children, hermaphrodites, and Siamese twins—was invariably the spectacle and final ruination.

Often referred to as a "freak of nature," the freak, it must be emphasized, is a freak of culture. His or her anomalous status is articulated by the process of the spectacle as it distances the viewer, and thereby it "normalizes" the viewer as much as it marks the freak as an aberration. And since the spectacle exists in silence, there is no dialogue—only the frame of the pitchman or the barker. Even when, as is sometimes the case in smaller and poorer carnival operations, the freak delivers his or her own "pitch," there is an absolute separation between the tableaulike silence of the freak's display and the initial meta-commentary of the pitch. This separation

is poignantly felt by the viewer as a hesitation: the pause before the curtain closes or before the viewer walks on. And the viewer *must* go on; dialogue across that silence is forbidden, for it is necessary that, like the aberration, the normal be confined to the surface, or appearance, of things. We find the freak inextricably tied to the cultural other—the Little Black Man, the Turkish horse, the Siamese twins (Chang and Eng were, however, the children of Chinese parents living in Siam), the Irish giants. Accounts of pygmies, for example, date back to Homer (*Iliad* 3.3), Hesiod, Herodotus (who places them both in Africa and in Middle India), Ovid (who includes in the *Metamorphoses* the legend of the battle between the Pygmies and the Cranes), and thus to the West's earliest encounters with other traditions. We find further accounts of pygmies in Mandeville's *Travels* and in a study of the Outer Hebrides made by Donald Monro in 1549.[10] The body of the cultural other is by means of this metaphor both naturalized and domesticated in a process we might consider to be characteristic of colonization in general. For all colonization involves the taming of the beast by bestial methods and hence both the conversion and projection of the animal and human, difference and identity. On display, the freak represents the naming of the frontier and the assurance that the wilderness, the outside, is now territory.

Repeatedly in the history of freaks it has been assumed that the freak is an object. The freak is actually captured and made a present of to the court or to the College of Surgeons, as the case may be. Or the contingencies of the economic system force the freak to sell himself or herself as a spectacle commodity. Except for the famous midget welders of World War II propaganda movies, there are few examples of any other existence made possible to the "prodigy." Thus, Fiedler notes, it is particularly shocking that the Siamese twins Chang and Eng, themselves brought to America in bondage, eventually owned slaves in the period just before the Civil War.[11] The physiological freak represents the problems of the boundary between self and other (Siamese twins), between male and female (the hermaphrodite), between the body and the world outside the body (the *monstré par exces*), and between the animal and the human (feral and wild men). These are the same problems that we see explored in grotesque representation. Ontology is not the point here so much as the necessity of exploring these relations, either through the fantastic or the "real."

It is significant that in the presentation of the freak, language is made object, divorced from communication. Gulliver's native tongue is condescendingly called "his little language" by the Brobdingnagians, and the dwarf as court jester is admired for his wit. Among the earliest recorded Siamese twins were "the Scottish Brothers," who served in the court of James IV. They "won the hearts of the court by playing musical instruments, singing in 'two parts, treble and tenor,' and making witty conversation in Latin, French, Italian, Spanish, Dutch, Danish, and Irish."[12] Similarly, the London Daily Advertiser for August 18, 1740, advertised: "To be seen, at the Rummer Tavern, Charing-cross, a Persian dwarf, just arrived, three feet eight inches high, aged 45 years ... he is justly called the Second Sampson. He also speaks

eighteen different languages."[13] The language of the spectacle is properly that of the showman, the hyperbolic pitch which further distances the points of equivalence between audience and object, which presents another layer of surface as it articulates the to-be-presented façade.

The freak must be linked not to lived sexuality but to certain forms of the pornography of distance. The spectacle results only in speculation. Hence, as Fiedler suggests, the actual sexuality of the freak, encumbered by a host of biological limitations, has an independent life from the spectacle sexuality that coexists with it in legend. This sexuality is an imaginary relation, just as, for example, the "girlie" poster on which a woman's body is mapped out, like the body of a steer, into various territories representing cuts of meat is far removed from the festive images of sexuality and consumption found in carnival. As opposed to the "body in the act of becoming" of carnival, the body of the side show offers a horrifying closure. Thus it does not matter whether the freak is alive or dead: John Hunter, the father of British surgery, was just as happy to have the bones of the giant James Byrne as to study him alive. Similarly, Frederick I of Prussia, attempting to kidnap a giant named Zimmerman, smothered him in a coffin, yet was just as satisfied with his skeleton as with the living giants he had brought to his court.[14] Even more crucially, the façade of the pitch or patter makes it of little significance whether the freak is authentic or not. It is the possibility of his or her existence that titillates; it is the imaginary relation, not the lived one, that we seek in the spectacle.

Notes

1. Mikhail Bakhtin, *Rabelais and his World,* trans. Helene Iswolsky (Cambridge: MIT Press, 1968), p. 317.
2. See D. W. Robertson, *Preface to Chaucer* (Princeton: Princeton University Press, 1962), for a discussion of how Chaucer's portraits in *The Canterbury Tales* are mock descriptions in the same way that Gothic portrayals of the vices in the late-thirteenth and fourteenth centuries parodied official modes of representation.
3. Natalie Zemon Davis, *Society and Culture in Early Modern France* (Stanford: Stanford University Press, 1975), p. 137.
4. Paul Radin, *The Trickster* (New York: Schocken Books, 1972). For an anthology of approaches to symbolic inversion, see Babcock, *The Reversible World.* In addition, see the author's survey of several approaches to reversal and inversion in chapter 3 of *Nonsense* [S. Stewart, *Nonsense: Aspects of Intertextuality in Folklore and Literature* (Baltimore: Johns Hopkins University Press, 1979)].
5. Philip Fisher, "The Construction of the Body," p. 8 (author's photocopy); see also Fisher, "The Recovery of the Body," *Humanities in Society* 1(1978): 133–146.
6. Leslie Fiedler, *Freaks: Myths and Images of the Secret Self* (New York: Simon & Schuster, 1978), p. 20.

7. Jonathan Swift, *Gulliver's Travels,* edited by Robert A. Greenberg (New York: W. W. Norton, 1970), p. 81.

8. Edward Wood, *Giants and Dwarfs* (London: R. Bentley, 1868), pp. 313–14.

9. Fiedler, *Freaks,* p. 107.

10. Joseph Ritson, *Fairy Tales, Legends, and Romances Illustrating Shakespeare and other early English Writers to Which Are Prefixed Two Preliminary Dissertations: 1: On Pygmies, 2. On Fairies.* Edited by William C. Hazlitt. (London: F. and W. Kerslake, 1875), p. 6, note.

11. Fiedler, *Freaks,* p. 214.

12. Ibid., p. 201.

13. Wood, *Giants and Dwarfs,* pp. 310–11.

14. Fiedler, *Freaks,* pp. 113, 108.

–2.9–

Lifting the Veil: Shared Cultural
Values of Control
Patrice Caldwell

The Arabian peninsula was the cradle of three of the world's religions—Judaism, Christianity, and Islam. It should come as no surprise, then, that they share important cultural patterns, particularly in the role and perception of women. Specifically, the symbolism of the veil reveals their suspicion of woman, who represents both a challenge to spirituality and, more dangerously, a locus of evil. Although all three religions provide examples of veiled women and men, only the veiling of women implies the need to control those veiled. For example, the customs of Moslem tribes of the Tuareg and the Teda in Northern Africa, whose men, not women, "veil," contrast sharply with the laws of Islam requiring women to veil; Greek Orthodox priests veil themselves for high ceremonies, while Western Christians veil only their religious women. The Jewish ceremony of the husband "veiling" his bride dates from the second century, one of the oldest Hebrew ceremonies that has no supporting Talmudic text. The comparable male "unveiling," circumcision, clearly has different connotations; the uncircumcised male has no place or identity in Jewish law or society.

Because of the complex interaction of religion and custom that defines the veiling of women in cultures dominated by these religions, I propose to examine shared perceptions of women and veiling in Judaism, Christianity, and Islam, and to demonstrate in three modem examples how those perceptions continue to shape the perception of women today. I hypothesize that veils for men represent a veiling of sacred or secular power from the uninitiated; veils also mystify or distance the sacred from the (female) profane. For women, the veil's meaning stems from a recognition of evil or weakness in the female character. The nature of the veil has also been forcibly transformed from emblems of modesty, class, or leisure to a symbol of the need to control women and their dangerous or sinful allurements.

Understanding the religions that began on the Arabian peninsula begins by examining their shared cultural and social roots. Life on the Arabian peninsula until the seventh century AD was semi-nomadic and tribal. The pagan religions practiced in South Arabia accorded women, along with male priests, considerable power and prestige. And unlike the purely nomadic tribes of the north, the southern tribes practiced some agriculture in the more fertile coastal areas. Following the predictable curve of a

society converting from nomadic herding to primitive and then more advanced agriculture, the status of women in these societies declined. Specifically, the environmental hardships and the nomadic traditions dictated the supplanting of early (tribal) matriarchal systems by patriarchal and male kinship lineage. The tribes lost the practice of monogamy and started a transition to polyandry and eventually polygamy. In short, woman's status on the Arabian peninsula was pointedly diminished (Carroll 1983: 194–97). On land unable to sustain large populations, groups regularly broke off from the larger core to relocate to more remote areas of the peninsula. Two such "breakaway" tribes were the Hebrews and, much later, the Muslim Arabs, both groups distinguished by their patriarchal social organization and their religious monotheism. Indeed, the Jews, with some historical justice, view Islam and Christianity as younger "daughters" of Judaism. As evidence of this common heritage, veiling in Judaism, Eastern (Greek Orthodox) Christianity, and Islam indicate a distinct and shared pattern of the veil as a symbolic marking of women. Veiling of the sanctuary and veiling of a married woman share close connections in Judaism and Islam. The practice of the Jewish bridegroom "veiling" his bride (reversed in Western custom, where the groom lifts the bride's veil once the marriage vows have been pronounced) indicates her severance from the world (or glance) of men. Further, the Jewish wedding canopy or chuppah symbolizes the consignment of the woman to her husband's "tent," a concept echoed in Islamic purdah (the word means "veil"). The "veiling" of the Temple sanctuary has special significance for women as well. Behind this veil women may never step, only (male) priests of the tribe of Levi. Proscriptions against a woman's monthly "uncleanness" (barring her from normal social interactions during menstruation) seem to have been gradually extended to a perception that the "uncleanness" of women was a condition of her sex, hence her exclusion from sacred places.

Eastern Orthodox Christians repeat the Jewish custom of veiling the sanctuary with a more substantial barrier. The iconostasis is a solid screen pierced by three doors; a veil hangs behind the largest double door in the center. The image of the iconostasis is repeated in the religious icons that hang in the church and in every Orthodox home. The icon is, literally, the meeting place of heaven and earth, reminders of the invisible presence of the company of heaven at the liturgy or in everyday life. Thus the dualism that characterizes many religions, the sense of the spiritual defiled by the material and of the association of the material with women, is concretely demonstrated in sacred places and ceremonies. The separation of the sacred from the profane, spiritual from material, male from female, is echoed in the symbolism of the veiling of individuals.

Originally intended to protect religious women from Viking, Saracen, or Magyar invasion, political anarchy or violence common between 300 and 600 AD, the cloistering, veiling and active restraining of female religious since the fourth century came to be seen as a natural outgrowth of the negative perception of women in the early Christian Church. "Diana went out and was ravished," St. Jerome reminds Eustochium in 383 AD Accordingly, Pope Gregory the Great instructed that nuns should

confine themselves to convents lest they "suggest any evil suspicion to the minds of the faithful" (quoted in Schulenberg 1984: 53). The implication, of course, is that women, even religious women, outside their cloister, pose a serious threat to the spirituality of the laity. The role of female religious as the lesser sisters of the stronger male priests is ingeniously elaborated in the way that the Church awards diminutive status to female religious and translates secular society's life-states into weaker echoes of those relationships in religious life. Nuns are "handmaids" of the Lord, "Brides of Christ," defined by the secular state of wifely servitude, situated in an unconsummated marriage, without any of the benefits of the alliance.

The custom of veiling in Islam reflects more social and behavioral than religious origins, but there is a gradual religious re-definition of the veil until it becomes almost completely a religious emblem. The custom of female veiling originated with the Persians over a century after the death of the prophet Mohammed. At first a non-obligatory symbol of the women's class or status, and later, of her desire to protect her respectability, the veil gradually became an outward sign of purdah, the seclusion of women within the home (Strobel 123). In Iran, the recent appearance of the chador, the black cotton or silk fabric in which a woman wraps herself from head to toe, signals a return to traditional compulsory veiling, accompanying the returned conservatism of the country.

The connection between veiled women and the veiling of the sanctuary, while seeming to posit a sacred quality to both, actually proposes contrasting models for the veil's symbolic meaning. The sanctuary's veil shields the faithful from close contact with the sacred and signals its special status within the human community. The veiling of woman reflects her necessary exclusion from human society because of the inherent evil of her character. The veil, therefore, reflects two contrasting messages: in the veiled sanctuary, the sacred must be protected from the defilement of the human community; however, the veiled woman represents society's need to control the profane element in society, woman.

The Jewish community further refines the connection of women's veiling with a specific aspect of her profanity—her sexuality. The Talmudic law requiring women to cover their heads so as not to expose their hair is derived from a biblical injunction and dates at least to the second century. The issue was one of morality, not simply modesty; a woman's hair was considered sexually provocative. Virgins were exempt from the law to veil, since, presumably, their one beauty—their hair—was a way to catch a husband. Married women covered their heads with scarves or hats because frequently their heads were shaved at marriage, thus assuring their fidelity to their husbands by removing their "market value." Since the nineteenth century, Orthodox women have worn wigs (sheitel) in place of hats or scarves (Bloch 1980: 103). In conservative communities today, particularly devout Jewish women still wear wigs over their own hair in recognition of this precept.

The implication that a woman's hair may occasion the sin of lust, which "law" and the woman herself must control, contrasts with the equally ancient practice of

circumcision. The description of this procedure is instructive. After the foreskin of the male infant has been cut, the wound is dressed so that, according to theologian Abraham Bloch, "the head of the organ remains altogether exposed, an act termed 'Periah,' uncovering, without which the circumcision is null and void (1980: 133). Circumcision marks the Jewish male as "a son of the Covenant," a member of the Chosen People. Further, while woman's sexuality (represented by her hair) is shunned as evil, the ceremony of male circumcision authenticates the male's sexuality. This practice can be usefully contrasted with the practice of female circumcision, practiced with great regularity in the Muslim areas of North Africa. Sanctioned by health professionals, modified circumcision is practiced in modern hospitals throughout the West today; no rationale for female circumcision has ever been advanced, but it continues to be practiced. In a sense, the practice institutionalizes the mutilation and "sewing up" of the female genitalia, a more radical form, perhaps, of compulsory veiling.

Issues of veiling and circumcision divided the early Christian community, evidence that these religious "teachings" were almost immediately challenged as cultural practices peculiar to the Jews and thus inappropriately applied to Gentiles converting to Christianity. Ironically, the champion of no circumcision for adult Gentile male converts, the Apostle Paul, staunchly supported the veiling of women. His reasoning was based on women's subordination to her "head" (her husband) and a symbolic acknowledgement of the differences, ordained by God, between men and women. Paul's decision was also influenced by social practices in Corinth, where the unveiled head was the equivalent of the shorn female head, the contemporary punishment for prostitution (Vaughn and Lea 1983: 112). Priestesses of Isis were known to pray with their hair unbound and heads thrown back dramatically, an image of enthusiastic worship that Paul was anxious to erase as a model for the struggling Christian Church. Further, Paul preached and wrote against the practice in Corinth of women cutting short their hair and wearing men's clothing (Acts 3:25, 48), gestures motivated by the women's belief that their conversion to Christianity had conferred upon them a gender-blind equality with their male brethren. Paul also counseled against women being allowed to preach during a religious service. This behavior was doubly threatening, since women were not only playing a leading role in religious liturgy by preaching, but were uncovering their heads to speak (MacDonald 1987: 110).

Common traditions of the veiling of women are clearly present in early Judaic, Christian, and Islamic history. Although the veiling of women was originally associated with urban and upper-class Middle Eastern women as a mark of status or luxury, the systematic curtailment of women's participation in the new religions transformed the wearing of the veil into a mark of women's subordination to the authority of men. Such a transformation appears to occur as religious leaders, products of traditionally conservative societies, face the challenge of cementing and protecting a new religion (Carroll 1983: 203). The transition from religious precept to culturally sanctioned behavior is readily traced in the history of veiling practices. While Jewish law defined unveiled women as a source of sexual provocation, and Christians viewed woman

as a temptress and locus of evil, the veiling of women in Islam is a visible way of securing male honor by assuring the woman's modesty and purity.

Modern inheritors of ancient Judaic and early Christian practices, Christians of both West (Roman) and East (Orthodox) preserve vestiges of earlier veiling practices and many of the convictions about woman's nature that authorized the practice originally. Several aspects of the cultural and religious constraints imposed by veils are subtly demonstrated in the modern-day village of Vasilika in rural Greece. Older married women carefully cover their heads at all times with a brown kerchief wound around their heads to form a close-fitting cap. For field work, they (paradoxically) add a white kerchief on top of this scarf. Women frequently tuck the ends of the outer kerchief around their faces in a manner that covers their mouths as well. Anthropologist Ernestine Friedl notes that this practice carries none of the Muslim connotations of veiling, although it is speculated that the manner of draping the kerchiefs dates from the Turkish (Muslim) occupation of Greece (Friedl 1963: 45).

Friedl also reports on the ritual observances of the Eastern Orthodox Church, to which every member of this village belongs. For Easter, young girls are allowed to enter and decorate the Church unsupervised by men. Friedl reports that the girls stand at the chanter's table and chant some of the prayers of the service and tease each other about going behind the iconostasis, a place forbidden to women. Friedl notes that the girls seem very uneasy, even frightened, at this teasing (1963: 101). Girls and women are excluded from many of the activities of the Church and generally stand in the back of the church during services. To some extent, the position of Orthodox Judaism and the early Christian Church provides a rationale for the exclusion of women from engaging in liturgy. Because women were central to pagan ceremonies and the chief celebrants of most of those rites, Jewish law allowed only men to preside at Jewish liturgies (Getty 1983: 52). The Roman Church followed the same proscription, denying women participation in liturgy and requiring them to cover their heads during a service until the late 1960s.

The veiling of men also carries ritual significance that differs markedly from the veiling of women. The Greek Orthodox clergy or papas, for example, are a striking sight in the village of Vasilika, wearing their long black robes (longer and looser than the Western cassock), tall cylindrical caps—to which black veils are attached for high liturgies—and unshorn hair and beards. Clearly, the formal veiling of the priests reflects some connection with the sacred places where they may ritually enter. Informally, the village's life has also retained the female version of veiling, in the muffling of married and older women with not one but two head coverings. Women's diminished role in the liturgies of the Church further confirms their lower potential for spirituality. Permitted to clean and decorate the church, they are consigned to the back of the church for services, kept as far away as possible from the "sacred areas" of the liturgy.

In the Middle East, purdah is a central tenet of Muslim society, excluding women from the mosque and the marketplace. Despite considerable evidence that Muslim

women were not veiled during Mohammed's time, that they accompanied men into battle, that they made pilgrimages on their own and freely interacted with their husbands in their own homes (Hussain 35), the practice of veiling has been forcefully reintroduced in parts of the Middle East. The stated intent is to preserve the traditional order of Islam and to fight corruption by the West. Interpretations of the Qu'ran in fact trace an increasingly stringent interpretation of the customs of veiling and of the seclusion of women in the two centuries immediately after the Prophet's death. Iran's recourse to the close veiling of women suggests a similarity between today's rigor and the increased interest in veiling women in the difficult times of the new Islamic religion (700–900 AD).

Unlike the "traditional" veiling practices of the Arab-Islamic countries, two nomadic herding tribes of modern North Africa present a very different view of veiling. Although Tuareg women do not veil themselves per se, they do wear a shawl loosely covering their head and shoulders. By contrast, the men's use of the veil has earned the Tuareg the designation "Al-el-Litham," the "people of the veil." The old Tuareg saying that "the veil and the trousers are brothers" reveals their conviction that bare-leggedness and bare-facedness are violations of male modesty and propriety (Nicolaisen 1959: 93). The veil is wound around the face first and then around the head, enabling the Tuareg male to pull his veil over his eyes or higher on the bridge of his nose to create a completely swathed face (Benhazera 1908: 32). While their neighbors, the Teda, are less particular about the draping of the veil, Teda men also veil their faces during their participation in all rituals, including that of adult circumcision (Kronenberg 1958: 58).

In analyzing this custom, anthropologist Robert Murphy suggests that the Tuareg women do not "veil" because they have no social, public reality, despite their traditional high prestige in a matrilineal tribal setting. Men veil to distance themselves from social interactions, particularly ones characterized by ambiguity or role conflict (Murphy 1970: 290–319). This contradictory notion of communication and simultaneous withholding of communication, participation in society and a symbolic distancing from it all communicated by the veil, is completely reinterpreted in the veiling of women.

The veiling of the Tuareg may share some affinity with the veiling of the sacred—the sanctuary of the Greek Orthodox Church, the Jewish "Holy of Holies," the draping (and veiling) of ordained priests and rabbis. Far from a consistent application of the imagery of the veil, the symbolic content varies by gender rather than by culture. The image of the icon of the Greek Orthodox Church perhaps best summarizes the complex interaction of religion, women, and the traditions of veiling. The Orthodox icon represents the contact point between the real and the spiritual worlds, re-enacting as it does the incarnation of Christ—God becoming man. Valued for her fertility, woman is inevitably tied to the "material" realm, while man is specially privileged in the religions of Islam, Judaism, and Christianity; he alone can be the intermediary with the divine. Ironically, the first intermediary, in Christianity, the woman who

bears the Christ Child, is immediately consigned to a lower, material world for her physical contribution to salvation history. The icon, or the veil which separates sanctuary from congregation, becomes the dangerous, mysterious, even erotic contact point for these two powerful forces.

The evidence from these three religions all demonstrate a striking similarity in their use of the veil in ritualistic as well as daily practice, differences largely consistent across cultures by gender. When men take the veil, it represents religious or personal power that they control. But when women take the veil, or when they are veiled, they signal their acceptance of man's law to subdue and control their errant natures. Although many Westerners are quick to assume the sexist nature of Middle Eastern societies, they overlook the close connections among the three cultures that emerged on the Arabian peninsula, particularly in their cultural definitions of men and women. Clothing and hair are still used in the Western world to convey underlying cultural assumptions about women. Not surprisingly, the veiled women of Western culture, the nuns, continue to enjoy a surprising level of interest, bordering on the erotic, in popular media. Despite the abandonment of the traditional habits by many Roman Catholic orders of nuns, the media continue to use the recognizable figure of the veiled nun to represent the unknown, the alien, the "asexual." Ironically, the draped figure and particularly the veil heighten rather than quench the latent sexuality that the veil is intended to obliterate.

The message of woman's fallen nature that the veil both symbolizes and, perversely, evokes is a striking, shared cultural manifestation among the three religions that arose on the Arabian peninsula. All three found ways to consolidate patriarchal power by silencing the competing arguments of female goddess worship and of gender equality in a new religion. The veiling of women is only one manifestation, although one of the most visible, of many practices that label women as aberrant, dangerous, and in need of male control.

Bibliography

Benhazera, Maurice (1908). *Six Months Among the Ahaggar Tuareg*. Algiers: n.p.

Bloch, Abraham P. (1980). *The Biblical and Historical Background of Jewish Customs and Ceremonies*. New York: KTAV Publishing House.

Carroll, Theodora Foster (1983). *Women, Religion, and Development in the Third World*. New York: Praeger.

Friedl, Ernestine (1963). *Vasilika: A Village in Modern Greece*. New York: Holt, Rinehart, Winston.

Getty, Mary Ann (1983). *First Corinthians: Second Corinthians*. Collegeville, MN: The Liturgical Press.

Koso-Thomas, Olayinka (1987). *The Circumcision of Women: A Strategy for Eradication*. London and Atlantic Highlands, NJ: Zed Books.

Kronenberg, Andreas (1958). *The Teda of Tibesti.* Horn-Wien: Ferdinand Berger, Publisher.

MacDonald, Dennis R. (1987). *There is No Male and Female.* Philadelphia: Fortress Press.

Mandelbaum, David (1988). *Women's Seclusion and Men's Honor: Sex Roles in North India, Bangladesh, and Pakistan.* Tucson: University of Arizona Press.

Murphy, Robert F. (1970). "Social Distance and the Veil," in *Peoples and Cultures of the Middle East* ed. L. Sweet. New York AMNH 1: 290–314.

Nicolaisen, Johannes (1959). *Political System of Pastoral Tuareg in Air and Ahaggar.* Copenhagen: Danish Ethnographical Association.

Schulenberg, Jane Tibbets (1984). "Strict Active Enclosure and Its Effect on the Female Monastic Experience (500–1100)." In *Distant Echoes,* Vol. 1 of *Medieval Religious Women.* Eds. John A. Nichols and Lillian T. Shank. Kalamazoo, MI: Cistercian Publications, 51–86.

Vaughan, Curtis, and Thomas D. Lea (1983). *1 Corinthians: Bible Study Commentary.* Grand Rapids, MI: Lamplighter Books.

–2.10–

Jacqueline Onassis and the Look-Alike
Jane Gaines

In *Ownership of the Image,* Bernard Edelman shows how nineteenth-century French law originally would not extend legal protection to the photograph because it was machine-produced, thus denying it protection as the work of an author-creator, and how the law later reversed its position, maintaining that the photographer *did* have an author's right in the photograph. But the author was admitted at this stage, Edelman says, on condition that he not merely "reproduce" the "real" before the camera but actually "produce" it.[1] He must become a creator of it. Much of Edelman's argument has to do with showing how the creative subject inserted between the world before the camera and the machine itself is that legal subject who has been historically constructed as holding rights. This notion of the subject endowed with rights in turn depends upon an earlier Hegelian sense of the free subject who possesses both himself and his attributes or characteristics.[2]

But what if the real (before the camera) is neither municipal building nor land-scape scene, which as public domain belong to everyone, but instead is the face and figure of another person who, by the same basic principle, already owns the real that the photographer appropriates? As Edelman theorizes this issue: "the subject makes 'his' a real which also belongs to the 'other.' In the very moment they invest the real with their personality, the photographer and the filmmaker apprehend the property of the other—his image, his movement, and sometimes 'his private life'—in their 'object-glass,' in their lens."[3] It is, as it happens, this same subject thus apprehended who, by virtue of the possession of himself and his attributes, lays claim to the image of himself in the photograph. Thus it is that, as Edelman points out, two contradic-tory claims can be advanced over the same object before the camera, both with their basis in a culturally secured notion of personhood and personality.

I want to move from Edelman's point about the intervention of the photographer as creative subject in the act of picture-taking to concentrate on the construction of the legal real on the other side of the camera, so to speak, taking with me Edelman's concept of the insertion of the legal subject. For it seems to me that there is a kind of symmetry in the way the photographer-subject stands in relation to the mechanical act and the way the photographed-subject stands (on the other side, now) in rela-tion to the natural body before the camera. What I want to consider next is how it is that the law deals with conflicting claims advanced by two different legal subjects

who assert proprietorship over the same photographic likeness, on the basis that they are both entitled to "authorize" the use of their own images. The notion of "authorization" importantly emphasizes the symmetry of the photographer and the photographed, both of whom assert "something irreducibly" their own,[4] something unique, that no one else could possibly assert in the identical way. The photographer and the photographed might also be seen as having a parallel material-mechanical connection with the photographic act, the one having clicked the shutter (and in French law thus having effected the "imprint of personality")[5] and the other having left an imprint on the chemically sensitive surface of the photographic film or plate effected by light reflected from her own bodily presence. It hardly needs repeating that in both cases the claim of the subject is based on the notion that even though this is the act of a machine, the contribution of the personality outweighs what might be considered purely mechanical functions.

The right of the photographer is also similar to the right of the photographed because of an underlying deference to "origin" in Anglo-American law. Authorship in copyright law is understood as meaning "originating" as much as or more than "originality" in the sense of uniqueness. The human subject before the camera could, in some sense, be seen as the origin of the photographic image: that is, following the cause-and-effect version of how photography works, the subject's physical presence creates the image-impression. This version of the process might correspond to Charles Sanders Peirce's concept of the indexical relation between the sign (the photograph) and the referent (the subject before the camera), in which case the subject is a kind of originator. The subject as the originating source stands in relation to his photograph as, for instance, Christopher Wren stood in relation to the form of the death mask produced by his facial features.[6]

Where the subject behind the camera (the photographer) differs from the subject before the camera is in the advantage the latter enjoys by virtue of a one time appearance as "reality." However fleeting the fraction of a second before the camera, early attempts to theorize photography and motion pictures gave significant weight to that fraction of experience. Not only could the photograph testify to the existence of an empirical world, but it was itself a kind of translucent "skin" of that real.[7] Although contemporary theories of film and photography have been dedicated to showing up the fallacy of the claims to truth status made by and for photographic signs, common sense persists in granting this special status to these images. And it is this commonsense assumption about the empirical real and its evidence (which tempts even the most sophisticated of theorists in their everyday lives) that is often, though not always, at work in the legal decisions that interest me here.

For instance, privacy doctrine and the publicity right that has evolved out of it (as they have dealt with issues regarding celebrity images) depend upon an unexamined assumption that the unauthorized use of a photograph is an appropriation of the identity of the person photographed. The authority of the real here is seen in the way the photographic image serves as the support for the reassertion of the rights of the subject photographed, assumed to be the same subject whose resemblance is, so

to speak, "captured" in the image. We will later see how in a 1972 California trial involving a dispute over the image of Bela Lugosi in the role of Dracula, the judge found that Lugosi's right of privacy did survive him, resulting in a decision in favor of the Lugosi family over the actor's former employer, Universal Pictures. According to the reasoning of the judge in this first decision, although Lugosi was not alive to object to any invasion of his privacy caused by Universal's use of his photograph in the role of Dracula on T-shirts and swizzle sticks, the photographic "proof" of his existence in the past overwhelmed the portion of the image shared with the fictional character Dracula. Although the California Court of Appeals later reversed this decision and the state supreme court finally upheld the appellate reversal in 1979, the point is that *Lugosi v. Universal Pictures, Inc.,* suggests the threat posed to the law by the return of the referent. Bela Lugosi, a person no longer alive and thus not able to assert a right of privacy, still asserts a presence more potent (although with fewer legal teeth) than the character of the Count, which is still protected by the Universal Pictures copyright in the motion picture *Dracula* (1931). The presence of Bela Lugosi's body (before the camera) in the past, preserved intact in the image in the present, threatens to displace the right to Bela Lugosi as Dracula that Universal Pictures argued that is held in perpetuity.[8]

What, however, does the law do with a photographic likeness of a living celebrity that has not been created in the past by that celebrity's physical presence but has its origins in the empirical body of a second person before the camera? According to the spirit of privacy doctrine, which assumes an identity between the photographic sign and its referent, the person to whom the photographic image "belongs" is the person ultimately concerned with the use of the image. It would seem that the owner of the body before the camera is the legal subject whose publicity right is at stake and who is negotiating the right to have his or her privacy invaded. But the question becomes somewhat different when one legal subject is a celebrity and the other is an ordinary person who has an identity of her own. Whose identity is signified, the identity of the person to whom the body belongs or the identity of the celebrity? Can one body (without the aid of a masquerade) stand for two identities at once?

Onassis v. Dior

Those are the issues raised on appeal in a 1984 right of privacy action heard by the Supreme Court of New York. In this action, Jacqueline Kennedy Onassis brought suit against Christian Dior for use of her image without consent in an advertisement for Dior sportswear. The image of Jackie Onassis appeared in a one-page color photograph portraying the mock wedding of the Diors, a fictional couple created in a series of advertisements photographed by Richard Avedon for J Walter Thompson's Lansdowne Division. The staged wedding advertisement appeared in the September or October 1983 issues of *Harper's Bazaar, Esquire, Time, The New Yorker,* and *New York* magazines, along with the caption "The wedding of the Diors was everything

a wedding should be: no tears, no rice, no in-laws, no smarmy toasts, for once no Mendelssohn. Just a legendary private affair."[9] To suggest the social prominence of the fictional Diors, actresses Ruth Gordon and Shari Belafonte and television film reviewer Gene Shalit were represented along with Jacqueline Onassis in the crowd watching the bride throw the customary bouquet.

Onassis brought suit against Dior on the basis of a violation of her right of privacy granted by section 50 and 51 of the New York civil rights law, which prohibit the commercial use of the portrait of a living person without consent.[10] To knowingly use for trade purposes the "name, portrait, or picture" of any living person without written consent gives rise to criminal and civil liability. The injured party is entitled to recovery of damages and the right to injunction. Onassis, who sought an injunction on the basis that she had suffered irreparable injury, maintained in an affidavit that she did not give consent for the use of her image in the Dior campaign and that she had never allowed her name or her picture to be used in conjunction with advertisements for commercial products. Only in a very few instances had she given consent for the use of her name in connection with the arts, education, or civic causes with which she was affiliated.[11] The defendant's argument in this case was that the New York law of privacy had not been violated. The woman in the photograph was not, after all, Jacqueline Kennedy Onassis, but Barbara Reynolds, a Washington secretary hired by Dior as a model for the advertisement. Dior's position was based on the fact that the person photographed was Barbara Reynolds and that it was her identity that had been used, with her permission. The Dior lawyers argued that Onassis sought to prohibit Reynolds from using what was, after all, Reynolds's own image, or, as Judge Edward J. Greenfield phrased this issue, "[C]an one person enjoin the use of someone else's face?"[12]

Barbara Reynolds was described in the case headnote as "masquerading" as Jacqueline Onassis, and the judge stated that she had "misappropriated" Onassis's identity. But what must be understood immediately is that Barbara Reynolds did not disguise herself with the aid of props, costumes, or special makeup, which would indicate that she had assumed a false identity. Neither was she an actress playing the role of the famous wife of the former president. If she was not disguised and if she did not use an actor's skills of impersonation, how is it that she was seen as someone else? Barbara Reynolds was taken to be Jacqueline Onassis because, colloquially, she "looks like" Jacqueline Onassis—so much so, in fact, that she worked part time for the Los Angeles firm Ron Smith Celebrity Look-Alikes, making appearances as Jacqueline Kennedy Onassis.

The Legal Real

In criminal cases the law tends to regard the camera as witness and the photograph as empirical proof of events in the real world. When it comes to cases of image

appropriation, which are usually taken up in terms of the "likeness," the emphasis upon identification and recognizability suggests that legal practice has again constructed the representational image as transparent. The question of recognition becomes, "Could one see the person in the likeness?" In its discussion of the Dracula image, the California Supreme Court made a distinction between the likeness of Lugosi in the portrayal of Dracula and Lugosi's "natural" likeness, but the medium conveying this likeness would seem to have evaporated. Does "natural" likeness in this case refer to a drawing that resembles, to a photographic image of Lugosi himself, or to his real-life physical features?

The point is that privacy law has tended to treat iconic likeness as straightforward and unproblematic: a likeness is that which someone recognizes as someone else. What makes the Onassis case significant is not only that the law is forced to take the conveyors or vehicles of likeness into consideration in its decision but also, in deciding whether or not the image of Jacqueline Onassis had been appropriated by Dior, the law had to construct the legal real. By "legal real" I do not mean a real that operates only within the closed system of Anglo-American law, since, because of the relation between law and society, the construction will have ramifications elsewhere. Suggesting the way this concept works, Paul Hirst and Elizabeth Kingdom say, "Law both 'imaginably' fixes and sanctions social relations. It compels things to be as it recognizes they are."[13] What *Onassis v. Dior* shows is that the real we would have expected the law to recognize does not turn out to be the final real. If the law of privacy were interested in the empirical evidence offered by the photograph, there would be no doubt that the image in question belonged to Barbara Reynolds and therefore that Dior had a right to use it. But photographic realism and privacy doctrine in this case want different guarantees. The one defers to a conviction that there is a final, verifiable, empirical real, and the other defers to a construction of personhood that does not necessarily require the existence of a real body (whether in the past or the present) as its support.

Photographic realism, with its empirical stance, asks, "Who is the real referent?" But privacy law is finally not interested in this question. First of all, let's look at how the judge in *Onassis v. Dior* got around the issue of the empirical evidence of the photograph. In his ruling, Judge Greenfield aligned the case with precedents based on the problem of appropriation of the image without authorization in a wide range of media—from sound recording to literary fiction. The "truth" status of the photographic image was thus circumvented by the court's interpretation of the New York Civil Code's "portrait of picture" in the widest possible way as "a representation which conveys the essence and likeness of an individual, not only actuality, but the close and purposeful resemblance to reality." In other words, Dior may not have appropriated Jacqueline Onassis's *photograph,* but it used her "portrait or picture" without permission. And thus the court declared that for legal purposes, Barbara Reynolds photo was Jacqueline Onassis's "portrait or picture."

In arguing that it does not matter whether resemblance is created with recorded sound, photography, drawing, or word portrait, the law whisks away any privileged

relation between the subject before the camera and the photograph. Essentially, then, what the Onassis decision did was to skip over the photographic signifier medium and to consider only the look-alike body as medium, the signifier whose signified is "Jacqueline Onassis."

The legal problem posed by the look-alike returns us to the epistemological issues raised by the iconic sign. We are again faced with Umberto Eco's "mysterious phenomenon of the image which 'resembles'" and which is commonly thought to deliver the world to us in some way, whether by capturing some part of it or by reflecting it back.[14] And if we stop at the photographic sign, that is just what we have before us—an image of the wife of the former president. Except that the image in question is not the photographic image of Jacqueline Onassis. We are dealing not just with an image that resembles but rather with an image of a person who resembles. And if the iconicity of the photographic sign has made it susceptible to transparency, to our seeing through it, then how do we consider the iconicity of the look-alike, which is transparent only if we actually mistake her for the celebrity referent? And if we don't mistake her for the celebrity, but take the person to be herself, then the look-alike in this case is not operating as a sign, since something cannot stand in for or represent something with which it is identical.

The perversity of the look-alike phenomenon is that we *are* tempted to say, "But the woman in the photograph really is Barbara Reynolds," and for a moment we are returned to the stage in the theorization of iconic signs at which these illusive signifiers seemed to have successfully eluded systematic analysis. We rehearse the dilemma of the semiotician's approach to photography, cinema, and television, those mimetic technologies that mass-produce look-alike signs. We understand again the legacy of the false start in this field—Roland Barthes's declaration that the photograph was a message without a code.[15] And we realize how very little theoretical help we have (as well as very little confirmation of what we see as astonishing similarity) in Eco's correction of Barthes: If the only thing that the iconic sign has in common with its referent is the perceptual habituation of the viewer who confronts two similar visual patterns, then why are we so impressed with and so susceptible to being convinced by look-alike signs?[16] It might at this time be useful to say that the frustration with the iconic sign is entirely a poststructuralist condition. In a way, then, the Onassis case confirms the poststructuralist insight about the way signification works, since we have in the legal dilemma an admission that the meaning of the figure in the Dior ad is indeterminable, or at least put off indefinitely. It even seems that we have nabbed the discourse of advertising in the very act of creating the postmodern aesthetic, in Jean Baudrillard's words, "the virtual and irreversible confusion of images and the sphere of a reality, whose principle we can grasp less and less."[17] The admitted goal of the creators of the campaign featuring a semi-scandalous ménage à trois in the style of the film *Design for Living* was, after all, "to specify nothing but suggest everything."[18] But it would seem that it is the Onassis and not the Dior argument that is aligned with postmodernism and poststructuralism. While Dior's argument about the

photograph is in essence, "it is what it *is,*" the Onassis argument, "it is what it *says* it is," comes down on the side of the reader. It appears, then, that since the law doesn't hold the photographic sign at its word, it is just as well that we no longer consider that sign able to access the real world, and therefore we cannot expect it to take any responsibility for what happens in that world.

Isn't that, after all, the conclusion that feminist film theory came to in regard to the cinematic representation of the female body? In our earliest formulations, commercial cinema used her body decoratively, negating "woman," who as "woman" could never be grasped or signified by patriarchal discourses.[19] Later, the argument was advanced that not only was she not really present in representation but her femininity was itself a masquerade.[20] Even the documentary film that featured women's struggles in the workplace (showing their real relations to production) could not be said to deliver the "truth" of their oppressive circumstances or the analysis of the economic conditions that maintained these circumstances.[21] There were, after all, no real bodies or actual lives that we could hope to know about in any other way except via the photographic, linguistic, and electronic signs that delivered them to us. Is Barbara Reynolds, then, part of this long legacy of female body signs fitted up as models and actresses in magazine advertising, television drama, and fiction film, drained of meaning and stripped of identity in order to serve as vehicles for the discourses of commerce?

But isn't there something slightly different about the Barbara Reynolds case? One could say that the law is on some level concerned about the commercial appropriation of bodies and that it was deployed as an objection on behalf of society to the way Dior emptied Barbara Reynolds's body in order to fill it with the connotation "Jacqueline Onassis." The judge's concerns were stated in terms of the theft of the celebrity's identity, but he also asked what should be done with the identity claim of the noncelebrity as he returned to the issue: "[C]an one person enjoin the use of someone else's face?" From my point of view, the significance of the Onassis case *is* the stand it took against "theft" of identity as well as against the "confusion" of identities. At this point, however, my argument will swerve away from the concerns of feminist film theory. Therefore, I will not be objecting to the commercial uses of the female body. I have a different interest in "theft" and "confusion," terms that open out onto legal issues on unfair competition law and that thus lead in another direction. In the end, protection of personhood, difficult to fault from a humanistic point of view, turns into something quite different as it contributes (incrementally and almost imperceptibly) to the creation of a new legal entity. That entity (which I have not yet identified) is one and the same as the "legal real" to which Judge Greenfield defers and which wins out over the photographic real and its claim.

While the law in *Onassis v. Dior* appeared to be concerned only with personal injury and unauthorized appropriation, it was equally concerned with other principles signaled by the references to "theft" and "confusion." In order to show up the double development whereby it becomes possible to engage sympathy for prohibiting injury

to one's feelings in support of prohibiting injury to one's commercial value (a distinctly different kind of offense), I need to refer back briefly to the origins of privacy law in New York. The issues that are primary in *Onassis* were first raised in *Roberson v. Rochester Folding Box Co.* (1902), in which Abigail Roberson objected to the unauthorized use of her photographic image on a flour-mill company advertising poster placed in warehouses, saloons, and other public places. Roberson was denied relief in this case, but the public outcry in response to the outcome encouraged the legislature to enact a statute prohibiting the use of a person's name, portrait, or picture for trade without his or her consent.[22] The original spirit of sections 50 and 51 of the 1903 New York Civil Rights Act was, as one would expect, maintained in Judge Greenfield's language in *Onassis:*

> If we truly value the right of privacy in a world of exploitation, where every mark of distinctiveness becomes grist for the mills of publicity, then we must give it more than lip service and grudging recognition. Let the word go forth—there is no free ride. The commercial hitchhiker seeking to travel on the fame of another will have to learn to pay the fare or stand on his own two feet.[23]

Privacy, the umbrella doctrine encoded in sections 50 and 51, and at issue in *Roberson* and later *Onassis,* does not, however, have its origins in protection against marketplace exploitation. Neither does it derive from a concept of defamation, as one might expect. The branch of American law referred to as "privacy" has its historical origins in a particular idea of a right to seclusion from the public eye. Paradoxically, over the course of this century, the same doctrine that promised to shelter private persons from the public circulation of their names and likenesses (an inevitability produced by the development of mass information technologies) has come to allow the reverse. Privacy law as it becomes publicity law makes it possible for celebrities to circulate their images in public without fear of commercial piracy.

There is an equally important question that suggests a historical parallel with the development of "privacy" into "publicity," and it is worth a digression here to fill out this perspective. The question is this: Why is it that the public circulation of a person's photographic likeness should be analogous to intrusion into one's private life, analogous even to the public exposure of inner thoughts and feelings? Social historians have shown that the notion of the body as somehow synonymous with selfhood is a modern concept. The contemporary sense we have of the body as expressive of the notion of a "personality," evidenced on it through gesture and expression, almost as an involuntary symptom, is as recent as the turn of the century.[24] But whereas one might think that the use of a mechanical instrument would interfere with the pure essence of the person before the camera (as it had negated the unique touch of the photographer-creator in French legal history), portrait photography was thought to investigate scientifically, to probe the "inner" character, more and more thought to be the "true" person.[25] Why is it that two layers of mediation (the

face as medium in addition to the photograph), rather than distancing or distorting, are thought to render the "real" person more immediate? Film theorists from Bela Balázs to Roland Barthes and Gilles Deleuze have considered the language of the motion picture close-up, which seems to have ratified the contemporary currency of and the recent fascination with the face. Although early critics argued that the close-up was a kind of disorienting dismemberment, Balázs would argue that it was not a part but had come to assume the proportions and the significance of a self-sufficient whole.[26] Deleuze would take Balázs a step further and suggest that the image of the face in close-up (the affection-image) is a "component of all images" and a quality ("faceicity") transferable to representations of other parts of the body and even to other objects.[27] The question arises as to why the face would fuse so easily with the forms produced by new mechanical and electronic technologies. And why, further, in the face (so to speak) of the potential of mass replication, would the face in close-up still stand for the individual, one-of-a-kind personality? It is almost as though the Romantic ideal of humanness, developed as a countervaluation against the institution of "the market," had persistently planted itself right where it had been permanently obliterated—in the reproducible image of the human face. If the face were unreadable and unfathomable, epitomized by the image of Garbo, which, Barthes says, "plunged audiences into the deepest ecstasy,"[28] why would the image-visage still be a means of identification, based on its readability? At some point, Deleuze says, when the close-up is taken to the limit, as in Ingmar Bergman's modernist moments when the depths of the face engulf us in nothingness, individuation is "suspended."[29] Andy Warhol's postmodern postage-stamp portraits of Liz Taylor, Elvis Presley, and Marilyn Monroe make this clear: Individuation is stamped-out, mass-produced. So why the insistence that the photographic portrait is one's identity when by now it should be clear that the image has undergone a thorough transformation and even devaluation in this regard?

Onassis v. Dior asserted the opposite, that is, that in the contemporary world the face has come to stand for the honor and integrity of the individual. Judge Greenfield advanced the position that the facial image had superseded the name, which was once thought to be personhood's nugget of value. After citing Shakespeare on how for men and women the good name is "the immediate jewel of their souls,"[30] the judge went on, "In those days, as the touchstone of recognition, name was all, conveyed in writing or by word of mouth. Today, the visual have superseded the verbal arts, and news photography, television, and motion pictures can accord instant world-wide recognition to a face. For some people, even without their American Express cards, the face is total identification, more than a signature or a coat of arms."[31] The judge further asked why it was that, since the image was "total recognition," the unauthorized use of it was not treated as similar to the use of a person's signature: "The unauthorized use of a person's signature would not pass muster under the statute because it was claimed merely to be facsimile. Is a picture or a portrait intended to look like someone not that person's picture if it is similarly a facsimile or a simulation?"[32]

The emphasis on facsimile is finally telling in another way. As we have seen, for privacy law, the "real" is not the natural world. This law is finally not interested in what is commonly thought to be a natural bond between the body and the self, summarized in the idea of proper name, personal image, and the self-evidence of the identity between the body and the person, which tautologically becomes "proof of identity." Privacy law is no longer, if it ever was, about personal offense and affrontery. *Onassis v. Dior* is structured along lines of copyright law, which asks questions about authorial creativity in order to determine whether or not there has been theft of a work. In a way, this explains the jaded attitude the decision takes toward look-alikeness. Copyright law, having seen so much of similarity, is unimpressed with it, and thus returns some sanity to the iconic sign. In this regard, I like what W.J.T. Mitchell has said about the problem semiotics has had with systematizing analogical representation. Iconicity, it seems, is everywhere: "One reason the icon has proved so difficult for semiotics to define is that similarity is such a capacious relationship that almost anything can be assimilated into it. Everything in the world is similar to everything else in some respects."[33] Copyright law, then, cannot be based on the commonsense notion of absolute uniqueness or a one-of-a-kind ideal. It recognizes claims based on firstness in order to break ties when two objects of culture appear to be identical or, in legal terms, "substantially similar."[34] In order to dismiss Dior's claim that Barbara Reynolds had a right to use her image as she saw fit, the judge constructed the Dior ad as similar to an act of plagiarism, a substitution of a copy for the real: "The juxtaposition of the counterfeit figure just behind the real-life figures of a veteran actress, a television personality, and a well known model lends to the whole ensemble an air of verisimilitude and accentuates the grievance, for it imparts an aura of authenticity to the trumped-up tableau."[35] Further, the judge's remarks echoed the terms of the Romantics' disdain for imitation, now become the commonsense wisdom of the elementary school science lesson: "while some imitators may employ artistry in the use of voice, gesture and facial expression, a mere similarity of features is no more artistry than the mimicry of the Monarch butterfly by its look alike, the Viceroy butterfly. To paint a portrait of Jacqueline Kennedy Onassis is to create a work of art; to look like Jacqueline Kennedy Onassis is not."[36] Theoretically, then, would copyright law defer to Barbara Reynolds's claim if she had impersonated Jacqueline Onassis or if she had painted her picture? If Reynolds had performed a parodic interpretation of Onassis, U.S. copyright law would have protected that expression. Or, if the model has painted the image of Onassis, it would have been protectable as an "original work of authorship." However, Barbara Reynolds cannot just "be herself" and advance any claim to the "portrait" of Jacqueline Onassis that her face and body effortlessly make. She must produce this likeness.[37] We come around again to Edelman, and although still on the other side of the camera, we note the remarkable symmetry in the two problems in the production of the real. Just as French law would not defer to the claim of the photographer without first seeing his human hand at work "producing" the real, so the look-alike cannot by nature and sheer existence be

the image of a celebrity, but must "produce" that likeness as a fine artist. Neither the mechanical act nor the fluke of nature is protectable without the intervention of the authorial hand of the creative subject. The body of Barbara Reynolds is a mere copy of the body of Jacqueline Onassis produced by no one (and here it is clear that the divine hand has no legal subjecthood); a sketch, the judge called Barbara Reynolds's body—a sketch evidencing neither "creativity" nor "originality." According to this interpretation although one can "authorize" the use of one's image, one cannot "author" one's physiognomy.[38] An actor or actress may use the "raw material" of a star image, but he or she must create a public persona, and with that a secondary meaning (requiring public recognition), in order to have a fully protectable image-property.[39] This is yet another reminder that the "real" to which privacy law defers (and that it has itself created) is not the empirical real (as we would have thought). What, then, is this real, reconstituted, as Edelman says, as a legal object "susceptible to appropriation, sale, and contracts?"[40]

I have argued thus far that the Onassis case shows that privacy law, contrary to our expectations, does not automatically defer to the authority of a real tangible presence backing up the photographic image and neither does it hold that the signifier is bound of its real-world referent. The "real" that is signified, although intangible, is nevertheless constituted by the law as its "real." The law does not always match up rights with empirical bodies, as we know from the struggles of the women's movement to assert the right to abortion as a woman's right to control her own body. Rather, the law respects rights in the "real" that it constructs. It is a characteristic of law, says Edelman, to recognize reciprocally through legal mechanisms the very legal subject that it has constituted.[41] And that is what the law did in *Onassis v. Dior.* Dior came up against a "real" that was already the property of another subject, an intangible property (the image), but nonetheless a property and nonetheless constituted as more "real" than a body before a camera. The question "[C]an one person enjoin the use of another person's face?" might then mean that the judge did not deny Barbara Reynolds's property in her own face. In legal terms, two rights were asserted that matched up with two property-images. One way that the judge could then find for one property over another would be to argue that one of the two properties had been "stolen" on the analogy of infringement in copyright law. Thus the objection to the Dior advertisement was that using the natural body of the look-alike was copying the original, protected body. But the final concern, and, in my analysis, the unacknowledged issue upon which the outcome of the case rested, was not copying but the "confusion" of the copy with the original. To quote Judge Greenfield: "No one has an inherent or constitutional right to pass himself off for what he is not."[42] "Passing off" and "likelihood of confusion," of course, are tests of trademark violation, not copyright infringement. Trademark, a branch of unfair competition law, regulates the marketplace by upholding clarity of delineation between products and consistency in the indication of commercial sources standing behind consumer goods. This law stands against the attempt to confuse the consumer and the attempt to misrepresent

or pass off the goods of one merchant as the goods of another. The "passing off" argument in *Onassis v. Dior* indicates a parallel development in privacy law, which is nowhere more clearly seen than in the right of publicity, affirmed in state statutes in the latter half of the eighties. What we see in Onassis is that the image is, as it were, more protectable on the analogy with commercial property than it is on the analogy with the person who experiences injury to feelings, the older basis of privacy. This also means that if the judge was ultimately concerned about "passing off," then the decision in favor of Onassis was not a decision for the multiplicity of meaning but against it. And therefore those who view postmodern culture with alarm should not be concerned. U.S. courts, as they resolve disputes in terms of "passing off," are holding the line against massive slippage.

Dior, then, attempted to appropriate intangible private property—the image of Jacqueline Kennedy Onassis. And Dior lost the suit. The judge's assertion that the image of the wife of a former president was protectable private property has ramifications beyond the publication of one advertisement that ran in several upscale magazines in 1983. Because of its status as private property, if it appears as an illustration within a scholarly publication it is at the risk of being enjoined. For the entire text of the advertising copy in question is now placed in a kind of authorial limbo. If, as the answer to my request for permission to reprint the advertising copy suggests, Christian Dior–New York, Incorporated, is not "at liberty" to authorize the reproduction of this text, the question remains whether Jacqueline Onassis is "at liberty" to authorize the use of Barbara Reynolds's face, as she could encounter, in reverse, the private property "real" of the other woman's image. This problem in the circulation of texts that are at once shared culture and private property lurks in every public use of such protected discourse. I am reminded of Judge Learned Hand's description of the ordinary sign that achieves secondary meaning and thus protected trademark status as wearing its protection as a "penumbra" or fringe.[43] And culture that is widely circulated yet tightly held as private property is similarly edged or bordered on all sides.

Notes

1. Bernard Edelman, *Ownership of the Image: Elements for a Marxist Theory of Law.* Translated by Elizabeth Kingdom. London: Routledge and Kegan Paul, 1979, 42–43.
2. See Georg Wilhelm Friedrich Hegel, *The Philosophy of Right.* Translated by T. M. Knox. 1821. Reprint. London: Oxford University Press, 1965.
3. Edelman, *Ownership of the Image,* 39.
4. Bleistein v. Donaldson Lithographic Co., 188 U.S. 239 (1903).
5. Edelman, *Ownership of the Image,* 51.

6. This is a reference to André Bazin, "The Ontology of the Photographic Image," *What Is Cinema?,* translated by Hugh Gray. Berkeley: University of California Press, 1967, 1: 12.

7. Oliver Wendell Holmes, "The Stereoscope and the Stereograph." In *Classic Essays on Photography,* edited by Alan Trachtenberg. New Haven: Leete's Island Books, 1980.

8. Lugosi v. Universal Pictures, 25 Cal.3d 813 (1979).

9. Onassis v. Christian Dior-New York, Inc., 122 Misc.2d 603 (1984), 605.

10. Ibid., 603. Technically, Onassis brought suit against Christian Dior, Lansdowne Advertising, Inc., Ron Smith Celebrity Look-Alikes, and Barbara Reynolds.

11. Ibid., 605. If the socialite had been agreeable to the commercialization of her name and likeness, we would have had "Jackie Onassis" instead of "Gloria Vanderbilt" jeans. Hong Kong jeans manufacturer Murjani was turned down by Onassis before he settled on the Vanderbilt image for his line of designer clothes (Deyan Sudjic, *Cult Heroes: How to Become Famous for More than Fifteen Minutes.* London: André Deutsch, 1989, 83).

12. Onassis v. Dior, 603.

13. Paul Hirst and Elizabeth Kingdom, "On Edelman's 'Ownership of the Image.'" *Screen* 20, nos. 3–4 (Winter 1979–80), 139.

14. Umberto Eco, "Articulations of the Cinematic Code." In *Movies and Methods,* edited by Bill Nichols. Berkeley: University of California Press, 1976, 595.

15. I refer to Roland Barthes, "The Photographic Message," and "Rhetoric of the Image," *Image/Music/Text.* Translated by Stephen Heath. New York: Hill and Wang, 1977, 15–51.

16. Eco, "Articulations of the Cinematic Code," 595.

17. Jean Baudrillard, "Beyond Right and Wrong or the Mischievous Genius of Image." In *Resolution: A Critique of Video Art,* translated by Laurent Charreyon and Amy Gerstler, edited by Patti Podesta. Los Angeles: Los Angeles Contemporary Exhibitions, 1986, 8.

18. Onassis v. Dior, 605.

19. I allude to the "impasse" in feminist film criticism, effected by the theorization of "woman" as absence. For an overview, see Doane, Mellencamp, and Williams, eds., "Feminist Film Criticism: An Introduction." In *Re-vision,* edited by Mary Anne Doane, Patricia Mellencamp, and Linda Williams. Frederick, Md.: University Publications of America, 1984, 1–17.

20. Doane, "Film and the Masquerade—Theorising the Female Spectator." *Screen* 23, nos. 3–4 (September–October 1982).

21. See E. Ann Kaplan, *Women and Film: Both Sides of the Camera.* New York: Methuen, 1983, chap. 10, for a good overview of the position.

22. For a succinct discussion of Roberson v. Rochester Folding Box Co. and its relationship to the 1903 New York statute enacted as the result of its outcome, see

McCarthy, *The Rights of Publicity and Privacy*. New York: Clark Boardman, 1988, 1.14–1.16, 6.56–6.65.

23. Onassis v. Dior, 612.

24. Richard Sennett, *The Fall of Public Man*. New York: Vintage Books, 1974, chap. 8; Warren Susman, *Culture as History: The Transformation of American Society in the Twentieth Century*. New York: Pantheon, 1984, chap. 14.

25. See Alan Sekula, "The Traffic in Photographs." In *Modernism and Modernity: The Vancouver Conference Papers*, edited by Benjamin H. D. Buchloh, Serge Guilbaut, and David Solkin. Halifax: Press of the Nova Scotia College of Art and Design, 133, for a discussion of the "scientific" portraiture of August Sandler.

26. Bela Balázs, *Theory of the Film*. Translated by Edith Bone. 1952. Reprint. New York: Arno Press, 1970, 51–52, 60–61.

27. Gilles Deleuze, *Cinema 1: The Movement Image*. Translated by Hugh Tomlinson and Barbara Habberjam. Minneapolis: University of Minnesota Press, 1986, 87–88.

28. Roland Barthes, *Mythologies*. Translated by Annette Lavers. New York: Hill and Wang, 1972. *56*.

29. Deleuze, *Cinema 1*, 100.

30. Onassis v. Dior, 610.

31. Ibid., 611.

32. Ibid.

33. W.J.T. Mitchell, *Iconology: Image, Text, Ideology*. Chicago and London: University of Chicago Press, 1986, 29. Part of the difficulty of this case has to do with the tendency to confuse iconicity (similarity) with indexicality (the contiguity between the photograph and photographed).

34. See Arthur R. Miller and Michael H. Davis, *Intellectual Property: Patents, Trademarks, and Copyright*. St. Paul: West Publishing Co., 1983, 255–68, for a discussion of similarity as it applies to both copyright and trademark.

35. Onassis v. Dior, 613.

36. Ibid.

37. Elizabeth C. Lee, "Celebrity Look-Alikes: Rethinking the Right to Privacy and Right to Publicity." *Entertainment and Sports Law Journal* 2 (Fall 1985) argues that one of the issues that the Onassis court overlooked pertained to Barbara Reynolds's right to labour, since under the Fourteenth Amendment this right would be constitutionally guaranteed property. For Lee, who especially objected to the tendency to make individual look-alikes liable, "[t]he constitutionally protected right to labour should take precedence over the publicity right" (217).

38. McCarthy, in a different vein, says, "One is not the 'author' of one's face, no matter how much cosmetic surgery has been performed. Either God, fate, or our parents' genes 'authored' this 'work'" (*The Rights of Publicity and Privacy*, 5.44).

39. Edgar Morin, *The Stars.* Translated by Richard Howard. London and New York: Grove Press, 1961, 140, first referred to the actor's physiognomy as "raw material," but later Richard Dyer, *Stars.* London: British Film Institute, 1979, 17, would integrate the concept into his theory of industrial production of the star image; McCarthy, *Trademarks and Unfair Competition.* 2d ed. Rochester, NY: Lawyers Co-operative Publishing Co., 1984, 1: 656–717.
40. Edelman, *Ownership of the Image,* 38.
41. Ibid., 101.
42. Onassis v. Dior, 614.
43. McCarthy, *Trademarks,* 1: 663.

Part 3. Orderings

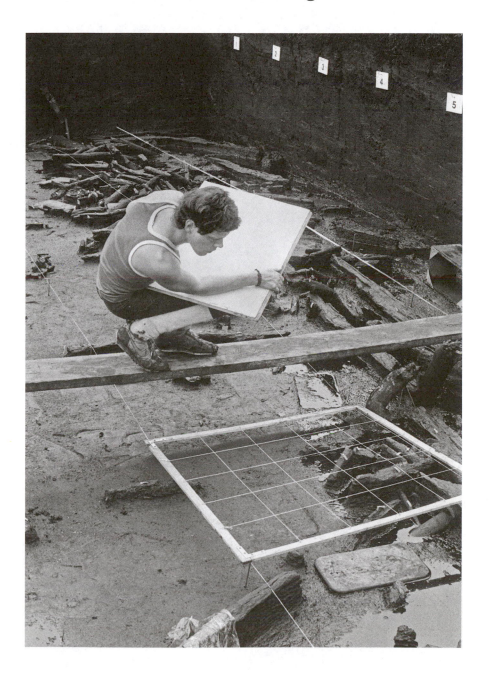

Figure 3 (overleaf) Frames: Producing archaeological knowledge. Reproduced by courtesy of Patrick Sutherland.

This section explores how different qualities of vision, linked to the other senses, are used to order the empirical, hermeneutic and political experience of the world. These latter concerns have been at the centre of visual studies, namely the role of the ideological, cultural and social in constructing visual practices.

While a Foucauldian sense of ordering resonates through the section, the extracts juxtapose different cultural ways of constructing, ordering and reproducing knowledge. It would be useful to see the essays in this section as emerging from attempts at orientation in the labyrinth of sight, as suggested by the Readings in the last section. They present a variety of attempts to cut through that opaque labyrinth and make sense of the world through the embodied use of sight. For in a world which is labyrinthine and unstable, sight needs to be ordered and managed through the practices of observation, classification and foci of attention. However, in stressing the embodied and multi-sensory nature of uses of sight, we try to move away from the taxonomic impulse of traditional interpretations of visual culture toward an understanding of sight in action. The readings demonstrate various embodied modes of seeing which involve different controlled forms of visual experience. While they stress political and disciplinary control and the use of taxonomy to open or close specific gazes, they represent different qualities of density and lightness, sophistication and orderliness, in the practices of organisation of visually created knowledge.

Of course, a single mode of investigating the seen, such as detection, can be carried out in widely different ways and in very different cultural contexts to produce different orders of knowledge. Consequently, those 'orders of knowledge' are not as clearly defined despite the efforts of 'orderings' to contain or suppress other possible meanings. There are resonances between and across the various forms of investigations articulated by the visual field, between voyeurism and detection, for example, or between artistic practices and scientific ones.

Rachel Dwyer's Bombay film world demonstrates such an example. She explores how the everyday is made special, and even spectacular, through a gossipy voyeuristic reporting of the ordinary activities of media-shy film stars. It translates the sense of the spoken and written into visual form. Here oculocentric drives coincide with logocentric ones in much the same way as in the scandalous reports about the Ottoman harem presented in the preceding section. The difference is that while Europeans sought distance from scandal, the fans of Bollywood stars dream that their lives will someday be like those of the stars they read about. Voyeurism here serves to order the ordinary world in the image of the 'extraordinary ordinary' in times of turbulent and spectacular social mobility.

There are two Readings centred around the idea of detection. Detection can be seen as a process through which the invisible or the unknown is made visible or

knowable and thus ordered. One extract is from Tom Gunning's magisterial study of the work of German expressionist filmmaker Fritz Lang, who was one of the first directors of the silent era to create well-crafted, carefully ordered films about the relations between the city, communications and mass paranoia. Gunning shows how a genre of cinema—the serial film—as reworked in Lang's early career shows up the European colonial enterprise as detective work. In these films the colonial adventure, and indeed cinema itself, is coded as an act of detection consisting of a mutually informing dynamic between voyeurism about the exotic 'Other' and a ceaseless attempt to order the unknown but colonially desired worlds. This is achieved through searching out and excavating visually the meanings of mysteries that such a world poses, just as a detective would.

Anthropologist Karen Strassler's essay explores the student as eyewitness to political upheavals in modern Indonesia. She presents these eyewitnesses as revealing the invisible through the use of their cameras. Moving through the spaces of political contestation, with camera in hand, they reveal visually, through their embodied presence, the political realities of the postcolonial modern state. In a repressive regime this action in itself can be marked as a form of detection through which the 'hidden' story of state atrocities becomes apparent through piecing together the fragments inscribed in disseminated photographs to create the solid sense of a 'witness'. These processes and actions, visual in themselves, hold the hope of a political reordering.

All detection is, of course, a form of observation, at once more concentrated and 'lighter' in the sense that it is conventionally not thought of as creating encyclopaedic knowledge about the world. The section opens with three essays on visual taxonomy, by historian of science Lorraine Daston on eighteenth-century natural history, Andrew Zimmerman writing on late nineteenth-century German anthropology and Fernando Feliu on American epidemiology in early twentieth-century Puerto Rico. Each deals with the qualities of observation that go into the creation of the encyclopaedic knowledge of the Western sciences. They mark the emergence of a disciplinary and professional way of seeing through the management of attention in ways deemed appropriate. In their different ways, all three are concerned with the management of 'attentive' sight that lies at the base of the creation of cultural and disciplinary constructs that underpin the master narratives of Western knowledge systems. However, this classic relationship between vision and the construction of knowledge is seen to be provisional and complex, depending on managing practices of 'not seeing' and 'seeing'.

The section concludes with a set of four essays, including Strassler's noted earlier, which provide further, and very different, cultural perspectives on ordering. They are in some ways contrapuntal to those of Daston, Zimmerman and Feliú in that they present ways of constructing knowledge about the world through an ordering visual experience other than those of disciplining the eye to the detective's or the Western scientist's empirical exactitude. These pieces demonstrate very different sensory registers through which knowledge emerges. This does not mean that sight

is disregarded or valued less. Rather, it is valued differently, in a different set of relationships, in which sight operates as integral to the other senses in a more overt dynamic. Significant in all these extracts is the way in which the visual ordering of the world defies reductionist and isolatory models. Thus Gulam Mohammed Sheikh's interpretation of the artist's intent in the canon of Mughal miniature paintings, and their modern variants, leads us through the socially and culturally embodied recreation of social scenes of the Indian everyday in these paintings. They require the viewer's view to be fluid and mobile, and by implication multi-sensory, rather than the fixity of the gaze and visualist aesthetic demanded by what Sheikh sees as the perspectival prison-house of European art.

Constance Classen's piece on the relations between sight and hearing/sound in an Andean society offers yet another form of ordering. She presents a practice of 'sight' that privileges sound. She demonstrates the complex play between two sensory modes in constructing an Andean cosmology in which the hierarchy of the senses places hearing over vision. Yet it impacts profoundly on vision. Visual worlds are effectively 'heard', creating a synaesthetic quality which manifests itself in the myths and rituals of the Andes. In the final piece of this section on 'Orderings', Norma Field, a specialist on Japanese literature, explores the classical Japanese poetic epic *Tales of Genji* composed in the early eleventh century by Murasaki, an aristocratic woman. She gives a poignant reading of the subtle relay of the sensuous that brings together the visual qualities of a flower with those of a heroine. Here, the culture of visualization enables the flower and the heroine to begin to resemble one another through elaborations of material design and the poetics of imperial etiquette. It produces an ordering which brings them into alignment. It also points, more generally, to the relationship between language, the written word and the evocation of a sensory visual imagination. Thus it stresses the role of creativity and imagination in the act of ordering, forming a link with the next section, which focuses on the multi-sensory character of visual creativity.

–3.2–

Attention and the Values of Nature in the Enlightenment
Lorraine Daston

The Cult of Attention

In eighteenth-century Enlightenment natural history, what distinguished genuine naturalists in the eyes of their peers was not professional status, but rather the practice of heroic observation, described as at once a talent, a discipline, and a method. None sufficed without the others. Attentive observation was firmly distinguished from mere seeing, and even from remarking upon. In his letters to the naturalist René Antoine Ferchault de Réaumur, the young Charles Bonnet dismissed his own earlier observations on caterpillars as what "mediocre attention could perceive," since he "was not yet well instructed in all the precautions required for the exactitude of an observation."[1] To observe an object attentively meant first and foremost to observe it distinctly, which the naturalists defined as a kind of mental as well as visual dissection. Microscopes and magnifying glasses were standard tools of the trade, and some of the most vaunted feats of observation in nineteenth-century history, such as fellow naturalist Jan Swammerdam's remarkable account of the ovaries of the queen bee, were anatomies of minutiae: the intestines of a caterpillar or the subcutaneous membranes of plants.

Naturalists took apart their objects with the mind and eye as well as the scalpel: Réaumur spoke of the need to view every operation in the bee-hive "sharply and distinctly";[2] Bonnet thought the mental act of abstraction was at root nothing more than a form of attention that focused on one aspect of an object to the exclusion of others.[3] Hence *l'art d'observer* was as essential to metaphysics as to physics.[4] Through masterworks of attentive observation one could scale the heights of genius in natural history as well as in celestial mechanics. When Bonnet was first confronted with observations suggesting that worker bees could sometimes lay eggs and even metamorphose into queens, he justified his incredulity by an appeal to the lynx-eyed virtuosity of the greatest observers of the age: "Nothing in the world is better

confirmed by the repeated researches of SWAMMERDAM, of MARALDI, of REAUMUR than the absolute sterility of worker bees. How would it be possible for the ovaries of these bees to have escaped the great Anatomist of Holland, he who so well described and represented the ovaries of the Queen-bee?"[5]

What finally persuaded Bonnet to take the startling new observations seriously was the care with which they had been executed and, above all, the detail with which they were reported in subsequent accounts.[6] Eighteenth-century naturalists developed many ingenious instruments to observe the otherwise invisible and the hidden, ranging from magnifying lenses to glass-fronted, flattened beehives.[7] But the *sine qua non* of the sterling observation was fastidious attention to detail in word and deed. And since deeds were ultimately reduced to words in the naturalists' reports, it was above all the techniques of description that certified attentiveness. They are long, articulate in the root sense of the word, and stuffed with adjectives. Here is Bonnet on a caterpillar he found in October 1740:

> It was of a middling size, half-hairy, with 16 legs, of which the membranous [ones] have only a half-crown of hooks. The base of the color on the bottom of the body is a very pale violet, on which are cast three yellow rays, which extend from the second ring to about the eleventh [the description continues for about a page] ... Yellow spots are strewn on the sides. The head is violet-colored.[8]

And here on the colors and sheens of aphids:

> The greatest diversity that one observes among different species of Aphids is in the color: there are green, yellow, brown, black, white [ones]. Some have a matte color; that of the others has a sort of lustre; but often that lustre is due to a small worm that the aphid nourishes in its interior, and which kills it. Finally, some species are prettily spotted, sometimes brown and white, sometimes green, black, or other colors.[9]

The tools of description were the journal, the table, and, to a lesser extent, the illustration.[10] Somewhat alarmingly, considering the length of his printed descriptions, Bonnet told his readers that these were only excerpts from his far more copious journal.[11] Early in his career as a naturalist he had formed the habit of writing down everything that he saw.[12] Like the journal, the tables structured repeated observations chronologically—in the case of his aphid observations, Bonnet noted day and hour of each birth as exactly as he could, marking cases where he was not actually present with an asterisk.[13] Both methods of recording strung details together one after another, like beads on a chain; their narrative structure, like that of the journal and the table, was that of temporal sequence, intertwined with the daily rhythms of the observer.

It was not so much the content as the texture of these descriptions that made a naturalist's reputation. Modern naturalists have found it difficult to make taxonomic identifications on the basis of Bonnet's descriptions, despite (or perhaps because of)

their length and specificity.[14] Descriptions bristled with details, each as sharply etched and distinct as the lettered parts of the accompanying figures. The object as a whole shattered into a mosaic of details, and even the tiniest insect organ loomed monstrously large. The literary effect achieved by these descriptions uncannily mimicked in words the visual experience of magnification, in which the part overwhelms the whole, and the small grows in significance. As Diderot remarked of his attempts to describe a very small painting by Hubert Robert at the Salon of 1767, "There's an infallible way of making the person listening to you take a greenfly for an elephant; all you have to do is describe in extreme detail the anatomy of this living atom." Inevitably, the example Diderot adduced for this kind of field-filling description came from the natural history of insects: "Monsieur de Réaumur didn't suspect this, but get someone to read you a few pages of his *Treatise on Insects* and you'll discover the same absurd effect as in my descriptions."[15]

Despite the specificity of these descriptions, they were usually composites of multiple observations under varying conditions, for the naturalists insisted on numerous repetitions.[16] The point was not always or even habitually to replicate controversial observations, but rather to redirect the necessarily narrow focus of attention to other facets of the same object or phenomenon. As the Genevan pastor Jean Senebier explained in his treatise on observation, which was larded with examples taken from the works of Bonnet, Réaumur, and other naturalists, one could shift one's attention from one part of the object to another with each repetition, "reserving for another time the circumstantial examination of those one neglects," like a spotlight systematically scanning a surface, point by point.[17] Once again, observation cultivated an intense, laser-like attention. Horace Bénédict de Saussure, Bonnet's nephew and protégé, reassured Albrecht von Haller that he had observed many plants, "in all the ways and in all the positions that I could imagine, with different Microscopes, some simple, others compound; on all sorts of days: and when my Microscope was found to be strong enough, when the object was sufficiently illuminated, and my attention was redoubled, I constantly saw that membrane."[18] Hence it is more accurate to speak of a regimen of observations in eighteenth-century natural history, rather than individual sightings or aperçus.

"Regimen" is meant here in the double sense of a program and a discipline. The program might consist of a series of experiments, such as Réaumur's introduction of foreign queens (painted to distinguish them from the native queen) into beehives, or the intensive scrutiny of a single phenomenon, such as Bonnet's study of aphid generation or Saussure's investigation of plant membranes. The program of vigilant observation imposed a strict discipline on the observer that was scarcely compatible with any other activity. Réaumur, for example, counted the number of bees leaving the hive in one day, arriving at a sum of over eighty-four thousand departures in fourteen hours (approximately one hundred per minute).[19] Bonnet's sequestered study of his *pucerone* had its precedent in Swammerdam's arduous researches on bees, which "began at six in the morning, when the sun afforded him light enough

to survey such minute objects," and continued long into the night, when he recorded his observations.[20]

Both naturalists paid for these strenuous efforts with ruined health, including badly weakened eyesight.[21] Senebier thought the risks to naturalists (especially of premature loss of sight) so great that he exhorted them to avoid long bouts of exacting observations; moreover, "when the senses are fatigued, they become unfaithful."[22] But he agreed with the prevailing view among naturalists that observations demanded stamina and courage. François Burnens, servant and collaborator of the blind naturalist François Huber, often observed bees for twenty-four hours at a stretch, "without permitting himself any distraction, taking neither food nor rest," and on one occasion examined every single bee in a hive by hand, refusing to stun them first with a cold bath lest certain "small differences" in form be obliterated, "examining them with attention without fearing their rage ... and even when he was stung, he continued his examination with the most perfect tranquility."[23] The meticulous patience and manual delicacy of great naturalists was proverbial: magnifying glass in hand, staring for hours at the tongue of a bee or deftly stripping the skin of a caterpillar.

Yet despite the rigorous demands that attentive observation made on mind and body, the naturalists testified unanimously to its pleasures. Describing his taxing and dangerous ascent of an alpine glacier, André Deluc claimed that the diversions of observing new objects staved off vertigo along treacherous mountain passes, and reported that "the attention with which I carried out my [thermometric] observation" assuaged the pain of a foot injury.[24] Réaumur forgot the broiling summer heat while happily watching bees in a glassed-in hive.[25] Bees replaced poetry in Schirach's affections, as he came to distinguish the insects from "my usual objects" and turned to them with "a special attention."[26] Saussure rhapsodized over the beauty of the surface of a flower petal viewed under the microscope;[27] Swammerdam delighted in the "beautiful appearance" of a dissected caterpillar, "especially as the pulmonary tubes were at the same time observed to glitter like pearls".[28] Linnaeus found in natural history a foretaste of "heavenly delight, a constant joy of the spirit, the beginning of perfect consolation and the highest summit of human felicity."[29] These pleasures partook of the aesthetic and the sensuous, but they also partook, quite explicitly, of the absorption and pinpoint focus of attention.

The faculty of attention and its distinctive pleasures were objects of considerable theorizing in the late seventeenth and eighteenth centuries.[30] Key to the enjoyments of attention was a cultivated oblivion to one's surroundings and, as critics complained, to all other ordinary obligations. According to contemporary physiology, attention diverted nervous fluid from all other fibers of the brain so that no other external impression could register upon the soul in that rapt state. The saturated fibers held the soul in contented captivity, mingling intellectual concentration with sensory and emotional transports. The philosopher and theologian Nicolas Malebranche had conceded that the passions and senses, although in excess detrimental to attention,

may be useful, even necessary, to excite and sustain it.[31] Bonnet posited that attention was proportional to the pleasure excited by the object.[32] But the experiences of observation narrated by the naturalists suggested that the equation could be reversed: attention also created pleasure, even when directed to objects initially deemed trivial or disgusting.[33]

My thanks to Matthias Doerries, Amy Johnson, and Andrew Mendelsohn for their comments on an earlier draft of this essay. Unless otherwise noted, all translations are my own. For archival material, the original text is given in the footnotes.

Notes

1. Bonnet to Réaumur, 3 November 1738, Dossier Charles Bonnet, Archives de l'Académie des Sciences, Paris. Original: "Elles [observations] serviront à vous prouver que je ne vois guères que ce qu'une médiocre attention peut apercevoir; … je n'étois pas encore bien instruit de toutes les précautions requises pour l'exactitude d'une observation."
2. Réaumur, *Mémoires* (note 17), 5: 223.
3. Bonnet, Philalethe ou Essai d'une méthode pour établir quelques vérités de philosophie rationelle (comp. 1767–68), in *Oeuvres* (note 20), 18: 237.
4. Bonnet, "Préface," in *Oeuvres* (note 20), 1:x.
5. Bonnet, "Ire Lettre à Monsieur Wilhelmi, Au sujet de la découverte de M. SCHIRACH, sur les Abeilles," 10 November 1768, in *Oeuvres* (note 20), 10: 99; compare 10: 163. For the eighteenth-century controversy over Schirach's observations, see Renato G. Mazzolini and Shirley A. Roe, eds., *Science against Unbelievers: The Correspondence of Bonnet and Needham, 1760–1780* (Oxford: Voltaire Foundation, 1986), 157–69. Recent observations confirm that worker bees do occasionally deposit eggs and can undergo ovary development when the colony loses its queen. R. E. Page Jr. and E. H. Erikson Jr., "Reproduction by Worker Honey Bees (*Apis mellifera* L.)," *Behavioral Ecology and Sociobiology* 23 (1988): 117–28. However, dissections reveal that only one in about ten thousand workers has a fully developed egg in her ovary, which explains why Swammerdam et al. would not have found any even after many dissections. Francis L. W. Ratnicks, "Egg-Laying, Egg-Removal, and Ovary Development by Workers in Queenright Honey Bee Colonies," *Behavioral Ecology and Sociobiology* 32 (1993): 191–98.
6. Bonnet, "Ier Mémoire sur les Abeilles, où l'on rend compte de la découverte de Mr. Schirach," in *Oeuvres* (note 20), 10: 131–32.
7. Réaumur, *Mémoires* (note 17), 5: 220ff.
8. Bonnet, *Observations diverses sur les insectes,* in *Oeuvres* (note 20), 2: 212–13.
9. Bonnet, *Traité d'insectologie,* in *Oeuvres* (note 20), 1: 6.

10. Swammerdam was unusual among naturalists of this period in making his own drawings. Réaumur depended heavily on the skills of his artist Mlle Dumoutier de Marsilly, whom he praised warmly in his will and made his heir. Maurice Caullery, *Les Papiers laissés par de Réaumur et le tome VII des Mémoires pour servir à l'histoire des insectes* (Paris: Paul Lechevallier, 1929), 8–9. Bonnet was dissatisfied with his Parisian engraver and contended that the descriptions were more exact than the figures. Bonnet, *Traité d'insectologie,* in *Oeuvres* (note 20), 1: xxiv.

11. Bonnet, *Traité d'insectologie,* in *Oeuvres* (note 20), 1: 21.

12. Bonnet to Réaumur, 3 November 1738, Dossier Charles Bonnet, Archives de l'Académie des Sciences, Paris.

13. Bonnet, *Traité d'insectologie,* in *Oeuvres* (note 20), 1:27. Most of the starred observations are between 5:00 and 6:00 A.M., presumably the first observations of the day, suggesting that the birth had occurred sometime during the night.

14. Jean Wüet, "Bonnet face aux insectes," in Marino Buscaglia, René Sigrist, Jacques Trembley, and Jean Wüest, eds., *Charles Bonnet: Savant et philosophe (1720–1793)* (Geneva: Editions Passé Présent, 1994), 149–62, 153.

15. Denis Diderot, "Salon of 1767," in *Selected Writings on Art and Literature,* ed. Geoffrey Bremner (Harmondsworth: Penguin, 1994), 280; Diderot, *Oeuvres complètes,* ed. J. Assézat and Maurice Toumeux, 11 vols. (Paris: Gamier, 1875–77), 11: 233.

16. See, e.g., Bonnet, "IIIe Mémoire sur les Abeilles, Où l'on donne un précis des observations faites sur ces Mouches, par M. RIEM," in *Oeuvres* (note 20), 10: 190; Réaumur to Jean-Baptiste Ludot, 1 March 1751, in *Lettres inédites* (note 31), 124; see also, more generally, Jean Senebier, *L'Art d'observer* (Geneva: Chez Cl. Philibert & Bart. Chirol, 1775), 188 passim.

17. Senebier, *L'Art d'observer* (note 47), 192. On Senebier's relationship to Bonnet, see Carole Huta, "Bonnet-Senebier: Histoire d'une relation," in Buscaglia et al., eds., *Charles Bonnet* (note 45), 211–24.

18. Horace Bénédict de Saussure, *Observations sur l'écorce des feuilles et des pétales* (Geneva: n.p., 1762), xviii (dedicatory epistle to Albrecht von Haller).

19. Réaumur, *Mémoires* (note 17), 5: 433; see also Jean Torlais, "Réaumur et l'histoire des abeilles," *Revue d'Histoire des Sciences* 11 (1958): 51–67.

20. Hermann Boerhaave, "Life of John Swannerdam," in *The Book of Nature; or The History of Insects,* trans. Thomas Floyd (1737–38) (London: C. G. Seyfert, 1758), note 26, ix.

21. Ibid., ix–xii; Jean Trembley, *Mémoire pour servir à l'histoire de la vie et les ouvrages de M. Charles Bonnet* (Bern: Société Typographique, 1794), 26–27; see also Raymond Savioz, ed., *Mémoires autobiographiques de Charles Bonnet de Genève* (Paris: J. Vrin, 1948).

22. Senebier, *L'Art d'observer* (note 47), 213.

23. François Huber, *Nouvelles observations sur les abeilles, adressées à M. Charles Bonnet* (Geneva: Chez Barde, Manget & Compagnie, 1792), 10.

24. André Deluc and Jean Dentand, *Relation de différents voyages dans les Alpes du Faucigny* (Maestricht: Chez J. E. Dufour & Ph. Roux, 1776), 29, 38–39.

25. Réaumur, *Mémoires* (note 17), 5: 251.

26. Schirach, *Melitto-Theologia* (note 24), xi.

27. Saussure, *Observations* (note 49), 92.

28. Swammerdam, *Book of Nature* (note 26), Part II, 53.

29. Linnaeus, *L'Equilibre* (note 22), 143.

30. For a general bibliography, see Lemon L. Uhl, *Attention. A Historical Summary of the Discussions concerning the Subject* (Baltimore: Johns Hopkins Press, 1890); on the place of absorption in eighteenth-century French art criticism, see Michael Fried, *Absorption and Theatricality: Painting and Beholder in the Age of Diderot* (Berkeley: University of California Press, 1980); and on links between forms of attention and modernism in art, Jonathan Crary, *Suspensions of Perception: Attention, Spectacle, and Modern Culture* (Cambridge: MIT Press, 1999); in literature, Roger Chartier, "Richardson, Diderot et la lectrice impatiente," *Modern Language Notes* 114 (1999): 647–66, and Adela Pinch, *Strange Fits of Passion: Epistemologies of Emotion, Hume to Austen* (Stanford: Stanford University Press, 1996), esp. 152–63; in pedagogy, Christa Kerstig, "Die Genese der Pädagogik im 18. Jahrhundert. Campes 'Allgemeine Revision' im Kontext der neuzeitlichen Wissenschaft," Ph.D. diss., Freie Universität Berlin, 1992; and in medicine, Michael Hagner, "Psychophysiologie und Selbsterfahrung: Metamorphosen des Schwindels und der Aufmerksamkeit im 19.Jahrhundert," in Aleida Assmann and Jan Assmann, eds., *Aufmerksamkeiten* (Munich: Wilhelm Fink Verlag, 2001), 241–64.

31. Nicolas Malebranche, *Recherche de la vérité* [1674–75] (Paris: Galerie de la Sorbonne, 1991), Vl.i.3, pp. 735–39.

32. Bonnet, *Essai analytique sur les facultés de l'ame* [1760], in *Oeuvres* (note 20), 13:128.

33. Senebier, *L'Art d'observer* (note 47), 215.

–3.3–

Scientific Seeing: Commodities, Curiosities, and Anthropological Objects
Andrew Zimmerman

The Royal Museum of Ethnology (Königliches Museum für Völkerkunde), which opened in 1886 in Berlin, was intended to stabilize the bodies and the possessions of the colonized as natural scientific objects. However, the moment curators broke open the shipping crates packed with scientific cargo from every part of the globe, these objects became enmeshed in new interpretive struggles within the urban culture of Berlin. To retain the bodies and possessions of the colonized for their science, anthropologists had to prevent them from entering the popular European culture of exotic spectacles, a culture that had claimed these objects long before the opening of the museum. Presenting colonial objects to the public gaze, however, also placed these museum pieces in an uneasy relation with the burgeoning consumer culture of Berlin. Even though museum curators dismissed this culture of commodities and curiosities as "mere voyeurism" (*bloße Schaulust*), fundamentally different from their own scientific interests, the very idea that humans could be known by the objects that they possessed was informed by commodity fetishism. Indeed, anthropologists even borrowed technologies of display from the glass and iron commercial arcades that sprang up in Berlin and elsewhere in Europe. The museum sought to stabilize oppositions between science and mass culture, museum objects and consumer goods, and anthropology and the humanistic disciplines. However, the very success of the museum made it an arena in which these oppositions, as well as the basic project of anthropology, could be challenged by its visitors, by its political patrons, and by a new generation of anthropologists, trained in the museum.

Anthropologists exhibited conventional anxieties about the market, which offered new objects but also presented new threats to what was perceived to be a traditional order prior to the market, an order that anthropologists wished to study.[1] They were aware that the political economic system that made their study possible was based on a global intensification of commercial capitalism. Indeed, promoters of the discipline promised that it would improve the performance of German merchants in the world market, for example, by providing information on the fashions and tastes of areas in which they wished to conduct business.[2] However, anthropologists also realized that "international-cosmopolitan world trade" would change forever the "natural" character

of the societies that they studied.[3] Particularly troublesome to anthropologists was the possibility that anthropological objects had been produced only to be sold to European collectors.[4] Indeed, this was one of the reasons that military expeditions were such valued sources of artifacts, for they took things not meant for Europeans. Luschan expressed typical anxieties about the commodification of anthropological objects in the Admiralty Islands: "What we have recently received from there is all absolutely inferior, often even intentionally 'slapped together' for export; it does not even remotely compare to our own older pieces. It is possible that one still might find some 'curiosities' in the interior, but I would not expect large, valuable series or significant museum acquisitions from the Admiralty Is[lands]."[5] Anthropological objects differed not only from commodities made for export but also from curiosities. Anthropologists regarded a single object by itself as a mere "curiosity."[6] As Bastian explained, since anthropology was an inductive science, it required "comparative series that are as complete as possible."[7] An anthropological object could be neither a commodity, made only to be sold, nor a curiosity, a unique object separated out from a series of other, similar objects.

Anthropologists described individual curiosities as the province of the general public's "voyeurism" or "lust for a show" (*Schaulust*). The distinction between anthropological ways of collecting and observing objects and Schaulust was especially urgent because, as we have seen, anthropologists often looked at the same things that titillated the audiences of popular exotic shows. Anthropologists spent considerable energy distinguishing their own projects from what they called varyingly a "cabinet of curiosities," a "panoptical," or "black vaudeville" (*schwarzes Tingl-Tangl*).[8] Differentiating themselves from these popular phenomena was particularly difficult because, even after the Royal Museum of Ethnology opened in 1886, anthropologists continued to conduct research in cabinets of curiosities, panopticons, and exotic vaudeville shows. Anthropologists believed that they could utilize these shows without suffering from the taint of mass-culture because they differentiated the way in which they viewed them from the way in which ordinary people viewed them. Anthropologists asserted that, while others visited the panopticons simply to satisfy their "desire for the new" or their "simple lust for a show," they themselves attended these performances in a scientific way for scientific purposes.[9] They supposed that they had a special way of observing the bodies and possessions of the colonized, one that allowed them to obtain knowledge rather than mere entertainment.

Indeed, the anthropological gaze—at least according to its practitioners—transformed the commodities and curiosities of the metropolis, even pornography, into scientific evidence. In the first edition of a book describing his expedition to Brazil in 1887–88, the anthropologist Karl von den Steinen included as a frontispiece a photograph of a nude Brazilian whose penis was clearly visible. Apparently, Steinen received criticism for this photograph, which was not reproduced in a popular *Volks-Ausgabe* of the book. In the preface to this popular edition, Steinen challenged those who, in his words, had suggested "that we can regard [*anschauen*] valuable pictures only with the same eyes with which we regard piquant photographs from European

metropolises." According to Steinen, pornography demanded a different way of see-ing, different "eyes" than the eyes required for anthropological photographs. To the uninitiated, all nude photographs might appear pornographic, but anthropological modes of vision cancelled the "piquant" element of the images. Steinen encouraged the readers of his popular book to "learn to grasp the naked body anthropologically and culture-historically, as in art they had learned to enjoy it aesthetically."[10]

Anthropologists made liberal use of their purported ability to see nudes anthropo-logically rather than pornographically. Indeed, the Berlin Anthropological Society's collection "Nude Studies of Races" contains numerous pornographic images, many of which depart widely from the conventions of anthropological photography.[11] Twenty-one images in this collection are pornographic in the most literal sense, rep-resenting prostitutes (Greek: *pornē*), mostly from Egypt and Japan. The collection also included prints from Wilhelm von Gloedden's famous nineteenth-century erotic photographs of young men and adolescent boys in classical settings, categorized as anthropological studies of the Sicilian race and sometimes, because they were often posed with sea creatures, as zoological, too (Figure 4). Other "racial nudes" are la-beled "female American," "female European," "female Berliner," "Else Breipöhler," "Hilda Breipöhler," "male model, name unknown," "Lionel Strongart, German-American," "L. Strongart as Boxer," "L. Strongart as Theseus in the battle with the Amazons." The photographs of men followed contemporary conventions of erotic nude photography, casting the models as classical figures or as athletes.[12] While it may be tempting to expose anthropology as a cover for the sexual pursuits of bour-geois men (much like Kingsley Amis's *Egyptologists*), in fact the scientific perusal of pornography was one aspect of a larger attempt to reclassify the commodities and curiosities of the modern metropolis as natural scientific objects.

In contrast to popular *Schaulust*, anthropologists defined their way of seeing as a gaze that would take in all anthropological facts in a single, summarizing glance. This anthropological gaze also provided, as we have seen, an alternative to the "inspired insight" (*geniale Anschauung*) that Dilthey attributed to humanists. Anthropologists sought to achieve what Bastian called a "total impression" of the variety of empiri-cally given "natural peoples." Anthropologists hoped that this method would allow them, as it had allowed botanists, to create a "natural system," a classification of their objects of study based on their true nature. They opposed this natural system, based on a total impression, both to historicist methods of interpretation and narrative and to the popular curiosity and to the commodity. From the beginning, Bastian recognized the amount of work that gaining an anthropological total impression would demand.[13] At the most basic level, it required simultaneously viewing people spread all over the globe, a feat that would have been physically impossible for an unassisted individual. It would also have been impossible for an individual in the field, who could consider only one particular society. A complete collection of anthropological objects displayed in a museum, it was hoped, would allow an individual to achieve the anthropologi-cal total impression. One of the most important practical tasks of anthropology was

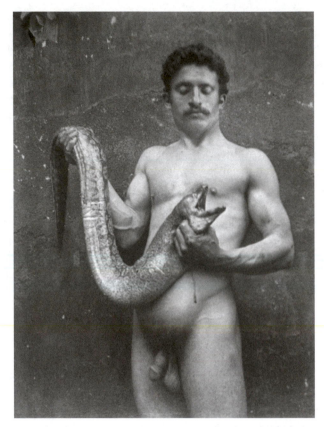

Figure 4 *A Representative of the Sicilian Race.* Photographer Baron von Gloedden: Reproduced by courtesy of Berliner Gesellschaft für Anthropologie, Ethnologie und Urgeschichte (P.11463).

creating a mode of vision that posited the objects of the colonized as natural rather than historical and as the objects of science rather than of *Schaulust.*

The Royal Museum of Ethnology was to institutionalize this anthropological mode of vision. It was designed in consultation with anthropologists to house both the royal anthropological collections as well as the collections of the Berlin Anthropological Society. Bastian and others spent much time planning the new structure, for they hoped that it would become a model for all future anthropology museums.[14] As Bastian explained to Virchow: "Before now ethnological museums were sometimes natural scientific museums, sometimes art museums, and sometimes a kind of ... chamber of horrors, and now we have reached the time to build the first ethnological museum as it should be."[15] There was a self-consciously utopian aspect to the museum construction, as anthropologists hoped to spread their own understanding of their discipline through this visual technology. The defining feature of the Berlin museum was to be its completeness. As Adolf Bastian wrote to the minister of cul-

ture in one of his early memorandums on the museum, it would bring together "the monstrous mass … necessary to sufficiently represent in a systematic, methodological order the ethnological provinces of the earth in their full extent."¹⁶ The museum was designed as an apparatus that allowed an individual to view all humanity simultaneously by surveying the totality of the artifacts of humanity's natural representatives, the natural peoples.

Notes

1. As Raymond Williams has shown, anxieties about a modern urban economy replacing a traditional pastoral economy emerged even in classical antiquity. See Raymond Williams, *The Country and the City* (London: Chatto & Windus, 1973).
2. See, for example, Adolf Bastian to General Administration of the Royal Museums, December 1894, MfV, XIIa, vol. 1, 1178/95.
3. See, for example, Adolf Bastian to General Administration of the Royal Museums, October 1899, MfV, I/1, vol. 1, 1134/99.
4. The anthropologist Oswald Richter, for example, worried about artifacts becoming "objects of speculation for the world market." See Oswald Richter, "Über die Idealen und Praktischen Aufgaben der Ethnographischen Museen," *Museumskunde* 2 (1906): 189–218; 3 (1907): 14–25, 99–120; 4 (1908): 92–106, 156–68, 224–35; 5 (1909): 102–13, 166–74, 231–36; 6 (1910): 40–60, 131–37. The quotation is from 4 (1908): 95.
5. Felix von Luschan to Edgar Walden, 29 May 1908, MfV, IB71, vol. 2, 1136/08.
6. For example, Luschan found the Berlin Museum's Oceanic and African collections superior to those of the British Museum "because here [in Berlin] we have systematic series, while the Brit. Museum possesses only individual 'curiosities.'" Felix von Luschan to Adolf Bastian, 25 October 1899, MfV, Ic, vol. 4, 639/99.
7. Adolf Bastian, memo, 1885, MfV, IB Litt C., vol. 1, 216a/85.
8. Bastian, *Die Vorgeschichteder Ethnologie;* Adolf Bastian to General Administration of the Royal Museums, 28 January 1899, MfV, Ic, Bd. 4, 467/99; Felix von Luschan to Rear-Admiral Franz Strauch, 29 November 1897, MfV, IB 46, Bd. 2, 1427/97.
9. [?] Castan and Rudolf Virchow, "Australier von Queensland," *VBGAEU* 16 (1884): 407–18, 417; Felix von Luschan to Direction of the Royal Museum of Ethnology, 7 November 1900, MfV, I/1, Bd. 1, 985/00.
10. Steinen, *Unter den Naturvolkern Zentral-Brasiliens,* viii.
11. "Aktstudien von Rasse Typen meist aufgenommen durch Prof. Gustav Fritsch," box in the Archive of the Berliner Gesellschaft für Anthropologie, Ethnologie und Urgeschichte, Schloß Charlottenburg, Berlin.
12. On nineteenth-century erotic photographs of males, see F. Valentine Hooven, "The Birth of Beefcake," in *Beefcake: The Muscle Magazine of America,*

1950–1970 (Cologne: Benedikt Taschen, 1995), 16–51. On pornography and representations of prostitution, see Walter Kendrick, *The Secret Museum: Pornography in Modern Culture* (New York: Viking, 1987), 1–32. The essays collected in Lynn Hunt, ed., *The Invention of Pornography: Obscenity and the Origins of Modernity,* 1500–1800 (New York: Zone, 1993), also present pornography as an important aspect of modern sensibilities and view it as directed against traditional religious and political authorities. Anthropologists thus may have figured themselves as modern men by consuming pornography.

13. See Adolf Bastian to Adalbert Falk (minister of culture), 3 January 1878, GStA PK, I. HA, Rep. 76Ve, Cultusministerium, Sekt. 15, Abt. III, Nr. 2, Bd. I, unnumbered sheets (M).

14. Adolf Bastian to General Administration of the Royal Museums, 23 August 1876, GStA PK, I. HA, Rep. 76Ve, Cultusministerium, Sekt. 15, Abt. III, Nr. 2, Bd. I, unnumbered sheets (M).

15. Adolf Bastian to Rudolf Virchow, 29 August 1878, NL Virchow, 117, pt. I, Bl. 25–26.

16. Adolf Bastian to Adalbert Falk (minister of culture), 3 January 1878, GStA PK, I. HA, Rep. 76Ve, Cultusministerium, Sekt. 15, Abt. III, Nr. 2, Bd. I, unnumbered sheets (M).

–3.4–

Science, Sight and the Ordering
of Colonial Societies

Fernando Feliú

... At the beginning of the twentieth century, yellow fever, malaria, and cholera manifested themselves through devastating epidemics; however, other diseases, such as uncinariasis, or "hookworm disease," popularly known as anemia, also wreaked havoc, particularly among the Puerto Rican population. According to Blanca Silvestrini, at the close of the nineteenth century the mortality rate for anemia reached nearly 90 percent, a figure higher than that of either malaria or yellow fever. Although by the final third of the nineteenth century, Salvador Brau, Francisco del Valle Atiles, and Manuel Zeno Gandía had made note of the endangered health of Puerto Rico's rural populations and the deplorable conditions in which they lived, anemia still had not received the necessary attention from health authorities. This attention was not given until 1904, when army doctor Bailey K. Ashford managed to convince health authorities of the need to design a plan for eradicating anemia. That same year, the U.S. War Department named Ashford as president of the Anemia Commission, a body subsidized by the state and charged with organizing and directing the hygiene campaigns in the coffee-growing towns of Puerto Rico's interior. My intention here is to examine the theoretical and practical strategies behind these campaigns. I identify two principal mechanisms: the first, rendering the visible invisible; and the second, rendering the invisible visible. In addition to fighting the disease, the interaction of both mechanisms had a colonizing role: they helped to shape a health code vertically imposed upon the Puerto Ricans. The health code illustrates what Foucault calls the "microphysics of power," or measures that permit the state to exercise direct control over the body and conduct of the citizen (*Discipline* (b), 26–27). The interaction of these mechanisms produced a series of binaries, among them that of civilization versus barbarism, the racial contrast between black and white, and the tensions between the modernization of the island and the weight of a premodern tradition, all of which correspond to what Abdul Jan Mohamed calls the "Manichean allegory."

The production of this allegory was supported by the results of the scientific studies published in the medical reports of the Anemia Commission (Jan Mohamed, 61–63). In these reports, the Manichean allegory is created through the descriptions of direct interactions with Puerto Rican patients, as well as descriptions of

the environment and topography, and their influence on anemia's spread. However, it is necessary to clarify that as the commission instituted a microphysics of power through public health campaigns widely accepted by the rural populations and by the elite minority alike, there were also examples of the practices employed by the *jíbaros* (Puerto Rican peasants) to reject the regulations imposed upon them.

Unlike yellow fever, whose transmitting agent is the Anopheles mosquito, the organism that produces hookworm diseases is invisible to the naked eye. Intrigued by the numerous anemia cases in Ponce, Puerto Rico, Ashford discovered that in all of the examined fecal samples there appeared a high number of the worm *Necator americanus.* This 1899 discovery significantly altered anemia's etiology. From then on, anemia was no longer considered a disease in and of itself but, rather, one of the symptoms of what came to be known as "hookworm disease." Moreover, linking uncinariasis's origins with a pathogenic agent refuted the prevailing tendency to attribute the Puerto Rican peasant population's ill health to poor nutrition and excessive labor. Similarly popular, though mistaken, notions also contributed to uncinariasis's longtime status as an "invisible" ailment whose symptoms were often confused with those of a head cold or, according to Ashford, with those of yellow fever or malaria. While the incubation period for yellow fever and malaria is short, with patients suffering from chills and dehydrations, uncinariasis patients agonized in a slower and less dramatic way. The parasite slowly takes possession of the organism, nourishing itself through the food consumed by the victim. The parasite, which grows in manure, perforates the organism's skin and, traveling through the blood stream, establishes itself in the intestines, where it reproduces. Once afflicted, the patient gradually loses energy and spirit until he or she dies of inanition. This quality thus makes the *Necator americanus* one of the "invisible monsters" to which Georges Vigarello (1988: 15) refers: a silent killer that the *jíbaros* referred to as *la muerte natural* (a natural death).

The worm's invisibility demanded that the commission devise a strategy that would permit a better understanding of the worm's life cycle in hopes of designing a treatment and plan for eradicating uncinariasis altogether, hence the need to make the parasite perceptible. In other words, it was a question of rendering the invisible visible, or providing the *jíbaros* natural assassin with form and content. The preoccupation with visually defining the etiology and pathology of a disease is clearly outlined in the opening pages of Ashford's autobiography, *A Soldier in Science:* "And so this afternoon, his research directed hither by his many days of examining blood, he was *staring* at a thin film of feces crushed between clover-glass and glass-slide. It was his first *look* at feces" (emphasis mine, 1998: 3). Here the narrator emphasizes the "stare" and the "look," both terms related to visual perception and, more specifically, to the magnifying power of the microscope, the instrument that renders the worm's visibility a reality.

This reference to the microscope directly locates the reader in the laboratory, or in the space where the invisible is rendered visible. In order to examine blood and fecal samples, the commission furnished each of its treatment centers, or dispensaries, as

Ashford called them, with laboratory equipment. Much like the nineteenth-century hospitals where, according to Foucault in *The Birth of the Clinic,* research and instruction were inextricably linked, the dispensaries simultaneously conducted medical research and restored health as primary objectives (107–123). Hence the blood and fecal analyses and fecal samples undertaken in the centers facilitated nosological knowledge of various diseases while informing the staff of patients' levels of infection. Thanks to the dispensaries' structure, by 1905, just one year after their creation, the fatalities attributed to uncinariasis were reduced from 17,009 to 414. By 1911, when the Anemia Commission ceased to exist, more than 300,000 patients had been treated. These figures demonstrate that the treatment devised by the Anemia Commission was a success. But the success of the dispensaries was not limited exclusively to the treatment of uncinariasis; they also contributed directly to improving the general health of the Puerto Rican peasants. Patients suffering from other diseases, such as malaria, yellow fever, and colds, were also treated at no cost. In fact, Ashford wrote in his autobiography that the success of the dispensary treatment lay in the ability to show the *jíbaros* "how to avoid death from preventable illnesses of all sorts" (1998: 88). And indeed, that was the case. Ironically, the success of the Anemia Commission made postmortem research far more difficult. The decrease in the death rate led Ashford to express concern about the difficulties of obtaining cadavers. The lack of corpses, ironically, made "complicated the study of the disease's pathology." Rendering the invisible visible therefore reconfigured the meaning of death. Death was no longer just considered the end of life, but rather an anatomic state that enabled a gathering of knowledge related to the effects of uncinariasis on human organs. If *jíbaros* feared anemia as *la muerte natural,* Ashford valued death and used human remains in order to understand better the hookworm's effects.

Thus Ashford's work suggests a semantics of observation. Observation (in addition to its literal value in the physician's work, as he first employs observation to examine superficial symptoms such as pigmentation, frequency of pains, or the presence of fever) also serves as a methodological stereoscope or as a system for interpreting, analyzing, collecting, and, most importantly, ordering the Puerto Rican reality. Aiming to catalog this reality and its inhabitants, medical discourse organized patients' records according to skin color (white, black, or mulatto), gender, and municipality. But more interesting than the racial nomenclature (which was typical of census terminology of the period) was the clinical taxonomy used to divide patients. Patients were labeled as either "cured," "partially cured," "improved," "unimproved," or "dead." This system of classification reveals the intimate relationship between the direct observation of the patient and the creation of the medical map of anemia in Puerto Rico. One defines what one can observe; consequently, the observable is classifiable, definable, and can be converted into statistical data. However, Ashford abandons the use of statistical data and instead emphasizes clinical observation of the *jíbaros,* which becomes an emblematic feature of his style: "we still have an unseen army of pale people hidden away in the mountains where coffee is grown.

These are almost never observed by the tourist and casual visitor" (*Uncinariasis in Porto Rico,* 1911: 51). Hidden in the mountains, the peasant population remains an anonymous mass that acquires individuality only upon admission into the dispensaries. Not visiting the dispensaries meant remaining invisible. This invisibility was not due to the physical distance between the *jíbaros* and the dispensary (though in many cases this was considerable, since the commission's centers were often located on the outskirts of cities), but to the fact that the *jíbaros* took on a concrete and immediate form only as patients of the commission. The visit to the dispensaries gave the *jíbaros* a specificity relative to the anonymous masses. Upon arrival at a center, the subject assumed a clinical existence as he/she was examined by the physician's clinical eye, an eye that scrutinizes in hopes of diagnosing the patient's illness and of identifying its corresponding taxonomy. Observation allowed description, an act which in the Foucauldian sense made the invisible accessible (although it is doubtful that Ashford permitted his patients to examine their blood samples under the microscope) and produced a language that rendered visible and intelligible what was once a mystery to the *jíbaros.* One hoped that the patient could "see without looking" via the doctor's technical jargon (*Uncinariasis in Porto Rico,* 1911: 115).

Ashford's interest in giving visibility to the invisible is also present in his book's format, which includes numerous photographs. Of particular interest among these is the photo of Dr. Ashford taking a blood specimen. As its caption indicates, the photo shows Ashford extracting blood from the ear of a young boy. Ashford's location in the center of the photo underscores his authoritative position. Next to Ashford, the beakers and other instruments, all neatly placed on the table, suggest that the action depicted, taking a blood sample, is an action in progress, to be completed once the sample has been analyzed ... The role of the laboratory in the economy of the commission's campaigns takes on even more significance in the modernizing process that Ashford deemed the only possible means of improving the condition of the anemic *jíbaro.* "Better homes, better means of communication with towns, now becoming an accomplished fact, better food, education, in which remarkable progress has been made at this day, better habits of life, especially those relating to the modern prevention of disease, must form part of any plan adopted to improve his condition" (*Uncinariasis in Porto Rico,*1911: 15). Thus sanitary management depends upon the development of a structure of power that regulated the transition from the premodern to the "modern." From this perspective, laboratory work was the foundation of Puerto Rico's scientific modernization. The photograph epitomizes the transition from the invisible to the visible and the passing from the superstitious, *la muerte natural,* to a supposedly objective analysis based on a series of facts. It is, in the end, an image that captures the physical and cultural encounter between colonizer and the colonized—an image governed by a clear hierarchy in which the doctor assumes an active role while the patient remains a mute spectator in the face of the changes to his physical identity and health care, or, in other words, to the changes to his way of life. A close examination of the photo thus reveals a significant contrast

between the visual and the audible. Ashford observes the ear while the child attentively gazes at the camera. The child's expression communicates his displeasure in the face of such pain and discomfort. However, what appears to be a gesture of contained rejection, which could easily represent the reaction of thousands of other patients, demonstrates, according to Ashford, the innate submissiveness and obedient nature of the *jibaros*. "We have been agreeably surprised how readily they comprehend and how faithfully they obey our counsel in the matter." However, perhaps this gesture of discomfort, with its distant gaze and subtle way of expressing resistance to the body's colonization, as minute a tactic as it may seem, reveals that the faith of the *jibaro* in the counsel of the doctor was not as blind as Ashford perceived it to be. Instead, the *jibaro*'s gesture is a reaction that could well be attributed to the fear inspired by the deployment of such intimidating and powerful technologies. Thus the child's resistance in the face of the medical treatment to which he is subjected hints at the possibility that within the nicely arranged order of the laboratory there is a fissure or a symptom of disorder.

Even though the photograph isolates the laboratory from the social context, Ashford was aware that in order for the commission's work to be successful, it was imperative to make the knowledge produced in the laboratories accessible to the patients and to other doctors. Ashford addresses this concern directly in his autobiography when he describes the first years of the campaigns: "That objective [eradication of uncinariasis] we had carried by centering the work in one place, and then by gradually and cautiously extending our front by throwing out sub-stations in the charge of men in whom we could trust" (*A Soldier in Science,* 1998: 81). By expanding and increasing the numbers of dispensaries or substations, Ashford attempts to reach more patients in order to change *jibaros* mentality: the *jibaros* had to believe, first, that anemia was a disease and did not signify the presence of supernatural powers, and second, that anemia was in fact curable and preventable, given certain precautions. Instead of isolating himself within the laboratory and avoiding contact with his surroundings, Ashford labored, as Pasteur before him, to abolish the boundaries between the laboratory and society. The knowledge produced in the laboratories had immediate and important social repercussions. As Ashford states, anemia "cripples industrial effort, limits mental expansion, weakens the body, and depresses the spirit, until laborers in a country where agriculture is the chief course of revenue are enervated, despondent, without the power to save themselves" (*Uncinariasis in Porto Rico,* 1911: 168). Improving the physical condition of the coffee workers was directly related to the economic situation of the new colony. The production of information in the laboratory made accessible to the public not only the treatment and prevention of uncinariasis, but also health and public hygiene themselves. The application of these discourses improved the overall economic development of the island. Furthermore, the success of the commission not only consolidated the prestige of its members, Ashford, Walter King, and Pedro Ingar·Videz, but also contributed significantly to the creation of permanent regional laboratories. As P. Morales Otero, director of

the Biological Laboratory of the Department of Health, indicates, the overwhelming success of the anemia campaigns led the legislature to pass a law in 1909 that appointed "a physician for each of the senatorial districts where laboratories were to be established" (Morales Otero, 10). The institutionalization of these laboratories demonstrates that the modernization of the health infrastructure, a process Ashford had been clamoring for since the beginnings of his research, was significantly influenced by the effectiveness of the commission in dealing with the sick. But it also demonstrates that since its inclusion as part of the dispensaries, the laboratory was increasingly called on to authenticate knowledge.

As part of the microphysics of power enacted by the commission, treatment centers served as spaces in which to glorify the conquest, or in Ashford's words, the "scientific reconquest" of Puerto Rico. He declares in a military briefing that according to the peasants of Aibonito, the commission is "the best thing that has occurred since the age of sovereignty" (*A Medical Economical Problem,* 2), a comment that implicitly equates health with better quality of life and makes this improvement the direct contribution of the colonizer. Thus Ashford implies that the *jíbaro* should accept this intervention because it supposedly serves only to benefit him or her, as he indicated at an international medical conference in Providence, Rhode Island. At the Providence conference, Ashford exhibited a group of Puerto Ricans afflicted with uncinariasis. As Ashford declared, the members of this group were valuable precisely due to their role as objects on display: "They were useful to me not only as sources for a continuation of my study, but also as living examples of this new disease, on which I was asked to discourse at the Annual meeting of the Westchester Country Medical Society" (*A Soldier in Science,* 49). The display of these Puerto Ricans as objects imparts a new meaning to the strategy of rendering the invisible visible. The staging turns observation into a theatrical act corresponding to what Warwick Anderson calls "the medical spectacle" ("Where Every Prospect Pleases," 519). Participation in the conference was considered a patriotic gesture: the peasants, adds Ashford, "had made their first contribution to their new Patria" (*A Soldier in Science,* 63). Although exposure of human subjects in scientific congresses might have been a common practice during the early years of the twentieth century, in this case the peasants' participation transcends the scientific and becomes and takes on a nationalist hue. But it is not the peasants who are expressing their patriotism, it is Ashford who imposes on their participation an ideological value. To be displayed is, then, a contribution to the new patria, that is, the United States, not Puerto Rico ...

In the commission's briefings, as in Ashford's autobiography, the *jíbaros* are reduced to the status of laboratory specimen, but they appear in a more favorable light than do other sectors of the Puerto Rican population. Puerto Rican blacks suffered the most prejudice. According to Ashford, the African slaves who were brought to the island during the seventeenth century carried within them the *Necator americanus.* Ashford presents this as an historical fact from which he concludes that the blacks "infected the soil" and "cursed Puerto Rican history" (*Uncinariasis in Porto*

Rico, 23). The alleged black immunity to anemia is a construct that precedes Ashford. As Benigno Trigo ("Anemia and Vampires") has suggested, nineteenth-century intellectuals, immersed in a political struggle against Spanish authority, had equated blacks with a parasitic agent. In Ashford's work, proposing racial criteria as the root of genetic immunity amounts to a tautological move: race determines immunity as much as immunity defines race. Implicit in Ashford's work is the concept that races were fixed criteria, "pre-existing natural entities," as Nancy Stepan defines them. What seems to be a clearly racist approach to the study of races was a generalized tendency in American scientific discourse during the late nineteenth century and early twentieth century, as John Haller has demonstrated. Ashford's racial construction partakes of this metanarrative. Furthermore, by establishing that African slaves brought the worm, Ashford is explicitly linking the black body with bodily fluids where the worm procreates. If rendering the invisible visible facilitated a physiological sketch of the hookworm, then the next step was to eradicate the worm, cleansing the topography of the "putrid" material. In the battle against anemia, the theoretical knowledge regarding uncinariasis's pathology led to the practical concealment of excrement. Thus we have before us the justification of the second strategy put into effect by the commission; rendering the visible invisible.

Rendering the Visible Invisible

While the first strategy is undertaken in the laboratory, rendering the visible invisible gathers meaning beyond that realm. If the first strategy facilitated the attainment of knowledge that could cure the sick, or rather, combat anemia, the second strategy was directed towards the elimination of hookworm as a practical problem. As such, these strategies should not be understood as opposing each other, nor as two phases of a long-range program, but rather as complementary expressions of the Anemia Commission's methodology, two complementary fronts whose interaction depended on the success of the Anemia Commission's operations. First, the doctor researches, observes through the microscope, and counts the cells or corpuscles in order to later conceal, dispose of, and remove from sight the "excrement," all actions that cleanse the face of the nation, as Mary Louise Pratt states ("Scratches on the Face," 1985). The methods adopted by the commission were principally aimed at avoiding physical contact with solid wastes. Rain scattered the larvae, thereby contaminating the soil and allowing the worm to multiply on mountain slopes or in bodies of standing water such as small ponds. Deodorization was not an option, since the danger lay in direct contact with the feces, not exposure to its odor. By the same token, it was impossible to eliminate the parasite through the use of aerosols because the carrier was not a mosquito, as in the case of malaria and yellow fever. Considering these limitations, the commission stressed prevention, prescribing the use of footwear and the installation of latrines. Since the initiation of his research, Ashford had

maintained that the use of footwear as well as the construction of latrines represented the most effective ways of minimizing exposure to the parasite; he even went as far as to consider mandating the use of shoes, a notion that he later abandoned. In contrast, the construction of home latrines was obligatory from the very onset of the commission's campaigns, although in 1905 Ashford confessed that such a strategy "would work harm by creating opposition which would be hard to overcome, as it would appear to them as purely arbitrary and an unreasonable piece of nonsense." However, the Puerto Ricans' resistance was gradually worn down, in part because affected patients understood that the latrines limited the possibility of contracting the disease and of suffering a relapse, and in part because the installation of latrines became law. Not having a latrine or keeping one in an unsanitary condition constituted a punishable offense. To ensure that these latrines were assiduously used, the commission formed a body of "health officials" whose duties, as defined by Ashford, involved overseeing the ingestion of required medicines and supervising the latrines' maintenance. In this way, the strategy of rendering the visible invisible was legalized and endorsed by the legal system. Health and hygiene were transformed from a body of knowledge designated for improving health, as in the illustrated pamphlets that the commission passed out to the sick, into a discourse that redefined criminality and validated the incipient social order that the colonial military authority was imposing on the country. Thus personal hygiene was subordinated to the collective will, and the biological act of defecating became a potentially criminal act, an affair of state that justified the interference in the private life of the citizen.

The explicit association of the *jíbaros* with the production of excrement contrasts with Ashford's interest in concealing the waste. Unlike the infirm, the commission's doctors take notes, measure, weigh, examine patients, crisscross the island's towns, and appear immersed in labors that transcend the natural necessities of the human body. In this fashion, Ashford's body is idealized, while that of the *jíbaro* embodies all that is filthy, vulgar, and scatological. As author, Ashford constructs an image of himself as an individual capable of evaluating the island's health, curing patients and directing complex campaigns at the national level without so much as hesitating or committing an error. This rhetoric promotes the briefings' appearance as a monolithic source of information, or a closed, self-sufficient universe, much like the laboratory space. Furthermore, the inclusion of data that supports evidence of a decline in anemia in all regions containing dispensaries simultaneously constructs an efficient image of the commission as an entity that controls (via health officials) the private lives of thousands of peasants, a type of Big Brother whose power rests in the conjunction of legal support and the voluntary complicity of the *jíbaro*. According to Ashford, upon embracing the norms, the Puerto Rican acquires an acceptable identity and is transformed into one who is "faithful and warm" (*Uncinariasis in Porto Rico,* 20). By the same token, rejection of the norms renders him or her "a violently prejudiced *jíbaro*" (*A Soldier in Science,* 73) This limits the complexity of power relations between the colonizer and the colonized to a reductionist, idealized binary.

Ashford observes that Puerto Ricans accepted voluntarily the construction of latrines "without coercion or harsh compulsion," as if health officials or the fear of being fined did not influence the *jíbaros'* will.

In a significant passage of his autobiography, Ashford convinces the mayor of the town of Utuado to install a latrine at his home. Some weeks later, Ashford returns to the neighborhood and finds the "*jíbaro alcalde* with the torn shirt and the bare feet at work in a tobacco patch" (*A Soldier in Science,* 71), who takes him to the recently built latrine located far from his home. Surprised, Ashford reprimands the mayor, who replied: "The law requires us to have one, and there it is, but neither my wife nor I believe in these things, as they produce constipation. And besides, it is a nasty thing to have near the house. But the law requires it, and everybody else has one, too" (*A Soldier in Science,* 72). The anecdote's presentation is noteworthy; words such as *jíbaro* and *alcalde* are included in italics as if their presence were contaminating the discourse. As narrator, Ashford places himself in a supposedly objective position from which he maintains some distance in relationship to the mayor, the Other, and from which he is able to register and transcribe the observed events. The description is suggestive of the writing of his briefings, where Ashford also deliberately attempts to remove himself from events in order to "report on" advances in the eradication of uncinariasis.

But perhaps more important than the presentation, the anecdote provides an example of the complexities of colonizer-colonized relationships. For Ashford, the incident is presented as proof of the ignorance that justifies the commission's intervention in Puerto Rican daily life. If we take the perspective of the mayor, however, we can interpret in his response a tactic of resistance in the face of the imposition of a sanitary economics. The mayor is complying with the law while simultaneously subverting Ashford's prophylaxis: he refuses to build the latrine near his house since it causes "constipation." The mayor's refusal "tricks" the law and affirms, in the process, his own beliefs about what is sanitary and what is not—a code of values that evidently rejects those promoted and sponsored by the American colonial authorities. Moreover, in light of the mayor's refusal, which could easily have represented the cases of thousands of Puerto Ricans, it is fitting to ask just what percentage of them fully accepted the prescribed use of latrines and just how many Puerto Ricans were fined for infringing on health regulations. Ashford's anecdote downplays the tensions between the military and islanders. Hence rendering the visible invisible transcends a purely sanitary practice (concealing excrement) and also works on a symbolic plane as a device that minimizes or even hides the everyday tactics of resistance articulated by the natives against the sanitation rules promoted by the commission.

Although rendering the visible invisible operates on a literal as well as on a symbolic level, its practicability depended upon the knowledge produced in the laboratory, that is, in making the invisible visible. If rendering the invisible visible provided the theory, the body of knowledge that enabled the physician to understand the *Nectar americanus* life cycle, rendering the visible invisible translated this body of

knowledge into practice. But even more important is that the interaction of these strategies comes into being in the context of the colonization of Puerto Rico. From this perspective, these strategies acquire in Ashford's briefing and in his autobiography an ideological meaning as they construct a scientific discourse which in turn proposes a new pathology of the colonized body. In narrating this new pathology of the Puerto Rican, Ashford writes of the encounters with the Other in a way that erases the tensions between colonizer and colonized and treats the Puerto Rican subject as a monolithical entity. There is no racial or class distinction in the descriptions of the *jíbaro*. The little boy of the photograph is as much a *jíbaro* as the mayor of Utuado, although the latter holds a public office. Ignoring these important differences that contributed to the heterogeneity of the native population, Ashford reduces the Puerto Rican island inhabitant to an infirm and ignorant patient waiting to be brought by science into modernity.

Bibliography

Anderson, Warwick, " 'Where Every Prospect Pleases and Only Man Is Vile': Laboratory Medicine as Colonial Discourse." *Critical Inquiry* 18.3 (1992): 506–529.

———, "Excremental Colonialism: Public Health and Poetics of Pollution," *Critical Inquiry* 21.3 (1995): 640–669.

Arnold, David, *Colonizing the Body: State Medicine and Epidemic Disease in Nineteenth-Century India.* Berkeley: University of California Press, 1992.

Ashford, Bailey K., *A Soldier in Science.* Rio Piedras: Editorial de la Universidad de Puerto Rico, 1998.

Ashford, Bailey K., *Uncinariasis in Puerto Rico: A Medical and Economic Problem.* Washington, DC: Government Printing Office, 1911.

Brau, Salvador, "Las Clases jornaleros de Puerto Rico." *Ensayos,* San Juan, 1983 [1882], 9–75.

Chandravarkar, Rajnarayan, "Plague Panic and Epidemic Politics in India, 1896–1914" in Terence Ranger and Paul Slack (eds), *Epidemics and Ideas: Essays on the Historical Perception of Pestilence.* Cambridge: Cambridge University Press, 1992, 203–240.

De Certeau, Michel, *Practice of Everyday Life.* Berkeley: University of California Press, 1984.

Foucault, Michel, *Discipline and Punish: The Birth of the Prison.* New York: Random House, 1979.

Haller, John, "The Physician versus the Negro: Medical and Anthropological Concepts of Race in the Late-Nineteenth Century." *Bulletin of the History of Medicine* 44.2 (1970): 145–167.

Jan Mohamed, Abdul, "The Economy of Manichaean Allegory: The Function of Racial Difference in Colonial Literature," *Critical Inquiry* 12 (1985): 59–87.

Morales Otero, P., "The Work of the Biological Laboratory of the Department of Health," *Puerto Rico Health Review* 2(9) (1927): 10–16.

Pico, Fernando, *La Guerra después de la Guerra.* Rio Piedras: Editorial Huracan, 1988.

Pratt, Mary Louise, "Scratches on the Face of the Country: or What Mr. Barrow saw in the Land of the Bushmen." *Critical Inquiry* 12 (1985): 119–143.

Santiago, Kevin, *Subject Peoples and Colonial Discourses: Economic Transformation and Social Disorder in Puerto Rico, 1898–1947,* Philadelphia: Temple University Press, 1994.

Stephan, Nancy Leys, *The "Hour of Eugenics": Rave, Gender and Nation in Latin America,* Ithaca, NY: Cornell University Press, 1991.

Trigo, Benigno, *Subjects of Crisis: Race and Gender as Disease in Latin America,* Middletown, CT: Wesleyan University Press, 2000.

Vigarello, Georges, *Concepts of Cleanliness: Changing Attitudes in France since the Middle Ages,* trans. Jean Birrell, Cambridge: Cambridge University Press, 1988.

Gossip and the Creation of Cinematic Space
Rachel Dwyer

Stardust is the flagship magazine of Magna Publications,[1] a Bombay-based publishing company owned by Nari Hira. Hira founded *Stardust* in 1971 as a marketing opportunity for his advertising business. The only major film magazine at the time was *Filmfare,* which ran film information and uncontroversial stories about the lives of the stars. His idea was to publish a magazine on the lines of the American *Photoplay* with celebrity gossip journalists like Hollywood's Hedda Hopper and Louella Parsons. Twenty-three-year-old Shobha Rajadhyaksha (later Dé), who had been working for Hira for eighteen months as a trainee copywriter, was hired as the first editor. She had no interest in the movie world and had never worked as a journalist, but was given the job on the strength of an imaginary interview with Shashi Kapoor, whom she had never met. She and a paste-up man produced the first issue in October 1971 from unglamorous offices in south Bombay.[2] Later they were joined by a production staff of three, and a team of freelance reporters collected stories which she wrote up. Dé stubbornly refused to move in the film world, only meeting the stars if they came into the office. The style of the magazine was established during her time as editor and has been maintained under the succession of editors who followed. The first issue of *Stardust* appeared in October 1971. A statement of intent was given underlining the magazine's purpose in its 'Snippets' column:

> Very few movie magazines and gossip columns are either readable or reliable and hardly any are both. Most of them are inadequately researched and are the result of second and third hand reporting. One theory put forward has it that what often passes for news and fact is really much hearsay and gossip. Another claims that the people in the movie trade who are in a position to know are too busy to write or find it impolite to write down what they know.
>
> So, this column—largely as its reason for being—will be a reporter's column and not a mouthpiece of publicists and ballyhoos of the film trade. And here we go.…[3]

The magazine's manifesto is discussed throughout the whole issue, in particular in the Q&A page and letters page (presumably written by Dé since it was the first issue). The production features were much less glossy than they are today. Colour was used only for the cover, an unflattering picture of the top box-office star, Rajesh

Khanna, and a series of photographs of the leading female star, Sharmila Tagore. The front-page headlines were very suggestive—'Is Rajesh Khanna married?' and 'Rehana Sultan: all about her nude scene'—but the stories were quite innocent. The main features were uncontroversial stories about Sharmila Tagore and her husband, the Nawab of Pataudi, the international cricketer. Along with the expected combination of photos, news and gossip, some of the staple features of *Stardust* appeared in the first issue, including 'Neeta's natter', written by 'The Cat', the letters page, and the Q&A columns. The trademark Bombay English is not much in evidence, and there is little innuendo and few of the double entendres that become a central feature in later issues (the only example in the first issue was the mention of eating 'red-hot pickles' on a date). Several of the features were later dropped, including Hollywood coverage, 'A day on the sets', 'What's shooting', cartoons, and film criticism, features which brought it closer to *Filmfare*. Within a year more of the staple features were established, including 'Court Martial' (October 1972), and the special use of language is soon seen throughout the magazine. Many of the major themes which are discussed below emerged during the early numbers, including images of the body, and issues of sexuality centred around the affairs of stars and their scandalous behaviour off the sets. The magazines also have the usual self-reflexive coverage, writing about themselves, in particular about the special relationship of the magazine to the film industry, the definition of the star and discussion as to whether stars have the right to privacy …

…

The stories cover fifty or more stars, concentrating on cover girls and glamorous figures who lead exciting lives or make controversial statements, rather than the top box-office stars. For example, Aamir Khan is a big box-office star and also a pin-up but since there are no interesting stories about him, and he gives few interviews, he features rarely in the magazine. Salman Khan, another pin-up but a more variable box-office star, is a more controversial figure and the magazine publishes many stories about his off-screen activities. *Stardust* also promotes stars by putting in glamorous photos, and making romantic link-ups with other stars. This promotion was evident with the model Sonali Bendre, who won a talent competition for a place on the 'Stardust Academy', an annual sponsored programme for would-be starlets. While few heroines have more than minor roles in the films (even an important heroine like Kajol may take such minor roles that they have to justify their choices in the magazines: 'I did *Karan-Arjun* because I wanted to know how it feels to be an ornament. I had nothing to do in the film except look good.'),[4] yet great importance is given to them in the magazines, especially on the covers, since the editors believe that a woman ('Cover girl') on the front generates sales. Some actresses have had magazine careers which outshone their screen roles, notably Rekha. Although she has acted in some great roles (in 1981 *Umrao Jaan* and *Silsila*), she has remained more famous for being desirable, beautiful and unattainable and for the scandal which has dogged her.[5]

This is part of the fairly fixed style of the magazine cover. In addition to the main picture, there is usually a woman or a star couple in an amorous pose, surrounded by up to four cut-outs of stars with sensational headlines, at least one of which mentions sex. The headlines are usually far more salacious than the stories inside the magazines. The magazine's regular features include the opening quasi-editorial 'Neeta's natter', short paragraphs of gossip, written as if by a celebrity about her social life in the film world, covering openings, films' jubilees,[6] weddings, parties, etc. The stories praise those who are 'in' and mock those who are 'out'. This is where the exaggerated language of the magazine is strongest, full of innuendo and puns. There is some photographic coverage of industry events, but the majority of photos are the session photos found elsewhere in the magazine. The other insider gossip sections are 'Star Track', which covers incidents in stars' lives, mostly stories from childhood, and events on the sets, and 'Snippets', which is more humorous, consisting mainly of jokes about stars' gaffes in English, in etiquette, and then short puns and jokes; 'Straight talk' covers other news items about the stars ...

...

Stardust has kept very much to the style established during its first decade, apart from the increase in the number of interviews by letter of the stars by the fans. Some of the graphics, such as those for 'Neeta's Natter', have remained unchanged and look very dated with their 'flower power' image, but these have provided the magazine with a recognizable identity. In fact, the black cat with a jewelled necklace smoking a cigarette in a long holder is printed on company stationery. The general consensus is that although the other glossies are of high quality and good reportage, in particular *Filmfare,* which many read in addition to *Stardust,* the latter still stands out from the other magazines because its gossip has more 'bite' ...

Notes

1. Other Magna publications include *Showtime* (1984–) (a star magazine), *Savvy, Health and Nutrition, Parade, Society, Society Interiors, Society Fashion, Island* (a Bombay magazine), *Family* (a Bangalore magazine) and *Citadel* (a Pune magazine). Magna also publishes romantic fiction and biographies of the stars.
2. The Magna group now has its own seven-storey building in the inner suburb of Prabhadevi.
3. *Stardust,* October 1971: 39.
4. *Stardust,* March 1995: 112.
5. 'One of the few contemporary Indian film stars with a legendary status far outstripping her screen roles.' A. Rajadhyaksha and P. Willemen, *Encyclopaedia of Indian Cinema,* New Delhi: Oxford University Press. 1995: 186.
6. Celebrations of the number of weeks a film has run. Hence, a silver jubilee means the film has had a twenty-five-week run.

–3.6–

The Films of Fritz Lang
Tom Gunning

Although Fritz Lang never fully abandons the allegorical mode, his contemporary films evolve in a different genre, the detective/adventure film. Like science fiction, the detective genre provides fertile ground for allegorical devices, as G. K. Chesterton and others demonstrated, but it also supplies allegory with an alibi, as it absorbs transcendent mystery into a more tangible form of the mysterious. As Kracauer says, 'the composition of the detective novel transforms an ungraspable life into the translatable analogue of actual reality'.[1] When Lang entered the film industry, according to his own accounts writing scenarios while convalescing from war wounds sustained during World War I, it was the genre of detective and adventure film which originally attracted him. From the beginning of the 1910s or a bit earlier the emerging narrative cinema had embraced the detective and crime film as a genre that provided ready-made plot formulas familiar to a mass audience and also challenged filmmakers to develop visual means for telling economic and fast moving stories with a certain degree of complexity. The French first developed detective series with Nick Carter (at Eclair) Nick Winter (Pathé) and Nat Pinkerton (Eclipse), soon followed by films of master criminals, *Zigomar, Fantomas, Les Vampires.* The Nordisk company in Denmark, a major source for films in Germany before World War I, supplied early Sherlock Holmes films as well as the exploits of the oriental criminal Dr. Gar el Hamma. Shortly before the war, Germany began the extremely intriguing series of girl detective films, Miss Nobody, as well as a number of crime features by directors Franz Hofer and Max Mack. During the war the enormously successful Stuart Webb series was initiated by director Joe May and star Ernst Reichert. According to some sources, one of Lang's first scenarios, *Der Peitsche,* was sold to the Stuart Webb Detective Company. More certainly, Lang sold one to the detective rival to Webb that Joe May created after breaking with Reichert, Joe Deebs, for a film May directed as *Die Hochzeit in Exzentrikklub* in 1917.

Critics have often spoken of the debt Lang's films owe to the serial form, an insight of great importance in spite of an error in terminology. This detective tradition does not derive primarily from the film serial, the ongoing narrative form released in weekly instalments, of which the most and influential were undoubtedly the films Pathé released starring Pearl White, *The Perils of Pauline* and *The Exploits of Elaine.* Of more direct influence on Lang were the series films such as the detective and

criminal films mentioned above which consisted of self-contained films all featuring the same character (and sometimes actor). These films were often feature-length and more were not portioned out in weekly segments. However, the narrative form of the series and the serials, as well as other self-contained adventure films were similar. They consisted of a concatenation of exploits by heroes or villains, whose narrative momentum seemed unstoppable. Based on conflicts between sharply opposed characters or groups of characters, and measured out in battles, defeats, successes, deceptions, captures, and escapes, their structure is additive rather than being based on the resolution of a central conflict. Encounters between detectives and criminals multiply as individual films or series continue, with new obstacles appearing on the horizons as soon as old ones are dispensed with.

This popular adventure detective form should be distinguished from the classical detective story as it developed (or atrophied) particularly in England as the rationalist puzzle based on intricate clues, the pastime of academics and politicians. The series-based detective stories were a more popular form based on a succession of exciting sequences (derived largely from their origin as *feuilletons,* serial fiction) rather than a tightly plotted central mystery awaiting a clever resolution. The battle between detective and criminal in a potentially endless series of encounters, mysterious locations borrowed from the gothic novel and death-defying situations taken from adventure novels made up the loose and baggy form of these works, quite in contrast to the precision of an Agatha Christie mystery or even the economy of a hard-boiled Dashiell Hammett novel. The early detective films owed a great deal to the cinema of attractions, the form of early cinema made-up of spectacular visual moments strung loosely together, and even *Dr. Mabuse, the Gamble* still shows this rather loose form of a series of sensational adventures and episodes held together by a central conflict.

The term generally used for this form in Germany was 'sensation film' (like the sensation dramas and novels of the late nineteenth century from which they spring), accenting their structure around a series of sensational scenes rather than character-based drama. 'Sensation' referred to the direct visceral effect the scenes were designed to have on their viewers, with moments of heightened danger, suspense and terror, as well as a spectacular visual presentation. This modern genre conceived of its viewer or reader in a materialist manner: as a bundle of sensations to be played upon, and the successful artist knew how to evoke responses from carefully arranged stimuli. Rather than the traditional viewer coming from novels and theatre who was addressed through character psychology and dramatic conflicts, the viewer of the sensation-drama and film was pummeled and shocked, directly shaken by the events portrayed. This distinctly modern dramaturgy of shock, aimed at physical excitement rather than mental engagement, was the bane of the Film Reform movement in Germany from the early 1910s on. Based on a mechanistic theory of spectator and mass psychology that cloaked an alarm about both the conditions of modernity and the rise of mass culture, the Film Reform movement attacked film generally and

the sensational film in particular as deleterious to the audiences' moral, mental and physical health.[2] Like the other daily 'shocks' of modern life, the cinema seemed to undermine a sense of moral and mental equilibrium and a calm rational sense of the self. As late as 1924 Lang wrote an essay to defend the sensation-film, claiming its violence and gruesome situations were no worse than the incidents found in the popular *Märchen* and epics of traditional literature.[3]

In this article Lang defends the sensation-film and sees two vital centers of film making in 20s Germany: the art cinema typified by *The Cabinet of Dr. Caligari* and the sensation-film designed for the masses. Lang is consistent throughout his career in proclaiming his view that film is a democratic art form and that art films must be accessible to large audiences. His own filmmaking, he proclaimed, attempted to create works of art that could also be successful with general audiences. Linking the sensation-film with traditional popular forms was one method of creating this artistic/popular synthesis, directly applied in *Der müde Tod* and *Die Nibelungen*. In the sensation-film Lang believed he had found a form that could be simultaneously traditional and modern, popular and artful.

Lang's earliest surviving film *Spiders* displays his inheritance from the sensation-film. The first film of this two-film series, *The Golden Sea,* employs motifs from the *feuilleton* literature which had been accumulating stock characters and situations for nearly a century. The message found in a bottle, the remnants of an ancient civilization, quests for hidden gold mines, secret criminal organizations complete with hidden headquarters and occult emblems and codes, balloon ascents and parachute jumps, battles with giant snakes, rescues from human sacrifices, desperate encounters in subterranean caverns, an athletic upper-class hero adventurer (Kay Hoog) and an exotic female villainess (Lio Sha)—all of these are the rich, if well-worn, devices of the boyhood reading of Lang's generation: Alexandre Dumas, Wilkie Collins, Jules Verne, Karly May, H. Rider Haggard. *The Golden Sea* adds little that is new to this tradition, other than the impressive sets by Hermann Warm and Erich Kettelhut of the supposedly 'Incan' (stylistically Mayan) temples.

Few critics, however, have seemed to notice the emergence of Lang as a truly innovative sensation-filmmaker with the second *Spiders* film, *The Diamond Ship.* In between he had filmed the quite powerful *Harakiri* which turns its Madame Butterfly plot of a Japanese woman seduced and abandoned by a European officer into a drama of paternal interdiction and shame (the father performs the first hara-kiri, the daughter the last at the film's end) and religious fatality, exemplified by the figure of the *bonze* who pursues the heroine throughout the film trying to force her to return to her role as priestess (like the priest in Murnau's *Tabu*). But it is precisely from the exoticism of both *The Golden Sea* and *Harakiri* that *The Diamond Ship* departs in order to create the first of Lang's truly modern thrillers. In his 1924 article discussing the sensation-film, Lang admitted the debt his film, *Dr. Mabuse, The Gambler* owed to the sensational tradition, but had also claimed his film's appeal was due to its portrayal of its time (the subtitle for the Mabuse film is 'ein Bild der Zeit'—'an

image of the times'). Mabuse showed the 'man of today', Lang claimed, 'not simply some man from 1924, but *the man* of 1924'.[4] This, Lang declared, was the ultimate vocation of the cinema, to provide a record of contemporary times.

The contemporary sensation-film, the urban thriller, deriving from the tradition of detective and master criminal stories, novels, plays and films, provided Lang with his ultimate allegory of modernity. While the cinema may well have an affinity with the tradition of magic and myth, it has also—from its origins—claimed the privilege of mirroring its own times. Lang's belief that future generations would be able to understand this century simply by opening a film tin which contains a condensed version of that earlier period may be naively put,[5] but a close examination of his contemporary films shows his claim of representation went beyond a naive realism. As he stated in this article, the portrayal of contemporary reality would need a 'foundation of stylization, just as much as the past centuries have'.[6] The image of his times that Lang constructs through the detective and sensation genre quickly becomes as complex as his allegorical representation of the past and the future.

The Diamond Ship profits greatly from the collaboration of Karl Freund, master of German camera stylistics and later cameraman on *Metropolis* (as well as Murnau's *The Last Laugh*). The opening sequence flaunts both Freund's originality and Lang's substitution of the modern for the exotic. The first action of the film takes place in a large American city of skyscrapers, as the spider gang pull off a jewel heist from a bank vault. Lang and Freund shot this heist as a high angle long shot, the overhead view transforming the bank's cubicles and corridors into a checkerboard maze of gridded space as doorways open and close and the gang (attired in top hats and domino masks) play hide-and-seek with the night watchman. Lang intercuts the robbery with a cop on the beat outside, law and order unaware of what takes place behind the building's' façade. Lang/Freund may have taken their visual approach from Maurice Tourneur's masterful gangster film of 1915, *Alias Jimmy Valentine,* which portrays the safecracking of a bank vault in a similar manner, a high angle looking down into a labyrinth of cubicles and hallways as the burglars make their way to the safe and then try to avoid the night watchman. Tourneur's sequence works better as drama. His slightly higher angle looks more clearly into the cubicles and makes the burglars' pathways and dodging of the watchman easier to follow and more suspenseful. Lang's shot is not quite high enough and the geometry of the partitions dominates over the human actions. But while this may be awkward dramatically, this shot presents the first instance of a major Langian stylistic device, the topographical view which renders a locale as a geometrical field within which human actions and pathways seem to trace out pre-existent pathways. Production stills at the Cinématheque Française reveal that Lang apparently shot—but did not use—a similar overhead view of the ransacking of the warehouse office building in *M,* in the search for the child murderer, a sequence which would have therefore directly recalled this one.[7]

The Diamond Ship finds Lang ready to mine the existing visual and narrative vocabulary of the detective-crime-sensation-film, and to use it to explore a contemporary

environment. The sequence that immediately follows the diamond heist takes place in a hotel lobby, a recurring locale in the film, and for Siegfried Kracauer one of the essential emblems of the detective genre. For Kracauer, the hotel lobby exemplified the empty, purposeless and anonymous space of the modern world based on the *Ratio,* the calculating intellect and the reified relations between alienated individuals under capitalism:

> Remnants of individuals slip into the Nirvana of relaxation, faces disappear behind news-papers and the artificial continuous light illuminates nothing but mannequins. It is the coming and going of unfamiliar people who have become empty forms because they have lost their password, and who now file by as ungraspable ghosts.[8]

In the hotel lobby in *Spiders* anonymous guests pass without interacting, negotiating a complex flow of crisscrossing trajectories. Two men pass in top hats, but one hesitates to identify them with the masked bandits. Lang cuts to a medium shot of an elegantly dressed woman sitting with her newspaper in the background. Lio Sha simultaneously announces and conceals her presence: the emblem of the Spider gang sits pinned to her gown like a delicate ornament rather than a sinister sign. But the muted reaction of the men in top hats, picked out by Lang's cut to them in medium shot, leaves no doubt that we are now dealing with an action with two levels: the appearance of everyday and purposeless action of the lobby cloaking criminal activity. The men sit casually next to Lio Sha and pick up newspapers. In close-up we see their hands creep beneath the newspaper, touch Lio Sha surreptitiously and hand over the stolen diamonds. The modern world (and Kracauer's study of the detective genre shows that the literary genre had fully absorbed this lesson) provides a variety of concealing surfaces, such as the codes of anonymous behaviour in the hotel lobby that provide the perfect camouflage for devious purposes.

The detective genre relies heavily on disguise and deceptive appearance; early detective films adopted these highly visual devices more than ratiocination or the scrutiny of clues. (As Carlo Ginsburg demonstrates, the two are interrelated: 'Reality is opaque, but there are certain points—clues, symptoms—which allow us to decipher it.')[9] Mysterious appearances could also become spatialised. As a direct descendant of the gothic novel, the detective genre, especially the sensation-film, showed a fascination with subterranean spaces, secret passageways and hidden rooms—spaces concealed within spaces. Although the fascination with such hidden spaces comes from many sources, psychoanalytical and phenomenological as well as historical, Lang (and his predecessors, such as Victorin Jasset, director of *Zigomar* and Louis Feuillade, director of *Fantomas* and *Les Vampires*) explored strange interstices of spaces that were peculiarly modern, even if more unusual than the hotel lobby.

Rosalind Williams has explored the hold such underground spaces have on the modern imagination, supplementing an ancient fascination with caverns and underworld realms with the development of modern technology.[10] The mine supplied the

first images of a totally technological environment as Lewis Mumford pointed out.[11] The subterranean spaces such as the Incan gold mine in the climax of *The Golden Sea* and the pirate's cave in the penultimate adventure of *The Diamond Ship* are natural spaces that have been created or appropriated by man. As in *Metropolis,* the modern city was, as Williams puts it, an excavated city, digging into its depths to lay a technological infrastructure.[12] The tradition of the urban thriller endowed this modern environment with mysterious associations deriving partly from the legendary caves of treasure (such as Alberich's cavern in *Die Nibelungen*), but also with peculiarly urban topography and the expansion of human technology into the bowels of the earth.

The Spiders' subterranean headquarters beneath Lio Sha's house bristle with modern technology, constructed of riveted steel plates like a battleship with a mechanical sliding door. In *The Golden Sea* Lio Sha uses a closed circuit television to watch her underlings. Using a switchboard with multiple hook-ups, her Chinese minion arranges a meeting of unscrupulous diamond merchants to evaluate the gang's booty in *The Diamond Ship.* Likewise, the police raid which Kay Hoog arranges against the Spiders is described by an intertitle as a 'modern' raid. Unlike the club-swinging but ineffective cop patrolling outside the despoiled bank, plainclothes detectives loiter outside Lio Sha's house as anonymous passersby, communicating while seeming to share a light for a cigarette, or pick up a piece of litter. Kay Hoog dramatically descends to the house's roof from an aeroplane (a ploy included more for its technological edge than its surreptitious effect, one presumes). Lio Sha learns of the police invasion of her stronghold through an alarm bell and immediately pushes a concealed button which opens a secret elevator by which the diamond merchants can evade the police. Another turn of a switch, and the same elevator becomes a compressor in which Hoog and the police are nearly crushed. Released from this mechanical vice, Hoog pries open yet another secret passageway, only to glimpse the Spider gang and their accomplices speeding away in a waiting getaway car. As Lio Sha said, her organization functions like a machine, and control over the anonymous space and the subterranean passageways that modern technology opened up demonstrates how smoothly her machine fits into the mechanical routines and rationalised spaces of modernity.

The exotic continues to play a key role in *The Diamond Ship,* but becomes absorbed into the subterranean structures of the modern metropolis. Thus Kay Hoog discovers a key-shaped talisman covered with obscure figures on the body of a guard killed during the raid (another message from a dead man). Decoding it with the aid of an antiquary, Hoog discovers it is the pass-key to a secret subterranean city that exists beneath Chinatown. Entered through secret doorways and passageways, this subterranean space contains the repressed and dangerous elements of an exotic society; opium dens, caged tigers, criminal meetings, and oriental guards with weapons whose intricate blades resemble insignia. The idea of a secret city of vice which existed within the everyday city was a basic trope for the modern metropolitan experience, the 'city of dreadful delight' that Judith R. Walkowitz describes, the locale

of one genre of the sensation-novel, the 'Mysteries of the Great City' which sprang from Eugene Sue, with its 'literary construction of the metropolis as a dark, powerful, seductive labyrinth ...'[13] Thus the working-class areas of the metropolis, often populated by immigrants with foreign speech and habits, became figured as unexplored territories, filled with danger and excitement. Kay Hoog's descent into the hidden bowels of Chinatown (like Freder's descent to the depths of metropolis) literalises a powerful social fantasy of the era.

The Spiders' relation to the ancient and exotic is constantly mediated by modern technology and contemporary modes as if the primitive and the technological met in a form of modern magic. A Yogi's visionary trance which reveals the whereabouts of the Buddha-head diamond the Spider gang seeks is brought on by a gang member using modern hypnosis (which he later uses to control Ellen Terry, the kidnapped daughter of a London diamond merchant). The Spiders' ship sailing around the world in search of the legendary magical diamond stays in touch with its network of spies through a wireless, and abruptly changes course based on new information received over the airwaves.

Although the search moves from India to the Falkland Islands, it returns to London for the climax which takes place again in the anonymous space of a hotel. In the hotel, criminals and agents crisscross without acknowledging each other beneath the everyday surface of hotel business. At the lobby desk, among the traffic of other guests and bellboys the members of the Spider gang register under false identities (Dr. Telphas disguised as a bearded old man with Ellen in a hypnotic trance identified as his daughter), as do turbaned agents for the Asian Committee, also in pursuit of the diamond. Within their room the disguised members of the gang identify themselves through secret gestures, but cannot evade surveillance. Lang intercuts Kay Hoog and a Pinkerton detective spying on them through binoculars, while the Indian agents eavesdrop on their conversation from the next room. One member of the gang is captured in the lobby by hotel detectives whom a moment before had seemed to be guests idly reading newspapers.

As an unabashed sensation-film, *Spiders* introduces the repertoire of plot situations and images of intrigue and mystery from which Lang will continue to draw throughout his career. But even before his grand experiment to transform the sensation-film into an 'image of its times' in the first Dr. Mabuse film, Lang demonstrates that the tradition of the crime thriller supplies many links to the themes of modernity he will develop further. As G. K. Chesterton had claimed as early as 1901, the detective genre became the form 'in which is expressed some form of the poetry of modern life'.[14] In many ways the detective genre serves as a form in which modernity is both displayed and de-familiarised, modern urban spaces and technology providing a modern form of mystery that Lang (and his predecessors in the genre) freely combined with older motifs of the exotic and magical. With Mabuse, however, Lang brings a new degree of organization to this amalgam, moving away from the image of the Destiny-machine as mythical and magical.

Notes

1. Kracauer, 'The Hotel Lobby' in *The Mass Ornament; Weimar Essays,* trans. and ed. Thomas Y. Levin (Cambridge MA, Harvard University Press, 1995), p. 175.
2. Discussions in English of the Film Reform movement in Germany appear in Sabine Hake, *The Cinema's Third Machine: Writing on film in Germany 1907–1933* (Lincoln: University of Nebraska Press, 1993), pp. 27–41 and with great insight in Scott Curtis, 'The Taste of a nation: Training the Senses and Sensibility of Cinema audiences in Imperial Germany', *Film History,* vol. 6, no. 4, Winter 1994, pp. 445–69. The essential source in German is, of course, Anton Kaes (ed.), *Kino-Debatte texte zum Verhaltnis von Literatur und Film 1909–1929* (Tubingen: Max Niemeyer, 1978).
3. Fritz Lang, 'Kitsch, Sensation-Kultur und Film' in E. Beyfuss and A. Kossowksy (eds), *Das Kulturfilmbuch* (Berlin: Carl P. Chryselius Ed., 1924), reprinted and translated into French in *Positif,* no. 358, December 1990, pp. 151–3.
4. Ibid., p. 152.
5. Ibid., p. 151.
6. Ibid., p. 152
7. The still is reproduced in Helmut Farber, 'Trois Photos de Torunage de M', in Bernard Eisenschitz and Paolo Bertetto (eds), *Fritz Lang: La mise en scène* (Paris: Cinémathèque Française, n.d., [1993]), pp. 140–1.
8. Kracauer, p. 183.
9. Carlo Ginsburg, 'Clues: roots of an Evidential Paradigm', in *Clues, Myths and the Historical Method,* trans. John and Anne Tredeschi (Baltimore, MD: Johns Hopkins University Press, 1989), p. 123.
10. Rosalind Williams, *Notes on the Underground: An Essay on Technology, Society and the Imagination* (Cambridge, MA: MIT Press, 1990).
11. Lewis Mumford, *Technics and Civilization* (New York: Harcourt Brace Jovanovich, 1934), pp. 75–7.
12. Williams, p. 52.
13. Judith R. Walkowitz, *City of Dreadful Delight: Narratives of Sexual Danger in Late Victorian London* (Chicago, IL: University of Chicago Press, 1992), p. 17.
14. G. K. Chesterton, 'A Defense of Detective Stories', in *The Defendant* (London: R B Johnson, 1901), p. 158.

–3.7–

Viewer's View: Looking at Pictures
Gulam Mohammed Sheikh

Most optical paintings are windows into walls or magical mirrors. Ancient Romans in fact used to have false windows and doors painted—with views of the outside world—in their private villas (Janson 1977: 187) (if only to fool gullible "foreigners" with enchanted visions of paint!). The framed picture eventually perpetuated the legacy of the windowed vision. The Romans had also boasted of painted fruits that attracted bees to sit upon them: the Renaissance completed that myth. Every aspect of the world of appearances was arrested with utmost fidelity by means of the newly invented technique of oil. Illusionism became synonymous with realism.[1]

Illusionism changed the medieval European worldview as it intervened between the spirit of painting and the viewer. Now, the viewer was never left alone as he was in a non-illusionistic vision which allowed him to choose his own pictorial itinerary. The shadow of the artist hovered over every illusionistic picture like a ghost, asserting that the painting was his—and no one else's—a view taken from a particular point of time and space. In every viewing the viewer found himself in the company of the painter as he tried to adjust his eye with that of the painter.

Few paintings are more hauntingly illusionistic than Diego Velazquez' famous *Las Meninas*—the "Maids of Honour"—painted in AD 1656, four years before the artist's death. The large canvas (over ten ft in height) is exhibited in the Prado in a special room. A spot at some distance from the painting indicates the point from where the painter took the view. The picture ostensibly represents the princess Infanta Margarita with her retinue on a casual visit to the studio of the court artist. As we assume the position of the artist indicated by the spot on the floor, the stunningly illusionistic tableau becomes apparitional with every character in the picture related to us in space and scale. The next moment, our bewilderment at the illusionistic visage turns into an uneasy sensation as we spot the painter in the picture (behind a large canvas) looking straight into our eyes. Our discomfort at being forced into the position of the artist's models is relieved only when we discover a faint reflection of the royal couple in a mirror on the distant wall. Evidently, the painter is engaged in painting a large portrait of his exalted patrons. The king and queen are standing outside the picture (*Las Meninas*) we are looking at and exactly at the place we are. But that is a lie.[2] Viewing through the artist's eye we *know* that he is *in fact* painting *Las Meninas*—the casual visitors who have come to observe him paint the royal couple.

This is further complicated by the fact that with the Infanta and the Maids of Honour he is also painting himself and the rest of the scene as reflected in the eyes of the royal couple. Having usurped the place of the royal couple, the scene also belongs to our eyes. The painter implies that while painting his own self in the act of painting *Las Meninas* and the royal couple, he is simultaneously painting every viewer who faces it. It is, however, revealed in the end that his eye is neither directed toward the king and queen, nor the spectator, but towards himself. Appearing both inside and outside the picture—visibly or subliminally—the painter has compressed his two selves in a rare, molecular moment of time—a feat only the magic of illusionism is capable of performing, a sort of mirror facing mirror which dissolves everything except the artist's ego into insubstantiality. The realization becomes unnerving when we find ourselves trapped between mirrors that do not reflect us.[3]

With such a force of physical inducement in the picture, the space in *Las Meninas* is felt in measurable quantities of scale and weight despite the evanescent quality of paint (De Salas 1962:15). Everything is made to look tangibly voluminous including the blank areas suggesting room for concrete objects. As we stand in front of the canvas we feel blocks of space in the arrangement of figures. The blank floor at the bottom extends between our feet and that of the dog and the lower edges of the canvas, the dramatis personae glitter at a middle distance, the painter on the left steps back in dark space shared by two elderly attendants on the right. Finally, we are brought close to a man at the steps of a distant, but blazingly bright exit. As we move along the adjoining wall, the mirror with the reflection of the royal couple throws us back, right out of the picture to where we stand. By making the unnamable space between the painting and ourselves palpable, Velazquez takes us into his picture. Like the projection of depth beyond the pictorial space the painting is also invested with space extending over its flanks. The partially visible canvas on the left "completes" itself beyond the frame of the painting and a prancing "child" on the right brings in another "outside" on the picture plane. Despite these openings, however, the overall feeling of space remains that of a dark enclosure. Intersecting lines run across walls, floors, canvas-frame as well as necks, waists and bodies of figures manifesting a spatial structure of crosses, rectangles and cubes—ostensibly emphasized to ensure gravitational stability of figures upon the ground they are standing on. Further scrutiny leads to the picture being divided in two halves, separating the figures (with the painter's head jutting slightly above the horizontal axis) from the space above. The painter's brooding image then begins to make sense. The darkness of the studio assumes greater volume than the concrete objects it surrounds—especially against the brightly lit dramatis personae and airy exits. Apparently, the light is construed to be theatrical and the figural tableau is quite well-rehearsed. The studio in fact is a stage acted upon and observed simultaneously by the painter from inside as well as outside.

The painting in that sense does everything other than what it purports to represent. The subversive intention is evident. Using the means of Baroque drama and Mannerist "Concetto",[4] Velazquez has reversed their conventional meaning. He

has reduced royal personages to theatrical subterfuge to order to elevate his existential dilemma. The illusionistic device of mirrors[5] effectively renders substantiality ephemeral. The structural stability looks illusory under the ponderous gaze of the painter which fills the air with melancholy (De Salas 1962: 8). Transfixed in his place we view the world with him as he takes us into the pictorial space with his pervasive eyes.

Every painting draws us close to the artist's vision the moment we begin to probe his intentions. Often in the process we become party to the act of painting. The painter on his part invariably suggests points of contact with his viewer.

Being essentially an outdoor vision, most Indian and oriental painting in general is independent of the windowed view which, among other reasons, renders illusionism unsuitable for pictorial expression. The kind of naturalism the oriental artist evolved was born of a purpose free of illusionism. Having grown along calligraphic practice, the manuscript illustration prompted reading across rather than looking into the pictorial field. The murals similarly indicated a scanning (Lannoy 1975: 48) method corresponding to the successive opening of spatial units as the viewer walked. (The pleasure of Chinese scrolls lies in joining the trekking of mountain paths the tiny figures suggest.) In such practices, the prolonged sequence of time involved in appraising the pictorial space is antithetical to the notion of arresting a climactic moment illusionism so faithfully adheres to. It is important to note how the attitude of the Indian artist remained unchanged even after the introduction of illusionism at the Mughal court. The appeal of the new formal technique lay in effects of graded tones (rather than chiaroscuro), showing distance (rather than foreshortening), muted characterization (rather than dramatic denouements), in short, as an aid in making the pictorial imagery believable, rather than "scientifically" reproducing optical sights. The Mughal artist continued to use phased spacing of durational units with the result that the viewer read details as he scanned the pictorial field. The points of contact with the viewer still lay in the narrative structure—both thematic and visual—which he often indicated through a subliminal linkage of details.

The House of Shaikh Phul (AD 1605–15) painted by the Jehangiri artist Bishan Das, involves subtle structural manoeuvres the unsuspecting viewer might miss at first glance. He would, however, be immediately entranced by the amazing sense of empathy with which details are drawn and a close reading of the details would subsequently uncover the hidden structure. The stark figure of the dark, lean mendicant instantly attracts the viewer's attention as it is isolated, repeatedly smudged and redrawn for accurate delineation. Literally carved out of the ground he is in the process of digging, the image of Shaikh Phul emerges as a pulsating relief. The entire scene is, however, drawn in matter-of-fact, local colours with little use of metaphoric means. The accent on details is deceptively documentary; it conceals the breathing, delicate sensitivity. But no sooner one begins to respond, every part of the painting emerges as a felt and touched entity. The dents and marks of the paved platform and its peeled plaster, the colour and texture of built structures and street dust, the varied

tints of clothing recording periods of wear, the multilayer translucence of ochres and white (so subtly graded in the complexions of multi-racial characters; even in the teeth of a young noble man!). The amazing perceptivity revealed through details invites us to unravel the content of the picture image by image.

The principal figure of Shaikh Phul, "a mad devotee who now lives in Agra" (as the inscription on the paving reads), is perhaps a Sufi. He appears to belong to the tradition of self-effacing saint-poets of medieval India who called for a unity of diverse faiths and initiated a quiet revolution from the lower rungs of the society. Many in fact belonged to the working class or identified their mission with manual work.

The picture shows that the mendicant saint has just moved away from the centrally located doors of his modest shelter, the dome of which displays the dark ravages of time. A minor panorama unfolds as we move along the images of people gathered around him. While a rotund young disciple leans forward behind the saint to offer a bowl presumably filled by a hawker (?), on the other side of the platform, a man (a royal emissary?) respectfully bows behind the boy to deliver some message to which the "mad devotee" is totally oblivious. Further right in the street, a group of people including "a man of the book" is led by a young noble or a prince pointing at the wayward life of the saint. A pedlar with pots and scales turns around from the extreme right corner as a Muslim soldier in uniform passes by and salutes. To his left, a *bhishti* enters from the middle of the lower edge, exclamating. Above, to the left of him, a sweeper dutifully cleans the street before the saint's abode. Diagonally positioned against the leaning boy on the platform, the sweeper does not look up: his homage lies in the act of sweeping. Further left, a Hindu martial character (with a *chandan* mark on his forehead) haughtily looks up with a sword on his shoulder. A woman in white steals a glance before leaving the scene from the extreme left corner. Above her figure, a hefty man raises his hand over his head in respect and further above, two men enter talking—one with a pot or offering (?)—moving towards the saint. Behind them, a well-dressed boy hails the "mad devotee" from a lane and three whispering women shyly and incredulously observe the "naked" faqir. Moving upwards from the narrow lane rubbed by a broken, brick wall, we find two ubiquitous crows atop roofs of houses set against soft, yellow-blue splashes of an early morning sky. Further above on the right, the thick foliage of *neem* crowns the dome while another hangs over a shack with a waiting attendant near the kitchen.

As we follow the directions indicated by the figures and enjoined by aspects of the environment, a microscopic spectrum of the street gathered around the uncaring saint emerges in a circular configuration, virtually circumambulating him. The painter also pays his tribute by taking us round the image of Shaikh Phul. The painting emphasizes the gazes of people and the animated environment—both converging on the focal centre. The lack of reciprocation from the centre diverts them back to their places. The tension between the movements of closing in upon the image of the saint and an outward ejection constitutes the structure of this remarkable painting.

Naturalistic technique is used here to enhance plastic configuration: to string motifs of movement in a visual continuity. The gestures and stances of figures (as also the swaying foliage) are carefully coordinated to circulate within the central orbit, simultaneously opening and closing. The arrested moment from the daily routine of a saint is loosened by a series of connecting motions observed in time. We watch him communally or individually through the multiple eyes of the onlookers in a prolonged sequence as we follow the subliminal pictorial route. The painter thus invites the viewer to join the scene from a number of points of entrance (or exit) in an open street.

It is no coincidence that Binode Eehari Mukherjee's mural at Santiniketan (painted in 1947–48) represents accretions of the continuing tradition of medieval saints. For Bishan Das, Shaikh Phul was a contemporary whom he painted from life. For Binodebabu, however, Ramanuja, Kabir, Tulsidas, Suradas, and Guru Govind Singh were not living personalities of contemporary times, but still a vital force in literary lore and life. He looked for their likenesses and legends among the masses and found his Kabir in a common weaver.

The large mural (77 ft × 8 ft) was executed on the walls of Hindi Bhavana, then headed by Hazari Prasad Dwivedi—himself an authority medieval Hindi poetry. The verses of Kabir, Tulsidas and Suradas inscribed on the south wall are indicative of the rapport between the artist and the scholar. The artist who had suffered from poor eyesight from an early age (he totally lost his eyesight in 1956) did not make any facsimile drawings—except a few small ones of individual figures and groups—and worked directly on the wall (Mukherjee 1972: 7). Presumably planned units covering a span of manual reach, the mural evolved a continuity with the physical pace and rhythm of work (Mukherjee 1972: 7). The viewer senses intervals and links in the process of artistic execution as he walks the length of the mural. The units of space conceived as continually growing forms suggest several trajectories. The itinerant eye is led to traverse in multiple directions with the result that it returns to the point of takeoff with a series of focal surprises. The engaged vision gets a concerted view of life.

The variety of scale and dimensions of figures works as an essential ingredient for the optical flexibility required for scanning the wall while moving. One remembers the discomfort illusionistic murals with a single point of view cause, not allowing the moving eye to adjust. Here, depth and scale, though indicated, are balanced out by means of telescoping the far and the near into each other in order to retain the imagery on the frontal plane. The technique of repeated layers of contours enhances the density of figures and projects them forth (Lannoy 1975: 46). Perhaps the artist who had difficulty seeing beyond a certain distance, was able to feel the space that came within his optical range more concretely and articulated it in the form of a palpable entity. Thus the imagery is brought close to the viewer's sense of touch: he can grasp it without straining.

With the imagery advancing from three walls—as the viewer faces central panel—the effect is akin to being in the middle of a crowded street. Notwithstanding

the height of the mural painted eight feet above the ground, the vibrant imagery hoists him up amidst the panorama. One recalls the experience of walking through a maze of streets, opening and closing in its lanes and bylanes, with houses laid out in a bewildering array of open doors, windows, balconies and niches—each quivering with animated inhabitants. I have often wondered how so many individuals could fit into those staggeringly small interiors. We seem to have an amazing capacity to makeshift and adjust under acute spatial constraints. One feels that it could be possible only if the space becomes elastic enough to expand as humans push in for accommodation. The logic of elastic space, closely following the life-pattern, seems to inform the structure of the mural as figures diminish in scale to fit into narrow enclosures or grow in size as they come out in open.[6] It provides the mural with a kind of heaving wall-space that ebbs and swells as the figures change dimensions.

The architectural components serving as "conjunctions" to divide and link the narrative[7] are reduced to a relative significance in the process. The figural imagery overflows and dominates the entire environment and simultaneously provides another, if not too obvious, a structural cue. The human movements exude a rhythm of work and relaxation which is in fact derived from occupational habits. And the individual rhythm subliminally reflects in the composition of the crowds. The physical actions and gestures, culled from an observation of life are behavioural, not mimetic. Is it possible to define the nature of these movements? Perhaps one could recall the crowds of Ajanta and Akbar Nama where a delicate equilibrium of animation and restraint is achieved in the form of a collective body rhythm. Binodebabu's perspicacity touches that insight.

The theme of *Medieval Saints* has epic dimensions. Freely woven around the lives of five men, it runs into a number of subplots strewn in an organic pattern. Despite the intimate proximity with which the figures are modeled, brimming sentiment or sensuousness and dramatic climaxes are transmuted into a measured continuity of understatements. The narrative unfolds as a wide panorama projecting the mundane and the profound moments of life with equal love and objectivity. A number of touching vignettes of humour, however, relieve the grave tenor of the narrative.

Perhaps a brief itinerary of the mural would reveal the points under discussion. It opens with sadhus and pilgrims in the mountain retreat and gradually spills into a spectrum of the street punctuated by heightened images of saints and a militant Sikh Guru—all finally absorbed in the spinning rhythm of village life (Subramanyan 1978: 75). In the first panel, the assembly of bearded, bundled sadhus pop up from rocks like sculptured steles as others preach, ponder, gesticulate. One is found napping on the slopes. As we enter the town a *panihari* turns away, an oversized child dangles at a mother's breast, a sadhu stands for alms and tiny heads of women float in far space peering down at the assembly of disciples around the tall, grave figure of Ramanuja in discourse. The disciples, including Ramananda,[8] are immersed in deep rapture. Further along we recognize a mendicant with a *kamandala* we had seen before in a wide street populated with a number of figures; a *bhishti,* a group of

dyers; a couple of wandering *pinjaras* (cotton carders), a group of holy men including an orthodox religious head being carried in a *palakhi*. Somewhere in the middle a man is washing his foot (for ablution?) and above, a half-clad dyer is wringing out clothes, the movements of both radiating the rhythm of work and ritual. The solemn figure of Kabir with folded legs emerges as a realization of stored up strength. He incarnates the world of work he belonged to and celebrated in his verse. The panel ends with a musician and audience on the right including a mother and boy intently watching the saint.

The second panel has dramatic overtones. A towering image of Tulsidas faces his guru (?) whose expression of mocking incredulousness with an exclamating mudra and a serpentine staff, alludes to a climactic episode in the saint's life. While the right illustrates other events in the life of Goswami, on the left busy Banaras ghats are rendered with great delight. As shopkeepers, sadhus and men crouch in or emerge from interiors (including an animated barber at his job!), women bathe in the river or comb their hair on the shore. The effortless ease of the brisk curves with which the rippling women are rendered matches their carefree grace.

In the third panel the figures move towards the blind bard Suradas. Led by a young companion he monumentally blends in the environment. The movement of the musicians in the street along with a man who has suddenly burst into song is completed by a couple of travelers who turn back to look. An entranced mother folds her son in an embrace behind the saint; her expression of awe, wonder and reverence draws us close to the saint's melodious message. The tempo accelerates into a martial rhythm as we approach the last of the principal protagonists, Guru Govind Singh, on horseback with his equestrian and foot-soldiers. The elegant curve of Govind Singh's steed (emulated from a Chinese jade sculpture) and two crouching beggars facing the Guru provide food for thought. Behind them women grinding flour or churning milk, men relaxing or working in and around huts and a cluster of trees, absorb the arrival of soldiers and sadhus in an open rural environment. The scenario concludes with the recurring image of mother with child—now with a newborn baby at her breast.

It is evident that the continuity of the epic moral is maintained by gestures and movements of figures. In other words, the "story" emerges front corporeal rhythms. It is necessary to reiterate this fact as it defines a significant feature of the Indian tradition. The figures speak as much (or more) with their bodies as with their heads. Significance of the head as the crown of the human anatomy to be isolated from the torso did not appeal to the indigenous sensibility as it viewed the body as an indivisible whole. The Western tradition, however, used the head as an independent unit to convey all aspects of physical and psychological conditions in the genre of portraiture. The ancient Indian artist had, on the contrary, sought to transmute all forms of stress by infusing in the image a state of abiding grace, the practice ruled out facial and bodily contortions and excluded ugliness and violence from its repertory, to enforce an assertive vision of the fullness and regeneration of life. (Even the demons are somewhat redeemed or rendered grotesque rather than diabolic creatures.) With

the absence of the requisites/requisities of portraiture, the figures did not assume roles of "characters" or "personalities", but remained self-contained presences. It hardly needs repetition that barring isolated examples of individual characterization, portraiture did not find roots in India until the Mughal times.

Binodebabu's vision endorses this essential goodness of life although he uses dramatic effects when necessary and strips from his saints overt spiritual connotations. His characterization is, however, less dramatic than suggestive more in the Far Eastern than European tradition. Emulating the archetypal Indian tradition, the bodily eloquent figures pronounce and celebrate their physical being; speech by implication is underplayed. Communicating without words—through collective action—forms the basis of a bond that often holds groups and crowds in India together. Such a relationship between people negates alienation. Is it incidental that there is not a single outsider either in the *House of Shaikh Phul* or the *Medieval Saints?* No one is looking at the viewer. The figures are not performing for him and hence are totally unselfconscious of his presence. He is not seen as a witness but a participant through an act of empathy. In *Las Meninas* the viewer is made to identify his destiny with the painter's in a confessional cube: his gaze is arrested and stilled until he grasps the truth of the moment. Of course, the very use of mirrors can allow an illusionist painter to trespass beyond simple reflection and construe structures for multiple entry. The Mughal miniature liberates the viewer from his seat to wander off with the images; the mural makes him physically move in confluence with the emanation of pictorial space. This dual mobility forms spatial structure in oriental painting.

Notes

1. "What distinguishes oil painting from any other form of painting is its special ability to render the tangibility, the texture, the lustre solidity of what it depicts. It defines the real as that which you can put your hands on." Berger (1972).
2. The joint portrait of the royal couple purportedly painted by Velazquez is not known.
3. This was written before reading Michael Foucault's penetrating essay on *Las Meninas.* Subsequently I have come to know of some German publications on the subject. None of these, however, necessitate any change to my views.
4. "Concetto" allows the central theme to be relegated to a secondary plane and vice versa.
5. Jan Van Eyck had used a convex mirror to record his presence in *Marriage of Arnolfini* (AD 1434). In Velazquez' *The Toilet of the Venus* (about AD 1650) Cupid holds a mirror for the Venus who has her back turned at an angle that reflects her face for the viewer—and hence that of the viewer for her. In *Las Meninas* the mirror device is more complex. Although the scene appears to have been painted as reflected in a mirror, it is controverted by the presence of a mirror in the painting.

6. The method is constantly used in Ajanta, Hamza Nama, etc.
7. Similar to Mahajanaka Jataka at Ajanta (Cave 1) where a gate dividing scenes simultaneously serves as both enclosure for the palace and an exit for the king's departure.
8. The smaller figure to the right as we face the mural. Ramananda's face is drawn on the lines of Ramakriahna Paramahamsa indicating a similarity in their syncretisticism. (The information by K. G. Subramanyan who had assisted Binode Behari Mukherjee on the Hindi Bhavana mural is gratefully acknowledged.)

Bibliography

Berger, J. (1972), *Ways of Seeing,* London: Harmondsworth.

De Salas, X. (1962), Velazquez, Barcelona: Noguer, D. L.

Janson, H. W. and Janson, D. J. (1977), *A History of Art,* 2d ed, New York: H. N. Abrams.

Lannoy, R. (1975), *The Speaking Tree,* London: Oxford University Press.

Mukherjee, B. B. (1972), "My Experiments with Murals," Lalit Kala Contemporary, no 14.

Subramanyan, K. G. (1978), *Moving Focus,* New Delhi: Lalit Kala Akademi.

–3.8–

An Andean Cosmology
Constance Classen

Cosmogonies, or creation myths, can vary significantly in the imagery they use to evoke the creative process. In one, the world may be moulded into existence, in another, spoken into existence, in another it may arise from pure thought, and so on. The method(s) of creation manifested by the cosmogony of a particular culture is therefore often revealing not only of that culture's symbolic order, but also of its sensory order, the relative importance it assigns to the various senses.

The Andean cosmogony presented here was first recorded at the time of the Spanish Conquest in the sixteenth century. It was popular throughout the Central Andes and appropriated by the Incas who established an empire in the region. It still survives in various forms, interpenetrated with Christianity, in the Andes today. In this cosmogony, sound is the medium of creation: the world is called into being and animated by the voice of Viracocha, the creator:

> Viracocha ... sculpted and drew on some large stones all the nations he thought to create. This done, he ordered his two servants to commit to memory the name he told them of the peoples he had painted and of the valleys and provinces and places from where they would emerge, which were those of all the earth. He ordered each of them to take a different route and call the aforementioned peoples and order them to come out, procreate and swell the earth.
>
> The servants, obeying Viracocha's command, set themselves to the task. One went along the sierra of the coast by the Southern sea, and the other along the sierra of the ... Andes, to the east of that sea. Along these sierras they walked, calling out: "O peoples and nations! Hear and obey the commandment of [Viracocha] who orders you to come out, multiply and swell the earth." And Viracocha himself did the same along the lands in between those of his two servants ... On hearing their calls, every place obeyed, and some people came out of lakes, others out of springs, valleys, caves, trees, caverns, rocks and mountains, and swelled the earth and multiplied into the nations which are in Peru today. (Sarmiento de Gamboa 1965:207–10)

Touch, sight, and hearing are intimately related in this cosmogony. The human prototypes are sculpted, painted, then named; in other words, given a tactile, visual, and aural identity. Of these three senses, hearing plays the dominant role. Human

beings are called into life and purpose by the divine word. As an Inca prayer puts it: "O Viracocha who … said let this be a man and let this be a woman, and by so saying, made, formed and gave them being" (Molina of Cuzco 1943: 20).

Viracocha, above all, is the one who speaks. He knows all languages better than the natives do (Pachacuti Yamqui 1950: 215). He names all the plants and animals (Molina of Cuzco 1943: 14). With his word alone he is able to make the corn grow (Cobo 1964: 150). The first order given to humans is to "hear and obey" the command of Viracocha. The transgressions listed further on in the cosmogony result from a refusal to hear and obey the creator.

The profound religious significance of the sense of hearing is brought out by an Inca myth in which the Inca, who is suffering from an earache caused by the piercing of his ears, prays for a river for the Inca capital, Cuzco. As he is praying he hears a clap of thunder and falls down with fright, putting his ear to the ground. Suddenly he hears the sound of running water under the earth. The Inca orders the spot dug up until a spring is found and then builds a canal to carry the water to Cuzco (Cieza de León 1985: 118–9).

The Inca's earache can be understood as caused by a lack of sacred aural communication—symbolic fluidity. This metaphorical "drought" is relieved by the thunderclap which comes in response to the Inca's prayer. With his newly pierced ears the Inca hears both the sacred thunderclap, signalling the presence of water, and the water itself running underground. The result is that Cuzco is provided with an irrigation canal and the Inca establishes a channel of oral communication between himself and the deities. Sound, like water, vivifies the cosmos.

Many Andeans today look back nostalgically on the Inca period as a golden aural/oral age when the world was animated by sound. An Andean from the town of Pinchimuro, Peru, comments: "The people of old used to help Ausangate [a mountain deity] quite a bit. They respected him very much. In those days they didn't go to mass and they weren't baptized. They simply spoke with Ausangate" (Condori and Gow 1982: 56). Andean myths on the whole are dominated by orality. Not only does speech animate the cosmos, mythological characters reveal themselves through dialogue: the Earth tells people how they should act towards her, animals have conversations with humans, the Sun speaks when it rises, and so on (Condori and Gow 1982).

The emphasis on orality manifested by Andean mythology pervades Andean religion. The primary characteristic of the Andean diviner is his ability to make anything talk, that is, to establish communication with anything in this world, the upper world, or the under world. The diviner then reports the information gained in this way to the people. The Inca high priest, in fact, was called *Villac Umu,* "the one who tells."

Andean holy objects, *huacas,* from rocks to mummies to mountains, are oracles which above all speak to their worshippers. At the time of the Conquest an Inca leader urged his people to forsake the false religion of the Spanish, declaring that "[the Christian God] is a painted cloth … the *huacas* speak to us" (Titu Cusi Yupanqui

1985: 2). In this proclamation we find a rejection not only of the religion of the Spanish, but also of their visual, surfaced-oriented culture.

Modern Andeans continue to resist the extreme visualism of the West. A good example of this is provided by the Andean writer José María Arguedas in his novel *Yawar Fiesta*. When the Peruvian government decrees that professional bullfighters must be hired for the traditional local bullfights, the Andeans protest, "And what's the bullfight going to be like? Aren't the Indians going to do anything but watch it? ... Is the bullfight just going to be held in silence?" (Arguedas 1985: 45).

In his article "The Coherence of Social Style and Musical Creation among the Aymara in Southern Peru," Thomas Turino describes how the Andean social ideal of group solidarity is expressed musically through integrated ensemble performance, so that "the sonic result of musical performance becomes an iconic reproduction of the unified nature of the community" (Turino 1989: 29). Andean life, in fact, has been described as a musical composition. Thérèse Bouysse Cassagne writes of the Aymara of the Andes: "The sung word marked and continues to mark the high point of Aymara social life. They sang to glorify the victor or bury the dead. Hunters enhanced their hunts with their songs ... Each activity and each sex expressed itself according to a specific rhythm, and music had distinct movements according to the rhythm of the seasons, so that each song had a particular meaning and place within the ritual cycle" (Bouysee Cassagne 1987: 171).

Into this musical composition, Western culture with its industrial din introduces discordant notes. Some Andeans consider the sounds produced by industry to mimic those produced by a mythical monster, the Pishtaco, when he crushes his human victims and sucks out their fat (Sullivan 1986: 15–16). The relentless whining of industrial machinery represents an endless process of death for the Andeans. The sounds of Andean culture sustain life, the sounds of Western culture destroy it.

The visual parallel of the destructive noise of industrialism for the Andeans is writing. The following account of the Andean experience of writing, given by a contemporary Peruvian Andean, expresses the violent impact of this medium on the oral culture of the Andes:

God had two sons: the Inca and Jesus Christ. The Inca said to us, "Speak" and we learned to speak. From that time on we teach our children to speak ... The Inca visited our Mother Earth. He conversed with her and took her gifts and asked her for favours for us. The Inca married Mother Earth. He had two children ...

When they were born it made Jesus Christ very angry and unhappy ... The moon took pity on him. "I can help you," she said, and sent him a paper with writing. Jesus thought: "This will certainly frighten the Inca." He showed him the paper in a dark field. The Inca was frightened because he didn't understand the writing ... He ran far away ... He slowly died of hunger.

When the Inca was no longer able to do anything, Jesus Christ struck Mother Earth and cut her neck. Then he had churches built on her. (Ortiz Rescaniere 1973: 239–243)

The conflict of European literacy and Andean orality is presented here as a conflict between cosmologies. Implied in this presentation is the association of orality and hearing with exchange, and writing and sight with unilateral domination. Thus, dialogue with the Earth is transformed into exploitation of the Earth after the introduction of writing. Life is brought to the Earth through sound and taken from her through sight.

While Andeans find extreme visualism of the West foreign to their way of life, sight nonetheless plays a fundamental role in their cosmology. In the cosmogony the original world is dark and chaotic. The creation of humans and a structured world takes place only after light (and thereby sight) has been created by Viracocha calling the luminaries out of a lake (Sarmiento de Gambóa 1965: 208).

Light and sight were particularly important to the Incas because the patron deity of their state was the Sun. One Inca myth relates, in fact, how the Incas controlled the orality of the *Huacas* through the power of their sight (Pachacuti Yamqui 1950: 230): "The Inca Capac Yupanqui wanted to see how the *huacas* spoke with their followers. The ministers of a *huaca* took him into a dark hut and called on their *huaca* to speak to them. The spirit of the *huaca* entered with the sound of the wind, leaving everyone afraid. The Inca then ordered that the door be opened so that he could see the *huaca.* When the door was opened the *huaca* hid his face. The Inca asked him why, if he was so powerful, was he afraid to raise his eyes? The figure, who was repulsive, then shouted like thunder and rushed out" (condensed from Pachacuti Yamqui 1950: 229–30). The *huaca,* who is evidently a thunder god, intimidated his ministers through sound, but the Inca is able to control him through sight. The Inca's purpose, however, was not to negate the power of sound and hearing, but to control it. Later on in the myth we learn that after Capac Yupanqui defeated the *huaca,* the Incas obliged all of the *huacas* of their empire to respond to their queries in the name of "the one with strong eyes" (Pachacuti Yamqui 1950: 229–30).

Many of the Inca *huacas* were situated along sight lines radiating out from the central Inca temple, which may have been one way in which the Incas controlled the *huacas* through sight. These sight lines, called *ceques,* also served to order Inca social structure, for different Inca kin groups were associated with different lines. Another way in which Inca society was structured through sight was through visually perceived distinctions, such as land boundaries, and regional differences in dress. Oral traditions were visually structured through the use of the *quipu,* a mnemonic device consisting of a main cord from which different colored threads with knots were hung. Finally, through observation of the stars, sight was used by the Incas to structure time. In its role in enabling the recognition and establishment of categories, so essential to Inca cosmology, and in its dominance over hearing, sight would seem to have been the most important sense for the Incas.

Modern Andeans do not claim the reputed power of the Incas to dominate the *huacas* through sight. In the present-day Andes, communication between *huacas* and their followers generally takes place in the dark, much as described in the Inca

account given above. Compare that account, for example, with the following account of a modern Andean curing ritual: "The brujo [sorcerer] darkens the room and calls on his tutelary Auki [mountain spirit]. The door is closed, the brujo whistles three times, and the Auki responds by entering through the roof ... Then, by the aid of ventriloquism, a conversation is held between the brujo and the Auki in which the Auki reveals the cause of the illness and advises a remedy. Moving his wings, the Auki leaves again by way of the roof" (Mishkin 1946: 469–70). No strong-eyed Inca appears here to stare down the voluble spirit. Modern Andeans, in fact, are afraid to see spirits, as they believe that to do so will hurt their eyes (Tschopik 1951: 191). Superior visual power would now seem to belong to the westernized literate elite in the Andes.

Nonetheless, although the Inca emphasis on visual dominance and on light is no longer evidenced in modern Andean culture (and the Sun is no longer the most prominent deity), sight continues to be used in similar ways—creating sight lines, establishing categories, structuring time, etc.—to those of Inca times.

Data exist which suggest that the Andeans of today continue to consider sight the highest sense. In a study of indigenous medicine in the Ecuadorian Andes, the eyes ranked above the ears (and below the stomach, brain, and heart) in the hierarchy of body parts presented by one informant (Balladelli 1988: 28). Billie Jean Isbell (1978: 139) reports that in the Peruvian Andean community she studied, the term for eye, *ñaui,* also means "first" and "best." Regina Harrison (1982: 85) in an examination of Andean epistemology suggests that sight is the sense most closely linked to knowledge among both the Inca and present-day Andeans.

The Andeans, however, are attentive to all the senses, not simply hearing and sight. In a dictionary published in Peru in 1613 we find terms in Quechua, the language of the Incas and many modern Andeans for "to see subtly," "to hear subtly," "to smell subtly," "to taste subtly," "to touch subtly," and "to understand subtly" (suggesting that reason was considered a sense). A *ccazcaruna,* in Quechua, was "one who used all his senses sharply and subtly" (González Holguín 1952: 63–4).

Inca ritual customarily engaged all of the senses, for example, through pageantry, song and dance, food and drink, and incense. Charlene and Ralph Bolton (1976) have examined how modern Andean rituals also make use of all the senses. They find that a ritual intended to please and attract employs agreeable sensory perceptions, sweet flavours, pleasant odours, etc., while one intended to harm and repel employs disagreeable perceptions, bitter flavours, foul odours, etc.

Given that the proximity senses of touch and, particularly, taste and smell are not well represented in Andean myth, why are they so well brought out in Andean ritual? This may be because in ritual it is considered necessary for all the senses to be engaged for the ceremony to be completely effective. The use of the proximity senses in ritual, however, usually serves to underscore the message conveyed through the dominant media of hearing and sight; for example, a prayer offered to a deity, may be accompanied by incense.

In the creation myth sensory perceptions are found to overlap in several ways. In one version of the myth, for example, Viracocha's oral teachings are said to be embodied in a staff which he hands down to his followers (Pachacuti Yamqui 1950: 211), a merging of hearing and touch. Such sensory overlap also occurs in ritual. In the Inca male puberty rite the elders whipped and lectured the initiates at the same time, possibly in the belief that their words would thereby physically penetrate the boys' bodies (Molina of Cuzco 1943: 51). Similarly, in another rite, after an oath of allegiance to the Inca was sworn, food symbolizing the oath would be eaten by the participants (Molina of Cuzco 1943: 37).

An interesting example of sensory overlap, or synaesthesia, in the modern Andes is that of the *kisa*. The Aymara-speaking residents of the Chilean Andes use this term, which means the concentrated sweetness of dried fruit and also pleasant speech and a soft tactile sensation, to refer to a rainbow effect in weaving. (This penetrating "sweetness" of the rainbow, along with the transgression of categorical boundaries it manifests in its gradations of color, may be why the Incas believed that looking at a rainbow caused one's teeth to decay [Garcilaso de la Vega 1945: 175].) The rainbow is such a powerful image that it automatically stimulates all the senses. An Andean healer can make use of the rainbow's power by creating a rainbow out of wool in order to diffuse a patient's illness through the gradual transformation of colours and sensory perceptions (Cereceda 1987: 200–4).

Synaesthesia in Andean ritual is perhaps best illustrated by an Inca harvest rite in which hearing was united with sight. In this rite the Incas would go before dawn to a plain outside Cuzco. As the sun began to rise they would start to sing in chorus. The higher the Sun rose, the louder they sang. When the Sun set they sang more and more softly, stopping when it disappeared from sight (Molina "el Almagrista" 1968: 82).

A similar interrelationship of the visual and the auditory is manifested in the version of the cosmogony recorded in the seventeenth century by Pachacuti Yamqui, a native Andean. After describing how Viracocha burnt a mountain he comments: "up to the present day there remain signs of that terrifying miracle, never before heard in the world" (Pachacuti Yamqui 1950: 212). Orality was ultimately so basic to Andean culture that even visual manifestations (such as the rising sun or a burnt mountain) had to be made oral.

References

Arguedas, J. (1985). *Yawar Fiesta,* trans. F. Horning Barraclough, Austin: University of Texas Press.

Balladelli, Pier Paolo (1988). *Entre lo mágico y lo natural, la medicina indígena.* Testimonios de Pesillo. Abya Yala.

Bolton, C. and Bolton R. (1976). "Rites of Retribution and Restoration in Canchis," *Journal of Latin American Lore,* 2(1): 97–114.

Bouysse Cassagne, T. (1987). *La Identidad Aymara,* La Paz: Hibol.

Cereceda, V. (1987). "Aproximaciones a una estética andina: de la belleza al *tinku*" in J. Medina (ed) *Tres reflexiones sobre el pensamiento andino,* La Paz: Hisbol.

Cieza de Léon, Pedro de (1985) [1583]. *El Señorio de los Incas.* Edited by M. Ballesteros. Madrid: Historia 16.

Cobo, Bernabé (1964) [1653]. 'Historia del Nuevo Mundó', in F. Mateos (ed) *Obras del P. Bernabé Cobo II,* Biblioteca de Autores Españoles. Vol. 92. Madrid: Esòciones Atlas, pp. 7–275.

Condori, B. and Gow, R. (1982). *Kay Pacha,* Cuzco, Perú: Centro de Estudios Rurales, "Bartolomé de Las Casas".

Garcilaso de la Vega (1945)[1609]. "El Inca", *Comentarios reales de los Incas, vol. 1.* Ed by A. Rosenblat, Buenos Aires: Emecé.

González Holguin, D. (1952)[1608]. *Vocabulario de la lengua general de todo el Perú llamada lengua quichua,* Lima: Universidad Nacional Mayor de San Marcos.

Harrison, R. (1982). "Modes of Discourse: The *Relación de Antigüedades deste Reyno del Pirú* by Joan de Santacruz Pachacuti Yamqui." In R. Adorno (ed) *From Oral to Written Expression: Native Andean Chronicles of the Early Colonial Period,* Syracuse, NY: Maxwell School of Citizenship and Public Affairs. pp. 65–99.

Isbell, Billie (1978). *To Defend Ourselves: Ecology and Ritual in an Andean Village,* Austin: University of Texas Press.

Mishkin, B. (1946). "The Contemporary Quechua" in J. H. Stewart (ed) *Handbook of South American Indians, II: The Andean Civilizations,* New York: Cooper Square. pp. 411–40.

Molina el Almagrista, C. (1968)[1552]. "Relación de muchas cosas acaecidas en el Perú" in F. Barba (ed) *Crónicas de interés indígena.* Biblioteca de Autores españoles, vol 209, Madrid: Ediciones Atlas. pp. 55–95.

Molina of Cuzco, C. (1943)[1575]. "Fábulas y ritos de los Incas", in *Las crónicas de los Molinas,* Lima: Los pequeños grandes libros de la historia Americana. pp. 7–84.

Ortiz Rescaniere, A. (1973). "El mito de la escuela" in J. M. Ossio A.(ed) *Ideología mesiánica del mundo andino,* Lima: Colección Biblioteca de Antropología. pp. 238–250.

Pachacuti Yamqui, J. (1950). "Relación de antigüedades deste Reyno del Piru in M. Jimenez de Espada (ed) in *Tres relaciones de antigüedades peruanas,* Asunción: Editorial Guaraní.

Sarmiento de Gamboa (1965)[1572]. "Historia Ondica" in C. Senz de Santa María (ed) *Obras completas del Inca Garcilaso de la Vega IV.* Biblioteca de Autores Españoles, Vol 135, Madrid: Ediciones Atlas. pp. 195–274.

Sullivan, L. (1986). "Sound and Senses: Towards a Hermeneutics of Performance." *History of Religions* 26 (1):1–33.

Tito Cusi Yupanqui, Diego de Castro (1985) [1570]. *Ynstrución del Ynga don Diego de Castro Titu Cusi Yupanqui.* Edited by L. Millones. Lima: Ediciones El Virrey.

Tschopik, H. Jr. (1951). "The Aymara of Chucuito Perú," in H. L. Shapiro and B. Weitzner (eds) *Anthropological Papers of the American Museum of Natural History* 44, New York: American Museum of Natural History. pp. 133–308.

Turino, T. (1989). "The Coherence of Social Style and Musical creation among the Aymara in Southern Peru." *Ethnomusicology* 33: 11–30.

Zuidema. R. T. (1964). *The Ceque Systen of Cuzco,* Leiden: E. J. Brill.

–3.9–

Witness of History: Student Photography
and *reformasi* Politics in Indonesia
Karen Strassler

When protests against General Suharto's New Order regime began on campuses throughout Indonesia in early 1998, a number of students reached for their cameras.[1] As one student put it, "I had this tool. How could I let history pass me by?" In photographing the student-led reform movement known as Reformasi, students actualized themselves as particular kinds of actors: "witnesses of history" (*saksi sejarah*). In addition to defining a form of historical agency, the trope of the "witness of history" articulates a popular theory of photographic efficacy. Reformasi images, as well as their makers, were called "witnesses of history." As "witnesses of history," both photographers and photographs lay claim to an authority that rests not only on the camera's transcriptive powers of mechanical mimesis, but also on the morally-charged, intensely personal act of seeing, or bearing witness. The photograph acts as an extension of the photographer's vision, an embodiment of his agency and quality of vision.

The idiom "witness of history" in Indonesian historical discourse evokes the ordinary person present on the scene of history-in-the-making. To be a witness is to be "aware" (*sadar*) of oneself as a certain kind of historical subject; it is to stand self-consciously at the juncture between individual and national history. Although it predated the Reformasi period, the term gained new currency in this moment, as official historical narratives of the New Order regime increasingly became subjects of public contestation. Participants in various historical events began coming forward to offer personal accounts that were often at odds with official versions. As "witnesses of history," they called upon their status as participants and the authority of eye witnessing to attest to the truth of their claims. The idea of the "witness of history" came to have an aura of opposition, conjuring truths carefully secreted away in personal memory, truths that only now could be released into public view to challenge New Order histories.

Extended to the photograph itself, the trope of the historical witness places emphasis on an aspect of photographic indexicality and a sense of embodied presence that is not typically fore-grounded in Western theories of photography. While the latter tend to stress the physical connection between a photograph and the scene

before the lens—between image and its pre-photographic referent—here, emphasis is placed on the physical connection the photograph appears to establish between an original act of witnessing an event and future acts of witnessing via the image. The photograph, in this understanding, preserves and embodies the *subjective* act and moral force of *seeing*. The photographic witness enables an act of seeing located in a particular time and place to be extended and collectivized: the camera "functions as a space-time machine capable of instantiating a potentially infinite chain of eye-witnesses" (McQuire 1998: 133).

Amateur Authenticity: Student Photographers as Ideal Witnesses

Student photographers were accorded particular authority as historical witnesses in the reformasi period. In large part, this authority stemmed from discourses that positioned students in general as ideal agents of Indonesian history. In leading the reform movement, students were fulfilling a role laid out for them in the official narrative of Indonesian nationalist history, which figures the *pemuda* (youth) as ideal-istic actors putting their lives at stake for the betterment of the nation. The narrative positions students as the vanguard of political transformation in Indonesia. But, as elaborated during the New Order, the narrative contains student activism even as it celebrates it. Having risen up in moral indignation, students are to disappear again from the political stage once a proper order has been restored. New Order efforts to depoliticize students following major student protests in the 1970s (known as the "normalization" of campus) cast students as the "moral" conscience of the nation untainted by the messy and corrupt world of "*politik.*" As Aspinall has argued, this effort effectively resulted in a "mainstream tradition of student dissent" emphasizing a "moral politics" (1995: 33) and a "pure" stance located "outside and independent of a tainted power structure" (40).

These ideas about students as morally pure agents ideally detached from estab-lished structures of power played out in specific ways to shape the authority of stu-dent photographers as "witnesses of history." Students worked independent of—and often explicitly in opposition to—the mainstream media. Suspicious of the heavily censored and self-censoring news media, many students were motivated to photo-graph by a fear that their history might be distorted or go unrecorded unless they provided their own "facts" and "visual files," as they put it. Especially important was their status as amateurs rather than professionals. Although some student photog-raphers collected clippings of journalistic photographs they admired, in our con-versations they also continually underlined the difference between themselves and professional photographers, who, they pointed out, were motivated by a paycheck rather than idealism. A faculty member at the Indonesian Art Institute in Yogyakarta articulated this vision of student photographers: "That is what I always admire about the students [who photograph]. No one pays them. They are pure."

More accustomed to the camera's use as an instrument of power than an empowering instrument, many students in the movement viewed photographers with suspicion. They were well aware of the New Order state's reliance on photojournalists and intelligence agents posed as photographers to gather information on student activists. A former photojournalist at a local newspaper confirmed that, during student protests in 1974 and 1978, he had regularly turned over photographs of activists to the police.

> We'd be asked to photograph, the police asked for documentation ... you know, who are the protesters in front? Who are the ones running [the protest]? ... [T]hey don't know that I am photographing for the police, helping the police, no. What they know is I'm a journalist ... I take the photos, "snap, snap, snap," you know, and then I would process them, and then I'd give them to the police ... and they'd pay for the cost you know, it was for documentation. "So this is the person, this is the person," then another time there'd be another demonstration, "Hey it's the same person," so they'd match it up.[2]

Intelligence agents posing as journalists were also present at *reformasi* demonstrations. In December 1998, for example, students apprehended an agent who was a bit too enthusiastically taking photographs of student activists.[3] Student photographers were not immune from suspicion. One student photographer recounted an incident when a group of students demanded to see his student card, and then suggested that it was false. As an angry crowd of students formed around him, he tried to calmly persuade them of his authenticity as a student, but they remained unconvinced. Fortunately, a student leader who knew him arrived on the scene and told everyone he was trustworthy: "If he hadn't come, I would have been finished that time."

The hardships student photographers faced as they pursued their self-appointed role as documentarians of the movement enhanced their authenticity as witnesses. Their equipment was unsophisticated and often second-hand: their cameras lacked auto-focus, telephoto lenses, and other staple features of contemporary photojournalistic gear. Students had to run into the fray, carefully aim and focus their lenses (sometimes in the midst of tear gas), and get out again without being hit by a student's rock or a policeman's baton. Funding was even more of a challenge. Although photography had become widely practiced on campus as a hobby and a leisure activity by the mid-1990s, the student movement took place at a moment of severe economic crisis. When a single roll of film could cost as much as food for a week, each photograph became a precious commodity for students who often lived on extremely limited budgets.[4] Asked how they managed to photograph under these conditions, one student shrugged and said, "idealism." Another, asked the same question, replied, "guerrilla tactics."[5]

Photographing demonstrations was dangerous work for photojournalists and students alike, but most students carried no press badge to give them even the modicum of security provided by professional affiliation. Those holding cameras were often

the targets of particularly vicious police and military violence; in September 1999, Saidatul Fitria was beaten to death while she was photographing a demonstration at Lampung University.[6] In addition to bodily harm, students risked the destruction or confiscation of their cameras and film. They also faced intimidation from plainclothes intelligence officers who monitored campus actions and who sometimes lurked at photo finishers.

The lack of a press badge also directly affected the appearance of their images, for students could not stand with journalists, protected behind the police lines. This not only meant that they were more vulnerable to violence; it also meant that their photographs often more literally represented the student perspective, since they were taken from the student side. As one student noted at a public discussion held at an exhibition of reformasi images, the photographs taken by journalists looked like pictures of a "stage"—because they were taken from behind the police lines—while the student photographs brought the viewer right into the middle of the action. Students' images also appeared more authentic to other students because they often showed more violence than those taken by professional journalists who were positioned further away. Moreover, their amateur quality (the result of both inexperience and poor equipment) sometimes more effectively evoked the chaotic atmosphere of the demonstrations.

This visual alignment with the student experience points to perhaps the most important source of the authenticity of student photographers as witnesses: their sense of personal stake in the events recorded by their cameras and their identification with the student movement. Committed to notions of photographic objectivity, some students experienced conflict between their identification with the student cause and their role as documentarians. One student commented, "I'm confused about where to position myself. Sometimes the students come on too strong ... but then again, they have to. So as a photographer I put myself in a neutral position. If the students are throwing [rocks], I photograph that, too." Others found they had to suppress their sentiments in order to photograph effectively: "Sometimes in the middle of a demonstration, my emotion makes me want to just hand my camera over to someone else, so I can join in fully with my friends. But I don't ..." Some students, however, were clear about their position. Emphasizing that he was producing interested, positioned documents, one student commented: "These are records of the student perspective. Surely the *aparat* has its own." As ideal witnesses, student photographers were simultaneously disinterested (in their lack of financial gain and ties to the established power structure) and interested (in their commitment to the student cause).

Circuits of Witnessing

Suharto's resignation on May 21, 1998 was quickly followed by the relaxation of controls on expression and the press. In this new climate, reformasi images could circulate, moving out of personal collections and into public spaces. Put on exhibition in

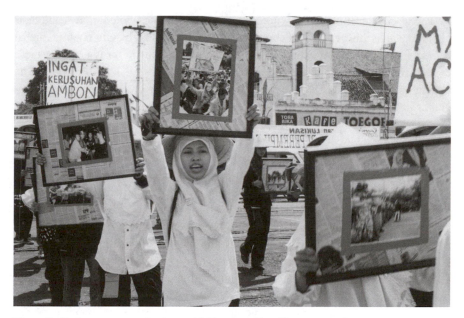

Figure 5 Student protesters: Outdoor exhibition. Reproduced by courtesy of Karen Strassler.

galleries and museums, they became signs of history available for students' own nostalgic recollections and for incorporation into mythic national narratives. Reformasi photographs rendered students *subjects* of history in the double-edged sense of that term. On the one hand photographs of demonstrations allowed students to recognize themselves and be recognized as actors producing their own history. On the other hand, these images *subjected* them to a visual iconography not entirely of their own making, an iconography of "youth struggle" that was integral to the narratives of the very regime they were opposing.

A public anxious to affirm their participation in and support of the movement through contact with its visual traces eagerly consumed Reformasi images in the first two years following Suharto's resignation. In December 1998, for example, thousands crowded into a cultural center in Yogyakarta to see the "Exhibition of Indonesian Student Photographs: Witnesses of the 1998 Actions" (*Pameran Foto Mahasiswa Indonesia: Saksi Seputar Aksi 1998*), a traveling exhibition organized by students in Jakarta, Yogyakarta and Surabaya. In March 1999 an exhibition of student photographs and film footage of the reform movement was held at the University of Udayana in Den Pasar, Bali, on the occasion of a national meeting of students (Figure 5).[7] Professional photojournalists also exhibited their photographs in this period. The Association of Indonesian Photo Journalists (*Pewarta Foto Indonesia*, PFI), founded in 1998, sponsored a large, extremely popular reformasi exhibition in Jakarta in December 1998; a popular calendar made from its images sold out in bookstores across Java.

The discourse of historical witnessing surrounded both photographers and their photographs in this period. In February 1999, for example, a young photojournalist named Eko Boediantoro exhibited eighty photographs in the provincial Javanese capital of Yogyakarta in an exhibition titled "My Witnessing" (*Kesaksianku*).[8] The exhibition's title emphasized the personal nature of the vision captured in the photographs and conflated the act of witnessing with its material traces. An appreciative visitor writing in a comment book, meanwhile, articulated the idea that the photographs had extended and collectivized the photographer's original act of seeing: "Thank you, because your witnessing has become our witnessing too … !"

Promotional materials for many of these reformasi photo exhibits also pointed out that many of the photographs now on display had until now been stored within the photographers' "private collections" because they could not be published due to conditions of censorship and terror. As one organizer of an exhibition that included both journalists' and students' photographs told me, in displaying "these historical witnessings … we want to reopen the album of history." Photo exhibitions were also occasions for screenings of unedited and unaired television footage of demonstrations. Echoing the "historical witnesses" coming forward to reveal their long held secrets, the dramatic release of these never-before-seen images into public exposure lent an aura of reformasi authenticity to the exhibitions themselves.

Photographs of students united in protest displayed at public exhibitions and in museums acted as "screen images" that celebrated student heroism and elided more disturbing fissures in Indonesian society that were emerging in the post-Suharto period.[9] As the center of reform activity increasingly shifted off campus into the realm of electoral politics, and as ethnic and religious conflicts erupted in various parts of the country, students were increasingly nostalgic about the glory days of their struggle. This nostalgia seemed to confirm the efficacy of New Order efforts to contain student activism; even as the achievements of reformasi remained uncertain and many of its goals unmet, student were already consigning their historical agency to the past.

Some students, however, fought against their photographs' transformation into mythic "screens," seeking instead to expand the circuit of witnessing they might generate. In April 1999, students from Yogyakarta's Indonesian Islamic University and other local campuses held what they called an "Outdoor Exhibit" [*Pameran Outdoor*]. In the glaring mid-day heat, a small procession marched through the main streets of the city: a group of drummers, followed by twenty-six students, each holding a framed student photograph showing police brutality against student protesters, followed by another group of students holding banners painted with slogans. After a certain number of paces, the drums would roll and the students would stop in the middle of the road, turn to face the sidewalk, and hold the pictures up, silently, for about 15 seconds, before continuing on again.

As they marched, the protesters chanted in rhythmic monotone, "Our History is Always Full of Tears" (*Sejarah Kita Selalu Ada Air Mata*), a slogan also scrawled in red paint on their white cloth banners. Other banners listed violent events in the

nation's history and present, which onlookers were urged to recall: "Remember: Aceh, Ambon, Tanjung Priok, Timor." "Remember: 1965, Malari."[10] Linked to these other events, the photographs of reformasi were thus extended as metonymic witnesses to an entire New Order history of violence. Using the inclusive form of the word "our" (*kita*), students invoked a broadly shared national inheritance of violence, refusing the singularity of a "student" history.

The "outdoor exhibit" aimed to protest Indonesia's pervasive "culture of violence" (*budaya kekerasaan*) at a moment of intensifying religious conflict in Ambon and anxiety leading up to the general election in June 1999. Its organizers sought to create a more public space—neither the elite exhibit hall nor the state-controlled museum—where "history" could circulate and be seen. The photographs would "make the people closer to the events," explained a student photographer involved in the protest, transforming passersby into witnesses of state violence.

The protestors concluded their march at the monument to the General Offensive of 1949, an enshrined event of revolutionary history that had recently become a sign of New Order historical manipulation. Suharto had buttressed his heroic, revolutionary credentials by claiming to have been the mastermind behind this attack on the Dutch-besieged city of Yogyakarta—a highly contested claim.[11] After several brief statements by student activists, those who had been carrying photographs unfurled rolled photocopies of the images they carried. One by one, they pasted them to the walls of the monument gates. Left to blemish the white-washed surfaces of monumental national history, the photocopies remained as unruly reminders of a legacy of state-sponsored violence. The outdoor exhibit offered the possibility that reformasi images might do more than isolate students within their own mythic history, serving to extend their witnessing to other witnesses, their history to other histories.

Notes

1. The student-led Reformasi or "Reformation" movement began in response to the lingering effects of the severe economic crisis that crippled Southeast Asian economies in 1997. The movement soon broadened into a push for widespread democratic reforms and culminated in General Suharto's resignation on May 21, 1998, after thirty-two years of authoritarian rule.
2. Interview with a former photojournalist, March 21, 2000, Yogyakarta. This is not, however, to diminish the bravery and political commitment that motivated many Indonesian journalists who photographed reformasi demonstrations.
3. *DR* no. 18, vol. 30, 19 December 1998, p. 26.
4. Photojournalists faced similar constraints of poor equipment and lack of pay. Photographers working for Yogyakarta's newspapers, for example, had to buy their own film and received payment only for photographs actually printed in the paper.

5. At least one photo studio in Yogyakarta gave students discounts on developing, and others sold students just-expired film at a significant discount.

6. "Mahasiswa Tewas Bertambah Seorang," *Republika,* October 4, 1999; see also "Persma Berkabung Korban Lampung," *Jateng Pos,* October 5, 1999.

7. "Foto Gerakan Reformasi Dipamerkan di Denpasar," *Bernas,* March 29, 1999.

8. See "Pameran Foto 'Kesaksianku' Eko Boediantoro: Media Refleksi Mengakhiri Kekerasan," *Kedualatan Rakyat,* February 5, 1999; "Pameran Foto 'Kesaksianku' Eko Boediantoro, Meski Pahit Realitas Perlu Ditampilkan," *Kedaulatan Rakyat,* February 11, 1999; "Fotografi Jurnalistik Diuntungkan Situasi," *Kedaulatan Rakyat,* February 14, 1999.

9. My use of the term "screen images" is indebted to Marita Sturken's reformulation of Freud's concept of a "screen memory," which she uses to describe the processes by which representations of national pasts serve as "screens, actively blocking out" more disturbing and unresolved memories (Sturken 1997: 8).

10. Each of these names refers to past or present violent events: Aceh refers to the military occupation and ongoing violence in that province; Ambon refers to the religious violence that erupted in early 1999 and was also ongoing; Tanjung Priok refers to the massacre of Islamic protesters in Jakarta in 1984.

11. In December 1948, the Dutch occupied the city of Yogyakarta, which had been serving as the Republic's capital, and put President Sukarno in jail. In March 1949, in an effort to prove to the international community that the Indonesian Revolution was not over, Indonesian guerrilla forces led by Suharto staged an attack on the city, holding it for six hours. Subsequent controversy has arisen about Suharto's claim not only to have led the attack but to have initiated and designed its plan.

References

Aspinall, Edward. (1995). "Students in the Military: Regime Friction and Civilian Dissent in the Late Suharto Period." *Indonesia* 59 (April): 21–44.

McQuire, Scott. (1998). *Visions of Modernity: Representation, Memory, Time and Space in the Age of the Camera.* London: Sage Press.

Sturken, Marita. (1997). *Tangled Memories: The Vietnam War, the Aids Epidemic, and the Politics of Remembering.* Berkeley: University of California Press.

−3.10−

The Naming of a Heroine
Norma Field

...

In the ancient Japanese poetry relating to *The Tale of the Genji* written by Mura-
saki Shikibu around AD 1000, the very name of the heroine is a beautiful but un-
compromising statement of her essence: connectedness to another. In the first days
of his acquaintance with the child who will come to be known as Murasaki, Genji
utters the following poem to himself:

Te ni tsumite	When shall I pluck
itsushika mo min	and hold in my hand
murasaki no	the young field plant
ne ni kayoikeru	whose roots
nobe no wakakusa	join the roots of the *murasaki?* (1:314; S 102; W 98)

The child has already been described as a "young plant" (*wakakusa*) by both her
nun-grandmother and her nurse. Genji's poem draws on an anonymous *Kokinshū*
poem:

Murasaki no	A single clump
hitomoto yue ni	of *murasaki*
Musashino no	makes all the grass
kusa wa minagara	of Musashino
aware to zo miru	dear to my heart. (KKS 867, "Miscellaneous, 1")

The roots of the *murasaki,* which goes by the unpromising name of "gromwell"
in English, were used for extracting medicines and a purplish dye. I have left it un-
translated in the poems not only for the obvious disadvantages of the English name
but also because there is no one word that will capture both plant and color. "Laven-
der" is an attractive possibility but limits us to the light blue end of the color. Purple,
in its range from the palest of lavenders or pinks to the deepest red, almost black,

blues occupied a special place in the extraordinary visual sensibilities of the Heian period. Here is how one writer describes it:

> As for colors, with the development of dyeing techniques, they were able to produce over 110 hues and achieve the heights of splendor thanks to abundant financial resources, resulting in a golden age of color: both furnishings and clothing dazzled with gold and silver, with gems, with crimson and emerald, white and scarlet. Within this panoply of hues, it was purple that was idealized as the king of colors.[1]

It was fixed by code that only the highest ranking of the aristocracy could wear purple, the dark hues being restricted to princes of the blood of the fourth order or above and officials of the first rank, while medium hues could be worn by princes of the second to fifth rank and officials of the second and third ranks. It also connoted imperial rule, Buddhist law, and even the Taoist paradise.[2] As suggested by the gradations of court rank, the precise nuance carried by purple was indicated by the depth of the hue: hence, its remarkable connotative range from awesome taboo to intimacy and affinity. For example, we just saw Reizei and Tamakazura exchanging poems using purple as a sign of both court rank and relationship. The anonymous poem from the *Kokinshū* that I have just cited is thought to be the source of the phrase *murasaki no yukari,* which refers to one who is related to the beloved or to the transfer of affection from the beloved to the kin.[3] The strength of the dye and its capacity to stain its surroundings was a metaphor for human relationships. At any rate, the place name Musashino and the *murasaki* plant are repeatedly evoked to define the child Murasaki's position. Once Genji has succeeded in removing Murasaki to his own home, the Nijōin, he neglects all his other duties for two or three days to closet himself with her, for, as he scrawls on a piece of purple paper, he feels "reproachful when someone says 'Musashino'" (1:333; S 110; W 107). Another old poem, this time from the *Kokin Waka Rokujō* collection (compiled by an unknown editor late in the tenth century), makes this notion intelligible:

Shirane domo	Though I don't know the
Musashino to ieba	place,
kakotarenu	if someone says "Musashino,"
yoshiya sa koso wa	I sigh and complain
murasaki no yue	it must be because
	of the *murasaki* plant.

(*Zoku Kokka Taikan* 34353)

In this apparently rustic poem, the speaker professes such fondness for the *murasaki* plant that mere mention of Musashino, where it is presumably plentiful, stirs his heart. For Genji, the poem secures the association of Musashino and Murasaki, so

that Musashino can be used to evoke Fujitsubo as well, since *fuji* is the wisteria. Just as the strong dye *murasaki* must be distinguished from the lighter hue of the wisteria, however, niece will have to be distinguished from aunt. Genji elaborates:

Ne wa minedo	Though I haven't seen its roots
aware to zo amou	dear to me is this plant,
Musashino no	kin to the one in Musashino,
tsuyu wakewaburu	the one I cannot visit,
kusa no yukari oh	so thick is the dew.
(1:330; S 110; W 107)	

The terms are familiar to us by now, but what about the young Murasaki to whom this poem is addressed? Even if she were to know the *Kokin Rokujō* source of the phrase "when someone says 'Musashino,' " she cannot have any inkling of Genji's interest in Fujitsubo, and she may not even know of her own kinship to her. Moreover, the ten-year-old who still sleeps with her nurse until Genji separates them probably does not recognize the pun in his first line, ne, "roots," for "sleep" (*neru*). (There is a fine echoing of sound and sense in the two first lines of Genji's poem and of the *Kokin Rokujō* poem: "Shira*ne* domo"—though I don't know—and "*Ne* wa mi*ne*do—though I haven't seen its roots.) Murasaki, coaxed to write something in response, valiantly produces her first poem in the tale:

Kakotsubeki	Not knowing why
yue o shiraneba	you should complain,
obotsukana	I am lost;
ikanaru kusa no	what plant might it be
yukari naruran	that I am kin to?
(1:334; S 110: W 107)	

A venerable poetic history is being brought to bear on Murasaki, a history that prefigures the fictional demands to be placed on her, still but a "young plant" or *wakakusa*. *Wakakusa* as an image for young women or girls appears very early in Japanese poetry. Since seedlings often sprout two leaves in the beginning, *wakakusa* is also an epithet for "husband" or "wife," or for a couple's first night together. The young plant is pure, tender, in need of protection—but also brimming with vitality and therefore nubile and seductive to the beholder. Genji's poem to Murasaki anticipates a day when the plant's roots will be revealed. It reminded a fifteenth-century reader, Ichijō Kanera, of the following poem from *Tales of Ise:*

Ura wakami	So new and tender,
neyoge ni miyuru	so good for sleeping

wakakusa o	is this young grass—
hito to musuban	ah, to think
koto o shi zo omou	of its being tied by another!
(*Ise* 49)[4]	

The poem plays on the conventions of travelers on the road gathering grass for pillows and of lovers pillowing each other with their arms. Here, the speaker is addressing his sister, who exclaims over her brother's "unexpected thoughts" in her response. It is provocative that Genji's poem on unseen roots (Murasaki) and an unvisited plant (Fujitsubo) should have reminded the poet Kanera of the *Ise* poem on brother-sister incest. He clearly had in mind the sum of the Fujitsubo story together with its Murasaki subplot: that is, he was reading as the *Genji* demands to be read—each part evoking the whole, with constant mutual modification. And, as this example shows, the "whole" includes not only the tale itself but also previous literature.

The reiteration of the place name Musashino brings to mind another *Ise* poem, this time from episode 12. There, a young man has abducted a young woman, and the two are in flight from the village authorities. The hero leaves his lover to hide in a grassy field, which the pursuers prepare to set on fire. The woman cries out,

Musashino wa	On this day, do not set fire
kyō wa na yaki so	do not set fire
wakakusa no	to the fields of Musashino:
tsuma mo komoreri	my husband hides
ware mo komoreri	in the young grass and I am hiding, too.
(*Ise* 12)	

This poem appears as KKS 17 in the spring section with Kasugano as the setting rather than Musashino. It is anonymous and was possibly a folk composition on the springtime custom of burning fields to stimulate new growth. The Ise, having already dwelt on the abduction of the young woman who was to become the "Empress of the Second Ward," skillfully transforms the light-hearted KKS poem through the prose context. The association of Musashino with *wakakusa* (here serving as an epithet for "husband") begins to show a dark side. Now, going back to Genji's first poem on the child Murasaki, we notice that *tsumite,* "pluck," contains *tsumi,* or "sin."[5]

We have traced the development of *murasaki* as a figure for kinship. *Murasaki* is also a fixed epithet, frequently used for the following words and names: (1) because it is a deep (koshi) hue, for the place name Kodaka; (2) because it is a noble and celebrated hue, for the place name Nadaka ("famous"); (3) because clouds (especially in Amida's paradise) and wisteria blossoms are purple, for these objects; and (4) because it is a beautiful, shining hue, for *niou,* "to gleam," or "to shine."[6] The first memorable use of *murasak*i in Japanese poetry occurs in poems 20 and 21 of

the *Man'yôshû*. The first is by Princess Nukada, the poet who declared herself for autumn.[7]

Akane sasu	You go
murasaki no yuki	through the crimson-glowing *murasaki* fields,
shime no yuki	the royal fields—
nomori wa mizu ya	won't the guardsman see you
kimi ga sode furu	wave your sleeves at me?

The occasion, as the headnote tells us, is a hunt by Emperor Tenji (r. 668–671). The "you," to judge from the pairing of the poem with number 21, is the Crown Prince, Tenji's younger brother, who was to succeed him as Emperor Temmu (r. 672–686). Nukada was first loved by Temmu and bore him a daughter, but she then became a consort to Tenji. The following poem is given as Temmu's reply:

Murasaki no	If you,
nioeru imo o	so beautiful in crimson glow,
nikuku araba	were odious to me,
hitozuma yue ni	why would I long for you,
ware koime ya mo	being the wife of another?

Was Nukada already in Tenji's service but still attached to Temmu at the time of these poems? There is no assurance that the poems were actually composed as a pair. Little does it matter. What counts is the association of *murasaki* with exquisite beauty and illicit love, an association supported by other names and words in three centuries of poetry.

Notes

1. Maeda Yukichika, *Murasaki Kusa* (Kawade Shobō, 1956), p. 4. I am grateful to Kawazoe Fusae for bringing this and the following two items in the text to my attention.
2. Itō Aki, *Heianchō Bungaku no Shikisō* (Kasama Shoin, 1965), pp. 162–63.
3. Hirota Osamu, "*Genji Monogatari* no Hyōshō Kōzō—Shikisō to Shinshō" in Hirokawa Katsumi, ed., *Genji Monogatari no Shokubutsu* (Kasama Shoin, 1978), p. 279. KKS 867 is generally thought to have been read metaphorically from the Heian period on. KKS 868, by Ariwara no Narihira (also appearing in *Ise* 41), uses 867 to describe the effect of love on one's perception of the beloved's kin. See comments in KKS p. 330, as well as Katagiri Yoichi's comments in his *Zen Taiyaku Kokinwakashū* (Sōeisha, 1980), p. 344.

4. I am taking Kanera's citation of the *Ise* in his *Kachō Yosei* from Kitamura Kigin's *Kogetsushō,* 1: 307.
5. For the *Ise* serving to impart a sense of "sin," see Mitani Kuniaki, "Fujitsubo Jiken."
6. Adapted from the *Iwanami Kogo Jiten* and the *Ōbunsha Kogo Jiten* (1965).
7. I have used the text prepared and annotated by Nakanishi Susumu, *Man'yōshū* (Kodansha, 1978), 1: 58–59.

Part 4. Creating

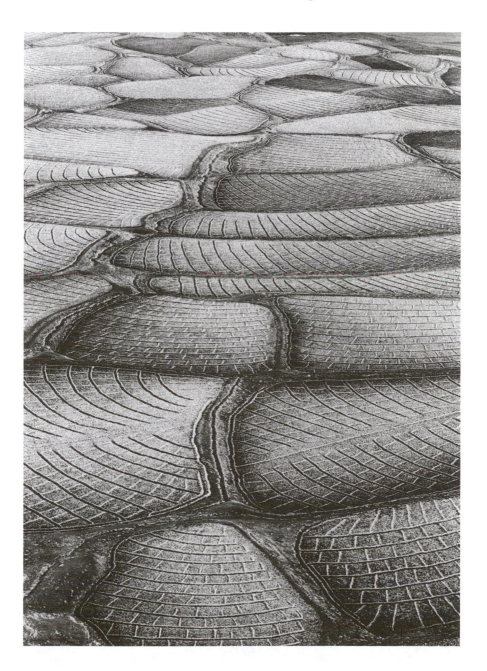

Figure 6 (overleaf) Created landscape:
Rice fields. Reproduced by courtesy of
Patrick Sutherland.

The Readings in this section address the creative potential for 'thinking visually'. They all explore the way in which creative visuality can shape the social spaces 'lived in' and 'acted' within a broader sensory register. The processes involved are closely related to those of Ordering in the last section, but these Readings explore the role of multi-sensory visual imaginings, often experimental, in constructing the social field. What unites them is a sense of the worlds created through visual action and articulated by visual sense, harnessed towards the realization of imagined, desired, even Utopian possibilities.

Arguably any act of creation, even the most routine object created, involves these processes, intervening in the unconscious sensory flows. These processes focus attention towards artifice and therefore a break in the 'ordinary'. The pieces in this section range from the naturalized and mundane creation of the world in the everyday to the projection, performance, and fantasy of cultural experience. A uniting thread is a slippage between the quotidian and the utopian. Everyday life, as theorists from Erving Goffman to Judith Butler have argued, is a performative projection of culture, of self, of hope, of emotion, into the visual field. The 'new' is created with the aim of transforming or going beyond the everyday, the quotidian. Creating through vision brings together the qualities, intensities and roles of the visual, and through them encountered materialities are fine-tuned to a certain intensity of a 'visual personality'. This creates fluid relations between the everyday, the spectacular or the marvellous as elements emerge from an expanded 'everyday'. They are made to work in new configurations and on new scales, whether through art, the architecture of the urban space, the reinvigoration of traditional, or the emergence of the modern nation-state.

Standish's essay on the postmodern Japanese *anime* (animation) classic *Akira* demonstrates creative visualizations in a global environment. It explores the youth subcultures that mix an extraordinarily wide range of cultural references from all over the world to create a salvational poetics for a dystopian Japan on the edge of the twenty-first century. Conversely visual anthropologist Liam Buckley discusses the dynamic absorption and refiguring of visual practices of the colonial to create an expressive mode of well-being and modernity in The Gambia, West Africa. This involves everyday objects and spaces being endowed with creative sets of meanings to enhance the sense of 'being cherished'. The processes, which link performance and spectacle in visual experience, also become clear in David Morgan's exploration of controversies around the display in public spaces of a painting of the head of Christ. It demonstrates the complex dynamics between images, belief and the secular in the political and religious negotiations of identity and nation in the contemporary USA.

A different space of a visual performance of the hope of salvation is explored by historian of Africa Paul Landau. He discusses the way in which Christian missionaries

in the 1920s, and their salvatory hopes, were articulated through the performative medium of the lantern slide. This cannot be reduced to a visual experience alone but, like cinema, it was an experience which encompassed the body, transcending the visual. However, the affects of such technologies cannot be assumed; as Landau argues, local people of the Kalahari Desert absorbed these experiences into their own cultural ranges, refiguring the intentions of the missionaries, thus stressing the multi-sensory 'situatedness' of vision and sight.

In a similar vein, art historian Lois Parkinson Zamora explores the impact of a clearly articulated visual world in her account of the legacy of preconquest Central American vision explored through the myth of 'Quetzalcóatl's Mirror', which is associated with both Toltec and Maya cultures. The story demonstrates the way in which, in these traditions, images do not represent or resemble the object in they way they are thought about in Western traditions, but rather contain it and animate it through performance. In this, Zamora demonstrates that the work of visual images is not merely as 'representation', but as active presentation which defines 'sight worlds.'

The punctuation of the everyday by the potential for the marvellous in artistic and cultural creations is not restricted to collective and public creation of the social around special symbols and performative arenas. Creative individuals have throughout history marked their presence in society through spectacular acts of creativity and visual invention. Indeed, numerous commentators have singled out modernity as being defined by the cult of the individual defining the self through spectacular performances. Spectacle casts performance as one 'worth remembering'; it calls attention to its dynamics in an overt manner. Cultural critic Annalee Newitz's pithy discussion of the spectacle that has been, and continues to be, Madonna reveals and exemplifies the emergence of the ordinary as the extraordinary. She argues that Madonna brings in tabooed images from the margins of culture and class hierarchies to create a new space for cultural activism: a process of making visible. In Madonna the extraordinary is revealed as an aspect of ordinary life, something that critics would say defines postmodernity, for it demonstrates, cogently and precisely, the way in which identities are thought of as 'image'.

The section includes two Readings on the theory of cinema which, in their different ways, address creativity. The first piece presents a discussion between cultural critic Youssef Ishaghpour and French filmmaker Jean-Luc Godard. In it Godard claims that cinema is alone amongst the arts and the practices of artifice with its ability to 'capture an image on the scale of the man in the street, not the infinitely small atomic scale or the infinitely huge galactic one'. Through this history of the ordinary, cinema can create or contour 'History' with a capital H, impacting on the historiographical potential of the age. He then goes on to enunciate the historic responsibility of a medium as powerful and creative as cinema in respect to the violence of the twentieth century. Filmmaker and composer Michel Chion provides a further elaboration on cinema's creative relationship with history by emphasizing the anchoring

qualities of sound in the complete audiovisual experience that is cinema. In both essays one will find resonances of an exploration of the possibility of 'redemption' of ordinary reality in history that the invention of cinema made possible. Like Classen in the last section, this reminds us that the visual cannot be distilled out separately from an embodied experience of life that is by definition a rounded experience in all the senses at once. Edwards's essay on photography as a multi-sensory experience picks up the theme in a way that resonates with Chion's stress on the aural and indeed oral qualities of the image. Using examples from Australian Aboriginal communities she demonstrates how the practices of 'telling history' creates a space with and around photographs for thinking about identity and history in ways that cannot be reduced to the visual but are dependent on the embodied experiences of the visual and the oral. What unites all these three papers is the centrality of a visuality, integrally embedded in broader sensory registers, in contouring the experience of history.

Running through all the Readings is a tension between the ordinary and extraordinary uses of sight and visualisation or even a sense of the sublimation of one in the other. For beyond the everyday is Utopia, the creative desire for the extraordinary, an impulse of which performance and spectacle constitute important elements. Consequently the section concludes with historian Marla Stone's essay on patronage of architecture in Fascist Italy. It demonstrates how the construction of a Utopia in concrete drew inspiration from imagined Roman pasts and cutting-edge modernist minimalism at one and the same time. What is worth noting, in the contexts which we are considering here, is that such a Utopia was meant to heighten the experience of the everyday, to inspire ordinary people to noble impulses in the here and now, through visual effect, while at the same time to provide images of an extraordinary future to come under Mussolini's leadership.

Utopian vision also becomes disembodied through daydream and imagination. This is one of the cross-fertilisations which form the ethos of this Reader, as dream and imagination will be taken up again in the Readings in the last section, *Extensions*. In this section the Readings focus on demonstrating ethnographically the ways in which the visual sense is mobilized by artists and culture producers in acts of creation to comment upon the historical and cultural currents in society while invariably also revealing, to a greater or lesser extent, a utopian dimension to such creations purporting to comment on the present. All ultimately point to the multi-sensory nature of the processes of visual creativity, for none, as the Readings demonstrate, can be reduced to vision alone; they are integrally entangled with a more extended sensory, and indeed emotional, range.

−4.2−

Photography, Elegance and the Aesthetics of Citizenship

Liam Buckley

A house is first and foremost a geometrical object, one which we are tempted to analyze rationally. Its prime reality is visible and tangible, made of well-hewn solids and well-fitted framework. It is dominated by straight lines, the plumb line having marked it with its discipline and balance. A geometrical object of its kind ought to resist metaphors that welcome the human body and the human soul. But transposition to the human plane takes place immediately whenever a house is considered a space for cheer and intimacy, space that is supposed to condense and defend intimacy.

<div align="right">Bachelard, Poetics of Space</div>

In The Gambia, West Africa studio photographers practice a style of portraiture that depicts the sitter within a parlour (see Figure 7). Sometimes, a person will visit a studio known to look like a parlour. On other occasions, the photographer will leave his studio and walk to a nearby compound, responding to an invitation to photograph a client in an "actual" parlour. In both locations, the arranged environment contains the same items—air fresheners, the sofa, the chair, the table, the telephone, the lacework hanging over the back of the sofa, over the arm rests of the chair, over the top of the table, the curtains hanging on the wall, the television set, the radio, the calendar on the wall. Studios look like parlours and parlours look like studios.

The photographers' clients describe the experience of appearing in a parlour with the expression "*ya ma sagal,*" meaning "you make me feel cherished." Indeed, clients often choose "*ya ma sagal*" as a caption for their portraits to be inscribed at the bottom of the photograph. In a wider cultural context, this feeling of being cherished usually occurs when one receives a treasured gift, and has a double connotation—in receiving the gift as an honoured recipient, the person feels luxurious and gift-like. Cherished and portrayed people sense that they are elegant as they engage a relationship of intimacy and trust with their material environment (Figure 7). In turn, elegant surroundings generate the experience of comportment within the sitters' bodies and the sense of being well composed. As such, portraiture distributes people in a visual field of tension with the world, and makes them look taut in the same way that the tuned guitar string is taut. The photography involved in this portraiture is not

<div align="center">− 183 −</div>

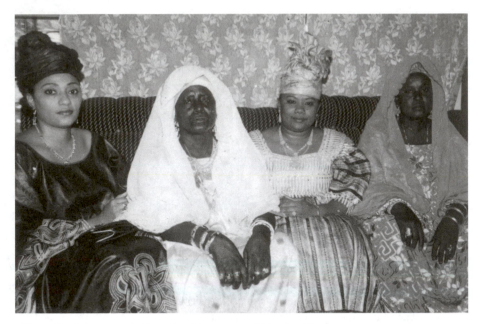

Figure 7 Parlour portrait. Reproduced by courtesy of Liam Buckley.

merely as a visual process but also as a phenomenological and nondiscursive position that links the visual to other sensory registers, including the embodied emotion of elegance.

. . .

Occasions for Elegance

The sensation of being cherished, as experienced during the time one spends as a sitter in a furnished portrait studio—or as a honoured guest in an elegant parlour—begins with an invitation: to look at the camera, to sit down and stay for a while. As such, the visit to a studio or to a parlour belongs to a category of occasion during which a person feels his or her presence to be desired by others, and in turn feels ready to be photographed. This category is known as *xew,* which literally mean a "happening"—the term is used in the greeting *lu xew?* "what's up?" These events include naming ceremonies (*nginteh*), baptisms (*botiseh*), birthday parties (*magal besi judu*), as well as "programs" such as nightclub dance competitions and pop concerts. People consider these occasions as suitable staging areas for portraits because, first, they are joyous occasions (content *xew*), and secondly, these are events to which guests are personally invited. Thus, a funeral (*daigh*) is not a *xew* and therefore not a place for cameras because the event is sorrowful (*nahal*) and because the mourner's

attendance is not in response to an invitation, but to an announcement, made over the radio or in a newspaper obituary, to an unnamed audience of potential sympathizers.

The postcoloniality of being cherished places contemporary parlours and studios along an embodied aesthetic continuum that links portraiture with the administration of new nation building. The relationship between the invitation to be photographed and the feeling of being wanted originated during Independence and the first national census, which was the first opportunity that most Gambians had to stand in front of the camera. Since Independence, this invitation has been issued in a range of ways and settings. Whether the invitation is to appear in a portrait or to consider oneself a citizen, it is modern to the extent that it asks that it makes people feel elegantly at home and comfortable—that is, elegantly, not merely in an abstract manner, but in a way that has been strongly embodied and materially articulated.

…

Maintaining Elegance

A parlour is like a studio in that they both require continual upkeep. Householders and portrait photographers follow the same annual cycle of decorating and updating the appearance of their parlours and studios respectively. In parlours and studios, the sensorium of elegance remains keenly aware of the world as long as it is dynamic. People renew their material environments and the feeling of being comfortable in those spaces, following an eye for change that keeps up with fashion. The season for decoration follows a religious calendar, beginning with the festival of Koriteh that marks the end of Ramadan, and reaching its peak sixty days later with the Tabaski festival. During the two-day Tabaski festival celebrants slaughter a sheep to commemorate the ram that God had supplied to Abraham, as he was about to sacrifice his son. It is a day of fine dressing, of extended visits to the mosque, for visiting friends, giving charity, and for having one's picture taken. In the two months that follow Koriteh, householders buy new furnishings for their parlours and new clothes for themselves. People increasingly dress up in the evening and walk out to their local studio to have their portrait taken in their new finery. In the meantime, photographers decorate their studios with new furnishings and get ready for the newly updated and beautified appearances of their clients.

During my fieldwork Koriteh fell midway through January (2000). Gambians—although mostly Muslim—enjoy participating in the festivities of Christmas. The possibility of a visit from Santa Claus is an exciting prospect for children for whom this old man is but one of the many masked figures that enter compounds seeking out naughty boys and girls and handing out treats at this time of the year. During the time of my fieldwork, however, Christmas Day itself had been a slow occasion as it was still Ramadan. Not long after, however, Ramadan ended and Koriteh began with added enthusiasm, as it was this year coinciding with the millennium celebrations.

Dodging the masks that roamed the residential areas, children went door to door, asking for their Koriteh present (*salibo*). People attended a schedule of dances, grand shows, and sporting events that mark the celebration of Koriteh.

After Koriteh, people settle down to the often-painstaking job of getting ready for Tabaski. It is a process of calling on and mobilizing one's credit-worthiness—both socially and economically. In the markets, merchants draw on all the credit they can access to increase their stocks of cloth, household accessories, and furnishing. At work, employees ask their bosses for advances on their salary, so they can go to market to make the biggest buys of the year.

To decorate and arrange a room into a parlour (*sal*) is to "make up" a room, (*defaru*)—an activity that refers to both the application of cosmetics, and the activity of house cleaning and dusting. The contents of the parlour belong to the general category of *mobil,* ornaments or furniture that "makes the house nice" (see Figure 8). While the words used to name the contents of the parlour are of French origin, they connote a foreignness that Gambians associate more with neighbouring Francophone Senegal than with any Western nation. Chairs (*cis*) and a sofa (*cis bu mag*), made of wood with fabric-covered foam cushioning, face inward toward the middle of the room. Linoleum covers the floor—it is easy to clean and to transport should the occupant of the household move to a different residence. In one of the corners, a television sits on a small table. Some lace covers the top of the television—it is pulled down over the screen during the day and at night when the room is empty of

Figure 8 Parlour, Serrekunda, The Gambia, 2000. Reproduced by courtesy of Liam Buckley.

people (Figure 8). Some ornaments, maybe a framed photograph, face the middle of the room from on top of the television. On a shelf below the television, a VCR and a tape-rewinder. Lace also hangs in the windows, on the backs and the arms of the chairs and sofa, and on the top of a low table in the middle of the room. On top of the table there stands a vase holding plastic flowers, an ashtray, a pen, a pair of glasses. On a shelf beneath the tabletop are some old newspapers, lottery sheets. Along the walls, standing on the floor, wooden cabinets (*cabinet*), and cupboards (*armoire*). The cabinets usually lock, and the cupboards are often open to display the contents on the shelves. Sliding glass sometimes provides a transparent covering for the contents of the cupboards. Curtains (*gridox*) hang in the doorway (*bunta*), the window (*parenti*), and sometimes on the walls.

The days running up to Tabaski are devoted to the activity of dressing and dressing up. At the markets, the streets are awash with waves of cloth—cloth for new clothes, for sofa coverings, for new curtains. Traders hire drummers to stand on the street and draw people to their end-of-Tabaski sales (*wanter*) with talking beats. The sound of sewing machines fills the air, day and night, as tailors try to keep up with their orders for new clothes.

On the morning of Tabaski day families fill the streets walking in their new clothes to the mosque. After the prayers, the men return to the compounds to slaughter the rams. The older men will change out of their *bubbu* to avoid getting blood on the new cloth. The young boys remain in the prayer-clothes as they huddle around to watch the older boys and men hold the ram's neck over a hole dug in the ground at the back of the compound, and the head of the compound making the sacrificial slices. The women remain in their fine clothes all day. The younger women change from outfit to outfit throughout the day, displaying the range of their wardrobes as they would at an important birthday party. By the end of the day, all are dressed up again as they step out of the compound to visit the studio.

The period running up to Tabaski is also a time of excitement and some anxiety for portrait photographers. A month before the feast, I visited the portrait photographer Abdoulie Kanteh in Brikama, and complimented him on how well-stocked his studio was. It looked like an overflowing emporium of furnishings and household accessories—a TV, a sofa, various cabinets, some toys, plastic plants, a globe, photographs in frames on top of every possible surface. Looking around his studio, Kanteh just shook his head and said that the contents needed to be changed in time for Tabaski. His clients were already well familiar with the items in his studio, and he would need to update its look to keep their business. He showed me a new piece he had just acquired—a corner cabinet. He was trying to figure out where he could put it—there wasn't much space left.

The photo labs play a central role in rallying the photographers to meet the challenge of the heavy workload associated with Tabaski time. After Koriteh, the labs announce the annual Tabaski competition, offering prizes to those who bring in the most film. The lab records each film that the photographer drops off, and give "gifts" as "motivation"—a free enlargement with each roll of 36 exposures (that

the photographer can either sell or use to decorate the display window of his studio advertising his products), new cameras, free film, cash prizes. Sometimes photographers pool their films under one name in an attempt to win the big prize. On Tabaski day itself, the photographer will get up early, get dressed in his new clothes, and go to the mosque with his camera. After participating in the prayers, and taking some pictures of families in the prayer ground, he will return home to quickly enjoy the day's feasting and get his studio opened up for business. Vans from the labs visit the studios throughout the evening, and late into the night, picking up film to be developed and printed. Tabaski day begins the most intense work period for the labs in the photographic year. For the next ten to fifteen days the labs will stay open and be busy around the clock, never closing their doors.

I visited Muntaga Jallow's Hollywood Studio in Serrekunda the day after Tabaski. He looked tired but happy: he'd been busy with work until 3 a.m. that morning. On the previous day, he had opened his studio around 2.30 p.m. and had snapped sixteen rolls of 36 exposures—a total of 576 portraits, at a rate of 48 per hour. The van from the Saffideen Lab made its last film run at 2.30 a.m. and had awarded him a new camera for his efforts. His doors re-opened at 9 a.m. for the clients who were eagerly awaiting the arrival of their prints and for those who did not have the chance to get to the studio the day before.

The fact that Hollywood Studio, with its beach backdrops, was not set up for parlour-type portraits did not stop Muntaga Jallow from taking many parlour portraits during Tabaski. Two children walked into the studio and interrupted my conversation with Muntaga Jallow. They delivered a message that he should bring his camera to a nearby compound. The kids followed us across the street and into the compound, crouching down and imitating Muntaga Jallow's poses as a cameraman. Jallow worked quickly so he could get back to his studio. The first shot was of a woman in her room—it was not strictly speaking a parlour, as it contained a bed. But the bed was nicely made, with new covers. There were photos in the glass cupboards of the bed's headboard, and the room had enough space for a cushioned chair. The woman sat on the elegant bed in her elegant clothes and posed for Muntaga Jallow who was holding the door curtain with one hand and standing in the doorway, as there was not enough focal distance for him to remain inside the room.

Muntaga Jallow moved onto the second household, stood in the doorway of another elegant chamber, and took three snaps—one of the woman, and two of each of her children. At the third household, he had to wait a few minutes as the woman prepared her baby. When they were ready, Muntaga Jallow positioned them on the ornate bed, and snapped them. At the fourth and final household in the compound, Muntaga Jallow snapped a woman with her two children—two portraits—one of the three together, and one of the youngest child sitting on his toy bicycle. Muntaga Jallow worked quickly and was soon back at his studio.

As this account of Muntaga Jallow's Tabaski parlour-portraits suggests, the space of the parlour is a flexible concept. Maintaining a parlour requires a luxurious use

of space that many people cannot afford, especially when people need somewhere to sleep. In that case, the parlour may in fact be a bedroom—this does not detract from its parlour status. Not all bedrooms are parlours, however. The parlour, then, is not fixed to any one residential space. The parlour might be better understood as an attitude to decorating and arranging household space—that is, as a sensual space, where persons participate in specific sensory relations with the material environment. It would make sense, then, to step into the front room of a household, and see a parlour even if the room contained a bed, as long as the bed conformed to parlour standards: for example, if the bed had cupboards built into the headboard, and cabinets built into its base. What finally and crucially distinguishes the parlour from bedroom is the question of whether or not the room is a "photographable" space. A bed can be said to exist in a parlour if it were considered to be a suitable place to pose for a photograph, as well as a place that one would decorate for Tabaski. Neither the kitchen nor the bathroom—nor a "plain" bedroom—could be a candidate for parlour status. The parlour contains a transportable disposition that touches many domains of life, and is found not only in studios but in the lacework and air fresheners that taxi drivers place over their dashboards, or in the cushions and comfortable chairs that hosts of dances and funerals bring outside for their honored guests as they sit in the heat.

Parlours, Studios, and Postcolonial Sensoria

With their flashguns, auto-focus cameras today yield portraits prized for the way that the sitters appear to shine and look as clearly in focus as the furnishings that surround them (see Buckley 2001). The profession of portraiture has established environments that have become jural entities in themselves (see Levi-Strauss 1988: 163–88). In these spaces, portrait sensoria have explored ideas of obligation, association, and membership in terms of an idiom that describes what it is to appear elegant and in tune with one's surroundings. In parlour-like settings today, people sense the types of things and desires—modern, global, and postcolonial—they must engage if they are to remain feeling wanted.

Within Western popular tradition, the parlour is a room one step away from the world. It is a place for conversation and entertaining, as well as a site of possible mischief, where people tempt social norms by breaking rules when playing games. The category of social skill developed in the parlour—the parlour trick—fulfils the obligations of amusement rather than those of work. It is a social accomplishment that is functionally useless, and is thereby capable of stimulating moral outrage. The regularity and seriousness of the society of the world outdoors comes indoors only when it can shrink itself, become light, and serve as a game that promises delight and does not require professional membership or training—parlour cricket, parlour billiards, parlour croquet, parlour tennis, parlour bowls, parlour quoits. The parlour is by definition handsomely furnished, full of elegant coverings. People inhabit its

comfortable circumstances, sitting in cushioned chairs, supporting the projects of modernity at work in the outdoors (politics, social movements, anthropology) without having to participate directly—a parlour Socialist, a parlour Bolshevik, a parlour Fascist, an armchair anthropologist.

In the world outdoors, commerce takes on the look of the parlour (see Benjamin 1999), when the consumption of some services depends on affording the customer the nonparticipatory feeling of being at home, on providing first and foremost the chance to find some respite along the main street from the pressurized world of goods. In these cases, storefronts open into interiors that resemble elegantly fitted apartments. Here, in ice-cream parlours, tanning parlours, beauty parlours, manicure parlours, massage parlours, undertaker's parlours, customers can cool down, drop their guards, and let out the visceral sounds of relaxation and release (sighs, a heavy breath, a loud sob).

For people in The Gambia, the parlour is an "exhibition room" (Aspen 1986: 20), a place to offer an especially appreciated form of hospitality (*teranga*) that is based mainly on the activity of showing (*woon*) and inviting the guest to see what is on display in this front stage. An appreciative guest will say "*chalit la,*" a statement of gratitude that anticipates the future presence of *chalit*—the thing (an umbrella or a bag for example) that one leaves behind during the first visit—that necessitates a return trip. At all times, the host carefully manages the guest's viewing experience (see Rosselin 1999). Upon entering, the guest is able to see a level of display immediately open to anyone in the room—the furnishings, and the pictures, calendars, and photographs on the walls. At first there is little chance for the guest to inspect the display very closely. The good host, following etiquette, will almost immediately ask him to sit down (*toggal!*).

The guest participates in a second level of display when the host decides to turn on the TV set (first lifting up the lace covering) or to play a video. Another, more intimate form of display begins when the host offers the guest photograph albums for viewing, and the chance to listen to the narratives of travel, parties, dances, and previous visitors which accompany the images:

> The host's eldest sister, his eldest brother now in Angola, a shot of a woman sitting on a sofa in a parlour with a telephone in front of her on a coffee table, two photographs—a man sitting on a sofa holding a telephone, in the second a woman sitting on the same sofa holding the same telephone—later these two people were married. A double page of six photographs taken during a naming ceremony, all taken in the parlour of the host's eldest sister. A photograph of the daughter of his eldest sister—"the one you met in my sister's parlour when you first arrived." A photograph of his mother on her return from pilgrimage to Mecca, dressed in her *Ajaratou* white, sitting next to the host's eldest sister in her parlour. (author's field notes 4/14/00)

As the narrative progresses, the pages of the album turn over, moving backward and forwards. The viewer sees more portraits and appreciates more links between

those in the portraits. The connections start to build up. As an arena for display, the parlour serves as both a room to show photographs and a room in which to pose for photographs. The activity of parlour viewing ascribes high household rank to the person who appears photographed in the parlour with the greatest frequency, the person with whom others always pose for photographs when they visit the compound.

The parlour in The Gambia has only recently become a site for representing the consumption of goods and services that promise and guarantee good taste and fulfilling sensations. The majority of television commercials promote Gambian businesses and products that people can only engage when they step out of their compounds— banking and shipping services, European-style supermarkets, kiosks selling lottery tickets, wrestling competitions, pop concerts at hotels and the national stadium, for example. During my fieldwork, only two types of commercials depicted Gambians at home. In the first, a woman who chooses to use "Jumbo," a ready-made vegetable cooking stock, enjoys an easier and more successful life as a wife. Two men—one the head of the household and the other a guest—sit in a parlour enjoying a large food bowl of *bennachin,* making appreciative sounds of digestive approval. The woman who has chosen to use Jumbo walks into the parlour and is greeted by her head-of-the-household husband who praises how well the food tastes, her "tasty hand" (*saf loxo*—the sign of a expert cook) and her status as a good wife. In the second commercial, a man enters a parlour to ask his host for the loan of some money—he has bills that are piling up and no way of clearing them. The head of the household welcomes him in, asks him to sit down, but does not agree to the loan. Instead the host reminds his friend of the relative who now lives abroad, and suggests that he contacts this person and ask him to send some money via Western Union. The procedure is easy and a representative from Western Union will call when the money arrives. The call will most likely come through on the telephone located in the parlour where the two men are sitting. Although the host will not lend his friend money, he will presumably allow him to use his private telephone line.

According to the imagined world of these commercials, the parlour is a site linked to a global network of goods and finance, where Gambian cooking can become modern as long as it does not alter perceived gender relations or the taste of good food, and where information and banking technology do not defeat local systems of credit but serve to extend them out across the Atlantic (there's no suggestion of borrowing from a bank). The parlour is an anchor point—a place where you can feel welcomed, sit comfortably, and think about people who have gone away and where calls can come in.

References

Aspen, Harald (1986). "Ghost Corporations: The Gambian Aku's Responses to Dethronement." MA Thesis, Department of Social Anthropology, University of Trondheim.

Bachelard, Gaston (1994). *The Poetics of Space.* Boston, MA: Beacon.

Benjamin, Walter (1999). *The Arcades Project.* Cambridge, MA: Belknap.

Buckley, Liam (2001). "Self and Accessory in Gambian Studio Photography." *Visual Anthropology Review* 16(2): 71–91

Lévi-Strauss, Claude (1988). *The Way of the Masks.* Seattle, WA: University of Washington Press.

Rosselin, Celine (1999). "The Ins and Out of the Hall: A Parisian Example." In *At Home: Anthropology of Domestic Space,* ed. Irene Cieraad, 53–9. Syracuse, NY: Syracuse University Press.

−4.3−

Akira, Postmodernism and Resistance
Isolde Standish

Contemporary urban style is empowering to the subordinate for it asserts their right to manipulate the signifiers of the dominant ideology in a way that frees them from that ideological practice and opens them up to the sub-cultural and oppositional uses. (Fiske 1991: 253)

Introduction

This essay is concerned with a textual analysis of *Akira* (1988),[1] the highly successful cyberpunk film created by Otomo Katsuhiro. This analysis is an exploration of the complex systems of codes and practices employed by the film and the spectator[2] in the creation of meaning; however its main emphasis will be on the perspective of the spectator. As with most commercial films produced by the Japanese studio system, *Akira* (Tôhô Studios) is aimed at a specific audience: adolescent males who are fully conversant with the codes and cultural systems employed in the film.[3] Therefore, to reach an understanding of how a Japanese adolescent male creates meaning (and so derives pleasure) from *Akira* involves not only an understanding of the uses the film makes of other textual systems, but also an understanding of the position occupied by some adolescent males in Japanese society.

. . .

Through an examination of the bôsôzoku subculture as a cultural expression of a section of Japanese youth, the first part of this essay will demonstrate how *Akira* uses bôsôzoku style to reflect a youth culture of resistance which exists alongside mainstream contemporary Japanese society. This raises many questions in relation to the myths of Japanese social and cultural homogeneity and the supposed classless nature of Japanese society.[4] For ethnographic detail I shall be largely drawing on Satô's (1991) study of the bôsôzoku and yankô (punk) youths. I shall then proceed with a structural analysis of *Akira* as a text which draws on a postmodernist pastiche of conventions to create a mise-en-scene which denotes chaos and corruption.

It should be noted that while Satô provides a useful ethnographic account of bôsôzoku he fails to present the sub-culture adequately within its larger social, political and economic contexts and as a result he fails to answer the following questions

which are crucial to understanding the underlying causes of the development and at-
traction of the sub-culture. First, why is the membership of bôsôzoku gangs predom-
inantly made up of youths from manual working-class backgrounds? Second, why is
their behavior in opposition to the norms and standards of Japanese society? On the
other hand, Satô does refute the psychological "strain theory" which he states was
the most common explanation cited by Japanese academics and the media during the
1970s for the occurrence of bôsôzoku activities and which he defines as a behavioral
expression of frustrated wants and needs, resulting from an incongruity between cul-
turally induced aspirations and socially distributed legitimate means. (1991: 3)

Satô argues instead that bôsôzoku behavior is an expression of asobi (play) which
forms part of a rite of passage marking the change from childhood to maturity.

Asobi is an important factor, but it is only one in a multiplicity of factors which
are related to the occurrence of bôsôzoku activities. By emphasizing asobi, Satô fails
to explain adequately the social and historical causes which lie behind the manifesta-
tion of this particular form of delinquent behavior. Therefore I intend to broaden the
discussion by taking up these issues and by suggesting that at the social level, the
factors listed below have contributed to the emergence of a generational conscious-
ness which, despite myths of the classless nature of Japanese society, is linked to a
post-war polarization based on occupational status. The development of the youth
sub-cultures in the post-war period should be viewed as one of the expressions of
this generational consciousness through its manifestation of style and behavior. The
factors we need to consider are:

1. Post-war changes in the Japanese systems of education and work, part of which
 was a shift to a meritocracy and achievement-oriented social status;
2. changes in the structure of the family, especially the gradual decline of the
 extended family;
3. the proliferation of the mass media. Television was first broadcast in Japan
 in 1953. At that time there were 866 television sets, but by 1959 this number
 had jumped to two million and was increasing at a rate of 150,000 a month
 (Anderson and Richie 1959: 254);
4. the changes in the comparative ranking of work and leisure. Material affluence
 has also increased the importance of leisure and recreation in the lives of all
 Japanese. Technological innovations in industrial production and the demands
 of unions for fewer working hours have, since the early 1970s, reduced work-
 ing time (Satô 1991: 184);
5. the emergence of adolescence as a socially constructed category which accom-
 panied the increase in the spending power of Japanese youth and the growth of
 a market designed to exploit this surplus spending power.

Bôsôzoku sub-culture, seen as an outward manifestation of a new genera-
tional consciousness poses a direct challenge to the traditional "work ethic" and

achievement-oriented ideology of the previous generation. Bôsôzoku have adapted and inverted images, styles and ideologies to construct an alternative identity, an otherness, which challenges the ideals of Japanese social and cultural homogeneity. Hence, the moral panic[5] which followed media reports of bôsôzoku activities in the mid-1980s may be explained in part as the fear of difference, "otherness".

Satô states that "the majority of those who participate in gang activities are from middle-class families" (1991: 2). There is a problem here as most Japanese define themselves as middle-class, despite economic and occupational differences. Thus Satô goes on to state that the majority of bôsôzoku youths come from "blue-collar" backgrounds, a point supported by DeVos in his psycho-cultural study of deviancy in Japanese society (1973).[6] Therefore, it would perhaps be more accurate to say that most bôsôzoku youths do not come from economically disadvantaged backgrounds, such as in the UK and the USA where academic studies have made the link between delinquency and economic deprivation, but from lower status groups who do not fit in with the Japanese ideal of the white-collar salaryman and his family. So despite the fact that the majority of Japanese consider themselves to be middle-class, it is clear that there is a polarity of occupational status in society which can be said to be divided along the lines of blue-collar/low status workers, and the salaryman/white-collar/high status workers. The polarity of occupation is determined by education and is reflected in the emergence of distinct youth cultures divided along these lines.

Traditional explanations of the classless nature of Japanese society are by and large dependent on the linking of income to class and do not take into account the status attached to certain occupations and denied to others.[7] They also tend to ignore the fact that social standards and norms are determined by dominant elites, filtering down through society to become the consensual view. A person's ability to achieve status depends upon the criteria of status applied by other people in the society (seken) in accordance with the consensual view (sellen-nami), that is, the standards and norms individuals use in evaluating other people (Cohen 1955: 140).[8] This raises "status problems" for those who fail to achieve in a highly competitive education and employment system. Hence, the desire of the bôsôzoku youths to establish a set of status criteria outside the consensual view, in terms of which they can more easily succeed. Bôsôzoku discontent with mainstream society reflects the polarization between blue-collar and white-collar status groups whose position is determined by their children's access to education. The emergence of two distinct youth cultures divided along these same lines, the manual working-class youth, bôsôzoku, and the college students' dokushin kizoku (literally, unmarried aristocrats) youth culture reflects this contraposition. It is also evident in the geographical division of Tokyo into the Yamanote region, mostly populated by salarymen, and the Shitamachi area where blue-collar workers tend to congregate.

From this perspective of occupation-determined status divisions, the reason for the emergence of bôsôzoku can be explained in Cohen's (1955) terms of "the compensatory function of juvenile gangs". He suggests that working-class youths who

under-achieve at school and who are unable to conform to "respectable" society, often resort to deviant behavior as a solution to their problems:

> It is a plausible assumption … that the working class boy whose status is low in middle-class terms cares about that status [and] that this status confronts him with a genuine problem of adjustment. To this problem of adjustment there are a variety of conceivable responses, of which participation in the creation and maintenance of the delinquent subculture is one. Each mode of response entails costs and yields gratifications of its own … The hallmark of the delinquent subculture is the explicit and wholesale repudiation of middle-class standards and the adoption of their very antithesis. (Cohen 1955: 128–9)

This point is further supported by Satô when he states that while they may be faceless unskilled labourers or not very promising high school students in their everyday lives, they can become "somebody" with definite status through their universe of discourse. (1991: 69)

This "compensatory function" is crucial to an understanding of *Akira* and the bôsôzoku sub-culture as a whole. In the analysis of *Akira* which follows, it will be demonstrated how, by drawing on the imagery of kôha (hard type) as a defining feature of masculinity, the narrative performs Cohen's "compensatory function" which, I believe, is one of the reasons for *Akira*'s huge box-office success.

Akira and Postmodernism

… *Akira* is a film which legitimates and mythologizes the position of bôsôzoku youth on the periphery of Japanese society and so becomes a sharp critique of contemporary corporate Japanese society.[9]

Akira is a text which simultaneously displays the two distinct characteristics of the postmodern which Fredric Jameson (1983) discussed: an effacement of boundaries, for instance between previously defined stylistic norms (Eastern and Western) and between past and present, resulting in pastiche and parody; and a schizophrenic treatment of time as "perpetual present". In *Akira,* this effacement of the boundaries between stylistic norms and between past and present does not manifest in an appeal to "nostalgia" as Jameson has argued it does in Western postmodernist films. For example, Scott's *Blade Runner* (1982), although set in a futuristic Los Angeles/Tokyo[10] cityscape in the year 2019, simultaneously plays on 1950s' conventions of film noir. The Raymond Chandler image of the hero detective (Harrison Ford), the emphasis on faded sepia family photographs and memories, establish a nostalgic humanness which is contrasted with the alien cyborgs who also inhabit the film's space. *Akira* similarly draws on the 1950s and 1960s conventions of a specific male genre based on the drifter film (nagare-mono)[11] in the construction of the character called Kaneda. Kaneda displays all the positive attributes of the outsider as represented

by the actors Ishihara Yujirô and Takakura Ken, all of whose films are still widely available. The outsider is physically strong, but, above all else, he remains loyal to the code of brotherhood, regardless of personal cost. He is thus brought into direct opposition with the establishment, represented in the films by the scheming, self-interested politicians and the moguls of the military-industrial complex. As an archetypal outsider, Kaneda is not bound by any of the conventions of the "legitimate" society which, as the following discussion makes clear, is portrayed as corrupt and degenerate. *Akira* thus conforms to a central theme that runs through the films of the nagare-mono and the yakuza genres, that is, the clash between male codes of brotherhood and the constraints imposed on male freedom by the law and social institutions, such as the family. Hence the nagare-mono always exists on the margins of society, for it is only there that he can remain true to his moral code.[12]

Akira, while set in a futuristic present, takes four historical signifiers which are juxtaposed to underscore the corruption and degeneration of contemporary Japanese society, creating an historical "pastiche". The first historical signifier derives from the kurai tani (dark valley) period (1931–1941) of pre-war Japan when right-wing military factions combined with zaibatsu (industrialists) and vied with politicians for political control of the country. In *Akira,* the Colonel is symbolic of this sort of military faction. The film's representation of the Colonel is so constructed that he is easily identified with the portrayal of General Anami, the War Minister in Prime Minister Suzuki's cabinet of 1945, in the highly successful film *Japan's Longest Day* (*Nihon no ichiban nagai hi,* directed by Okamoto Kihachi, 1967).[13] The industrialists, with whom the Colonel is in collusion, are shown to have connections with the terrorists, while the politicians are depicted as weakened through internal conflicts.

The second historical signifier relates to the dropping of the atomic bombs on Hiroshima and Nagasaki. The opening credit sequence of the film is dominated by a silent white flash which destroys the cityscape leaving only the impact crater over which the title *Akira* appears in red letters. When they lose control of their power, Akira, the most powerful of the mutant children, and Tetsuo become metaphorical nuclear weapons. Takeshi, Kyoko and Masaru, the spectral children, are haunting images of post-nuclear mutants. They are the result of the obsession of the military scientists' research into the psyche and, at the end of the film, they will destroy the corrupt world as it is depicted in the first part of the film.

The third signifier relates to the Tokyo Olympics (1964) and the fourth to the political unrest and student demonstrations against the revision of the US-Japan Security Treaty (Anpo) in the 1960s. Kaneda and his bôsôzoku friends exist in a quintessential postmodern city, Neo Tokyo 2019, where the "evils" of each modern historical period coalesce into a post-atomic world-war futuristic present. The havoc and destruction of the past is being simultaneously criticized and contrasted with a future utopian society that will come about after the film.

Akira is, above all else, concerned with the esthetics of movement and destruction, subordinating any sense of narrative sequence to images of the spectacular;

a point which was partially determined by the serial nature of the manga (comic) series from which *Akira* the film was derived. *Akira* the comic first appeared in *Young Magazine* in December 1982. The long-running serial structure of the manga narrative directly influenced the structure of the film version. Serial forms are influenced by several factors; first, serials are resistant to narrative closure and they have an extended middle. Traditional Hollywood realist narratives are generally constructed in the Todorovian sense, that is, the narrative begins with a stable situation which is disturbed by some force and, finally, there is a re-establishment of a second, but different equilibrium. The serial structure of a long-running manga is naturally resistant to the re-establishment of a final equilibrium.

Secondly, the serial form has multiple characters and sub-plots. Hence, the compression of this long-running manga serial into a feature-length film curtailed the development of the multiplicity of sub-plots which developed individual characterizations, enhancing the film's sense of fragmentation and disruption of narrative flow. For in *Akira,* there is no one central character; there are multiple characters who interact within a given set of circumstances, reducing the film to a montage of multiple patterns of action. The bôsôzoku youths, Tetsuo and Kaneda, form the catalyst around which these multiple patterns of action coalesce.

The fast editing, the dislocation of narrative sequence and the disruption of the diegesis produce the sensation of fragmentation of images where meanings are disjointed and referential. This emphasizes the sense of movement and the physical experience of "flow" and the sensuality of destruction. Satô links the concept of "flow" which refers to the "holistic sensation that people feel when they act with total involvement," to the physical sense of pleasure that bôsôzoku experience when they hold mass bike and car rallies. Satô quotes from Mihaly Csikszentmihalyi:

> In the flow state, action follows upon action according to an internal logic that seems to need no conscious intervention by the actor. He experiences it as a unified flowing from one movement to the next, in which he is in control of actions, and in which there is little distinction between self and environment, between stimulus and response, or between past, present and future. (1991: 18)

In fact, the whole structure of *Akira* is similar to that of a bôsô drive where there are periods of dare-devil driving which involve extreme concentration followed by rest periods at pre-arranged meeting places. These rest periods allow for stragglers to catch up with the main group and for the release of tension. In the film, there are periods of intense violence, destruction and physical movement punctuated by quiet periods when, for example, Kaneda is involved with his terrorist girlfriend Kei, or when the three mutant children converse. These quiet periods in the film allow the spectator to relax before the next sequence of violent and destructive images.

Through the techniques of fast editing and others listed above, the film reproduces the sense of "flow" in, for example, the bike chase at the beginning of the film when

Kaneda and his gang have cornered the Clown gang on the freeway and are in pursuit. The animation is that of a camera following the chase, sometimes from aerial shots which highlight the bike's headlamps as they pierce the empty night sky, and at others from low-angle shots which emphasize the size and power of the bikes as the wheels rotate with a whirring sound. When the gang members do engage in combat, the camera speed changes to slow motion as a biker is thrown over the handle-bars, and as soon as he hits the tarmac, the camera reverts to normal speed, maximizing the sensation of the bike's movement as it speeds away leaving the victim instantly miles behind. These images, by emphasizing the sensual experience of movement, are not in any sense representations of the "real"; they are images of what Baudrillard (1988) has called the "hyperreal". The "hyperreal" effaces the "contradictions between the real and the imaginary"; the "sensuous imperative" of these images becomes our experience of the event depicted and our site of pleasure (Baudrillard 1988: 143–7). The sequence of the bike chase replicates, in the sensation of hallucinatory and hyperreal images, the "flow" as experienced by actual bôsôzoku and described by Satô. The sound track further enhances the "sensual imperative" of the images as the low key mechanical "post-rock" music pulsates in time with the bike engines throughout the chase, complementing the metallic sparks that fly forth as bike hits tarmac and bodies fall to the ground with a thud. Satô noted the elaborate modifications bôsôzoku made to their vehicle exhaust systems and the importance of massed engine sounds to their pleasure in a bôsô drive. This pleasure is reproduced in the film through the sound track.

Baudrillard's concept of the "hyperreal" also applies to the historical signifiers listed above. As stated earlier, *Akira* was targeted at a particular audience: adolescent males, who could relate to the bôsôzoku sub-cultural images and styles which pervade the film. These targeted spectators are at least one generation removed from the actual experiences of the historical events and so their knowledge of the "dark valley" period and the political unrest of the 1960s is already indirect and fragmentary, a point the film exploits in its structuring of the images of demonstrations and the violence and degeneration of this cybernatized society.

The film reproduces futuristic images of a city in the age of simulation, where signs now bear no relationship to reality and the definition of the real becomes, in Baudrillard's words, *"that for which it is possible to provide an equivalent representation ...* the real becomes not only that which can be reproduced, but that which is always already reproduced: the hyperreal" (his emphasis; 1988: 145–6). As already noted, the Neo Tokyo cityscapes that punctuate the film are drawing on the iconography of *Blade Runner*'s Los Angeles/Tokyo in the year 2019, which has become a metaphor for urban decay. The warm orange colors which Otomo uses in the night scenes are taken directly from the polluted haze of *Blade Runner. Akira*'s Neo Tokyo is a "critical dystopia" in that it projects images of a futuristic city which perpetuates the worst features of advanced corporate capitalism: urban decay, commodification and authoritarian policing. High-rise buildings representing corporate wealth exist

alongside the dark decaying streets of the old town, highlighting the divisive nature of the society. Colored neon signs and holographs dominate the skyline, signifying commercialization. They also provide the dominant source of light for the night scenes, complementing the motorcycle headlights of the bôsôzoku.

The cityscapes thus represent an esthetic of postmodern decay, as well as revealing the dark side of scientific experimentation and technology. The uniqueness of architecture to a specific place, culture and time has been lost in Neo Tokyo. These images of a cityscape could be taken from any late capitalist city, such as New York, London. There is nothing in the scenes to link these images specifically to Tokyo.

As also has been noted, the film makes no attempt to place the images of violence and destruction within any logical form of cause-and-effect narrative. The images exist alone, relying on the shared cultural knowledge of the audience to produce meaning. The only assistance the audience is given is through a double mediation of news reports, which are either distorted background voice-over, as in the opening sequence, or television news flashes, complete with commercials, that echo forth from multiple video monitors in shop windows during riot scenes. The effect of this technique is to encourage the spectator to identify with Kaneda whose knowledge of the causes of the chaotic world in which he exists is at best fragmentary. It also works to foreground Kaneda and the Colonel who are, apart from Tetsuo and the three mutant children, the only characters given a semblance of a narrative flow in the film.

Both Kaneda and the Colonel are kôha types, the embodiment of a hard masculinity to which actual bôsôzoku youths aspire. Satô defines kôha as "the hard type [that] is a traditional image of adolescent masculinity which combines violence, valour, and bravado with stoicism and chivalry" (1991: 86). The kôha type of masculinity is contrasted with the nanpa, or soft type: "a skirt chaser or ladies' man" (Satô 1991: 86). The college student/dokushin kizoku belong to this latter group. The kôha school of masculinity also carries with it connotations of makoto (purity of motive) which is very much evident in the characters of Kaneda and the Colonel. Neither have been taken in by the corruption that characterizes the degenerate society in which they live. Their use of violence is legitimated by their purity of motive and so, despite his extremely violent behavior, Kaneda is the real hero of the film.[14]

In Japanese popular culture, makoto takes precedence over efficiency as an esteemed cultural value, hence the Japanese predilection for the "tragic hero" who proves his purity of spirit in death. However, Kaneda is also "efficient". He is loyal as well, another highly valued characteristic in Japanese Confucian-based society. The flash-backs to the orphanage, where he first met Tetsuo, reinforce these characteristics while simultaneously exposing Tetsuo's deepening dependence on him. These flash-backs have two functions: first, they are constructed to arouse a sense of sympathy in the spectator for Kaneda and Tetsuo; and thereby they reinforce the simplistic media-perpetuated view that the break-down of the traditional family is to blame for adolescent delinquent behavior. But more importantly for their young audience, the flash-backs are liberating, picking up on the conventions of

the nagare-mono[15] and reflecting a trend in recent films targeted at the young, for example *Kitchen* and *Kimi wa boku o suki ni naru* (*You Are Going to Fall in Love with Me*), in which young adults (dokushin kizoku) are portrayed as being without the emotional clutter of the traditional extended family.

Kaneda's qualities of makoto, efficiency and loyalty are continually compared to the bumbling of the other "bad" characters in the film, particularly with Tetsuo, his one-time friend who, through his own personal weakness and as a result of experiments carried out on him by a scientist, metamorphoses into a destructive mass of protoplasm and metal.[16] Tetsuo's character is carefully structured in one of the multiple character sub-plots (fully developed in the manga series, but only hinted at in the film through flash-backs) to provide a foil for Kaneda. As children they lived in the same orphanage and Tetsuo came to rely on Kaneda's superior strength. But Tetsuo's envy of Kaneda was the weakness which inadvertently led him to become a test case for scientific experiments, after which his nascent psychic powers make him go on the rampage, killing the barman from the gang's local haunt and Yamagata, another gang member. These incidents provide Kaneda with the legitimation necessary to confront the power that Tetsuo has become in the final climactic half of the film, for Tetsuo is no longer himself. As Yamagata asks just before his death, "Are you really Tetsuo?".

Kaneda, a bôsôzoku youth, through his academic failure, has been placed on the margins of this corrupt and emotionally empty society. His qualities of efficiency and loyalty, combined with his failure at school and his ignorance, make him the film's embodiment of innocence and purity. Therefore he is qualified to become the founder of a new utopian society that will be formed after the old society has been purged through cataclysmic destruction.[17] In the final scenes, Akira and the other three mutant children, the gods of the post-atomic war age, sacrifice themselves (as would have the traditional "tragic hero") so that a new society can come into being with Kaneda as its progenitor. Apart from Kaneda, his girlfriend Kei and one other junior gang member, the Colonel is the only other survivor. He has also shown attributes of efficiency and sincerity of purpose, but more importantly, he is in control of artifacts, such as helicopters, advanced scientific weapons, etc. As Sontag states, in science fiction films things … are the locus of values because we experience them, rather than people, as the sources of power. According to science fiction films, man is naked without his artifacts. (1979: 494) Since the Colonel and Kaneda are both representations of the kôha school and are shown to be efficient, loyal and competent in their use and control of artifacts, they are obvious survivors in a film which seeks to promote this image of masculinity.

The core values of makoto and loyalty which the film promotes give the characters (particularly Kaneda and the Colonel) a sense of historical continuity, as these are themes which, as I have already argued, go back through yakuza, nagare-mono and war-retro films to the jidai-geki (period/historical films) and Chūshingura story. This historical continuity is brought into sharp contrast with the fragmented time-frame

and postmodernist mise-en-scène of the film. These values of the kôha hero are seen to override the postmodern social conditions which, according to the film, will self-destruct. Only those few, the bôsôzoku, who refuse to conform to the values of the corrupt world and who were forced to live on the margins of society, will survive to form a new and—by definition—a better world. The characters in *Akira* are spared the psychological struggle that Deckard experiences in *Blade Runner* over questions of how humanness is defined in a world of "simulacrum". It is the bôsôzokus's ignorance which shields them. Kaneda has no doubt about his basic humanness, his core values of makoto and loyalty, his "morality", are never questioned in the film. As Harvey explains:

> The depressing side of the film [*Blade Runner*] is precisely that, in the end, the difference between the replicant [cyborgs] and the human becomes so unrecognizable that they indeed fall in love … The power of the simulacrum is everywhere. (1992: 313)

Akira, on the other hand, becomes a re-affirmation of recognized core values of traditional Confucian society and so provides a continuity of "morality" which is felt to be lacking in the outside "de-industrializing" world where traditional values are threatening to disintegrate.…

Notes

1. The film, *Akira,* grew out of a best-selling manga (comic) series of the mid-1980s.
2. This essay will attempt to explore the culturally specific codes and practices which a Japanese spectator employs to create meaning and derive pleasure from *Akira.* (Obviously, Western audiences will apply different—non-Japanese—codes and practices in their construction of meaning, thus leading to a different interpretation of the film, an issue not dealt with here.)
3. In Japan, manga and animation films tend to be gender-specific. There is very little cross-readership and cross-spectatorship. In bookshops signs clearly indicate which comics are for girls and which for boys, as does the color-coding of the comic jackets: dark hard colors, blacks and blues, for boys and soft pastel shades of pink for girls. I suspect that at home siblings might engage in a degree of cross-gender readership; however, the industry itself appears to be structured so as to discourage this, despite the fact that thematically gender-specific manga and anime are often similar. At the time of writing (1996) the two top-rated series for boys and girls, *Dragon Ball Z* and *Sailor Moon,* are, despite plot differences, thematically similar. In 1988, at about the same time that *Akira* was released, *Hana no Asuka-gumi* (*The Flower of the Asuka Gang*) was also released. This film is also set in a post-World War III dystopic society where gangs rule the streets, the principal differences being that the main gang members and leaders are adolescent girls.

4. For a detailed exposition of the myths surrounding Japanese cultural and social homogeneity see Dale (1988), Mouer and Sugimoto (1990) and Weiner (1997).

5. A film that plays on this "moral panic" is *Sono otoko kyôbô ni tsuki* [*Because that Guy is Tough,* released in the UK as *Violent Cop*] 1988, starring Kitano (Beat) Takeshi in which he plays a tough policeman fighting corruption inside the police force on the one hand, and drug pushers on the other. The film feeds on fears of the degeneration of Japanese youth and of wanton violence. For example, the film opens with a group of relatively young high school boys beating up a tramp in a park. This is closely followed by a scene in which a group of young primary school boys (wearing yellow caps) are seen throwing cans from a bridge at a boatman passing below.

6. Mouer and Sugimoto also cite Japanese studies which confirm that 'juvenile delinquency ... occurs more frequently among young people whose parents are in blue-collar occupations and self-employed ...'' and that ''... education is not unrelated to the occupational hierarchy. Those with higher levels of education are much less likely to commit crimes, particularly those of a violent nature. Juvenile delinquency is tied to the parents' level of education. Delinquency is lowest among those whose parents have had a university education, regardless of their occupation" (1990: 352–3).

7. The ideal is also based on how Japanese answer questions about their class position—not a very reliable way of assessing status evaluations.

8. For a more detailed discussion of the role of seken and its relationship to the formation of subjectivity, see Sugiyama-Lebra (1992).

9. *Akira* does not have a narrative structure in the traditional Hollywood style, therefore, a plot summary is not very practical. However, the Collectors' Edition Double Pack Video released in Britain provides a file on the principal characters to assist non-Japanese viewers. Here is a brief summary from the tape:

Introduction

Akira ... awakened to his hidden powers, powers that he could not control; powers that swept the megalopolis of Tokyo and the world in the maelstrom of World War III. Our stage is Neo Tokyo, the super techno city of 2019, thirty years after the holocaust—a ravaged city and one totally unaware of the cause of its misery ...

Characters—Data File

KANEDA: AGE 16.
 An outsider who is far from obedient and cooperative. He is known to act before thinking things out. The leader and organizer of a bike gang, he is perceived by his fellow students as more than a little egotistical.

TETSUO: AGE 15.

The youngest member of Kaneda's gang. Known to have an inferiority complex because he is thought to be weak and immature. He is also thought to be extremely introverted.

KAY: AGE 16.

Government assigned code name, her real name remains classified. Joined and became active in a terrorist group shortly after her brother died in prison. Strong willed yet sensitive.

THE COLONEL: AGE 42.

Career military, on special assignment in Neo Tokyo. Father was a member of the Self-Defence Forces and participated in the original Akira Project prior to the start of World War III. The Colonel knows the secret of Akira.

KYOKO.

Sequestered by government. Realized extra-sensory powers at age 9; adept at telepathy and clairvoyance. Number 25 in the top secret Akira Project.

TAKESHI

Sequestered by government. Realized extra-sensory powers at age 8. Especially adept at psycho-kinesis. Number 26 in the top secret Akira experiment.

MASARU

Sequestered by government. Paralyzed from the waist down by polio age 6. Realized extra-sensory powers at age 8. Especially adept at second sight and psycho-kinesis.

AKIRA

28th and most successful ESP experiment. File access restricted.

10. The designer of *Blade Runner* was inspired by the Californian designer Syd Mead who works for Bandai, a Japanese games company, where he designs futuristic images for Japanese computer games. It is more than a little ironic that *Blade Runner*'s cityscape was influenced by Tokyo and then that Otomo Katsuhiro should reproduce it once again, drawing on *Blade Runner*'s 2019 Los Angeles to create his 2019 Tokyo.

11. The nagare-mono film has its antecedents in the matatabi-mono (the wandering samurai/yakuza) genre. In the post-war period the actor Ishihara Yujirô came to prominence as an archetypal outsider in films such as *Ore wa matteruzo* (*I'll Wait*) 1957, and *Arashi O yobu otoko* (*The Man Who Calls the Storm*) 1957. However, Tayama, a Japanese critic writing in 1966, argued that by the early 1960s Ishihara had become entrenched in the establishment by appearing on television variety and talk shows. According to Tayama, this destroyed his nagare-mono persona, at which time the actor Takakura Ken took over the

persona with his success in the highly popular Abashiri bangaichi (Abashiri Wastelands) series.

12. In the nagare-mono films of the 1960s, this code is referred to as jingi, which translates as "humanity and justice". However, in this case, "justice" is not to be confused with the Western juridical-based definitions, but forms part of a nativist Confucian ethic. This term is also used extensively in yakuza films from the 1970s on, for example, the Jingi naki tatakai (War without Morality) series. *Akira,* as a cybernatized version of the nagare-mono film, is primarily concerned with male/male relationships and the strains imposed on those relations by modern society. Female characters are marginalized, their principal function being to shore up the heterosexual imperative of the film.

13. This was ranked third in the Kinema Junpô Top Ten Films for 1967 and is still widely available on video.

14. As television studies on police dramas have shown in the West, the "main difference between heroes and villains is the greater efficiency of the heroes and the sympathy with which they are presented. Otherwise, there are few clear-cut distinctions, particularly in morality or method" (Fiske and Hartley 1989: 29).

15. In the first film of the Abashiri bangaichi series (1965), Tachibana's (the main character, played by Takakura Ken) unhappy childhood is depicted in flashbacks that show him and his mother being abused by his stepfather. This leads to a climactic clash and with Tachibana being thrown out of the house. The earlier films of Ishihara Yujirô are all similarly structured around generational conflict

16. Tetsuo's very name is a play on his changing status in the film, as it means "iron man".

17. Here we have a re-working of a dominant theme of the war-retro genre of the early post-war period in which, through World War II, Japan is purified by destruction only to emerge stronger in the post-war period. This theme is evident in films such as *Daitôyô Sensô to Kokusai Saiban* (*The Pacific War and the International Tribunal*) 1959, and *Japan's Longest Day,* 1967.

Bibliography

Allen, R. C. and Douglas Gomery (1985). *Film History, Theory and Practice.* London: McGraw-Hill.

Anderson, J. T. and D. Richie (1959). *The Japanese Film, Art and Industry.* Tokyo: Charles Tuttle.

Baudrillard, Jean (1988). "Symbolic Exchange and Death" in *Jean Baudrillard,* selected writings edited by Mark Poster. Cambridge: Polity Press.

Cohen, A. K. (1955). *Deliquent Boys: The culture of the gang.* Glencoe, Ill.: The Free Press.

Dale, P. (1988). *The Myth of Japanese Uniqueness.* London: Nissan Institute/Routledge Japanese Studies Series.

DeVos, George (1973). *Socialization for Achievement, Essays on the Cultural Psychology of the Japanese.* Berkeley and Los Angeles: University of California Press.

Fiske, J. and John Hartley (1989). *Reading Television.* London: Routledge.

Fiske, J. (1991). *Television.* London: Routledge.

Greenfeld, Karl Taro (1994). *Speed Tribes: children of the Japanese bubble.* London: Boxtree.

Harvey, David (1989). *The Condition of Postmodernity, an Enquiry into the Origins of Cultural Change.* Oxford: Basil Blackwell.

Hebdige, Dick (1991). *Subculture, the meaning of style.* London: Routledge.

Jameson, Fredric (1983). "Postmodernism and the Consumer Society" in *The Anti-Aesthetic, Essays on Postmodern Culture* edited by Hal Foster. Port Townsend, W.A.: Bay Press.

Lash, Scott (1991). *Sociology of Postmodernism.* London: Routledge.

Mouer, R. and Sugimoto Yoshio (1990). *Images of Japanese Society: A study in the social construction of reality.* London: Kegan Paul International.

Otomo, Katsuhiro n.d. *Akira* (orginal screenplay in Japanese).

Satô Ikuya (1991). *Kamikaze Biker, Parody and Anomy in Affluent Japan.* London and Chicago: University of Chicago Press.

Sontag, Susan (1979). "The Imagination of Disaster" in *Film Theory and Criticism, Introductory Readings* edited by Gerald Mast and Marshall Cohen. Oxford: Oxford University Press.

Sugiyama-Lebra. E. (1992). "Self in Japanese Culture" in *The Japanese Sense of Self* edited by Nancy R. Rosenberger. Cambridge: Cambridge University Press.

Tayama R. (1966). "Abishiri Bangaichi: Nagare-mono no Erejii" in *Shinario* (October): 134–7.

Weiner, M. (ed.) (1997). *Japan's Minorities: The illusion of homogeneity.* London: Routledge.

–4.4–

Patriotism and Nationalism: The Face of Consensus: Mid-Twentieth Century and the Image of Jesus
David Morgan

As an image that appealed to both Protestant and Catholic subcultures, Walter Sallman's picture of Jesus, *Head of Christ* was used to redirect the nineteenth-century crusade to make the United States a *Protestant* nation toward a twentieth-century campaign to promote the United States as a *Christian* nation. During World War II, Sallman's picture was distributed as a non-sectarian image of Christ among American servicemen in Europe and Asia through the United Services Organization (USO) by the YMCA and the Salvation Army. The filial piety of Jesus, gazing reverently to heaven and bearing an expression of solemn, self-effacing submission to his father's will, also characterized the proper attitude of self-sacrifice encouraged by the government during the war … Following the war, Sallman's imagery was put to more aggressively exclusivist use. A Lutheran businessman in Indiana undertook a project called "Christ in Every Purse." His aim was to distribute wallet-sized versions of the *Head of Christ* as widely as possible. The businessman contrasted the need for "card-carrying Christians" to the threat of "card-carrying Communists." His campaign continued through the 1950s and into the 1960s as cold war anticommunism gripped America.[1] A similar, yet historically ironic development took shape in Oklahoma in the late 1940s and 1950s as Ora O'Riley, a Choctaw Indian and Roman Catholic, led a local campaign to make her hometown of Durant, Oklahoma, the only city in the United States to display a picture of Christ in every home and public building. Whereas nineteenth-century evangelical publications often pictured Protestant missionaries at work among Native American communities, O'Riley returned the favor in the mid-twentieth century as a Roman Catholic and Indian placing Christian images in the public spaces of her town in eastern Oklahoma, where the Choctaw nation had migrated in the late eighteenth century, after a colonial history of alliance with the French and enmity with the British. In 1949 O'Riley persuaded a district judge to hang a copy of Sallman's *Head of Christ* in his courtroom in Durant. Soon the image was proudly placed in the local municipal court, city hall, the fire department, and the chamber of commerce. In 1962 the city of Durant was pleased to have an autographed copy of Sallman's picture accepted by Vice President Lyndon

Johnson, who posed in a publicity photo gazing reverentially at the picture of Jesus (Figure 9).[2]

Why was Sallman's image the one to be so widely distributed, avidly received, and ecumenically approved of by diverse Christian groups—from Catholic to Lutheran, Methodist, Baptist, and even Mormon? Surely its nonsectarian portrayal helped. Sallman created an image that avoided the specificity of any denomination and combined with that a direct appeal to the pietistic inwardness that corresponded to a dominant strand of popular evangelical Protestant belief. At the same time, the image's soft demeanor registered among Catholics as a devout portrayal of the Savior that comported visually with the mass-produced images of saints so popular on holy cards before the reforms installed by the Second Vatican Council (1962–65) consigned them (at least for many younger Catholics) to an embarrassing and Old World past. Moreover, in the midst and then the wake of World War II, Americans experienced what was doubtless the last moment in the twentieth century when Christianity could represent a broad national consensus. If the national star of Protestantism had dimmed, the war did much to stoke the flames of Christian piety and national fervor, and Sallman's image of Jesus, more than any other, became the emblem of a national Christianity, a generic religion that served in a period of national crisis to evoke the pieties of hearth and home and patriotic cultus. The ascendancy of this face of Jesus, which avoids the paraphernalia of divinity and stresses his human submission of his father's mission, may mark what sociologist Will Herberg hailed as the tripartite religion of America in mid-twentieth century in his widely noted book, *Protestant-Catholic-Jew.* Herberg described the social function of religion in American life: being Protestant, Catholic, or Jewish had become for Americans the

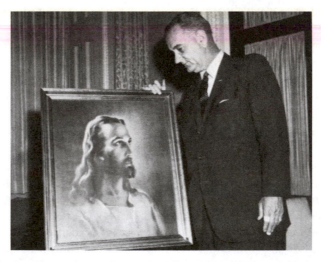

Figure 9 Vice President Lyndon B. Johnson with Sallman's *Head of Christ.* Reproduced by courtesy of the *Durant Daily Democrat.*

"specific way ... of being an American and locating oneself in American society."[3] Protestantism was no longer the sole official, national religion of the United States but one of the three official ways in which Americans understood their national identity as Americans. Sallman's picture of Jesus was accepted by many Protestants and Catholics as the image of their savior and widely recognized by many Jews, no doubt, as the Christian savior. But the image also served as a very familiar symbol of American piety. Local chapters of the American Legion used the image to publicize that organization's "Back to God" campaign in 1955, which President Eisenhower helped inaugurate with an address in which he asserted that belief in a supreme being was the "first, the most basic, expression of Americanism. Without God, there could be no American form of government, nor an American way of life."[4] It didn't matter what particular supreme being that might be, only that one had belief in it. Yet Herberg suggested that Protestantism, Catholicism, and Judaism collectively constituted this "way of life" for Americans. Although he warned that such culture-religion lacked the prophetic voice of genuine biblical faith, Herberg insisted that the "American Way of Life" was a real religious sensibility, what he called a "civic religion," that bound Americans together into a middle-class ethos.[5] For many Americans but not all, Sallman's Jesus visually expressed this ethos and national identity, placing a Christian face on America. The image was able to signify simultaneously the non-sectarian consensus of faith at mid-century in the nationalist civil religion *and* the sectarian beliefs of groups as disparate as Baptists, Methodists, Lutherans, and Roman Catholics. The *Head of Christ* silently assured American Christians that the "supreme being" of the national religion was Jesus Christ. Once again, a symbol became an icon and infused patriotism with the religious fervor of nationalism.

The cold war-era campaign to place pictures of Jesus in public buildings marched in step with the infusion of theological language in the Pledge of Allegiance but was perhaps an even more obvious attempt to turn the clock back to the days of the Bible in the classroom. The need for certainty in an atmosphere of panic and fear could express itself in the paranoia of McCarthyism and, less fanatically and more prosaically, in the impulse to secure public spaces and institutions as well as children under the protective presence of the nation's totem. In 1965 a copy of Sallman's familiar picture of Jesus was hung in the hallway of a Michigan public high school to commemorate a beloved secretary. It remained there without comment until 1992, when a student objected to its presence and the American Civil Liberties Union (ACLU) filed suit on the student's behalf in federal court, charging violation of the constitutional separation of church and state, since the local school board supported the superintendent's refusal to remove the picture.[6] After receiving an offer of assistance from evangelist Pat Robertson's 700 Club, the school board agreed to accept legal defense free of charge from the conservative Rutherford Institute of Charlottesville, Virginia, an evangelically sympathetic, private legal foundation committed to promoting freedom of religion. In an attempt to conceal the particularist aspect of the image's meaning for Christians, the school's lawyer argued that the image did not

endorse a particular religion but represented Jesus as a historical figure and therefore served a secular purpose rather than a religious one in the public school. Frequent editorials in local newspapers contended that removing the image contradicted the principles enshrined in the Constitution by the founding fathers. "Our country," as one editorialist wrote, "is founded on the principles of God and the morals He teaches through the Bible, his recorded word."[7] The ACLU maintained that the image offended the agnostic student by promoting Christianity.

In a nineteen-page decision, district court judge Benjamin Gibson rejected the school's argument and ruled in favor of the plaintiff, stating that "the true objective [of the image's display] is to promote religion ... in general and Christianity in particular." Gibson also found that the defendants' "declaration that the picture is displayed as an artistic work or that it is a depiction of a historical figure does not blind this Court to the religious message necessarily conveyed by the portrayal of one who is the object of veneration and worship by the Christian faith."[8]

Supporters of the school board ritualistically cloaked the image (Figure 10) in a red shroud produced by a local women's group and cheered successive attempts at appeal all the way to the United States Supreme Court, which, on May 1, 1995,

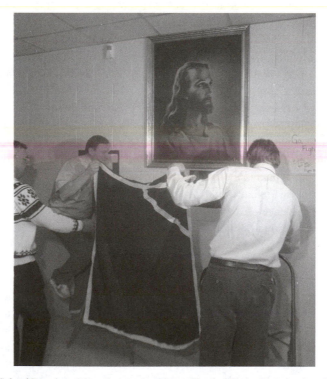

Figure 10 School Board president places a shroud over *Head of Christ*. Photographer: Jim Merithew. Reproduced by courtesy of the *Herald-Palladium*.

announced its decision not to hear the case, letting stand the appellate decision to support Gibson's ruling.[9] When the image was finally removed, local clergy led prayer as supporters wept. School officials left in place of the image the shroud that had covered it. In following days students pinned picture buttons of Jesus to the shroud, but these were removed shortly later after the ACLU threatened to take the school district back to court.[10]

The story turns on the recurring recourse some Americans have made to religious visual culture in order to respond to the perceived instability of their democracy, through the recent and decisive rejection of the placement of a mass-produced picture of Jesus in a public space, however generic or putatively "historical" that Jesus may be claimed to appear.

The image served as the means for dispersing influence in a nation for which any religious definition of national identity could only be voluntary and not endorsed by the state. In each case the subtle but significant transformation of patriotism into nationalism is evident in the symbols and paraphernalia of an American nationalist cultus.

Notes

1. See David Morgan, "Would Jesus Have Sat for a Portrait? The Likeness of Christ in the Popular Reception of Sallman's Art," in *Icons of American Protestantism: The Art of Warner Sallman,* ed. David Morgan (New Haven, Yale University Press, 1996), 192–3. The campaign persists to this day in the work of a Florida man named Morris Richardson, who began in 1949 to hand out wallet-sized images of Sallman's picture after the manner of the Indiana businessman, Carl Duning, who had initiated the project during World War II. See Sharon Kirby Lamm, "His Nickname Is Just Picture Perfect," *St Petersburg Times,* February 18, 1995, 10; and Jim Carney, "Faith Is in the Cards," *Akron Beacon Journal,* November 29, 1997.
2. For a photograph of O'Riley posing with the *Head of Christ* and district court judge Sam Sullivan, see *Durant Daily Democrat,* Sunday, August 28, 1949, 1; see also *Covenant Weekly,* 39, March 24, 1950, 1. Judge Sullivan appears in another photograph with an autographed picture by the artist, Warner Sallman, which Sullivan placed "on the wall above his bench in the district courtroom here" (*Durant Daily Democrat,* December 6, 1950, 1). The police chief, the mayor of Durant, the postmaster, and the president and the manager of the Durant Chamber of Commerce were also presented by O'Riley with Sallman's image (*Durant Daily Democrat,* December 22, 1949, 2; April 30, 1950, 1; May 4, 1952, 4).
3. Will Herberg, *Protestant, Catholic, Jew: An Essay in American Religious Sociology,* rev. ed. (Garden City, NY: Anchor Books, 1960), 39.
4. Ibid., 258.

5. Ibid., 75, 80, 263.
6. By the 1990s, a wing of American evangelicalism had emerged as a prominent conservative force committed to the political Right. Led by such media-savvy figures as Rev. Jerry Falwell and Pat Robertson, the evangelical Right abandoned the apolitical position espoused by earlier generations of fundamentalists, Pentecostals, and evangelicals for an explicit advocacy first tapped into by Ronald Reagan during the 1980s.
7. Vera Stafford, "Christians need to speak up about Christ's picture," Letters to the Editor, *South Haven Tribune,* December 4, 1992.
8. Hon. Benjamin F. Gibson, *Washegesic vs. Bloomingdale Public Schools,* February 3, 1993, United States District Court, Western District of Michigan, Southern Division, File No. 4:92-CV-146, pp. 9–10. It is worth comparing the judge's rejection of the argument that the image was acceptable as a historical portrayal or an artistic work with previous case law. In the 1869–70 Cincinnati case, lawyers for the defendants, the board of education, argued the *McGuffey's Readers,* six of which the plaintiffs had entered as exhibits (as evidence that removing religious instruction from the public schools would require the elimination of all *Readers* at great expense to the school system, even leaving students without books), were not in fact religious books and therefore did not contradict the board's decision to eliminate Bible reading and religious instruction from the class room (*The Bible in the Public Schools,* Cincinnati, OH: Robert Clarke, 1870, reprinted by Da Capo Press, 123, 211). As one attorney claimed, when the Bible is read in opening exercises accompanied by singing, it becomes an act of worship; but when "the class takes up the Fifth Reader and reads the fifth chapter of Matthew ... it is done ... if your Honors please, not as the words that fell from the second person of the Godhead, when incarnate on earth, but as a beautiful specimen of English composition—fit to be the subject of the reading of the class—and stands, so far as that exercise is concerned, on the same footing precisely as a soliloquy from Hamlet, or the address of Macbeth to the air drawn dagger" (211). In a much later instance, a similar appeal to historicity prevailed: when requested by Muslim groups to remove a sculptural portrayal of Muhammed from a frieze in the U.S. Supreme Court building, Chief Justice William H. Rehnquist defended the presence of the image as "intended only to recognize [Muhammed] among other lawgivers, as an important figure in the history of law" (as discussed by Sally M. Promey, "The Public Display of Religion," in *The Visual Culture of American Religions,* ed. Morgan and Promey, 40–41). The difference would appear to consist entirely in the pedagogical setting of the first instance and the visual context of Sallman and Court building images in the other two examples. Were Christ's image hanging beside honorific portraits of Washington and Lincoln in Bloomingdale High School, and therefore displayed as portraits and as historical persons, one wonders if the judicial judgement might have been otherwise.
9. "Supreme Court Roundup," *New York Times,* May 2, 1995, A12.

10. The ongoing event stimulated robust press coverage and a flood of editorials from Michigan residents. See Cathy Sisson, "Citizens: Christ's Picture Belongs," *South Haven (MI) Daily Tribune,* November 5, 1992, 1, 3; Cris Robins, "Cover Hung over Jesus after Vigil," *Herald-Palladium,* March 1,1993, 1, 4; Charlotte Channing, "Jesus Portrait Ruled Illegal," *Kalamazoo Gazette,* September 7, 1994, 1, 2; Rod Smith, "Jesus Portrait Down, Not Necessarily Out," *Kalamazoo Gazette,* February 2, 1995, 1, 2; and "Bloomingdale Must Remove Jesus Portrait," *Kalamazoo Gazette,* February 9, 1995, 1. It is noteworthy that no editorial writers that I am aware of identified themselves as Roman Catholic. The only view taken publicly by a Catholic person in the community was from a local priest, who dismissed the importance of the entire affair, stating, "I think the Lord is much more concerned about [starving children today] than … where his picture is on the wall in a school in Bloomingdale" (Dave Person, "Priest, Nun Bidding Farwell to St Thomas More," *Kalamazoo Gazette,* June 18, 1995, D1, D3).

–4.5–

The Illumination of Christ in
the Kalahari Desert

Paul Landau

A Journey

Towards the end of the year 1920 the Kanye Church had completed its preparations to send me to visit the Churches at Lehututu. That place lies in the Kalahari Desert about 300 miles West of Kanye and just beyond what is known as "The Thirst Belt". It was arranged that one of the Kanye Elders named Peco, who had been there on several occasions, should accompany me, also the Rev. T[sibalala] S. Maalane, Native Minister of Moshupa.

 We left Kanye per ox-waggon on the afternoon of the 24th of January 1921, and reached our destination on the 21st of February where we spent a very busy fortnight. The heat on the outward journey was intense. The waterholes were from 50–100 miles apart and as the roads were very sandy and the rate of travel slow the oxen suffered a good deal from thirst.[1]

This laconic announcement opens the 1921 annual report for the southern African town of Kanye, Botswana, submitted to the London Missionary Society (LMS) by the Rev. Ernest Dugmore. Dugmore was a Calvinist by training, but he had married into one of the few dynastic families of the mainly Congregationalist LMS. After ten years of teaching at the premier "Native College" in South Africa, at age 35 he joined the Society and became a missionary to the BaNgwaketse (BaTswana) people of the then Bechuanaland Protectorate. While Ernest Dugmore was perhaps "not very quick," as mentors remarked, he was aptly named; and in his third year of work he took the unusual step of enclosing with his report an eighteen-page typescript diary of the evangelical journey into the Kalahari.[2] In the diary Dugmore gave himself freer rein. The desert (properly, the Kgalagadi) becomes The Desert, and he becomes its latter-day apostle. His recurring metaphors position Africans as "lost" (spatially

and spiritually) and as suffering "thirst" (for water and for salvation). Less appropriately for the cloudless Kgalagadi, Africans are also thrown into the trope of darkness, hesitantly peering into the Light.

From his redactive report:

> I spent a fortnight among the people trekking about from village to village, preaching by day and showing the Life of Christ by night by means of a Magic Lantern. The interest was intense. One could feel the soul-hunger, the thirst for more knowledge.[3]

By including an extract from his diary Dugmore illustrates this thirst which was also a getting lost in the desert night:

> After dinner an old man … came to me with the question, What must I do to find the Way? … Then he, Tsibalala and I knelt down in front of the waggon and he gave himself to Christ. Poor old man; he had waited more than a hundred years [his supposed age] for the Light. It was worth coming to the Desert to bring it to him.

But only the diary continues directly with the sentence: "I took his photo but I am afraid it won't be a success as the camera did not work properly."[4] Not only was the old man subjected to the strange spectacle of the Magic Lantern. His seminal prayer finished with Dugmore turning on his heels and aiming at him a similar machine—in fact, the lantern's small cousin. Dugmore had intended to operate both, in tandem. The first worked, the second did not.[5]

Fortunately, the Rev. Dugmore valued the lantern especially highly. Its presence shaped his thoughts during his weeks in the desert. He wrote, "Shall we, whose souls are lighted/With wisdom from on high—/Shall we, to men benighted,/The lamp of life deny?" And he sought to deny no one his lamp. In Lokgwabe (population 300), on 25 February,

> the [lantern] pictures were a great success. One man and one woman broke down and sobbed aloud when I showed Christ knocking at the door and we sang "Behold me standing at the Door" … The people hung around singing hymns for at least half an hour after the pictures.[6]

> …

> I showed the lantern here tonight; there was quite a good crowd present. About a dozen women went into hysterics during the singing of the last hymn. Some of them were pretty bad; one or two seemed to get a fit and had to be held down by their friends.[7]

A few days later Dugmore was in Kwatle, showing his Life of Christ to Namaqua Christians. They had demanded Dugmore come with his slide show, and offered him a team of oxen to carry his lantern the thirty miles. These Namaqua had built a mud pulpit in a huge hut (labeled "House of the Lord" on the entrance in Dutch), perhaps

in emulation of the Rhenish mission churches they had left when the German army drove them out of Namibia sixteen years before. On 1 March, Dugmore went back to Gukuntsi, ... and "immediately unpacked the lantern and showed the pictures to a big crowd. The chief and Ethiopian leader were both present to welcome us.—a number of women went into hysterics." Dugmore thinks of the apostle Paul, but preaches from Isaiah. He writes:

> Many who are very poor have brought [their monthly contributions] or money to buy a book; all are seeking light—oh what darkness—sitting in the shadow of death—groping for God—Lord help me that I may help them.[8]

It was this emotionalism that rendered Dugmore's diary unpublishable for the LMS Directors; a note after its title reads, "File as report." And in fact, Dugmore's ruminations grew even more unusual a week later:

> *8th March, 9.30 a.m.* Ready to leave, wagon went round by wells to fill tanks [where there was a?] lot of limestone. The lamp again fell on to some clean s[u]gar bought from the local store, the paraffin ran out but fortunately the sugar was not touched as it was in a tin. This is the third time the lamp has emptied its paraffin over the sugar. The second time was when in a dream I was running away from an ostrich I kicked the lamp over on to the sugar tin, fortunately no damage seems to be a strong affinity between sugar and paraffin.[9]

At home in the world of his own dreams and musings, Dugmore was strangely confounded by the reactions of Kgalagadi people to his "pictures." His only written comment was, "rather weird. Well, it is past midnight—this is not good preparation for a busy day tomorrow." As fervent and emotional as Dugmore's world was, nothing articulates its insular nature more clearly than those inarticulate words.

The Magic Lantern

Dugmore's lantern was an old, heavy-weight projectionist's model, probably made from brass or "Russian iron" lined with asbestos, and bussed about by "Scotch cart." He used it outside, at night, projecting onto a damp sheet Dugmore's party draped where they could. Its illuminant was acetylene gas. Calcium carbide was kept in an airtight container until it was brought into contact, with water; this produced acetylene, which was then forced through a nozzle and lit. Such a lantern was almost a curio in 1920, as the day of the lanterns was passing in Europe by the time cinema arrived in the early years of the century. Where they still made an appearance, the older method of "limelight," burning a cylinder of lime with an oxyhydrogen gas jet, was more common than acetylene. Both techniques sometimes resulted in explosions and sometimes killed the lantern operator or members of his audience.[10]

In a sense Ernest Dugmore's tangible Kgalagadi world, as opposed to his inner realm of evangelical emotion, was made of cameras, lamps, sugar, paraffin, calcium carbide, and other items literally coming to hand. The local tailor's tanned leather "looks exactly like khaki." The wheels of his cart become clogged with mud and "look like huge tank wheels." Material objects grew especially visible when surrounded by the desert. Moreover, they possessed a certain willfulness, like objects in a painting by Magritte. Cameras malfunctioned, paraffin slid into sugar, and the whole mess—twice in the diary!—segued into dreams. The incongruousness of the lantern did not escape Dugmore. "As I was showing the pictures I suddenly realized that I was the only white man present and that I was hundreds of miles from my home." Air travel became a topic of conversation two days later: Gukuntsi's "old chief, Lekaukau ... was very interested in aeroplanes. It seemed incredible to him that a machine could fly to Kanye and back again on the same day." But aeroplanes often crashed in the early 1920s; "Scotch carts" overturned with their cargo; and now, even the lantern misbehaved:

When packing the lantern [in Kwatle] I nearly had a nasty accident: there were a few unused carbon stones [i.e. calcium carbide pieces] so to show the people how the gas was generated I dropped these into the water. The man with the lantern held the flame just above the gas and there was a terriffic [*sic*] explosion.[11]

One suspects this stymied people's curiosity.

How came the lantern into Dugmore's hands? Many Nonconformist missionaries used the device in Africa, starting with David Livingstone in the 1840s, who may have relied on it to attract "gifts" of food for his retinue. Here is Livingstone's most notable description of its use, with a levered slide:

The first picture exhibited was Abraham about to slaughter his son Isaac; it was shown as large as life, and the uplifted knife was in the act of striking the lad; the Balonda men remarked that *the picture was much more like a god* than the things of wood or clay they worshiped.... [W]hen I moved the slide, the uplifted dagger *moving toward them,* they thought it was to be sheathed in their bodies instead of Isaac's. "Mother! mother!" all shouted at once, and off they rushed. [My italics][12]

The lantern really came into its own thirty years later. Companies such as Primo, Briggs, and Bramforth produced hundreds of sets of lantern slides using the innovation of dry-plate photographic reproduction. Cheaper cameras and available stock sets soon resulted in a rampant amateurism, which chipped away at the "profession" of lanternism. Nonetheless, in the 1880s the lantern entered a short period of equilibrium, wherein its use became *de rigueur* for the interventionism of Victorian moral teaching

. . .

Among the testimonials included in the "lantern mission's" newsletter were, "I felt as if I was there walking about with Christ," and "The music and the pictures broke

down my infidel philosophy."[13] Many English church goers in fact learned about infidel philosophy through the same medium. Pictures of pyramids, African villages, and Indian princes were put in the service of raising local funding for missionaries' efforts in foreign lands. The dimensions of space and time were uncoupled in these shows as the lanternist often gathered his own images of exotic locales and grouped his slides together as he wished. Each slide held its own cohesive bundle of meaning, yet each was deposited into an apparently coherent narrative; one abrupt leap to the next image occupied the same logical space as the last. Even in a standardized slide set, "England Before the Roman Invasion," one finds for instance "slide 35, African village. It is concluded, perhaps somewhat too hastily that [English] houses were little better than the huts of the rude tribes of Africa or Asia."[14] For an East End London audience in a darkened room, "disbelief was suspended"; viewers seemingly confronted real artifacts from other times and places, in—as one lanternist put it—"an imaginary trip around the world."[15] There were different levels of lantern entertainment, encompassing both the itinerant showman's "scenes" of the Orient and the Royal Colonial Institute's fare, which in 1898–99 included views of the Malay peninsula, Trinidad, "The Native Races of South Africa," and Queensland.[16] Always, however, the lantern lecture pointed to the ultimate superiority of European civilization, so that when the spectators awoke at its end, as it were, they found themselves in the best of all times and places, even if their homes lay in crowded slums.

The "suspension" of the observer in the dark, the displacement of him or her into a nonspace, is a part of the visual world familiar to most people today. It is what happens when one goes to the movies. As Walter Benjamin put it, technology has "subjected the human sensorium to a complex kind of training."[17] Alongside, and indeed before, cinema, photography, and stereoscopes, lantern shows initiated this training. Paul Virilio would include swift travel by rail, automobile, and "aeroplane": all these mechanisms tend to erase distance and disengage time from its normal referents.[18] The stereoscope user and airplane passenger do not reenter the world unchanged, and they pass their transformation into the fabric of their culture.

It was this very experience that Kgalagadi people lacked.

"Christ" Seen and Christ Spoken

On the one hand, Dugmore's habituation to the seeming portability of rooted things enabled him to come to the Kgalagadi. He carried the world he understood with him. On the other hand, even the unspoken assumptions behind imagery in his representations of Christ and other figures were strange to BaKgalagadi. BaKgalagadi did not implicitly date the images to after Christ's life, nor possess a context in which to set such an historical knowledge. If Dugmore wanted to say "picture," the word he or Peco or Maalane used was *setshwantsho*, "thing similar to another thing," or a cognate of the term, for which there is no evidence of usage before the colonial advent

of pictorial imagery.[19] *Setshwantsho* is a revealing word; according to the traveler Henry Methuen,

> there were in Mr. Moffat's house two good likenesses of himself and his lady, on first beholding which, the Bechuanas were struck with amazement; saying they were glad that the originals of the pictures were both present, else they should have concluded that these were their ghosts, or their skins stuffed.[20]

We may reject Methuen's condescension but perhaps not his reportage. Rural southern Africans knew ghosts and skins but not Europeans' language of pictorial imagery. One further example shows this clearly. In 1879, a band of Jesuits passed through the Tswana town of Shoshong, carrying with them an unusual canvas:

> For two days the entire population of Shoshong came along to admire our picture of Christ. But they were shocked at seeing a Zulu, a Matabele and a Becwana in adoration at the foot of the cross. They were unable to understand how or why these Blacks were there. We could not make them realize that this symbolized the calling to the faith ... In desperation, we feel that we shall have to alter the figures in the picture.[21]

The Jesuits assumed that images encapsulate and explain themselves, but for BaTswana the painting was either a lie or it was not.

Now, what of the projected lantern image itself? It was neither fixed on a canvas nor framed but floated and shimmered. As experienced in the dark by BaKgalagadi, it shared some of the characteristics that John Tagg has attributed to the photograph: that is, it concealed the contingencies of its own presentation. Tagg argues that the means by which photographs fix and frame objects and people seem to vanish when we look at a photo, as the signified is "collapsed" into the signifier. And indeed one man who witnessed the lantern in Kanye supposedly told Dugmore's driver, "This missionary not only talks about the Son of God but he shows us His photo. I now know what he looked like, and I can believe what the Missionary says is really true."[22] Yet whichever word was spoken, *setshwantsho* or even *photo,* it is very unlikely that Dugmore had photographs of live models playing Christ. Would it have mattered if he had? In the end it is not the presence or absence of photographs that is critical (though photographic reproduction was important). The transparence of the lantern's pictorial signification, and what such "transparence" meant, has to be gauged by people's reactions.[23]

Transparence presumes some unadulterated original, at least an original experience. But here we have come to a new obstacle. The lantern, pictorial reproduction, and the night sky allowed each viewer to make the image of Christ his or her own: to have a moment where other people vanished as He loomed large.[24] But Who was He? What were such images "of"? "Christ Knocking at the Door," one of Dugmore's slides, demonstrates the complexity of this problem. William Holman Hunt's picture

The Light of the World, of which the slide was some version, was the first piece of "high art" to be mass reproduced (and pirated) by mechanical means. One critic noted in 1890 that "there is scarcely a home in England which does not possess it in some form, as an etching, or an engraving."[25] Hunt himself painted several copies, and one of them even traveled to the South African countryside, where Boer farmers marveled at its lifelike quality. Such was Hunt's plan, for he wished his Christ to appeal in this way to everyone.

BaKgalagadi, however, would not have been struck by Hunt's attempt at a stark humanization of Jesus—not from a slide shown on a wet sheet, many times removed from the painting. And though it is hard to know how the BaKgalagadi saw Hunt's precise symbolism, adapted from Revelation, of the lamp and so on, it may be that they supplied their own symbology to the image of a robed man at a door after dusk. After seeing slides in Lokgwabe, congregants also sang the following hymn, fervently, and well into the night:

Look, I stand at the doorway,
Still crying out a prayer;
I keep on saying: Your heart,
May I enter? May I enter? [Etc.][26]

While there was no precolonial SeTswana idiom for "entering a heart," there was one for entering a hut: this meant a man had assumed the privilege of sexual intercourse. Huts belonged to women; the homestead grounds as a whole, with their several enclosures, were common family property. I do not want to argue that fainting Kgalagadi women interpreted the knocking Christ as actually claiming sexual rights over them, but this hovering meaning of "to enter a hut," *go tsena motlong,* certainly added the most intimate flavor to His presence.[27]

The BaKgalagadi were not participants in the culture that predicted, in its confluence of artistic traditions, nearly everything about Christ's pictorial form. And if this seems an overly general way to put things, it should be remembered that from the Kgalagadi perspective the similarities between Hunt's Christ and the homogenized Jesus of Briggs & Co.'s pastel stereotypes completely overmatched their differences. The amoeboid "model" of these images was obscure. On the other hand many BaKgalagadi read the Bible and hymn book, and lantern images necessarily found meaning in Kgalagadi ideas moving from them. All biblical persons in Dugmore's slides were equivalent in this way, in that they echoed Kgalagadi images and interpretations of text.

The same was true for the spoken word; BaKgalagadi had to mediate statements "identifying" the images presented. They were *spoken of* as Christ (and other biblical figures). Although sermons indexed Christ in biblical time, how much mitigating context did this provide? BaKgalagadi held no notion of the "ancient" in the Western, literary sense, no unapproachable realm of narrative, and the Christ they saw existed in their cyclical time, which extended back only a few generations. *Ke Jesu*

Keresete meant "This is Jesus Christ" but, in a particular *Sprachenspiel,* one that named forms in a way sensible to learnt, normalized situations. A new situation arose in the Kgalagadi, and Dugmore or Peco still had to say, "This is Jesus Christ." In Gukuntsi, after women became "hysterical," Dugmore chose to preach from Isaiah 55.6–7: "Seek the Lord *while he is present,* call to him while he is *close at hand.*"[28] Indeed He might be "felt" to be "close."

Perhaps women's hysteria erupted out of this discordance of meaning. For not merely was a luminous picture of Christ (or Isaac, Mary, etc.) not Christ; it was not even of the "real" Jesus, the one who missionaries told their audiences walked, lived, and died. Whether the image before BaKgalagadi was explicitly identified as the Son of God, or as a "thing similar" or "like" Jesus, it was BaKgalagadi who had to fit His presence where they could.

Dreams

I would suggest that His illuminated image fit best in the realm of those other nocturnal visitations, dreams. It is known that dreams and visions were often the means by which departed ancestors communicated with the living in southern Africa. Men and women referred to them in order to explain the necessity of propitiating their ancestors. There was thus an expressive tradition, an internal frame always ready to be externalized, which had developed as an interface with dis-corporeal, "spiritual" beings. The magic lantern played into it.

Did BaKgalagadi suddenly imagine themselves asleep? No. *Dream* is too precise a term, and we must merge dreams and visions—perhaps into "dreams/visions"—in southern Africa. However we define our Western notion of "the dream," its semantic contours were not shared by Kgalagadi people, who talked of *ditoro* (now glossed as "dreams") and *diponatshego* ("visions") and *dipono* ("seeings") in various contexts now forgotten or mnemonically altered.[29] To ask what "dreams" exactly were to BaKgalagadi is to drop an English-language term into a distinctly non-English discourse. The issue is not whether "they" felt *dreams* had great import, or saw *dreams* somehow as less divorced from waking life than "we" do. The question should be how Kgalagadi societies constructed categories of personal visual experiences, and how they then used those experiences.[30]

At the turn of the century, a sick southern African (Christian or no) might well "see" their deceased grandfather, who would command them: "Arise and depart."[31] Christians sometimes heard this as a directive to attend church. In this way many people used and still use the space of dreams/visions to "explain" and construct the rationale for their conversions.[32] One man I spoke with said,

> I saw a light in my dream. I saw somebody standing in the middle of the light with a white jersey-coat in the light ... He [was neither African nor European], he had the color of the light.[33]

Another man told me that, sometime in the 1940s,

> in the night while we were still sleeping I heard a person calling my name, saying "Koowetse, Koowetse, get up and pray." But I did not know how to pray ... He was a person of whiteness only dressed in white cloth, not wearing a hat or any shoes.[34]

People do not *re-cognize* sensations along paths for which they have no sense of direction; no people assimilate experiences into categories that they cannot express. If we take seriously the idea that BaKgalagadi had to "see" lantern images of Christ in terms that they themselves "spoke," then the acetylene-bright images seen in the central Kgalagadi in 1921 had to be spoken later. Dreams/visions provided a compartment for their digestion, as they did for any apprehension of luminous nocturnal images.

After all, apart from fire and paraffin lanterns, there were few sources of terrestrial nocturnal light experienced by BaKgalagadi other than the imagined light of dreams/visions. And light and whiteness in dreams were not neutral phenomena; they were qualities of the space of the ancestors. The ancestral world was conceived as being bright, clear, and yet concealed, attributes that also prepared it for biblical imagery. In 1901 the Rev. W. C. Willoughby spoke to a catechumen in Phalapye, GammaNgwato, who dreamed of a "very lovely city, full of strange people, white and glistening. The town, also, was radiant with splendour and there was not a stump in it." Later in 1902, another man had a vision of "a very bright light."[35] Visions/ dreams associated Dugmore's illumination with the "white" realm of dis-corporeal beings for the BaKgalagadi, which then embraced God as well.

Such an apprehension of the image of Christ thus resonated with biblical revelations as well as personal ones. But, moreover, it was completely in accord with the half-forgotten essence of the lantern. The lantern was after all magic; the prototype lanterns of the seventeenth century projected imagery from "nature," transposing one part of space as a ghostly echo into another. Christian Huygens explained the point of the lantern in 1659 as "to frighten people," and it was sold at the time as "the lantern of fear." The Leipzig coffeehouse owner, Schropter, who pioneered back-projection onto smoke, claimed "to bring back spirits from the dead."[36] Dugmore felt himself to inhabit a world of the Spirit and of dreams, but he was unaware that his apparatus lived partly in that world, too.

This essay is based on research conducted in Botswana and the United Kingdom in 1990, with a Department of Education Fulbright grant; and in Rochester, New York, and London with grants from the College of Liberal Arts of the University of New Hampshire, for which I am most grateful. It is part of the core of an ongoing, comparatively based work that will trace the serial and parallel trajectories of Christianity, image reproduction, the lantern, the gun, the lens, and the camera through the Kalahari Desert.

Notes

1. Council for World Missions (London), London Missionary Society, South Africa (hereafter LMS/SA), Reports, box 6, file 1 (i.e., 6/1), Ernest Dugmore, "Report for 1921, Kanye, B. P."
2. The comment "not very quick," and several remarks on Dugmore's "earnest" turn of mind, appear in file 9in LMS, Candidates Papers, 2nd ser., box 11.
3. Dugmore, "Report for 1921."
4. Both quotes are from Ernest Dugmore, "Across the Thirst Belt to Lehututu" (1921), LMS/SA, Reports, 6/1, p. 5. Dugmore capitalizes *Light and Desert.* In the report proper, the "excerpt" differs mainly in having "the Master" for "Christ."
5. For the lantern/camera connection, see Hermann Hecht, "History of Projection I," *New Magic Lantern Journal* 6, no. 1 (June 1989); Josef Maria Eder, *History of Photography,* trans. Edward Eptean (first published in Germany and subsequently revised; New York, 1978). As is well known, both mechanisms descend from the medieval *camera obscura,* which resolved an inverted image onto a surface inside or beneath it.
6. Dugmore, "Across," 12. The slide shown was thus some version of William Holman Hunt's The Light of the World, or an image drawn from it. See below.
7. Dugmore, "Across," 13.
8. Ibid, 14.
9. Ibid, 16. The spacing is as it is in the typescript.
10. I would like to thank Dr. Rudolf Kingslake and the staff of the George Eastman House Museum for helping with this identification and for showing me the museum's collection of period catalogues (i.e., *Catalogue of Science Lanterns, Optical Lanterns, and Dissolving View Apparatus, Newton and Co. 1904,* etc.). See also *Optical Magic Lantern Journal and Photographic Enlarger* (1889–1903), held at the British Library, hereafter *OMLJ.* Acetylene illumination was introduced in 1895.
11. Dugmore, "Across," 13. I think Gwyn Prins's emphasis (in "The Battle for Control of the Camera in Late Nineteenth-Century Western Zambia," *African Affairs* 89 [January 1990]: 97–106) on the "supernatural aura" of the camera is insufficient as a framework for conceptualizing various African understandings of its technology. Dugmore here demonstrated that it was not easy to dispel distrust, and many other traveling photographers found the same.
12. *OMLJ* 1, no. 3 (August 1889): 20, citing David Livingstone's comments to W. D. Clark; and Livingstone, *Missionary Travels and Researches in South Africa* (New York, 1858), 322. Livingstone's slide was a hand-painted one, with Abraham's arm slotted or levered so as to move.
13. *OMLJ* 5, no. 59 (April 1894): 75; and Nash, "Lantern in Church," 78; and *OMLJ* 5, no. 62 (July 1894): 117.

14. Anon., "England Before the Roman Invasion," *Optical Lantern Readings* (Bristol, n.d.). See also Daile Kaplan, "Enlightened Women in Darkened Lands," *Studies in Visual Communication* 10, no. 1 (1984): 61–77, for an example of mission fundraising with lantern slides.

15. *New Magic Lantern Journal* 5, no. 3 (April 1988), reprint from unknown source, 1897; also *OMLJ* 5, no. 66 (November 1894): xvi.

16. Max Quanchi, "Representation and Photography on the Papuan Coast, 1880–1930" (Unpublished paper, Pacific Arts Association Conference, Adelaide, Australia, 13 April 1993).

17. Jonathan Crary, *Techniques of the Observer: On Vision and Modernity in the Nineteenth Century* (Cambridge, Mass., 1990), quoting Walter Benjamin on p. 112. Privileging visual experiences may, however, render this distinction harsher than it has to be. Other personal displacements might be found in reading a novel, or for that matter hearing a folktale.

18. Crary, *Techniques of the Observer,* 149; Paul Virilio, *Speed and Politics* (New York, 1986). In much of his work Virilio seems to argue that the resulting "disappearance" of the observer is the central feature of modern technology.

19. He may have said "Bonang, ke Morena Jesu" or "Ke setshwantsho sa Jesu." I suspect the history of the introduction of figurative representation to Africa needs fresh treatment. On the language used, see note 29.

20. Henry Methuen, *Life in the Wilderness; or, Wandering in South Africa* (London, 1846). It is likely that the evangelist Morakile as a lad saw these very pictures.

21. H. Depelchin and C. Croonenberghs, *Journey to Gubulawayo: Letters of Fr. H. Depelchin and C. Croonenberghs, S. J., 1879, 1880, 1881,* trans. Maria Lloyd (Bulawayo, Rhodesia, 1979), 133.

22. LMS/SA, Reports, 6/1, Ernest Dugmore, "Report of the L.M.S. Kanye Church for the Year 1920." I dissent from theorists who go so far as to claim that there is no such thing as transcultural verisimilitude in representation. We need qualifiers (e.g., John Wilson, "Comments on Work with Film Preliterates in Africa," *Studies in Visual Communication* 9, no. 1 [Winter 1983]), but the broad version of this Gombrichian stance does not, from African and Polynesian evidence, seem to stand up.

23. John Tagg, *The Burden of Representation: Essays on Photographies and Histories* (London, 1988), 35. And so (in a different vein) Rembrandt's faces, with their "uncanny aura of private character," also obscure their status as signs playing within a certain convention, as Joseph Leo Koerner, "Rembrandt and the Epiphany of the Face," *Res* 12 (August 1986): 9, reminds us. I have found no "live model" slides of Christ.

24. Walter Benjamin, "The Work of Art in the Age of Mechanical Reproduction," in *Illuminations,* ed. Hannah Arendt (New York, 1969), 219–21 especially.

25. Wyke Bayliss, *Rex Regum: A Painter's Study of the Likeness of Christ from the Apostles to the Present Day* (London, 1898), 171–72. See also Mary Warner Marien, "Go Forth, Then, Little Prints," *Views: The Journal of Photography in*

New England 11, no. 4/12, no. 1 (Fall 1990/Winter 1991) (thanks go to Barbara Michaels); Anne Clark Ames, *William Holman Hunt: The True Pre-Raphaelite* (London, 1989); Mark Roskill, "Holman Hunt's Differing Visions of the 'Light of the World,'" *Victorian Studies* 6 (1963): 229–44; and Jeremy Maas, *Holman Hunt and the Light of the World* (London, 1984), 67ff. especially.

26. Roger Price, "Bona, Ke Eme Moyakoñ," hymn 130, *Dihela* (Johannesburg, 1973); my translation.

27. This impression is supported by my own field research. One woman conflated Matt. 22.28, a Sadducee's complex riddle about the practice of the levirate with seven brothers and one bride, with Christ knocking repeatedly at a door behind which stand "seven bridesmaids" (Matt. 7.7 or Rev. 3.20).

28. Isa. 55.6 is quoted, with my italics. *Tshwano ya ga Jesu* and *setshwantsho sa ga Jesu* meant "image" of Jesus, or "quality-of-alikeness of Jesus," and "thing-similar of Jesus," respectively.

29. These are SeTswana words, which were spoken and understood by most Kgalagadi people. Many also spoke SeKgalagadi proper, and Afrikaans and Nama were also spoken by some. Most BaKgalagadi belonged to the same cultural nexus as BaTswana, and partake of an overlapping general history. "Kgalagadi" is not a cultural unit but a status, lent a name by stronger groups on better pastureland; diverse groups of settlers ended up as "BaKgalagadi." Although Edwin Wilmsen has provided a much-needed framework for clarifying their history, there is still much disagreement here; see his *Land Filled With Flies: A Political Economy of the Kalahari* (Chicago, 1989); Isaac Schapera, "A Short History of the Bangwaketse," *African Studies* 1 (1942): 1–11; also R. K. Hitchcock and A. C. Campbell, "Settlement Patterns of the Bakgalagari," *Symposium on Settlement in Botswana,* ed. Renee Hitchcock and Mary R. Smith (Gaborone, Botswana, 1980); and Kuper, *Kalahari Village Politics,* 8–9.

30. This point would further improve the otherwise subtle and learned introduction by Rosalind Shaw and M. C. Jędrej, editors of *Dreaming, Society, and Religion in Africa* (Leiden, 1992). Achille Mbembe devotes his analyses to the *sleeping* dreams of Ruben Um Nyobe, the Camerounese patriot, in "Domaines de la nuit et autorité onirique dans les Maquis du Sud-Cameroun, 1955–1958," *Journal of African History* 31 (1991): 89–121. Because he places Um's recorded dreams squarely within the totality of colonization and struggle, and focuses on expression ("la production onirique," 99), I would like to think that this work supports my assertion. See also J. S. Mbiti, "God, Dreams, and African Militancy," in J. S. Pobee, ed., *Religion in a Pluralistic Society* (Leiden, 1980); and Vittorio Lanternari, "Dreams and Visions from the Spiritual Churches of Ghana," *Paideuma* 24 (1978).

31. W. C. Willoughby, *The Soul of the Bantu* (New York, 1928), 100–101.

32. Shaw and Jędrej, "Introduction," *Dreaming, Religion, and Society in Africa,* 8; and see J. P. Kiernan, "The Social Stuff of Revelation: Pattern and Purpose in Zionist Dreams and Visions," *Africa* 55 (1985): 304–18.

33. Interview with *Moruti* Maatlametlo Mokobi, Mahalapye, 20 January 1989; translation Gabriel Selato and myself.

34. Interview with Koowetse Molebalwa, *kgosi* Matalaganya *kgotla;* Tlhakadiawa tshimo, Lerala, Botswana, 9 April 1990; my translation.

35. Willoughby, *Soul,* 99. John Thornton has discussed conversion as a dovetailing of methods of validating "revelations." His compelling argument pertains to central Africans both in Africa and coming into the New World, but they may also have utility here; *Africa and Africans in the Making of the Atlantic World, 1400–1680* (New York, 1992), 242–62.

36. Hecht, "History of Projection, I."

–4.6–

Quetzalcóatl's Mirror

Lois Parkinson Zamora

The Spanish adventurers whom we now refer to as *conquistadores* sailed from Cuba and landed on the island of Cozumel in March of 1519, where they immediately confronted innumerable images of supernatural creatures. Initially comparing them to the pagan gods of Greece and Rome, the soldier and chronicler Bernal Díaz del Castillo tells of Cortés' approach to these "idols of most hideous shapes": "Cortés ordered us to break up the idols and roll them down the steps, which we did. Next he sent for some lime, of which there was plenty in the town, and for some Indian masons; and he set up a very fair altar, on which we placed the image of Our Lady. He also ordered two of our carpenters ... to make a cross of some rough timber ... Meanwhile, the *cacique* and the *papa* and all the Indians stood watching us intently."[1] Fortunately, some of the colonizing clergy who followed Cortés had a more ample optic. Conversion justified conquest, so they, like Cortés, were required to substitute Catholic images for indigenous "idols." Nonetheless, a few friars worked to preserve indigenous myths in their verbal and visual forms, and their names are justly celebrated because their records, however tendentious, remain central to our knowledge of Mesoamerican cultures before European contact.[2] We have, then, significant number of Nahua and Maya myths, preserved by the same men who were engaged in banishing them from the collective memory.

Quetzalcóatl is both a deity and a human leader associated with the Toltec ceremonial center of Tula and with the Maya center of Chichen Itza.[3] The story of his encounter with a mirror encompasses both his historical and mythic identities, and it dramatizes his protean capacity to move from one condition to the other. The details are recounted in the *Anales de Cuauhtitlán,* a collection of oral narratives from the central highlands of Mexico, written down before 1570 in Roman script in Náhuatl (the language of the ancient indigenous groups of the *altiplano* and still spoken by more than a million Mexicans[4]), and published, probably in the seventeenth century, with two other post-conquest texts as the *Códice Chimalpopoca.*[5] The compiler is unknown, as is his informant (or informants); in fact, the whereabouts of the original manuscript is also unknown.[6] The compilation was named *Chimalpopoca* in 1885 for the man who translated a part of it into Spanish; only in 1945 was it translated in its entirety from Náhuatl into Spanish, and into English only in 1992. Here,

I cite Mexican novelist Carlos Fuentes's restatement of this myth. His reference to Quetzalcóatl's "fall," with its Christian resonance, already suggests the process of transculturation that we are tracing here.

Tezcatlipoca, Ilhuimécatl y Toltécatl decidieron expulsar de la ciudad de los dioses a Quetzalcóatl. Pero necesitaban un pretexto: la caída. Pues mientras representase el más alto valor moral del universo indígena, Quetzalcóatl era intocable. Prepararon pulque para emborracharlo, hacerle perder el conocimiento e inducirlo a acostarse con su hermana Quetzaltépatl.... ¿Bastarían las tentaciones humanas? Para desacreditar al dios ante los hombres, sí. Pero, ¿para desacreditarlo ante los dioses y ante sí mismo? Entonces Tezcatlipoca dijo: *"Propongo que le demos su cuerpo"*. Tomó un espejo, lo envolvió y fue a la morada de Quetzalcóatl. Allí, le dijo al dios que deseaba mostrarle su cuerpo. "¿Qué es mi cuerpo?", preguntó con asombro Quetzalcóatl. Entonces Tezcatlipoca le ofreció el espejo y Quetzalcóatl, *que desconocía la existencia de su apariencia,* se miró y sintió gran miedo y gran vergüenza: "Si mis vasallos me viesen—dijo—huirían lejos de mí." Presa del terror de sí mismo—del terror de su apariencia—Quetzalcóatl bebió y fornicó esa noche. Al día siguiente, hujó. Dijo que el sol lo llamaba. Dijeron que regresaría.[7]

[Tezcatlipoca, Ilhuimécatl and Toltécatl decided to banish Quetzalcóatl from the city of the gods. But they needed a pretext: a fall from grace. Because while he still represented the highest moral values of the Indian universe, Quetzalcóatl was untouchable. They prepared to make him drunk so that he might lose consciousness and be induced to lie with his sister Quetzaltépatl.... Would human temptation be enough? To discredit the god before men, yes. But to discredit him before the gods and before himself?

Then Tezcatlipoca said, *"I propose that we give him his body."*

He took a mirror, wrapped it up and went to Quetzalcóatl's house. There he told the god that he wished to show him his body.

"What is my body?" asked Quetzalcóatl in surprise.

Then Tezcatlipoca offered him the mirror and Quetzalcóatl, *who did not know that he had an appearance,* saw himself and felt great fear and shame.

"If my vassals should see me like this," he said, "they would flee from me."

Full of fear of himself—the fear of his appearance—Quetzalcóatl drank and fornicated that night. The following day he fled. He said that the sun had called him. They said that he would return.][8]

Quetzalcóatl's enemies mean to undo him. Their strategy is to give him an image, that is, to embody him and thus make him visible, vulnerable, vain. Tezcatlipoca is an adversary worthy of Quetzalcóatl: he is the god of the "smoking mirror" (in Náhuatl *tezcatl,* mirror, and *tlepuca,* a combination of *tletl,* spark, and *puctli,* smoke) and is frequently shown to have a circular mirror in place of one foot, from which issues two plumes of smoke, or in other representations, a stream of water or flames, or a serpent.[9] The Codex Borgia, housed in the Apostolic Library of the Vatican since the late nineteenth century, shows four embodiments of the red and black embodiments of Tezcatlipoca, their relative sizes reversed from the upper to lower registers, each with his foot of polished obsidian. In fact, art historian Mary Ellen Miller states

that in late postclassic central Mexica culture, Tezcatlipoca also appears to have been embodied as the obsidian mirror itself.[10] He is as protean as Quetzalcóatl and, in fact, mirrors Quetzalcóatl: in one of his forms, he *becomes* Quetzalcóatl, his opposite other, a kind of evil twin.[11] John Bierhorst's translation of the *Chimalpopoca* gives to Quetzalcóatl's enemy an even more sinister aspect than Fuentes' version. The smoking mirror/Tezcatlipoca approaches Quetzalcóatl with his *tezcatl,* his obsidian mirror, and speaks to him not of his "body" but his "flesh": "I've come to show you your flesh." Quetzalcóatl responds, "Where have you come from? What is this 'flesh' of mine? Let me see it."[12]

Quetzalcóatl immediately understands the power, and the danger, of this flesh. He understands that his image endows him with the status of a sentient being in a physical world, and also with a communal role and responsibility: he accepts his "appearance"—his image—as his destiny. The Nahua storyteller tells us that that he looks in the obsidian mirror and sees "verrugas de sus párpados, las cuencas hundidas de los ojos y toda muy hinchada su cara ... deforme" ("his eyelids were bulging, his eye sockets deeply sunken, his face pouchy all over—he was monstrous.").[13] It seems that the reflection he sees is merely a snake. What, Quetzalcóatl asks himself, will my vassals think? Here, by vassals, we must understand believers, those who over centuries created and venerated his countless images. Quetzalcóatl sees himself through others' seeing him; his image contains and reflects himself to himself through the perceptions of others.

Oddly, Fuentes does not finish retelling the story but stops before the most interesting, and surely the most important part: Quetzalcóatl's transformation into the plumed serpent. Quetzalcóatl's enemies have thought to disempower him by imaging/embodying him. But like so many plots against so many gods in diverse world mythologies, this one also backfires. Tezcatlipoca has forced Quetzalcóatl to recognize his appearance (his image) and the latter leaves, but not in shame (Fuentes's Christian interpretive adduction) and not without a plan to reestablish himself. He will fight image with image. The myth continues as Quetzalcóatl goes to Coyotlinahual, a "featherworker" who fashions him a mask.

> En seguida le hizo su máscara verde; tomó color rojo, con que le puso bermejos los labios; tomó amarillo, para hacerle la portada; y le hizo los colmillos; a continuación le hizo su barba de plumas, de *xiuhtótol* y de *tlauhquéchol,* que apretó hacia atrás (*Códice Chimalpopoca,* 9)
>
> [Then he fashioned his turquoise mask, taking yellow to make the front, red to color the bill. Then he gave him his serpent teeth and made him his beard, covering him below with cotinga and roseate spoonbill feathers. (Bierhorst, 33)

Again, Quetzalcóatl is brought a mirror. Again he sees his image, which is now an elaborate mask—an image that conveys both the storyteller's and the listener's amplified experience of the god. Such specific physical description expresses the culture's investment in the power of the image to *become* the body of a god.

Consider the Mesoamerican belief that a divine essence will recognize an image appropriate to itself. By virtue of what we might call a visual sympathy between a god and his/her/its image, the god will inhabit and possess the sculpted or painted or carved material. This understanding of visual sympathy implies a reciprocity between image and object that goes beyond verisimilitude to what Inga Clendinnen calls "significant appearance," and Serge Gruzinski calls "an extension of essence."[14] The spirit recognizes its physical and moral correspondences because the sculptor or painter has properly conceived and executed the image; the image-maker has penetrated the essence of that spirit and incorporated it in paint or wood or stone. This reciprocal relation of spirit and image is dramatized in the myth we have just considered. Quetzalcóatl recognizes himself in the reflected gaze of his believers. His mask now embodies his appropriate role and responsibilities; he is not simply as a serpent with feathers and human characteristics but a metamorphic presence that is simultaneously and variously a sacred quetzal bird, a serpent and a human being. That the Mesoamerican gods were often represented as priests wearing masks confirms the power of the image and echoes Quetzalcóatl's historical, human identity as priest/prophet of Tula. This time, when Quetzalcóatl sees his image, we are told that "... quedó muy contento de sí" (9) ("Seeing himself, Quetzalcóatl was well pleased" [33]).

Scholarly commentary on the iconography of Quetzalcóatl is extensive. Román Piña Chan follows the archeological evidence of Quetzalcóatl from the earliest appearances of the figure in Olmec culture (1500–900 BC) through numerous transformations, up to his encounter with European culture. He shows how

> ... an aquatic serpent or spirit of terrestrial waters becomes the magic concept of a dragon in the forms of a serpent-jaguar; how this dragon gave way to bird-serpents or winged dragons whose domain was the sky; how, in turn, they were transformed into the beautiful plumed serpent, in the cloud of rain that accompanied the serpent of fire; how these serpents or celestial dragons became the animals who announced the god of rain; and how too the plumed serpent, with spirals engraved on his body, became Quetzalcóatl, the god man-bird-serpent.[15]

This passage underscores the permanent dynamism of the mythic image; feathered serpents appear, then disappear, the better to appear again, and again, as Quetzalcóatl.[16] His image/mask appears hundreds of time in sites throughout Mesoamerica, carved on columns and friezes and monoliths, painted on walls and in codices, incised in ceramics, and composed of fitted stones to adorn the façades of ceremonial structures.

The temples dedicated to Quetzalcóatl—at Teotihuacan, Uxmal, Xochicalco—capture this sense of perennial becoming in the rhythmic repetition of varied forms of the image over the stone surfaces of their façades.[17] So, too, the painted and sculpted images of the plumed serpent express the dynamism of the Mesoamerican world, with its reigning principles of *nahualli* and *ollin* (complementarity and movement), and its conception of calendrical cycles that allow for the reappearance of the gods

in altered forms.[18] Octavio Paz finds metamorphosis to be *the* essential characteristic of the Mesoamerican pantheon. In his essay on Mesoamerican visual culture published in English as the introduction to the exhibition catalogue *Mexico: Splendors of Thirty Centuries,* Paz refers to a Maya creation narrative, an analogue to the Nahua narrative of Quetzalcóatl's mirror:

> The Plumed Serpent: Quetzalcóatl on the highlands and Kukulcan in the Yucatan, the god who emerged from the Gulf and who blows a conch shell and is named Night and Wind (*Yohualli Ehecatl*), god of vital breath and the destroyer god of the second era of the world, Evening and Morning Star, god I Reed, who disappeared in the place where "the water of the sky joins the water of the sea" (the horizon) and who will return in the same place and on the day to reclaim his inheritance—Quetzalcóatl, the sinner and penitent god, the painter of words and sculptor of discourse.[19]

Like Quetzalcóatl, the more than two hundred deities of the Mesoamerican pantheon constantly change names, places, roles and appearances; they are spirit forces rather than individualized gods. Their images shift according to situation, teller, and cultural context, and this metamorphic capacity necessarily defers definition; the avatars are not innumerable, but neither is there is any Bullfinch-type catalogue of who's who because the Mesoamerican gods are multiple and volatile.[20] The boundaries between human, animal and natural forms are permeable; the plenitude of being, not idiosyncratic identity, is their referent.

The Indigenous Image-as-Presence

The intertwining of visual forms and narrative identities depends upon a conception of the human body that precedes (and still today evades) the modern Western separations of mind from body, self from world. In Mesoamerican myth cultures, the body is co-extensive with the world, an expressive space that contains—rather than filters or fixes—the world. Here, we may usefully speak of an embodied culture, a culture of embodiment. In Náhuatl poetry, the image for "human being" is *in ixtli, in yollotl—rostro y corazón,* face and heart. The great scholar and translator of Náhuatl literature Miguel Leon-Portilla writes that for the ancient Mexicans *in ixtli, in yollotl* was "la fisonomía moral y principio dinámico de un ser humano" ("the moral physiognomy and dynamic principle of the human being").[21] Similarly, in Maya hieroglyphics, the glyph for "self" has cognate meanings of "face," "head," "image," and "portrait." According to archeologists Stephen Houston and David Stuart, "The self extends visibly to other representations, yet essence transfers along with resemblance; the surface, the 'face,' does not so much mimic aspects of identity as realize them. In terms of being, an image embodies more than a clever artifice that simulates identity; it both resembles and *is* the entity it reproduces."[22] Houston and Stuart further chart the permeable boundaries of self and world in the use of bodily metaphors

to describe buildings (the door is the "mouth of a house," the post its "foot," the ridgepole its "head"). On the façades of the Maya "masked temples," faces were painted and/or carved around the door, transforming the entrance of the building into the jaws of a terrestrial monster who "devours" those who enter and "vomits" those who exit.[23] Clearly, significant information resides in the mythic penetration and transformations of human bodies and the natural world.

It will be clear by now that Mesoamerican cultures were (and are) based on belief systems that posit the sacred significance of the physical universe. In their discussion of Mesoamerican cultures and people, Roberta and Peter Markman refer to a "shamanistically conceived world [that] was not a world of animals and plants, of killing and harvesting so that they might survive, but a world of the spirit made manifest in these material things".[24] The visual image was not a question of mimetic resemblance, and certainly not of individual artistic expression in any modern sense. Rather, it made manifest the spirit world in material form. Whether sculpted in stone, painted, or molded from clay, images were conceived and executed to fulfill specific cosmic functions—calendrical, ritual, prophetic, propitiatory—and they were believed to bring into presence the represented god. While some Mesoamerican images may be said to be "secular"—historical record-keeping, genealogical charts of rulers—they share with "sacred" images the purpose of participation in natural and cosmic processes.

In *The Blood of Kings,* a magisterial study of the visual codes of the Mayas, Linda Schele and Mary Ellen Miller show how the secular and sacred converged in the Maya king's presumptive capacity "to host the supernatural":

> Ritual was conceived as the bridge between the supernatural and the mundane worlds, and the king was the agent of power who made the transition from the sacred to the mundane. Thus, Maya art depicts the historical action of civil kings, but those kings acted with sacred authority and supernatural power. The imagery of art was a symbolic language that depicted both the historical actions of kings and the supernatural framework of the cosmos that gave those actions sacred purpose.[25]

The king "when dressed in the costumes of different gods, was more than just their symbolic stand-in. He was a sacred conduit, a vessel that gave flesh to the god by ritual action" (302). The power of the image in such ritual transactions was considered so dangerous that "the Maya regularly 'killed' buildings by removing faces of sculptures depicting both humans and zoomorphs and drilling holes in pottery. Much of the deliberate damage done to the faces of kingly portraits and other sculpture was the result of these killing rituals" (43–4). A carved relief featuring the Maya king Shield Jaguar and his wife Lady Xoc depicts a bloodletting ceremony that makes explicit the identity between the ruler's body and the cosmic order. Her blood drops from the rope that pierces her tongue onto pieces of *amate* paper in the basket below; the paper will be burned during the ritual so that its smoke may nourish the

gods.[26] Cosmic survival was believed to depend upon the ruler's ritual practice and physical participation, and the visual image was believed to bring this symbiosis into presence.

Carolyn Dean affirms a similar ontology of the image in Inka culture. She discusses portraits of Inka rulers, differentiating between the postcontact representation and their pre-contact *embodiment.* In prehispanic Peru there were no portraits in the Western sense, no representations of an absent person or thing:

> in the Andean tradition, the powerful essences of rulers (rather than their superficial form) were housed in (rather than recorded on) rocks and/or bundles of their bodily excrescences (e.g., hair and nails); these were referred to as their *wawkis (huaques),* or "brothers." In part because *wawkis* and mummies of the royal deceased were revered, kept, and treated as though they were still animate or capable of imminent animation, there was no Andean tradition of sublimational image-making because there was no absence to disavow.[27]

Prehispanic images did not *resemble* the royal deceased but rather contained them—*were* the rulers. Dean shows how postcontact Inkas appropriated the canons of Western portraiture to encode their precontact traditions and articulate a transculturated native identity.[28]

Despite the diversity of indigenous groups in pre-contact America, then, a shared cultural substratum emerged that now allows us to generalize an indigenous *image-as-presence.* Indigenous American cultures privileged the capacity of the visual image *to be,* or *become,* its object or figure. The image *contained* its referent, *embodied* it, made it present physically and experientially to the beholder. There was no dichotomy between presence and absence, no assumed separation between image and object. The image was not separated from its referent but integral to it according to culturally determined systems of analogy. Still today, in ritual dances performed in festivals throughout Mesoamerica and the Andes, the spirit of the animal carved on a mask recognizes and inhabits its wearer: in what is called the wearer's *nagual,* the image and its meaning are one. A spirit may also abandon its image for a variety of reasons—anger, boredom, a fickle nature. An image contains the special history of the spirits that have inhabited it; in rural Mexico, Catholic images of the same saint may contain very different histories and attributes from village to village. The *image-as-presence* thus constitutes a fundamental integrity of image and object—an integrity easily (mis)taken for magic by modern Western culture, which, of course, maintains the separation between images and their objects.

Consider a recent example. Reports in Mexico's newspapers in the fall of 2000 on the activity of the volcano Popocatépetl, east of Mexico City, included scientific information, but most accounts focused on the ways in which local populations personified the volcano and understood its activity as coded information from ancient gods. In Náhuatl, Popocatépetl means "Smoking Mountain" or "Lord of the Lighted

Torch"; the volcano, which has been sending up smoke and ash for millennia, has long been a site of religious devotion. Early Spanish chroniclers described the religious practices associated with the site, and contemporary residents still refer to the volcano as "Don Goyo." The name is a term of endearment for Gregorio Chino Popocatépetl, a combination of St. Gregory the Great, for whom a neighboring village is named, and an old man associated with the prehispanic deity Tlaloc, lord of rain. An article in a magazine devoted to Mexican culture reports that for contemporary residents of the villages on the skirts of the volcano,

> Gregorio Popocatépetl is as much volcano-nature as man-god. As mountain, it is the water that runs from springs, the fertilizing ash and powerful landscape; as human being, he is the old man known to many who suddenly appears and disappears, the one who asks for food and gifts but only accepts them if they are placed in the sacred sites on the heights of the volcano.[29]

So a Catholic saint merges with the Nahua god of rain in the form of an old man who regularly appears to the residents of villages on the slopes of the volcano. Don Goyo's cave is the navel of the volcano, and his feast day is March 12. Spirit forces simultaneously occupy natural forms and Catholic figures, combining topographic attributes and diverse theological systems in culturally significant ways.

My discussion of Don Goyo is intended to suggest that mythic understanding continues to operate in Mexico, but I would also suggest that most image-consumers no longer consciously ascribe to such an understanding. The *Anales de Cuauhtitlán,* the 1570 compilation in which the story of Quetzalcóatl's mirror appears, is at the beginning of this long process of loss. The myth was written down in European alphabetic script, a mode that favors discursive narration, whereas before the arrival of Europeans, it would have been recorded in elaborate visual structures comprised of non-alphabetic systems—glyphs, pictographs, ideographs—painted on the folded texts we now call codices and then performed by a *tlacuilo* before an audience. John Bierhorst speculates that the postconquest "informant" still had access to pre-conquest visual sources. In certain passages, Bierhorst notes that the teller "speaks to us as though we were looking over his shoulder, while he points to the painted figures.... In places the text reads like a sequence of captions, as though the unseen pictures could carry the burden of the tale."[30] In the written transcription of this oral account, Bierhorst identifies the transcultural operations whereby the teller moves between his traditional visual, performative mode and his new discursive medium in order to remember and record the story of his (former) culture's mythic origins.[31]

So we recognize that visual embodiment and oral performance were integral to the metamorphic identities and shifting powers of the Mesoamerican gods. The visual and performative media that embodied them were fluid enough to encompass a cosmogony based upon principles of complementarity, movement and metamorphosis, a cosmogony that the alphabetic medium cannot adequately represent.[32] On

the contrary, alphabetic documents tend to fix the universe, to record and preserve knowledge, and thus ensure stability. While we celebrate the preservation of indigenous American myths in whatever modified form they have come to us, we must also understand how far we are from their original participatory visual/oral medium. As we read the story of Quetzalcóatl's mirror, whether in Náhuatl, Spanish, or English, we recognize that it is *about* a mythic image, but no longer *is* a mythic image. Its figural text and communal performance have been supplanted by the silent abstraction and discursive logic of European alphabetic form.

Notes

1. Bernal Díaz del Castillo, *The Conquest of New Spain,* trans. J. M. Cohen (New York: Penguin, 1963), pp. 61–2. This text was completed in 1568. The English translation comprises only about three-fourths of the original Spanish; below, I cite passages not included in the English translation, and thus provide translations of my own.

2. Among them are Bernardino de Sahagún, Jerónimo de Mendieta, Diego Durán, Juan de Torquemada, Juan de Acosta, to name only a few of the most important. In this regard, see George Kubler, *Esthetic Recognition of Ancient Amerindian Art* (New Haven: Yale University Press, 1991).

3. The ubiquity of this mythic figure in central Mexican and Maya cultures is linked to his historical identity as a priest who left the sacred site of Tula and traveled to Chichén Itzá, disappearing to the East with the promise to return. For an account of Quetzalcóatl's historical and mythic displacements, see William Ringle, Tomás Gallareta Negrón, and George J. Bey III, "The Return of Quetzalcóatl: Evidence for the Spread of a World Religion during the Epiclassic Period," *Ancient Mesoamerica* 9 (1998): 183–232; and Enrique Forescano, *The Myth of Quetzalcóatl* (1995), trans. Lylsa Hochroth (Baltimore: Johns Hopkins University Press, 1999).

4. According to the 2000 Mexican Census, Nahuátl is still spoken by 1,448,936 speakers. Twenty-eight indigenous languages are counted, with "other languages" also a category, for a total of 6,044,547 speakers of indigenous languages, or approximately 5 per cent of the Mexican population. See the website of Mexico's Instituto Nacional de Estadística, Geografía e Informática: http://www.inegi.gob.mx/inegi/default.asp.

5. *Códice Chimalpopoca; Anales de Cuauhtitlán; Leyendas de los soles,* trans. Primo Feliciano Velásquez (1945; 3rd ed; Mexico City: UNAM, 1992). The three manuscripts listed above comprise the *Códice Chimalpopoca,* the first and third in Náhuatl, dated 1558 and 1570, by anonymous authors, the second in Spanish by Pedro Ponce. They are written on European paper rather than amate (bark paper), and first appear in a bibliographic catalogue in Mexico in 1736.

6. The manuscript has been missing from the archives of Mexico City's National Museum of Anthropology since 1949. This fact is noted in the introduction to John Bierhorst's complete English translation to the *Codex Chimalpopoca, History and Mythology of the Aztecs: The Codex Chimalpopoca* (Tucson: University of Arizona Press, 1992), p. 10.

7. Carlos Fuentes, "La violenta identidad de José Luis Cuevas," in *Casa con dos puertas* (Mexico City: Joaquín Mortiz, 1970), pp. 259–60, my emphasis.

8. Fuentes's retelling of this myth is translated under its Spanish title: *El mundo de José Luis Cuevas,* trans. Consuelo de Aerenlund (New York: Tudor Publishing Co., 1969), pp. 24–5, my emphasis.

9. See Silvia Trejo, "Tezcatlipoca: 'Espejo humeante,'" in *Dioses, mitos y ritos del México antiguo,* pp. 59–81.

10. Mary Ellen Miller and Karl Taube, *The Gods and Symbols of Ancient Mexico and the Maya: An Illustrated Dictionary of Mesoamerican Religion* (London: Thames & Hudson, 1993), p. 114. The reflecting surfaces of stone and water played important roles in divinatory rites from the earliest evidence of Mesoamerican cultures.

 For a study of the thematics of mirrors and reflections in Latin American literature, including a discussion of Narcissus-Huitzilopochtil, see Marta Gallo, *Reflexiones sobre espejos: la imagen especular: cuatro siglos en su trayectoria literaria hispanoamericana* (Guadalajara: Universidad de Guadalajara, 1993).

11. The metamorphoses of Tezcatlipoca according to colors are well known. Octavio Paz writes: "Which Tezcatlipoca? There are four. The black Tezcatlipoca, Smoking Mirror, is the jaguar god who in his mirror sees into the depths of men; he is converted into his opposite and double, the young Huitzilopochtli, the hummingbird, who is the blue Tezcatlipoca. At another point in space appears the white Tezcatlipoca, who is Quetzalcóatl. And at the fourth point, between the green maize and ocher earth, appears the red Tezcatlipoca, who is Xipe Totec." "Will for Form," in *Mexico: Splendors of Thirty Centuries* (New York: The Metropolitan Museum of Art/Little Brown and Company, 1990), p. 19.

12. John Bierhorst, *History and Mythology of the Aztecs,* p. 32.

13. *Códice Chimalpopoca,* p. 9. John Bierhorst, *History and Mythology of the Aztecs,* p. 32.

14. In *Aztecs: An Interpretation* (Cambridge: Cambridge University Press, 1991), Inga Clendinnen refers to a text that exhorts the Mexica sculptor to unravel the implications of appearance, to penetrate the object and incorporate his findings in the image. Clendinnen imagines the aesthetic and cultural charge of the indigenous image-maker:

 Vegetable beings offer only their appearance as clues, so appearance must be immaculately reproduced. Creatures which move and act betray their sacred affiliations by behaviour as much as by appearance: both must be studied,

and the representation made to incorporate the findings. And animate and inanimate things alike reveal significant relationships by context, and by (not necessarily obvious) resemblance in some detail of appearance. (226)

15. Román Piña Chan, *Quetzalcóatl: Serpiente emplumada* (Mexico City: Fondo de Cultura Económica, 1977), p. 67, my translation.
16. See William Ringle, Tomás Gallareta Negrón, and George J. Bey III, "The Return of Quetzalcóatl: Evidence for the Spread of a World Religion during the Epiclassic Period," cited above.
17. Xochicalco is interesting in this regard, for it was a crossroads of cultures; the presence of Maya, Teotihacan, Totnac, Zaptec and Nahua cultures are found there, and it is known to have been an important center for astronomical and calendrical research. See Leonardo López Luján, Robert H. Cobean T., and Alba Guadalupe Mastache R., *Xochicalco y Tula* (Mexico City: Consejo Nacional para la Cultura y las Artes, 2001).
18. The narrative of Quetzalcóatl's mirror explicitly details the calendrical principles operating in this story: see Bierhorst, *History and Mythology of the Aztecs,* p. 4.
19. Octavio Paz, "Will For Form," in *Mexico: Splendors of Thirty Centuries,* p. 19.
20. This volatility of forms and functions is well conveyed in the admirable overview of the Mesoamerican pantheon by Mary Ellen Miller and Karl Taube, *God and Symbols of Ancient Mexico and the Maya: An Illustrated Dictionary of Mesoamerican Religion,* cited above.
21. Miguel León-Portilla, *Los antiguos mexicanos a través de sus crónicas y cantares* (Mexico City: Fondo de Cultura Económica, 1961), p. 149.
22. Stephen Houston and David Stuart, "The Ancient Maya Self," *RES* 33 (Spring 1998): 77, emphasis the authors'. This entire issue of RES is devoted to "Pre-Columbian states of being."
23. Claude-François Baudez, "Los templos enmascarados de Yucatán," *Arqueología mexicana* VII, 37 (May–June 1999): 54–59.
24. Roberta H. Markman and Peter T. Markman, *The Flayed God: The Mesoamerican Mythological Tradition* (New York: HarperCollins Publishers, 1992), p. 5
25. Linda Schele and Mary Ellen Miller, *The Blood of Kings: Dynasty and Ritual in Maya Art* (New York: George Braziller, 1986), p. 42.
26. See the following sites on Maya ritual practice: http://www.utexas.edu/courses/ wilson/ant304/projects/projects98/gafford//art.html and http://www.nga.gov/ exhibitions/2004/maya/womenatcourt-p.2.htm
27. Carolyn Dean, *Inka Bodies and the Body of Christ,* p. 114, my emphasis.
28. The exhibition catalogue *The Colonial Andes: Tapestries and Silverwork, 1530–1830,* eds. Elena Phipps, Johanna Hecht, and Cristina Esteras Martín (New York: Yale University Press/The Metropolitan Museum of Art, 2004) includes several useful essays on the transculturation of self-representation during the viceregal period.

29. Edgar Anaya Rodríguez, "¡Feliz cumpleaños, Don Gregorio!" *México descono-cido,* March 2001, p. 31; my translation follows.
30. John Bierhorst, *History and Mythology of the Aztecs,* p. 7.
31. Useful discussions of how the prehispanic codices were performed are by Mark King, "Hearing the Echoes of the Verbal Art in Mixtec Writing," and Peter L. van der Loo, "Voicing the Painted Image: A Suggestion for Reading the Reverse of the Codex Cospi," in *Writing without Words: Alternative Literacies in Me-soamerica and the Andes,* eds. Elizabeth Hill Boone and Walter D. Mignolo (Durham: Duke University Press, 1994), pp. 102–36, 77–86.
32. León-Portilla writes about this translation from an oral medium to an alphabetic one. Referring to a number of contemporary Mesoamericanists, he writes:

> They affirm that the simple fact of transforming indigenous orality into fixed, established texts radically changes what was recited or sung. Oral-ity, always open to enrichments and adaptations in diverse circumstances, cannot be encapsulated or confined in alphabetic writing or converted into something totally outside the original culture. Such a transformation does not coincide with mental procedures associated with the indigenous vision of the world.

> *El destino de la palabra: De la oralidad y los códices mesoamericanos a la escritura alfabética,* [*The destiny of the word: from the orality of the Meso-american codices to alphabetic writing*] (Mexico City: El Colegio Nacional y Fondo de Cultura Económica, 1996), pp. 22–3, my translation.

–4.7–

Photographs, Orality and History
Elizabeth Edwards

Photographs are the focus of intense emotional engagement. In premising photographic effect on the visual and the forensic alone, we limit our understanding of the modes through which photographs have historical effect because photographs both focus and extend the *verbal* articulation of histories and the sound world they inhabit.

In the everyday use of photographs as conduits of historical consciousness photographs are spoken about and spoken to—the emotional impact articulated through forms of vocalisation. Just as there has come to be a greater awareness of the interaction between oral and written forms of history (Finnegan 1992:50), there is a sense in which we should consider photographs not only as visual history but a form of oral history, and, by extension, the way in which the oral constitutes an embodied vocalisation.[1] The oral penetrates all levels of historical relations with photographs to the extent that spoken and seen cease to be separate modalities. Orality is not simply the verbalising of content, a playing back of the forensic reading—'this is where we had a fishing camp'—but the processes and styles in which photographs have dynamic and shifting stories woven around and through them 'imprinting themselves and being played back repeatedly through different tellings' (Edwards 2003:89). Photographs and voice are integral to the performance of one another, connecting, extending and integrating ways of telling histories. As anthropologist Roslyn Poignant has reported of the response to photographs at Maringrida, Arnhem Land, Australia, not only was a community view that photographs were like bark paintings in that they had stories (Poignant 1992:74) but:

> Sometimes, an elder's use of the photographs to transmit his reflections of a past time and a way of doing things to the young who had gathered around took on the character of storytelling, so that the integration of photographs seemed no more than an extension of traditional oral modes of representing the past. For others in the community, some of whom were already involved in the integration of traditional forms of visualising the past in present-day recording systems, the introduction of the photographs—an additional resource—sparked notions of history that went beyond a genealogical patterning of history. (1996:8)

Photographs are therefore enmeshed in oral stories—personal, family and community histories. They are performed through the spoken or sung human voice telling stories to an audience—formal or informal. Martha Langford, in her interesting analysis of Canadian photographic albums has positioned series of photographs in terms of the oral in and around them—the narratives they engender (2001:122–57). Her analysis draws heavily on the work of Walter Ong and as such she positions photographs within formal definitions of oral literature. It thus shares the problems of Ong's characterisation of oral culture as overly ahistorical, undynamic, totalised and technically determined. However her stress on the orality of photographs, the specificity of oral consciousness, and the way in which 'an album's oral structure and interpretive performance will bring us closer to understanding the photographic work' (Langford 2001:122–3) is pertinent and instructive in the contexts we are considering here.

My argument here extends Langford's notion of the oral dimension of the photographs by placing oral responses to them in the active sensory, experiential reiterations of history-telling and in the social embeddedness of photographs, rather than in formal terms. Contemporary Aboriginal communities should not, of course, be characterised 'oral societies' in the sense that anthropologists and linguistic theorists have talked about them in the past. Rather Aboriginal societies, on the whole, have a wide range of imaging and textualising powers and experiences across a multiplicity of media including the photographic and oral (Langton 1993:9) which makes such an analysis appropriate. What is important here is the way in which the links between the oral and the visual can counter and mesh with other forms in a contemporary society, shifting the balance and allowing 'traditional' and multiple forms of history transmission to operate.[2]

Yet this oral dimension is also highly regulated and will inflect responses to photographs. This is because the oral expression of photographs embeds them in local structures. For instance, in traditional Australian contexts speaking rights are carefully controlled, knowledge itself being a form of property. Violating those rights of speaking is a form of theft (Michaels 1991:260). There are rights to stories and histories and the control of photographs as objects is integrally related to the social patterns of the transmission of knowledge.[3] Thus the articulation of stories themselves, as an act of oral transmission and communication, are inflected and constrained through sets of relationships.

However vocalisation and performance must not be thought of simply in terms of 'writable' words. If the 'gaze of Western thought' has ignored the material, it has also ignored the dimension of sound (Stoller 1984:560). We need to see the oral expressions around photographs in a more extended acoustical form, which takes account of paralinguistic vocalisations such as sobbing, laughing or the production of melody. For these create the affective tone through which photographs are apprehended.

> Here is a subtle intermingling of individually-sounded and -heard creations, of specific context, and of patterns which are more or less enduring and agreed with others. In its

own capacity to draw on auditory resources in this versatile mix of ways, human vocal interaction makes up a remarkable, highly flexible and enormously far-ranging human-created tool for sonic communication (Finnegan 2002:80)

Indeed, it is, as Howes has argued a 'curious fact that anthropologists, for all their concern with language and "discourse" rarely pay much attention to the *medium* of speech, namely sound which is taken for granted' (2003:36). For if photographs are enmeshed in the oral, they are also enmeshed in sound—the sound of voices, spoken or sung, in rising and falling rhythms, tones and volumes. Sound creates the environment for viewing photographs and constitutes a social act in that it reinforces sociality of objects and the relations in which they are enmeshed and the sense of the social self (Tacchi 1998:25–7). Feld has described the flow of sound as 'The flow of poetic song paths [which] is emotionally and physically linked to the sensual flow of the singing voice'; 'a fusion of space and time that joins lives and events as embodied memories' (1996:91). Further as Ingold has argued, sound communicates directly and immediately through hearing. Hearing forms a porous boundary between the external and the internal, which appeals directly to 'the "inwardness" of life' (2000:245–7). But hearing also implies listening, which is an engaged intentional hearing (Carter 2005). Thus one can argue that the heard sound of the oral, listened to, draws the visual apprehension of the photograph, deeper into the world of the perceiver and their social relations, reinforcing and moulding the understanding of the photograph.

As performative objects, photographs create the frame for patterns of telling, or reinforce extant ones, reinforcing memory not simply through the image but through the structure of repetitions—both the shape of telling and the contests of telling. Sound, utterance, like the photographic moment is fugitive (Langford: 2001:122), but repetition, the continual re-performance of photographs within the oral dimension, ensures the longevity of both. However silence, the absence of voice or sound, is equally significant. Forgetting and loss are the silences or the non-functioning of the oral around photographs. The power of this suggestion is demonstrated in the way that photographs are often described in oral metaphors. For example, an exhibition *Lost Identities: A Journey of Rediscovery* (1999) curated by Shirley Bruised Head of the Peigan Nation, Canada,[4] proclaimed on its website that 'photographs can speak, they can whisper or shout' but they are also described as voiceless: 'Many photographs ... are silent. When individuals, events or other details are not known, photographs do not have voices'. People were asked to 'find voices and stories buried in the pictures' (*Lost Identities* 1999). Oral articulation, the naming of names invests tellers with a dynamic power over their own history, breaking the silence (Langton 2001:122; Driessens 2003), articulating the interaction of photographs and people in historical relations hence the importance of photographs in telling genealogies (Macdonald 2003:235–6) as photographs return or reinforce the power to speak of one's history.[5]

Oral expression demands the interaction of a specific audience at a specific time, that is it is lodged in relationships, creating the contexts for the transmission of stories. 'Understanding … photographs is a process of reaching out for what is finally absent, rather than grasping the presence of new "truths" ' (Lippard 1992:20). The narrated story allows the audience to respond (Ong 1982:42) as stories are woven around photographs which are held, passed from hand to hand and caressed, or even amongst groups clustered around the computer screen. These are not single voices of linear narrative but polyphonic, dialogic narrations in which the narrator shifts from point to point, adopting appropriate modes, effecting responses from his/her audience (Brown and Peers 2005:230–1). The rhythms shift from straight narration, song, lamentation, laughter, all demanding different sets of responses from listeners. But responses are not necessarily ordered, but multi-layered and dynamic. Perhaps the sound is of more than one language, especially in situations where the younger generation do not necessarily have the local language. Photographs allow people to articulate histories in interactive social ways which would not have emerged in that particular figuration if photographs had not existed. Photographs become a form of interlocutor, literally unlock memories and emerge in multiple soundscapes, allowing the sounds to be heard and thus enabling knowledge to be passed down, validated, absorbed and refigured in the present. They can 'reunite communities which are fragmented by the disparities in generational experience and knowledge' (Peers personal communication). Thus the oral entanglements of photographs render them truly multi-vocal.

As this suggests, orality does not exist outside the broader patterns and practices of embodiment.[6] Photographs are viewed in groups—bodies touching, a proxemic sense of an interpreting community. As such, proximity is not only constituted through 'presences and co-presences' (Finnegan 2002:104), but also within that space proximity brings into play non-verbal channels of communication—facial expression, gesture, even smell (Howes 1991:171)—all of which contribute to photographic meaning in that they create environments for the affective experience of images.

There is a strong tactile and haptic component in oral expression of photographs as persons must be in the presence of one another to communicate. Touch is in many ways the most intimate of the senses for it registers the body to the outside world. It is arguably the touch on the photograph which mediates the presence of the ancestor, confirming vision in that touch and sight are bridged to define the real (Ong 1982:168–9) as the finger is run over the images. It creates what Taussig, following Benjamin, terms 'optical tactility', 'the plane where the object world and the visual copy merge', fulfilling the desire to get hold of something very closely (Taussig 1993:35). Touch gives solidity to the impressions of the other senses (Jay 1993:35); it connects people to things. Photographs are held, caressed, stroked, sung to. In this sense the distributed personhood invested in the photograph is made material, in that the photograph, through its indexical trace, becomes an extension of the person, the ancestor performed through physical engagement. As MacDonald records of her own response to watching and hearing Wiradjuri/Koori people respond to photographs: 'I began … to see them as real people rather than simply images' (2003:231).

As Finnegan has argued, touch itself is not disconnected to the telling of history. 'Human memory is extended and embodied through our tactile as well as our visual or auditory experience. Something of a commemorative function can be performed through the handling of familiar objects ... symbolic tactile contact between humans through external artefacts is yet another way in which human beings extend their experience beyond the here and now into the longer ranges of the past' (2002:213–4). If the tactile qualities of photographs, with their smooth surfaces and delicate paper bases are secondary to visual, they are none the less highly significant in the transmission of shared values and memories. As a number of commentators have suggested history and memory are embodied and materialised (Fentriss and Wickham 1992, Connerton 1989, Kuechler and Forty 1999), 'Human memory [and thus history] is extended and embodied through tactile as well as visual and auditory experience' (Finnegan 2002:213). Not only are photographs touched, but they are enmeshed in a fluid continuum of touch and gesture cohering groups of interlocutors. Touching is one of the most expressive gestures which both links the personal, idiosyncratic and context specific to socially regulated aspects and frames the pragmatic content of the oral image, marking the story (McNeill 1992:2, 183). By gesture I mean not a formal sign language[7] but the 'spontaneous creations of individual speakers' (McNeill 1992:1). I am marking it here only as the articulation of touch and embodied responses to photographs. However it is worth noting in our relational concerns here that in aboriginal sign-language kin and social interaction is mediated through the body (Kendon 1988:330–68). Gesture co-exists with speech, in that we should 'regard the gesture and the spoken utterance as different sides of a single underlying mental process' (McNeill 1992:1) closely intertwined with the oral in time, meaning and function and thus the telling of history. Even small movements, which are themselves of course visually apprehended, reinforce both voice and image and thus narration, making it more vivid and revealing the speakers' conception of the discourse (Finnegan 2002:111; McNeill 1992:217). While a detailed analysis is beyond the scope of this paper, and in any case requires specific ethnographic grounding, it is essential that we see photographs as embedded in gesture just as they are in oral expression. This link between body, gesture and historical narration has, of course been widely recognised by oral historians (for example Finnegan 1992:106–7, Tonkin 1992:51–2), it is equally important to recognise that the presence of the photograph will elicit specific gestural and haptic forms which shape the communication of history.

<p align="center">***</p>

This important point is demonstrated by Poignant's description of Frank Gurrmanamana, the principal Anbarra owner of the Jambich Rom ceremony, singing a series Jambich *manikay* songs (Figure 11).[8] This he does in response to a series of Axel Poignant's photographs of the *rom* ceremony, and he does so by matching the appropriate verse in the series to the image. The verbal imagery of the songs mirrors the visual imagery of the indexical trace of the *rom* pole motifs (Poignant

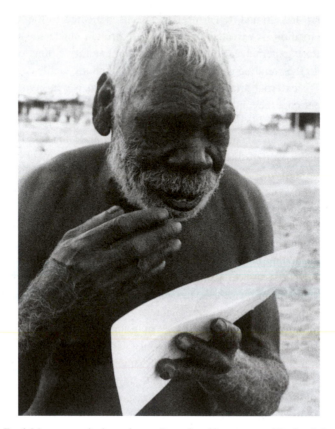

Figure 11 Frank Manamana, singing stringray. Reproduced by courtesy of Roslyn Poignant.

1996:23). But the embodied interaction is extended beyond the visual as Frank Gurrmanamana uses the photographs themselves as clapping sticks to accompany his singing (Poignant, personal communication), holding them in his hands, beating them rhythmically with his fingers, recalling the sound of the clapping stick and its significances. The experience of the photographs, their meaning and impact cannot be reduced merely to a visual response but must be understood as a corpothetic engagement with photographs as a bearer of stories in which visual, sound and touch merge.

Notes

1. My concern here is with the condition and process of the oral—orality—rather than the specifics of language itself.

2. The precise dynamics of this will, of course, vary across different kinds of communities, whether 'remote' or 'settled' (Langton 1993:11–13).
3. Isaac has explored ways in which access to photographs was controlled through the structures of traditional knowledge at Zuni, New Mexico (Isaac 2002).
4. In collaboration with the Alberta Community Development project.
5. 'Giving voice' has also, of course, had a literal and metaphorical meaning in reflexive anthropological practices in recent years, including in visual anthropology. See for example MacDougall 1998:93–122.
6. As Merleau-Ponty argued, "Embodiment is the existential condition of possibility for culture and self" (Csordas 1994:12).
7. Kendon's argument that in formal Aboriginal sign language not only is kin articulated in gesture and sign by pointing to a part of the body but that "The body-articulated character of kin-signs appears to be a reflection of how social interaction, within a given relationship, is mediated by way of the body". This in its turn is reflected in language (Kendon 1988:330–1).
8. Significantly in the context of my argument here the *Rom* is ceremony about making and consolidating friendly relationships and the sharing of special knowledge (Poignant 1996:21).

References

Brown, A. K., and Peers, Laura, with members of the Kainai Nation (2005), *'Pictures Bring Us Messages': Sinaakssiiksi aohtsimaahpihkookiyaawa: Photographs and Histories from the Kainai Nation,* Toronto: University of Toronto Press.

Carter, Paul (2004), 'Ambiguous Traces: Mishearing and Auditory Space', in V. Erlmann, ed., *Hearing Cultures,* 43–63, Oxford: Berg.

Connerton, P. (1989), *How Societies Remember,* Cambridge: Cambridge University Press.

Csordas, T. J. (1994), 'Introduction: The Body as Representation and Being-in-the-World' in *Embodiment and Experience,* Cambridge: Cambridge University Press.

Dreissens, J-A., (2003), 'Relating to Photographs', in C. Pinney and N. Peterson, eds, *Photography's Other Histories,* 17–22, Durham, NC: Duke University Press.

Edwards, E. (2003), 'Talking Visual Histories: Introduction', in Laura Peers and Alison Brown, eds, *Museums and Source Communities,* 83–99, London: Routledge.

Feld, Steven (1996), 'Waterfalls of Song', in Steven Feld and Keith Basso, eds, *Senses of Place,* 91–135, Santa Fe: School of American Research Press.

Fentriss, J., and Wickham, C. (1992), *Social Memory,* Oxford: Blackwell.

Finnegan, R. (1992), *Oral Traditions and the Verbal Arts: A Guide to Research Practices,* London: Routledge.

——— (2002), *Communicating: The Multiple Modes of Human Interconnection.* London: Routledge.

Howes, David (1991), 'Sensorial Anthropology', in D. Howes, ed., *The Varieties of Sensory Experience,* Toronto: University of Toronto Press.

—— (2003), *Sensual Relations,* Ann Arbor: University of Michigan Press.

Ingold, T. (2000), *Perception of the Environment,* London: Routledge.

Isaac, G. (2002), Museums as Mediators, unpublished D.Phil thesis, University of Oxford.

Jay, M. (1993), *Downcast Eyes: The Denigration of Vision in Twentieth Century French Thought,* Berkeley: University of California Press.

Kendon, Adam (1988) *Sign Languages of Australia: Cultural Semiotic and Communicative Perspectives,* Cambridge: Cambridge University Press.

Kuechler, S., and Forty, A., eds (1999), *The Arts of Forgetting,* Oxford: Berg.

Langford, Martha (2001), *Suspended Conversations: The Afterlife of Memory in Photographic Albums,* Montreal: McGill-Queen's University Press.

Langton, Marcia (1993), 'Well I Heard It on the Radio and I Saw It on the Television', Woolloomooloo: Australian Film Commission.

Lippard, Lucy R., ed. (1992), *Partial Recall: Photographs of Native North Americans,* New York: New Press.

Lost Identities (1999), *Lost Identities: A Journey of Rediscovery,* available at http://www.head-smashed-in.com/frimidentity.html (accessed 6 October 2004).

Macdonald, Gaynor (2003), 'Photos in Wiradjuri Biscuit Tins: Negotiating Relatedness and Validating Colonial Histories', *Oceania* 73(4): 225–42.

MacDougall, David (1988), *Transcultural Cinema,* Princeton, NJ: Princeton University Press.

McNeill, (1992), *Hand and Mind: What Gestures Reveal about Thought,* Chicago: University of Chicago Press.

Michaels, Eric (1991), 'A Primer of Restrictions on Picture-Taking in Traditional Areas of Aboriginal Australia', *Visual Anthropology* 4: 259–75.

Ong, Walter (1982), *Orality and Literacy: The Technologising of the Word,* London: Methuen.

Poignant, Roslyn (1992), 'Wúrdayak/Baman (Life History) Photo Collection', *Australian Aboriginal Studies,* 2: 71–7.

—— (1996), *Encounter at Nagalarramba,* Canberra: National Library of Australia.

Stoller, Paul (1984), 'Sound in Songhay Experience', *American Ethnologist* 11 (3): 559–70.

Tacchi, Jo (1998), 'Radio Texture: Between Self and Others', in D. Miller, ed., *Material Cultures: Why Some Things Matter,* 25–45, London: UCL Press.

Taussig, M. (1993), *Mimesis and Alterity: A Particular History of the Senses,* New York: Routledge.

Tonkin, Elizabeth (1992), *Narrating our Pasts: The Social Construction of Oral History,* Cambridge: Cambridge University Press.

−4.8−

Sound Film—Worthy of the Name
Michel Chion

Sixty Years' Regrets

Films projected in theaters have had soundtracks for sixty years now, and for sixty years this fact has influenced the cinema's internal development. But for the past sixty years as well people have continued to wonder whether the cinema did right in becoming "the talkies." One form of this tenacious prejudice is the widespread opinion that in all this time no valuable contributions (or almost none) have been made by sound. The Sleeping Beauty of talking cinema forever awaits her prince, her new Eisenstein or Griffith. Surely whoever holds such idea runs no danger of being proven wrong. In fact, why not extend this criticism to cinema's visual dimension? For, indeed, not a whole lot has been dared in that department either, compared to what remains possible. Discussions of image and sound might thus easily remain stuck at the protest stage: since what we dream of doesn't exist, there's no use in getting interested in what does exist.

But rather than speculate in the abstract about what remains to be done, I would like to question whether we have properly assessed those changes that have occurred. I think there is a tendency to look at the sound film with our eyes staring directly backward, regretting (overtly or not) that the confounded thing didn't remain a nice little silent cinema, the way we once loved it.

Reevaluating the role of sound in film history and according it its true importance is not purely a critical or historical enterprise. The future of the cinema is at stake. It can be better and livelier if it can learn something valuable from its own past.

So far the history of film sound has almost always been told in relation to the supposed break it caused in a continuum. Everything since is related to the coming of sound. This rupture can conveniently be pinpointed historically, especially in that it happened to affect all the aspects of cinema at once: economic, technical, aesthetic, and so forth. But after the coming of sound, you'll find, if you leaf through essays on the subject, it is as if nothing ever occurred since. Historians continue to apply the same models and voice the same regrets that people expressed fifty years ago. But it seems to me that beyond the cinema's discontinuous history, marked by recognizable break points, which are like easily memorized dates of major battles, there lies

a continuous history, made up of more progressive changes that are more difficult to detect. This is the history that interests me.

An Ontologically Visual Definition

Ontologically speaking, and historically too, film sound is considered as a 'plus,' an add-on. The underlying discourse goes like this: even though the cinema was endowed with synchronous sound after thirty years of perfectly good existence without it, whose soundtrack in recent years has become even richer, crackling and pulsating, even now the cinema has kept its ontologically visual definition no less intact. A film without sound remains a film; a film with no image, or at least without a visual frame for projection, is not a film. Except conceptually: Walter Ruttmann's 1930 limit-case film *Weekend* is an "imageless film," according to its creator, consisting of a montage of sounds on an optical soundtrack. Played through the speakers, *Weekend* is nothing other than a radio program, or perhaps a work of concrete music. It becomes a film only with reference to a frame, even if an empty one.

The sound film, as I have said, is just this: sounds in reference to a locus of image projection, this locus being either occupied or empty. Sounds can abound and move through space, the image may remain impoverished—no matter, for quantity and proportion don't count here. The quantitative increase of sound we've seen in films in the last few years demonstrates this. Multiplex theaters equipped with Dolby sometimes reduce the screen to the size of a postage stamp, such that the sound played at powerful volume seems able to crush the screen with little effort. But the screen remains the focus of attention. The sound-camel continues to pass through the eye of the visual needle. Under the effect of this copious sound it is always the screen that radiates power and spectacle, and it is always the image, the gathering place and magnet for auditory impressions, that sound decorates with its unbridled splendor.

How can it work this way? Let us recall several facts about the cinema. The projector is located behind the spectator, the speaker in front. The speaker is not strictly the equivalent of a screen, but of a projector. Only doesn't the word projector have a different meaning here? For we must consider the mode of dissemination too. Light propagates (at least apparently) in a rectilinear manner, but sound spreads out like a gas. The equivalent of light rays is sound waves. The image is bounded in space, but sound is not.

Sound is mental, cannot be touched. An image can; this is what is done in religious ceremonies. You can touch the screen.

With film we can also say that the image is projected and the sound is a projector, in the sense that the latter projects meanings and values onto the image.

Today's multipresent sound has insidiously dispossessed the image of certain functions—for example, the function of structuring space. But although sound has modified the nature of the image, it has left untouched the image's centrality as that

which focuses the attention. Sound's 'quantitative' evolution—in quantity of amplification, information, and number of simultaneous tracks—has not shaken the image from its pedestal. Sound still has the role of showing us what it wants us to see in the image.

Nonetheless, Dolby multitrack sound, increasingly prominent since the mid-seventies, has certainly had both direct and indirect effects. To begin with, there is the new territory noises have conquered.

Sound Infuses the Image

It can be said that sound's greatest influence on film is manifested at the heart of the image itself. The clearer treble you hear, the faster your perception of sound and the keener your sensation of presentness. The better-defined film sound became in the high frequency range, the more it included a rapid perception of what was onscreen (for vision relies heavily on hearing). This evolution consequently favored a cinematic rhythm composed of multiple fleeting sensations, of collisions and spasmodic events, instead of a continuous and homogenous flow of events. Therefore we owe the hyper-tense rhythm and speed of much current cinema to the influence of sound that, we daresay, has seeped its way into the heart of modern-day film construction.

Further, the standardization of Dolby has introduced a sudden leap in an older and more gradual process that paved the way for it. There is perhaps as much difference between the sound of a Renoir of the early thirties and that of a fifties Bresson film as there is between the fifties Bresson and a Scorsese in eighties Dolby, whose sound vibrates, gushes, trembles, and cracks (think of the crackling of flashbulbs in *Raging Bull* and clicking of billiard balls in *The Color of Money.*)

Be that as it may, the fact remains that Dolby stereo has changed the balance of sounds, particularly by taking a great leap forward in the reproduction of noises. It has created sonic raw materials that are well defined, personalized, and no longer conventional signs of sound effects; and it has led to the creation of a sort of super-field, a general spatial continuum or tableau. Which changes the perception of space and thereby the rules of scene construction.

Superfield

I call superfield the space created, in multitrack films, by ambient natural sounds, city noises, music, and all sorts of rustlings that surround the visual space and that can issue from loudspeakers outside the physical boundaries of the screen.[1] By virtue of its acoustical precision and relative stability this ensemble of sounds has taken on a kind of quasi-autonomous existence with relation to the visual field, in that it does not depend moment by moment on what we see onscreen. But structurally speaking the sounds of the superfield also do not acquire any real autonomy, with

salient relations of the sounds among themselves, which would earn the name of a true soundtrack. What the superfield of multitrack cinema has done is progressively modify the structure of editing and scene construction.

Scene construction has for a long time been based on a dramaturgy of the establishing shot. By this I mean that in editing, the shot showing the whole setting was a strategic element of great dramatic and visual importance, since whether it was placed at the beginning, middle, or end of a given scene, it forcefully conveyed (established or reestablished) the ambient space, and at the same time re-presented the characters in the frame, striking a particular resonance at the moment it intervened.

The superfield logically had the effect of undermining the narrative importance of the long shot. This is because in a more concrete and tangible manner than in traditional monaural films the superfield provides a continuous and constant consciousness of all the space surrounding the dramatic action.

Through a spontaneous process of differentiation and complementarity favored by this superfield, we have seen the establishing shot give way to the multiplication of closeup shots of parts and fragments of dramatic space such that the image now plays a sort of solo part, seemingly in dialogue with the sonic orchestra in the audiovisual concerto.[2] The vaster the sound, the more intimate the shots can be (as in Roland Joffe's *Mission,* Milos Forman's *Hair,* and Ridley Scott's *Blade Runner*).

We must also not forget that the definitive adoption of multi-track sound occurred in the context of musical films like Michael Wadleigh's *Woodstock* or Ken Russell's *Tommy.* These rock movies were made with the intent to revitalize film-going by instituting a sort of participation, a communication between the audience shown in the film and the audience in the movie theater. The space of the film, no longer confined to the screen, in a way became the entire auditorium, via the loudspeakers that broadcast crowd noises as well as everything else. In relation to this global sound the image tended to become a sort of reporting-at-a-distance—a transmission by the intermediary of the camera—of things normally situated outside the range of our own vision. The image showed its voyeuristic side, acting as a pair of binoculars—in the same way that cameras allow you to see, when you're at a live rock concert, details, projected on a giant screen, otherwise inaccessible to fans in the back rows.

When multitrack sound extended into nonmusical films, and eventually into smaller dramas with no trace of grand spectacle, filmmakers retained this principle of the "surveillance-camera image." This development obviously might shock those who uphold traditional principles of scene construction, who point an accusing finger at what they call a music video style. The music video style, with its collision editing, is certainly a new development in the linear and rhythmic dimensions of the image, possibly to the detriment of the spatial dimension. The temporal enrichment of the image, which is becoming more fluid, filled with movement, and bubbling with details, has the image's spatial impoverishment as its inevitable correlate, bringing us back at the same time to the end of the silent cinema.

Toward a Sensory Cinema

Cinema is not solely a show of sounds and images; it also generates rhythmic, dynamic, temporal, tactile, and kinetic sensations that make use of both the auditory and visual channels. And as each technical revolution brings a sensory surge to cinema it revitalizes the sensations of matter, speed, movement, and space. At such historical junctures these sensations are perceived for themselves, not merely as coded elements in a language, a discourse, a narration.

Toward the end of the twenties most of the prestigious filmmakers like Eisenstein, Epstein, and Murnau were interested in sensations; having a physical and sensory approach to film, they were partial to technical experimentation. Very few of their counterparts today are innovators ready to meet challenges of new technical possibilities, especially concerning Dolby sound. A symptom, perhaps, of a new stage in the eternal "crisis" of the cinema.

Frankly, many European directors have simply ignored the amazing mutation brought on by the standardization of Dolby. Fellini, for example, makes use of Dolby in *Interview* in order to fashion a soundtrack exactly like the ones he made before. In Kubrick's latest films there is no particularly imaginative use of Dolby either. With *Wings of Desire,* Wenders puts Dolby to a kind of radiophonic use, in the great German Hörspiel tradition.[3] As for Godard, for whom expectations were high, he has not fundamentally revitalized his approach to sound in his two films with Dolby. Neither in *Detective* nor *Signe ta droite* does he offer anything original in lapping an adjoining of sounds, by comparison to what he already achieved in monaural films; in addition, for *Nouvelle Vague* he has returned to his usual monophonic technique.

We could continue down the list and note that from the oldest (Bresson) to the youngest (Carax), there seems to be a context of who can show the least enthusiasm for the new sound resources: just about everyone either neglects them or uses them without inventing anything new. To end on a positive note we should point out Kurosawa's purity and sure hand in mastering Dolby in his *Dreams.* But there are many other directors not necessarily classified as great auteurs and many films not generally revered as great works that are developing these resources in new ways. Some recent examples: the films of David Lynch, of course, but also Coppola's *One From the Heart,* William Friedkin's *Cruising,* and Terence Malick's *Days of Heaven.*

Just what does Dolby stereo offer to a director? Nothing less than the equivalent of an eight-octave grand piano, when what she or he had before was an upright spanning only five octaves, less powerful and less capable of nuance. In short, Dolby offers a gain in resources on the level of sound space and sound dynamics that, of course, no one is obliged to use all the time but that is nevertheless available.

Let us recall that Beethoven wrote his piano sonatas for a smaller instrument than the piano of today: where he reached the limits of his keyboard, we have another two or three octaves. In this sense it is perhaps more correct to play Beethoven on the piano of his era. But there would be something absurd in seeing today's composers

writing pieces for modern pianos with the same limitations as those that constrained the author of the Pathétique. We'd call that working with blinders; and this is precisely what many filmmakers are doing these days, irrespective of any issues of finances.

For writing big does not necessarily mean filling up the whole available space. It means that even when you write only one single note or melodic line, the empty space around the note is bigger. Dolby stereo increases the possibility of emptiness in film sound at the same time that it enlarges the space that can be filled. It's this capacity for emptiness and not just fullness that offers possibilities yet to be explored. Kurosawa has magnificently exploited this dimension in *Dreams:* Sometimes the sonic universe is reduced to a single point—the sound of the rain, an echo that disappears, a simple voice.

Notes

1. With the term *superchamp,* Chion is describing a new and vaster space beyond the merely off-screen (*hors-champ*). The term is translated as "superfield", rather than "superscreen"—[transl.].
2. When sound is more and more frequently in long shot, the image tends to differentiate itself from the soundtrack on the level of scale—i.e., there are more close-ups. I call this a spontaneous phenomenon because I think it has developed without a great deal of conscious intellectual thought. As for the tendency to complementarity: the idea is that in the combining of auditory long shots and visual close-ups, image and sound do not create an effect of contrast, opposition and dissonance, but rather an effect of complementarity. They bring different points of view to a same scene.
3. Particularly at the beginning of *Wings of Desire,* the numerous characters' internal voices, and Peter Handke's literary text ("Als das Kind Kind war …"), are clearly inspired from the Hörspiel tradition, a form of radio composition that used the human voice and text often in very complex ways.

−4.9−

Cinema and History: Jean-Luc Godard in Conversation with Youssef Ishaghpour
Only Cinema Narrates Large-Scale History by Narrating Its Own History

YI Only cinema can narrate History with a capital H simply by telling its own history, the other arts can't.

JLG Because it's made from the same raw material as History. The fact is that even when it's recounting a slight Italian or French comedy, cinema is much more the image of the century in all its aspects than some little novel; it's the century's metaphor. In relation to History, the most trivial clinch or pistol shot in cinema is more metaphorical than anything literary. Its raw material is metaphorical in itself. Its reality is already metaphorical. It's an image on the scale of the man in the street, not the infinitely small atomic scale or the infinitely huge galactic one. What it has filmed most is men and women of average age. In a place where it is in the living present, cinema addresses them simply: it reports them, it's the registrar of History. It could be the registrar, and if the right scientific research were done afterwards it would be a social support; it wouldn't neglect the social side.

YI Cinema has this archive aspect because it's about recording. That's why, you say, there ought to be equality and fraternity between reality and fiction in cinema. Because it's both things together, cinema can bear witness. Even independently of the war news, a simple 35mm rectangle saves the honor of reality, you say; every film is a news document. Cinema only films the past, meaning what passes. It is memory and the refuge of time. Because of this recording aspect there's a relationship between photography or cinema and History that doesn't exist elsewhere. Cinema has this dimension of historicity that the other arts don't have. That's why, as you have said, even a fiction film is metaphorical in relation to History, because it's a trace of the outside … This was the case even if films were unaware of it, until it becomes obvious …

JLG Quite a bit of time has passed …

YI We were talking earlier about using transparencies and tricks of that sort. I think that was a case of reality being canned in advance to be projected on set and incorporated into a fictional world. In that way History, or the real world, was taken metaphorically inside fiction, while you took fiction into the real world. You recall it by saying, apropos the Nouvelle Vague, that you wanted the right to film boys and girls in a real world in such a way that when they saw the film they would be astonished to be themselves and in the world. Even more than Truffaut or Rivette, it seems to me that ever since *À bout de souffle* you've been violently exposing the fiction outside. To cite an idea of Benjamin we've moved from a magical value of cinema to a value of exposure, the historicity that is an effect of technical reproduction. And from that starting point what you showed in *Histoire(s)* was all the historicity of cinema, not just as a historical record, all those images and sounds you took from newsreels, but also the metaphorical dimension of fictional cinema in relation to History. By insisting on the fact that these relations work in both directions, not just that History altered the destiny of cinema or that cinema as such had an effect on History, but that this reciprocity between cinema and History can be seen in very specific images, as in the case of *Ivan the Terrible* and Stalin, or by quoting what Bazin had written on Chaplin and Hitler ...

JLG I put that in, I showed how Hitler had stolen his moustache ...

YI Of course there's that overprint and metamorphosis, but that's not all there is. It's not just Hitler's theft of Chaplin's moustache. In that overprint there appears the idea of the presence in man of the "Other." Chaplin in a way is the emblematic figure of cinema. Your film starts with him; he's also one of the last figures to appear with Keaton, when you're talking about the end of cinema. But he's a constant presence throughout the film. Chaplin's Little Fellow is the emblematic character of cinema, also in a way a figure for the decent man, the man who doesn't aspire to power and hasn't got any, but at the same time through the fade-out/fade-in the Other appears from underneath, absolute horror or Hitler, not from the outside but from within the same humanity. That Other also has its emblematic figure in cinema and in your film: Nosferatu. Thus in relation to History there's something that appears with a sort of permanence, among other things in the repeated clips from *Alexander Nevsky* and the Teutonic knights massacring people, which is the horror characteristic of the twentieth century, whose most extreme manifestation is Nazism. Thus among a hundred examples, that of the wolf running through the desert shot dead from a helicopter, with voiceover describing the death of an unconscious woman buried alive by murderers who haven't even finished her off. But when you're talking about the camera not having changed for a long time, you show Gide's nephew's film on Africa, Captain Blood and his

cannon, Mussolini and the crowd and Mussolini behind a camera. Looking at *Histoire(s),* the first chapter especially, I got the impression there had been three major events in the twentieth century: the Russian revolution, Nazism and cinema, particularly Hollywood cinema, which is the power of cinema, the plague as you say.

JLG People usually mention the first two, the Russian revolution and Nazism, but not the third, which is cinema.

YI Of course the effects weren't the same, these three events, are not comparable, but they coexist and determine the century. You even make some of those juxtapositions of widely different things producing a violent shock effect: an advertisement for an American porn video following the image of Lenin's motheaten mummy; or when the question is raised of American cinema having destroyed the European cinemas, over the image of Max Linder with a caption reading *"help me,"* his last words, the voiceover is a woman's voice saying how long it takes to die in a gas chamber ...

JLG That's a matter of interpretation, because in me there's no idea of interpretation. But people often say you shouldn't make an amalgam, it isn't a question of amalgam, the things are set down together, the conclusion isn't given straight away, people ought to be stretched ... There's projection, that depends on the feelings people have, and Conrad says feelings are the handmaids of our passions ...

YI Of course, the film isn't linear or a discourse in the indicative, it's not a matter of cause and effect, or of comparison, let alone identification. There's contiguity because things existed together.

JLG They existed together, so one recalls that they existed together.

YI The importance you attribute to cinema, by saying specifically that the masses love myth and cinema is addressed to the masses, far outweighs the compliment usually paid to cinema, that it's the major art form created in the twentieth century. The power referred to is one that far outweighs the question of art and is indeed a historic force, full stop. Perhaps one of the differences between the Soviet Union, Germany and the United States is that the first two didn't have and couldn't have what Hollywood represented for American history. Because people are beginning to realize, in America at least, that modern big-city America and the absorption of the immigrant masses in the late nineteenth and early twentieth centuries was achieved as a result of the American dream created by Hollywood, with a weekly audience in its heyday of a hundred million people. That cinema also made the power of America abroad, its conquest of the world since the Second World War being due not only to military, technical and economic supremacy but also to the power of its cinema.

There was a dream factory that conquered the world and then there was the "utopia" of the Russian revolution which turned into a nightmare represented, with all that implies, by Lenin's obscene disintegrating mummy, by the fact of its exhibition ...

JLG Even Lenin's idea of communism wasn't the same as Marx's ...

YI What people forget is that Russia and its history existed in the background ...

JLG There's communism and then there are communists. The history of Russia isn't written, and it's really a pity from the historians' point of view. Even when Furet[1] does the history of the Revolution there are images, there's a mode of thought. When he does the history of Russia they're no longer there, there's text and not even overtext, as Péguy called it, but undertext, and despite the astonishing number of images that exist and that are starting to be seen today, Furet didn't even see a Russian peasant in an Eisenstein film. There was a sequence I wanted to do in *The Old Place* but didn't because of falling back into *Histoire(s) du cinéma,* I wanted to juxtapose two photos of corpses and say: "this one died in Russia and this one in Germany, where's the difference, where's the absence of difference?" I don't find the same thing in fascism and communism ... I'm not going to advance, you could call them hypotheses, or argue with someone by saying what you assert when you say that the evil was in communism, you should think it through, do further research, instead of all these ideological disputes which aren't a quest for truth, while the images are there. So this is the place to say that where cinema tripped over itself was with this obligation to see: it didn't know, it wouldn't, it couldn't, anyway it didn't at the time of Nazism. The obligation to resist, there's one film that did it knowingly—*Rome, Open City*—and after that it vanished. Nothing forced Roberto to make that film ...

YI It's because there was that moment of History in Italy and at that moment there was a favorable situation: cinema tells stories that have a metaphorical relation with History, but here History was a presence in the street, and Rossellini shot the movie in the street. You say yourself it's not just a resistance film, it's a film that resists the uniform way of making cinema.

JLG That's why I said out of uniform because Capra's films aren't like that but on the contrary are made to give America an all-conquering image. Because America needed to dominate the world bit by bit and used cinema, or cinema very consciously and politically volunteered to be used, and because that became customary and Europe accepted it ...

YI Getting back to this permanence of horror ...

JLG It's a matter of copying. It isn't just painters who made copies to learn, when they used to go to Italy to copy a Raphael, they didn't do a hundred, they made one copy, it's creation ...

YI It's Benjamin's idea about technical reproducibility ...

JLG From the moment it could be done technically, when cinema had the means to show its products by running off a number of copies, it also brought in the idea of copying on a larger scale. Since then, when horror is copied it's copied several times, so there aren't just the trenches of 1914 but there's Sarajevo, Rwanda, the Spanish Civil War. There's a lot more of it, you could say horror's being exploited, and that's the moment when the means of pure diffusion arrives, not even copying, just diffusion, and that's TV, and it's even going to be reproduced in cinema, since copies aren't even going to be made any more, films will be exploited by satellite instead. In other words there's going to be pure diffusion, production in the name of diffusion ... The twentieth century exploited that, there was more war, more horror ... horror had to be democratized too, so to speak ...

YI So if there's the money handicap on top of all the rest, why is cinema privileged? Since you say, in connection with Nazism, that cinema ought to have ... that film-makers tried ... that they had warned, or when you say that in the darkened auditoriums the masses had been seething with the imaginary for fifty years and reality was now claiming its share of tears and blood ... But you could say that it was the whole culture that had failed, not just cinema, it wasn't just a matter of cinema being privileged or being incapable ...

JLG All right, but cinema ought to have made it a point of honor ... That also means I would have wanted to do it, or even today I ought to, but I won't, it means that too. I'd like to have done more, perhaps too ambitiously although that isn't the right word in this case ...

YI As you say, "*what is cinema,*" compared to the horror of the real world? "*Nothing,*" "*it wants the lot*" and "*it can do something.*"

JLG It's strange, in literature, with communism and Nazism, a lot of intellectuals wrote books, those books were published and read, and yet everyone carried on just the same ... When Malraux and Gide went down to the Association they knew what was going on in Russia ... And it's still like that today, when Jospin says he's happy with the outcome of the Pinochet affair, or condemns dictators while rushing off to shake pincers with Kabila or someone ... It had all been said, all the German emigrés said it. You may think all those writers weren't big-circulation apart from Gide, and even Gide didn't have print runs of a million, it was for the intellectual milieu. While cinema had certain people of quality more or less, like Renoir, Ford and Chaplin in particular,

and they could have and it wasn't done. "Could do better" as they say, cinema was the favorite son, let's admit that it should have been first among the Cassandras and not a peep was heard. So I tell myself: there's something there. And then afterwards, books were published after the concentration camps. They couldn't be successful understandably but at least it had been done at last, while cinema still didn't do it and then when so-called Resistance films were made, and there were heaps of them, they were just spy thrillers and so on … Here too cinema had a second chance but didn't take it. That's why I quote the example of *Rome, Open City,* although it isn't quite there, although it's a bit fake, although Rossellini … actually Roberto's prewar past is not without a murky side that needs closer examination. But there's a bizarre aspect: why Italy? Why not Greece? Why not France? Perhaps because Italy had lost its soul, France hadn't lost it but no longer knew where it was.

YI Things were complicated in Greece, because after the Nazi occupation there was the destruction of the Communists so that the Tito story wouldn't be repeated, and it's that civil war, much more than fascism, that's still the repressed of Greek History. France's situation was very different, France had been occupied. French Resistance had consisted essentially of resistance to the occupier—*"the enemy"* to De Gaulle whom you quote in your film—rather than specific resistance to Nazism. While Italy had been a fascist country, indeed the first, and the Italians had mounted a resistance against themselves and their fascism … The reason why Italy is that the Italian republic dates from the Resistance. That shouldn't be forgotten. It was a new birth. You say Italian cinema is the identity of Italy, because Italy's new identity was formed at that time, formed in the Resistance.

JLG In the French Resistance as it really was, they were all men and women. I'd rather say boys and girls because they were all very young. They all had lovers or sweethearts. None of that exists for historians; they don't mention it. You don't imagine things like that in daylight; only cinema could do it. There must have been betrayals, jealousies, stuff like that. But for historians none of that exists, so it's pretty weird history they write about … Basically it takes fifty years—I don't know about other periods but since the beginning of the twentieth century it's taken fifty years to start. You have to skip the children's generation and go to the grandchildren's. After that it's gone. If you don't do it then it's lost, forgotten, or else it's memorized, or sanctified. It's all been seen in France; France is quite exemplary in this matter. It's doing its work in this area with Jean Moulin, with Papon. It's doing its work, but the way it's doing it … it isn't very well done. There's the time factor: I started making films in '60, and there were a few years before that. In the year 2000 that will be exactly fifty years, just the right moment for me to take an interest in those stories. There's more time between my first film and my latest than there

was for my father between the First and Second Wars, two-and-a-half times as long. When the time comes I can wonder: *"How did he see all that?"* Or when, for example, I read a historian who said that Pétain's Latin teacher had been at Waterloo—when you read something like that, straight away there's all that time between Waterloo and '40 … That time dimension, that's what cinema should devote itself to—properly made cinema. Even in documentary mode cinema can give that time scale that exists for everyone.

Note

1. François Furet (1927–97), French historian. A communist in youth, helped found PSC (Socialist Party) in 1960. A major writer on the French Revolution and subsequent French republican and monarchist politics, in 1995 published *Le Passé d'une illusion: essai sur l'idée du communisme au XXe siècle,* a self-critical reflection on the wilful blindness of intellectuals towards Soviet reality.

−4.10−

Madonna's Revenge
What Madonna has given to American culture, and culture throughout the world, is not a collection of songs; rather, it is a collection of images.
Annalee Newitz

Do we care what people think of us? No!

—Madonna and her entourage address the camera
in the film *Truth or Dare* (1991)

Madonna is not a musician. Certainly, she achieved fame within the music industry, but perhaps it might be more accurate to say that she *began* to be famous within the music industry. For what Madonna has given to American culture, and culture throughout the world, is not a collection of songs; rather, it is a collection of images. Madonna's images of herself, and increasingly of her own fans, have become popular shorthand for what gender and sexuality might look like for a whole generation coming of age in the 90s. Conservative public intellectual Camille Paglia has lauded Madonna's open flaunting of her 'whore's ancient rule over men' (*Sex, Art, and American Culture,* 1992), while academics in fields from theology to queer studies have written literally volumes on what Madonna's stardom means for gender relations, for American culture, and for the future. But clearly, Madonna is history. Her rise to fame during the 1980s with smash hit songs such as 'Material Girl' and 'Like a Virgin' culminated in the early 90s with her transformation into a self-conscious icon of gender confusion. The avant-garde documentary *Truth or Dare* (1991), which chronicles her 'Blonde Ambition Tour,' and the book *Sex,* her self-proclaimed 'aesthetic' representation of sexual fantasy, mark the moment at which Madonna ceased to be a hot commodity and became instead a comment upon herself as a star. This, again, is part and parcel of the way her image has evolved over the past decade. And it would appear that Madonna's evolution as a star is in direct relationship with the way she has responded to the popular reception of her work.

This, one might say, seems rather obvious. If any individual or corporation desires to retain a power it has gained, it must answer to the desires of those who help to make it powerful in the first place. For Madonna, fans of her music and critics of her image are her most important consumers and promoters. In large part, her fans

have been juveniles, mostly female; and her critics have been intellectuals, mostly involved in the study of gender, sexuality, and the mass media. Madonna has two—mostly divergent—target markets here. Her juvenile audience, called during the 80s 'Madonna-wannabes,' can be relied upon to purchase her CDs, fashion accessories, videos, and tickets to her latest feature film (although her films have, with the exception of *Desperately Seeking Susan,* largely gone unnoticed).

The market for Madonna among intellectual cultural critics is obviously smaller, but nevertheless important. Paglia's endorsement of Madonna in her bestselling works of non-fiction no doubt lend an aura of legitimacy to Madonna's work; and academics such as John Fiske and E. Ann Kaplan have represented Madonna to their academic audiences as a moment in which popular culture imitates critical theories of history, knowledge, and human identity. For university communities, academic endorsement of this kind has led to the inclusion of Madonna-as-text in the contemporary college classroom. Madonna occupies a definite place in the post-Western Cultures curriculum at universities everywhere—she might be taught alongside Spike Lee and Amy Tan as one 'identity' among many in a multicultural America.

Madonna is, in the early 90s, a cross-over act—those who legislate intellectual taste preferences have given her their stamp of approval, and furthermore, she has been lauded by one of the hippest (and most visible) 'alternative' communities around: the homosexual community. Like the juvenile and intellectual target markets Madonna has reached, the 'queer' markets have also avidly consumed Madonna's image and claimed a part of it as their own. This is perhaps most noticeable in male-to-female transvestite and lesbian communities, where Madonna 'dress up' is all the rage. But her popularity among homosexuals goes beyond their desire to imitate her style, for Madonna is one of the only powerful entertainment figures in America who celebrates and represents queer sexualities in her work. *Truth or Dare* features Madonna's entourage of homosexual male dancers, and her videos *Justify My Love* and *Erotica* contain explicit references to lesbian sexuality, as well as a few other kinds of minority sexualities like S/M. Madonna's act has truly crossed over, but she has crossed over *from the mainstream to the margin.*

This is not what we expect from a crossing-over in the entertainment industry. A 'cross-over' act, like Grunge band Nirvana, moves from an entertainment subculture toward mainstream popularity. When *Vanity Fair* (August 1993) promoted k.d. lang as a 'crossing over' act, the publication traced her career from sexual minority status (lesbian) and musical subculture (Country-Western) to sexy pinup gal—photographed with Cindy Crawford—and MTV sensation. The grief and heated debate sparked by k.d. lang and the new 'lesbian chic,' or Nirvana and the Grunge craze, is in most part due to the way minority cultures have felt abandoned by their own particular icons—who, now famous, are 'contaminated' by their answerability to an homogenizing mass market audience. Madonna, by contrast, has become in recent years the idiosyncratic female icon of a 'post-gender' queer community and academic theory communities. The work she has done since the 1980s is not intended to

be entirely comprehensible for a wide audience—juveniles, not yet educated in film or art history, will not likely understand 'subversive' references to Marlene Dietrich or lesbian photography of fin-de-siecle France contained in Madonna's recent work, nor are they likely to care either. It is also important to recall that Madonna has not been reabsorbed into some subculture she occupied before her fame. She became famous as a pop icon, not as a marginal figure who 'sold out' or accidentally hit the big time. Madonna made herself over into a symbol for, and promoter of, minority sexual and intellectual cultures as a result of those cultures having already responded to her as such. Is this, then, some Utopian account of the give-and-take involved in stardom, where Madonna sacrifices her mainstream popularity for the good of university curricula and queer people everywhere? Not hardly, as one of Madonna's former juvenile fans might say.

It is indeed Madonna's attention to her minority reception which has undone her mass appeal. The salient question to ask here, then, would be: so what's in it for Madonna? Why did she cross over into the margins of culture; and why did she see to it that her work became too sophisticated and avant-garde for mass distribution? To answer, we will take a detour through Madonna's images of herself during the course of her career. Precisely to the extent that Madonna's career has become intertwined with the history of the 1980s, and particularly the kinds of gendered and sexual representations popular during that era, we must also take into account what was going on outside, as well as inside, Madonna's work.

Ultimately, what I'll offer here is a way of understanding Madonna as an exemplary case study of gender and sexuality understood in multiculturalist terms. Insofar as she is an example of what minority cultures inside academia and out have endorsed as 'one of their own,' Madonna offers a case history relevant to identity politics—she represents to her fans and critics a fantasy of what their own gendered or sexual identities might mean. To the extent that her minority audiences have responded to Madonna by actively imitating her identity (or its image), understanding the meaning of Madonna's identity is also to understand what it is that people are trying to become when they act and look like Madonna does.

Madonna's rise to fame began in the 1980s, often remembered as The Reagan Era. The 80s were dominated by the image and leadership of conservative Republican President Ronald Reagan, another cross-over phenomenon who went from a mediocre career in the entertainment industry to a prosperous career in the political industry. It was, in fact, during the 1980s that it became commonplace for media commentators to remark upon the disturbing continuity of the two industries' power over American and global citizens. Moreover, during the 1980s, the AIDS crisis galvanized the homosexual community, and inaugurated a new kind of sexual coming-to-consciousness quite unlike the so-called 'sexual revolution' of the 1960s. While the 80s were a time when American political leadership advocated a return to 'traditional family values' and neo-conservatism, it was also a time when 'non-traditional' sexual communities were discovering new opportunities for organization

and public outreach. The safer sex/AIDS awareness movement, and the threat of anti-abortion legislation, became public issues which allowed for renewed, if sometimes covert, debate over homosexuality and women's rights. And finally, it was during the 1980s that the theoretical term 'postmodernism' came into vogue years after it had been first invented by academics and 'pop artists'—much, I would say, like the term 'Freudian analysis' finally hit the big time in American culture of the 1950s long after it had been 'discovered' by intellectuals and the avant-garde.

Madonna, you might say, was born on MTV in 1984 with the release of her video 'Lucky Star,' which featured her as a young 'post-punk' woman dressed in several rosaries, bangles, black mesh, a wrap-around mini skirt, and, most memorably, a bare belly. Her music was originally identified as part of the 80s 'Dance Music' craze, and she followed up her 'Lucky Star' success with another hit dance single 'Into the Groove' (1985). 'Into the Groove' is a song associated with the height of her 'boy toy' phase, coming as it did soon after her first Number One single 'Like a Virgin' (a song, incidentally, originally written for a man). The 1985 film *Desperately Seeking Susan* included Madonna as a character who resembled Madonna in nearly every way, and the soundtrack featured 'Into the Groove.' It is one of the only critically-acclaimed films Madonna has ever done (with *A League of Their Own being another*), and interestingly, she appears only as a supporting character who fuels the romantic fantasies of Roberta, a middle-class suburban housewife looking for adventure. Madonna, in this film, in this 'boy toy' phase, functions as an image of the repressed other half of the neo-traditional 1980s woman. Madonna's next major image overhaul came when she completely resculpted her body through aerobics and weight training, dyed her hair Marilyn Monroe blonde, and began to wear self-designed lingerie that resembled body armor. Two music videos epitomize this phase: 'Open Your Heart' (1986), in which Madonna portrays herself as a stripper in a peep show gallery, and 'Express Yourself' (1989), in which Madonna dresses up in masculine 'fascist drag,' wears chains, and sings to very wet, well-muscled men who appear to be slaves. 'Express Yourself' has been one of her most talked-about videos, particularly because of the many versions of her image she includes in it. In one scene, there are two Madonnas in the frame, one crawling across the floor like an animal and lapping up milk from a saucer, the other wearing a severe dark suit and watching from a black leather couch. This shot, in particular, serves to illustrate the mutation Madonna's image was undergoing: she's acting out self-consciousness by 'watching herself.' While she had certainly been interested in self-consciously making herself a reference to American female retro-icons in her 1984 'Material Girl' video (where she dresses up like Marilyn Monroe in *Gentlemen Prefer Blondes*), 'Express Yourself' gives its viewers a whole new series of image references to traditional American gendered and sexual icons—male and female—and a whole new level of irony.

In a 1991 interview with *Us* magazine (June 13, 1991), Madonna says, 'You only have to have half a brain in your head to see that I'm quite often making fun of myself. I mean, how obvious can I be?' What is important to think about here is

Madonna's relationship the maintenance of her famous identity. When a product is profitable, it is most often the case that those who sell the product are interested in repeating the formula that fostered success in the first place—this, at any rate, is the safest route to go if you're in the business of marketing. Madonna is quite aware that she is in this business. But instead of simply *repeating* the product/image formula that gave her success, Madonna chose to repeat it ironically, 'making fun' of her 'boy toy' self, which so many juvenile women had come to emulate in their own style of dress. That is, she was offering her audience a slightly differentiated Madonna image to keep them coming back for more product. This, as anyone knows, is good business sense.

You and I are probably both tired of hearing that the problem with Madonna is that she gets rich off her image while the rest of us pay to imitate or enjoy that image. Rock critic Andrew Goodwin has made this argument succinctly in his recent book on MTV culture, *Dancing in the Distraction Factory* (1992). At this point, it is patently obvious to nearly any fan or critic of Madonna that they can't be Madonna herself unless they become multi-millionaires. Nevertheless, there is a way that they can *imagine* themselves as *versions* of Madonna in their daily lives, and this certainly will affect the way they perceive their own identities and the social world.

Therefore, let me continue for a moment discussing Madonna's relationship to her own identity. During the early 90s, Madonna altered her image and identity once more. With the release of *Truth or Dare,* the book *Sex,* and the videos 'Erotica,' 'Vogue,' and even the recent 'Deeper and Deeper,' Madonna finally answered directly to her minority fans and critics in the homosexual and academic communities. She became, as it were, a self-conscious postmodern icon of gender and sexuality. While I realize postmodernism is a contested term and elicits sometimes incomprehensible debates when it gets used, here I intend it to be understood to designate a particular form of representation during a specific historical period. Postmodern representation, as art critic Hal Foster (*The Anti-Aesthetic,* 1983) and theorist Fredric Jameson (*Postmodernism,* 1991) have noted, is characterized by ironic self-consciousness and references to other kinds of representations in culture or history. Furthermore, postmodernism occurs in contemporary art and popular culture starting around the 1960s and continuing into the present. Madonna's relationship with her own image exhibits many of the most popular elements of postmodern representation: she comments ironically upon herself as an image and a product (she 'makes fun' of herself), and her image refers to famous gender icons of the past and present, such as Marilyn Monroe, 'military men,' or 'S/M lesbians.' Madonna, it might be said, understands her identity as a series of images which can be distinguished from each other mainly by understanding what they 'refer' to. We can look at her (or she can look at herself) and say, 'She's doing Marilyn,' or 'She's doing her 'fascist dictator lesbian persona.' But underneath our recognition of what Madonna is 'doing' is our recognition that she's still Madonna, that is, she's still one person who happens to be female and rather famously heterosexual. So although her act and image involve

referring to other genders, other people, and homosexuality, it just as importantly involves prior knowledge of her 'actual' identity. If we did not know her 'real' identity, then I think her personas might seem a little less like entertainment and a little more like schizophrenia.

Let's backtrack for a moment and look at Madonna's image-identities in relationship to history. First of all, she learns to don her 'boy toy' persona—and make ironic reference to the 'virtuous virgin' she clearly isn't—during Reagan's second term in office. By this time, the idea that Reagan himself is little more than an image, an affable figurehead who 'reassures' us, is a somewhat tolerated point of view in the mainstream press. This is largely because Reagan himself is ironic, and offers us jokes about his status as a former Hollywood actor even as he is describing a political event. Therefore, to a certain extent, Madonna learns image-production from a powerful political figure, who himself learned about image-production from the entertainment industry. But, you say, Madonna's 'boy toy' image is in many ways the *precise inversion* of Reagan's image: where he is 'wholesome,' conservative, and promotes 'traditional values,' Madonna openly flaunts her sexuality and unconventionality. I would argue her image is especially designed to elicit this response.

To the extent that Madonna deliberately sets out to oppose neo-conservative images of gender and sexuality from the 1980s, she shares something in common with the people participating in the homosexual and women's rights movements of that time. Because she is self-consciously opposing these images by 'referring' to them, her oppositional identity can also be understood in theoretical terms by academics who study postmodernism. This is where the adoration of two of her minority audiences comes from—they identify with her effort to oppose Reagan's conservative images of 'morning in America.' Although Madonna's 'boy toy' image and her subsequent 'dominatrix' image are references to some of the more hateful stereotypes of women and their sexualities perpetrated by neo-conservatives of the 80s, her minority audiences 'understand' in one way or another that Madonna is just 'making fun' of the images rather than 'meaning it.' The powerful seductiveness of Madonna's multiple identity-image, then, is precisely her ability to put identity-images on but remain uncontaminated by them. No one has so far *mistaken* Madonna for a man's plaything, or a lesbian, although she has teased us with the possibility that she might somehow be both.

I think therefore it is right to assume that identifying with Madonna, or teaching her as an exemplary female identity in the multicultural classroom, must always involve understanding her image(s) as a kind of revenge upon traditional representations of what is 'feminine' or what 'feminine sexuality' might look like. A homosexual man or woman, having been told all his or her life that homosexuality is wrong or disgusting from a traditional perspective, certainly might have good reason to wish for revenge upon such a tradition. And academics, forced to learn and teach the sometimes irrelevant Western 'tradition' at universities, might also want to get revenge upon it. Indeed, I am no stranger to a strong desire to wreak violent

revenge upon a tradition that tells me to be a submissive, heterosexual girl who studies Shakespeare and Plato.

But let's think carefully about what Madonna's revenge does for us. Or rather, let's look at her identity as a fantasy of revenge upon tradition, and see what that means for those of us who imagine 'Madonna' as a possible way to convey our postmodern 'female sexuality.' First of all, Madonna sexualizes (quite effectively, I'd say) all her identity-images. Since one generally associates the sexual with the pleasurable, we get a shot at pleasurable revenge when we do 'Madonna.' Of course, we also think of our identity as an image, that is, something we can change around without being essentially effected by it. Who do we think *will* be effected by these images of identities? Not us, but everyone else, and especially the 'traditional' people who deserve to be shocked and frightened by us anyway. But where do we get our identity-images from, besides Madonna herself? From 'tradition,' or history, which has left to us a number of images of minorities, most of them condescending, cruel, and even genuinely terrifying. However, our revenge comes when we dress up like Madonna's lesbian dominatrix—a staple of sexist stag films—and laugh at the terrified or hostile responses we get from a couple of businessmen strolling down the street. Our revenge is our irony, our laughter in the face of people who respond to us *as stereotypes,* as the terrifying 'women with whips' we are only pretending to be. While tradition may think we are scary and terrible, deep inside we know we are just regular people putting on a show.

. . .

−4.11−

A Fascist Theme Park
Marla Stone

At eight o'clock on the evening of November 18, 1938, Benito Mussolini threw a switch which opened the Mostra autarchica del minerale italiano (Autarchic Exhibition) and illuminated Rome's archaeological treasures, from the Palatine Hill to the Aventine Hill. As reported by the Fascist press agency, Mussolini activated a lever attached to "thousands and thousands of machines," while "an incandescent rain fell from above" and a series of sirens wailed.[1] Hundreds of party officials and thousands of eager spectators witnessed this spectacular nighttime sound-and-light show. In the weeks that followed, the official press and LUCE newsreels dramatically reproduced the attractions for those who had missed them.[2]

The Circus Maximus exhibitions, of which the Mostra autarchica was the fourth and last, materialized the Fascist regime's political, social, and economic concerns, from its demographic campaign to its autarchy policy. Between 1936 and 1939, the administrative offices of the Fascist Party mounted four major exhibitions in the Circus Maximus in Rome. Two of them addressed Fascism's social concerns, the Mostra Nazionale delle colonie estive e dell'assistenza all'infanzia (National Exhibition of Summer Camps and Assistance to Children) (June–September 1937) and the Mostra del Dopolavoro (Dopolavoro Exhibition) (May–August 1938). The Mostra delle colonie estive hailed government and party advances in infant health care and demographic growth. The Mostra delle colonie estive, by presenting all that the regime had accomplished in improving the social welfare of mothers and children, offered a vision of a healthy, racially fit people ready for war. Its displays and pavilions covered topics from the regime-led war against tuberculosis to its crusade against illiteracy. The Mostra del Dopolavoro highlighted the successes of Fascism's after-work organizations. It stressed the educational and leisure opportunities provided by the regime's coordination of the workplace and of workers' after-work time: the exhibition hosted sports competitions between groups of workers and a range of entertainments, including film festivals, concerts, and athletics.

The two other exhibitions in the Circus Maximus concentrated on Fascism's economic policies in the late 1930s. The Mostra del tessile nazionale (Exhibition of National Textiles) (November 1937–March 1938) and the previously mentioned Mostra autarchica del minerale italiano (November 1938–May 1939) translated late Fascist economic policies to a mass audience.[3] These two exhibitions focused on

developments in domestic industries in the wake of the Ethiopian War and the League of Nations sanctions against Italy for the invasion of Ethiopia. The Mostra del tessile nazionale centered around displays and demonstrations detailing government-supported advances in domestic textile production—from the cotton grown in recently conquered Ethiopia to the rayon and lanital synthetically produced in government-assisted industries. The Mostra autarchica, taking place in the months before World War II, stressed Fascist Italy's industrial self-sufficiency: the exhibition celebrated the glories of the autarchic heavy industry. Coal mining, synthetic fuels, and steel production all proved Italy's preparedness for war and its ability to fight that war.

The Circus Maximus exhibitions disclose shifts in the organization of culture that occurred during the regime's final years. They also reveal the abandonment of the modernist-inspired formula that had shaped state patronage to date. Fascist culture after 1936 challenged the eclecticism and modernism of the early and middle 1930s with an imperial and increasingly racial and militarist aesthetic. In its selling of war and empire, the Fascist Party rejected the dynamic format that had drawn the spectator into a transformative experience in favor of overwhelming displays of Fascism's triumphs and strengths. The post-1936 exhibitions pursued overawed, passive spectators convinced of Fascist supremacy, rather than the engaged participants of the Mostra della rivoluzione. State patronage at mass exhibitions after 1936 redefined the balance between art and propaganda. Official culture in this period segregated art from artifact: documents and artifacts returned to their display cases. The swirling of past and present, of fact and myth and the redemptive possibilities that had defined the Fascist *Gesamtkunstwerk* were replaced by static display cases, which convinced the visitor through facts and numbers. Late Fascist culture used art decoratively or monumentally to declare the power and legitimacy of the state and its explicit connection to historical elites. The art commissioned at the Circus Maximus, though in a few cases still drawing on futurist inspiration, was predominantly steeped in a representational imperial, monumental aesthetic, with *romanità* reganant.

The exhibitions of the Circus Maximus subordinated the viewer to the project, and did not draw him or her into it, other than to take pride in Fascist triumphs. Fascist mass culture had always depended on elements of spectacle and attracted audiences through the strategic use of the discourses of Fascist supremacy and Fascist-created national renewal. But by the late 1930s, the regime defensively exaggerated such strategies and became dependent upon militarist and xenophobic imageries. The exhibitions of the Circus Maximus mobilized spectacle to sell the Fascist project and the idea of Fascism's ability to resolve social, political, and economic conflict. These exhibitions proposed transcendence through Fascist technological and military predominance.

The Fascist Party built the exhibition city of the Circus Maximus (1936–39) in the final phase of state patronage. These final years (1936–43) witnessed the fragmentation of Fascist aesthetic pluralism into its constituent cultural fiefdoms, with some bureaucrats advocating emulation of National Socialist cultural politics and others

defending aesthetic pluralism as authentically Fascist. In response to political and economic pressures, such as the war in Ethiopia, the alliance with Nazi Germany, and internal political crises, the regime adopted a more coercive and authoritarian patronage style in the late 1930s. As war, international economic sanctions, and worsening economic conditions at home challenged the dictatorship from without, and as a faction of pro-Nazi hard-liners radicalized it from within, official culture increasingly diverted the gaze of the populace and emphasized a mass culture of didactic propaganda and illusion. The emotionalized, transformative rhetoric of Fascist modernism gave way to overbearing messages of power and might, given form through Romanized monumentalism and high technology: the dominant inspiration for official culture shifted from the art of the European avant-gardes to the art of the Caesars.

The vision of Fascist supremacy embodied in the theme park of the Circus Maximus distracted visitors from the real city and the growing fissures on the outside of the Circus Maximus. Rosalind Williams, in her study of consumption strategies at the 1900 Universal Exposition of Paris, reveals the "dream worlds" created by the display of exoticized commodities.[4] In her conceptual framework, the arrangement and variety of new mass-produced goods forged worlds of fantasy and desire in fin de siècle spectators. In the case of Italian Fascist mass culture of the late 1930s, the "dream worlds" built from the mix of propaganda, spectacle, and mass entertainment offered ingestion of the national, Fascist project and participation in a high-technology utopia.

The Fascist Party built its theme park-ideal Fascist city in the middle of the actual city, in the historical heart of Rome. By constructing a parallel or analogous city in the center of the living city, the regime presented a utopian reflection of the world outside. As M. Christine Boyer has written in reference to contemporary "historical" urban renovations, such constructions "enclosed its spectators, regulated their pleasures, and focused their gaze."[5] The Fascist theme park, constructed in a monumental but also functionalist style, depicted a clean world of social peace, harmony, and Fascist predominance, devoid of the dirt, conflict, and ambiguity of the real city outside. The sleek, monumental promenades, fountains, and triumphal passageways of the exhibition city bespoke social order and progress. The pavilions and walkways combined modernity and imperial monumentality, using marble and metal—white, modern, and shining. The scale was grand. Forced-perspective architecture directed the visitor's gaze toward the main facades and walkways. For each of the exhibitions, the spectator faced entry boulevards drawing the eye toward a central facade or a series of monumental sculptures. To stress the hierarchies of Fascism at war each exhibition was built around a central axis, a triumphal boulevard. These constructions stood in oversized contrast to the crowded medieval ghetto neighborhoods on the other side of the Palatine Hill, which the regime was in the process of tearing-down, relocating its working-class inhabitants to new suburbs on the outskirts of Rome.

By building an imperial theme park between the Roman Forum and the Aventine Hill, the dictatorship forced spectators to associate the Roman past and Fascist future. The Fascist future, according to the exhibition, while distinctly different from

imperial Rome, could nonetheless be comfortably nestled in the glorious Roman cradle. The choice of the Circus Maximus, the ruins of the Roman Empire's site of sport and leisure, was a rich one. It was a reminder of the regime's desire to occupy physically the space left millennia earlier by the Romans. The use of a red-brick second-story by Adalberto Libera and Mario De Renzi for their Padiglione dei congressi (Congress Hall) at the Mostra delle colonie estive mirrored the colors and materials of the imperial Roman residences on the Palatine Hill, which looked down upon the exhibition, making clear the historical legacy of ancient Rome. The repeated use of marble, fountains, and columns reinforced the connection to the Roman monuments in the Roman Forum, just the other side of the Palatine.

Such a "framing" of Rome turned the city itself into a spectacle. The Fascist theme park's relationship to Rome parallels Disneyland's relationship to Los Angeles. In the Circus Maximus, all visitors had access to the planned, technological Fascist society depicted in the displays and entertainments, just as in Disneyland all could partake of Main Street's American Dream.[6]

A utopian city created by its organizers in the Fascist Party, this city was a controlled and orchestrated version of a functioning city. It was removed from external social and political contexts. The clean, new public spaces of the exhibition city were climate-controlled piazzas where the state determined both the spectators and the shape of the spectacle. Just as there are no demonstrations in Disneyland, dissent was irrelevant in the Fascist utopia of the Circus Maximus.[7] Instead of the spontaneity of normal city streets, the public spaces of the Circus Maximus hosted the rallies and parades of the party's mass organizations, from the Fasci femminili (Fascist Women's Organization) to the Gruppi universitare fascisti (Fascist University Groups).

The theme cities of the Circus Maximus were self-enclosed and self-sufficient environments. Late Fascist culture pursued a variety of forms of analogous and "new" cities at home and in the newly established empire. The phenomenon began in the middle 1930s with the "new towns" built on the drained swampland of southern Italy and was repeated in North Africa and Ethiopia. The final and most extensive of such analogous cities was to be the Esposizione universale di Roma (Universal Exposition of Rome), which the regime planned as a grandiose Fascist-built "new" Rome located between the actual Rome and the sea.

Not only were the Circus Maximus exhibitions analogous cities, they were autonomous cities. Each exhibition boasted a full range of facilities from restaurants to hotels to theaters. The Mostra delle colonie estive, which advertised itself as "The City of Children," ran a functioning summer camp on the site for the duration of the exhibition.[8] The exhibitions re-created on site wholesale environments, from regional villages to hospitals. In its stress on technology and Fascism's ability to procure it, the exhibition's party organizers bragged that the Circus Maximus provided full accommodations for journalists, replete with offices, typewriters, telephones, and telexes—making recourse to the outside world unnecessary. The cities of the Circus Maximus were expansive in scale as well: the twenty-three pavilions of the Mostra

autarchica spread over 35,000 square meters and its piazzas, boulevards, and garden areas occupied an area of 24,000 square meters.[9] As a sign of its Herculean urbanistic powers, the dictatorship heralded its ability to build a full-scale city in seventy days, with the mobilization of "2,500 workers, thirty-five participating firms, forty architects, fifty engineers, and 1,750,000 man hours."[10] Powerful evidence of changes in official culture can be seen in the roles played by art and architecture. At the Circus Maximus, the regime separated and distanced art and architecture from one another and from the artifacts and information displayed. This quarantining of aesthetics was in striking contrast to the interpenetration of art, architecture, and artifacts that had defined the Mostra della rivollizione fascista. Gone were the three-dimensional *plastica murale* that projected from the walls in an array of modernist angles and textures. In their place, the Fascist party commissioned primarily Roman-inspired art, such as at the entryway of the Mostra del Dopolavoro, which displayed monumental allegories of "work," "sport," and "culture" in linear triumphal procession. These marble statues of oversized classical proportions represented Fascist translations of Roman imperial statuary.

Each of the exhibitions contained a central pavilion with a facade. Again, these exhibition facades reveal the distance traveled by state patronage between 1932 and 1937. The facade of the main pavilion of the Mostra autarchica consisted of "aluminum and glass [which] sends blinding rays and broadcasts in cubic characters the word autarchy." Below the giant metal letters spelling-out autarchy hung an enormous metal imperial eagle. Underneath the eagle, along the pediment, ran the words, in capital letters, "Mussolini ha sempre ragione" (Mussolini is always right). This overbearing combination of text and monumental sculpture left no doubts regarding the dominance of the dictator and the empire. The increasingly shared tastes of the now allied Nazi and Fascist regimes were obvious in the similarity between Kurt Schmid-Ehmen's *Eagle and Swastika* of the facade of the National Socialist Pavilion at the 1937 Paris International Exposition and the Mostra autarchia facade. In both cases the power of the state is represented by imperial eagles with full-spread wings; the claws of these eagles grasp, in the Nazi case, the wreathed swastika, and in the Fascist one, branches.

The art that the exhibition organizers chose to support the displays at the Circus Maximus exhibitions was separated from the displays and educational materials. The exhibition built a positivist cordon sanitaire between decoration and information, rejecting an earlier appeal to emotions through the collapsing of documents and art. The party was loathe to lose the support of prominent and committed artists, but their work—rejecting the modernist project of arousing emotion through shape, form, and color—played a different and secondary function. Mario Sironi, a leader of the Novecento movement in the arts and best known as the official artist of *Popolo d'Italia,* contributed mosaics and murals to two of the exhibitions.[11] The futurist painter Enrico Prampolini designed the entrance of the autarchy pavilion, which reviewers described as a "plastic synthesis of Italian autarchy."[12] In his wall

panel, Prampolini encircled a graphic design of Mussolini's decrees on autarchy with replications of abstracted Roman battle standards. In each of these examples, the mosaics and wall panels remained separate from and not touching the display cases.

As a result of state patronage's rejection of the modernist aesthetic project, official culture turned to earlier artistic traditions. The Circus Maximus's party organizers embraced Italy's art of the past. As it abandoned the possibility of using contemporary aesthetics to construct a Fascist imaginary, the regime mined evermore the Italian historical patrimony, particularly those aspects of it which stressed *italinatà*. The Mostra del tessile nazionale boasted a display of antique and arts textiles, on loan from the great museums of the nation. Other exhibitions included masterpieces of the Italian patrimony, albeit often in a contrived manner. The Mostra delle colonie estive included an "Exhibition of the Child in Art," displaying a range of Italian Renaissance and baroque art, but only pieces in which motherhood or a baby appeared. In this way, working-class Italians who were unlikely to have the trained aesthetic eye of bourgeois audiences, could learn to appreciate a Raphael or a Botticelli.[13] The Mostra autarchica presented a sculpture exhibition of works "created with material of the Italian soil: marble, bronze, iron, etc."[14] The inclusion of high art in legible guises brought spectators to identify with the national cultural patrimony, which the regime hoped to co-opt in its favor. The appearance of historical artwork identified Fascism with the past and offered messages of stasis and continuity, rather than experimentation.

The displays reasserted the distance between the spectator and the material. The objects returned to static, enclosed glass cases. At the Mostra della rivoluzione fascista, the artifacts—the relics of the Fascist assumption of power—had been immediate and open, reaching into the expository space. For each of the four exhibitions in the Circus Maximus, graphs, figures, and documents offering data of production quotas, economic growth, and industrial development drove the narrative of Fascist success.

While the displays and the art used to support them marked a shift in state patronage, the exhibition buildings of the Circus Maximus still bore a modernist influence. The same architects who had given Fascist modernism its character remained. Modernist-inspired architecture gave form to the representations of Fascist progress and supremacy. The pavilions, halls, and theaters of the exhibition city were functionalist, with an emphasis on open spaces, glass, industrial design, and minimal ornamentation. For the Exhibition on Summer Camps, Adalberto Libera and Mario De Renzi constructed the Padiglione dei congressi (Congress Hall), a building of sleek lines, rounded corners, and a cantilevered second story. The exhibition city's overall look was contemporary, or, as a recent critic has written, "The exhibitions were extremely popular and were well served by a building style as lightweight, airy, and modern as anything in Europe."[15] At the time, a reviewer labeled the Mostra delle colonie estive the product of young architects "raised in the clarifying atmosphere of functionalism."[16]

The celebrities of Italian modernist and rationalist art and architecture contributed to the exhibitions and experimented with their government commissions. The Italian branch of the international movement in architecture, rationalism, which drew its

inspiration from the Bauhaus and Le Corbusier, figured prominently. Leading members of the rationalist movement, including Libera and De Renzi, as well as younger modernist architects such as Luigi Moretti and Ettore Rossi participated. More precisely, the architecture of the Circus Maximus reflected the hybrid modernist-monumentalism of Fascist Italy's post-1935 cultural patronage. A monumental functionalism particularly suited late Fascist culture in its ability to articulate a range of messages and in its capacity as an embodiment of both modernity and tradition. Together with the continued remnants of International Style modernism, the buildings carried a consistent overlay of classicism and monumentalism. The architectonic embodiment of imperialist rhetoric transformed the ideal Fascist city into an imperial city. Classical proportions, triumphal arches, and columns, although stylized, predominated. The urge toward classicism was greatest in the Mostra autarchica of 1938. Mario De Renzi, Giovanni Guerrini, Mario Paniconi, and Guido Pediconi executed a general plan emphasizing a central axis which concluded on the dominant autarchy pavilion. The blend of modernism and classicism continued the connection to the archaeological monuments surrounding the exhibitions. As it reinforced the regime's staging of itself as the new Roman empire, this architecture also deepened the spectators' fantasy of participation in a grand new imperial project. The monumental proportions and imperial Roman motifs simultaneously inspired and overwhelmed the spectator, encouraging collectivism in the face of Fascist achievements.

In the buildings of the Circus Maximus, modernist-monumental architecture became a container of shifting messages.[17] The exhibitions' varied rhetorical needs demanded that the buildings articulate changing aspects of Fascist progress and power—from Fascism as protective parent to Fascism as economic giant able to battle successfully the economic sanctions of the League of Nations. The architects of the Mostra delle calonie estive built a site that balanced a festive sense with the scientific sobriety required by the regime's demographic campaign. For Giuseppe Pagano, one of the most visible proponents of rationalist architecture, this exhibition's thirteen pavilions on subjects from schools to health care combined "unity of style, a clear urbanistic sense, [and] an expository vigor."[18] The next exhibition in the series, the Mostra Dopolavoro, which celebrated the regime's efforts at organizing the working class, called for an ambience of sport and propaganda. Architects constructed a grand park with three pools, an ice-skating rink, and a number of theaters.[19] According to *Architettura,* the Mostra autarchica, the last in the series, was a "constructed environment, suited to an industrial and autarchic exhibition, achieved with sobriety and elegance through the use of the most common industrial elements. This architectonic-urbanistic complex is different from the previous shows, as it is much more unitary and lucid."[20]

The exhibition city's simple but imperial ornamentation reinforced messages of Fascism's Brave New World. The dominant and repeated iconography stressed stylized fasci, eagles, workers, and soldiers often in marble or metal. The monumental and Romanized statuary of the exhibition depicted, as the case required, the fertility of Fascist motherhood or the strength of the Fascist worker and soldier. For spectators

well accustomed by the late 1930s to Fascism's iconographic repertoire of fasci, eagles, and soldiers, the symbols of the Circus Maximus were familiar and decipherable. The architecture of the Circus Maximus mobilized theatrical design elements, such as the manipulation of scenery, perspective, and facades, to create an environment of illusion and pleasure.[21] Spectacular nighttime inaugurations, with their emphasis on lighting, deepened the theatrical quality by providing dramatic scenes. Architects used large reflecting pools and fountains to further the holiday-garden sensibility. Theater design allowed for physical and rhetorical flexibility. The metal skeletons of the exhibition pavilions awaited redesigning for the regime's next "staging." As in set design, facades and perspective were central, particularly forced-perspective architecture, which regulated viewing. For each of the exhibitions, the spectator faced entry boulevards drawing the eye toward a central facade or a series of monumental sculptures. The visitor to the Mostra autarchica immediately faced the full-spread imperial eagle of the autarchy pavilion, with its injunction from Mussolini just below. The gaze then moved to the four petroleum extraction pumps flanking the pavilion.

In addition to the influence of set design, the architects borrowed from advertising, especially the then recent application of avant-garde design to the selling of commodities. The influence of advertising was evident in the facades and the graphic displays. At the Mostra delle colonie estive, the entry sign consisted of a simple square with the letters PNF (National Fascist Party) and the Roman numerals XV to designate the year of the Fascist era and, finally, the title of the event. Highly abstracted fasci decorated the base of the structure. The sans serif letters and an abbreviated and staccato style came directly from the Bauhaus and the International Style. The constructivist and Bauhaus influence is clear in the bold, sans serif lettering and the ability to see through to the internal structure. Another view of the entryway reveals the metal fasci which also refer to constructivism, with its use of sheet metals and provisory character.

By the time of the Circus Maximus exhibitions, state patronage had created a group of architects who had achieved national reputations and exposure based on their exhibition architecture. The scale of the Circus Maximus exhibitions provided a large number of architects and artists with work and public notoriety. By way of example, the Mostra autarchica del miner ale italiano hired 40 architects, 50 engineers, and 160 artists and technicians to construct its twenty-three pavilions.[22]

Many artists and architects, traveling from exhibition to exhibition, executed some of their most significant work of the decade at official exhibitions. The rationalists often experimented on exhibition architecture and were given space at official exhibitions at a time when commissions for less temporary structures went to the romanizing, monumental faction of Fascist architecture. Mario De Renzi constructed parts of the Mostra della rivoluzione, the Mostra delle colonie estive, the Mostra del tessile nazionale, and the Mostra autarchica del minerale italiano. Adalberto Libera collaborated with De Renzi on the general plan of the Mostra delle colonie estive and its Padiglione dei congressi. Libera joined Giovanni Guerrini on the Mostra del tessile.

The Mostra delle colonie estive had a full showing of rationalists, with Luigi Moretti designing the Organizzazione nazionale balilla pavilion and Ettore Rossi the tourism pavilion. Moretti had been a mainstay of official culture and had winning entries in the Palazzo di littorio and Esposizione universale di Roma (EUR) competitions. Rossi was later involved in the general plan for Esposizone universale di Roma.

Visual artists, as well as architects, devoted large portions of their careers to official exhibitions. Mario Sironi, who had designed the core cycle of rooms at the Mostra della rivoluzione fascista, contributed to the Mostra aeronautica, painted a mural for the Mostra del Dopolavoro, and executed murals and mosaics for the Italian pavilion at the 1937 Paris International Exposition.[23] Enrico Prampolini, the futurist painter, created a range of artwork—installations, paintings, frescoes, and mosaics—for the major Fascist Party exhibitions of the 1930s. For prominent artists in search of exposure or aspiring artists in search of commissions, official exhibitions offered notoriety, work, and the opportunity to give form to Fascist priorities.

Notes

1. "Agenzia Stefani," November 18, 1938, ACS, PCM (1937–39), 14.1.6198.
2. The government newsreels, produced by the Istituto Luce, emphasized exhibitions, the preparations surrounding them, their inauguration, the visits of prominent guests, and other aspects of interest. By law, these newsreels were shown before and after feature films. The Mostra autarchica appeared ten times between November 19, 1938, and February 2, 1939, in the twice-weekly newsreels. The LUCE filmed the construction and the inauguration of the Mostra autarchica, as well as the visits of Nazi officials and group tours by various Fascist mass organizations. Cinecitta, Istituto Luce, Cinegiornali, 1938, nos. 1392–1453.
3. See Gino Salocchi, ed., *Mostra nazionale delle colonie estive e dell'assistenza all'infanzia,* cat. exh. (Milan: Unione Tipografica, 1937); *Mostra del Dopolavora,* cat. exh. (Milan: Unione Tipograficia, 1938); and *Mostra autarchica del minerale italiano,* cat. exh. (Rome: Pubblicazione ufficiali a cura della direzione della Mostra, 1938). See also *Partito Nazionale Fascista, Mostra delle colonie estive e dell'assistenza all'infanzia: Guida del padiglione della scuola,* cat. exh. (Rome: Societi Tipografica "Leonardo Da Vinci," 1937); *Prima Mostra nazionale del Dopolavoro—Guida per stranieri,* cat. exh. (Rome: Partito Nazionale Fascista, 1938); and *Ministero dell'Educazione Nazionale, Istruzione tecnica alla Mostra autarchica del minerale italiano* (Rome: Fratelli Palombi, 1939).
4. Rosalind Williams, *Dream Worlds* (Berkeley: University of California Press, 1982).
5. M. Christine Boyer, "Cities for Sale," in *Variations on a Theme Park,* ed. Michael Sorkin (New York: Noonday Press, 1992), p. 186.
6. "Disneyland" currently composes one of cultural studies' and deconstruction's "hottest" topics and has been dissected from many sides as a way into the social

formations and the consumption modes of the future. For a series of essays on Disneyland, see Susan Willis, ed., "The World According to Disney," *South Atlantic Quarterly,* 92, no. 1 (Winter 1993).

7. Michael Sorkin, "See You in Disneyland," in Sorkin, *Variations on a Theme Park,* p. 231.

8. Saloccchi, *Mostra nazionale delle colonie estive e dell'assistenza all'infanzia,* preface.

9. Claudio Longo, "Mostra autarchica del minerale italiano a Roma," *Architettura* 7, no. 4 (April 1939): 197.

10. Press release, Agenzia Stefani, November 18, 1938, ACS, PCM (1937–39), 14.1.6198.

11. The novecento movement in the arts declared its goal to be the reconciliation of modernity and tradition within an Italian context. The group of artists who painted, sculpted, and designed under its banner was highly patronized by the dictatorship. See Rossana Bossaglia, ed., *Il "Novecento italiano"—Storia, documents, iconographia* (Milan: Feltrinelli, 1979). On Mario Sironi's contribution to official culture, see *Mario Sironi 1885–1961,* cat. exh., Galleria nazionale di arte moderna (Rome: Electa, 1993), and Emily Braun, "Illustrations of Propaganda—The Political Drawings of Mario Sironi," *Journal of Decorative and Propaganda Arts* 3 (Winter 1987): 84–107.

12. Longo, "Mostra autarchica del minerale italiano a Roma," 216.

13. Alberto Neppi, "Alla Mostra delle colonie estive," *La rassegna italiana* 2 (July 1937): 508.

14. Salocchi, *Mostra nazionale delle colonie estive e dell'assistenza all'infanzia,* p. 22; Longo, "Mostra autarchica del minerale italiano a Roma," p. 201.

15. Dawn Ades, Tim Benton, David Elliot, and Iain Boyd White, eds., *Art and Power: Europe under the Dictators, 1930–45,* cat. exh. (London: Hayward Gallery 1 South Bank Centre, 1995), p. 125.

16. Neppi, "Alla Mostra delle colonie estive," p. 506.

17. Diane Ghirardo, "Italian Architects and Fascist Politics: An Evaluation of Rationalists in Regime Building," *Journal of the Society of Architectural Historians* 39, no. 2 (May 1980): 113.

18. Salocchi, *Mostra nazionale delle colonie estive e dell'assistenza all'infanzia,* p. 12.

19. "La prima Mostra del Dopolavoro inaugurata dal Duce," *L'illustrazione italiana,* May 29, 1938, p. 895.

20. Longo, "Mostra autarchica del minerale italiano a Roma," p. 216.

21. On the application of such techniques in contemporary urban architecture, see Boyer, "Cities for Sale," p. 184.

22. Press release, "Agenzia Stefani," November 18, 1938, ACS, PCM (1937–39), 14.1.6198.

23. *Prima Mostra nazionale del Dopolavoro—Guida per stranieri.*

Part 5. Ruptures

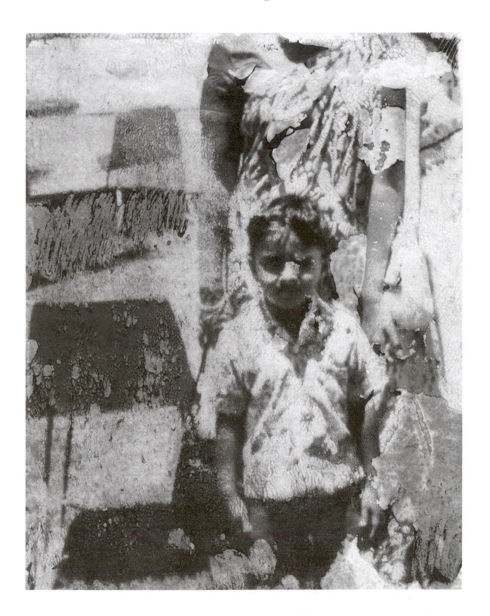

Figure 12 (overleaf) From *Travels in a New World*. Reproduced by courtesy of the artist, Mohini Chandra.

This section explores the link between cultural disruption and the rupture of the visual field. It suggests that all cultural disruption necessarily entails such a process. As a result there emerge differently figured experiences of sight, which range from discontinuous visual experience, to the willful shattering of the visual fabric by revolutionary force, to the denial of the visual, and to an ultimate revisioning of culture. Rupture permeates the visual at many levels and in many contexts—political, religious, social, economic and aesthetic. The chapters in this section all engage with different forms of rupture which have different visual resonances—from mild disengagement through active revolt and renunciation to an emergent revisioning which constitutes both politics and the utopian dream.

The line between creation and rupture is a thin and fragile one, because rupture generates creativity. There are arguably epochal moments in cultural history when certain cultural practices, like the first cinematic film, or the first manned space mission, shatter the very co-ordinates of assumed sensory experience, and the very parameters for seeing. Some of the essays in this section, such as that on the visual affects of the advent of the railway age by Schivelbusch, deal with epochal impact in visual sense, a shifting of cultural paradigms that inaugurated completely new ways of seeing, and indeed new forms of creativity. Such epochal shifts are the result of not a single act of visual creation but a summation of many acts at certain historical moments which demand new ways of seeing and the creation of different visual practices and symbolic systems.

Disengagement from earlier forms of cultural engagement informs chapters by Augé, Schivelbusch and Nochlin. Marc Augé, in his classic postmodern exploration of the 'non-place' of supermodernity, considers the cultural implications of desensitized spaces: the body in the fractured landscape of the supermarket, parking lot and airport lounge; the drift of the body into a metaphorical sensory vacuum. A new body, removed from historical space and sensorially distracted, is being forged here and therefore a new way of seeing as well. Marking an important moment in this process of the drift of the body away from the materiality of embodied experience is Wolfgang Schivelbusch's essay on the railway journey in the first half of the nineteenth century. It examines the shift from the embodied experience of travel in natural time in the late eighteenth century to the accelerated travel and temporal and spatial disjuncture of railway travel. This was realised through embodied optical effect as the view of the passing landscape from the railway carriage, framed by the window, was distorted through the dislocating effect of speed in space and time. Visual historian Lynda Nead's exploration of the visual and haptic effects of the management of light in the nineteenth-century city continues the theme of the shifting and destabilizing sensory rhythms of modernity. Her discussion of literary responses to the impact of

gaslight on the 'feel' of the nineteenth-century city (in this case London) employs Freud's concept of the uncanny to explore the rhythms of light and dark and the embodied and disembodied sensing of the city space.

The effects of the uncoupling of body and eye of which Schivelbusch, and to an extent Nead, speak can be seen to relate to art historian Linda Nochlin's classic essay on the French impressionist painter Camille Pissarro. This engages with the aesthetic and artistic consequences of a sense of fracture, a disengagement from, or rather reformulation of, the tenets of realism. The relationship between modernity, vision and Impressionism has, of course, been extensively explored, as has the later fracturing of vision forcefully articulated in relation to Cubism, but Pissarro is an interesting example to consider. Significant here is not merely the rupture of vision represented by the creative forces of Impressionism. The perceptual rupture and anarchy of Pissarro's artistic vision also constituted a critique of the everyday and was integrally linked to his political radicalism and thus the possibility of political rupture.

Moves away from 'traditional' modes of cultural perception can be heightened to actuate violent ruptures in historical time during periods of social and political revolutions. On the one hand, visual sense is a prime agent of revolutionary violence, as Strassler's essay in *Orderings* suggested, guiding critiques of the symbols and practices of the old order and their destruction. On the other hand, such revolutions are invariably accompanied by profound changes in the regimes of cultural production in a society, implying a new way of looking at things and new symbolic orders.

A range of examples is presented here. At one end of the spectrum Chantal Thomas discusses the centrality, in popular opinion, of visualizations of Marie Antoinette's fashion preferences as a point of political fracture and focus for angry emotions. Focusing on her shoes and her hair (head), these created a consensus around the myth of the wicked queen who in the end has to be decapitated. The visual here is a prime motivator of revolt, a signpost pointing towards the object that has to be willfully overthrown, an element arguably integral to all revolutions.

In another example of political rupture, but this time an artist's response, anthropologist Clare Harris's study of the biography and works of the contemporary Tibetan painter Gonkar Gyatso tracks the self-conscious visual and stylistic choices made by the artist in response to the fractured and revolutionary condition of Chinese-occupied Tibet. Here is an artist who deliberately uses personal biography and identity to create an art that at once is at home in adapting classical Tibetan motifs to the tenets of modernity, but also, in its themes and styles, indicates the profound rupture that the Chinese occupation brought about in Tibet. This rupture is not just reducible to the sudden eruption of the Communist Socialist Realist in Tibetan art but can also be understood through Tibetan art's relation to Western modern art and modernist internationalist art. As China emerges into supermodernity with a vibrant art scene, an artist like Gyatso encompasses these ruptures, as do other postmodern artists, bringing together in his work an ensemble of artistic references and styles that

have ruptured the various tropes through which art is conventionally understood—nationalist, classicist, modernist, popular or realist, for instance.

Flood's essay uses the fate of rock-cut Buddhas at Bamiyan under the former Taliban government of Afghanistan and responses to their destruction to explore iconoclasm, the rupture of the power of the visual through rendering it illegible or invisible. Through this case study he addresses ways in which the visual violence of iconoclasm has been understood as an essentialised cultural pathology to position Islamic cultures outside Western modernity. However, Flood demonstrates how the rupture of iconoclasm can no longer be contained with the concept of the 'other' but belongs to a broader politics of rupture which inform iconoclasm and responses to it over a wide range of cultural and intellectual environments—from the Taliban to the suffragette movement and the concerns of museums. Rupture here is not merely in the act of iconoclasm but in the understanding and systems of value around objects as multiple sites of rupture.

A very different role for visual sense and its rupturing potential is explored by anthropologist Elisha Renne in an examination of visibility and invisibility as represented by the front and back of cloth. Discussing this in relation to women's activities—weaving and child care—in southwestern Nigeria, she shows how social and spiritual powers are vested in the invisible or concealed (the back of the cloth) as opposed to the visible 'front'. This process constitutes a revisioning of the everyday, as represented through the ubiquitous cloth, revealing power in unusual ways. Here the ruptures are not of political revolt or social collapse but of the social significance of the everyday working through of visible and invisible, front and back, material and immaterial. The potential for social fracture implied in this is explored in the second part of the essay, which uses these ideas to tell a story about visibility/recognition and invisibility/misrecognition as they are played out through the understanding/misunderstanding of cloth in a photograph.

From rupture, or at least from intimations of rupture, can emerge the need to renounce the present in order to re-envisage the order of the world in the light of changes. Times of rapid social change can sometimes create the need for the rupture of the individual self from the body social, an act of renunciation, in order to make sense of change and rethink a new order. Eric Wilson, in his piece on the imaginings of the significance of ice for modern Western culture since the nineteenth century, shows how Romantic visions guided the scientific interest in ice as well as literary responses to the natural world in the late eighteenth and early nineteenth centuries. It makes an interesting counterpoint to the ordering of the natural world described by Daston in Part 3, *Orderings*. For many intellectuals, the yearning to merge with the infinity and purity of ice reclaimed the Romantic sublime for a self that had been torn apart by the violent modern. While Wilson, like Field in her analysis of a Japanese poem in Part 3, is not discussing the visual as such, he analyses the profoundly visual and sensory language to express the experience of cold, clean white ice, setting up a sublime vision of ice as an essential element of modern sensory experience.

The Readings in this section thus, in their different ways, track the idea of rupture of vision through the politically cataclysmic, the aesthetic and the ordinary, suggesting different intensities and responses to the experience of visual destabilization and fracture. They can also be seen to resonate with Readings in other sections, as rupture also opens the space for creativity, imagination and reordering.

The Railway Journey: Panoramic Travel
Wolfgang Schivelbusch

Dreamlike traveling on the railroad. The towns which I pass between Philadelphia and New York make no distinct impression. They are like pictures on a wall. The more, that you can read all the way in a car a French novel.

—Emerson, *Journals,* 7 February 1843

In Goethe's journal on his trip to Switzerland in 1797, there is the following entry:

Left Frankfurt shortly after 7:00 A.M. On the Sachsenhausen mountain, many well-kept vineyards; foggy, cloudy, pleasant weather. The highway pavement has been improved with limestone. Woods in back of the watch-tower. A man climbing up the great tall beech trees with a rope and iron cleats on his shoes. What a village! A deadfall by the road, from the hills by Langen. *Sprendlingen.* Basalt in the pavement and on the highway up to Langen; the surface must break very often on this plateau, as near Frankfurt. Sandy, fertile, flat land; a lot of agriculture, but meagre ...[1]

As Goethe told Eckermann, this journal was 'merely jotted down as given by the moment'. Thus it is no poetic text, but a description of a journey by coach in the late eighteenth century, a record of impressions received on that journey. Goethe's trip from Frankfurt to Heidelberg consisted of a continuous sequence of impressions that demonstrate how intense was the experience of traversed space. Not only the villages and towns on the way are noted, not only the formations of the terrain, but even details of the material consistency of the pavement of the highway are incorporated into his perceptions.

The railway put an end to this intensity of travel, which had reached its peak in the eighteenth century and had found its cultural expression in the genre of the 'novel of travels'. The speed and mathematical directness with which the railroad proceeds through the terrain destroy the close relationship between the traveler and the traveled space ... The modern forms of traveling in which intervening spaces are, as it were, skipped over or even slept through, strikingly illustrate the systematically closed and constructed character of the geographical space in which we live as human beings. Before the advent of the railroad, geographical connections evolved, for the traveler, from the change in landscape. True, today the traveler also goes

from place to place. But now we can get on a French train in the morning, and then, after twelve hours on the train (which is really being nowhere), we can get out in Rome. The old form of traveling provided for a more and better balanced relationship between landscape and geography.[2]

The nineteenth century found a fitting metaphor for this loss of continuity: repeatedly, the train was described as a projectile. First, the projectile metaphor was used to emphasize the train's speed, as in Lardner: a train moving at seventy-five miles an hour 'would have a velocity only four times less than a cannon ball'.[3] Then, as Greenhow points out, there is the cumulative power and impact that turns a speeding train into a missile: 'When a body is moving at very high velocity, it then, to all intents and purposes, becomes a projectile, and is subject to the laws attending projectiles'.[4] In 1889, after the complete cultural assimilation of the railroad, the projectile metaphor was still quite attractive. 'Seventy-five miles an hour', says a technical text published in that year, 'is one hundred and ten feet a second, and the energy of four hundred tons moving at that rate is nearly twice as great as that of a 2,000-pound shot fired from a 100-ton Armstrong gun.'[5]

The train was experienced as a projectile, and traveling on it, as being shot through the landscape—thus losing control of one's senses. 'In travelling on most of the railways ...', says an anonymous author of the year 1844, 'the face of nature, the beautiful prospects of hill and dale, are lost or distorted to our view. The alternation of high and low ground, the healthful breeze, and all those exhilarating associations connected with "the Road", are lost or changed to doleful cuttings, dismal tunnels, and the noxious effluvia of the screaming engine.'[6] Thus the rails, cuttings, and tunnels appeared as the barrel through which the projectile of the train passes. The traveler who sat inside that projectile ceased to be a traveler and became, as noted in a popular metaphor of the century, a mere parcel.[7] 'It matters not whether you have eyes or are asleep or blind, intelligent or dull', said Ruskin, 'all that you can know, at best, of the country you pass is its geological structure and general clothing.'[8]

This loss of landscape affected all the senses. Realizing Newton's mechanics in the realm of transportation, the railroad created conditions that also 'mechanized' the traveler's perceptions. According to Newton, 'size, shape, quantity, and motion' are the only qualities that can be objectively perceived in the physical world. Indeed, those became the only qualities that the railroad traveler was able to observe in the landscape he traveled through. Smells and sounds, not to mention the synesthetic perceptions that were part of travel in Goethe's time simply disappeared.

The change effected in the traveler's relationship to the landscape became most evident in regard to his sense of sight: visual perception is diminished by velocity. George Stephenson testified to this in a statement given at a parliamentary hearing on safety problems 'on the railways in 1841: when asked for his estimation of the engine-driver's ability to see obstacles, he replied: 'If his attention is drawn to any object before he arrives at the place, he may have a pretty correct view of it; but if he only turns himself round as he is passing, he will see it very imperfectly'.[9]

Unlike the driver, the travelers had a very limited chance to look ahead: thus all they saw was an evanescent landscape. All early descriptions of railroad travel testify to the difficulty of recognizing any but the broadest outlines of the traversed landscape. Victor Hugo described the view from a train window in a letter dated 22 August 1837: 'The flowers by the side of the road are no longer flowers but flecks, or rather streaks, of red or white; there are no longer any points, everything becomes a streak; the grainfields are great shocks of yellow hair; fields of alfalfa, long green tresses; the towns, the steeples, and the trees perform a crazy mingling dance on the horizon; from time to time, a shadow, a shape, a spectre appears and disappears with lightning speed behind the window: it's a railway guard'.[10] And Jacob Burckhardt wrote in 1840: 'It is no longer possible to really distinguish the objects closest to one—trees, shacks, and such: as soon as one turns to take a look at them, they already are long gone'.[11] In a text from 1838 we find the statement that it is impossible to 'recognize a person standing by the road while driving past him' at the 'greatest speed',[12] which prompted the following advice: 'He who has good eyesight ... does well to acquire the habit of observing from a certain distance everything that attracts his attention while traveling: given some power of observation, he will not miss anything at all, not even during the stage of utmost velocity'.[13]

The recommendation to look at things 'from a certain distance' does not seem entirely realistic, in view of the traveler's situation in the train compartment: enclosed in it, the traveler has no way of distancing himself from the objects—all he can do is to ignore them and the portions of the landscape that are closest to him, and to direct his gaze on the more distant objects that seem to pass by more slowly. If he does not modify his old way of observing things while traveling—if he still tries to perceive proximity and distance in equal measure—the result, as noted in 1862 by *The Lancet,* a medical journal, is fatigue:

> The rapidity and variety of the impressions necessarily fatigue both the eye and the brain. The constantly varying distance at which the objects are placed involves an incessant shifting of the adaptive apparatus by which they are focused upon the retina; and the mental effort by which the brain takes cognizance of them is scarcely productive of cerebral wear because it is unconscious; for no fact in physiology is more clearly established than that excessive functional activity always implies destruction of material and organic change of substance.[14]

Increased velocity calls forth a greater number of visual impressions for the sense of sight to deal with. This multiplication of visual impressions is an aspect of the process peculiar to modern times that Georg Simmel has called the development of urban perception. He characterizes it as an '*intensification of nervous stimulation* which results from the swift and uninterrupted change of outer and inner stimuli'.[15] (Italics in original.) 'Lasting impressions', Simmel says, 'impressions which take a regular and habitual course and show regular and habitual contrasts—all these use up, so to speak, less consciousness than does the rapid crowding of changing images, the sharp

discontinuity in the grasp of a single glance and the unexpectedness of onrushing impressions.'

The difference between the quality of stimuli in the metropolis and those of railroad travel need not concern us here: what is decisive is the quantitative increase of impressions that the perceptual apparatus has to receive and to process. Contemporary texts that compare the new travel experience with the traditional one demonstrate how that stimulus increase produced by increased velocity is experienced as stressful. The speed causes objects to escape from one's gaze, but one nevertheless keeps on trying to grasp them. This is implied in Eichendorff: 'These travels by steam keep on shaking the world—in which there really is nothing left but railway stations—like a kaleidoscope, incessantly, the landscapes speeding by in everchanging grimaces even before one has been able to perceive any genuine traits of physiognomy; the flying salon presents one with ever new coteries, even before one has been able to really deal with the old ones'.[16]

John Ruskin, whose dislike of the railways created the most sensitive descriptions of the peculiar traits of pre-industrial travel, proposed an almost mathematical negative correlation between the number of objects that are perceived in a given period of time and the quality of that perception:

> I say, first, to be content with as little change as possible. If the attention is awake, and the feelings in proper train, a turn of a country road, with a cottage beside it, which we have not seen before, is as much as we need for refreshment; if we hurry past it, and take two cottages at a time, it is already too much; hence to any person who has all his senses about him, a quiet walk along not more than ten or twelve miles of road a day, is the most amusing of all travelling; and all travelling becomes dull in exact proportion to its rapidity.[17]

. . .

While the consciousness molded by traditional travel found itself in a mounting crisis, another kind of perception started to develop, one which did not try to fight the effects of the new technology of travel but, on the contrary, assimilated them entirely. For such a pair of eyes staring out of the compartment window, all the things that the old consciousness experienced as losses became sources of enrichment. The velocity and linearity with which the train traversed the landscape did not destroy it—not at all; only under such conditions was it possible to fully appreciate that landscape. Thus, a description of a trip from Manchester to Liverpool in the year 1830:

> The passenger by this new line of route having to traverse the deepest recesses where the natural surface of the ground is the *highest*, and being mounted on the loftiest ridges and highest embankments, riding above the tops of the trees, and overlooking the surrounding country, where the natural surface of the ground is the *lowest*—this peculiarity and this variety being occasioned by that essential requisite in a well-constructed Railway— a level line—imposing the necessity of cutting through the high lands and embanking across the low; thus in effect, presenting to the traveller all the variety of mountain and ravine in pleasing succession, whilst in reality he is moving almost on a level plane

and while the natural face of the country scarcely exhibits even those slight undulations which are necessary to relieve it from tameness and insipidity.[18]

That is not a picturesque landscape destroyed by the railroad; on the contrary, it is an intrinsically monotonous landscape brought into an esthetically pleasing perspective by the railroad. The railroad has created a new landscape. The velocity that atomized the objects of Ruskin's perception, and thus deprived them of their contemplative value, became a stimulus for the new perception. It is the velocity that made the objects of the visible world attractive. Let us compare the following passage with Ruskin's comments, and we shall see how differently velocity and evanescence can be experienced during the same period of time: 'The beauties of England', an American traveler wrote in 1853, 'being those of a dream, should be as fleeting':

They never appear so charming as when dashing on after a locomotive at forty miles an hour. Nothing by the way requires study, or demands meditation, and though objects immediately at hand seem tearing wildly by, yet the distant fields and scattered trees, are not so bent on eluding observation, but dwell long enough in the eye to leave their undying impression. Every thing is so quiet, so fresh, so full of home, and destitute of prominent objects to detain the eye, or distract the attention from the charming whole, that I love to dream through these placid beauties whilst sailing in the air, quick, as if astride a tornado.[19]

To Benjamin Gastineau, whose newspaper essays on travel were collected in 1861 in book form as *La Vie en chemin de fer,* the motion of the train through the landscape appeared as the motion of the landscape itself. The railroad choreographed the landscape. The motion of the train shrank space, and thus displayed in immediate succession objects and pieces of scenery that in their original spatiality belonged to separate realms. The traveler who gazed through the compartment window at such successive scenes, acquired a novel ability that Gastineau calls 'la philosophie synthétique du coup d'oeil' ('the synthetic philosophy of the glance'). It was the ability to perceive the discrete, as it rolls past the window, indiscriminately. The scenery that the railroad presents in rapid motion appeared in Gastineau's text as a panorama, without being explicitly referred to as such:

Devouring distance at the rate of fifteen leagues an hour, the steam engine, that powerful stage manager, throws the switches, changes the decor, and shifts the point of view every moment; in quick succession it presents the astonished traveler with happy scenes, sad scenes, burlesque interludes, brilliant fireworks, all visions that disappear as soon as they are seen; it sets in motion nature clad in all its light and dark costumes, showing us skeletons and lovers, clouds and rays of light, happy vistas and sombre views, nuptials, baptisms, and cemeteries.[20]

In another, roughly contemporary, French text we find all three essential characteristics of the panorama described. Jules Clarétie, a Parisian journalist and publicist,

characterized the view from the train window as an evanescent landscape whose rapid motion made it possible to grasp the whole, to get an overview; defining the process, he made specific use of the concept of panorama:

> In a few hours, it [the railway] shows you all of France, and before your eyes it unrolls its infinite panorama, a vast succession of charming tableaux, of novel surprises. Of a landscape it shows you only the great outlines, being an artist versed in the ways of the masters. Don't ask it for details, but for the living whole. Then, after having charmed you thus with its painterly skills, it suddenly stops and quite simply lets you get off where you wanted to go.[21]

What, exactly, did this new perception that we are referring to as 'panoramic' consist of? Dolf Sternberger uses this concept of the panorama and the panoramic to describe European modes of perception in the nineteenth century—the tendency to see the discrete indiscriminately. 'The views from the windows of Europe', Sternberger says, 'have entirely lost their dimension of depth and have become mere particles of one and the same panoramic world that stretches all around and is, at each and every point, merely a painted surface.'[22] In Sternberger's view, modern transportation, the railroad first and foremost, is the main cause for such panoramization of the world: 'The railroad transformed the world of lands and seas into a panorama that could be experienced. Not only did it join previously distant localities by eliminating all resistance, difference, and adventure from the journey: now that traveling had become so comfortable and common, it turned the travelers' eyes outward and offered them the opulent nourishment of ever changing images that were the only possible thing that could be experienced during the journey'.[23]

What the opening of major railroads provided in reality—the easy accessibility of distant places—was attempted in illusion, in the decades immediately preceding that opening, by the 'panoramic' and 'dioramic' shows and gadgets. These were designed to provide, by showing views of distant landscapes, cities, and exotic scenes, 'a substitute for those still expensive and onerous journeys'.[24] A newspaper of the year 1843 described the Parisian public 'reclining on well-upholstered seats and letting the five continents roll by at its pleasure without having to leave the city and without having to risk bad weather, thirst, hunger, cold, heat, or any danger whatsoever'.[25] That the diorama fad died out in Paris around 1840,[26] more or less at the same time that the first great railways were opened (lines from Paris to Orleans and Rouen appearing in 1843) would seem corroborative evidence for the presumed connection. The simultaneous rise of photography provides more support for the thesis. According to Buddemeier, the public became fascinated, at first:

> Not by the taking of a picture of any specific object, but by the way in which any random object could be made to appear on the photographic plate. This was something of such unheard-of novelty that the photographer was delighted by each and every shot he took, and it awakened unknown and overwhelming emotions in him, as Gaudin points out ... Indeed, the question arises: why did the exact repetition of reality excite people

more than the reality itself? Gaudin hints at an answer: he describes how intensely the first photographs were scrutinized, and what people were mostly looking for. For instance: looking at a picture of the building across the street from one's own window, one first started counting the roof shingles and the bricks out of which the chimney was constructed. It was a delight to be able to observe how the mason had applied the mortar between the individual stones. Similar instances occur in other texts dealing with photographs. Tiny, until then unnoticed details are stressed continuously: paving stones, scattered leaves, the shape of a branch, the traces of rain on the wall.[27]

Thus the intensive experience of the sensuous world, terminated by the industrial revolution, underwent a resurrection in the new institution of photography. Since immediacy, closeups and foreground had been lost in reality, they appeared particularly attractive in the new medium.

Sternberger observes that the vistas seen from Europe's windows had lost their dimension of depth; this happened first with the vistas seen from the train compartment window. There the depth perception of pre-industrial consciousness was, literally, lost: velocity blurs all foreground objects, which means that there no longer is a foreground—exactly the range in which most of the experience of pre-industrial travel was located. The foreground enabled the traveler to relate to the landscape through which he was moving. He saw himself as part of the foreground, and that perception *joined* him to the landscape, included him in it, regardless of all further distant views that the landscape presented. Now velocity dissolved the foreground, and the traveler lost that aspect. He was removed from that 'total space' which combined proximity and distance: he became separated from the landscape he saw by what Richard Lucae, speaking of ferro-vitreous architecture, has called an 'almost immaterial barrier'. The glass separated the interior space of the Crystal Palace from the natural space outside without actually changing the atmospheric quality of the latter in any visible manner, just as the train's speed separated the traveler from the space that he had previously been a part of. As the traveler stepped out of that space, it became a stage setting, or a series of such pictures or scenes created by the continuously changing perspective. Panoramic perception, in contrast to traditional perception, no longer belonged to the same space as the perceived objects: the traveler saw the objects, landscapes, etc. *through* the apparatus which moved him through the world. That machine and the motion it created became integrated into his visual perception: thus he could only see things in motion. That mobility of vision—for a traditionally orientated sensorium, such as Ruskin's, an agent for the dissolution of reality—became a prerequisite for the 'normality' of panoramic vision. This vision no longer experienced evanescence: evanescent reality had become the new reality.

Notes

1. *Werke,* East Berlin ed., vol. 15, pp. 348 ff.; the complete journal of the Swiss journey in *Werke,* Sophia ed., vol. 2, sec. 3.

2. Erwin Straus, *The Primary World of the Senses* (New York and London, 1963), p. 320.

3. D. Lardner, *Railway Economy* (London, 1851) p. 179.

4. C. H. Greenhow, *All Exposition of the Danger and Deficiencies of the Present Mode of Railway Construction* (London, 1846), p. 6.

5. H. G. Prout, 'Safety in Railroad Travel', in *The American Railway,* ed. T. M. Cooley (New York, 1889), p. 187.

6. *Horse-Power Applied to Railways at Higher Rates of Speed than by Ordinary Draught* (London, 1844), p. 48.

7. 'It [the railway] transmutes a man from a traveller into a living parcel.' (Ruskin, *The Complete Works,* vol. 8, p. 159.) Manfred Riedel provides the two following quotes from lesser authors: for Ida Hahn-Hahn, the traveler 'demotes himself to a parcel of goods and relinquishes his senses, his independence' (Manfred Riedel, 'Vom Biedermeier zum Maschinenzeitalter', *Archiv für Kulturgeschichte,* vol. 43, (1961), fascicle 1, p. 119); and, according to Joseph Maria von Radowitz, 'for the duration of such transportation one ceases to be a person and becomes an object, a piece of freight'. (Op. cit., p. 120.)

8. Ruskin, vol. 36, p. 62; this is essentially echoed by a French medical author: 'He [the traveler] hardly knows the names of the principal cities through which he passes, and only recognizes them, if at all, by the steeples of the best-known cathedrals which appear like trees by some faraway road'. (A. Aulagnier, *L'Union médicale de la Gironde* [Bordeaux, 1857], p. 525.)

9. Great Britain, *Parliamentary Papers,* 'Report from the Select Committee on Railways', vol. 5 of the section 'Transport and Communications' (repr. ed., Shannon, Ireland, 1968), p. 125.

10. Quoted in Baroli, Le *Train dans la Littérature Française,* Paris, 1964, p. 58.

11. From Manfred Riedel. op. cit., p. 112.

12. G. Muhl, *Die westeuropäischen Eisenbahnen in ihrer Gegenwart und Zukunft* (Karlsruhe, 1838), p. 18.

13. Op. cit., p. 19.

14. *The Influence of Railway Travelling on Public Health* (London, 1862), p. 44 (is a compendium of articles previously published in *The Lancet*).

15. *The Sociology of Georg Simmel,* ed. Kurt M. Wolff (Glencoe. Ill., 1950), p. 410.

16. Joseph von Eichendorff, *Werke* (Munich, 1970), vol. 2, p. 895.

17. Ruskin, vol. 5, p. 370. Elsewhere, Ruskin speaks of the travellers 'who once in their necessarily prolonged travel were subjected to an influence, from the silent sky and slumbering fields, more effectual than known or confessed' (Vol. 8. p. 246).

18. Henry Booth, *An Account of the Liverpool and Manchester Railway* (Liverpool, 1830), pp. 47–8.

19. Matthew E. Ward, *English Items; or, Microcosmic Views of England and Englishmen* (New York, 1853), pp. 71–2.

20. Benjamin Gastineau, *La Vie en chemin de fer* (Paris, 1861), p. 31.

21. Jules Clarétie, *Voyages d'un parisien* (Paris, 1865), p. 4.

22. Dolf Sternberger, *Panorama, oder Ansichten vom 19. Jahrhundert,* 3rd ed. (Hamburg, 1955), p. 57.

23. Op. cit., p. 50.

24. Hans Buddemeier, *Panorama, Diorama, Photographie: Entstehung und Wirkung neuer Mediem im 19. Jahrhundert* (*Origin and Effect of New Media in the Nineteenth Century*) Munich, 1970, p. 41.

25. Ibid., p. 45.

26. Ibid., p. 48.

27. Ibid., p. 78.

The Secrets of Gas
Lynda Nead

Secrets of the Gas

The Gas has its secrets, and I happen to know them. The Gas has a voice, and I can hear it—a voice beyond the rushing whistle in the pipe, and the dull buzzing flare in the burner. It speaks, actively, to men and women of what is, and of what is done and suffered by night and by day; and though it often crieth like Wisdom in the streets and no man regardeth it, there are, and shall be some to listen to its experiences, hearken to its counsels, and profit by its lessons.

I know the secrets of the gas, but not all of them.[1]

By the early years of Victoria's reign, gas lighting had converted London nights into day, and to many writers in this period it seemed that London was the most illuminated capital city in Europe. Gas, as a source of street lighting, had been introduced in the city at the beginning of the nineteenth century. Its social advantages and economic possibilities were soon realised and gas rapidly replaced oil as the main form of illumination in the public spaces of the city. As the demand for gas grew, so too did the companies that produced and supplied it. London was mapped by the boundaries of the competing gas companies, whose contours joined with those of the postal districts, railways and sewers to define modernising London.

Gas possessed a poetics as well as an economics. For writers in this period, London's temporal geography created two distinct worlds; a daytime world of organisation and commerce and a night-time world of danger and disorder. The street lamps occupied both of these worlds; they kept their place in the city, day and night, lit and extinguished. In the daylight the lamps stood dark and silent, but at night they became animated; not only casting light, but also understanding the scenes which they illuminated. It was at night, when the gas was lit and the flames were burning, that the street lamps became observers of the dark side of London. The gas had eyes; it bore witness to the strange and terrible life of London at night and could testify to those able to hear its quiet, whispering voice. The interpreters of the gas were the journalists and philanthropists who created the literature of the night-walk; who shared the temporality of the gas and who revealed its secrets to an audience eager

to share the pleasures and dangers of gaslight and to join authors in their passage through the fictional city.

The belief that the streets at night had a peculiar beauty and poetry was a product of the gas industry and the spread of public lighting to more areas of the city than had been lit by oil. The greater provision of light made the streets safer to move around in at night, but not completely safe. Gaslight made the illuminated night-walk possible; it allowed observers to see the night, to perceive its dangers and its attractions and to fictionalise them. The basic tenet of night—walk fiction is that the reader is safe and warm at home, while the author assumes the mantle of outsider and wanderer. Dickens was quick to exploit this symbiotic, literary relationship and to realise that the bleaker the night setting, the greater the possible pleasures for the domestic reader. 'The Streets—Night', a short essay on a winter's night in London, was first published in *Bell's Life* in London in 1836 and collected in the second series of *Sketches by Boz* in the following year. The first paragraph establishes the literary and aesthetic potential of the London night: 'But the streets of London, to be beheld in the very height of their glory, should be seen on a dark, dull, murky winter's night ... when the heavy lazy mist, which hangs over every object, makes the gas-lamps look brighter, and the brilliantly-lighted shops more splendid from the contrast they present to the darkness around.'[2]

The rhythmic alternation of light and dark is an essential backdrop to the creation of the attraction and threat of the city at night and the winter mist increases the disturbing ambiguities of the gaslight and its passages between illumination and obscurity. Dickens continued to explore the irrational elements of London at night in his later journalistic writings. By 1861, the date of the publication of 'Night Walks', in *The Uncommercial Traveller,* the trope of the author as homeless wanderer had become firmly established within contemporary fiction and far more developed. Usually the author assumes this identity as a result of a temporary altered physical state, which forces him out of the conventional temporality of the daytime city and on to the streets at night. Illness, or loss of house-keys might initiate these fictional night wanderings; in 'Night Walks', Dickens referred to a case of temporary insomnia that compels the fictional author to walk the streets, where he experiences the spectral and irrational side of London. Loss of sleep in this case creates a hallucinatory, dream-like evocation of the city as a phantasmagoria of past and present, inhabited by out casts, ghosts and traces of previous existences. At one point the author imagines all these lives brought together in the city: 'And indeed in those houseless nightwalks ... it was a solemn consideration what enormous hosts of dead belong to one old great city and how, if they were raised while the living slept, there would not be the space of a pin's point in all the streets and ways for the living to come out into.'[3] Possessed by this fantastic image of a city of ghosts, the sleepless author quite literally loses his senses and his perception of physical space:

When a clock strikes, on houseless ears in the dead of night, it may be at first mistaken for company and hailed as such. But, as the spreading circles of vibration, which you may

perceive at such a time with great clearness, go opening out, for ever and ever afterwards, widening perhaps ... in eternal space, the mistake is rectified and the sense of loneliness is profounder. (p. 195)

The literature of the night-side of London was always linked with the idea of the flight from the familiar, everyday existence of the daytime city. The convention of a temporary hiatus in the author's physical condition allowed him to cross the threshold of the night city and to enter a strange new world; a commingling of ghosts of the past and outcasts of the present. The seduction of the gaslit night lay in its invitation to leave the security of the everyday world behind and to experience the hallucinatory images of illuminated darkness.

In a compelling psychoanalytical study of the meanings of fire and candlelight, Gaston Bachelard has contrasted the poetry of the lamp flame with the mechanistic harshness of the electric lightbulb.[4] For Bachelard, the lamp is humanised and the experience of lamplight is an intense, psychological relationship. Time illuminated by the lamp is solemn and observes a slower tempo than the temporality of daylight or electric light. It is a period of dream, contemplation and reverie. It is what Bachelard calls: 'igneous time', that is 'time that passes by burning' (p. 69).This is the domain of darkness lit by a flame and its poetry is generated by the relationship between the individual subject and the lamplight, and the experience of its sober temporality. According to Bachelard, the perception of lamplight is not only that it casts light, but that it also sees; the illumination that it projects becomes a form of surveillance or gaze: 'This distant lamp is certainly not "turned in" on itself. It is a lamp that waits. It watches so unremittingly that it guards' (pp. 71–2). Bachelard's blend of phenomenology and psychoanalysis offers a helpful model for understanding the poetics of gas. His study is built on an opposition between lamplight (the flame) and electricity; there is no reference to gaslight. But if Bachelard's analysis is extended, gaslight can be understood to occupy a place somewhere between the archaic form of the lamp flame and the crude modernity of the electric light. Although gaslight was produced by means of a heavy, dirty industry, at its point of illumination—the flame in its glass case in the street lamp—it resembled most closely the psychological world of the lamplight. The city at night became the city of gaslight; it took on a different temporality, the temporality of gas, which reigned from the moment the lamps were lit until the break of day, when the flames were extinguished. At night space was rearticulated by gaslight, with its alternating rhythm of seeing illumination and blind shadow. This was London's gas time; the time that passed as the gas burned in the street lamps and when the city became a place given over to imagination, dread and dream.

There can be no doubt that this perception of the night city as the strange, irrational other of the daytime city was built upon a strong tradition of religious symbolism. The New Testament presents a daylight world of honest labour and a world of darkness inhabited by the vicious and evil: 'Work while it is called Today; for the Night cometh, wherein no man can work.'[5] The Victorian Church seized enthusiastically

upon this biblical language of light and darkness and Nonconformist groups, in particular, drew on its unambiguous moral message to represent their evangelical mission into darkest London. So the Christian missionaries joined the journalists in tramping the streets of night-time London and in their accounts of these mid-night missions produced a sub-genre of the literature of the night-walk. London by gaslight produced a dedicated group of Christian missionaries who specialised in night-time rescues and conversions. John Blackmore was probably the most well known amongst this group, a regular figure on the streets at night during his mission-ary cruises to distribute tracts amongst the fallen of the metropolis. He established two homes for rescued prostitutes, the London Female Dormitory and the Female Temporary Home, and published his accounts of his works on the streets of London. In order to convey the danger and immorality of London at night, Blackmore had, paradoxically, to evoke the seductive attractions of the city and, in this respect, his writing often comes uncomfortably close to the literary sketches of the wandering journalist. In *The London by Moonlight Mission,* published in 1860, each chapter is devoted to the story of a separate 'cruise' in the strange, entrancing world of night-time London. For Blackmore it was a world that was never seen by day and which presented a form of parallel existence, unknown to the honest inhabitants of the day-light world. In the writings of night missionaries such as Blackmore, there is a strong sense that while they have successfully carried out their work among the fallen, they have also succumbed to the bewitchment of the city at night and that they have seen things that they cannot properly recall in the daylight. In his account of *The Night Side of London,* J. Ewing Ritchie described the transformation of the streets in the centre of the city by day and by night. At night they are the scenes of crime and depravity but in the day they assume an ordinary and decent appearance and Ritchie himself appears to doubt whether he has actually witnessed the events of the night or whether he has imagined them. In one passage, he describes the transitional moment of daybreak and the passage from the world of the night to that of the day:

> As we go up Regent-street we see the lamps being extinguished, and the milk carts going round, and the red newspaper expresses tearing along to catch the early train, and the green hills of Hampstead looking lovelier than ever. In the sober light of day our night in the Haymarket will seem unreal, and when we shall tell our experiences, we shall be told possibly that our picture is overdrawn.[6]

Emergence from the night-time city is symbolised by the extinguishing of the gas lamps and the repetition of the ordinary rituals of everyday life. In this comfort-able and familiar world memories of the previous night seem vague and unreal. It is precisely at this transitional moment, when the author moves between the familiar everyday world of daylight and the unfamiliar, spectral scenes of night and when he is most unsure whether what he has experienced is real or imagined, that the night-walk text shares many of the qualities that Freud associated with the notion

of the uncanny. Freud's essay, published in 1919, defined the uncanny as a category within the field of what is frightening and which is distinguished by its tendency to lead back to what is 'known of old and long familiar'.[7] In this sense, then, there is a linguistic and psychic bond between the feeling of uncanniness and the familiar. This relationship is established by Freud through etymology, which confirms that the uncanny, the *unheimlich,* is rooted in and comes out of the familiar, the *heimlich.* Definitions of the *heimlich* associate the term with the domestic environment, with familiarity and comfort, but its meanings shade off to include that which is concealed or kept from sight; a usage that it shares with its opposite *unheimlich.* At this point, the *heimlich* and the *unheimlich* become identical and Freud concludes: 'Thus *heimlich* is a word the meaning of which develops in the direction of ambivalence, until it finally coincides with its opposite, unheimlich' (p. 226). For Freud the uncanny is much more than a sense of unfamiliarity; it is the tendency of the familiar to become defamiliarised, as in a dream, or in the confusion of dream and reality. The sense of the uncanny describes the return of something familiar and old-established, which has been repressed; it is 'something which ought to have remained hidden but has come to light' (p. 241). The uncanny is a condition of disturbing ambiguity; it is the point of slippage between the real and the unreal, the familiar and the strange, the living and the spectral. It is the condition of the partially illuminated darkness of gaslit London.

Freud offers one instance of his own experience of the uncanny, which occurs in the context of a strange experience of urban space. He recalls a visit to a provincial Italian town. Walking down the deserted, unfamiliar streets, he finds himself in a 'red-light' district:

> Nothing but painted women were to be seen at the windows of the small houses, and I hastened to leave the narrow street at the next turning. But after having wandered about for a time without enquiring my way, I suddenly found myself back in the same street, where my presence was now beginning to excite attention. I hurried away once more, only to arrive by another detour yet a third time. Now, however, a feeling overcame me which I can only describe as uncanny ... (p. 237)

Freud compares the helplessness of his condition with that of being in a dream-state and identifies the element of involuntary repetition as one source of his experience. If, however, the spatial context of Freud's memory is examined, it is surely significant that his experience of the uncanny takes place in sexualised space and that his distress at becoming lost in the labyrinthine streets and of constantly returning to the same spot is directly related to his identification of this area as a site of prostitution. The psychoanalyst shares with the journalist and the missionary a particularly spatialised experience of the uncanny. In all three cases, the writers move from the familiar world into the unfamiliar (the unknown provincial town, or the city at night). They are spaces of commodified female sexuality and, moving through these streets,

they are overcome by a sensory disorientation from which they finally re-emerge into the safety of the familiar piazza, or the reassuring routines of daily life. The uncanny effect is produced by a momentary dislocation of the self within urban space and the consequent dissolution of the boundaries between reality and imagination.

Darkness generates the conditions of the uncanny.[8] Gas illuminates the night; a place of secrets and fantasy, in which the familiar is rendered unfamiliar and those things: 'which ought to remain hidden … come to light' (p. 241). The discovery of the 'night-walk' is the turning-up of old anxieties in the fabric of the familiar. Gas-light might have been expected to eliminate these spectres, but, instead, it put them on show.

In his fascinating study *The Architectural Uncanny* Anthony Vidler has explored the spatial implications of the Freudian uncanny within the specific historical context of the emergence of the modern city. He identifies a 'recent history of modern space', which emerged with Michel Foucault's work on Jeremy Bentham and the paradigm of the panopticon, of total social control through transparency and complete visibility. Institutions and city plans in the eighteenth and nineteenth centuries were constructed on the principle of the opening up of space to the circulation of light and air: 'Transparency, it was thought, would eradicate the domain of myth, suspicion, tyranny, and above all the irrational.'[9] Following on from the initiatives of Foucault, Vidler suggests that historians have tended to concentrate on the technologies of transparency and have ignored the other side of Foucault's spatial paradigm, the presence and fear of darkened spaces. Any history of space, Vidler suggests, must not only describe the political role of transparent space, but must also provide 'a spatial phenomenology of darkness' (p. 169). Vidler points to the limitations of Foucault's account, which retains a polarised relationship between light and dark, transparency and obscurity and which resists a proper investigation of how the pairing and co-operation of these terms is productive of power. He concludes:

> For it is in the intimate associations of the two, their uncanny ability to slip from one to the other, that the sublime as instrument of fear retains its hold—in that ambiguity that stages the presence of death in life, dark space in bright space. In this sense, all the radiant spaces of modernism, from the first Panopticon to the Ville Radieuse, should be seen as calculated not on the final triumph of light over dark but precisely on the insistent presence of the one in the other. (p. 172)

All of the attempts in the 1860s to map, straighten and light London can be seen, therefore, not simply as a reaction to the fear of darkness, but as always bearing within their urban ideal the presence of obscurity and ambiguity; the presence of the uncanny. If metropolitan improvement was driven by the desire to eliminate disorder and superstition, then the night city represented a return of these old anxieties through the uncertain vision of mist, gaslight or the dream. Night-time London troubled the modernisers because the fears that it recalled could not be kept securely

in place but remained a part of the contemporary city, threatening at any moment to invade the bright light of day and to turn the feeling of being 'at home' in the city into an illusion.

Notes

1. George Augustus Sala, *Gaslight and Daylight: With Some London Scenes They Shine Upon* (London: Chapman Hall, 1859), p. 156.
2. Charles Dickens, 'The Streets—Night', *Sketches by Boz: Illustrative of Every-Day Life and Every-Day People,* The New Oxford Illustrated Dickens (London: Oxford University Press, 1957), p. 53.
3. Charles Dickens, 'Night Walks', *The Uncommercial Traveller* (London: Chapman and Hall, 1861), pp. 194–5.
4. Gaston Bachelard, *The Flame of a Candle,* trans. by Joni Caldwell (Dallas: Dallas Institute Publications, 1988).
5. John 9:4. Also cited in Lieut. John Blackmore, *The London by Moonlight Mission: Being an Account of Midnight Cruises on the Streets of London* (London: Robson and Avery, 1860), p. 47.
6. James Ewing Ritchie, *Night Side of London* (London: William Tweedie, 1857), p. 6.
7. Sigmund Freud, 'The Uncanny', in *The Standard Edition of the Complete Psychological Works of Sigmund Freud,* trans. and edited by James Strachey, vol. xvii (London: Hogarth Press and the Institute of Psycho-Analysis, 1955), p. 220. Hereafter page references to this edition will be given in the text.
8. Freud describes the couple who move into a house with a wooden table carved with crocodiles and who, in the darkness of night, imagine ghostly crocodiles moving around the house, ibid., pp. 244–5.
9. Anthony Vidler, *The Architectural Uncanny: Essays in the Modern Unhomely* (Cambridge, Mass, and London: M.I.T. Press, 1992), p. 168. Foucault explores the ideal of the transparent society in a number of publications including 'The Eye of Power', in Colin Gordon, ed., *Power/Knowledge: Selected Interviews and Other Writing,* 1972–1977 (Brighton: Harvester, 1980), pp. 146–65. The Freudian uncanny is worked into a compelling account of historical space in Michel de Certeau, 'Psychoanalysis and Its History', in *Heterologies: A Discourse on the Other,* trans. by Brian Massumi (Manchester: University of Manchester Press, 1986), pp. 3–16.

–5.4–

Supermodernity: From Places to Non-Places
Marc Augé

The shifts of gaze and plays of imagery [as a very particular and modern form of solitude], an emptying of the consciousness, can be caused ... by the characteristic features of what I propose to call 'supermodernity'. These subject the individual consciousness to entirely new experiences and ordeals of solitude, directly linked with the appearance and proliferation of non-places. But before going on to examine the non-places of supermodernity in detail, it may be useful to mention, albeit allusively, the attitudes displayed by the most recognized representatives of artistic 'modernity' in relation to the notions of place and space. We know that Benjamin's interest in Parisian 'passages'; and, more generally, in iron and glass architecture, stems partly from the fact that he sees these things as embodying a wish to prefigure the architecture of the next century, as a dream or anticipation. By the same token, we may wonder whether yesterday's representatives of modernity, who found material for reflection in the world's concrete space, might not have illuminated in advance certain aspects of today's super-modernity; not through the accident of a few lucky intuitions, but because they already embodied in an exceptional way (because they were artists) situations (postures, attitudes) which, in more prosaic form, have now become the common lot.

Clearly the word 'non-place' designates two complementary but distinct realities: spaces formed in relation to certain ends (transport, transit, commerce, leisure), and the relations that individuals have with these spaces. Although the two sets of relations overlap to a large extent, and in any case officially (individuals travel, make purchases, relax), they are still not confused with one another; for non-places mediate a whole mass of relations, with the self and with others, which are only indirectly connected with their purposes. As anthropological places create the organically social, so non-places create solitary contractuality. Try to imagine a Durkheimian analysis of a transit lounge at Roissy!

The link between individuals and their surroundings in the space of non-place is established through the mediation of words, or even texts. We know, for a start, that there are words that make image—or rather, images: the imagination of a person who has never been to Tahiti or Marrakesh takes flight the moment these names are read or heard. Hence the TV game shows that derive so much of their popularity from giving rich prizes of travel and accommodation ('a week for two at a three-star hotel

in Morocco', 'a fortnight's full board in Florida'): the mere mention of the prizes is sufficient to give pleasure to viewers who have never won them and never will. The 'weight of words' (a source of pride to one French weekly, which backs it up with 'the impact of photos') is not restricted to proper names; a number of common nouns (holiday, voyage, sea, sun, cruise …) sometimes, in certain contexts, possess the same evocative force. It is easy to imagine the attraction that might have been and may still be exercised, elsewhere and in the opposite direction, by words we find less exotic, or even devoid of the slightest effect of distance: America, Europe, West, consumption, traffic. Certain places exist only through the words that evoke them, and in this sense they are non-places, or rather, imaginary places: banal utopias, clichés. They are the opposite of Michel de Certeau's non-place. Here the word does not create a gap between everyday functionality and lost myth: it creates the image, produces the myth and at the same stroke makes it work (TV viewers watch the programme every week, Albanians camp in Italy dreaming of America, tourism expands).

But the real non-places of supermodernity—the ones we inhabit when we are driving down the motorway, wandering through the supermarket or sitting in an airport lounge waiting for the next flight to London or Marseille—have the peculiarity that they are defined partly by the words and texts they offer us: their 'instructions for use', which may be prescriptive ('Take right-hand lane'), prohibitive ('No smoking') or informative ('You are now entering the Beaujolais region'). Sometimes these are couched in more or less explicit and codified ideograms (on road signs, maps and tourist guides), sometimes in ordinary language. This establishes the traffic conditions of spaces in which individuals are supposed to interact only with texts, whose proponents are not individuals but 'moral entities' or institutions (airports, airlines, Ministry of Transport, commercial companies, traffic police, municipal councils); sometimes their presence is explicitly stated ('this road section financed by the General Council', 'the state is working to improve your living conditions'), sometimes it is only vaguely discernible behind the injunctions, advice, commentaries and 'messages' transmitted by the innumerable 'supports' (signboards, screens, posters) that form an integral part of the contemporary landscape.

France's well-designed autoroutes reveal landscapes somewhat reminiscent of aerial views, very different from the ones seen by travellers on the old national and departmental main roads. They represent, as it were, a change from intimist cinema to the big sky of Westerns. But it is the texts planted along the wayside that tell us about the landscape and make its secret beauties explicit. Main roads no longer pass through towns, but lists of their notable features—and, indeed, a whole commentary— appear on big signboards nearby. In a sense the traveller is absolved of the need to stop or even look. Thus, drivers batting down the *autoroute du sud* are urged to pay attention to a thirteenth-century fortified village, a renowned vineyard, the 'eternal hill' of Vézelay, the landscapes of the Avallonnais and even those of Cézanne (the return of culture into a nature which is concealed, but still talked about). The landscape keeps its distance, but its natural or architectural details give rise to a text, sometimes supplemented by a schematic plan when it appears that the passing traveller is not

really in a position to see the remarkable feature drawn to his attention, and thus has to derive what pleasure he can from the mere knowledge of its proximity.

Motorway travel is thus doubly remarkable: it avoids, for functional reasons, all the principal places to which it takes us; and it makes comments on them. Service stations add to this information, adopting an increasingly aggressive role as centres of regional culture, selling a range of local goods with a few maps and guidebooks that might be useful to anyone who is thinking of stopping. Of course the fact is that most of those who pass by do not stop; but they may pass by again, every summer or several times a year, so that an abstract space, one they have regular occasion to read rather than see, can become strangely familiar to them over time; much as other, richer people get used to the orchid-seller at Bangkok airport, or the duty-free shop at Roissy I.

In the France of thirty years ago, the *routes nationales,* departmental main roads and railways used to penetrate the intimacy of everyday life. The difference between road and rail routes, from this point of view, was like the difference between the front and back of something; the same difference is still partially perceptible today to anyone who keeps to departmental main roads and the railways (TGV excepted), especially regional lines (where they still exist, for significantly it is the *local* services, the roads of *local* interest, that are vanishing fastest). Departmental roads, which today are often rerouted to bypass towns and villages, used to pass through their main streets, lined with houses on both sides. Before eight o'clock in the morning or after seven at night, the traveller would drive through a desert of blank façades (shutters closed, chinks of light filtering through the slats, but only sometimes, since bedrooms and living-rooms usually faced the back of the house): he was witness to the worthy, contained image the French like to give of themselves, that every Frenchman likes to project to his neighbours. The passing motorist used to see something of towns which today have become names on a route (La Ferté-Bernard, Nogent-le-Rotrou); the texts he might happen to decipher (shop signs, municipal edicts) during a traffic hold-up, or while waiting at a red light, were not addressed primarily to him. Trains, on the other hand, were—and remain—more indiscreet. The railway, which often passes behind the houses making up the town, catches provincials off guard in the privacy of their daily lives, behind the façade, on the garden side, the kitchen or bedroom side and, in the evening, the light side (while the street, if it were not for public street lighting, would be the domain of darkness and night). Trains used to go slowly enough for the curious traveller to be able to read the names on passing stations, but this is made impossible by the excessive speed of today's trains. It is as if certain texts had become obsolete for the contemporary passenger. He is offered others: on the aircraft-like train the TGV has become, he can leaf through a magazine rather like the ones provided by airlines for their passengers: it reminds him, in articles, photos and advertisements, of the need to live on the scale (or in the image) of today's world.

Another example of the invasion of space by text is the big supermarket. The customer wanders round in silence, reads labels, weighs fruit and vegetables on a machine that gives the price along with the weight; then hands his credit card to a young woman as silent as himself—anyway, not very chatty—who runs each article

past the sensor of a decoding machine before checking the validity of the customer's credit card. There is a more direct but even more silent dialogue between the card-holder and the cash dispenser: he inserts the card, then reads the instructions on its screen, generally encouraging in tone but sometimes including phrases ('Card faulty', 'Please withdraw your card', 'Read instructions carefully') that call him rather sternly to order. All the remarks that emanate from our roads and commercial centres, from the street-corner sites of the vanguard of the banking system ('Thank you for your custom', 'Bon voyage', 'We apologize for any inconvenience') are addressed simultaneously and indiscriminately to each and any of us: they fabricate the 'average man', defined as the user of the road, retail or banking system. They fabricate him, and may sometimes individualize him: on some roads and motorways a driver who presses on too hard is recalled to order by the sudden flashing (110! 110!) of a warning sign; at some Paris junctions, cars that jump red lights are photographed automatically. Every credit card carries an identification code enabling the dispenser to provide its holder with information at the same time as a reminder of the rules of the game: 'You may withdraw 600 francs.' 'Anthropological place' is formed by individual identities, through complicities of language, local references, the unformulated rules of living know-how; non-place creates the shared identity of passengers, customers or Sunday drivers. No doubt the relative anonymity that goes with this temporary identity can even be felt as a liberation, by people who, for a time, have only to keep in line, go where they are told, check their appearance. As soon as his passport or identity card has been checked, the passenger for the next flight, freed from the weight of his luggage and everyday responsibilities, rushes into the 'duty-free' space; not so much, perhaps, in order to buy at the best prices as to experience the reality of his momentary availability, his unchallengeable position as a passenger in the process of departing.

Alone, but one of many, the user of a non-place is in contractual relations with it (or with the powers that govern it). He is reminded, when necessary, that the contract exists. One element in this is the way the non-place is to be used: the ticket he has bought, the card he will have to show at the tollbooth, even the trolley he trundles round the supermarket, are all more or less clear signs of it. The contract always relates to the individual identity of the contracting party. To get into the departure lounge of an airport, a ticket—always inscribed with the passenger's name—must first be presented at the check-in desk; proof that the contract has been respected comes at the immigration desk, with simultaneous presentation of the boarding pass and an identity document: different countries have different requirements in this area (identity card, passport, passport and visa), and checks are made at departure time to ensure that these will be properly fulfilled. So the passenger accedes to his anonymity only when he has given proof of his identity; when he has countersigned (so to speak) the contract. The supermarket customer gives his identity when he pays by cheque or credit card; so does the autoroute driver who pays the toll with a card. In a way, the user of the non-place is always required to prove his innocence. Checks on the contract and the user's identity, *a priori* or *a posteriori,* stamp the space of contemporary consumption with the sign of non-place:[1] it can be entered only by the

innocent. Here words hardly count any longer. There will be no individualization (no right to anonymity) without identity checks.

Of course, the criteria of innocence are the established, official criteria of individual identity (entered on cards, stored in mysterious databanks). But the innocence itself is something else again: a person entering the space of non-place is relieved of his usual determinants. He becomes no more than what he does or experiences in the role of passenger, customer or driver. Perhaps he is still weighed down by the previous day's worries, the next day's concerns; but he is distanced from them temporarily by the environment of the moment. Subjected to a gentle form of possession, to which he surrenders himself with more or less talent or conviction, he tastes for a while—like anyone who is possessed—the passive joys of identity-loss, and the more active pleasure of role-playing.

What he is confronted with, finally, is an image of himself, but in truth it is a pretty strange image. The only face to be seen, the only voice to be heard, in the silent dialogue he holds with the landscape-text addressed to him along with others, are his own: the face and voice of a solitude made all the more baffling by the fact that it echoes millions of others. The passenger through non-places retrieves his identity only at Customs, at the tollbooth, at the check-out counter. Meanwhile, he obeys the same code as others, receives the same messages, responds to the same entreaties. The space of non-place creates neither singular identity nor relations; only solitude, and similitude.

There is no room there for history unless it has been transformed into an element of spectacle, usually in allusive texts. What reigns there is actuality, the urgency of the present moment. Since non-places are there to be passed through, they are measured in units of time. Itineraries do not work without timetables, lists of departure and arrival times in which a corner is always found for a mention of possible delays. They are lived through in the present. The present of the journey, materialized today on long-distance flights by a screen giving minute-to-minute updates on the aircraft's progress. From time to time the flight captain makes this explicit in a somewhat redundant fashion: 'The city of Lisbon should be visible to the right of the aircraft.' Actually there is nothing to be seen: once again, the spectacle is only an idea, only a word. On the motorway, occasional luminous signs give the ambient temperature and information helpful to those frequenting the space: 'Two-kilometre tailback on A3'. This present is one of actuality in the broad sense: in aircraft, newspapers are read and reread; some airlines even retransmit TV current affairs programmes. Most cars are fitted with radios; the radio plays continuously in service stations and supermarkets: buzzwords of the day, advertisements, a few snippets of news are offered to—inflicted on—passing customers. Everything proceeds as if space had been trapped by time, as if there were no history other than the last forty-eight hours of news, as if each individual history were drawing its motives, its words and images, from the inexhaustible stock of an unending history in the present.

Assailed by the images flooding from commercial, transport or retail institutions, the passenger in non-places has the simultaneous experiences of a perpetual

present and an encounter with the self. Encounter, identification, image: *he* is this well-dressed forty-year-old, apparently tasting ineffable delights under the attentive gaze of a blonde hostess; *he* is this steady-eyed rally driver hurling his turbo-diesel down some god-forsaken African back-road; and that virile-looking fellow at whom a woman is gazing amorously because he uses toilet water with a wild scent: that is him too. If these invitations to identification are essentially masculine, it is because the ego-ideal they project is masculine; at present, a credible businesswoman or woman driver is perceived as possessing 'masculine' qualities. The tone changes, naturally, in supermarkets, those less prestigious non-places where women are in a majority. Here the theme of equality (even, eventually, disappearance of the distinction) between the sexes is broached in symmetrical and inverse fashion: new fathers, we sometimes read in 'women's' magazines, take an interest in housework and enjoy looking after babies. But even in supermarkets the distant rumble of contemporary prestige is audible: media, stars, the news. For the most remarkable thing in all this remains what one might call the 'intersecting participation' of publicity and advertising apparatuses.

Commercial radio stations advertise big stores; big stores advertise commercial radio. When trips to America are on special offer at the travel agencies, the radio tells us about it. Airline company magazines advertise hotels that advertise the airline companies; the interesting thing being that all space consumers thus find themselves caught among the echoes and images of a sort of cosmology which, unlike the ones traditionally studied by ethnologists, is objectively universal, and at the same time familiar and prestigious. This has at least two results. On the one hand, these images tend to make a system; they outline a world of consumption that every individual can make his own because it buttonholes him incessantly. The temptation to narcissism is all the more seductive here in that it seems to express the common law: do as others do to be yourself. On the other hand, like all cosmologies, this new cosmology produces effects of recognition. A paradox of non-place: a foreigner lost in a country he does not know (a 'passing stranger') can feel at home there only in the anonymity of motorways, service stations, big stores or hotel chains. For him, an oil company logo is a reassuring landmark; among the supermarket shelves he falls with relief on sanitary, household or food products validated by multinational brand names. On the other hand, the countries of East Europe retain a measure of exoticism, for the simple reason that they do not yet have all the necessary means to accede to the worldwide consumption space.

Note

1. The expression *non-lieu,* which in the present text usually means 'non-place', is more commonly used in French in the technical juridical sense of 'no case to answer' or 'no grounds for prosecution': a recognition that the accused is innocent. [Translator's note.]

–5.5–

Camille Pissarro: The Unassuming Eye
Linda Nochlin

"The gift of seeing is rarer than the gift of creating," Zola once remarked. Certainly, it is this rare gift, more than any other, which marks the work of Camille Pissarro (1830–1903). His long career encompasses the whole range of nineteenth-century French visual discovery, from Corot through Neo-Impressionism, and ends on the very brink of the Cubist rejection of perception as the foundation of art. Reversing the usual direction of the voyage of self-discovery, Pissarro fled his exotic but stulti-fying birthplace, Saint Thomas in the West Indies, for the stimulation of mid-century Paris and its infinitely civilized countryside, just in time to participate in the major artistic revolution of his epoch.

The present-day penchant for ferocity, single-mindedness, and ambiguity may stand in the way of a full response to an art at once so open and so limited as Pissarro's, unredeemed by either emotional undertow or technical bravura. The fin-ished work reveals that Pissarro's self-effacement before the motif was at times truly remarkable. In the late 1860s and early 1870s, with a modesty matched only by that of his first master, Corot, he produced a series of landscapes so disarming in their un-assailable visual rectitude, so unforced in execution and composition, that Cézanne said of them in later years: "If he had continued to paint as he did in 1870, he would have been the strongest of us all."[1] Cézanne's remark reminds us that Pissarro was endowed not only with the gift of seeing but with the even rarer ability to make other artists see for themselves: Cézanne, Gauguin, and van Gogh bear witness to the effectiveness of Pissarro as a teacher, or rather, one whose very presence in the vicinity of the chosen motif might serve as a catalyst, a liberating agent for the act of visual response, freed both from traditional *poncif* and subjective distortion. Nor was his role forgotten: Gauguin hotly defended his former master's "intuitive, purebred" art against charges of derivativeness as late as 1902, and the old, already venerated Cézanne, in an exhibition at Aix in 1906, the year of his death, had himself listed in the catalogue as "Paul Cézanne, pupil of Pissarro." More than any other Impression-ist, Pissarro remained faithful to the basic tenets of the group as they were formulated during the high point of the 1870s—he was the only one to participate in all eight Impressionist exhibitions—and to the end, he maintained his faith in natural vision as the guiding principle of art.

But this is far too simple and unproblematic a formulation of both the revolutionary nature of the Impressionist enterprise and Pissarro's specific contribution to it. Seeing, for a painter, must always involve a simultaneous act of creation if there is to be a work of art at all, and in any case, "la petite sensation," the whole notion that it is possible to divorce seeing from its cognitive, emotional, and social context is as idealistic, in its way, as any classical norm. The idea that there can be such a thing as a neutral eye, a passive recorder of the discrete color sensations conveyed by brilliant outdoor light is simply an element of Impressionist ideology, like their choice of "ordinary" subjects and "casual" views, not an explanation of the style itself. After all, the difference between what Vermeer "saw" when he looked out of his window in Delft in the seventeenth century and what Pissarro "saw" when he looked out of his in Rouen in the nineteenth can hardly be laid to mere physical differences like optic nerves and climate on the one hand, nor to willful distortion of the visual facts on the other. Yet the same light that crystalized and clarified forms on a surface of impeccable, mirror-like smoothness in the *View of Delft* seems to have blurred and softened them on Pissarro's crusty, pigment-streaked canvas. What an artist sees, as revealed by the evidence of the painted image, would seem to depend to an extraordinary degree on when he is looking and what he has chosen to look at.

For Pissarro, a convinced and professing anarchist, Impressionism was the natural concomitant of social progress, political radicalism, belief in science rather than superstition, individualism, and rugged straightforwardness in personal behavior. His lifelong insistence on art as truth to immediate perception, his faith in "les effets si fugitifs et si admirables de la nature"[2] were intimately related to his commitment to the progressive nineteenth-century belief in human and physical nature as basically good, corrupted only by a repressive and deceiving social order, by prejudice and obscurantism. Impressionism sought to restore the artist to a state of pristine visual innocence, to a prelapsarian sense-perception free of the a priori rules of the academy or the a posteriori idealization of the studio. Courbet professing ignorance of the subject recorded by his brush, Monet wishing that he had been born blind, Pissarro advising his artist son, Lucien, not to overdevelop his critical sense but to trust his sensations blindly—all testify to the same belief that natural vision is a primary value in art, and can only be attained through a process of ruthless divestment rather than one of solid accumulation, a rejection of past traditions rather than a building upon them.

Pissarro, in the course of one of the heated discussions of the young rebels at the Café Guérbois, once declared that they ought to "burn down the Louvre,"[3] surely the most extreme statement of its kind until the Futurist manifestos of the twentieth century. "L'Impressioniste," wrote the poet Jules Laforgue in a remarkable article of 1883, "est un peintre moderniste qui ... oubliant les tableaux amassés par les siècles dans les musées, oubliant l'éducation optique de l'école (dessin et perspective, coloris), à force de vivre et de voir franchement et primitivement dans les spectacles lumineux en plein-air ... est parvenu a se refaire un oeil naturel, à voir naturellement et à peindre naivement comme il voit."[4]

["[It] is a modern painter who ... forgetting the paintings, which the centuries have gathered in museums, forgetting the optical education of school (drawing, perspective, coloring), by dint of living and of seeing frankly and primitively in the luminous spectacles of the outdoors ... was able to remake a natural eye, to naturally see and to naively paint as he sees."]

Painting becomes a continual search and learning to paint the often agonizing process of a lifetime, not a set of rules to be mastered in a series of graduated stages within an academy. The rejection of "values" as the basis of painting in the progressive art after Corot can thus be interpreted both in the pictorial sense of an abandonment of under-painting—a fixed, hierarchical scheme of abstract light-and-shade predetermining the final "meaning" of the work—and at the same time, as the rejection of the social, moral, and epistemological structures which such a pictorial scheme presupposes. As such, it has constituted a permanent rejection on the part of avant-garde art right down to the present day.

Like the other Impressionists, and more strongly than some of them, Pissarro was convinced that what the purified eye must confront was contemporary appearance. "[Nous devons chercher] des éléments dans ce qui nous entoure, avec nos propres sens," he wrote to Lucien in 1898. "Et l'on ne travaille dans ce sens qu'en observant la nature avec notre propre temperament moderne.... C'est une erreur grave de croire que tous les arts ne se tiennent pas étroitement liés à une époque."[5]

["We need to search] elements within our surroundings, with our own senses ... And we can only work towards this by observing nature with our own modern temperament ... It is a grave error to believe that all arts are not tightly linked to an era."]

This sensitivity to the quality of his own time is evident in Pissarro's work as early as 1866, when a critic remarked on his landscape in the Salon of that year, *Bords de la Marne en hiver* (Banks of the Marne, Winter) that "M. Pissarro n'est pas banal par impuissance d'être pittoresque" ["M. Pissaro is not banal through his inability of being picturesque"] and has used his robust and exuberant talent specifically "à faire ressortir les vulgarités du monde contemporain." ["to reveal their vulgarities of the contemporary world."]. Zola commented on the harsh veracity of the same work, and of a similar view in the Salon of 1868, exclaimed: "C'est là la campagne moderne." ["There it is, the modern countryside."]

One is often aware of the more or less discreet encroachments of industrialization in Pissarro's landscapes: a smokestack appears as early as 1868 and there is a fine group of paintings of factories in 1873. Pissarro sees them neither as dark, satanic mills nor as harbingers of technological progress, but simply as elements, neither denied nor unduly emphasized, within an admirable, contemporary pictorial motif.

When he sought refuge in London from the rigors of the Franco-Prussian War, he chose to paint, forthrightly, with a sprightly, unromantic verve, that emblematic structure of modernity, the Crystal Palace, not just once but twelve times over. His vision of the railroad there is not visionary and excited like Turner's *Rain, Steam and Speed: The Great Western Railway,* but direct, vivid, matter of fact. Yes, the tracks

cut a path through the bosom, as it were, of nature. No, this is not horrific or menacing, but part of the modern given, how things are in the industrial world.

Yet, while he never said it in so many words, and generally insisted on equating Impressionist vision with scientific progress, human value and left-wing politics, Pissarro could not have failed to have been aware of the basically subjective, almost solipsistic bias with which Impressionism might be afflicted. The "petite sensation," the basis of Pissarro's art, while it made for the richness and range of individual styles within the Impressionist gamut, could also lead to fantasy and exaggeration—in short, to precisely that self-indulgent mysticism which Pissarro found so abhorrent and reactionary. What one might be painting might not be nature, not wholesome, everyday reality, but a shifting, floating, evanescent, even deceptive, veil of maya. Laforgue found this symboliste aspect of Impressionism much to his taste: the impossibility of attaining a stable, unequivocal reality, the inevitable exaltation of the individual sensibility at a unique moment in time. "Même en ne restant que quinze minutes devant un paysage, l'oeuvre ne sera jamais l'équivalent de la réalité fugitive ..." Laforgue wrote. "L'objet et le sujet sont donc irrémédiablement mouvants, insaisissables et insaisissants."[6] [" Even while spending only fifteen minutes in front of a landscape, the work will never be the equivalent of fleeting reality ... The object and the subject are then irremediably moving, un-graspable and un-grasping."] Pissarro, one imagines, did not feel easy with this aspect of the movement.

It was perhaps for this reason, among others, in the middle 1880s, when the Impressionist impulse was at a low ebb and the group itself disintegrating as a coherent entity, that Pissarro took temporary refuge in the solid theoretical basis and apparently universal objectivity of Neo-Impressionism, adopting the "scientific" color-division and painstaking, dotted brushwork of the young Seurat when he himself was fifty-five years old. The Neo-Impressionist affinity for the systematized and the socially progressive might also have been tempting at this time, as a comparison of the 1889 painting *Les Glaneuses* with some of Pissarro's earlier, less consciously monumental representations of peasants in landscapes would reveal. At this moment, he refers to the orthodox Impressionists as "romantic" (to differentiate them from his new, "scientific" colleagues), and criticizes Monet's work of 1887 as suffering from a "désordre qui ressort de cette fantaisie romanesque qui ... n'est pas en accord avec notre époque." [a "disorder, which comes from this romantic fantasy that ... is not in keeping with our times."][7]

Pissarro's whole series of paintings of peasant women in the decade of the 1880s raises certain interesting social and stylistic issues. Certainly, as Richard Brettell has pointed out, it is Degas who stands behind Pissarro in his renewed concentration on the expressive potential of the human figure in these paintings (as opposed to earlier ones, where they are just staffage) and doubtless, as Brettell says, it was Degas's images of the working women of Paris that provided a new repertory of poses, gestures, and viewpoints;[8] I think Degas's ballet dancers also figured in this process.

A few years before he painted *Les Glaneuses,* in the early to mid-1880s, Pissarro's resolute modernity, his intention not to sentimentalize but to be of his times, is evident in his choice of the theme of the peasant woman in the marketplace rather than the more traditional topos of the peasant woman working in fields or nourishing her young. These more traditional peasant themes evoke the connection of the peasant woman with the unchanging natural order. Pissarro's market woman, on the contrary, clearly demonstrates that the peasant woman like the rest of humanity and, perhaps in a heartfelt way, like the artist in particular has to hustle her wares for a living. The country woman is envisioned by Pissarro as an active and individuated force in contemporary economic life rather than as a generalized icon of timeless submission to nature. At the same time, town and country are seen to interact in the modest arena of commerce—briskly, not darkly—rather than being idealized as opposing essences.

One can see differences in a comparison of Pissarro's and Millet's *Les Glaneuses.* Pissarro has, in a sense, responded to the challenge of Millet by demystifying Millet's image, making it more irregular and variegated; by having one woman stand up in an assertive and dominating pose and talk to another, he refuses the identification of woman and nature suggested by Millet's composition. In the same way, Pissarro's *Paysans dans les champs, Eragny-sur-Epte* of 1890 seems to be a contemporary, up-to-date reinterpretation of the generalized pieties of Millet's *L'Angélus.* There are ways in which Pissarro's *Les Glaneuses* reminds one of the self-conscious multiplicity of poses and variations of Jules Breton's *Le Rappel des glaneuses* of 1859, although he has staunchly refused both Breton's glamorization of his subject and the slick, fussy detail of his style.

Still, one does not feel that either the ambitious monumentality or the systematic paint application of Neo-Impressionism have been satisfactorily assimilated by Pissarro. The ghostly example of *La Grande Jatte* lies in the background of works like the 1889 *Les Glaneuses* and accounts for its inner contradictions. The Seurat-inspired self-consciousness of the composition-rationalized brushwork, clarifying light, and measured space clashes with the spontaneous irregularity of Pissarro's figure style. Missing is that harmonious regularity of contour and volume with which Seurat had united his figures with their setting. The demands of systematization and the delights of informality; the countering signs of the colloquial and the monumental are left unresolved in Pissarro's paintings.

The same contradictions, redeemed by a more interesting decorative effect, mark another major Neo-Impressionist work, *La Cueillette des pommes, Eragny-sur-Epte* (Apple-Picking) of 1888. It is hard to escape certain allegorical significations of the theme itself in this painting, for the tree is deliberately, and apparently meaningfully, centralized and the composition regularized as though to insist upon its metaphorical status. The motif of fruit-picking with symbolic overtones becomes a kind of fin-de-siècle leitmotif. It is picked up in Mary Cassatt's 1893 mural for the Chicago World's Fair, *Allegory of Modern Woman,* a work which is more overtly utopian in its resonance than Pissarro's *La Cueillette des pommes:* the women are represented

plucking the fruits of knowledge. And certainly "utopian" is the word to describe Signac's social allegory, featuring a worker plucking fruit from a tree, *Au Temps d'Harmonie,* painted for the town hall of Montreuil in 1895. And, in a very different mood, fruit-picking figures as the central motif of Gauguin's dark allegory of human existence, *D'Où venons-nous? Que sommes-nous? Ou allons-nous?* of 1897.

Yet Pissarro's work, neither before nor after what Rewald has termed his "divisionist deviation," was never really threatened by the dissolution of objects into webs of broken color. In his *Boulevard Montmartre, mardigras,* for example, one of a series of city vistas of 1897, there is a sense of lively, all-over surface activation, merging people, buildings, and budding trees in a carnival atmosphere of colored movement, somewhat reminiscent of Monet's dazzling *La rue Montorgueil fête du 30 juin* of 1878, and illustrating his own advice to a young artist of the very year it was painted: "Ne pas faire morceau par morceau; faire tout ensemble, en posant des tons partout ... L'oeil ne doit pas se concentrer sur un point particulier, mais tout voir ..." [Not to make piece by piece; to make simultaneously, applying tones everywhere ... the eye must not concentrate on a particular spot, but see everything."][9] But at the same time, Pissarro's brush scrupulously maintains the individual rights of separate forms, substances, and textures within this context of unifying atmosphere, differentiating with staccato touches the crowd at the right from the longer, more continuous strokes of the procession in the background, and distinguishing by feathery, diaphanous swirls the tops of the trees from the solid rectangular patches of the kiosks beneath them, marking off the latter in turn from the more fluid, less substantial rectangles of chimneys and attics.

It was perhaps his feeling for things, his commitment to nature and human value, rather than theory or an innate sense of form which protected him, or limited his power of invention, according to how one chooses to look at it. Pissarro was never, as was Monet (or as the Monet mythology would have it) in his later years, forced into near-abstraction by the urgency of an obsessive chase after the wild goose of the *instantané;* for Pissarro, the vision of nature always implied a point of view, a certain distance, a beginning, a middle, and an end within a given canvas. One might even say (as one never could of the tormented old Monet, hovering feverishly over his ninety canvases in the Savoy Hotel in London, searching for exactly the right patch in exactly the right canvas for this particular instant of light), that Pissarro accepted nature's calm quiddity as simply more possible for the painter than the perpetual flow of her random splendor, more appropriate to his temperament and the nature of his task than a dizzying descent into the heart of process at the bottom of a lily pond. If one compares Pissarro's view of Rouen Cathedral with one of Monet's famous Rouen façades of the previous years, one immediately sees that while Monet completely identifies pictorial motif and painted object, dissolving the architectonic façade of the actual building in light, and then petrifying his sunset sensations into a corrugated, eroded pigment-façade, Pissarro has effected no such alchemical metamorphosis. Thoroughly familiar with Monet's series, which he had

admired at Durand-Ruel's, he deliberately chose a more panoramic, less destructive view. "Tu te rappelles," he wrote to Lucien, "que les *Cathédrales* de Monet étaient toutes faites avec un effet très voilé qui donnait, du reste, un certain charme mystérieux au monument. Mon vieux Rouen avec sa Cathédrale au fond est fait par temps gris et assez ferme sur le ciel. J'en étais assez satisfait; cela me plaisait de la voir se profiler grise et ferme sur un ciel uniforme de temps humide." ["You remember," he wrote to Lucien, "that Monet's Cathedrals were all done with an extremely veiled effect, which gave the monument, among the rest, a particularly mysterious charm. My old Rouen with its Cathedral in the background, is quite solid onto the sky. I was quite satisfied by it; it pleased me to see her standing out all grey and firm against a uniform, wet sky."][10] In Pissarro's painting, Rouen Cathedral remains Rouen Cathedral, paint remains paint, and both depend on the eye and hand of the painter, situated at a certain determinable point of distance from his motif.

The ultimately liberating implications of Impressionism, its freeing of the artist to establish a system of independent relationships of form and color on the canvas were obviously foreign to Pissarro's conception of it. Like others of his time, he saw Gauguin's synthetist symbolism and the decorative abstraction of the Nabis as rejections of Impressionism, rather than extensions of its inherent possibilities. Gauguin, with his turning away from natural perception in favor of "mysterious centers of thought" and his quasi-religious predilections, he considered an apostate if not an outright charlatan. "Je ne reproche pas a Gauguin d'avoir fait un fond vermillon ...," he wrote in 1891, "je lui reproche de ne pas appliquer sa synthèse à notre philosophie moderne qui est absolument sociale, antiautoritaire et anti-mystique ... Gauguin n'est pas un voyant, c'est un malin qui a senti un retour de la bourgeoisie en arrière ..." [" I am not reproaching Gauguin's use of vermillion as a background ...," he wrote in 1891, "I am reproaching his refusal to apply his synthesis to our modern philosophy, which is absolutely social, anti-authoritarian and anti-mystical ... Gauguin is not a seer, he's a shrewd who sensed the bourgeoisie's return from behind ..."][11]

In the last years of his life, a bent but indefatigable old man with a prophet's beard and ailing eyes, he returns to the deep perspectives and apparently spontaneous perceptions characteristic of the Pontoise landscapes of the 1870s, but this time, chooses to immerse himself in the variegated motifs offered by the boulevards and avenues of Paris. How little sense there is of the grimness of urban reality in these panoramas, viewed, generally rather distantly, from the height of a hotel window! It is not that the painter has avoided the issue, it is just that what he sees before him is anything but grim. "Ce n'est peut-être très esthétique," he writes to Lucien near the turn of the century, "mais je suis enchanté de pouvoir essayer de faire ces rues de Paris que l'on a l'habitude de dire laides, mais qui sont si argentées, si lumineuses et si vivantes ... C'est moderne en plein!" ["It may not be very aesthetic but I am enchanted in trying to make of these streets of Paris, which through habits we call ugly, but that are so silvery, so luminous and so alive ... It is fully modern"][12] *Allées* of trees are now replaced by vistas of stone façades, peasants by pedestrians, hedgerows by

carriages, cabbage fields by cobblestones, or, at times, nature is permitted to intrude, mingle with, enrich the cityscape. Although these late Parisian street scenes are uneven in quality, in the best of them there is an invigorating achievement of freshness, consummate control and freedom. In the *Pont Royal et Pavillon de Flore,* painted during the last year of the artist's life, a sense of vernal lightness arises from the delicate balance established between the demands of the motif—sprightly, wavering openness of the central tree, calm horizontal curve of the bridge, diagonal of facades on the opposite bank—and those of pictorial unity, the latter created by an all-over high-keyed pastel palette and the granular consistency of the surface texture.

Looking at this group of late cityscapes as a whole, no matter how we evaluate them—and certainly, they are not masterpieces in the usual sense of the term—we nevertheless tend to accept them as authentic records of how things looked, how things *were* in Paris at the turn of the century. Perhaps this is because they coincide so neatly with our own view of how Paris was—or even, if we are unabashedly romantic and Francophile, of how Paris is. Pissarro has created an imagery of liveliness rather than urban hysteria; of spontaneity rather than confusion; of pleasurable randomness within a setting of spacious order rather than alienation in an oppressively crowded chaos.

Yet Pissarro's vision of a motif like the Pont Neuf is as determining and chosen as any other: it is no more "real" Paris than, say, the photographer Hippolyte Jouvin's cooler and more utilitarian stereoscopic photograph of the same motif—the Pont Neuf of 1860–5. It involves a certain notion of the nature of the modern city itself and the artist's relation to it.

Nor is Pissarro's vision of urban reality any more privileged than Gustave Dore's melodramatic, exaggerated perspective of workday London in 1872, which emphasized the feverish pressure of a crowd in a blocked, funnellike space rather than easy recession. By "vision" I of course mean the social and psychological assumptions controlling vision at any moment in history as well as aesthetic decisions about vantage point, distance, or placing of the image within the frame. It is precisely the difference in these assumptions which, of course, makes Caillebotte's urban imagery in his *Boulevard vu d'en haut* of 1880 so different from Pissarro's boulevard paintings: so much more distanced, arbitrary-seeming, and aestheticized. And it is obvious that Pissarro was incapable of experiencing or setting forth the city as a projection of menacing alienation, as had Munch in 1889.

Pissarro's particular unstrained and accepting modality of urban vision had to do with a kind of freedom which he thought of as freedom of perception. We are, perhaps, more cynical about the possibilities of individual freedom, or, alternatively, conceive of freedom—artistic freedom at any rate—in more grandiose terms. But confronting some of these later urban vistas of Pissarro one feels ready to revise, no matter how little, one's twentieth-century prejudices about the nature of freedom in art, prejudices about the necessarily *extreme* character of all choice. Perhaps one can be relatively free without self-conscious rebellion or dramatic gestures, free like Pissarro to trust

one's own unassuming but unacerbated intuitions of truth and reality. For the old anarchist, freedom in this unspectacular sense seems to have been the essential condition of painting, of seeing; perhaps of living. "Il faut de la persistence, de la volonté et des sensations *libres*," ["One needs persistence, will and free sensations,"] he wrote, well on in years and neither very rich nor very famous, "dégagées de toute autre chose que sa propre sensation." ["cleared of all but one's own sensation."][13]

Notes

1. Letter from Cézanne to the painter Louis LeBail; cited by John Rewald, *The History of Impressionism,* rev. ed. (New York: The Museum of Modem Art, 1962), p. 536.
2. Pissarro to H. van de Velde, March 27, 1896 as quoted in J. Rewald, *L'Histoire de l'impressionnisme* (Paris, 1955), pp. 329–30.
3. Pissarro as cited in J. Rewald, *Camille Pissarro* (New York, 1963), p. 18.
4. *Oeuvres complètes de Jules Laforgue, Mélanges posthumes,* 3rd ed. (Paris, 1903), p. 133.
5. Camille Pissarro, *Lettres à son fils Lucien,* ed. J. Rewald (Paris, 1950), pp. 451 and 459 (March 7, 1898, and August 19, 1898).
6. Laforgue, op. cit., pp. 140 and 141.
7. *Lettres à son fils Lucien,* pp. III and 124 (November 1886 and January 9, 1887).
8. *Camille Pissarro 1830–1903,* London (Hayward Gallery), Paris (Grand Palais), Boston (Museum of Fine Arts), 1980–81, p. 29.
9. From the unpublished private notes of the painter Louis LeBail, who received Pissarro's advice during the years 1896–97, as quoted in Rewald, op. cit. (1955), pp. 279–80.
10. *Lettres à son fils Lucien,* p. 403 (March 24, 1896).
11. Ibid., pp. 234–35 (April 20, 1891).
12. Ibid., p. 442 (December 15, 1891).
13. Ibid., p. 291 (September 9, 1892).

–5.6–

The Wicked Queen–Marie-Antoinette
Chantal Thomas

Rouge

Between 1770 and 1780, in their effort to create a stir, beautiful women enlisted the aid of artifice, as they had always done. In the fashion world, as we know, the natural is the height of art.[1] And the natural responds to variable norms. Faces, until then dotted with beauty spots (as fashionable for men as for women), become more uniform, but the heavy application of rouge continued undaunted. Equal effort must be made to imagine the eighteenth-century faces or churches. Today the stone columns of those churches are bare. At the time, church columns and arches were painted, their yellows, blues, and reds harmonizing with the luminous stained glass windows and the congregation's shimmering clothes. Mass was then the worldly outing par excellence, a gaily colored festivity. For many women it was their only chance to show themselves. The passage of the centuries has brought about a decoloration, for people as for monuments. (This progressive effacement, this buffing of glaring color, is registered just as strongly in the evolution of the French language, which, becoming daily more insubstantial, drops the concrete meaning of a term in favor of its abstract sense.)

Censure by good taste, by the bourgeoisie, who preferred gray or beige to hot pink or orange, did not exist at that time: aristocratic pride went hand in hand with the idea of expenditure and a conspicuous presence. Like clothes, makeup declared confidence in the external signs of power. So the rouge of Versailles was worn redder than anywhere else: "Princesses wear it very bright and very strong in tone and they insist that women who are to be presented accentuate their rouge more than usual the day of their presentation ..."[2]—thereby fixing the flush of vanity that such an honor could not fail to arouse! On other less official occasions, heavily plastered-on rouge spared one the duty of blushing. While it often compensated for a lack of modesty, it was even more precious as an antidote to the ravages of age. In a letter to her mother, Marie-Antoinette spoke of "the rouge that old ladies continue to wear here, sometimes even slightly more than young people. For the rest," she adds, "after forty-five, they wear less bright, less striking colors, looser, heavier dresses, their hair is less curled, and their hairdos less high."[3] Gérard de Nenal saw as a sign of the age's decrepitude the powder that, replacing wigs, gave everyone a white head toward the end of the

eighteenth century. But if one thinks of the rouge that nourished on even the most crumpled cheeks, one may, conversely, see signs of that epoch's eternal youthfulness.

The "Bird's Nest"

Only twenty-one when she sent her mother this little chronicle on Versailles fashion, Marie-Antoinette did not fall in the hairdo-lowering category. She actually built hers up as high as possible, despite Mesdames' disapproval and her mother's remonstrations. She was reminded of the dignity of her role. She was told repeatedly that she should not get herself up like some actress or mistress. Marie-Antoinette did not deny her coquetry: "It is true that I am concerned with my appearance."[4] To reassure the empress, she offered to send "drawings of her different hairstyles" in one of her next letters (though she neglected to do so).

Hairdos in the mid-seventeen seventies reached staggering proportions. To achieve their chef d'oeuvres, hairdressers had to stand on a ladder. Women began traveling at knee height, carried on chairs. Certain doors become impractical. Caricatures of the time show hairdos catching fire, like sheaves of wheat, in candelabras hanging from the ceiling. But the dangers and drawbacks were immaterial: court ladies and elegant provincials had no choice. Surmounted by their "bird's nests," they hardly dared move. But height was not the only consideration, fantasy was also called into play. The hairdresser must not only have an architect's talent, he must also be a chronicler of events! Fashionable women had a choice between "the pouf with feeling," "bonnets at orchestra," "in an English park," "candid" coiffures, "Minervas," "Cleopatras," "Dianas," "the beautiful hen," "the globe of the world," "the barouche," and so on. They carried the world on their heads. And if they were bent on demonstrating their interest in current affairs, they could request "the inoculation" (after Louis XV's death from smallpox in 1774, the inoculation of closely related blue-blood princes hit the headlines of the gazettes) or "the Quesaco" (for the more cultured, who found this allusion to one of Beaumarchais's plays terribly chic). In the same register, note "the Iphigénie," a reference to the staging of Gluck's opera thanks to the queen's support, and, in a more political vein, "the insurgent," "the liberty," and "the Philadelphia," all evoking the American Revolution. More directly menacing for coiffed heads, some women wore "the bonnet of revolt," an erudite scaffolding of curls and ribbons inspired by an outbreak of famine in Paris after a hike in the price of bread. These baroque, artificial, provocative constructions evoke stylistic inventions of our own fin de siècle. They can only be seen as flirtations with catastrophe. "Cock's crest bonnets," for example, twisted hairstyles sculpted to form mountain peaks or cathedral spires were veritable announcements of their imminent collapse.

Why get yourself up like this if not to make the fall all the more glorious? The folly of the high hairdo was moving because it was an invitation to disaster: an admiral's wife wore the sea on her head, an endless interweaving of waves. The tiniest

movement, the least disturbance of one of these waves, was sufficient to bring down the whole creation.

Crazy about this fashion, Marie-Antoinette, as queen, courted disaster. She did so as soon as she decided to entrust her hair to a fashionable hairdresser, thereby flouting the tradition of assigning to the queens of France a titled hairdresser who acquitted the honorific post in sober fashion and who alone had the right to touch the royal head. By calling on the services of a male hairdresser then in vogue, Marie-Antoinette offered up her head to the common touch. Worse, she encouraged the man to diversify his practices in the further exercise of his talent. Marie-Antoinette protected the sovereignty of the "creative artist," Léonard; in so doing, she perpetrated the double scandal of having a hairdresser who was not exclusively attached to the queen's service and of having a man occupy a function hitherto reserved for women. "At the time," wrote Mme de Genlis, "there were lady hairdressers for women; it would have been considered indecent to have one's hair done by a man. A year later, the hairdresser Larseneur of Versailles was all the rage for young women's debuts ... Soon male hairdressers were established in Paris; *finally Léonard* arrived, and all the lady hairdressers fell into disrepute and obscurity."[5]

Léonard's success ended with the Revolution (success both as a hairdresser and as the queen's faithful servant, for his assistance to the queen, during the flight to Varennes was a disaster: "It was to master Léonard, most devoted but not terribly bright, that the queen entrusted her diamonds and the task of assisting Choiseul in the flight to Varennes; of course everything went haywire."[6]) The ever higher hairdos collapsed with the expression "to have oneself clipped" (that is, to be sent to the guillotine). Michelet assures us that "the most rabid royalists were perhaps neither nobles, nor priests, but wigmakers."[7] After the Terror, they could not resurrect the old spirit of construction. With the abundant crop of hair, cut wigs now fetched low prices.

The bond between wigmakers and the nobility was reciprocal. While the wigmakers lost their clientele during the Revolution, the aristocracy, deprived of their services, dragged out their days in the courtyards of the prisons of Saint-Pélagie and the Abbey, their hair disheveled, unpowdered, and unwashed.

Hair That Incites Hatred

According to Fleischmann, "The first attacks against the queen, which were rather moderate, belonging more to the spoken complaint than to the pamphlet, began with the fad for high hairdos that held sway around 1775."[8] These fairy-floss constructions excited public derision. Later, by 1789, the tone had shifted from laughter to reprobation. Exciting ridicule, the high hairstyle provoked reactions of sexual and political disgust. In its classifieds, *Le Petit* journal listed these objects for sale: "The complete toiletry of the duchesse de Duras, consisting of all known accessories, individually, false teeth, false chignons, false toupees, false curls, and a false MOUND

OF VENUS, invented by the queen's hairdresser, former director of Monsieur's theater."[9] The press mingled excitement and revulsion. It also warned against the seductive assets of Marie-Antoinette, who would stop at nothing to strengthen the royalist party. Suckers fall for her long hair; the pamphlets denounce "lovers of her red mane."[10] Marie-Antoinette's red "mane" (sometimes associated with the red hair of Judas) is deployed in the revolutionaries' imagination like a bloody standard.[11]

...

The Taste for Feathers

The use of feathers in high hairstyles particularly excited derision, as though the mobile plumes symbolized all too clearly the guilty flightiness of these bird-brained women.

The rumors and pamphlets that attacked the queen's interest in her appearance thereby attacked her for being excessively female, that is, vicious. The amount of time and money she spent worshiping at the altar of fashion reeked of the sins of the flesh: the craze for finery was merely the most obvious manifestation of more secret crazes, more perverse debauchery—betraying these, if not actually inspiring them. Wasn't the fashion for feather hairstyles directly responsible for a certain sexual quirk, which crops up several times in the pornographic press of the day? In *The Almanach of Honest Women for the Year 1790,* a taste for feathers is attributed to a M. Peixotte (or Pexioto): "The little Jew undressed his mistress, stuck peacock feathers up her bum, and got her to walk around the room on all fours; then he put his hands under her rump and cried: 'Oh! What a beautiful bird!' He himself was subject to the same metamorphosis and after a few moments' ecstasy, he finished by taking the place of the feathers." *The Libertine Catechism* offers the same quirk, here attributed to a priest rather than a Jew (both represent perverse characters in revolutionary propaganda): "Then he takes a lovely peacock's tail feather out of his pocket and unbuttons his trousers; he lies on my bed with his bum in the air and asks me to place the end of the feather in his arse, and I do; then to caress his bum, saying the words: 'Ah! What a beautiful peacock!' "[12]

These vicious pavans are one extreme of the simple charge of sacrificing too much to fashion. The taste for adornment is never far from the debauchery of the brothel. It is only a skip and a jump from coquette queen to prostitute queen. "The most elegant whore in Paris could not be more tarted up than the queen," in the words of the anonymous author of *Historical Essays on the Life of Marie-Antoinette of Austria, Queen of France.*

The Queen's Dresses

At the staging of her beauty, it was the queen who commanded. Every morning she consulted the ledger of frivolity. The first decision of Marie-Antoinette's day was

the choice of her outfits. The catalog of samples from her wardrobe was brought to her as soon as she awoke, immediately after her cup of coffee. She would choose from among the several patterns pinned to paper. The dresses she wore were the object of amorous attention on her part. She sometimes happened to launch a style, such as the "queen's shirt" (*chemise à la reine*) (a wide dress with flounces, attached sleeves, décolleté, the neck decorated with a strawberry), in vogue in 1780. But most of the dresses she wore were the creation of Mlle Bertin, her favorite couturier. Marie-Antoinette's recognition of Mlle Bertin's talents went even as far as authorizing her to enter the queen's apartments. Protocol on this point had hitherto been so strict that, when a doctor from the court of Vienna came to visit Versailles, Marie-Antoinette had to intervene to allow him to enter her room. Mlle Bertin, on the other hand, had no trouble threading her way through the court. She enjoyed more privileges than the high and mighty. (In this as well, Marie-Antoinette showed herself to be thoroughly modern, giving the art of fashion the place it enjoys today.)

Critics of the queen's costly coquetry targeted her exalted purveyor. Labelled the "female minister," Rose Bertin was, in the eyes of the public, the incarnation of arbitrary royal preferences—and the financial gains to be made from them. The couturier also symbolized the decadence that Marie-Antoinette was alleged to have introduced into French life and at court. In opposition to the virile ideal essential to the imaginary of the Revolution, Marie-Antoinette represented a principle of *effeminacy:* "As her Minister for Trinkets, the queen has taken on la Bertin, Fashion Merchant ... Another female minister is the dancer Guimard, of the Paris Opera, Minister for Muslin and Costumes ..."[13] (A century later, Ludwig II of Bavaria rose to the level of pamphlet exaggeration. From his Bavarian Trianon, he sent the court hairdresser Hoppe to Munich to form a new ministerial cabinet ... No one believed in the Devil any more in the nineteenth century—charges of mental illness were levelled instead; psychiatrists have replaced judges. Marie-Antoinette went before a tribunal which declared her guilty and condemned her to the guillotine. Ludwig II was deposed on the strength of a medical report which concluded that "His Majesty is no longer fit to exercise government and this incapacity will last not only more than a year but for the rest of his life." His Majesty was condemned to suicide.)

Marie-Antoinette, the "Trinket Queen," perverted the seriousness of affairs of state. Under her reign, the most grave problems were treated with more nonchalance than a point of fashion. Marie-Antoinette's occult power appeared all the more pernicious symbolizing as it did the power of feminine weakness. The pamphlets denounced a chain of influences: a weak king is manipulated by his wife, who is herself under the thumb of a couturier. The king's will goes no further than the circumference of the queen's frocks.

Mme Roland, whose philosophical head refused to sacrifice to fashion's feathers, was indignant to find, on venturing into the world of the salons, that "effeminate men proclaim their admiration for slender verses, aimless talents."[14] An enemy of the queen, she knew how to subtly insinuate the queen's sly presence. She recounts a

conversation between Louis XVI and Pétion, the mayor of Paris, in the following terms: "The faint rustling of silk behind the curtain persuaded Pétion that the queen was present without being visible, and the caresses of the king convinced him of his falseness: he remained firm and honest without yielding to the prince, who was trying to corrupt him …"[15]

We find a similar scene involving Marie-Antoinette's clandestine eavesdropping in the words of another woman, this time in praise of the queen's marvelous discretion. Mme de Genlis had come with the court to the château de Marly. She was in the habit of playing music in her room before bed:

> One night, between eleven o'clock and midnight, while I was playing the harp as I usually do, sight-reading a sonata, to my great surprise M. d'Avaray entered the room and whispered that the queen was in Mme de Valbelle's room, where she had come in order to hear me playing the harp. I immediately began playing the pieces and songs I knew best, which went on for an hour and a half without interruption, as I was waiting for a movement in the next room to tell me the queen was getting up to go; but there was absolute silence. In the end, genuinely exhausted, I stopped. Immediately, there were several bursts of vigorous applause and M. d'Avaray came to thank me for the queen, and he said wonderful things on her behalf. She repeated these to me the next day when I went to pay court.[16]

This anecdote, formally analogous to the one recounted by Mme Roland, works similarly to define a power exercised in the shadows, behind a partition, a curtain, a screen—an indeterminate but omniscient power, traditionally that of women. This is precisely what Mme Roland repudiated, influenced as she was by Rousseau, who abhorred the power of women and of the dark in equal measure. The honesty, frankness, and virility of a republican government was to stand in opposition to royalty, corrupted as it was at its (dark) source by the invisible omnipresence of the queen. The spineless drip of a king was the slave of the coquette queen. The entire realm was pervaded by weakness, falseness, the effeminate. When all is said and done, as Louise Robert wrote in 1791, the worst thing about kings is queens. These "crowned sirens" overstep their authority, from the conjugal bed to the state. From deep within their boudoirs, they rule over "the marching of armies, the fate of colonies." So, the author concludes, "Peoples who have not yet grown tired of kings should at least insist that they be atheists, bastards, and eunuchs."[17]

The queen whose splendor was bleeding the people dry—a theme overworked to the point of insinuating vampirism—became a favorite motif of the scandal sheets. Beaumarchais's continued employment as prosecutor of the gutter press was significant. First hired by Louis XV to destroy the lampoons directed against Mme du Barry, Beaumarchais was taken on by the king's successor to attack lampoonists hostile to Marie-Antoinette. Du Barry, whose life roused Théveneau de Morande's ire in his celebrated *Anecdotes Concerning the comtesse du Barry,* exemplified the

confusion between court and brothel. Indeed, she went directly from Jean du Barry, a cunning and seductive pimp ("She's his milking cow," one police report baldly states), to the bed of the king. Du Barry's coquetry is legendary: her two greatest pleasures, Théveneau wrote, were "doing nothing and being constantly engaged in dressing up."[18] All part of her profession.

The snickering over Marie-Antoinette's coquetry should be understood in the context of the aftermath of criticism of du Barry's costly ostentation: the queen inherited the favorite's renown; she was assigned both roles. Exceptional in the history of France, Marie-Antoinette was both queen and favorite simultaneously—Louis XVI having acquired the bourgeois taste of being faithful to one's wife. This situation, far from serving Marie-Antoinette's image, contributed to the public's attributing every vice to her. As sovereign, she was above the law. As favorite, she ruled over the king and subjugated the court to her pleasure. Marie-Antoinette combined the faults of the first role (arrogance, the arbitrariness of absolute sovereignty) with those of the second (duplicity, obsession with appearances). In the eyes of the public, her ruinous coquetry perpetuated the ostentation of du Barry, who, it was said, was having a dress of gold made for her while Louis XV lay dying. The nasty epigram aimed at Mme du Barry—"France what is your destiny? / To be crushed by a Female / Your salvation came from a Virgin [Joan of Arc] / You will perish under the Prostitute"—seemed even truer under the reign of Marie-Antoinette.

Next to the catalog of the queen's dresses, brought to her first thing every morning, one could place the accusing *Le Livre rouge* (printed in April 1790), which offers, along with proof of the greed of those in favor, proof of her spendthrift vanity. The simplistic notion of a country being ruined by one woman's expenditure is obviously pure fantasy. The height of a hairstyle, gold dresses, and shoes with diamond buckles did not cause a state to crumble. On the stage of history, however dolled up and fascinating they may be, queens and favorites are ever only extras.

Immanent Justice

Biographers, historians, and novelists are particularly keen to point out, as so much proof of the vanity of an immoral life and its ineluctable punishment, the marks of decrepitude in hardened libertines. That is why they never get tired of imagining Casanova's old age (he himself was silent about the third act of his life). It is precisely this fall into the common lot that excites posterity's interest: even he ends up getting old. This event, which isn't one, is banal, pitiful. The famous libertine, the glamorous playboy, must admit defeat, admit that he is barred from the exceptional destiny he had dared to choose. A moralizing discourse, more or less explicit, comments on the fornicator's defeat: "Heavens! Look what the years have done to him. He is ugly, broken, unrecognizable. He totters about the empty rooms of a castle, somewhere on the northern plains. The servants shun his caresses. The cooks mock his accent. So

this is the great Casanova, this grotesque old man!" This retrospective slaughter is all the more pleasurable because old age, far from being gradual, almost imperceptible, appears to occur overnight, striking like the Last Judgment or the intervention of the Commander at the end of *Don Juan.*

Marie-Antoinette also delighted her enemies with the spectacle of losing her looks. The woman they liked to represent as a libertine using and abusing her charms suddenly became an old woman. And, as with Casanova, they never ceased comparing her premature physical ruin with her stunning past beauty. Old age for the debauched is not access to a superior dignity. These people have learned nothing, understood nothing. It is useless hoping that they will convert.

Just after the dauphin's death in 1789, Marie-Antoinette's hair turned white. The episode is well known. No account of it fails to mention the sudden transformation of the young woman. Fleischmann depicts her "thin face with its halo of hair turned white from captivity." Gérard Walter describes her "physical collapse" with conviction: "In the very rare official ceremonies where she is still obliged to appear, excessively made up, and thanks to her hairdresser and her dressmaker, the queen succeeds in hiding her decrepitude, but close up the ravages her body is in the process of suffering are alarmingly visible. She cannot stop losing weight. Her breasts sag. Her inflamed face is covered with pimples. Her eyes have become dull and sunken. Saliva continually wets the corners of her mouth."[19] In this quasi-medical tone, which scarcely obscures acute revulsion, an ideology of truth is enunciated: the sudden laying bare of a woman's abominable nature, illusorily veiled by the glamour of appearances and the attractions of youth. Aged libertines are not only punished; in the end, according to the denouement of Laclos's *Dangerous Liaisons,* they wear their souls on their faces.

That Marie-Antoinette's soul might have nothing in common with a libertine's had no bearing on such representations of decrepitude. To underscore the disparity between her behavior and, say, Mme de Merteuil's intellectual and sexual audacity, let us recall that Marie-Antoinette's most wildly "libertine" exploits included such extravagances as wanting to see the sun rise (which immediately prompted a pamphlet) or continuing to go for donkey rides, despite her mother's haranguing her not to. And in Marie-Antoinette's antipathy toward Mme du Barry, one can detect a purely emotional reaction, primarily betraying her sense of rank and birth and her absolute contempt for a "common whore"—but also her sense of virtue. Warned that she would meet Mme du Barry the following day, Marie-Antoinette was deeply disturbed. "I was anxious about the indecisiveness I noticed the day before. I went to Mme the Dauphine's," Mercy-Argenteau reported. "She was just back from mass. 'I prayed hard,' she told me. 'I said, "Lord, if you want me to speak, make me speak; I will do whatever you deign to inspire me!" ' "[20] The Lord inspired her to say "The weather is bad, one can't go for walks during the day"—but her utterance was so lacking in conviction that it went unnoticed. A few days later, she would be divinely inspired to say to Mme du Barry that "There are a lot of people at Versailles today,"

an observation that spread through the courtiers like a powder trail. (At court, it was not the content of a sentence that mattered, but the fact that the king or queen, in pronouncing it, bestowed on the happy recipient the grace of their favor. Naturally, it was forbidden to address the former first. The extreme violation of this interdiction was found in the situation of a king appearing before a tribunal and being there only to answer the questions of his accusers. This reversal of all the rules of speech contributed to the sincere bewilderment of Louis XVI, who confided to his valet, after a hearing during his trial: "I was far from being able to think about all the questions they put to me.") Before the spectacle of Louis XV's passion for Mme du Barry, the woman Marie-Antoinette called "that creature," she must have felt curiosity, disgust, and perhaps fear, face to face with an unknown world ruled entirely by sensuality.

The immanent justice that caught up with libertines was scarcely appropriate for Marie-Antoinette, except in the register of the blithely improbable, wherein pamphlet writing is located. "No one could differ as much as she from the reputation her enemies have tried to pin on her," Mme de Staël remarked. "One did not even try to find the slightest grain of truth in the lie, one was so aware of that envy which is more than happy to satisfy slanderers' expectations."[21]

Notes

1. Simplicity can have serious consequences for a country. In launching a fashion for clothes made of linen, Marie-Antoinette ruined the Lyons silk manufacturers.
2. Edmond and Jules de Goncourt, *La Femme au dix-huitième siècle* (Paris: Flammarion, 1982), p. 257.
3. *Marie-Antoinette: Correspondance secrète,* vol. 2, p. 453.
4. *Ibid.,* p. 307.
5. *Mémoires inédits de Mme la comtesse de Genlis* (Paris: Ladvocat, 1825), vol. I, pp. 224–25.
6. Jules Michelet, *Histoire de la Révolution française* (Paris: Laffont, 1979), p. 552.
7. *Ibid.,* p. 552.
8. Hector Fleischmann, *Les Pamphlets libertins contre Marie-Antoinette* (Geneva: Slatkine, Megariotis Reprints, 1976), p. 44.
9. *Le Petit journal du Palais-Royal,* no. 6, p. 12.
10. "Madame ma chère fille, je suis bien aise que mes vieux grisons vous ont voulu faire tant de plaisir." *Marie-Antoinette: Correspondance secrète,* vol. 2, p. 265.
11. *Ibid.,* vol. 2, p. 156.
12. *Le Catéchisme libertin, par Mlle de Théroigne,* ca. 1791, p. 26.
13. *Essais historiques sur la vie de Marie-Antoinette d'Autriche, reine de France, pour servir à l'histoire de cette princesse* (London, 1789), p. 44.
14. Mme Roland, *Mémoires* (Paris: Mercure de France, 1986), pp. 280–81.
15. Ibid., p. 102.

16. *Mémoires inédits de Mme la comtesse de Genlis,* vol. I, p. 291.

17. L. Prudhomme, [Louise Robert], *Les Crimes des reines de France depuis le commencement de la monarchie jusqu'à Marie-Antoinette* (Paris: Bureau des révolutions de Paris, 1791), Preface, p. 1.

18. Théveneau de Morande, *Anecdotes sur Mme la comtesse du Barry* (London: John Adamsohn, 1776), p. 35.

19. Gerard Walter, ed., *Actes du Tribunal révolutionnaire* (Paris: Mercure de France, 1968), p. 56.

20. *Marie-Antoinette: Correspondance secrète,* vol. I, p. 370.

21. Mme de Staël, *Réflexions sur le procès de la reine* (Paris: Mercure de France, 1996 [1793]), p. 23.

–5.7–

Between Cult and Culture: Bamiyan, Islamic Iconoclasm, and the Museum
Finbarr Barry Flood

He turned his head like an old tortoise in the sunlight. "Is it true that there are many images in the Wonder House of Lahore?" He repeated the last words as one making sure of an address. "That is true," said Abdullah. "It is full of heathen *būts.* Thou also art an idolater."

"Never mind *him,*" said Kim. "That is the Government's house and there is no idolatry in it, but only a Sahib with a white beard. Come with me and I will show."

<div align="right">Rudyard Kipling, Kim.</div>

In other words, the unique value of the 'authentic' work of art has its basis in ritual, the location of its original use value. This ritualistic basis, however remote, is still recognizable as secularized ritual even in the most profane forms of the cult of beauty.

<div align="right">Walter Benjamin, "The Work of Art in the Age of
Mechanical Reproduction."[1]</div>

Introduction

There can be little doubt that the destruction of the monumental rock-cut Buddhas at Bamiyan by the former Taliban government of Afghanistan in March 2001 will define 'Islamic iconoclasm' in the popular imagination for several decades to come. To many commentators, the obliteration of the Buddhas seemed to hark back to a by-gone age. Even those who pointed to outbursts of image destruction in medieval and early modern Europe saw these as stages on the road to western modernity;[2] the persistence of the practice in the Islamic world offered implicit proof of an essential fixation with figuration fundamentally at odds with that modernity.

Common to almost all accounts of the Buddhas' demise was the assumption that their destruction could be situated within a long, culturally determined and unchanging

tradition of violent iconoclastic acts. Collectively or individually, these acts are symptomatic of a kind of cultural pathology known as "Islamic iconoclasm," whose ultimate origins, to quote Creswell's telling comment, lie in "the inherent temperamental dislike of Semitic races for representational art."[3] The iconoclastic outburst of Afghanistan's rulers thus confirmed the status of that country as out of time with western modernity, by reference to an existing discourse within which image destruction was among a number of practices that indexed the inherently medieval nature of Islamic culture in general. Discussions of "Islamic iconoclasm" in the aftermath of the Bamiyan episode were characterized by a number of paradoxes: the most obvious of these was the contradiction between representations of Islamic culture as timeless and unchanging, and the assumption that the actions of the Taliban indexed an atavistic reversion to medieval practice that is a recurring feature of Islamic societies.

The conception of a monolithic and pathologically Muslim response to the image elides the distinction between different types of cultural practice. It not only obscures any variation, complexity and sophistication in Muslim responses to the image, but also a priori precludes the possibility of iconoclastic "moments" in Islamic history, which might shed light on those complex responses.[4] To use a European analogy, it is as if the destruction of pagan images by Christians in late antiquity, the mutilation of icons in ninth-century Byzantium, the iconoclastic depredations of the Reformation, and the events of the French Revolution could all be accommodated under the single rubric Christian iconoclasm.

The methodological problems stemming from the naturalization of historical acts need hardly be highlighted, and are compounded by three further aspects of traditional scholarship on Islamic iconoclasm. The first is the idea that Islamic iconoclasm is the product of a specific theological attitude, with only secondary political, and no aesthetic content. A second, closely related assumption is that the iconoclastic acts of medieval Muslims were primarily directed at the (religious) art of the non-Muslim "other."[5] The third, and most striking, peculiarity of the existing discourse on iconoclasm in the medieval Islamic world is that, remarkably for a practice that concerns the physical transformation of material objects, such discussions are almost always confined to texts, only making passing reference to surviving objects, if at all. Despite the abundant material evidence, there is, as yet, not a single systematic survey (textual or material) of what precisely was done in any region of the medieval world to images by Muslims who objected to them. As a result, rhetorical claims of image destruction have often been taken at face value, even where not borne out by archaeological or art historical evidence.

Proscriptive Texts and Iconoclastic Praxis

The opposition to figuration in Islam is based not on Qur'anic scripture, but on various Traditions of the Prophet, the hadiths.[6] The two principal objections to figuration

in the prescriptive texts are a concern with not usurping divine creative powers,[7] and fear of *shirk,* a term which came to mean polytheism and idolatry, but originally meant associating other gods with God.[8] Both suggest a concern with the materialism of worship.

There is a general consensus in the hadiths forbidding all representations that have shadows (whose defacement is obligatory), and some schools of thought even go so far as to liken artists to polytheists. Such proscriptions were undoubtedly a factor in both promoting aniconism (the eschewal of figural imagery) and motivating acts of iconoclasm (the destruction or mutilation of existing figural imagery), but their impact on the arts in general varied greatly according to time and place. Detailed studies of figural ornament in medieval Islamic religious architecture are few and far between, but as a general rule, figuration was eschewed in the decoration of medieval mosques and *madrasas* (religious schools). Occasional exceptions include pre-Islamic monuments converted for use as mosques, in which figural ornament was often, but not always, defaced. In those mosques and *madrasas* where figural ornament did appear, it was generally avoided in the area around the prayer niche (*mihrab*), in accordance with specific injunctions, but even here there are exceptions.

By contrast, anthropomorphic and zoomorphic images proliferated in the secular arts. The ubiquity of figural ornament is especially noticeable in the arts of the eastern Islamic world from the eleventh century onwards, where one even finds three-dimensional sculpture being produced in a wide range of media. The profusion of figural ornament in every imaginable artistic medium attests that the gap between proscription and practice could be a wide one.

Pre-modern Islamic attitudes to figuration varied from individual to individual, and could change over time, or with the advent of new political regimes with different cultural values. Consequently, Muslims opposed to icons of various sorts, whether the art of previous Muslim generations, or those of the cultures with which Islam came in contact, developed practical strategies for dealing with them. Two basic alternatives emerge from the various Traditions dealing with figuration: recontextualisation in a manner which made clear that the images were in no way venerated (by reusing figural textiles as floor cushions, for example), or decapitation, so that they became inanimate, that is, devoid of the ability to possess a soul (*rūh*).[9] Defacement (or the mutilation of the affective parts of the face, such as the eyes and nose) often substituted for decapitation, a practice that finds a precedent in early accounts of the Prophet Muhammad's iconoclastic activities.[10] In terms of these practices, Muslim iconoclasts are themselves indistinguishable from other types of iconoclasts, for the same focus on the head and face is a feature of Roman, early Christian iconoclasm, and Byzantine iconoclasm, and the eyes of fifteenth-century Catholic images were scratched out by sixteenth-century Protestant reformers, even as French revolutionaries decapitated the icons of the *ancien régime*.[11]

Bamiyan and Iconoclasm in Pre-Modern Afghanistan

Even before their destruction in 2001, both Bamiyan Buddhas were faceless above chin level. Ironically, many of those who bemoaned the destruction of the Bamiyan Buddhas, but were unfamiliar with them, therefore assumed that this fate was illustrated by images of the Buddhas *before* the Taliban had attacked them. It has often been stated that the Buddhas were originally provided with masks of wood or copper, but little evidence has been adduced for this. It is equally possible that the upper parts of the faces were deliberately mutilated, reflecting the activities of medieval iconoclasts, for whom the face would have been an obvious target.

Any iconoclastic transformations of the Buddhas did little to dampen their enthusiastic reception by medieval Muslims, however. Between the tenth and thirteenth centuries, the Bamiyan Buddhas were often referred to in Arabic and Persian literature, where (along with remains of Buddhist stupas and frescoes) they were depicted as marvels and wonders.[12] Several writers emphasize that nowhere in the world can one find anything to equal the Bamiyan Buddhas, popularly known as *Surkh-but* (red idol) and *Khink-but* (grey idol).[13] Premodern accounts of the Bamiyan Buddhas often locate them within discussions of Indian religious practices and iconolatry, topics that were to increasingly preoccupy Arab and Persian writers as the cultural contacts between eastern Iran and India grew between the tenth and twelfth centuries, the result of military conquest and trade.[14] The idols (*aṣanām*) of Bamiyan were the subject of a lost work by the celebrated scholar al-Biruni, whose book on India, including a sophisticated explication of Indian religion and image-worship, has survived.[15]

Paradoxically, this eleventh-century work was written at the court of Mahmud of Ghazna in central Afghanistan, a historical figure who has assumed a paradigmatic role as the Muslim iconoclast par excellence in South Asia.[16] As was the case in other parts of the Islamic world, however, iconoclastic practice in medieval Afghanistan existed within a spectrum of responses to the image (religious, Islamic or otherwise), which also included aesthetic appreciation, awe, fascination, revulsion, and scholarship. Mahmud "the idol-breaker" issued bilingual Indian coins with a Sanskrit legend in which Muhammad is described as the avatar of God, a concept that, while somewhat unorthodox in an Islamic context, was clearly intended to frame Islamic doctrine within an Indic paradigm.[17] In the following century, Afghan rulers of India went further, continuing coin issues featuring the images of Hindu deities, despite their portrayal in contemporary histories and inscriptions as bastions of religious orthodoxy. However economically sensible this numismatic continuity may have been, it does alert us once again to the divergence between the normative values underlying textual rhetoric and the pragmatic concerns that governed actual practice when it came to the issue of figuration and non-Muslim religious imagery.

Further paradoxes lie in the fact that the central event of Islamic iconoclasm in South Asia concerns not, as one might expect, a precious metal anthropomorphic icon, but a *linga,* an aniconic stone image of Shiva. The *linga* was housed in one of

the most celebrated temples of medieval India, which stood in the coastal town of Somnath in Gujarat. In 1025 Mahmud raided Somnath and looted its temple. According to some renditions of the tale, the temple Brahmans attempted to ransom the icon, offering vast amounts for its safety. Mahmud rejected the offer, famously repudiating the idea that he should be known as a broker of idols rather than a breaker of them.[18] The *linga* was subsequently broken, and part of it used to form the threshold of the entrance to the mosque of Ghazna, a practice for which there are earlier textual and archaeological parallels, not just in the Islamic world.[19] The remainder was thrown down in the hippodrome (*maydān*) of Ghazna, where it joined a decapitated bronze image of Vishnu, looted on a previous Indian expedition. According to other accounts, it was set at the entrance to Mahmud's palace, so that the thresholds of both palace and mosque were comprised of fragments of the *linga*.[20]

The looting of portable icons was a common practice in medieval South Asian warfare even before the advent of the Muslims in the eleventh and twelfth centuries. Ignoring the lurid idol-bashing rhetoric of the medieval Islamic sources, therefore, the triumphalism inherent in the seizure and display of the Somnath *linga* in the dynastic shrines of Ghazna was in no way at odds with the rhetoric of contemporary South Asian kingship. What does distinguish Ghaznavid practice, however, is the treatment afforded the *linga* and other looted Hindu icons brought to Ghazna. Although images were sometimes contested to the point of destruction in medieval South Asia, looted icons were usually treated with respect and incorporated into the victor's pantheon in a subordinate capacity, often as doorkeepers. While invoking the "Hindu trope by which defeated enemies were subordinated into door guardians," the Somnath *linga* became the focus of a kind of performative iconoclasm, recontextualized to be trampled upon in a quotidian repudiation of idolatry by the populace of Ghazna.[21] Although this gesture is usually viewed through the lens of religious rhetoric, it also represents the literal enactment of a metaphorical conceit common to medieval Islamic and South Asian rulers, by which a victor claims to have trampled the defeated underfoot. The idea is enshrined in the titles of the Ghaznavid sultans who (along with many other eastern Islamic dynasts) styled themselves "lords of the necks of the people," a title which, while politically charged, was devoid of any sectarian associations.[22] The motif of a victorious ruler trampling a defeated rival was a common expression of royal victory rhetoric that was often adopted by iconoclasts. Similar adaptations are evident in medieval South Asia, where epigraphic claims of kings to have placed their feet on the necks of defeated rivals seem to be reflected in a remarkable series of tenth-century images from eastern India (an area contested between Buddhist and Hindu sects) that show Buddhist deities trampling their Hindu equivalents.[23]

The trampling of the tutelary deities of defeated rulers, no less than their display within the shrines of the victorious highlights the role of such icons as synecdoches, whose treatment in secondary contexts is directly related to their ability to articulate the idea of incorporation, however notional.[24] In both Islamic and Indic discourses

of looting, the recontextualized icon, whether desecrated or venerated, affirmed the center while indexing the shifting periphery.

The collection and display of defunct and antique icons in Mahmud's mosque at Ghazna, constituted it as what Michel Foucault has termed a heterotopia, a single space dedicated to the juxtaposition of several spaces that are culturally, chronologically, or otherwise incompatible, "a sort of simultaneously mythic and real contestation of the space in which we live."[25] In this sense, the mosque had much in common with the European museum, especially those museums established to commemorate the work of European missionaries.[26] In both cases selected objects assumed a didactic function as visual cognates of a concept of progress indexed by the demise of idolatry, a bringing into the fold dependent on the shifting economic, cultural, and military frontier. Within the European museum, exotic religious icons could also be assimilated as visually interesting in their own right, and even as art objects, a transmutation reflected in Mark Twain's description of nineteenth-century Benares as, "a vast museum of idols."[27] The hegemonic connotations of this shift from cult to culture came to the fore in surprising ways during the Bamiyan episode.

Mullah Omar and the Museum

As the examples discussed above indicate, Muslim iconoclasts have historically availed themselves of a number of options sanctioned by tradition that fall far short of physical obliteration; the Bamiyan Buddhas may themselves have attested this, as did the erasure of the faces of figural images in public places in Kabul after the advent of the Taliban.[28] Although the act invoked the rhetoric of the Islamic past or was represented as a reversion to medieval practice, by either standard the destruction of the celebrated Bamiyan Buddhas was highly anomalous. We may never know for certain why the Taliban reversed their previous policy on pre-Islamic antiquities in February 2001. The edict that inspired the action, and the various pronouncements that followed, suggest, however, that the Taliban's iconoclastic outburst was a peculiarly modern phenomenon, an act that, "under the cover of archaic justifications, functioned according to a very contemporary logic."[29] The timing of the edict, and the fact that it reversed a previous undertaking to protect the Buddhist antiquities of Afghanistan, suggest these events had less to do with a timeless theology of images than with the Taliban's immediate relationship to the international community, which had recently imposed sanctions in response to the regime's failure to expel Usama bin Laden.[30]

The Wahhabi version of Islam espoused by the regime's Saudi guest may have played a role in the events of February 2001, for the destruction of objects and monuments considered the focus of improper veneration has been a characteristic of Wahhabism from its inception.[31] However, as Dario Gamboni has pointed out, "often elaborately staged destructions ... of works of art must be considered as means of

communication in their own right, even if the 'material' they make use of is—or was—itself a tool of expression or communication."[32] In this case, the eventual transport of western journalists to the site to record the void left by the Buddhas' destruction suggests that the intended audience for this communiqué was neither divine nor local, but global: for all its recidivist rhetoric, this was a performance designed for the age of the Internet.

One can make a good case that what was at stake here was not the literal worship of religious idols, but their veneration as cultural icons. In particular, there are reasons for thinking that the Taliban edict on images represented an onslaught on cultural fetishism focused on the institution of the museum as a locus of contemporary iconolatry. The uncritical reception of a theological rationale that appeared to confirm Orientalist constructions of "Islamic iconoclasm" as an essential cultural value served to obscure a number of paradoxes that hint at the broader cultural significance of the events. To begin with, there are no Buddhists left in Afghanistan to explain the curious concern about the worship and respect afforded the idols in Mullah Omar's edict (see Appendix below), a fact acknowledged in the Taliban's paradoxical statement that the presence of practicing Buddhists in the country would have guaranteed the continued existence of the images.[33] Moreover, it should be borne in mind that the destruction of monumental sculpture was part of a broader iconoclastic program that arguably had its most disastrous effects not on images still in situ, but on those housed in what was left of the museums of Afghanistan.[34] According to one report, the Bamiyan episode was initiated after Taliban officials, horrified at being confronted by a semi-naked Boddhisattva in the Kabul museum, slapped it across the chest and face.[35]

Apocryphal though this story may be, in subsequent statements, Mullah Omar made clear the perceived relationship between iconolatry and the museum. Confronted with the threat to destroy the Buddhist icons, western institutions offered to purchase the offending items, in effect legitimizing the practice of looting Afghan antiquities from which some had benefited in the preceding decades. In an attempt to save some artifacts, Philipe de Montebello, the director of the Metropolitan Museum in New York, reportedly pleaded with the Taliban, "Let us remove them so that they are in the context of an art museum, where they are cultural objects, works of art and not cult images."[36] The response of Mullah Omar was telling, although its significance was missed at the time. The mullah replied on Radio Shari'a by posing the rhetorical question to the international Muslim community: "Do you prefer to be a breaker of idols or a seller of idols?"[37] If the question sounded familiar, it was intended to, for it self-consciously echoes the very words attributed to Sultan Mahmud of Ghazna when confronted with the offer of the Somnath Brahmans to ransom their icon. Although iconoclasm is often stigmatized as an act stemming from ignorance, this was a gesture that was particularly well informed about its own historical precedents. The artful mining of the Islamic past for authoritative precedent recalls Mullah Omar's earlier "rediscovery" of the celebrated *burda* (cloak) of the Prophet, in a Kandahar

shrine, thereby aligning himself with a historical chain of caliphs who had earlier laid claim to this cloak of legitimacy.[38]

The significance of these events was not lost in India, where the Somnath episode still resonates politically.[39] In contrast to the dominant western view that the Bamiyan debacle evidenced the eternal medievalism of Islam, in India it was represented as the return of the repressed. Jaswant Singh, Foreign Minister of a Hindu nationalist government told the Indian parliament that India "has been cautioning the world against this regression into medieval barbarism."[40] Accordingly, the traditional tropes of medieval desecration were invoked in a very modern way, with the radical Vishwa Hindu Parishad (World Hindu Council) protesting outside the United Nations headquarters in Delhi threatening to destroy Indian mosques in response to the destruction of the Buddhas.[41] In turn, a Taliban spokesman in New York weakly suggested that the actions in Bamiyan were in fact a (much delayed) response to the destruction of the Baburi Mosque at Ayodhya in 1992, in whose wake large numbers of Indian citizens perished in sectarian violence.[42]

The truly global implications of this event derive, however, from the fact that Mullah Omar's words were directed not eastward toward the Hindus of India or the Buddhist communities beyond, but westward, toward European and American museum directors seeking to ransom the ill-fated images. By his careful choice of language, Mullah Omar appropriated the authority of the Mahmud legend, while transposing the Brahmanical guardians of a religiously idolatrous past with the museological purveyors of a culturally idolatrous present.[43]

The idea of the museum as the locus of a kind of idolatry may seem absurd, since the distinction between cult icon and art object is an ancient one in western epistemology and, historically, has tended to be asserted as a defense against radical acts of iconoclasm. Moreover, as a response to French revolutionary iconoclasm,[44] the institution of the museum is itself the signifier of a shift from cult to culture that has indexed the transition to modernity in the West from at least the eighteenth century onwards.[45] If this was some idiosyncratic misreading of western cultural institutions and values, however, it finds an uncanny echo in the writing of Walter Benjamin and others, for whom the original use value of the artifact continues to inform its reception as an art object.[46] Although rooted in the "timeless theology of images" paradigm that I have criticized here, the tension between Abdullah's reading of the "Wonder House" of Lahore as the locus of idolatry, and Kim's perception of it as a governmental institution for the dissemination of Western rationality in my epigraph anticipates a paradox highlighted in the work of a modern anthropologist such as Alfred Gell:

> I cannot tell between religious and aesthetic exaltation; art-lovers, it seems to me, actually do worship images in most of the relevant senses, and explain away their de facto idolatry by rationalizing it as aesthetic awe. Thus, to write about art at all is, in fact, to write about either religion, or the substitute for religion which those who have abandoned the outward forms of received religions content themselves with.[47]

As its etymology (and often its architecture) implies, the museum is a type of secular temple, a "temple of resonance," within which modernity is equated with the desacralization and even "silencing" of inanimate objects by their transmutation into museological artifacts.[48] The ability of these muted idols to speak in novel ways is intrinsic to their existence as art, however, as is clear from one of the foundation documents of the modern museum, Abbé Grégoire's 1794 call for an institution to protect French national patrimony from the depredations of revolutionary iconoclasm: "In this statue, which is a work of art, the ignorant see only a piece of crafted stone: let us show them that this piece of marble breathes, that this canvas is alive, and that this book is an arsenal with which to defend their rights."[49] The work of Freedberg and Gell suggests that the animation implied here is something more than a metaphorical conceit. As the latter notes, "in the National Gallery, even if we do not commit full-blown idolatry, we do verge on it all the time," a point which the 1978 attack on Poussin's *Adoration of the Golden Calf* was presumably intended to underline.[50] It is in the museum that what might be crudely termed the secular and religious discourses of Euro-American iconoclasm coincide. Given the ways in which the aesthetic, economic and institutional aspects of modernity are articulated around the transmutation of the cult image into cultural icon, it is hardly surprising that in the modern nation state, it is the museum rather than the church which is the primary target of "traditional" iconoclastic behavior.[51] At the other extreme, occasional attempts to venerate the museological artifact also serve to highlight the often uneasy relationship between cult image and cultural icon.[52] Both in theory and practice, it seems that the distinction that underwrote Philipe de Montebello's appeal to the Taliban is far from clear-cut.

Moreover, as its origins in European religious and revolutionary iconoclasm imply, the institution of the museum, no less than the objects it houses, is a culturally constructed artifact, a product of a particular cultural attitude towards the past. As Gell puts it,

> We have neutralized our idols by reclassifying them as art; but we perform obeisances before them every bit as deep as those of the most committed idolater before his wooden god ... we have to recognize that the "aesthetic attitude" is a specific historical product of the religious crisis of the Enlightenment and the rise of Western science, and that it has no applicability to civilizations which have not internalized the Enlightenment as we have.[53]

As a product of the European Enlightenment, the museum stands among the range of institutions that construct and project a cultural identity defined in relation to the nation-state.[54] At a global level, the institution is part of the paradoxical interplay between structural similarity and cultural difference that characterizes the "community of nations." The objects it houses are central to its role in articulating and consolidating an idea of a national culture defined in relation to the cultures of this

broader community. As Carol Duncan notes, "What we see and do not see in our most prestigious art museums—and on what terms and whose authority we do or don't see it—involves the much larger questions of who constitutes the community and who shall exercise the power to define its identity."[55] Historically, the museum has often served to highlight the hegemonic nature of the "universal" values underlying the concept of nationhood that it embodies.[56] On the one hand, there is the awkward relationship between the museum, colonization, and modernity. On the other, there are the tensions between the idea of the museum as a showcase for national patrimony, the idea of art as a universal human value, and the historical collecting practices of many Euro-American museums vis-à-vis colonial and postcolonial states.[57] The gap between theory and practice here is often obscured by the assertion (implicit or explicit) that the inhabitants of lands such as Afghanistan are incapable of curating their own patrimony. This argument, a stalwart of the colonial era that resurfaced again during the Bamiyan episode, is somewhat ironic, given the damage done to many South and Central Asian archaeological sites in the nineteenth century by European scholars collecting for museums.[58] Moreover, it can be argued that the shift in signification inherent in the resocialization of the artifact within the museum, its transmutation from cult image to cultural icon, has much in common with the semiotic structure of iconoclasm itself.[59]

In the destruction of recontextualized museum artifacts, the literal and metaphorical senses of "iconoclasm," the destruction of images and an attack on venerated institutions, coincide.[60] It has been suggested that certain acts of iconoclasm directed against western museums represent "protests against exclusion from the cultural 'party game' in which only a minority of society participates."[61] Similarly, Taliban iconoclasm can be understood as constituting a form of protest against exclusion from an international community in which the de facto hegemony of the elite nations is obscured by the rhetoric of universal values. As an index of an idea of community which frequently falls far short of the ideal (and nowhere more so than in Afghanistan, where super-powers did battle by proxy), there could be few better targets to make the point. If the destruction of Afghan antiquities in March 2001 represented an attack on "a separate Afghan identity,"[62] this was a concept of identity rooted in the "universal" values of the nation-state. Just as the *linga* from Somnath served to evoke a relationship between Ghazna and the wider (Indic and Islamic) world, the Buddhas in the Kabul museum referenced the incorporation of Afghanistan into a global community of nations. Their destruction represented the definitive rejection of that ideal in favor of an equally hegemonic notion of pan-Islamic homogeneity constituted in opposition to it.[63] This relationship between the art object, Taliban iconoclasm, and the international community, was noted by Jean Frodon in an insightful article on the Bamiyan episode, which appeared in *Le Monde:*

If a transcendence inhabits these objects, if a belief that the fundamentalists perceive in opposition to their religion is associated with them, it is this and only this: to be perceived

as art objects (which evidently was not the meaning which those who sculpted the Bamiyan giants in the fifth century of our era gave to them). This cultural belief, elaborated in the West, is today one of the principal ties uniting that which we call the international community (which is far from containing the global population). It is against this, against a rapport with a world valorizing a non-religious relation with the invisible that the explosive charges that annihilated the Buddhas were placed.[64]

A further irony lies in the fact that the Afghan Buddhas were ideally suited to play the role assigned to them in the Bamiyan debacle, for they first came to the attention of western scholarship as evidence of a classical European influence on the early medieval art of the region. Indeed, the very idea of representing the Buddha anthropomorphically was ascribed to the impact of "the mysteriously transmitted Grecian touch."[65] Within this epistemological tradition, the origins of both the Bamiyan Buddhas and the museum as an institution lie in the same foundational stratum of classicism upon which the universalizing values of the Enlightenment were constructed. It was precisely as a reaction to the hegemonic cultural, economic, and political power of this Enlightenment tradition that the destruction of the Buddhas was undertaken.

The attack on the museum as an institution enshrining idolatrous cultural values resonates with a second rationale offered for the Taliban's iconoclastic edict: that it highlighted the hypocrisy of western institutions. These "will give millions of dollars to save un-Islamic stone statues but not one cent to save the lives of Afghani men, women and children."[66] Here the concern with the materiality of non-Islamic worship that we saw articulated in the Traditions regarding figuration coincides with a critique of "Western" materialism. The reluctance of the international community to aid Afghanistan, even in the face of a major threat of famine, derived from the earlier imposition of sanctions, an extension to Afghanistan of a type of collective punishment that had previously been visited upon the civilian population of Iraq, with devastating effects. It is also worth noting that the destruction of Buddhist antiquities followed an earlier massacre of the minority Hazara population of the Bamiyan Valley, which barely merited a mention in the western press, firmly focused as it was on the issue of the Buddhas.[67]

In claiming to be drawing attention to the fetishizing of inanimate icons at the expense of animate beings, the Taliban find themselves in curious company, for there is a striking parallel here with one of the most (in) famous acts of modern European iconoclasm. On March 10th, 1914, Mary Richardson slashed Diego Velázquez's celebrated seventeenth-century work now generally known as *The Rokeby Venus* where it hung in the National Gallery, London. This action, undertaken as part of a broader campaign for universal suffrage, was specifically intended to draw attention to the treatment of the imprisoned Emmeline Pankhurst. In Richardson's own words,

I have tried to destroy the picture of the most beautiful woman in mythological history as a protest against the government for destroying Mrs. Pankhurst, who is the most beautiful character in modern history ... If there is an outcry against my deed, let everyone

remember that such an outcry is an hypocrisy so long as they allow the destruction of Mrs. Pankhurst and other beautiful living women, and that until the public cease to countenance human destruction the stones cast against me for the destruction of this picture are each an evidence against them of artistic as well as moral and political humbug and hypocrisy.[68]

Freedberg has pointed out that iconoclasts seeking publicity target art objects precisely because

The work has been adored and fetishized: the fact that it hangs in a museum is sufficient testimony to that, just as the hanging of pictures in churches is testimony to religious forms (or less overtly secular forms) of adoration, worship, and fetishization. Furthermore—especially in the twentieth century—the better the art, the greater the commodity fethishism.[69]

As the "idol of the marketplace," the fetishized art object highlights "the problem of the nonuniversal and social construction of value."[70] Issues of gender notwithstanding, it was precisely their common role as fetishes of western modernity that rendered *The Rokeby Venus* and the Bamiyan Buddhas desirable targets for modern iconoclasts opposed to the values that they seemed to embody. Such actions reveal the double nature of the fetishized image or icon, which, as signified, can expose and even avenge wrongs inflicted on living persons, while as signifier, it facilitates "the dismissal of moral judgements passed on the destruction of what 'was only a picture'" in the case of *The Rokeby Venus,*[71] or only stones in the case of the Buddhas. In doing so they exploit the potential of the art object and its associated iconolatry to undermine the subject-object distinction in which Enlightenment epistemology is grounded. As Igor Kopytoff notes in his discussion of the cultural biography of things, "To us, a biography of a painting by Renoir that ends up in an incinerator is as tragic, in its way, as the biography of a person who is murdered."[72] Similar ironies underlie the central paradox of iconoclasm: visiting vengeance on the fetishized icon by slapping, slashing or smashing, iconoclasts no less than iconophiles engage with the power (if not the animateness) of the image.[73]

None of this is intended to condone the actions of any of the players in the events of March 2001, but it is imperative to recognize that those events have a logic rooted not in the fictions of an eternal or recurring medievalism but in the realities of global modernity. The Bamiyan debacle demonstrates the ease with which an index of cultural change rooted in specific historical circumstances can be ascribed to an essential cultural pathology. As I emphasized at the outset, this ahistorical paradigm should be rejected in favor of approaches that historicize iconoclastic events, acknowledging the agency of those involved, examining their motivation, and interrogating the narratives on which we depend for our information, whether courtly histories, fragmentary artifacts or Radio Shari'a. In the unfortunate event that the traditional attitude to "Islamic iconoclasm" were to prevail two hundred, five hundred, or one thousand

years from now and we came across a reference to the destruction of the Bamiyan Buddhas, we would invariably assume that this was a typically Islamic response to the image. In doing so, we would be overlooking the co-existence between the Buddhas and the Muslim population that marveled at them for over a millennium before they were obliterated by the Taliban. To miss the political portents in this radical break with tradition on the part of the ruling regime would be a serious omission, as subsequent events have demonstrated. Worse still is the fact that to memorialize these events as just one more example of "Islamic iconoclasm" would be to valorize the monument to their own brand of cultural homogeneity that the Taliban created at Bamiyan.

Appendix: The Taliban's Edict on Images

This is an unofficial translation of the edict concerning the destruction of religious images, prepared by the United Nations staff in Kabul, which was compiled by the Afghanistan Research Group (ARG) and circulated in an electronic newsletter as "News from Afghanistan," on March 2, 2001. The edict was published by the state-run Bakhtar News Agency and broadcast on Radio Shari'a on February 27, 2001. It has not proved possible to obtain a transcript of the original text; the sole transliterated Arabic term was garnered from among the partial translations given in other sources.

> Edict issued by the Islamic State of Afghanistan, in Kandahar on the 12th of Rabiul-Awwal 1421 (February 26th, 2001): On the basis of consultations between the religious leaders of the Islamic Emirate of Afghanistan, religious judgements of the ulema and rulings of the supreme court of the Islamic Emirate of Afghanistan, all statues and non-Islamic shrines located in different parts of the Islamic Emirate of Afghanistan must be destroyed. These statues have been and remain shrines of unbelievers and these unbelievers continue to worship and respect them. God Almighty is the only real idol (*ṭāghūt*) and all fake idols should be destroyed.
>
> Therefore, the supreme leader of the Islamic Emirate of Afghanistan has ordered all the representatives of the Ministry of Promotion of Virtue and Suppression of Vice and the Ministries of Information to destroy all the statues. As ordered by the ulema and the Supreme Court of the Islamic Emirate of Afghanistan all the statues must be destroyed so that no one can worship or respect them in the future.

This is an abbreviated version of an article of the same name, the original version of which can be found in the *Art Bulletin* 84/4 (2002): 641–59.

Notes

1. Rudyard Kipling, *Kim* (London: Penguin Books, 1989), 54; and Walter Benjamin. "The Work of Art in the Age of Mechanical Reproduction," in *Illuminations,* trans. Harry Zohn (London: Fontana Press, 1992), 217.

2. Daphné Bézard, "When Europe also destroyed its images," *The Art Newspaper,* 116, July–August (2001): 28.

3. K.A.C. Creswell, "The Lawfulness of Painting in Islam," *Ars Islamica* 11–12, (1946): 166. In fact it is striking how frequently the language of pathology permeates discussion of the topic.

4. As Oleg Grabar notes, 45: "The most obvious difference between Byzantine and Islamic iconoclasm is that the former is usually spelled with a capital "I" and the latter with a small "i". This secondary typographical distinction illustrates first of all the difference between a historical moment (these are presumably capitalised) and an attitude or mode of behaviour, the latter being apparently too common to deserve capitalization."

5. See André Wink, *Al Hind, the Making of the Indo-Islamic World, Vol. 2: The Slave Kings and the Islamic Conquest 11th–13th Centuries* (New Delhi: Oxford University Press, 1997), 317: "Unlike Christian iconoclasm, Islamic iconoclasm was virtually always directed against non-Muslim objects, with the exception of the late defacing of miniatures in manuscripts by pious librarians."

6. The hadiths concerning figuration are scattered through a number of collections of Traditions. The classic studies are those of Rudi Paret: Paret 1960; idem., "Das islamische Bilderverbot und die Schia," in *Festschrift Werner Caskel. Zum siebzigsten Geburtstag 5. März 1966 Gewidmet von freunden und Schülern,* ed. Erwin Gräf (Leiden: E. J. Brill, 1968), 224–32. A more accessible and recent discussion of the Traditions regarding figuration and their sources can be found in van Reenen.

7. Paret, 43–44; A. J. Wensinck [T. Fahd] "Sūra 1. In theological and legal doctrine," *The Encyclopedia of Islam,* new edition, Vol. 9 (Leiden: E. J. Brill, 1997): 889.

8. Hawting, 22, 49.

9. Ahmad Ibn Hanbal, *Musnad,* 6 volumes (Cairo, 1313/1895), vol. 2, 305, 308, 390, 478; Paret, 46–47; idem., "Die Entstehungszeit des Islamischen Bilderverbots," *Kunst des Orients,* 11, nos. 1–2 (1976–77): 158, 176. For an extensive list of the various collections of hadiths in which this Tradition appears see van Reenen, 33, 54.

10. Nabih Amin Faris, *The Book of Idols* (Princeton: Princeton University Press, 1952), 27.

11. Freedberg, 415; Bézard (as in n. 2).

12. Guy Le Strange, *The Lands of the Eastern Caliphate* (Cambridge: Cambridge University Press, 1905), 418; Muhammad ibn Ishaq ibn al-Nadim, *The Fihrist,* trans. Bayard Dodge, 2 vols. (Chicago: Kazi Publications, 1998), vol. 2, 82.

13. Melikian-Chirvani, 23–26, 59–60.

14. V. Minorsky, "Gardizi on India," *Bulletin of the School of Oriental and African Studies,* 12, no. 2 (1948): 629–39; Bruce B. Lawrence, "Shahrastānī on Indian idol worship," *Studia Islamica,* 38 (1973): 61–73; Yohanan Friedmann,

"Medieval Muslim views of Indian religions," *Journal of the American Oriental Society,* 95 (1975): 214–21.

15. Melikian-Chirvani, 60; Sachau, vol. 1, 111–24.
16. Davis, 96–99.
17. Hirananda Sastri, "Devanāgarī and the Muhammadan rulers of India," *Journal of the Bihar and Orissa Research Society,* 23 (1937): 495.
18. Peter Hardy, "Mahmud of Ghazna and the historians," *Journal of the Panjab University Historical Society,* 14 (1962): 1–36. Stories regarding the rejection of ransom for icons are also found in connection with European iconoclasm: David Freedberg, "The structure of Byzantine and European iconoclasm," in *Iconoclasm. Papers given at the Ninth Spring Symposium of Byzantine Studies, University of Birmingham, March 1975,* ed. Anthony Bryer and Judith Herrin (Birmingham: Centre for Byzantine Studies, University of Birmingham, 1977), 170 n. 58.
19. In the ninth century *Book of Idols,* a pre-Islamic Arabian idol named dhu al-Khalasa is said to have been reused as the threshold of the entrance to a mosque (Faris, as in n. 10, 31). A comparable reuse of the *linga* is attested archaeologically in the early Islamic mosque at Banbhore in Sind, Pakistan, where several were used as the lowest steps of a flight of stairs leading to each of the entrances to the Great Mosque: S. M. Ashfaque, "The Grand Mosque of Banbhore," *Pakistan Archaeology,* 6 (1969): 198–99. The veracity of the traditions regarding the treatment of the Somnath *linga* seem to be borne out by the find of an image of Brahma at Ghazna with its face worn away by the passage of feet: Umberto Scerrato, "The first two excavation campaigns at Ghazni, 1957–1958," *East and West,* new series 10 (1959): 40.
20. Sachau, vol. 1, 117; H. M. Elliott & John Dowson, *The History of India as told by its own Historians* (reprint, Delhi: Low Cost Publications, 1990), vol. 2, 454; H. G. Raverty, *Ṭabḳāt-i-Nāṣirī: A General History of the Muhammedan Dynasties of Asia, Including Hindustan,* 2 Vols. (reprint, New Delhi: Oriental Books Reprint Corporation, 1970), vol. 1, 82.
21. Davis, 108.
22. Sheila S. Blair, *The Monumental Inscriptions from Early Islamic Iran and Transoxiana* (Leiden: E.J. Brill, 1992), 183–84.
23. Gulab Chandra Choudhary, *Political History of North India from Jain Sources [c. 650 AD to 1300 AD]* (Amritsar: n.p., 1964), 287; B. P. Sinha, "Some reflections on Indian sculpture (stone or bronze) of Buddhist deities trampling Hindu deities," in *Dr. Satkari Mookerji Felicitation Volume* (Varanasi: Chowkhamba Sanskrit Series Office, 1969), 97–107.
24. For a full discussion of this topic see Flood, chapter 2.
25. Michel Foucault, "Of Other Spaces," *Diacritics* 16 (1986): 22–27.
26. Fisher, 20; Nicholas Thomas, *Entangled Objects: Exchange, Material Culture, and Colonialism in the Pacific* (Cambridge, Mass.: Harvard University Press, 1991), 155–56.

27. Mark Twain quoted in Diana L. Eck, *Darśan: Seeing the Divine Image in India* (Chambersburg, PA: Anima Books, 1981), 14.

28. Pamela Constable, "Taliban ban on idolatry makes a country without faces," *Washington Post,* March 26, 2001, A20.

29. After the French of Jean-Michel Frodon, "La guerre des images, ou le paradoxe de Bamiyan," *Le Monde,* March 23, 2001.

30. Isabel Hilton, "Blaming the breakers of statues," *Guardian,* March 7, 2001.

31. Esther Peskes, "Wahhābiyya: the 18th and 19th centuries," *The Encyclopaedia of Islam,* new edition, Vol. 11 (Leiden: E. J. Brill, 2000): 40, 42–43.

32. Gamboni, 22; see also Freedberg, 409; "Taliban Open Afghan Museum, Statues Gone," *New York Times,* March 22, 2001.

33. Associated Press, "Taliban: statues must be destroyed," *Guardian,* February 26, 2001.

34. Qadratullah Jamal, the Taliban information minister, referred to the destruction of artifacts in Bamiyan, Ghazni, Hadda, Herat, Jalalabad, and Kabul; Associated Press, "Taliban destroying all statues," March 1, 2001. In addition, in Kabul works in the National Gallery were threatened, and some of the National Film Archives destroyed; Kevin Sullivan, "Taliban had wrong impression: artists tricked police to save work with banned images," *Washington Post,* January 2, 2002, A1 & A8.

35. Associated Press, "Taliban praises statue destruction," *Guardian,* March 5, 2001.

36. Reuters, "New York's Metropolitan makes Afghan art offer," March 1, 2001, circulated electronically by the Afghanistan Research Group as "News from Afghanistan" 01/015, March 2, 2001.

37. Reuters, "Afghan Taliban say parts of statues blown up," March 5, 2001.

38. Tim Weiner, "Seizing the Prophet's mantle: Muhammad Omar," *New York Times,* December 7, 2001; Flood, chapter 3.

39. Davis, 186–221.

40. Associated Press, "India asks Taliban for statues," March 2 2001, H-ISLA MART list.

41. Reuters, "Indian Hindus protest Afghan statue destruction," March 5, 2001. The threat should be seen against the backdrop of the destruction of the Baburi Masjid by militant Hindu nationalists in 1992.

42. BBC, "Taleban 'attack' Buddha statues," March 2, 2001, circulated electronically by the Afghanistan Research Group as "News from Afghanistan" 01/015.

43. This rhetorical transposition of the religiously idolatrous past and the culturally idolatrous present is again evident in Osama bin Laden's characterization of the United States as "the Hubal of the age," Hubal being the preeminent deity of pagan Mecca: "These young men have done a great deed," *Washington Post,* December 29, 2001, A5.

44. Dominique Poulot, "Revolutionary 'vandalism' and the birth of the museum: the effects of a representation of modern cultural terror," in *Art in Museums,*

New Research in Museum Studies, 5, ed. Susan Pearce (London & Atlantic Highlands, NJ: Athlone, 1995), 192–214.

45. Robert S. Nelson, "The discourse of icons, then and now," *Art History,* 12 (1989): 145. On the transformation of the religious image into an art object in early modern Europe see Hans Belting, *Likeness and Presence: A History of the Image Before the Era of Art,* trans. Edmund Jephcott (Chicago: University of Chicago Press, 1994), 458–90.

46. Benjamin (as in n. 1), 217–8, 237.

47. Gell, 97.

48. Carol Duncan, "Art museums and the ritual of citizenship," in *Exhibiting Cultures: the Poetics and Politics of Museum Display,* ed. Ivan Karp and Steven D. Levine (London & Washington: Smithsonian Institution Press, 1991), 91; Fisher, 19–20; Joan R. Branham, "Sacrality and Aura in the Museum: Mute Objects and Articulate Space," *The Journal of the Walters Art Gallery,* 52–53 (1994–95): 33.

49. Abbé Gregoire, quoted in Poulot (as in n. 44), 194.

50. Freedberg, 378–85; Gell, 62. An unnamed gallery spokesperson commented at the time, without any apparent trace of irony: "I can't think why anyone would want to do this to a painting...It is not offensive. It just depicts the Israelites dancing around the golden calf": "Poussin painting slashed in London," *Washington Post,* April 4, 1978, A14.

51. John Dornberg, "Art Vandals. Why Do They Do It?," *Artnews*, March (1987), 102–9; Freedberg, 1989, 407–27; Jeffrey Kastner, "Art Attack," *Artnews,* October (1997), 154–56; Gamboni, 190–211.

52. Smita J. Baxi, "Problèmes de sécurité dans les musées Indiens," *Museum,* 26, no. 1 (1974): 52; Branham (as in n. 48), 37.

53. Gell, 97.

54. Benedict Anderson, *Imagined Communities* (London & New York: Verso, 1991), 182–84; Mark Crinson, "Nation-building, collecting and the politics of display," *Journal of the History of Collections* 13, no. 2 (2001): 231–50. The idea that ancient monuments constitute a type of national patrimony, so that whoever attacks them "is excluded *de facto* from the community of citizens," is already present in Abbé Grégoire's impassioned writing in favor of the museum; Poulot (as in n. 44), 203–4.

55. Duncan (as in n. 48), 102.

56. For a critique of the hegemonic potential of universalism see S. Sayyid, "Bad faith: anti-essentialism, universalism and Islamism," in *Hybridity and its Discontents: Politics, Science, Culture,* ed. Avtar Brah & Annie E. Coombes (New York: Routledge, 2001), 261.

57. Bernard S. Cohn, *Colonialism and its Forms of Knowledge: The British in India* (Princeton: Princeton University Press, 1996), 76–105; Duncan (as in n. 48), 89.

58. Stanley K. Abe, "Inside the Wonder House: Buddhist Art and the West," in *Curators of the Buddha: The Study of Buddhism under Colonialism,* ed. Donald S. Lopez, Jr. (Chicago & London: The University of Chicago Press, 1995), 89–90; I. K. Sharma, "Archaeological site museums in India: the backbone of cultural education," *Museum International,* 50, no. 2 (1998): 45.

59. Fisher, 10; Stephen Greenblatt, "Resonance and Wonder," in Karp & Lavine (as in n. 48), 44.

60. Gamboni, 18.

61. Pierre Bourdieu cited in Dornberg (as in n. 51), 105.

62. Nancy Hatch Dupree, "Import of the cultural destruction in Afghanistan," *Society for the Preservation of Afghanistan's Cultural Heritage (SPACH) Newsletter,* 7 (July 2001).

63. Sayyid (as in n. 56, 266) sees the conflict between Islamists and their enemies not as a contest between liberalism and fundamentalism, but between different types of hegemonic universalisms: "One may have one's own prejudices for preferring one to the other, but both are attempts to remake the world. Neither is sanctioned by any innate logic, both are themselves grand political projects: projects that aim to transform our cultures, histories, and societies."

64. After the French of Frodon (as in n. 29).

65. Kipling (as in n. 1), 54; Abe (as in n. 58), 77–84. The perceived European affinities of the Buddhas came to the fore in various ways during and after their destruction, with many observers mourning the loss of what was widely perceived as a link between Western and Asian culture.

66. W. L. Rathje, "Why the Taliban are destroying Buddhas," *USA Today,* March 22, 2001; Barbara Crossette, "Taliban Explains Buddha Demolition," *New York Times,* March 19, 2001.

67. Barry Bearak, "Where Buddhas fell, lives lie in ruins too," *New York Times,* December 9, 2001, A1 & B10; "Afghanistan: Taliban Massacres Detailed," Human Rights Watch press release, New York, February 19, 2001. The destruction of the Bamiyan Buddhas will have future economic implications for the local Hazara community, which formerly derived some of their income from tourism associated with the statues.

68. Mary Richardson, quoted in Gamboni, 94–95.

69. Freedberg, 409.

70. W.J.T. Mitchell, *Iconology: Image, Text, Ideology* (Chicago & London: University of Chicago Press, 1986), 163; Wyatt MacGaffey, "African objects and the idea of fetish," *RES,* 25 (Spring 1994): 123; and Peter Gathercole, "The Fetishism of Artefacts," in *Museum Studies in Material Culture,* ed. Susan H. Pierce (Leicester: Leicester University Press, 1989), 73–81.

71. Gamboni, 97.

72. Igor Kopytoff, "The cultural biography of things," in *The Social Life of Things, Commodities in Cultural Perspective,* ed. Arjun Appadurai (Cambridge: Cambridge University Press, 1986), 67.
73. See Freedberg, 418.

Frequently Cited Sources

Davis, Richard H., *Lives of Indian Images* (Princeton: Princeton University Press, 1997).

Fisher, Philip, *Making and Effacing Art: Modern American Art in a Culture of Museums* (New York: Oxford University Press, 1991).

Flood, Finbarr Barry, *Objects of Translation: Material Culture and 'Hindu-Muslim' Encounter, 800–1250* (Princeton: Princeton University Press, forthcoming).

Freedberg, David, *The Power of Images: Studies in the History and Theory of Response* (Chicago: University of Chicago Press, 1989).

Gamboni, Dario, *The Destruction of Art: Iconoclasm and Vandalism since the French Revolution* (New Haven: Yale University Press, 1977).

Gell, Alfred, *Art and Agency: An Anthropological Theory* (Oxford: Clarendon Press, 1998).

Grabar, Oleg, "Islam and Iconoclasm," in *Iconoclasm Papers Given at the Ninth Spring Symposium of Byzantine Studies, University of Birmingham,* March 1975, ed. Anthony Bryer and Judith Herrin (Birmingham, Eng.: Centre for Byzantine Studies, University of Birmingham, 1977).

Hawting, G. R., *The Idea of Idolatry and the Emergence of Islam: From Polemic to History* (Cambridge: Cambridge University Press, 1999).

Melikian-Chirvani, Assadullah Souren, "L'évocation littéraire du Bouddhisme dans l'Iran musulman," *Le Monde Iranian el l'Islam,* no. 2 (1974): 1–72.

Paret, Rudi, "Textbelege zum islamische Bilderverbot," in *Das Werk des Künstlers: Studien zur Ikonographie und Form geschichte Hubert Schrade zum 60. Geburtstag dargebracht von Kollegen und Schülern* (Stuttgart W. Kohlhammer, 1960), 36–48.

Sachau, Edward C., *Alberuni's India,* 2 vols. (1910; reprint, New Delhi: Munshiram Manoharlal, 1983).

van Reenen, Dan, "The *Bilderverbot,* a New Survey,' *Der Islam* 67 (1990): 27–77.

–5.8–

The Creation of a Tibetan Modernist:
The Painting of Gonkar Gyatso
Clare Harris

The biography of Gongkar Gyatso, who was born in Lhasa, in 1962, inscribes a narrative of 'the aesthetic and ideological imperatives of life in the Tibetan Autonomous Region (TAR) after 1959. Gyatso describes himself as 'a product of occupied Tibet'[1] and his paintings are also the products of an invaded space. His life and work reveal how being Tibetan in TAR involves negotiating between conflicting representational fields. In the course of Gyatso's career he was both the first Tibetan to paint a mural for the Tibet Reception Room in the Great Hall of the People in Beijing (entitled *The Yarlung River* and completed in 1985) and a founder member of the 'Sweet Tea Painting Association' (Cha ngarbo rimo tsokpa), the first independent Tibetan artists' association with an agenda that was by no means supportive of the Chinese regime. The evolution of his art practice parallels a political conversion from Maoist ideologue to refugee follower of the Dalai Lama.

As a child, Gyatso grew up under the totalitarian ubiquity of Maoist ideology and imagery. 'Everything in our home was Chinese and the entire family strictly adhered to party guidelines'.[2] The son of government employees (his mother was a clerk in a government office and his father a soldier in the People's Liberation Army (PLA)), he was educated in schools reserved for the offspring of such workers, where the Peoples' Republic of China (PRC) vision of 'minority' Tibet held sway. Students were drilled in reverence for Mao Zedong and the heroes of the Cultural Revolution and trained to despise the Dalai Lama and the religious system he embodied. At the age of seventeen, Gyatso took a job as a tour guide at the 'Museum of the Revolution' built on the site of the demolished Nangtseshar (a pre-1959 court house and prison) in Shöl. The museum contained a display of 'the evils of the old, "preliberation" society', such as the practice of Tibetan Buddhism. With an extensive background in party propaganda, Gyatso had little difficulty in adopting the Communist view that religion was a wasteful, oppressive system that had led to the iniquities of 'feudalism' in pre-1959 Tibet. His job at the museum began in the year after the death of Mao, hence he became part of the campaign to remind Tibetans of how bad their lives might have been without Maoist intervention. At this time Gyatso's education

had left him unable to imagine anything other than the PRC's representation of Tibet, past and present.

However, in 1978 his pro-Maoist world view received an abrupt jolt, partly as a result of his interest in art. During his time at the museum, Gyatso met some of the Lhasa University art teachers and was invited to accompany them on a project to make drawings and 'give ideological advice' to 'peasants' in Chamdo in Kham. The 'peasants' turned out to be his fellow Tibetans living in poverty as a result of government policies which demanded that Tibetan farmers donate half their yield to the Motherland, whilst the rest could be claimed by government employees. This experience raised some doubts in Gyatso's mind, and he began to question some of the assumptions he had held since childhood. When the opportunity to study art at the Minority School in Beijing arose in 1979 he found himself surrounded by students from 'forty to fifty' different 'minorities' and was again shocked by this experience. Of his 'minority' classmates, he and two other Tibetans were the only ones who retained some knowledge of their mother tongue and its script. Hence during four years of tuition in two styles of Chinese painting and the 'strict guidelines as to what art should be like'[3] Gyatso instead became highly conscious of the distinctiveness of his own 'minority' heritage. On visits to museums and libraries in the capital of the PRC he also discovered the culture of places further afield. He read Nietzsche and Sartre, books on Millet and Van Gogh and was introduced to Western Modernist art among the Beijing avant-garde. The son of Tibetan Communists decided that 'all these Western ideas flowing into China were the fruits of free societies with free markets, freedom of expression and concepts of democracy'.[4]

The lessons learnt during Gyatso's time in Beijing can be revisited in paintings which display an evolving fascination with the work of Braque and Picasso (especially in their Synthetic Cubist period). In one study, the colour range (browns, blacks and creams) echoes their palette, though where Braque and Picasso developed Cubism as a means of disassembling visible reality, Gyatso's pieces move straight to abstraction without the intermediate phase of the dissection of form. A similar composition, but with patches of more vivid pigment (red, blue and purple) occurring like disused shards of stained glass, owes its interplay of shape and colour to the experiments of Vasily Kandinsky (1866–1944), who in Concerning the Spiritual in Art famously compared his non-figurative painting to the abstract appeal of music.[5] The only specifically 'Tibetan' feature in these early works is the inclusion of the artist's signature in Ü-chen script. (What occurs here merely as an appropriate detail becomes a far more self-conscious statement in Gyatso's later works, such as *A Prayer* of 1993, where extracts from Tibetan religious texts predominate.)

In 1984 Gyatso returned to the TAR to continue his training at the fine art department at Lhasa University. His arrival coincided with the period of liberalization, when some restrictions on the practice of Tibetan Buddhism had been lifted. He therefore arrived in a rather different city from the one he had left: the Jokhang had been reopened and Tibetans (including his own grandmother) were once again

reciting mantras, using rosaries and generally reviving popular religious practices. At a less visible level, cassettes with speeches made by the Dalai Lama in exile were in circulation. When Gyatso heard the Dalai Lama's account of Tibetan history and its status as an independent nation, it galvanized his resolve to try to create 'something Tibetan'. But how was this to be achieved? Gyatso had no knowledge of 'Tibetan techniques' (such as thangka painting) and had only ever learnt Western and Chinese styles of oil painting, so his first attempts to illustrate the special characteristics of the Tibetan environment were still forged in the stylistic mould of Sino-Realism.

Ironically his abilities in this type of representation meant that the process of devising 'something Tibetan' was interrupted in 1985 when Gyatso was required to return to Beijing to complete the Yarlung River mural for the Tibet Reception Hall. Although the subject enabled Gyatso to depict the Yarlung Valley where the first Tibetan kings had ruled, it was an official commission for a Han Chinese audience. On his return to Lhasa, Gyatso became even more painfully aware of the contradictions between his status as the son of party workers (and now also an artist to the state) and his growing consciousness of the distinctiveness of his Tibetan heritage. Around this time he tried to express his frustration:

> ...all my attempts to get at my Tibetan identity and cultural roots. The result was a feeling of depression and emptiness, which I tried to depict in a self portrait. I drew myself with half a face, reflecting the boredom and feeling of vacuousness I had felt during these idle days of senseless arguments.[6]

In these 'senseless' discussions with other art students Gyatso had at first continued to defend Maoism, but he gradually came to the realization that his personal crisis was shared by many other young Tibetans in Lhasa. They too suffered from a sense of split personality as a result of reaching adulthood in a version of Tibet constructed by China. A solidarity emerged between them which further inspired the search for a new 'medium of expression'.

These debates about politics and the future of Tibetan art had occurred in the tea houses of the Shöl district near Lhasa University. In 1985 the university authorities proposed that its students should exhibit at the World Youth Day festival in Lhasa, but Gyatso and his friends realized that they would only be allowed to exhibit work 'whose social connotations conformed to the regime's views'.[7] Thus, with the model of the Parisian Salon des Refusés in mind, they decided to show their work in the alternative spaces where their discussions had taken place and to name themselves 'The Sweet Tea Artists' Association'. The tea-houses provided an ideal venue for other young Tibetans to view and comment upon their work without official interference.

The primary motivation for these artists came from a growing sense of the need to reinstate their Tibetanness and to reject the styles and institutions of their Chinese masters. As Gyatso recalled: 'By taking inspiration from the shapes, elements and events in our own environment, I and a group of art students in my college were

striving to create a form of specifically Tibetan modern art'.[8] The 'Sweet Tea House' identity and sensibility became heavily tied to nature and the physical environment as they attempted to reclaim the landscape of Tibet and to populate it not with ethno-kitsch reflections of themselves but with Tibetan signifiers. Excursions were made to remote areas of the country, such as Changthang in western Tibet, in order to 'seek affirmation of their traditional spirit from the sky, the mountains and the rivers of Tibet'.[9] Gyatso's Lhamo Latso is a prime example of the new antirealist approach which, instead of merely recording, sought to reattach Tibetan meanings to Tibetan places. As we established earlier, Tibetans believed the lake to be inhabited by the spirit of Palden Lhamo, the wrathful protector goddess, and it had therefore been a place of pilgrimage since at least the sixteenth century. In the twentieth century, a number of eminent religious figures are said to have experienced visions in its waters, as Reting Rinpoche did when he consulted Palden Lhamo during his search for the birthplace of the next incarnation of the Dalai Lama. The signs which appeared on the water led to the discovery of the current (fourteenth) Dalai Lama. Given the significance of the Dalai Lama, as the religious and political leader of Tibetans who seek an independent Tibet, and the Palden Lhamo, as the State Protector, a location such as Lhamo Latso has great potency for Tibetans both inside and outside the TAR. Gyatso's modernist evocation of it reanimates these historical, religious and political associations in an abstract, encrypted code.

The mid-1980s was a period of religious revivalism and Gyatso became interested in Tibetan Buddhism as a practice and philosophy as well as a source of aesthetic inspiration. He produced some studies of the monastic environment, but his 'Sweet Tea' colleagues complained that they were too realist. So he looked at the remaining paintings in the monasteries around Lhasa and tried to produce 'modern thangka' in which he quoted from traditional motifs. In one of these he expanded the traditional Tibetan style of painting clouds until it becomes a pattern of lines which play on the eyes like the Op Art of Bridget Riley. But, like the religious revival, the efflorescence of 'Sweet Tea' Tibetan modernism was not to last. In 1987, the year of the first of a series of demonstrations against Chinese rule, the group held an exhibition which was covered by Lhasa radio and television and attended by TAR dignitaries; shortly afterwards the authorities demanded that party-approved Han Chinese painters should be allowed to join. This was entirely contrary to the 'Sweet Tea' aim to produce an art form that was Tibetan in subject matter and style by artists who were ethnically Tibetan. Hence the group disbanded rather than adulterate this purity.

Following the dissolution of the association, Gyatso entered a period of retrenchment and a phase of rather nostalgic realism. His drawings of prostrating pilgrims at the Jokhang and men resting in the Barkhor became almost identical to portraits painted by Chen Danqing a decade earlier. But two years later, in 1989, demonstrations in Lhasa and the Tiananmen Square outrage shocked him into action again. With the knowledge of the brutal suppression going on in Lhasa and an increasing belief in the need for Tibet to regain its independence under the leadership of the

Dalai Lama, Gyatso returned to modernist experimentation and produced a series of fiery red seated Buddha images in which the basic colours are stained into cotton cloth and then drenched with further layers of black ink (Figure 13). The resulting image can be rolled and transported in the same way as traditional thangka, though the delineation of the Buddha has been simplified, making it closer to early Indian rather than Tibetan models. Though informed by Buddhist art of the past, Gyatso's compositions also depart from history under the influence of modernism. His *Buddha and the White Lotus* is divided into three sections with the central portion filled by a black void in which an elegantly sketched white lotus floats. Its roots drift into the left-hand segment where a cloudy mass of red and black pigment glows like a furnace of old but long burning coals. This flower, which exceptionally grows in water and was a symbol of Buddhahood in thangka painting, now appears to be

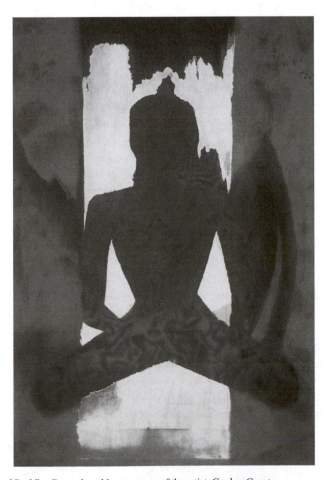

Figure 13 *Red Buddha.* Reproduced by courtesy of the artist, Gonkar Gyasto.

scorched by a red flame, while the Buddha is obfuscated, even obliterated, by the troubling black band in the centre. Expectations of frontality and symmetricality are confounded as the lotus appears at 90 degrees to the upright and the Buddha is depicted in half-silhouette. He is literally nebulous: more a ghost at the feast than a true presence. The artist has stated that at this time he believed that the Buddha 'could not look the Tibetans in the eyes',[10] hence the image is a statement about the facelessness and powerlessness of the Buddha whose teaching could not truly materialize in Chinese-run Tibet. Moreover, it is an essay on absence and mortality: the absence of the key representative of the Buddha in Tibet, the Dalai Lama.

In works like this, Gongkar Gyatso and the 'Sweet Tea' artists peeled away the surface details of traditional Tibetan iconography to present a pared-down expression of Tibetan identity. Their reference to the 'essence' of the past and of a non-Sinicized Tibet was designed to defy Chinese essentializing of 'minority' Tibet and depicted in realist images. Fifty years after Gendun Chapel's experiments, this new generation of Tibetan painters found an outlet for their anger and frustration through a modernist abstraction from the real. One of them even reinterpreted the 'wheel of existence' (as Chöpel had done in India) to create a commentary on life in the TAR. In it the elaborate symbolism of the twelve stages of the evolving consciousness, six realms of existence and three causes of delusion have been removed and replaced by a simpler, starker vision. The wheel is still held in the clawed hands of Shinge, the wrathful form of Avalokitesvara who is judge and lord of death, but a thin ring of skulls now encircles a naked corpse surrounded by vultures. This is a blunt depiction of the Tibetan method of burial which, as in the original wheel, requires the viewer to contemplate the end of existence. But this bleakness is relieved by a novel element in the composition. Whereas the mantric 'seed' syllables (Om, Ah, Hum) would have been inscribed on the reverse of a thangka canvas at the time of consecration, these redemptive letters are now part of the displayed image: a reminder of the possibility of a good Buddhist rebirth. As with many of the new Tibetan paintings, the political message of this image is by no means overt, but contextual information can help to elucidate it. During the 1987–90 'uprising' the practice of khorra (the ritual circumambulation of sacred sites) was reinvented for religio-political purposes. In September 1987 monks led a demonstration against Chinese rule which began with three circuits of the Barkhor (around the Jokhang). As Schwartz remarks, these 'could be seen as ritual preparation for a confrontation with the government'.[11] In the following month, following another demonstration, khorra accrued even more symbolic power when the bodies of those who had been shot dead by the Chinese police were carried around the Barkhor. Hence the wheel of existence described above must surely be read as another example of the politicized reinvention of Tibetan Buddhism of the 'uprising' period. The circle of skulls and the corpse within suggest that the ancient khorra routes had become zones of mortality, but that with Avalokitesvara, the protector of Tibet in wrathful form, to counteract the violence inflicted on Tibetan Buddhists there could be honourable death for the Tibetan cause. As Gendun

Chöpel had used a wheel of existence to comment on the horrors of a world war, so TAR painters have reinvigorated ancient imagery in the service of their battle for an independent Tibet.

Gongkar Gyatso and his 'Sweet Tea' colleagues had succeeded in devising a specifically Tibetan type of painting by reinterpreting the Tibetan landscape and Tibetan Buddhist iconography through the lens of modernist aesthetics. By asserting an independent Tibetan spirit, their works implied a critique of cultural and political conditions in the TAR. Hence the first Tibetan artists' association quickly attracted the unwelcome attention of the authorities. By the time of protests against Chinese rule in Lhasa (1987–90), the atmosphere of 'liberalization' had clearly evaporated and making images which expressed Tibetan anger and frustration (as *Buddha and the White Lotus* does) became an underground activity. This imagery could not be displayed or marketed in the galleries of Lhasa and artists like Gyatso faced a serious challenge. Many returned to painting the safe, Sinicized portraits of Tibetans which could be sold in the tourist galleries of Shöl. Gyatso could not stomach this descent into commercialism and deference to Chinese rule and continued to produce images of decapitated and dissected Buddhas in private until, like thousands of others before him, he decided to leave Lhasa and the hollow mausoleum of the Potala Palace to go in search of its rightful incumbent on the refugee pilgrimage to Dharamsala

Notes

1. K. Yeshi, 'Gongkar Gyatso: Creation of a Painter in Contemporary Tibet', *Chöyang,* vii (1996), p. 73.
2. *Ibid.,* p. 74.
3. *Ibid.,* p. 78.
4. *Ibid.,* p. 79.
5. Wassily Kandinsky, *Concerning the Spiritual in Art* (1914; repr. New York, 1977).
6. Yeshi, 'Creation of a Painter', p. 81.
7. *Ibid.,* p. 82.
8. *Ibid.,* p. 80.
9. J. Norbu, *The Works of Gongkar Gyatso* (Dharamshala, 1993), p. 5.
10. Gongkar Gyatso speaking at the Tibet Foundation, London, 1997.
11. See R. Schwartz, *Circle of Protest: Political Ritual in the Tibetan Uprising* (London, 1994).

–5.9–

Extraordinary Vision
and the Two Sides of Cloth
Elisha P. Renne

I know the time will come when
God shall open their eyes to
know themselves [and the] dust
and ashes and the Ifas which
they worship shall be taken from
their eyes.

James Thomas, September 26, 1858

Ifa is Light.

Business card of Mr. Yusufu Ikusika Megbóle,
Herbalist Doctor, Àkútúpá Kírí-Bùnú, 1988

In Bùnú and for Bùnú Yorùbá people, in central Nigeria, the world, like cloth, is described as having two sides—one obvious to everyone, the other only visible to certain individuals. This distinction also applies in cloth use. When an individual wears a cloth, the side facing outward projects its wearer's open sociality, while the side facing inward conceals thoughts and motives known only to the wearer.

The importance of the two sides is also reflected in cloth production. Normally, a woman sees only one side of the cloth she is weaving, while the other side is obscured. However, men weaving the anomalous red cloth, *apónúpónyìn,* used in the funerals of kings, were said to be able to see both sides of the cloth as they wove. Indeed, this ability was a prerequisite for learning to weave this dangerous cloth, which was said to hum and call for blood. In order to demonstrate such extraordinary vision, one must have "four eyes," i.e., two pairs, one for each side of the cloth.

The image of a person with four eyes (*olójúmérin*) seeing both sides of cloth implies exceptional power more generally. This ability is also associated with the practice of antisocial witchcraft. Not surprisingly, people said to have four eyes (i.e., witches) display other inversions of social behavior. Unlike ordinary people with monovision, people with four eyes can see in the day and night, both near and far, the invisible and the visible, the present and the future. By virtue of this extraordinary vision, individuals with four eyes are acknowledged to have special knowledge. On

the other hand, they are also ambiguously evaluated because they are capable of both socially beneficial and antisocial behavior. *Babaláwo* diviners, for example, exhibit this combination of potentially beneficial and destructive behavior. Because of their special sight and knowledge, they are able to divine the future and to know cures. Yet they are also suspected of practicing witchcraft.

Other individuals besides diviners may exhibit this extraordinary vision, their abilities enhanced or hidden through the use of cloth. When *ejínuwon* women wear àkì cloths, they are able to see, as if in a dream, the cause of illness and its cure. The masquerade performer, after donning the medicine-soaked costume of the masquerade Iyelúgbó, is able to see both great distances and invisible enemies, that is, witches and wizards, who also have "four eyes" but disguise themselves by wearing ordinary dress like everyone else. The problem with people who have extraordinary sight or power is that it is never exactly clear who they are or how their special abilities will be used.

This conflation of sight, special knowledge, and the ambiguous moral associations of the hidden side of social relations is not new in Bùnú. In the prayers of nineteenth-century Church Missionary Society catechist James Thomas for the Bùnú people's future that begin this chapter, he contrasts "the time … when God shall open their eyes to know themselves," implying lightness and clarity, with vision obscured by "dust and ashes and the Ifas which they worship." He seems to suggest that the knowledge contained in the Bible, available to all who could read, was open and good, while the knowledge of Ifá divination was secret and therefore suspect.[1] Through the Bible, all had access to òlàjú (enlightenment), this special knowledge supporting an ideal of equality and fellowship in village life, unlike "those with four eyes" whose hidden powers could be used to support the privileges of some at the expense of others.[2]

Ironically, this ideal of village egalitarianism was actually undermined by Christian conversion, which led to differential access to education and subsequent opportunities for employment. People might be equal in the eyes of God but the political and economical inequities of village life became more apparent as those with education were able to enhance their positions. Further, as many of the Bùnú villagers who converted to Christianity following the Omi Mímó movement in the 1930s discovered, unequal misfortune and disease still could not be explained. As Mr. Megbóle's business card, also quoted above suggests, Ifá divination continues to bring light to bear on these perplexing problems for some villagers.

Yet if continuing disparities of wealth and misfortune suggest that some individuals succeed through unholy means, the good fortune of some need not be equated with antisocial self-interest. As with òlàjú, such behavior is considered good when individuals are educated and then bring development to their home villagers. Òlàjú is bad, however, when, once educated, individuals abandon their villages and kin. Those able successfully to balance the need to give and share with the need to protect and keep their own advantage are likely to be praised for their achievements rather than accused of displaying uncivilized behavior or practicing

antisocial witchcraft. The moral evaluation of extraordinary sight, knowledge, and achievement—all potential signs of witchcraft—depends on the situation and the people involved.

To emphasize this point, I conclude with the description of a dispute, essentially a witchcraft accusation, which occurred during my stay in Bùnú. It illustrates several aspects of social life: resentment over disparities in wealth and power, unexplained illness, and extraordinary vision, all associated with witchcraft. It also displays an ambiguous mix of unintended consequences, misinterpretations, polyphonous voices, and indefinite conclusions, making this dispute an excellent example of the contextual nature of interpretations of witchcraft. Further, the dispute itself centered on the wearing of one particular cloth … More than any other event during my stay in Bùnú, it "opened my eyes" to the continuing importance of cloth in Bùnú social life.

The Dispute

In Bùnú in 1987 and 1988 I attended several traditional marriage performances, where I took photographs, some of which I promised to send to the brides. I also took pictures of various people whom I interviewed, planning to send them their pictures as well. After returning to the States, I sent many of these pictures, in envelopes according to villages, to a friend in Kàbbà to distribute for me in Bùnú.

When I returned to Bùnú two years later, people in one village began asking about one particular photograph. They insisted that I had taken a photograph of one woman and that another woman had appeared in her place. I could not understand what they were saying until I saw the photograph later that day. It was a picture of an older woman I had interviewed about Bùnú cloth. She had access to many different cloths which she showed me, even modeling some of them to demonstrate how they should be worn. In the photograph she was wearing *yísalà*, the traditional marriage cloth, which is only to be worn in the process of performance. What complicated the matter was that I had also taken photographs of a traditional marriage performance in the same village later that year. While I sent the bride several pictures, I did not send her a print of herself wearing the *yísalà* cloth.

Yísalà is used in traditional marriage in northern Bùnú (Kírí) but not elsewhere in Bùnú. It is even rare in northern Bùnú where it was said that only one or two cloths of this type remained. When I was first told about *yísalà* cloth, it was described as a white cloth with a picture of a child drawn on it. To me, it looked more like a long white cloth with a circular reddish blotch in the center. On the trip to the market during traditional marriage performance, this cloth is worn by the bride much as she would wear a baby tie. As she walks, her hand pats the cloth where the imaginary baby would be. Because of its rarity and the belief that it is both dangerous to look at and susceptible to disappearing, its use is closely guarded. After it is worn by the bride at the market, a woman stands by ready to whisk it away to be safely stored. *Yísalà* is not an ordinary cloth and it should not be worn lightly.

When I saw the picture of the older woman wearing the *yísalà* cloth, I knew that the problem was the unauthorized wearing of this cloth. The bride and many other villagers said that the older woman, who had not attended that particular day of the marriage and could not have worn the *yísalà* cloth in any event as she was not the bride, "pushed" the spirit of the bride out of the photograph and appeared there herself. Furthermore, when I took the photograph, I was overheard to have exclaimed about the older woman appearing in the picture. Finally, the photograph explained another unusual occurrence that day which I had noticed myself. As the bride's body was rubbed with red camwood, it had turned black. At the time this was ascribed to her *ejínuwon* spirit-double troubling her and a small sacrifice had been made. However, with the evidence of the photograph, this occurrence was attributed to the spiritual machinations of the older woman.

I retrieved the photograph and the next day a village moot was held, presided over by the king and several village chiefs. All parties stated their positions. I said that I had taken a photograph of the older woman, but, for fear of complicating matters further, that I did not know about the *yísalà* cloth. The older woman denied ever wearing the *yísalà* cloth. The bride and her family stated their argument about the replacement of her spirit, represented by the older woman wearing the *yísalà* cloth, and the bride's subsequent illness. The king asked for evidence—the photograph—but was surprisingly quiet. Several other people spoke at length, supporting the various interpretations. One Western-educated Bùnú man living outside of Bùnú but who happened to be visiting argued that it was absurd to think that a camera could photograph one woman and that someone else could appear, thus adding another perspective to the case.

I was then asked to promise that when I returned to the States I would send the photograph of the bride wearing the *yísalà* cloth, which I did. The photograph of the older woman was kept by the bride's family as evidence "for future generations." After that, the gathering dispersed though there had been no final judgment about what had happened. The case was left unresolved because the heart of the matter was too dangerous to discuss in a public setting.

In this case, a cloth and a photograph were used as vehicles for indicating resentment felt by the bride and her family toward the older woman and hers. The older woman's son was a wealthy manufacturer and as a result, his mother had more things than many people in the village. Further, she was not only thought to be ungenerous in sharing her wealth with others, but was also described as "syphoning off" the prosperity of others for herself.[3] The primary issue in this case was the disparity of wealth in the village. That the older woman had more wealth than others, who generally shared the same circumstances, led to suspicions that recourse to supernatural power, i.e., witchcraft, was involved. I was similarly implicated in these suspicions because of my special sight—my camera—and my unusual circumstances—my relative wealth, that I traveled alone, that I was a white foreigner.

None of this was voiced by the bride or her family, though other people I spoke with privately agreed that these suspicions and resentments underlay the events. Rather, *yísalà* was the vehicle through which these sentiments were expressed. The ambiguous ending of the affair and the ominous statement that the photograph would serve as evidence "for future generations" suggest that uncertainty surrounding the causes of inequality is likely to be a source of contention between these and other families for many years to come. It is also likely that people will continue to use cloth "in many ways" in the construction of these arguments and claims.

Notes

1. See J.D.Y. Peel, "Olaju: A Yoruba Concept of Development," *Journal of Development Studies,* 14 (1978):139–65.
2. The association of witchcraft with extraordinary financial and political success at the expense of others is depicted in the person of Madam Koto by Ben Okri in his novel *The Famished Road* (London: Vintage Press, 1991).
3. People gave as an example the story of a Yorùbá woman who used to come to the village to trade. The older woman was said always to sit next to the woman in the market. While the older woman sold well, the Yorùbá woman sold nothing and after a time stopped coming to the village.

–5.10–

The Spiritual History of Ice
Eric G. Wilson

Frozen Apocalypse

> Dazzling ice stars bombarded the earth with rays, which splintered and penetrated the earth, filling earth's core with their deadly coolness, reinforcing the cold of the advancing ice. And always, on the surface, the indestructible ice-mass was moving forward, implacably destroying life.

> —Anna Kavan, *Ice*

If a collective or cultural unconscious exists, then it was at work during the dawn of the third millennium. Millions quaked in expectation of apocalypse. Some feared that a vast computer crash might reduce the world to waste. Others nervously fantasized over the quick and the dead discovering a godly doom. Still more sunk into deeper dreams—luridly uncanny, ambiguous as Leviathan. In the midst of these prophetic reveries, from April 1997 to July 2001, the *New York Times* noticed at least twenty-two books on polar phenomena. During an earlier period, from April 1990 to June 1996, the *Times* reviewed only four polar texts.[1] What secret link exists between ice and apocalypse? What ghostly bergs cruise in the millennial undertow?

Perhaps on the surface of the apocalyptic unconscious floated terrifying visions of frozen deserts or melted icecaps smothering the post-Y2K world. Lower, under the dystopias of modem technology, there possibly lingered horrors of Dante's icy hell or hopes of St. John's crystal heaven. In more profound regions of this millennial abyss, in half-remembered dreams, stranger polar specimens likely lurked. Possibly there gleamed Madame Blavatsky's northern polar paradise shining at the beginning of time, an "Imperishable Sacred Land" inhabited by immortal Hyperboreans.[2] Near this fading image—ostensibly a harmless portrait of a first utopia—were perhaps Nazi nightmares of a eugenically engineered breed bent on reclaiming pristine Hyperborean origins.[3] Beneath this perniciously political Arctic, did there hover a more redemptive polar apparition: the axis mundi, still point of the turbid world, gathering enemies into secret concord?[4] These potential connections between millennial disquiet and polar meditation suggest that ice, in its striking, extreme forms—deathly

bergs and crushing floes, crevasses and calving glaciers—shares the same paradoxes as Western visions of apocalypse. Occidental Armageddons tend to picture both violent dissolutions of time and blissful revelations of eternal realms—annihilation and restoration, horror and joy. Likewise, polar terrae incognitae and other frozen shapes kill and cure. They blanch the earth into a corpse. They translucently reveal life's vital core. The whiteness of ice is the whiteness of the whale.

These significations of ice—paradoxical, revelatory, perhaps unexpected—inspire here: a spiritual history of Western representations of frozen shapes from ancient times to the early nineteenth century; an anatomy of these representations of ice; and an apology for a Romantic mode of seeing that ecologically inflects the spiritual history and anatomy of ice.

In tracking the spiritual history of ice, I focus on the exoteric and the esoteric. The exoteric way of seeing is interested in external surfaces, understandable visibilities, and social orders. This mode of cognition—shared by orthodox forms of Christianity, political systems, and conventional sciences—often views ice as a deathly coldness to be transcended, raw material to be converted into commodity, or static matter to be reduced to law. The esoteric perspective considers internal depths, invisible mysteries, and individual experiences. This mode of vision instanced by hermetic dreamers, alchemical adepts, and Romantic visionaries frequently sees icescapes as revelations of an abysmal origin, marriages of opposites, mergings of microcosm and macrocosm. Hence, while exoteric institutions tend to interpret ice from negative or neutral points of view, esoteric visionaries are disposed to read ice in positive lights. A medieval Christian degrades ice to waste. An eighteenth-century scientist studies frost as a manifestation of mechanical law. A Romantic poet finds in the frozen plane the universal no-color behind all particular hues.

This diachronic study of ice discloses an anatomy, a synchronic structure. Although representations of ice historically change, frozen phenomena in the West have been persistently figured in three forms: crystals, glaciers, and the poles. Each of these categories subsumes factual qualities and symbolic possibilities. The crystal class contains microscopic frozen shapes. These include the minuscule geometries and transparent prisms studied by physicists interested in the structures of matter and the laws of light; the transient hoar frosts and more enduring icicles read by exoteric Christians as signs of time's insubstantiality or harbingers of New Jerusalem's gems; the rime floating on the pond, celebrated by a Romantic seer—a Thoreau, for instance—as a clarification of vital energy into elegant form. The glacier category encompasses ice as mesocosm: the Alpine glaciers observed by geologists bent on understanding geomorphic agencies; the frozen peaks demonized or glorified by exoteric Christians as blights on God's harmony or reminders of heaven's heights; the roofs of sublime snow sought by Romantic climbers such as Shelley. The polar classification entails macrocosm: the immense Arctic and Antarctic regions explored by adventurers and scientists; the vast terrae incognitae cursed by exoteric Christians until they can transform them into holy cities; and the esoteric poles sought by

Coleridge, hungry for the harmony salving the hurt world. Until the Romantic age, most Western representations of these types of ice were exoteric and thus largely neutral or negative. With few notable exceptions, writers from Herodotus to Pope tended either to ignore the special qualities of ice or, worse, to demean frozen shapes to signs for aloofness, numbness, stasis, transience, monstrosity, or death. However, at the turn of the nineteenth century, scientists for the first time were beginning to understand that ice is not evil matter to be transcended or bland material to be commodified but is instead a vehicle and revelation of vital energy. In the early years of the century, Humphry Davy drew from the science of crystallography to find in the crystal a window to the laws of electromagnetism, and thus perhaps to the earth's vitality. At the end of the eighteenth century, James Hutton gleaned a theory of glaciation from Horace Bénédict de Saussure's observations of Mont Blanc and guessed that glaciers are agents of terrestrial transformation. Earlier, James Cook first crossed the Antarctic Circle. Though endless fields of ice horrified him, he nonetheless excited in his contemporaries dreams of the magnetic pole.

Aware of these emerging sciences of ice, Romantics on both sides of the Atlantic translated the data of the scientists into literary dreams. Poe's Pym, informed in polar explorations, is drawn to the unmapped ice at the South Pole, where his boat likely slides through a milky cataract into the interiors of the earth and, deeper, to the core of the cosmos. Coleridge, also versed in polar journeys, sends his Mariner into an Antarctic freeze that changes the sailor forever, teaching him that life thrives in birds and snakes as much as in men. Mary Shelley, well aware of the factual and symbolical densities of the Arctic, begins and ends her Frankenstein near the North Pole. But the creator of the "Modern Prometheus" was also schooled in glaciology, realizing that Alpine glaciers shape the globe. Ironically, Shelley stages the first meeting between her failed creator and his botched creation in the midst of Mont Blanc's demiurgic glaciers. Mary's husband Percy draws from the science of glaciers in "Mont Blanc," in which he likens the creative ice to the imagination, universal and individual. Byron places his magical protagonist in Manfred among the Swiss glaciers, where the conjurer discovers wondrous energies unknown below. If cosmic poles and massive glaciers reveal the life coursing within minuscule man, the tiny ice crystal opens into forces pervading the solar system. Aware of crystallography, Thoreau studies morning frosts and frozen ponds, finding in Concord ice analogues to reticulated leaves, feathered wings, the harmonies of the spheres. Likewise versed in crystals, Emerson in "The Snowstorm" and *Nature* casts ice crystals as transparent revelations of the currents of universal being.

These writers are among the first poets, essayists, and novelists to embrace ice as a positive—not neutral or negative—fact and symbol: as a unique manifestation of the principle of life. Transforming scientific ice into literary subjects, these Romantic figures thus not only point to a neglected hermeneutic context for reading their works; they also redeem ice from its exoteric past and establish it as a site of esoteric redemption. Hence, in interpreting Emerson and Thoreau in light of

crystallography, the Shelleys and Byron in the contexts of glaciology, and Coleridge and Poe against the backgrounds of polar exploration, one can analyse as well as ponder the ecological possibilities of ice—the ways in which frozen forms pattern and reveal invisible, imponderable, holistic, causal, vital powers, ranging from electromagnetic waves that can be measured to psychological energies, vague yet discernible, to cosmological principles beyond fact and image. A transparent window to lines of invigorating force; a mirror in which men and women behold interior hums; an indifferent blank, no color and all colors, void and plenitude: Ice, curiously, thrives in the living as much as the dead, in the gorgeous as well as the horrible—in winds, in spirits, salubrious and disturbing, that blow where they list.

Melting and Genesis

So he left the lagoon and entered the jungle again, within a few days was completely lost, following the lagoons southward through the increasing rain and heat, attacked by alligators and giant bats, a second Adam searching for the forgotten paradises of the reborn sun.

—J. G. Ballard, *The Drowned World* (1962)

In his *5/5/2000 Ice: The Ultimate Disaster* (1986), Richard Noone predicted that during the inaugural spring of the third millennium, Mercury, Venus, Mars, Jupiter, and Saturn would align for the first time in six thousand years and thus abruptly increase the earth's temperature. The polar ice caps would melt. The earth would drown. Tragically, the primal soup, inhuman, would again slosh.

Noone was mistaken in his apocalyptic prognostication. However, the polar ices are in fact thawing apace. Global warming is slowly dissolving them again into their primitive liquid states. In January of 2001 men and women for the first time actually beheld a hole at the pole. Rising ocean temperatures had dented the Arctic axis.

If American readers at the end of the second millennium were perusing fresh accounts of the polar freeze, then these same readers were also encountering the opposite of ice: melting. From October of 1998 to February of 2001, at least eleven articles on the thawing of the polar icecaps appeared in the pages of the *New York Times*. Among these articles was a January 23, 2001, report on how the Intergovernmental Panel of Climate Change has reaffirmed its consistent warning. Global warming is causing polar meltage, a process that could in the future precipitate disastrous flooding. These newspaper pieces have been supported by numerous books on global warming through the decade of the nineties, culminating most recently with Jeremy K. Leggell's *The Carbon War: Global Warming and the End of the Oil Era* (2001), John J. Berger's *Beating the Heat: Why and How We Must Combat Global Warming* (2000), and Francis Drake's *Global Warming: The Science of Climate Change* (2000).

The absence of ice is just as terrifying as a frozen earth. In both cases, the result would be the same: a return to undifferentiation—monotonous white, unbroken ocean. Yet, ends are beginnings. A universal freeze or flood, though it destroys the old, also clears ground for new growth. Significantly, numerous world myths of cosmic origin begin with a void—pristine indifference. This void is often figured by water: the primeval waters from which the first hill arises in the Egyptian Pyramid Texts; the milky ocean, bearing the endless serpent, upon which the Hindu deity Vishnu dreams and undreams the cosmos; the snaky oceans ruled by Tiamat; the deep over which Jehovah broods.

Hence, though ice suggests the original and final gulf, water, the complement of ice, its twin and necessary other, is the more fitting image of the end that begins. If freezing and melting—two sides of the same coin, two hands of the same being—are signs of apocalypse, of an undifferentiating destruction from which new differences might one day arise, then ice suggests conclusions while water intimates introductions. Frost is the clarity of closure. Thaw is the vagueness of the portal. Ice is the end of winter overlapped by the meltage that begins the spring. Ice is still, though invisibly, moving. Water moves, yet stays in one place. Ice is tight though on the verge of loosening. Water flows but can again freeze. Ice is the axle. Water is the turning world. Some of the moments of frozen gnosis have been accompanied by melting: relief and release. Thoreau's vision of the deep cut is an experience of the imbrication of freezing and melting. The oozing mud suggests the shapes of ice. The stark crystal points to living saps. His intuition of ice is a participation mystique in the spring thaw, a dive into the mud with an icy jewel in his hand. Likewise, Shelley's meditation on Mont Blanc begins and ends in meltwater. The poet begins the poem by contemplating the River Arve. He then elevates his gaze to the river's frozen source at the pinnacle of the White Mountain. He concludes by returning to the "rushing torrents" created by the thawing snow of the peaks. This movement mimics the poet's psyche, which moves back and forth between the frozen clarity of insight and the slippery ambiguity of doubt. Likewise, the Mariner's moment of polar insight—his vision of Antarctic whiteness wondrously interwoven with snakes in torrid seas—is simultaneous with a twofold melting: a dissolution of his stony heart into a gushing spring, a liquefaction of the sky into rain.

These meltings reveal this. The gnosis of ice is not a revelation of static truth, an unchanging clarity. An insight into the mystery of ice re-releases the adept into the ambiguous flows of life, wiser (and possibly sadder), more aware of the sources and rhythms of the currents but no closer to a stable principle in which he can rest. To grasp the ice—in its forms of crystals, glaciers, and the poles—as a revelation of the groundless ground is to find oneself unmoored, undone, distributed in the all, not attached to any particular thing. The ego melts, sinks back into the muck from which it arose. Yet, from this dissolution arise fresh resolutions: new patterns of being that are less egocentric and more open to the energies of other humans, animals, and lands. This is the secret of the alchemical work, of the philosophical Mercury. As he freezes

into the crystal stone he is already on his way to melting back into the prima materia, from which he will again rise into ice only once more to thaw.

Freezing and melting, clarity and confusion, organization and turbulence. These are the wonderful though hidden polarities by which the cosmos thrives. What, then, is the secret imperative of polar melting, of the apocalyptic global warming amid which we now live? It is perhaps this: The melting that we have wantonly made through our greed and waste should shock us into a new awareness of ice, of its place in the living whole—an awareness that might translate into new modes of being: less egocentric, more ecological. But the occult significance of Antarctic and Arctic thawing might be something else again, something more horrifying yet potentially more sublime. The human species, but an ambiguous instant in cosmological durations, might have already set unalterably in motion forces that will inevitably drown and dissolve the greed of men as well as civilized beauty. Possibly this—the removal from the planet of the most destructive species ever to exist—is the truest, and most tragic ecology, an end of wasteful death in the name of new life.

Notes

1. The books reviewed were James A. Houston's *Confessions of an Igloo Dweller* (New York; Houghton Mifflin, 1996) 19 May 1996; D. G. Campbell's *The Crystal Desert: Summers in Antarctica* (New York; Houghton Mifflin, 1992), 17 December 1993; Will Steger and John Bowermaster's *Crossing Antarctica* (New York: Knopf, 1991), 26 January 1992; and Harvey Oxenhorn's *Turning the Rig: A Journey to the Arctic* (New York: Harper and Row 1990), 22 April 1990.
2. H. P. Blavatsky, *The Secret Doctrine,* 2 vols. (London: Theosophical Publishing Co., 1888), 2: 310.
3. For the Nazis and polar myths, see Joscelyn Godwin's *Arktos: The Polar Myth in Science, Symbolism, and Nazi Survival* (Kempton, IL: Adventures Unlimited Press, 1996).
4. An encyclopaedic study of esoteric representations of the poles is John O'Neill's neglected *The Night of the Gods: An Inquiry into Cosmic and Cosmogonic Mythology and Symbolism,* 2 vols. (London: Harrison and Sons, 1893).

Part 6. Extensions

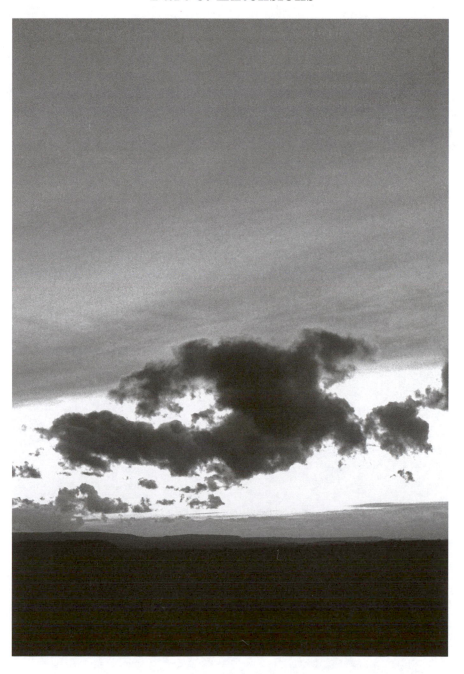

Figure 14 (overleaf) *Somerset Landscape.*
Reproduced by courtesy of Patrick Sutherland.

This section explores the extension of the visual beyond ordinary sight and seeing, both metaphorically and literally, and the opening up of visual fields in new sensorial relations, from digital surgery to the daydream.

The limits of vision have fascinated and disturbed commentators from the classical period onwards as the Readings in the earlier sections will by now have suggested. The digital age challenges the nature of those limits and presents a sense of the loss of traditional ideas of vision as new hyper-worlds emerge beyond the normal registers of the senses. However, the desire for the 'beyond' in sight and vision permeates many cultural practices. It is not solely or necessarily a condition of postmodernity of the digital world. Extensions can be, as the Readings in this section show, be realized through eye drops, standing in the wind or daydreaming, as much as through the digital and cyberspace. Such extensions, like dreams, are both in the body and beyond it and can be found to exist in every period of history and in many cultures.

The Readings in this section thus take on various modes of extending visual sense, from technological creations that serve fantasies of technical precision to the workings of the mind that see an ideal world. These latter, in ways that refer back to some of the Readings in *Creativity,* take their cue from a fragment of art or ritual or from the final frontier of daydreaming, where the stirrings of inner life can be indulged and guided along the pathways of fantasies inside the head. They point towards new discoveries and a new world.

The first reading is by anthropologist Tim Ingold. It starts by exploring the extensions experienced in the everyday through the perception of the weather. The visual is translated through the transcendent experience of light beyond the visual to an encompassing sensory experience. This clearly has implications for other Readings in this volume on the experience of the natural world, whether through taxonomic desire or through the description of ice. Ingold's paper extends such thinking into the realms of abstract experience felt but not seen in any concrete way,

The relationship between technical extension and haptic extension is clearly articulated in three of the essays. Historian of medicine Jan-Eric Olsén describes the radical changes in the embodied experiences of surgeons working in a digital environment. The interventionist practices of surgery become more akin to the video game than to the traditional relationships of hand/eye coordinated curative practices of medicine, refiguring the haptic relations of healing. It is a similarly shaped dislocation between the material seen and the mind's eye that informs film-theorist Catherine Lupton's reading of the latest digital multimedia work of the elusive French filmmaker and cinema-essayist Chris Marker. Marker mixes documentary, fiction and philosophy to set up the dreamlike atmosphere in which the world is apprehended

through the senses in an immediate, pre-linguistic and purely sensory entanglement. As such Lupton positions his work as a meditation on the haptic nature of human experience as a whole, something that the cinema seems to be particularly apt in capturing. Memory and image are entangled in the new digital screen that enhances capacities and enables an imaging of movements of the mind in material ways that are decidedly different from earlier such experiments in analogue film. Yet as the reading by Marks demonstrates, the idea of haptic extension can be productively applied to analogue film. She addresses overtly the theme of the haptic potential, and thus extension, of contemporary media in an exploration of the symbiotic relations between haptic qualities, of touch, smell and even taste expressed within film and the materiality of analogue film itself.

What this suggests, and what resonates through other Readings in this section, is the potential for the visually apprehended and materially experienced world to create an extension of experience into another realm. In many ways what characterises these Readings is that, in different ways, all the examples discussed feed off, invert, exaggerate, destabilise and subvert a standard understanding of sight that endows vision with a sure command over the visual object. This becomes very clear when one moves out of the obvious territory of the digital and cyberspace extensions and looks at more apparently traditional and materially grounded forms of visual practice. In such paradigms visual sense can be shown to extend way beyond the material object into realms of imagined, transcendent and ideal worlds.

Anthropologist and art historian Robert Faris Thompson describes that process of transforming sight in the rituals of the Basinjom cult in the Cross River region of Nigeria. In this ritual a plant juice squeezed into the eyes literally transforms and extends sight in order to let a person visualise, to see, the places where witchcraft resides. Very different is anthropologist Christopher Pinney's exploration of what he terms 'corpothetics'—the embodied aesthetic apprehension of visual images—in a village in contemporary central India. Whilst grounded in the everyday image experience of people, he demonstrates how an embodied approach to thinking about sight has the potential to open up the understanding of the apprehension of objects and images. As such it situates responses to images, from the postcard to the extended fantasy spaces of cinema, into a larger image world of the spiritual and the divine. In both these examples sight is extended and transformed in relation to the spiritual realm, beyond the body yet in connection to the body.

While many fantasized worlds of the residence of the witch or the Indian gods go unrecorded as a completed vision of a world beyond, Timothy Hyman's description of the famous fourteenth-century frescoes by Ambrogio Lorenzetti on the concept of good and bad governments in the Palazzo Publico in Siena, Italy, explicitly records visually the connections between the seen world of Siena and the beyond. As such it erases the distinction between the seen and its extensions. Hyman's analysis of the painted visions of the utopian state reveal how they were visualized specifically to perform ideas of the possible and the desired in the grounded public space of the

civic: but heaven and earth had to be brought into synchrony in order that harmony might reign in the universe.

In contrast to the world of fantasized extensions emerging from bazaar images in central India, or on the walls of public buildings in Siena, but in an experientially congruent field, film historian Yuri Tsivian's description of the reception of early cinema in Russia demonstrates that scenes such as a train rushing at audiences at full speed from cinema screens disturb normal human expectations about the order of the world. Extensions are thus ambiguous operations in a sensory field. They might shock but at the same time enchant human attention and, in the final instance, enlarge the field of sight itself. In Tsivian's case it is an unknown world that rushes at the spectator and thus extends his/her field of experience beyond the habituated visual sense. One could applaud at witnessing a new marvel or one could go home with a sense of shocked disorientation.

Like the other groupings in this Reader, *Extensions* and the Readings within it have porous boundaries, overlapping with other sections and Readings. Consequently they can, as we stated in the introduction, be superimposed on and against the previous Readings. For example, one could argue ruptures of sight as necessary for its extensions, in the same way that any attempt at creating or ordering becomes also a mode of extension. Crucially, extensions of sight also imply the possible extension of the other senses.

The final reading is from the French philosopher Gaston Bachelard and his classic book *The Poetics of Space*. This extract explores the daydream of what could be, or the pleasures that exist even now submerged in the labyrinth of our senses, creating a lightness of being which promises the realization of a personal idealized universe that encompasses the real world as well in its idealism.

The Eye of the Storm: Visual Perception and the Weather
Tim Ingold

On a breezy day in early March I was standing on the shore along which the North Sea laps the beach of the city of Aberdeen, in north-east Scotland, where I live. The tide was high, leaving only the narrowest strip of shingle free from the spray of ceaseless and tumultuous breakers. As a colleague once remarked to me, the sea on this side of Scotland has muscles. For a short while, the sky overhead was brilliantly clear, yet towards the north, whence the cold wind blew, mountainous clouds were building up, and a blur upon the horizon portended an imminent shower. Moments later it was upon us. The sea changed from a serene blue to an angry grey, the disappearing horizon swallowed up the ships in the distance, the white foam of the wave-crests that had once sparkled in the sunlight flickered eerily in the all-enveloping gloom, and a mixture of rain and sleet filled the air. Fortunately the shower did not last for long. Almost as suddenly as it had come, it slipped away southwards. The rain stopped, the horizon reappeared, the ships came back into view, and the cloud that had once merged with the sky itself reappeared as a massive presence in the sky, no longer threatening on the retreat. But for that brief period, the world looked completely different, and I felt different too. Yet I had been standing all the while on the same spot, looking out upon what was supposed to have been the same view.

There was, of course, nothing odd or unusual about this. We all know that as the weather changes, so does the look and feel of the world we inhabit. What is odd, however, is that in the scholarly literature on visual perception, scarcely a word is to be found on the question of how the weather impacts upon practices of vision. For the most part, you would think that there is no more weather in the world than in the studio, laboratory or seminar room. This essay is part of an attempt to take the study of eyesight back where it belongs, out of doors. A simple way of putting it would be to say that I am interested in the visual perception of the weather. How do we see what kind of day it is? The matter is immediately complicated, however, by two considerations. One is that our experience of the weather, when out of doors, is invariably multi-sensory. It is just as much auditory, haptic and olfactory as it is visual; indeed in most practical circumstances these sensory modalities cooperate so closely that it is impossible to disentangle their respective contributions. Thus we can normally see

what the weather is like only because we can hear, feel and smell it too. The second complication is that the weather is not really an object of perception at all. We might use our eyes to survey the scene and pick out objects as foci of attention. As I aim to show, however, the weather enters into visual awareness not, in the first place, as a thing we see, or even as a panorama, but as an experience of *light itself.*

Sight and Sound

In order to explain what I mean by this, I should like to dwell for a moment on the question of the difference, and the relation, between vision and hearing. For there is a curious and puzzling asymmetry in the ways these sensory modalities are commonly described. If you ask 'what do we see?', the answer usually comes back in the form of a list of visible *things*—commonly observable objects in the environment. But if you ask 'what do we hear?', the answer will typically comprise an inventory of *sounds*. For example: we see the door, but we hear the banging of the door when a gust of wind slams it shut; we see the black cloud but hear thunder; we see the waves but hear their breaking on the shore; we see the dog but hear its bark, see the man but hear his footsteps, see the bird but hear its call, and so on. Yet surely, vision depends upon light just as much as hearing depends upon sound. Thus if sound is what we hear, then why do we not see light? Why do we so readily assume on the one hand that we see things rather than light, but on the other that we hear sound rather than things? Why are we so convinced that the one thing we do not see, as James Gibson once put it, is 'light as such' (Gibson 1979, 55)?

Here is another indication of the same asymmetry. We often compare sight and sound. It is just as usual to compare sight and sound as it is to compare sight and hearing. Indeed many authors use the terms sound and hearing interchangeably, as though the phenomena to which they refer were really one and the same. But if sight and sound are often compared, light and hearing never are. And if hearing and sound are often regarded as synonyms, vision and light are more likely to be treated as antonyms. This passage from Walter Ong exemplifies the comparison of sight with sound, and the conflation of sound with hearing:

> Sight isolates, sound incorporates. Whereas sight situates the observer outside what he views, at a distance, sound pours into the hearer ... Vision comes to a human being from one direction at a time ... When I hear, however, I gather sound from every direction at once: I am at the centre of my auditory world, which envelops me, establishing me at a kind of core of sensation and existence ... You can immerse yourself in hearing, in sound. There is no way to immerse yourself similarly in sight. (Ong 1972, 82)

Had Ong been as prepared to substitute light for vision as he is to substitute sound for hearing, much of the force of this passage would be eliminated. If sound pours

into the hearer, does not light pour into the viewer? When I stood by the sea on that March day, was I not as much bathed in light as enveloped in sound?

The isolation of the observer that Ong attributes to sight appears to have its source in a peculiar topology of the human head whose roots run deep in western traditions of thought. In this topology the ears are imagined as holes that let the sound in, whereas the eyes are screens that let no light through. Inside the head, then, it is noisy but dark. As sound penetrates the innermost sanctum of being, mingling with the soul, it merges with hearing. But light is shut out. It is left to vision to reconstruct, on the inside, a picture of what the world is like on the outside. Such pictures can of course be wrong, and it is for this reason that philosophers through the ages have been so much more concerned with optical than with aural illusions (Rée 1999, 46). But how did this topology come to be established? How did light and sight find themselves on opposite sides of an apparently impermeable barrier, while sound and hearing did not? The answer lies in a key historical transformation in our understanding of what light actually means, and at the cusp of this transformation lay the towering figure of Renée Descartes.

What Is Light?

Philosophers of antiquity placed man at the centre of the cosmos. From his eyes, rays of light shone out to illuminate the world. But with the Copernican revolution, this anthropocentric cosmology was overthrown. At the centre now lay the sun, a source of radiant energy that—filtered through the atmosphere of our peripheral planet and reflected from its surfaces—excites the eyes of its human inhabitants. Thus the *lux* of the ancients, the light that illuminates the world of our perception, was replaced by the *lumen* of modern physics, an impulse that owes nothing to the human presence or to the workings of the eye. Yet as Descartes realized in his *Optics* of 1637, this physical impulse, striking the eye, gets no further than the back of the retina. So where, he wondered, does the essence of vision reside? Does it lie in the focusing of incident light and resulting stimulation of the retinal nerves, or in the operations of the mind upon the 'raw material' of nervous sensations subsequently passed to it? Is vision an achievement of the eyes or of the mind? To begin with, Descartes seemed to endorse the former view. Why else could he have been so impressed by the potential of the telescope to increase the power of sight? Yet his eventual conclusion was that it is the mind (or soul) that sees, and not the eye. And it sees by constructing an inner picture, on the basis of intelligence received by way of' the eyes, of what the world outside is like (Descartes 1988, 57–68).

So it was that sight, understood as a purely cognitive phenomenon went 'indoors', while light, understood as a purely physical one, went 'outdoors'. Sight and light, confounded in ancient optics, came to be separated on either side of a boundary between mind and world. Yet the true meaning of light remains as enigmatic in our

time as it was for Descartes almost four centuries ago. Thus the physics of light continues to be known as optics, even though it has nothing to do with the eye and repudiates any connection with mental phenomena. And when physicists tell us that light reaches our eyes from afar we believe what they say, even though in our everyday experience, luminosity saturates a world that is only revealed to us through vision. Is light, then, a precondition for, or a consequence of, visual perception? Does it shine in the world or in the mind? When we speak of light, do we mean the physical *lumen* or the phenomenal *lux?*

The answer, surely, is neither. Questions of the meaning of light must be wrongly posed if they force us to choose between regarding light as *either* physical *or* mental. The mistake is to imagine that vision proceeds along a one-way chain of connections starting with material objects and ending with their representation as images in the mind. If this were so, then at some point along the chain nervous impulses registered in the brain would have to be 'turned over to the mind', as Vasco Ronchi put it in his *Optics* of 1957—echoing Descartes' own claim that such impulses 'tickle' the soul (Descartes 1988, 65; Ronchi 1957, 288). While a physiology of vision might tell us what happens on the far side of the turn-over point, and a psychology of vision might tell us what happens on the near side, the turning over itself would remain a mystery.

This mystery, however, is not inherent in the phenomenon of vision itself, but is a by-product of our own categories of thought. In reality nothing is turned over from body to mind. This is because vision is not a one-way process leading from worldly object to mental image, by way of the eyes and the brain, but rather unfolds in circuits of action and perception, without beginning or end, that are set up through the placement of the perceiver from the outset as a being in the world. Thus the phenomenon known as 'light' is neither on the outside nor on the inside, neither objective nor subjective, neither physical nor mental. It is rather immanent in the life and consciousness of the perceiver as it unfolds within the field of relations established by way of his or her presence within a certain environment. It is, in other words, a phenomenon of experience, of that very involvement in the world that is a necessary condition for the isolation of the perceiver as a subject with a 'mind', and of the environment as a domain of objects to be perceived (Ingold 2000, 257–58).

The Light of Being

This is what the philosopher Maurice Merleau-Ponty was getting at, in his celebrated essay on 'Eye and mind'. That we can see *things,* objects in our environment, is obvious and unremarkable. That we can see, however, is astonishing. Yet we cannot see things unless we first can see, and we cannot see unless we are immersed, from the start, in what Merleau-Ponty calls 'the soil of the sensible'—that is, in a ground of being in which self and world are initially commingled (Merleau-Ponty 1964, 160).

For sighted persons, this ground is light. Or to put it another way, light simply means 'I can see'. We are, for the most part, so preoccupied with the things that occupy our attention that we tend to forget the foundational experience upon which it rests. But for a blind person to whom sight has been restored—and doubtless for a newborn baby opening its eyes to the world for the first time—the experience must be overwhelming. Quintessentially, light is an experience of being. As William James once put it, 'the first time we see light ... we are it rather than see it' (James 1892, 14). This is what Merleau-Ponty means by the magic—or delirium (1964, 162)—of vision: the sense that at every moment one is opening one's eyes for the first time upon a world-in-formation. And it is the task of the painter, above all, to recover this sense of being, to witness the 'continued birth' of the world, to rekindle in us the astonishment of vision, and to remind us that there are things to be seen only because we first can see. As Paul Klee wrote in his 'Creative credo' of 1920, 'art does not reproduce the visible but makes visible' (Klee 1961, 76). It brings the world to light.

Just what 'bringing to light' entails can be demonstrated by means of a simple experiment. Close your eyes for a while, then open them. So long as your eyes remained closed you may have felt as though you were shut up indoors, in complete darkness. But did it seem to you, when you opened them again, that you were looking out upon the world through the windows of your unlit house, having opened the shutters? Far from it. It was rather as if the very walls and ceiling of your house had vanished, leaving you out in the open. Bringing the world to light is not a matter of seeing out but of being out (Ingold 2000, 263). The space we inhabit is not set over against an outside world, but is already outside, open to the horizon. Thus, mingling with all we see, we are simultaneously somewhere and everywhere. Flitting like an agile spirit from one place or topic to another as the focus of our attention shifts, we do not so much see things as see *among* them.

Much the same argument can be adduced in the case of sound. If to see, we must be immersed in light, so also to hear, as Ong noted in the passage cited above, we must be immersed in sound. There is no fundamental difference between sight and hearing in this regard, which is one reason why—in practice—their respective contributions to normal multi-sensory perception are so hard to tease apart. Nor however, in order to establish the condition of immersion in sound, need we suppose that it enters the body through the earholes. No more with sound than with light does the physical impulse—in this case comprising vibrations in the medium—get inside the head. For sound, too, is a phenomenon of experience, another way of saying 'I can hear'. Ong, along with countless other writers, forces the contrast between hearing and vision by comparing sound as 'I can hear' with *sight* as 'I see things', rather than with *light* as 'I can see'. Making our way in the world, we hear among things, as we see among them.

Moreover we feel among them too. In just the same way that the experience of light is ontologically prior to the sight of things, so also *feeling* is prior to *touch*. Of course we are forever touching things in our everyday lives, whenever we make

them, or use them, or seek to identify them for what they are. And in more intimate forms of sociality we touch other people, as they touch us. But we could not touch unless we first could feel. Like light and sound, feeling is an experience of being—of a body that is open and alive to the world, or as Merleau-Ponty would say, immersed in the soil of the sensible. Feeling lies in that commingling of the perceiver with the world that provides a necessary foundation for the isolation of things as objects of touch, and of the perceiver as an agent who touches. The action of touch is generally delivered through particular organs, above all the hands, but also the lips, tongue and feet. However, it is the whole body that feels, including even the eyes. Indeed we have only to stand before a warm fire, or alternatively to find ourselves outside on a windy or frosty day, to realize that by opening our eyes we open ourselves to feeling as well as to light. With this observation in mind we can return, after that long detour on the meaning of light, to our original question of visual perception and the weather.

Medium, Substance, Surface

I have already posited that perceiving the weather is above all an experience of light, and have provided some explanation of what this might mean. But now we face another problem. Much has been written on the perception of the landscape; virtually nothing on the perception of the weather. It is extraordinary that something that has such a massive impact on people's activities, moods and motivations, indeed on the whole tenor of social life, has been so little considered. The problem, however, is this: is weather a part of the landscape or is it not? If it is not, does it swirl around above the landscape, or does it actually encompass the landscape, as the earth is encompassed by the great sphere of the sky? If the weather is not part of the landscape, is the landscape, then, part of the weather?

To begin to answer these questions, I turned to James Gibson's classic work on the *ecological approach to visual perception*. Here Gibson proposes a tripartite division of the inhabited world, into *medium, substances* and *surfaces* (Gibson 1979, 16–32). For human beings the medium is normally air. Of course we need air to breathe. But it also allows us to move about—to do things, make things and touch things. It also transmits radiant energy and mechanical vibration, so that we can see and hear. And it allows us to smell, since the molecules that excite our olfactory receptors are diffused in it. Thus the medium, according to Gibson, affords movement and perception. Substances, on the other hand, are relatively resistant to both. They include all kinds of more or less solid stuff like rock, gravel, sand, mud, wood, concrete and so on. Such materials furnish a necessary physical support for life—we need them to stand on—but it is not generally possible to see or move *through* them.

At the interface between the medium and substances are *surfaces*. They are where radiant energy is reflected or absorbed, where vibrations are passed to the medium, where vaporization or diffusion into the medium occur, and what our bodies come

up against in touch. So far as perception is concerned, surfaces are therefore 'where most of the action is' (Gibson 1979, 23). All surfaces have certain properties. These include a certain, relatively persistent layout, a degree of resistance to deformation and disintegration, a characteristically non-homogeneous texture and a particular shape. As illustration, Gibson offers a series of six photographs depicting different kinds of familiar surface (1979, 26–7). One shows the transverse surface of sawn wood, another a field of mown grass, another a woven textile, another the rippled surface of a pond, and another a patch of gravel. In each case, the texture of the surface immediately allows us to recognize what it is a surface *of.*

But there is an odd-one-out in this series. For a sixth photograph is of clouds in the sky. The picture is included alongside the others, an example of just another kind of surface, on a par with wood, gravel, grass and so on. Yet if this were the case, and if surfaces had all the properties that Gibson attributes to them, air travel would be decidedly hazardous! Take a look at the sky on a day such as the one I described at the outset, when I stood by the sea on Aberdeen beach. Shower clouds were building in an otherwise bright blue sky. What kinds of surfaces can you see? Are there really any surfaces at all? Do clouds have surfaces? Indeed Gibson has a particular problem with the sky, which he never manages to resolve. It stems from his peculiarly Cartesian insistence—peculiar, because of his avowed rejection of the Cartesian programme—that while we see by means of light, the one thing we do not see is light itself (Gibson 1979, 54–5). What we see are the *surfaces of things,* by way of their illumination.

You might wonder, then, what we are to make of those phenomena that announce their presence directly, as radiant light. How do we perceive a flaming fire, a candle lamp, the sun, a rainbow, the scintillation of light off water? Gibson's answer, which becomes increasingly strained and unconvincing as his argument proceeds, is that these are all 'manifestations of light, not light as such'. How, then, are we to distinguish 'light as such' from its manifestations? Only by reducing light, in essence, to the *lumen* of modern physics. And this is precisely what Gibson does. 'All we ever see', he insists, 'is the environment or facts about the environment, never photons or waves or radiant energy' (1979, 55). It is at this point that Merleau-Ponty's phenomenology of perception takes over from Gibson's ecological approach. As I have already shown, Merleau-Ponty goes behind the ordinariness of 'I see *things*' (or rather the surfaces of things, what Gibson would call 'facts about the environment') to capture the astonishment of vision, namely the discovery that 'I can *see*'. Another way of saying 'I can see' is light. Seeing is the experience of light, *what* you see is *in* the light.

Let me present an imaginary scenario, nevertheless scripted with actual words. So far as I know, Gibson and Merleau-Ponty never met. But let us suppose that they did, on a fine summer's day. There they are, stretched out on the grass, looking up into the sky. 'What do you see?', Gibson asks Merleau-Ponty. To which the latter dreamily replies: 'I am the sky itself as it is drawn together and unified, and as it begins to exist

for itself; my consciousness is saturated with this limitless blue' (1962, 214). Gibson is unimpressed. Why, he wonders, will this Frenchman not answer the question? He had asked what his companion can *see,* not what he *is.* And in any case, how can he claim to be the sky when he is stretched out here on the ground? Eventually, Gibson responds, 'To me it seems that I see the sky, not the luminosity as such' (1979, 54). Gibson's problem, however, was that he could never figure out *how* the sky should be distinguished from its luminosity. Since all visual perception, for him, is the perception of surfaces, he could only imagine the sky as a sort of surface, set over against the perceiver. To which Merleau-Ponty could respond that the sky is not a surface at all but the world of light itself, to which we *open ourselves up* in vision. 'As I contemplate the blue of the sky', Merleau Ponty insists, 'I am not *set over against* it as an acosmic subject ...' (1962, 214). To see the sky is to *be* the sky, since the sky *is* luminosity and the visual perception of the sky is an *experience of light.* For sighted persons, light is the experience of inhabiting the world of the visible, and its qualities—of brilliance and shade, tint and colour, and saturation—are variations on this experience.

Weather and Landscape

We can now return to our earlier problem. What is the difference, and the relation, between perceiving the weather and perceiving the landscape? 'The atmospheric medium', Gibson writes, 'is subject to certain kinds of change that we call weather' (1979, 19). Thus weather is what is going on in the *medium.* The landscape, by contrast, consists in the first place of *surfaces.* So at a first approximation, we could say that the question of the relation between weather and landscape is really one about the relation between medium and surfaces. For Gibson, as we have seen, while the medium affords perception, *what* we perceive are surfaces, together comprising a landscape. That is why he includes a photograph of a cloud-studded sky in his illustrative series demonstrating the varieties of surface texture. But if the surface is defined as an interface between substance and medium, how can the sky possibly be a surface? What substance lies behind it? If, on the other hand, the sky is not a surface, then how can we possibly see it?

Merleau-Ponty, for his part, does not deny that we see things or features of the landscape, and his account of how this happens has many resonances with Gibson's—for example in his insistence that it involves movement, exploration and discovery rather than the construction of mental representations from the raw material of optical sensation. But vision, according to Merleau-Ponty, goes on against the ground of our immersion in the *medium.* In visual, as indeed in auditory and haptic perception, we open ourselves up to the medium, and this opening is experienced as light, as well as sound and feeling. If, then, landscape is to weather as substance is to medium, could we not conclude that perceiving the landscape differs from

perceiving the weather precisely as the sight of things differs from the experience of light? Thus:

Landscape	**Weather**
Properties of surfaces	Properties of medium
Seeing, hearing and	Experience of
touching things	light, sound and feeling

Perceiving the landscape, then, is a mode of *observation,* perceiving the weather is a mode of *being.*

Let me return to the scene from which I began. I am standing on the beach, on a cold, blustery and showery day. Looking around, what can I see? Starting with a downward glance and then casting my eyes gradually upwards, I see first my own trousered legs and shod feet, then the stones of the shingle on which I stand, then the surging breakers collapsing on the shore, then waves upon waves, capped with foam, gradually panning out into the level expanse of the ocean, then apparently motionless ships silhouetted on the horizon. Continuing the ascent beyond the horizon line, I see the sky, billowing clouds, seagulls wheeling in the sky, and off to the right, the grassy slopes of a peninsula, with a lighthouse at the tip and buildings along the shore leading to the harbour. But I wondered: was I seeing all these things in the same way? And were they really things at all?

There were some things, to be sure. A particular pebble caught my eye. I stooped to pick it up. Holding the stone in my hands, I examined it, and knocked it against another stone to listen to the sound it made. The stone was indeed an object separate from myself, in a way that my legs and feet were not. For I could walk away and leave the stone behind! But what of the ships in the distance? They were visible only from the vantage point at which I stood. I could not walk around them. For this reason they appeared almost two-dimensional, as recognizable shapes rather than the hulking objects they really were. The same was true of the distant buildings and the lighthouse. Most remarkable were the seabirds. Watching a gull wheeling in the sky is quite different from seeing it perched motionless on one of the great wooden pillars of a breakwater. I observed the latter as a thing at rest which, when it subsequently launched into flight, was observed to move. In the sky, however, I recognized the gulls by their characteristic movements, which would only congeal into objective forms when they came in to land. I perceived the bird, upon landing, not as a thing that ceased its movement, but as a movement that was resolved into a thing.

But the movement of the waves never ceased. Unlike a seabird, which can be all movement at one moment and a motionless thing the next, the waves could not reappear as things. They were movements-in-themselves. And the clouds? They did not exactly move, but nor did they stand still like solid objects. Rather they appeared to drift in nebulous formations that billowed up ahead as fast as they faded away

behind. A storm progresses in the same way, continually winding itself up on the advance and unwinding on the retreat. But when the storm cloud is right overhead, you do not see it as a cloud in the sky. Rather the cloud becomes the sky itself and the 'limitless blue' of which Merleau-Ponty spoke so evocatively is replaced by a leaden grey. Moreover the surf of the sea, reflecting the sky, changes colour to match. Thus the sea is ever-changing too, not just in its surface texture, according to the strength and direction of the wind, but also in its brilliance and colour, depending on the luminosity of the sky.

Despite the sheer diversity of phenomena presented to me in my field of vision—feet, stones, birds, ships, waves, sea, clouds, sky—I had no sense of incongruence, disjunction or rupture as I cast my eyes from one to the other. I did not feel immersed in the world at one moment and set over against it at the next. I did however have a powerful sense that behind my recognition of various kinds of objects and surfaces, such as the pebbles of the beach and the waves of the sea, there lay the experience of inhabiting an illuminated world, and that this illumination was in some way *constitutive of my own capacity to see.* The implication is that as the weather changes we do not see different things, but we do see the same things differently. That is why I have gone out of my way, at the risk of some stylistic awkwardness, to avoid referring to the weather as an *object* of perception. Strictly speaking, the weather is not what we have a perception *of,* it is rather what we perceive *in.* For if weather is an experience of light, then to see in the light is to see in the weather. It is not so much an object as a medium of perception.

References

Descartes, R. (1988). *Descartes: Selected philosophical writings,* translated by J. Cottingham, R. Stoothoff and D. Murdoch. Cambridge: Cambridge University Press.

Gibson, J. J. (1979). *The ecological approach to visual perception.* Boston: Houghton Mifflin.

Ingold, T. (2000). *The perception of the environment: Essays in livelihood, dwelling and skill.* London: Routledge.

James, W. (1892). *Psychology* New York: Henry Holt.

Klee, P. (1961). *Notebooks. Vol. I, The thinking eye.* London: Lund Humphries.

Merleau-Ponty, M. (1962). *Phenomenology of Perception,* translated by C. Smith. London: Routledge & Kegan Paul.

——— (1964). *Eye and mind,* translated by C. Dallery. In *The primacy of perception, and other essays on phenomenological psychology, the philosophy of art, history and politics,* edited by J. M. Edie. Evanston, IL: Northwestern University Press.

Ong, W. (1982). *Orality and literacy: The technologizing of the word.* London: Methuen.

Rée, J. 1999. *I see a voice: A philosophical history of language, deafness and the senses.* London: Harper Collins.

Ronchi, V. (1957). *Optics: The science of vision,* translated by E. Rosen. New York: Dover.

–6.3–

Basinjom and the Witches
Robert Farris Thompson

The Basinjom cult is one of the two most important traditional societies of the upper Cross River in Nigeria. The origin of the cult is Ejagham. "Basinjom" in Ejagham literally means "the future brought by God,"[1] an allusion to the divinatory powers of the spirit and the belief that the goodness of his power, to heal and protect the people, stems ultimately from God. The Basinjom cult seems to have emerged in what is now southeastern Nigeria in the Oban region about 1909. It was then called *Akpambe;*[2] there were cognate societies with masks of a similar kind in existence in that area at the time. Thereafter it spread, to the northeast, so that by 1930 the cult was present among the Ekwe Ejagham near the present Nigerian border, in Cameroon.

The main purpose of the Basinjom cult is the detection and exposure of witchcraft. The success of the society in Kenyang—the first lodge in upper Kenyang in the Mbang clan area was at Defang in 1932[3]—relates to the prohibition of older methods of exposing witchcraft.

The essential power of Basinjom lies within his eyes: "to see pictures of the place of witchcraft—that is the force of the Basinjom image."[4] The importance of mystic vision controls as an operating metaphor, both the initiation and masked dancing within the cult. Thus when a man is initiated, in a ceremony called The-Pouring-Of-The-Medicine-Within-The-Eyes (*bajewobabe*), the initiating priest and an assistant, prepare a mixture of material taken from the African Tulip Tree and palm wine. They place the fluid in the specially prepared, folded, conical leaf which serves as eyedropper. They allow the mixture to marinate in palm wine.[5] The medicine is dropped in the eyes of the initiate, through the aperture at the point of the cone of the folded leaf container. The medicine stuns the initiate. It is believed to, "wash his eyes magically, so that he can see the place of witchcraft." The medicine also aids him to gain the possession state without which he cannot wear the gown.[6]

Upon initiation into the second grade, eyedrops are administered to the postulant. He stands on two stones, has the drops put into both eyes by the priest, stares at the light of the sun for a second, and is given his own cutlass and told to wipe the droplets from his eyes with the sharp edge of this instrument. He does this. He then immediately extends his right hand, holding the matchet, and cries, *Kwa! Ko Haiyo!* His fellow initiates answer, *njom!*

Following cash payments, ritual scarification of his ankles, wrists, forehead, and back, "to make the person lighter, so that when he carries the gown if he should meet any charms set within the road their force will be kicked back to their makers," he is given a fascinating array of protective pieces of bark (from several species of trees) which space does not allow me to discuss.

He is taken to the Basinjom grove for further instruction. In the grove he is given the lore of the cult. He is fed several feasts of boiled bush pig, pepper, and rice. He is given further dosages of the African Tulip Tree medicine in his eyes. In an initiation,[7] an initiate receives eyedrops in the *bajewobabe* portion of the ceremony, the initial stunned reaction, as the full effect of the stinging drops is felt, the ritual cleansing of the eyes with the sharp edge of a cutlass, and the return to laughter of another initiate, who has successfully mastered these tests. Later the initiate will be shown how to mime in Ejagham action writing the details of this ceremony, including a mime of administering the eyedrops in which he will play the roles of both initiator and initiate.

The brief staring at the heat of the sun, the hot sting of the drops in the eyes, and the ability, while in a stunned state, to calmly lift a sharp instrument (itself born in the heat of the forge) to the eyes, are orchestrated demonstrations of manful "cool" and discipline. These tests prove the member will know what to do and how to conduct himself when confronted later with the horrific heat of the vision of the place of witchcraft.

Iconographically, the essential moment of the initiation to the second grade follows after another dosage of eye medicine. The senior priest leads the postulant to an opening in the Basinjom grove where he discovers the Basinjom mask and gown displayed next to an image of the *ekponen* owl. The initiate has, according to instruction, picked up a pebble, moistened it with his mouth, and placed it within the vessel supported by the abstract image of the owl. This act combines his spirit with that of his brothers, all of whom have deposited similar pebbles from their mouths within the water in the vessel. The priest begins a lengthy exegesis:

> Here is the *ekponen* owl, representing all the medicines of the forest, the whole study of them. It is a bird which will see demons for you. In the night, when you sleep, you will hear it, *kwa! kwa!*, the sound of that owl late at night.
>
> As that pot sounds, so you will stand, in truth, with your brothers. If you lie to a member, the owl will paralyze your hand and leg and you will never walk again.
>
> The egg inserted in the staff which supports the vessel is a watchman, guarding the bird, protecting the *ekponen* owl.
>
> The chains [of braided vegetal matter] are the legs of the bird. These legs move in the night and the bird looks around.
>
> The water in the vessel is a power. If a person comes to this place to work evil against us, the whole area becomes as a sea.
>
> The raffia fronds are a sign of danger, that you should know this is a forbidden thing of the forest.
>
> As that pot stands, all the medicines of Basinjom stand. This bird is the source of your vision and your power. All the medicines that compose the Basinjom arc put within that

vessel. The medicine we have placed in your eyes purifies your sight so you can see. As you go deep into our society you will learn to enter the body of that bird to spy on the place of witchcraft, to see 'the place.'[8]

The words of the initiator reveal Basinjom and the owl as an essential Janus, a polarity in act and vision which cannot be guessed at in the context of the dance in public. The priest turns to the Basinjom gown. The explanation of its elements is given:

You see the knife, resting on the gown. This is the knife called *isome*. It is for strong members [initiates to the second grade]. With this knife one sees many things. You see the place of the witches. You see fully what is happening there. The other instrument [made of wicker; you place with your left hand to your ear] to hear, the *sound* that evil makes.

The blue feathers [of the touraco] mean: 'war bird.' You know this spirit goes to war against the witches. These are feathers of a very strong bird. One that cannot be easily shot by a gun. It moves around with the brothers in Basinjom. It is a very strong kind of bird.

The three red feathers stand for the same danger that the blue feathers stand for—anything that comes from a bad, hot thing is symbolized by these feathers which are red.

The porcupine quills [inserted among the feathers] stand for prevention against the whole of the work of thunder and lightning; they are very strong medicine.

The roots [inserted within the feathered headdress] symbolize members entitled to wear this gown. You will be given a root. If there are five members who can wear this gown in our lodge, there will be five roots standing on the head. If you are going to dance in the gown, I will remove the root, chew on alligator pepper, take the root, and blow on it, repeating your name, and crying *apa toi! apa toi! toi!* mention your name and finish with the word *aba!* This will awaken the spirit and make you become possessed by Basinjom.

The eyes of Basinjom are mirrors. Mirrors are a sign of seeing into other worlds, to the place of witchcraft. The mirror eyes move in the night to see and predict. The mirrors are also examples of the work of the medicine we have put in your eyes. It stands for the work of the medicine, that you can now see anything.

The long snout is the mouth of the crocodile. It is for controversial things, to speak far for the people. We break eggs in their shells over this snout to feed Basinjom [the snout has a deeper meaning which is not revealed until the fourth stage, *i.e.*, that a person in the last grade becomes as a member or brother to crocodiles in the river who become intimate with him and love him. The bones and shells found inside the Dwarf Forest Crocodile [*Osteolamus tetraspis*] are sewn to the outside of the gown of the wearer, as a sign of embodied and controlled evil].[9] The shells 'come from a bad thing, fighting bad things, using parts of the body of bad animals.'

In the mouth of Basinjom is a piece of the King Stick, the most powerful tree in the forest. No witch can fly over the tree from which the King Stick comes. We use it for our bodies, to protect against the witch-sent illness and against lightning barrages.

The back of the head of the crocodile is made of many herbs, collected and pounded together and mixed with liquid medicines and applied to the back of the head to protect the mask from thunder and poisoned magic. At the back of the head is a small mirror,

meaning Basinjom 'sees behind' and a small upright peg, 'something like a small body-guard, with an amulet attached to his tiny neck, both protecting Basinjom against thunder or any danger coming from the rear.'

The gown is dark, deep black; someone who will do evil will wear a dark gown. It is, as we say, something which will 'not hold death.' That is, when you are in darkness, no one can see you, no witch can perceive you.

The raffia hair and hem are taken from the forest and they mean: danger, something men who are not strong should avoid.

The skin of the genet cat is a demon who catches fowls from our farms. We use it to invoke the spirit of that animal-familiar so as to have protection against them.[10]

The preceding exegesis—actually a composite from explanations given by initiators from Kendem, Mamfe, and Defang—does not, for all its detail, exhaust the iconic complexity of the Basinjom image. Like a witch moving with familiar animals, Basinjom mixes in a marvelous way parts of one dangerous animal with another and garnishes the combination with further additions of natural power from the animal and mineral realm. He is owl, crocodile, war bird, tree, lightning, darkness, and cat—all at once, all at the same time.

Standing beside him in his forest grove is the image of his other pair of eyes, the eyes of the owl. They form, I repeat, the essential Janus, reminiscent of the whole world of Janus allusions which so strongly colors the visual tradition of the Ejagham people who first imagined this extraordinary weapon. The *ekponen* owl kills with water, Basinjom kills within water as a crocodile. The feathered owl of magic vision is transformed into the blue-feathered bird of war. The owl is guarded by an egg; Basinjom is guarded by the tiny image set within his occiput. Both take the dress of danger, raffia fronds. Both are conceived in terms of magic ambulation, the owl of the forest walking on strange, long legs, Basinjom, as we shall very shortly see, moving about, like a mystic hovercraft.

The explanation of the meaning of these forms within the grove is a necessarily didactic moment, in which the initiate is given a body of traditional notations, about the powers of the owl and the powers of the Basinjom image, from which he takes his justification. But in the dance, the owl and image run together in a single form. All the elements of necessary danger fuse, with a self-sufficiency and fullness reminiscent of the force of music. Basinjom, in the dance, speaks of the conquest of all evil, with an ascending tone, a pure poetic act which fuses his gown and motion in single symphonic structure.

Notes

1. Informant, Peter Eno, Mamfe, June 1969.
2. P. Amaury Talbot, *In the Shadow of the Bush* (London: William Heinemann, 1912), p. 198.

3. Informant: Chief Defang, Upper Banyang, 1973.

4. *Ibid.*

5. I am grateful to the elders of the Defang Basinjom society for the privilege of documenting initiatory details within their grove on the outskirts of Defang in March 1973.

6. There are four grades within the society; I am concentrating on the second, that which entitles a man to wear the gown and learn its meaning. For the sociological background of the Basinjom cult among the people of Kenyang see Malcolm Ruel, *Leopards and Leaders: Constitutional Politics Among a Cross River People* (London: Tavistock 1969), pp. 210–3.

7. Videotaped in a Basinjom grove in upper Banyang in March 1973, then copied, photographically, from the videotapes, in Los Angeles.

8. Solomon Ekong, priest of Basinjom spoke; his words were translated by Chief Defang and later glossed both by Defang and Ako Nsemayu, independently, the latter receiving my materials with great care at Mamfe, both in March and June 1973. At Mamfe, Moses Akpa added details missing from the original documentation. The account is therefore a synthesis.

9. There are examples of the Basinjom head and gown in the collections of the Museum für Völkerkunde, Basel, in the Dublin Museum, and the Nigerian Museum, Lagos.

10. Eking, Defang, Nsemayu and Akpa, March and June 1973. The merits of this account belong entirely to these men.

–6.4–

The Cultural Reception
of Early Cinema in Russia
Yuri Tsivian

The Arrival of a Train: Distorted Space and Yawning Foreground

Can we hope to reconstruct the figure of the 'first viewer' of the then-new medium of film by assembling scraps of non-filmic evidence? The impression made by Lumières' early film *The Arrival of a Train* (1895) could not be repeated by later filmmakers, however hard they may have tried. Similarly, there is no point in scrutinizing other films released by the Lumières in order to establish their initial impact. One can say that it was not so much the Lumières as the viewer personally who authored the train effect. The film survives but we have lost its viewer.

From 1907 on (or did it start earlier?) memoirists and film historians began trying to construct a figure of the 'naive viewer', someone who believed in the reality of what was, in fact, a mere image. Should we take for granted the viewer implied by the screenwriter Alexander Voznesensky when he recalled the calming assurances that the management felt compelled to issue at the entrance to the cinema: 'It is a real train, but it cannot come off the wall'?[1] The fictional nature of such a figure has been exposed by Christian Metz and Tom Gunning.[2] An alternate approach should probably focus on the reconstruction of the cognitive experience of the first viewers. While the 'naive viewer' is a historiographic fiction, the 'innocent' viewer, that is, a viewer with untrained cognitive habits, can be proposed as a historically more helpful figure. Not only did the reactions of a person totally unfamiliar with moving images belong to a different emotional register, his 'reading of space' was different from ours. Was moving photography perceived as something so life-like as to be confused with reality? Yes and no. While all accounts of a first visit to the cinematograph stressed how 'life-like' it seemed, some also mentioned that the space on the screen looked distorted. Two accounts published in 1896 complained that the screen perspective was 'not right'. O. Winter wrote in an English newspaper in May 1896:

> The disproportion of foreground and background adds to your embarrassment, and although you know that the scene has a mechanical and intimate correspondence with truth, you recognize its essential and inherent falsity ... the most delicate instrument [the

Lumières camera] is forced to render every incident at the same pace and with the same prominence, only reserving to itself the monstrous privilege of enlarging the foreground beyond recognition.[3]

While specialists in cognitive psychology and perspectival research may have their own explanation of this effect,[4] a Russian press review of 1896, quoted in his memoirs by the cameraman Alexander Digmelov, tended to explain it by positing the excessive clarity of background images. Background objects—argued the reviewer—had to be portrayed with a certain indistinctness (called aerial perspective in classical art theory) in order to signal that they were further away:

> Were it not for the unfortunate *lack of aerial perspective,* which makes the background figures seem incredibly tiny, while those at the front are grotesquely enlarged, the Lumière cinematograph could fool even the sharpest eye. [my emphasis][5]

The 'lack of aerial perspective' signaled that the image was perceived as being all too clear, with too many things in it to see. In fact, the Lumière films contradicted a basic convention, almost a reflex drilled into the European viewer by the canons of post-renaissance painting: the image should have one focus, the centerpiece preselected by the artist and signaled to the onlooker by obscuring other, less important details, either by deliberate overlapping or by the indistinctness of aerial perspective or by some other definition-reducing technique. Some nineteenth-century artists questioned the convention by giving equal weight to all parts of the painting (like Pierre Puvis de Chavannes), by denouncing aerial perspective (like Ferdinand Hodler) or by giving too much realism to peripheral details (the Pre-Raphaelites). In such cases the cultural norm of realism (which is always lower than the contemporary technique of representation is able to offer) was exceeded, which paradoxically, resulted in loss of image credibility. The uncentred image refused to guide the gaze, and was perceived as cold, neutral and uninhabited. The neutrality of treatment made the world of the image look metaphysical and dreamlike.[6] The effect was similar to that of the trompe-l'oeil, to hyper-realist painting, or—to return to the Lumières—to the impact of the moving image upon the first film viewers: the image was too perfect to be true.

In terms of its reception, *The Arrival of a Train* fell into two parts: before and after the train stopped. Before it stopped the viewer reacted to the engine bearing down on him. As soon as it stopped, the second 'attraction' was on display: the crowd swarming on the station platform. Georges Sadoul has observed the importance of this moment: 'twenty doors all opened at once and the whole composition suddenly changed.'[7] Because of this constantly shifting overlapping, the moving image must have looked as though it was randomly generated, the embodiment of chaos. We only have to imagine what an inexperienced viewer might have felt seeing figures hurrying along a platform (towards the camera) and overtaking one another, i.e. in turn

overlapping others and being themselves overlapped, to sympathise with the English reviewer, Winter, who complained feelingly:

> A railway station, for instance, is a picture with a thousand shifting focuses … Both the cinematograph and the Pre-Raphaelite suffer from the same vice. The one and the other are incapable of selection.[8]

However, what made the image look really strange was the effect of disappearing figures. The great majority of accounts mention the fear of the train bearing down upon the viewer. We are not given much information about what happened at the Lumière shows when this tension was resolved. In this respect L. R. Kogan's recollection is important because it registered a quite separate moment of 'attraction' in the Lumière film: the cognitive (or should we say, 'geometric'?) riddle that confronted the viewer as soon as the locomotive was out of frame—'where has the engine gone?' according to Kogan's memoirs, 'a train appears in the distance coming with great speed right towards the auditorium. There is an involuntary commotion in the audience, a cry of alarm, *then laughter:* the engine and the carriages have slipped away somewhere to the side [my emphasis]'.[9] For the viewer who did not yet have any cognitive model helping him to account for the disappearance of the locomotive, it was easier to image that the train swerved away at the last minute than to place it mentally (as we do not) in a topologically ambivalent 'buffer zone' which we sense simultaneously behind our backs (a signal coming from the camera's field of vision) and, as it were, between us and the screen (a proprioceptive awareness that the position of the viewer and the camera's field of vision do not coincide).[10]

Disappearing figures turned the screen into an uncanny kind of 'black hole' swallowing up everything coming near its edge. Gorky was particularly hypnotized by this quicksand effect. Writing about what seems to be *La Place des Cordeliers* (1895) (titles are not mentioned in his articles), Gorky observed: 'the carriages come straight out towards you, straight out into the darkness where you are sitting … [Life is] in motion, alive, vibrant; it comes into the foreground of the picture and then just vanishes.'[11] Gorky had published two articles on the Lumière Cinematograph, and in both of them he dwelled upon the bizarre phenomenology of the screen as a singular zone of non-being that the characters could not surmount and that turned them to nothingness.

Awareness of the Screen

Unlike the modern spectator, the early viewer was very screen-conscious. In his memoirs Ivanov-Barkov described the metamorphosis of the screen from rectangle on the wall to window on the world as an attraction in its own right.

> Suddenly a blueish flickering rectangle flashed up in front of us … And then something miraculous that we had never seen before the walls of the booth instantly vanished and

the rectangle turned into a window thrown wide open, right on to one of the most famous cities in the world—Paris! ... Live people—walking, running, rushing in all directions! One of them came right up to us, said something, gave us a wave and hurried on.[12]

The screen appeared as an ambiguous and elusive membrane, a boundary between 'us' and 'them' that—at the same time—insisted that no boundary existed at all. As we know from a number of accounts, this curious surface appealed to the sense of touch. Most memoirists explain it by referring to the realism of the medium: 'the picture show made such an amazing impression on me that after the train scene I got up to take a look behind the screen.'[13] Of course such a response may well have been prompted by straightforward curiosity, and perhaps it is only a myth that the 'naive' spectator wondered 'how they managed to get Paris behind that screen?'; when we see a rabbit produced out of a hat we are more intrigued by the hat than by the rabbit. The desire to touch must have been caused by the substance of the screen rather than by the image on it. What magic stuff was it made of? What did it feel like? What is waterproof? The ladies watching the Lumière film *A Boat Leaving Harbour* [Barque sortant du port, 1895] gathered up their skirts, and after the performance was over anybody who wanted to was allowed to touch the screen.[14] The paradox of the screen was that its surface seemed at once penetrable and impenetrable, substantial and immaterial, transparent and opaque. Early accounts are often more rewarding than memoirs. Stasov's letter of 1896 describing *A Boat Leaving Harbour* indicated the very subtle way awareness of the screen interfered with the perception of the image; one feels its rectangle engraved into the scene:

> Imagine that you suddenly have the open sea in front of you, no shore at all: the shore is the bottom edge of the picture right in front of where we are sitting in our chairs and armchairs ... And the waves are getting bigger and bigger all the time, they are rolling in from far out and coming on right up to you ... on and on, leaping up and crashing down, and the lines of surf are breaking right against the front edge of the picture.[15]

Stasov's way of describing the film (actually, of misreading it) clearly reveals the perception 'error' the contemporary viewer made while watching the Lumière films: a discursive component of the image ('the front edge of the picture') was 'mistaken' for its diegetic component—the missing shore ... Such 'misprojections' of discourse upon diegesis were a universal rule of early film reception. Of course, we can only call it 'misreading' in a very relative sense. No one was ever really deceived by early films but, rather, as Gunning has shown, the spectator was willingly misled by the optical games they offered.[16]

Very soon, however, acute awareness of the screen gave way to its opposite. While the very first exhibitors exposed the screen to touch, in the early 1910s we observe the tendency to conceal the screen, to cover it with a curtain ... This new attitude towards cinema's technological anatomy was part of its ongoing cultural

absorption. The exhibitors' desire to make their theatres conform to the received cultural norm coincided with the filmmakers' growing inclination to tell conventional stories in a convention manner. The Screen was not only covered up, it was suppressed as a factor of text reception.

Notes

1. A. Voznesenskii, 'Kinodetstvo. (glava iz 'Knigi mochei')' [A Childhood at the Moving Pictures. (A chapter from 'A Book of Nights')]. *Iskusstvo Kino,* 1985, no. 11, p. 78.
2. C. Metz, The Imaginary Signifier: Psychoanalysis and the Cinema (Bloomington, 1982), pp. 72–3. For Gunning's polemics with Metz see his 'an aesthetic of Astonishment: Early Film and the (In)credulous Spectator,' *Art and Text,* spring 1989, no. 34, pp. 32, 42.
3. O. Winter, 'The Cinematograph'. *Sight and Sound,* autumn 1982, pp. 294–5.
4. The most likely explanation is that this was due to the persistence of habits of vision that were not accustomed to, and not activated by, the flickering impulses of screen movement. At a seminar on film reception conducted at the British film Institute in 1990, Geoffrey Nowell-Smith suggested that the observer's ability to read perspective could also have been dependent on where he or she sat in the auditorium.
5. A. D. Digmelov, '50 let nazad' (Fifty Years Ago), p. 2. Typescript in the V. Vishnevsky archive, GFF.
6. The effect is convincingly analysed in: A. Mackintosh, *Symbolism and Art Nouveau* (London, 1975).
7. G. Sadoul, *Louis Lumière* (Paris, 1964), p. 48.
8. Winter, 'The Cinematograph', p. 295. Compare with what Gunning has to say on crowd views as focuses of attraction: 'New centers of interest bob into the frame unexpectedly, while others depart beyond reclamation. The receptive spectator approaches these images with the global curiosity about its 'many interesting phases', a curiosity that is being endlessly incited and never completely satiated. The street is filled with endless attractions' (T. Gunning, 'The Book that Refuses to be Read: Images of the City in Early Cinema', forthcoming).
9. L. R. Kogan, *Vospominaniya* [Memoirs] pt. 2, no. 1, 1894–7, GPB, 1935/35, p. 39.
10. If it really was the Lumière film that Kogan was remembering, and not another film in which the train actually cut away at the last moment, one may assume that the early viewer constructed the space within the shot as curving within the diegetic area close to the screen. The gradient of depth that the growing size of the locomotive signaled while it was within the field of the image disappeared as soon as the locomotive was out of field—and the space immediately 'flattened'. If this hypothesis is valid (which only a specialist in visual perception can tell),

it can be confirmed by a similar effect described in a contemporary account of the Lumière film *La Place des Cordeliers* (1895): 'One of the carriages, drawn by galloping horses, was coming straight at us. A woman sitting next to me was so frightened that she jumped to her feet ... and wouldn't sit down *until the carriage had turned round and disappeared* [my emphasis]' (quoted in: Sadoul, *Louis Lumière,* p. 32).

11. M. Gor'kii, 'Beglye zametki' [Fleeting Notes], *Nizhegorodskii listok* [The Nizhny Novgorod Newsletter], no. 182, 4 July 1896, p. 3.

12. I. N. Ivanov-Barkov, 'Vospominaniya', p. 105.

13. Ya. A Zhdanov, 'Po Rossii's kinogovoryashchimi kartinami'. [around Russia with Talking Pictures], p. 1. Typescript in the Soviet Cinema Section of VGIK.

14. This fact is referred to in: D Vaughan, 'Let There be Lumière', in: T. Elsaesser and A. Barker (eds), *Early Cinema: Space, Frame, Narrative* (London, 1990), pp. 63–75.

15. 'Stasov o kinematografe', pp. 127–28.

16. Gunning, 'An Aesthetic of Astonishment', pp. 31–45.

–6.5–

Haptic Cinema

Laura U. Marks

Whether cinema is perceived as haptic may be an effect of the work itself, or it may be a function of the viewer's predisposition. Any of us with moderately impaired vision can have a haptic viewing experience by removing our glasses when we go to the movies. More seriously, a viewer may be disposed to see haptically because of individual or cultural learning. The works I describe here have intrinsic haptic qualities, to which a viewer may or may not respond. Similarly, there may be historical periods when cinema is perceived more or less optically or haptically.

In its early years cinema appealed to the emerging fascination with the instability of vision, to embodied vision and the viewers' physiological responses (Gunning 1990, Lastra 1997). Like the Roman battle of the haptic and the optical a battle between the material significance of the object and the representational power of the image was waged in the early days of cinema (at least in the retrospection of historians). The early cinema phenomenon of a "cinema of attractions" (Gunning 1990) describes an embodied response, in which the illusion that permits distanced identification with the action on screen gives way to an immediate bodily response to the screen. Noël Burch (1986) also notes this connection, suggesting that early cinema appeals to the viewer not through the analog representation of deep space but more immediately. As the language of cinema became standardized, cinema appealed more to narrative identification than to bodily identification. In theories of embodied spectatorship, we are returning to the interest of modern cinema theorists such as Benjamin, Bela Balász, and Dziga Vertov in the sympathetic relationship between the viewer's body and the cinematic image, bridging the decades in which cinema theory was dominated by theories of linguistic signification.

The term *haptic cinema* has a brief history. The first attribution of a haptic quality to cinema appears to be by Noël Burch, who uses it to describe the "stylized, flat rendition of deep space" in early and experimental cinema (1986, 497). Antonia Lant (1995) has similarly used the term "haptical cinema" to describe early films that exploit the contrast between visual flatness and depth. She notes the preponderance of Egyptian motifs in such films and posits that early filmmakers were, like Riegl, fascinated with Egyptian spatiality. Deleuze uses the term to describe the use of the sense of touch, isolated from its narrative functions, to create a cinematic space in Robert

Bresson's *Pickpocket* (1959). He writes, "The hand doubles its prehensile function (as object) by a connective function (of space): but, from that moment, it is the whole eye which doubles its optical function by a specifically grabbing' [*haptique*] one, if we follow Riegl's formula for a touching which is specific to the gaze (1989, 12). To me, Deleuze's focus on filmic images of hands seems a bit unnecessary in terms of evoking a sense of the haptic. Looking at hands would seem to evoke the sense of touch through identification, either with the person whose hands they are or with the hands themselves. The haptic bypasses such identification and the distance from the image it requires. A writer whose use of "haptic cinema" is most similar to my own is Jacinto Lejeira (1996), who discusses the relation between haptic and optical visuality in the work of Atom Egoyan. He notes that Egoyan uses different processes, such as speeding up video footage in the film, enlarging the grain, and creating *mises-en-abîme* of video within film, to create a more or less optical or haptic sensation. "These techniques function in such a way that the overall image ... seems to obey an instrument capable of bringing the spectator's opticality or tactility to a vibratory pitch of greater or lesser intensity" (1996, 44). I agree with Lejeira that these visual variations are not formal matters alone but have implications for how the viewer relates bodily to the image (46).

How does cinema achieve a haptic character? Many prohaptic properties are common to video and film, such as changes in focus, graininess (achieved differently in each medium), and effects of under- and overexposure. All of these discourage the viewer from distinguishing objects and encourage a relationship to the screen as a whole. Haptic images may raise ontological questions about the truth of photographic representation: this is the effect of the reproduced image in films such as *Blow-Up* (1966, Michelangelo Antonioni), *Sans soleil* (1982, Chris Marker), and works by Atom Egoyan that employ video within the film (for example, *Family Viewing*, 1987, and *Calendar*, 1993). Haptic images may also encourage a more embodied and multi-sensory relationship to the image in films that use haptic imagery in combination with sound, camera movement, and montage to achieve sensuous effects, such as *The Piano* (1993, Jane Campion) and *Like Water for Chocolate* (1993, Alfonso Arau).

Both film and video become more haptic as they die. Every time we watch a film, we witness its gradual decay: another scratch, more fading as it is exposed to the light, and chemical deterioration, especially with color film. Video decays more rapidly than film, quickly becoming a trace, a lingering aroma with few visual referents remaining. As the tape demagnetizes, lines drop out, and in analog videocolor becomes distorted. Video decay is especially significant for emigrants and exiles who treasure old, hard-to-get, or boot-legged tapes from "back home." Because they are so hard to find, these videos quickly lose their status as mechanically reproduced media and become rare, unique, and precious objects. A tape that deals poignantly with video decay is *Sniff* (1996) by Ming-Yuen S. Ma, who has used haptic imagery in several works, including *Aura* (1991) and *Slanted Vision* (1995). In this short tape, the

decay of the video image evokes the failure of memory. A man, played by Ma, crawls naked on his bed, bending to the sheets to search for traces of smells. Repetitively, Ma's voice-over describes his one-night stands: "M came over last night. He had two scoops of ice cream, and some chocolate." Though the telling is coy, the increasing desperation of his search makes this a work not only about the transience of love, but also about loss in the time of AIDS. Optical images of Ma crawling on the bed give way to tactile close-ups, for example, of the individual hairs gleaming on his shorn scalp. Finally, through analog dubbing, the image begins to break down: it loses its coherence the way smell particles disperse, taking memory away with them.

Other haptic effects are medium-specific. In film, techniques such as optical printing, solarization, and scratching the emulsion work with the physical surface of the medium. For this reason it is commonly argued that film is a tactile medium and video an optical one, since film can be actually worked with the hands. My definition of visual tactility, however, has little to do with physical texture and mainly to do with the way the eye is compelled to "touch" an object in the way I have described. The techniques noted above do not necessarily make a film look tactile. However, optical printing can build up many layers of images on the film, producing a thicket of barely legible images. Many experimental filmmakers have used optical printing and physically worked the emulsion to achieve effects that can be described as haptic. The works of a relative newcomer to the tradition, Canadian filmmaker Gariné Torossian, *Visions* (1991), *Girl from Moush* (1993), and *Drowning in Flames* (1994), make a nod to postmodernism in that the images they draw from are already once-reproduced: photographs, reproductions of artworks, images shot from a video monitor. However, Torossian physically reworks these images in a way that thoroughly restores their aura, or endows them with another aura. Every frame contains two or more optically printed images and more images that Torossian cuts out and glues onto the film. Many frames are scratched for additional texture, or discolored and bubbled by the glue she uses. Her sound tracks are similarly layered and dense. To look at these works is to be drawn into a world where scale is completely different, as though one has to become miniaturized like Alice in Wonderland in order to perceive the complex texture of the films. These richly textured, miniature scenes compel a viewer to move close, yet they also multiply points of visual contact all over the screen. At the same time, they inhibit identification with the pictured objects, so that in *Girl from Moush* the icons of the artist's ancestral country, Armenia, including churches like those featured in Egoyan's *Calendar,* are ever more difficult to distinguish, let alone to fetishize as the photographer of *Calendar* does. Torossian says that the densely worked surfaces of her films pay homage to her Armenian aunts' and grandmothers' knitting and crocheting (Hoolboom 1997, 149, 151; Torossian 1998). Like the sweaters and doilies they produced, her films embody hours of women's labor in the complexity of their textures.

For 16mm and 35mm film, the contrast ratios (ratios of light to dark areas of the image) approximate human vision, or about 300:1 (Belton 1996, 71). Their grain is

not visible under normal conditions (unless you sit too close to the screen). However, the grain of 8mm film is easily visible, as is the grain of higher-gauge film shot at high speed or in low light. Graininess certainly produces a tactile quality, as the eye may choose between concentrating on figures and ignoring the points that make them up or bracketing the figures and dissolving among the points. Interestingly, it can also be the high resolution of film that gives it a tactile quality. Films that, like Torossian's, seem to contain more visual texture than the eye can apprehend, have the effect of overwhelming vision and spilling into other sense perceptions.

The main sources of haptic visuality in video are more varied: they include the constitution of the image from a signal, video's low contrast ratio, the possibilities of electronic and digital imaging, and video decay. The video image occurs in a relay between source and screen. As Ron Burnett (1995) and others note, the video image's status as index is less secure than that of the film image, since it does not originate from a material object (of celluloid/acetate). Hence variations in image quality, color, tonal variation, and so forth occur in the space between source and viewer, affected by conditions of broadcast or exhibition as well as (literal) reception. Control of the image is much more open to negotiation in video, while in film the qualities of the image are chemical effects that cannot be significantly changed after the film has been processed.

Another source of video's tactile, or at least insufficiently visual, qualities is its pixel density and contrast ratio. VHS has about 350,000 pixels per frame, while 35 mm film has twenty times that (Bordwell and Thompson 1997, 31). The contrast ratio of video, or ratio of dark to light areas in the image, is 30:1, or approximately one-tenth of that of 16 mm or 35 mm film (Belton 1996, 71). Thus while film approximates the degree of detail of human vision, video provides much less detail. When vision yields to the diminished capacity of video, it must give up some degree of mastery; our vision dissolves in the unfulfilling or unsatisfactory space of video. The same effects can occur in multigenerational or badly recorded video images—but their implications are quite different, for in these works the viewer is more likely to find the image's blurriness merely a frustration and not an invitation to perceive in a different way.

A third intrinsic quality of the video medium, and an important source of video tactility, is its electronic manipulability (see Herzogenrath 1977). The tactile quality of the video image is most apparent in the work of videomakers who experiment with the disappearance and transformation of the image due to analog and digital effects. Electronic effects such as pixellation can render the object indistinct while drawing attention to the perception of textures. Pixelvision, the format of the discontinued Fisher-Price toy camera that used audiocassette tapes, is an ideal haptic medium. Pixelvision, which cannot focus on objects in depth, pays a curious attention to objects and surfaces in extreme close-up. As a result, some of the best Pixelvision works focus on scenes of detail. Yau Ching's three *Video Letters* (all 1993) take advantage of the medium's visual poverty to suggest all that cannot be conveyed in a letter, using simple still lifes to create recollection-objects. Azian Nurudin's lesbian

s/m scenes in *Sinar Durjana* (*Wicked Radiance*) (1992) and *Bitter Strength: Sadistic Response Version* (1992) become elegantly abstract in Pixelvision; she uses the high contrast of the medium to echo the effects of Malaysian shadow plays.

In utter contrast to McLuhan and the many critics who followed him in asserting that video is a "cool" and distancing medium, I argue that video's tactile qualities make it a *warm* medium. It is the crisp resolution into optical visuality that makes an image cool and distant.

Uses of Haptics

The haptic qualities I have described can be found in many works. Independent film- and videomakers have experimented with haptic visuality throughout the history of the media. Borrowing these techniques, commercial movies also make occasional use of haptic visuality. The opening-credit sequences of many movies take place over haptic images, as though to slowly ease the viewer into the story. I have noticed this, for example, in the opening sequences of *Casino* (Martin Scorsese, 1995), where big blurry colored lights eventually reveal themselves to be the marquee of a casino; *The English Patient* (Anthony Minghella, 1996), in which the camera moves over a skin-like surface that turns out to be a close-up of rough watercolor paper; and *The Usual Suspects* (Bryan Singer, 1995), which begins with a very dark ground with wavy colored shapes, reflections of lights in the harbor. Films like these are predicated on the audience's uncertain or false knowledge, and so it seems appropriate to begin them with haptic images that make viewers unsure of their relationship to the image and the knowledge it implies.

Intercultural films and videos take advantage of the haptic qualities of their media in a number of ways. Fundamentally, haptic images refuse visual plenitude. Thus they offer another of the Deleuzian time-image strategies to prevent an easy connection to narrative, instead encouraging the viewer to engage with the image through memory. As fetishes protect their memories, haptic images can protect the viewer from the image, or the image from the viewer. It is fairly common for experimental ethnographic films and videos to use haptic images to counter viewers' expectations of informative or exotic visual spectacle. Hatoum's *Measures of Distance* (1988) protects its images from viewers' realization that we are gazing upon a naked woman, until it resolves into an optical image. Works that mediate between cultures, such as Trinh's *Re: Assemblage* (1982), Marker's *Sans soleil* (1982), and Edin Velez's *Meta Mayan II* (1981) occasionally "clothe" their ethnographic images in soft focus or electronically processed textures. Portia Cobb's videos *Species in Danger Ed* (1989) and *Drive By Shoot* (1994) and Lawrence Andrews's "*and they came riding into town on Black and Silver Horses*" (1992) represent young Black urban men, people who are usually subject to ethnographic scrutiny on the nightly news, but swathe their images in digital graininess and layers of multiple exposure. Ken Feingold's faux-ethnography *Un Chien Délicieux* (1990) shifts to tasteful digitization for the

only truly "documentary" portion of the tape, in which the Burmese villagers he is taping kill and cook a dog. *New View/New Eyes* (1993), a tape made by Gitanjali on her first visit to her ancestral country, India, is symptomatic of the reluctant-tourist strategies of experimental documentary. Unwilling to subject the land and its people, especially the very poor, to her camera, the artist seeks blurry images, like the reflection in puddles of "untouchables" sweeping a wet courtyard on a misty morning. Many of the works I discuss make similar protective gestures toward the people and places they represent.

Haptic images can give the impression of seeing for the first time, gradually discovering what is in the image rather than coming to the image already knowing what it is. Several such works represent the point of view of a disoriented traveler unsure how to read the world in which he finds himself. Bill Viola's *Chott el-Djerid (A Portrait in Light and Heat)* (1979), for example, gives a view of the Tunisian Sahara not with the certain knowledge of Baedeker-clutching tourists but with disorientation and wonder, the shimmering desert reflected in the air. Phil Hoffman's *Chimera* (1995) is composed of shots at dozens of sites around the world that begin and end in blurred motion, so that a "cut on blur" reproduces the tourist's experience as a sea of uncertainty punctuated by moments of clear perception. In *Brasiconoscopio* (1990), Mauro Giuntini sees anew his town of Brasilia, the prototype of the chilly, optical city, with haptic eyes, in a series of scenes that use slow motion, painterly digital effects, and blurring and blossoming colors to blur its inhabitants together in a great flow of life. Another artist who sees mirages is Seoungho Cho, who writes, describing *The Island with Striped Sky* (Seoungho Cho and Sang-Wook Cho, 1993): "Prolonged exposure and thirst may induce one to experience a mirage in the desert. The mirage is filtered through undulating waves of air. In this video, the mirage of the city is captured through its reflection" (Cho 1994). The island of the title is Manhattan, and the tape reflects a profound sense of the traveller's disorientation. Meanings float loose from objects and merge: reflections in puddles, windows, and revolving doors are at least as palpable as the insubstantial figures of moving people and vehicles.

The first image in Cho's *Identical Time* (1997) is light coming through curving white filaments, with bright spots of red and green light behind them. As the focus shortens, it turns out we are looking through the window of a subway car in which somebody has scratched a name. *Identical Time,* shot in the New York subways over the course of a year, wrings beauty out of the ordinary things most riders ignore, by rendering them first as haptic images. The images are paired with an exquisite score for string instruments by Steven Vitiello, which ranges from a gentle melody on a guitar to the harsh scraping of cello strings in an aural echo to the lines scratched into the window. During the course of the tape, words at the bottom of the screen read:

> Today I am alive and without nostalgia
> The night flows
> > The city flows

I write on this page that flows
 I shuttle with these shuttling words
...

 I am
 one pulsebeat in the throbbing river
...

Is not beauty enough?
 I know nothing
I know what is too much
 not what is enough
...

There is another time within time
still
 with no hours no weight no shadow
without past or future
 only alive
like the old man on the bench
indivisible identical perpetual
We never see it
 It is transparency

They are excerpts from a translation of Octavio Paz's poem "El Mismo Tiempo" (1961). The tape, like the poem, is a song for the sort of travelers who become "one pulsebeat in the throbbing river" when they enter the subways, travelers who, looking up from their newspapers, might lose their gaze in a delicate pattern of vertical lines that turns out to be droplets of rain and dust, dried on the subway window. Such contemplative opportunities are not as rare as one might think, even, or especially, on the subway.

Cho's videos dwell on the tactile qualities of seeing, at the same time that they question the ability of vision to yield knowledge. He connects this kind of baffled vision with the experience of cultural displacement—both the displacement of a Korean born person living in the United States and the general displacement of the tourist or anyone living with the daily sensory barrage of Manhattan (Cho 1997). Figures cannot be clearly distinguished, and layers of images move in an uncertain relation to the plane of the lens. Unsure what he or she is seeing, the disoriented viewer suspends judgment (unless he or she makes a snap judgment, hastening the images into intelligibility), and tests the images by bringing them close. The viewer's vision takes a tactile relation to the surface of the image, moving over the figures that merge in the image plane as though even faraway things are only an inch from one's body. Looking in such a way requires of the viewer a certain trust, that the objects of vision are not menacing but will patiently wait to be seen. Yet one might ask whether Cho trusts his senses: in his work all materiality seems to

disappear, and the images that swirl to the screen's surface do not necessarily attest to the existence of objects.

Some intercultural works use the shift between haptic and optical ways of seeing to emphasize the makers' tactile connection to their environments. Rather than represent well-known and beloved places in the harsh light of optical vision, they begin with the intimate look of one who already knows what he or she is going to see (though viewers may not share this familiarity). Victor Masayesva's *Hopiit* (1982) uses haptic images to touch affectionately the ordinary things that are the center of his Hopi community. The tape is structured by the annual life cycle of corn, and by the special celebrations and everyday acts related to it. Like Cho, Masayesva often changes exposure or focus very slowly, allowing the object of vision to emerge gradually from its environment. The green leaves of corn plants, apple blossoms, and a spider working on its web emerge into focus gradually, as though to stress that all these things, including the viewer, are interconnected. The videomaker uses a similar strategy in *Itam Hakim Hopiit* (1985) and *Siskyavi: The Place of Chasms* (1991) in a gesture toward his environment that is simultaneously loving and protective. Masayesva's use of soft focus implies an affectionate and intimate relationship with things too familiar to require the close scrutiny of the optical.

Similarly, Philip Mallory Jones's videos, installations, and digital works use haptic imagery in a conscious effort to convey the multi-sensory environment of the places he visits throughout the African diaspora. Composed of scenes from villages in Burkina Faso, his "music videos" *Wassa* (1989) and *Jembe* (1989) are electronically processed to enhance their texture and rich color. *Wassa* moves in dreamlike slow motion to the music of Houstapha Thiohbiano: from the combination of rhythm, color, and video texture, the viewer gets a sense of warmth and fragrance emanating from shots of boys playing in a dusty street and a woman moving languidly in a dim room. Jones's search for a pan-African aesthetic, which has developed into the multimedia work in progress *First World Order,* makes him less a tourist than an inhabitant of a global Africa.

References

Belton, John (1996). "Looking Through Video: The Psychology of Video and Film." In M. Renov and E. Suderberg. *Resolutions: Contemporary Video Practices,* Minneapolis: University of Minnesota Press, 61–72.

Bordwell, David and K. Thompson (1997). *Film Art: An Introduction.* New York: McGraw-Hill.

Burch, Noël (1986). "Primitivism and the Avant-Gardes: A Dialectical Approach." In P. Rosen (ed) *Narrative, Apparatus, Ideology.* New York: Columbia University Press.

Burnett, Ron (1995). "Video Space/Video Time: The Electronic Image and Portable Video." In Marchessault, *Mirror Machine.* Toronto: YYZ/Center for Research, 142–96.

Cho, Seoungho (1994). *The Island with Striped Sky* and *Iris Electronic Arts Intermix Catalogue,* ed Lori Zippay. New York: Electronic Arts Intermix.

Deleuze, Gilles (1989). *Cinema 2: The Time Image,* trans. Hugh Tomlinson and Robert Galeta. Minneapolis: University of Minnesota Press.

Gunning, Tom (1990). "The Cinema of Attractions: Early Cinema, Its Spectator and the Avant-Garde." In T. Elsaesser (ed) *Early Cinema: Space-Frame-Narrative.* London: British Film Institute. 56–62.

Herzogenrath, Wulf (1977). "Notes on Video as an Artistic Medium." In D. Davis and A. Simmons, *The New Television.* Cambridge MA: The MIT Press.

Hoolboom, Mike (1997). "Gariné Torossian: Girl from Moush." In *Inside the Pleasure Dome: Fringe Film in Canada.* Toronto: Gutter Press. 148–55.

Lant, Antonia (1995). "Haptical Cinema." *October* 75 (Fall): 45–73.

Lastra, James (1997). "From the Captured Moment to the Cinematic Image: A Transformation in Pictorial Order." In D. Andrew and S. Shafto (eds) *The Image in Dispute: Art and Cinema in the Age of Photography.* Austin: University of Texas Press.

Lejeira. Jacinto (1996). "Scenario of the Untouchable Body." Trans B. Holmes. In D. Tomas (ed), "Touch in Contemporary Art." Special issue of *Public* 13: 32–47.

Torossian, Gariné (1998). Talk at screening at Canadian Film Institute and SAW Video Co-op, Ottawa, November 8.

–6.6–

Chris Marker: Memories of the Future
Catherine Lupton

As far back as 1989, Anatole Dauman's memoirs mention an upcoming feature-film project for which Chris Marker was developing a science-fiction, computer-based scenario to examine the history of the Battle of Okinawa, the final battle of the Second World War, launched in April 1945 when US forces invaded the island in the closing stages of the Pacific campaign.[1] This project would finally surface in 1996 as *Level Five,* a film that engages the virtual universe of computer games, databases and the Internet as the conduit for interweaving a searching documentary account of the battle with a fictional drama of lost love. A woman known as Laura (played by Catherine Belkhodja) is trying to complete the design of a computer game about the Battle of Okinawa left unfinished by her lover, who has died in mysterious circumstances. She speaks constantly to the dead man, communing with him through the computer they shared and her efforts to fathom the game programme. Laura's research into Okinawa's history—much of it conducted on-line through Optional World Link (OWL), a science-fiction alter ego of the World Wide Web—forces her to confront the devastating consequences of the battle for the island's civilian population. Renowned in history for their gentleness and pacifism, one third of the native islanders (approximately 150,000 individuals) perished during and after the battle, the great majority pressured by the 'never surrender' ethos of the Imperial Army into killing themselves and the members of their own family, rather than fall alive into the hands of the victorious Americans. Laura is overwhelmed by the ghosts of Okinawa's past as well as her own (she speaks of suffering from 'a migraine of time'), and at the end of the film disappears in her turn, leaving behind a video diary. Parts of Laura's story, and Okinawa's, are narrated by her editor friend Chris (Marker in an uncharacteristically transparent guise, speaking in his own voice and under his most familiar pseudonym), and we may surmise that it is he who has discovered the video diary and assembled the film we have just watched.[2]

Sandor Krasna had alluded to the rupture of Okinawa's history in *Sunless,* but in *Level Five* Chris accuses himself of having become so Japanese that he blindly shared in the general amnesia about the battle. The destruction of Okinawan civilization, and the searing trauma of the mass suicides, went unacknowledged in many Japanese and American accounts of the Pacific War, in large part because neither

nation recognized, or valued, the cultural autonomy of the Ryukyu Islands. Japan had annexed the islands in 1875; the American Occupation force simply regarded them as part of Japan. Okinawa's pivotal role in the war had also been obscured behind its fateful consequences for the Japanese cities of Hiroshima and Nagasaki. The refusal of the Japanese command to surrender after they lost control of the island, after three months of savage fighting and massive military casualties on both sides, directly determined the US decision to deploy the atomic bomb against Japan, rather than risk further devastating losses in a land invasion of the main islands. Okinawa's history speaks to Marker's long-standing concern for aspects of the past that have been written out of existence by those in power, and his interest in exposing decisive events that languish forgotten and obscured behind the official versions of history.

Raymond Bellour has heralded *Level Five* as a new kind of film, the first cinema release to examine the links between cultural memory and the production of images and sounds by computer.[3] The literal presence of the computer and the virtual realm of cyberspace function, like the implied process of editing in *The Last Bolshevik*, was the screen for assembling and questioning the visual evidence of the historical past. Many of the raw materials and visual special effects assembled for the Okinawa strand of *Level Five* are much like those found in *The Last Bolshevik*—solarized and coloured footage, framed images, borrowed extracts from other films, interviews, contemporary sequences depicting the battle museums and memorial sites on Okinawa and the people who visit them. Laura relates two parables about representations insinuating themselves in place of actual events, which echo *The Last Bolshevik*'s story of the Winter Palace photograph. Gustav, the all-purpose burning man of the wartime newsreels, gets up and walks away in a few frames that were never shown. A US Marine named Ira Hayes never forgave himself for his part in creating what would become an iconic image of American troops raising the Stars and Stripes on Iwo Jima, because it was a re-enactment. The crucial innovation made by *Level Five* in treating this material is that the computer is firmly established as the mediating link. Full-screen sequences frequently reappear on a monitor next to Laura in her workspace. File menus classify sources under headings such as 'Media Coverage' and 'Witnesses'; and two of the latter, the film director Nagisa Oshima and the karate master Kenji Tokitsu, first appear as flat silhouettes emerging from graphic designs on the computer screen. Composite digital images, which are often extremely intricate and visually dazzling, pervade *Level Five* alongside more conventional documentary source material, to depict the cyber-worlds of the computer game and the OWL network.

Level Five's computer is not simply a neutral tool that enables Laura to investigate Okinawa's past (as a conventional understanding of what computers do might lead us to expect). It is the moral arbiter of her encounter with history. The game program will not allow Laura to create a more favourable outcome for Okinawa, but compels her to replay the battle and its consequences in all their horror, to search to

the end for the crucial witness, Kinjo Shigeaki, who recounts the circumstances in which, with his brother, he killed his mother and younger siblings rather than permit them to be captured by the Americans. There is an opacity in Laura's relationship with her computer, which works to disrupt the easy access to information that we are conditioned to expect, and restores to the gradual unfolding of Okinawa's history a sense of appropriate gravity and risk. Fed up with the computer crashing when she tries to reinvent the battle, Laura feeds it a series of joke command words, for the pleasure of seeing it admit 'I don't know how to cauliflower', or 'I don't know how to shoe'. In the final image of the film, after she has disappeared, it signals 'I don't know how to Laura'. She also confesses her fear at discovering something dreadful lurking unseen in the computer files and databases—which, more than the revelations about Okinawa, turns out to be her own face in the on-line Gallery of Masks. The computer is a screen in both senses: it transmits information, but it also has a protective or concealing function that provokes terrible consequences for Laura when it dissolves. It marks Okinawa as a site of trauma, which still has the capacity to overwhelm the present, and resists being consigned to a benign and readily consumed historical narrative. The originality of Marker's treatment of new media in *Level Five* is matched, in terms of his own films at least, by the presence of Laura: the 'cyberpunk Lorelei' who is the first fictional character ever to appear and speak directly in one of his films. Marker's meeting with the actress Catherine Belkhodja had proved decisive in his plans for the film, crystallizing the character of Laura as an intended point of identification for the audience, a bridge between a recognizable loss (the death of a lover) and the almost unimaginable sufferings of Okinawa.[4] With her name taken from Otto Preminger's film noir of 1945 and the overt allusion of her story to *Hiroshima mon amour,* Laura is an avatar of fiction cinema itself and in respect of her link to Resnais' actress, to its most radical engagements with questions of history and memory. Marker has jokingly referred to *Level Five* as a 'semi-documentary', on the basis of the remark by Harry S. Cohn, the Columbia Studios boss, that a documentary can't have a woman in it. This underlines Laura's allegiances to the classical cinema, even though she breaches one of its most basic conventions, by looking directly into the camera and addressing the viewer, when within the story she stares at her computer screen and converses with her dead lover. Laura's status as a projection is scrupulously observed: at one point her image 'downloads' into the workroom, and she goes in and out of focus when she adjusts the video camera with a remote control. Her link to Preminger's heroine, who appears first as a painting and then seems to appear as a ghost in the dream of a police detective, hints at the spectral status she enters with her disappearance at the close of the film: the elusive 'Level Five'. Like the chain of women and works of art who appear near the close of *If I Had Four Camels,* Laura entertains a special relationship with death: she herself is a screen that can communicate on the audience's behalf with the ghosts of Okinawa, even though the cost of such an encounter ultimately proves too great.

Level Five returns Marker by an oblique route to the experiences of the Second World War in Europe, when Chris remarks that, proportionally, the only population to have suffered as much as the Okinawans were the deportees. It also closes the circle of his involvement with cinema. Marker has said that *Level Five* will be his last theatrical feature film (it was shot on video and digital video and transferred to 35 mm), and that in future he intends to work only with the computer.[5] Marker offers a final homage to the lost world of the classical fiction film by entering at least half-way onto its terrain, folding it and the conventions of documentary historiography into the databanks of the computer, before finally entering them for good himself.

The figures of Marcel Proust and Alfred Hitchcock preside over the entry into the Memory zone of Marker's CD-ROM *Immemory*. Developed in collaboration with the Centre Georges Pompidou, as the first in a planned series of artists' CD-ROMs concerned with questions of memory, *Immemory* was premiered there during 1997 with the title *Immemory One* (to allow for subsequent modifications), and then released commercially in 1998 (an English version appeared in 2003). In an essay written to accompany *Immemory*, Raymond Bellour writes: 'Whatever he may or may not do after his CD-ROM, it is clear that the latter already stands as a final work and a masterpiece, in conformity with its craftsmanly character and with its programmatic value.'[6] What Marker proposes in *Immemory* is the geography of his own memory to be traced via the accumulated signs and mementos of a lifetime. His hypothesis is that 'every memory with some reach is more structured than it seems', that 'photos taken apparently by chance, post-cards chosen on the whim of the moment, begin once they mount up to sketch an itinerary, to map the imaginary country which spreads out inside of us.'[7] Each one of these elements is for Marker a madeleine shared by both Hitchcock and Proust, a frail and inconsequential object that by itself can support, as Proust wrote, 'the immense edifice of memory'.

The portal into *Immemory* is a welcome screen with the icons for seven separate Zones: Cinema, Travel, Museum, Memory, Poetry, War and Photography, plus a zone devoted to X-Plugs—dense digital collages that have also appeared as an on-line slide show. From there on in, the pathways through *Immemory* fork and diverge on to infinity—until you click on the red arrow at the top of the screen that takes you back to the opening page. Certain zones overlap with each other (Memory with both Travel and Cinema); one click of the mouse can propel you from one zone into another if you choose a certain route. Photography, Poetry and Cinema offer a subsidiary menu; Museum offers a choice of how to navigate it. Every so often, the cartoon image of Guillame-en-Egypte, the 'silent-movie cat' and obliging tour guide through *Immemory*, will pop up to pass comment, reveal another layer of the image or invite you to take a detour somewhere else. It is also possible to tour *Immemory* via the Index, which serves as a handy reminder of all the elements you haven't managed to see yet.

The user instructions to *Immemory* advise 'Don't zap, take your time'. The un-folding screens have a built-in element of discretion: it is often necessary to linger a while and wait for things to happen or to move the mouse slowly over the screen in

order to discover the small eye icon that, when clicked, will unfold another change—as in the Poetry zone, where clicking on concealed eyes in a suite of images will cause part of the picture to slide up and reveal a scrolling poem. At certain points, moving the mouse also triggers the appearance of layers of text, which will hastily roll back out of sight if you skate around too quickly. The experience of navigating *Immemory* is precisely like rummaging through a virtual attic of stored treasures, time in suspension as you become absorbed in poring over the random, forgotten mementos of the past that rise to the surface as you delve through with your hands.

The materials that Marker assembles in *Immemory* are signs and traces that propel the user back across his entire career as a writer, image-maker and compulsive hoarder, and through a strand of autobiographical revelations that are firmly stated to be true, but which the seasoned tourist of planet Marker is nonetheless likely to suspect of being dressed up a little (in the spirit of all good family legends). The intimacy of the family album is a leitmotif of *Immemory,* and we discover in it a picture of Marker's mother Rosalie, an album in the Photo zone of 'assorted fairies' ('feés diverses' in French, a pun on *faits diverses*) containing photos of women he has loved (if only as images), and in particular many tales of his Uncle Anton and Aunt Edith Krasna, cosmopolitan travellers of Hungarian and Russian extraction who are the elective parents of his passion for travel and photography. In the Travel zone, Marker revisits an illustration from Jules Verne and one of his own photos to replay *Sunday in Peking*'s transport back to the alley that supposedly led to the tombs of the Ming emperors. Between these images (which appear in stages with separate clicks of the mouse), he puts a photo of the Ming alley taken by Uncle Anton in the 1930s. Meanwhile, in the Cuba segment of the Photo zone, we discover that Marker spent two years in Cuba as a young boy, in the company of his uncle and aunt.

At the end of *Sunless,* Sandor Krasna's film images entered the zone and were transformed into memories. The zones of *Immemory* are the logical culmination of this virtual space that extends outside the parameters of place and time, via their intermediate dispersal across the multiple screens of Zapping Zone and Silent Movie. Marker reabsorbs past works into *Immemory:* the photo-text albums *Coréennes* and *Le Dépays* are re-presented as subsections of the Photo zone, with only slight modifications of layout, and the spatial layout of the book is replaced by unscrolling layers of image and text. Marker also uses the text of his *Vertigo* essay 'A free replay' in the Vertigo segment, which is shared by Cinema and Memory. Yet, like the amassed footage used to compose *Le Fond de l'air est rouge,* Marker does not present this material as a flat, routine, unmediated archive. *Immemory* is more properly what Thomas Tode calls a 'recycling plant', in which images familiar from Marker's earlier works are put into different contexts, by being combined with new texts and associated with other images.[8] Many past works are conjured in *Immemory* in the blink of an image: the photograph of a wrecked military vehicle in the Negev Desert that opened *Description of a Struggle;* and the faded sepia photo of a group of young men who push their faces through the cut-out holes in a fairground group painting.

Marker had placed this image in *Regards neufs sur la chanson;* in *Immemory* he names the participants, who included two Chinese visitors, Joseph Rovan and the gifted young writer François Vernet (who would die in Dachau), and offers the caption 'That's what you call a generation.' Other suites of images, particularly those of Cuba and Russia (again in the Photo zone), supply fresh and expanded perspectives on the films devoted to those countries.

The capabilities of the CD-ROM provide the ideal vehicle for Marker's virtual projection of his memory, since they enable him to draw together text and images in new, mobile, infinitely open-ended hypermedia constellations that transcend the existing models of both book and film. One of Marker's crucial conceptual sources for *Immemory* is the philosophical model of memory proposed by the seventeenth-century English savant Robert Hooke, whose studies anticipated Newton's theory of gravity. Hooke postulated the existence of a point in the human brain, the seat of the soul, where 'all sense impressions are transmitted and gathered for contemplation'.[9] The CD-ROM, and the electronic technology that designs and powers it, becomes the equivalent to Hooke's seat of memory, processing impressions of the past that seem to arise on the screen from nowhere, and then disappear again without leaving any trace (except in the navigator's own memory). The sound and cinematic elements of *Immemory* (the latter in the form of small QuickTime projections) are limited for reasons of memory space and the same practical consideration led Marker to favour written texts over spoken commentary; but the result is that writing can be made an integral component of the image in a way that speech never can. The CD-ROM in fact has the capacity to stretch beyond the book and the film to incorporate all types of image in digitized form: paintings, engravings, ticket stubs, postcards, the impression of physical objects (like the handprint found in the Museum zone), newspaper cuttings, letters, posters torn from walls. *Immemory* recapitulates and expands the promiscuity of images first apparent in Marker's Petite Planete layouts, displaying the same fluent, inventive and playful handling of graphic space, but with the added dimensions of movement, transition and superimposition. The way that Marker works over and transmutes his source material (which he did by himself, designing *Immemory* alone using Roger Wagner's Hyperstudio software) offers an instructive parallel with the ideas of the new media theorist and historian Lev Manovich, who sees in the creative techniques of digital media a return to the handmade processes of painting, drawing and animation, rather than the mechanically generated images of photography and cinema.[10] In some parts of *Immemory,* the analogy is quite literal: Marker and Guillame have much fun in the Museum section tweaking a few pixels to wipe the smile off the Mona Lisa's face, and make a languid Renoir bather appear to breathe. We can also click through imaginary galleries in which Marker has turned photographs of his friends (including Simone Signoret) into paintings, and morphed together famous paintings with images of warfare.

Marker's final wish for *Immemory,* the same one he had expressed with regard to *Silent Movie,* was that the visitor might be furnished with enough familiar cues—the

family album, the holiday snapshot, the totem animal—to superimpose gradually upon Marker's chosen images the treasured contents of his or her own memory, so that, as he had written in *Sunless,* everyone might write poetry, and compose their own list of things that quicken the heart. Although this modest gesture of deferral to the visitor is well meant and taken, it is a moot point whether the user of *Immemory* ever really replaces the style and artistry of Marker's words and images with their own personal reveries, and whether the attraction of *Immemory* is not precisely that Marker has fashioned a global memory out of the signs of his own life, through which complete strangers may experience all the emotion and shocks of intimate recognition that they would normally obtain only from their own private worlds.

Notes

1. Jacques Gerber, ed., *Anatole Dauman: Souvenir-Écran* (Paris, 1989), p. 151.
2. This retrospective assembly of Laura's diary by Chris is suggested by Ian Hunt. 'Okinawa Replay: Chris Marker's *Level Five*', *Coil,* 5 (1997), n.p.
3. Raymond Bellour, 'L'Entre-image aujourd'hui: Multiple Cinemas—The Cinema Only', lecture delivered at Tate Modern, London, 23 May 2002.
4. See 'Chris Marker ne laisse pas souffler la vérité', interview with Catherine Belkhodja, *L'Humanité,* 19 February 1997, p. 21; and interview with Chris Marker by Dolores Walfisch, *Vertigo.*
5. Thomas Tode, 'Cinema—That Was Last Century!'
6. Raymond Bellour, 'The Look, Back and Forth', p. 119.
7. From the introductory text to the CD-ROM *Immemory* (Paris, 1997), n.p. My translation from the French.
8. Tode, 'Cinema—That Was Last Century!'
9. Quoted in the introductory text to *Immemory.*
10. Lev Manovich, 'Digital Cinema and the History of a Moving Image', in *The Language of New Media* (Cambridge, MA, 2001), pp. 293 ff.

–6.7–

What Do Pictures Want Now:
Rural Consumers of Images in India
Christopher Pinney

The name of the village is Bhatisuda, located on the Malwa plateau in Madhya Pradesh, roughly halfway between Bombay and Delhi in India. Here chromolithograph images portraying Gods are popular across all castes and religious groups. Jains and Muslims own images as well as Hindus, and Scheduled Caste Chamars and (warrior) Rajputs or (priestly) Brahmans own similar numbers of images. (Across the village as whole there is an average of seven images per household.)[1]

Bhatisuda's population is spread through 21 castes, and although village income is still overwhelmingly derived from agriculture (the main crops being maize, sorghum and wheat), the presence of the largest viscose rayon factory in Asia a mere 6 kilometres away in the town of Nagda has had an enormous impact on the economic fortunes of landless labourers, and has structured local discourses on history and the nature of progress. The village cosmology reflects the nature of popular Hinduism in this area and there are temples and shrines to the main gods: Ram, Hanuman, Krishna, Shiv, Ganesh, Shitala; and also to local deities: Tejaji, Ramdevji, Jhujhar Maharaj, Bihari Mata, Lal Mata, Rogiya Devi, Nag Maharaj and many more.

. . .

While there are regularities in caste ownership of images there is a huge divergence in the images owned by individual households. To give just one example, the average of three images owned by Mukati (high-status agriculturalists) households is the average of all the five households in the village, which individually owned zero, two, two, three, and eight images respectively. I am tempted to claim that the unpredictability of image ownership demonstrates the purely personal factors that dictate distribution between households. I found myself completely unable to predict the numbers of images that might be concealed behind the wooden doors of the mud houses of which Bhatisuda is almost exclusively comprised. The devotionalism, or questioning irascibility, of villagers was no guide to the number of images they might display within their homes.

Chromolithographs assume a specific importance for Scheduled Caste members who, in Bhatisuda as in many other Indian villages, are still prevented from entering village temples. Although many Scheduled Castes have their own caste specific

shrines (*autla, sthanak*) they are generally unable to enter village temples to the main gods. The data from my village survey records a democracy of the printed image in which Scheduled Castes, denied access to most village temples, are able to control their own personal pantheon. Some isolated Scheduled Caste households, such as Bhangi and Bargunda, pursue this strategy with particular enthusiasm.

Deities accessible to all castes—meat-eating as well as higher caste vegetarians—are often described as *sarvjanik* (universal, common, public). Chromolithography makes vegetarian deities accessible to Untouchables but only in the realm of the home. These mass-produced images permit a new *sarvjanik* ritual practice but only in the private sphere.

...

The Quest for Plenitude

In Bhatisuda visual forms are desired for the access they facilitate to divine energy and to *barkat,* or plenitude. Although it is undoubtedly true that in certain key respects popular Hinduism mobilizes a recuperative idiom within a decaying universe, it is fundamentally constructed by what the playwright Brian Friel (in a very different context) once described as a 'syntax opulent with tomorrows'.[2] Mass-reproduction gives formerly excluded classes access to all the high gods, whom they can approach directly without the intercession of priests. In evaluating the potentiality of images *barkat* emerges as the key concept. Villagers are not interested in what images 'look like', but only in what they can 'do'—the nature and extent of the *barkat* that they are capable of conducting.[3]

Villagers have hardly any interest in the producers or publishers of the images that adorn almost every home. Occasionally, following meetings with artists I particularly admired, I was unable to resist remarking to a village friend that the image hanging on his wall was the work of an individual with whom I had some personal connection. But this information was never greeted with any fascination, and there was never any attempt to uncover further information about the artist or his work. The blank indifference my immodest claims provoked indicated a profound and utterly deep indifference to the circumstances in which these all important images were created. This reflected villagers' engagement with images as the sources of future interventions, rather than as embodiments of past intentionalities.

In a similar way, most aspects of form did not feature in any significant way in any of the hundreds of conversations with villagers about their pictures. Instead of exegesis about the nature of the image's execution, there was comment about content, efficacy, and about the praxis that surrounded the acquisition and ongoing maintenance of pictures. They were interested not in what artists had put into pictures, but in what they as supplicants—with all their complex predicaments—could get out of the images.

The 'syntax opulent with tomorrows' that emerges in Bhatisuda practice is one that springs from a corporeal practice in which it is the devotee's visual and bodily

performances that contribute crucially to the potential power—one might say completion—of the image. Most villagers 'seat' their pictures without the assistance of Brahmans, although some will call a Brahman to install newly purchased images. On these occasions the priest will swing the image in front of a mirror and perform a *sthapana* (installation) of the deity.

Most, like Lila Mehtarani, who lives in a low mud house on the eastern periphery of Bhatisuda, are the sole authors of the pictures' conversion from mere paper to divine simulacra. When asked about pictures of deities lying on market stalls in Nagda (deities jumbled up with film stars and 'scenery', Hindu with Muslim images, Sikh with Jain) she responded: 'It's just paper ... [they haven't] been seated'. She then pointed to the images in her own domestic *jhanki*: 'you see those pictures that are seated? Those are paper but by placing them before our eyes, energy (*shakti*) has come into them ... We entreat the god and the god comes out because the god is saluted. That's how it is.'

Some Bhatisuda images are thought to be more opulent with tomorrows than others. Samvaliyaji is an example par excellence of a deity who gives *barkat*. Whereas orthodox deities such as Shiv are considered essential to *alaukik labh* ('disinterested, or unworldly, profit'), that is transcendental concerns, Samvaliyaji can produce *bhautik labh,* that is material, worldly or physical profit. *Bhautik* problems (for instance, uncertainties relating to wealth, bodily health and illness, matters relating to employment and agricultural productivity) are the ones that most concern villagers.

Like the vast majority of villagers Pannalal Nai, a retired factory worker, lights incense sticks in front of his images at sunrise and dusk. He asks for the protection of all that is most valuable to him: 'give *barkat,* food, water, children, small children, protect all this'. As Pannalal performs this *puja,* appealing for a protective plenitude in the face of harsh uncertainties, he murmurs to himself, waves his incense sticks, rings a small bell and crumbles whatever marigolds might be lying on the *puja* shelf in front of his images. As he does this his eyes maintain an intense visual intimacy with the gods and his body describes a gentle swaying, yearning, movement as though caught in the force field around the image.

Every conversation about images is likely to invoke the term *barkat*. But there are other ways of expressing the efficacy of images. *Chamatkari* (miraculous, wondrous) suggests an extramundane power that exceeds the quotidian requirements of *barkat,* and *akarshan* (allurement) is a way of describing the particular ability that certain images have to call to the devotee in ways that are often disruptive of daily life.

The interconnectedness of these terms was apparent in the response of Pukhraj Bohra (a Jain landlord living in the central square of Bhatisuda) to a question about the special powers of images in the locality:

Nageshvar Pareshavar near Alod [a Jain pilgrimage site] is a very *chamatkari murti* (image) ... when I first went there fifteen years ago I made a *man* (wish). I asked that my business should go well, that the crops should prosper and then I came back. But there was some *mansik* (psychic) effect from this, some *akarshan* (allurement) born in

the image. When I was away I felt that I had to go back and see the image, had to see it again and again.

The consumption of images by Bhatisuda villagers needs to be understood in terms of these processes of bodily empowerment, which transform pieces of paper into powerful deities through the devotee's gaze, the proximity of his/her heart and a whole repertoire of bodily performances in front of the image (breaking coconuts, lighting incense sticks, folding hands, shaking small bells, the utterance of *mantras*).

Elementary Aspects of Peasant Visuality

The most fundamental mark of the images' sensory quality—their predisposition to this corpothetic regime—is their non-absorptive directness. The vast majority of images behold their owners directly, engaging and returning their vision. As Diane Eck observes, the primacy of sight as the idiom of articulation between deity and devotee is lexically marked so that devotees will usually stress that they are going to the temple for *darshan,* to see and be seen by the deity: it is this 'exchange of vision that lies at the heart of Hindu worship'.[4]

However, the *darshanic* relationship that devotees cultivate engages vision as part of unified sensorium. The eye in *darshan* is best thought of as an organ of tactility,[5] an organ that connects with others.

. . .

One of the strategies through which peasants are able to 'get hold' of images is through the creation of a zone of mutuality that encompasses devotee and image: the 'locking in' of vision. This relationship is clearly expressive of *darshan,* which is after all predicated on the mutuality of 'seeing and being seen' by the deities in the images one worships. However, it would be misleading to conclude that this is simply the specific outcome of this particular 'cultural' practice. Local understandings of *darshan* must certainly nuance and finesse our understanding of popular Indian visuality, but underlying this there is a much more widespread practice of what I term 'corpothetics' (sensory, corporeal aesthetics). This local Indian practice is certainly on the face of it dissimilar to dominant class 'Western' practices, which privilege a disembodied, unidirectional and disinterested vision, but not strikingly unlike a whole range of culturally diverse popular practices that stress mutuality and corpo-reality in spaces as varied as those of religious devotion and cinematic pleasure. So while the power and specificity of local discourses is clearly crucial I would resist the wholesale reduction of meaning to such discourses. Rather than create a specifically Indian enclave of *darshan*-related practices we should also be aware of the continu-ities and resonances with popular visual practice elsewhere. The choice here should not be seen as simply one between a universalism and a cultural specificity[6]: rural Indian corpothetics exist in a space that is less than universal and more than local.

The Double Sensation

The villagers' chief requirement is for images of deities that can see them ... This desire to be seen necessitates hieratic frontal images in which the deities stare forth at their beholders. Balu Bagdi had purchased six postcards separately in Nagda and then taken them to a framing shop (of which there are several in the town). The resulting artefact (Figure 15) clearly embodies this rural preference for the non-absorptive and theatrical (to recall, respectively, Fried and Diderot's terminology) ... The deities in all six images invite a reciprocating gaze; none of them permits of any 'indirectness'.

The profound mutuality of perception that such images make possible has parallels with what the phenomenological philosopher Merleau-Ponty terms the 'double sensation' of touching and being touched. In his *Phenomenology of Perception* he considers what occurs when he touches his right hand with his left and the resulting 'ambiguous set-up in which both hands can alternate the roles of 'touching' and being 'touched'.[7] Each hand has the double sensation of being the object and subject of touch. Merleau-Ponty then applies this model of the double sensation (and of the reversibility of the flesh) to vision, arguing that, 'he who looks must not himself be foreign to the world that he looks at. As soon as I see, it is necessary that vision ... be doubled with a complementary vision or with another vision ... he who sees cannot possess the visible unless he is possessed by it'.[8]

The commercial cinema of Bombay frequently invokes a mutuality of vision that presupposes this 'double sensation.' The celebrated film *Jai Santoshi Ma* (1975) included several sequences in which the desperate heroine Satyawadi implores the assistance of Santoshi Ma. In these sequences the goddess's vision is shown as a physical extrusive force (a beam of scorching fire). In two key episodes in which the heroine beseeches the goddess to intervene, intercut shots of Satyawadi's and Santoshi's faces are used repetitively to inscribe the mutuality of vision that binds the devotee to the goddess, and the camera also pans in between their gaze, further accentuating this crucial axis.[9]

In *Amar Akbar Anthony,* released two years later in 1977, the process of *darshan* is literally vision enhancing: being seen becomes the ground from which one's own vision is possible. Chased by ruffians, the blind elderly mother of the three central characters is attracted by the noise of an ecstatic song in praise of the Shirdi Sai Baba conducted in keeping with the ecumenical spirit of the film, by her son Akbar. (For recondite reasons the three sons have been raised in different religions.) While the congregation praises the visibility of god in Sai Baba and his ability to relight lamps and turn dark nights of sorrows into brightness, the blind mother is ineluctably drawn by some mutual corporeal attraction towards the image in the temple. Although blind, she is drawn compulsively to the face and body of Sai Baba who—as the song proclaims the relighting of lamps—reciprocates her devotion with his own brightness in the form of two flames that migrate from his eyes to hers, liberating

her from blindness. Touching Sai Baba's feet she proclaims her ability to see and to have *darshan* of the god, and tells Akbar that it is thanks to his devotion (*bhakti*) and the Baba's 'magic' (*chamatkar*).

I have proposed the use of the term 'corpothetics' as opposed to 'aesthetics' to describe the practices that surround these images. If 'aesthetics' is about the separation between the image and the beholder, and a 'disinterested' evaluation of images, 'corpothetics' entails a desire to fuse image and beholder, and the elevation of efficacy (as, for example, in *barkat*) as the central criterion of value.

The consequences on the form of images of the desire for fusion—for the subject/object dissolution of the 'double sensation'—is nowhere more apparent than in the many mirrored images that are to be found in Bhatisuda, such as an image of Badrivishal purchased at Badrinath. Most images of this type were purchased at pilgrimage sites. This is a common mode of customization that allows local artisans to add value to machine-printed images, which become crafted relics of a spiritually charged place. The key figures from chromolithographs are cut out, pasted behind glass and the remaining clear glass is silvered to produce a mirror. But the additional benefit from the purchasers' point of view is that they can now visually inhabit the space of the picture, alongside the deity with whom they desire the double sensation. Mirrored images allow the devotee to (literally) see him or herself looking at the deity. In the case of mirrored pilgrimage images there is what might be termed a double corporeality; firstly of the devotee's movement through space on pilgrimage where she or he bought the image; secondly of the devotee's visual elision with the deity when he places himself in front of the image.[10]

Other modes of image customization—such as the application of glitter, or *zari* (brocade) or the adhesion of paper surrounds or plastic flowers—might also be considered as corpothetic extensions that move the image closer to the devotee, transforming the ostensible representation or window into a surface deeply inscribed by the presence of the deity.

Objects of value are also occasionally introduced onto this surface. 'Found' banknotes, which are considered auspicious, may be pasted on the glass of framed images, and Muslims may similarly attach banknotes containing the auspicious sequence '786' in their serial numbers.[11] The dressing of images takes the place of words. Instead of exegesis, instead of an outpouring of language, there is a poetics of materiality and corporeality around the images.

The progressive empowerment of images through daily worship involves a continual burdening of the surface with traces of this devotion. Although some households replace all their images every year at Divali, the majority retain old images, which continue to accumulate potency as they become accreted with the marks of repeated devotion. These marks include vermilion *tilaks* placed on the foreheads of deities, the ash from incense sticks, smoke stains from burning camphor, remnants of marigold garlands and other traces of the paraphernalia of *puja*.

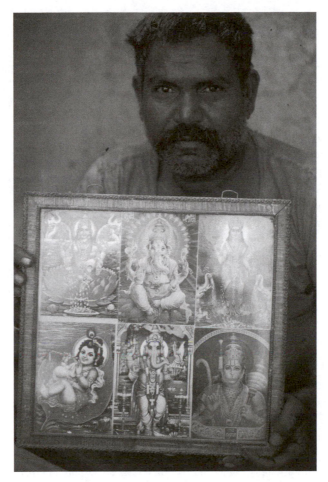

Figure 15 Balu Bagdi holds a frame of *darshanic* postcards, 1994. Courtesy of Christopher Pinney.

Even at the end of its life, a picture's trajectory is determined by corpothetic requirements, in this case the necessity of ensuring that the image never comes into contact with human feet. Lila Mehtarani explains the constraint:

[the images] are paper and when they have gone bad (*kharab*) we take them from the house and put them in the river. That way we don't get any sin (*pap*) ... we don't throw them away. You take them out of the house and put them in the river or in a well, and place them under the water.[12] This way they won't come under anyone's feet. You mustn't throw them away or they will get lost. That's the proper (*tamizdar*) way to do it—in the river or well. In our *jat* we say *thanda kardo*—make cold. That way they won't come under [anyone's] feet.

In Hindi the phrase *pair ankh se lagana* literally signifies to look at the feet, and idiomatically 'to respect, venerate' and to touch someone's feet is to physically express one's obeisance. Certain images in Bhatisuda encode this hierarchical relationship in which the devotee submits his body, through his eyes, to the feet of the deity. Photographs of holy persons' feet permit this physical acting out of the devotee's obeisance. Correspondingly, it is fundamentally important to Bhatisuda villagers that the bodies of the deities that they have so carefully brought to life should not suffer the dangerous indignity of having this relationship reversed.

The democratic praxis that chromolithography engenders is thus one that in certain key respects recapitulates the protocols and hierarchical codes of orthodox Hindu practice. But it also occasionally comes close to destabilizing long-established ritual and social hierarchies. Formally, all deities, and the different media through which they manifest themselves, are conceptualized as part of a complementary and harmonious project. A common response by villagers when questions of differences between deities is discussed is to throw up their hands and say *ek hi maya hai* ('it is all just one illusion', one 'play'). They mean by this that 'ultimately' all the differences are resolvable into a single central imaginary form. In this sense villages affirm that the various gods can be thought of as variations on a central, common theme.

Notes

1. I surveyed 117 households in October/November 1993 and March/April 1994 and counted a total of 810 images, giving an average of 6.9 images per household. As is clear from the following figures, my sample can only be taken as a statistically significant guide to the practices of Rajputs (a high caste group who were traditionally warriors) and Chamars (an Untouchable Scheduled Caste who were traditionally tanners). I recorded data on 32 and 28 households respectively, providing a reasonable comparative base for these two jatis, which lie near the top and the bottom of the local caste hierarchy. My next largest sample was of Scheduled Caste Bagdi households (10), following by Brahmans (8). All the other caste samples consist of lower numbers and a full seven consist of only one household. In isolation these clearly generate statistically insignificant numbers, but collectively do provide useful indicators. It should also be noted that the data provides, in some instances, complete samples (there are, for example, only one Bhangi, one Lohar and only two Bargunda households in the whole village). The following list is arranged by average number of images by *jati* and gives the size of the sample for each *jati* in parentheses. It should be noted in this connection that there were individual Brahman, Jain, Gosain, Banjara and Chamar households who had equal or larger numbers of images than the sole Bhangi household that heads the list: Bhangi 16 (1); Lohar 14 (1); Darzi 14 (1); Bairagi 14 (1); Banjara 12 (4); Jian 12 (3); Gosain 11.3 (3); Gujar 10 (4),

Bargunda 9 (2); Nai 9 (2); Kunhar 8 (3)_; Mina 7 (3); Teli 7 (1); Brahman 6.4 (8); Chamar 6.4. (28); Rajput 6.3 (32); Sutar 6 (1); Muslim 5 (2); Gario 4 (1); Mukati 3 (5); Bagdi 3 (10).

2. Brian Friel, *Translations* (London 1981), p. 42.
3. This recalls Diane Losche's suggestion that to ask the Abelam of Papua New Guinea about the way their images 'look' is as meaningful as asking a Euro-American what their refrigerator 'means'. Diane Losche, 'The Sepik Gaze: Iconographic Interpretations of Abelam Form'. *Social Analysis,* xxxix (1995), pp. 47–60.
4. Diana L. Eck, *Darśan: Seeing the Divine Image in India* (Chambersburg PA, 1981), p. 5.
5. See also Michael Taussig, *Mimesis and Alterity: A Particular History of the Senses* (New York, 1993), p. 217.
6. As implied by Richard Davis in his excellent *The Lives of Indian Images* (Princeton NJ, 1997), p. 265, n. 5.
7. Maurice Merleau-Ponty, *Phenomenology of Perception,* trans. Colin Smith (London, 1962), p. 93.
8. *Ibid.,* pp. 134–5.
9. cf. Lawrence Babb, 'Glancing: Visual Interaction in Hinduism', *Journal of Anthropological Research,* XXXVII/4 (1981), pp. 378–410.
10. This corpothetics is often reinscribed as the owner traces the journey with his eyes or his fingers as she or he recalls the journey. Bhavaralal Ravidas pointed out various parts of his Pavagadh image, 'there is a temple here that you can't visit because there's a tiger living near the path.'
11. cf Christopher Pinney, *Camera Indica: the Social Life of Indian Photographs* (London, 1997), p. 171.
12. In the local Malwi dialect this is referred to as *paraba,* in Hindi as *visarjan.*

–6.8–

Surgical Vision and Digital Culture
Jan Eric Olsén

This essay explores the aesthetic, functional and ideological aspects that link contemporary biomedicine with other manifestations of digital culture, looking at digital technology as an intersection between biomedicine and other forms of cultural activities depending on information networks.

Reorganizing the Operating Room

When we think of surgery, certain images are likely to come to our mind; the incised body of the patient, the unpleasant sight of the exposed organs, the surgical crew encircling the patient and the blood smothered gloves of the surgeon conducting the operation. These images, which have been culturally manifested all through the last century, are presently being overlayed by new ones. Today the operating room has been transformed into a high technological unit that bears little resemblance to the theatres of prior days. Computer consoles, video terminals, monitors and robots have gradually changed the appearance and design of the classical operating theatre as well as the art of surgery. Instead of gazing into the body, as is the case in classical surgery, surgeons today are making use of optical technology which enable them to visualize the body indirectly. Take for instance the photograph of a keyhole surgery, depicted here (see Figure 16). Live images of the operation are displayed in two different ways: on the video monitor at the back of the room, and on the stereoscopical devices, fixed before the surgeon's eyes. The latter technique makes it possible to view the operation in 3D. Images stemming from a stereoscopical video camera, inserted in the patient's body, are transmitted to the surgeon's monitors, one image for the left eye and one for the right. Whereas the images on a video monitor are limited to two dimensions, stereoscopical devices allow surgeons to keep a sense of depth perception, and conduct the operation in a three dimensional field of view.

Keyhole surgery, or minimal invasive surgery as it is also called, emerged in the 1970s and 80s, as an alternative method to open surgery. By that time, attempts had already been made to illuminate the interior parts of the body for diagnostic reasons. Two such similar techniques are endoscopy and laparoscopy, where thin optical instruments are inserted in the body, either through natural openings or by way of

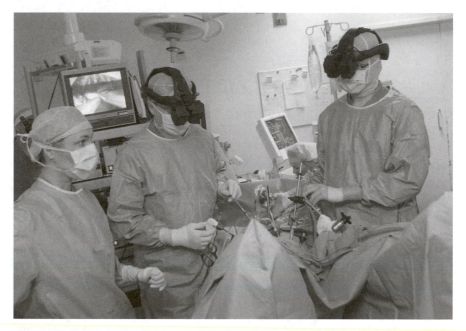

Figure 16 Surgeons using head-mounted displays. Photographer: Rolf Hamilton. Reproduced by courtesy of *Uppsala Nya Tiding*.

tiny surgical incisions. Both of these techniques have been modified to fit surgical purposes as well. An important innovation in the history of minimal invasive surgery, was the computer chip video camera. It appeared in the late 1980's and brought about a significant reorganization of surgical procedures. Placed inside the body, along with the surgical instruments, the video camera records the operation and transmits it to a video monitor, where it is displayed for the surgeons to see. Among other things, the use of fibre optics, has redirected the attention of the surgeon from the body towards the images on the monitor. Hence, the naked eye of open surgery has given way to the techno-optical gaze of keyhole surgery and its various components.

Surgery Mediated

The head mounted displays worn by the surgeons (Figure 16) have other advantages, besides providing the means for 3D-vision. Connected to a computer, the surgeons can consult a data bank of facts and figures. Previously taken X-rays and graphical data concerning the patient's blood pressure or pulse, can be superimposed on the images of the operation. In this respect, optical systems that fuse real-time data with preoperative data, do not simply aid the sense of vision, but enhance the faculty of perception in a very precise manner. Other visual techniques, currently employed in

the operating room, include computer aided design, graphical models of the body, which are used to prepare the operation and are accessible during surgery. As a result of this computerization of surgery, the surgeon is primarily apprehending the patient's body in the form of pixels. Anatomical strata are being converted into electronic information, digital dots that make up the images on the screen. Surgery in gross anatomy scale is gradually being replaced by virtual anatomies, digital tools and software engineering.

Digital technology has undoubtedly opened up new possibilities for surgeons to interact with the patient's body. The question is to what extent computers will alter hospital routines and the professional identity of doctors, nurses and other specialists, not to mention our concepts of surgery, health care and the body. Consider again the surgical crew in Figure 16. No one is actually looking at the body on which the operation is being performed. Rather, their attention is drawn to the representations of the body, mediated through various optical apparatus. If the crew performing open surgery were focused on the body per se, optical technology has gradually drawn the attention of surgeons and nurses away from the very same body to images displayed on video monitors, computer screens and 3D devices. Linked to computer networks, operations are even distributed outside the surgical room, for medical professionals to follow elsewhere or even for a lay audience to view on the Internet.

Presence and Telepresence

Lately, the term telepresence has been used to describe the shrinking of temporal and spatial distances between doctors, patients and hospital units inscribed in global information networks. Nik Brown and Andrew Webster, for example, argue that electronic circuits are destabilizing the actual locus of the body. Once converted into electronic format, patient data tend to be "everywhere and nowhere at once" (Brown and Webster 2004: 91). Likewise, powerful optical systems are creating complex gaps between the corporeal existence of the body and its visual representations. These optical networks imply a proliferation of real-life images of the body as well as a general tendency towards a telepresent state in which spatial and temporal distances no longer pose an obstacle to action and communication. According to the French philosopher Paul Virilio, the digitization of Western society has brought about a dramatic change as to how we interact with our physical environment. Architecture used to imply the question of how physical space best can be arranged, in order to fit our bodily activities. Today, it is only concerned with how electronic online technology can be used to control our environment. "People are not so much in the architecture …", says Virilio, "… it is more the architecture of the electronic system which invades them" (Virilio 2000: 66). For Virilio, digital technology constitutes the peak of a scientific-technological development which has promoted the invention of ever faster modes of transportation and communication. Paradoxically, this fierce

upgrading of vehicles culminates not in bodily motion and action but in inertia, a domestic inertia which obliterates all differences between action and remote action, presence and telepresence. Virilio's notion of a domestic inertia, symbolized by the remote control and the joystick, also includes what is referred to as the logistics of perception. Historically, the logistics of perception runs parallel with the speeding up of life. Since the days of the photopioneers Nicéphore Niépce and Henry Fox Talbot, visual perception has undergone a thorough mechanization in Western society. Faster exposure times and powerful optical machines have eventually rendered the viewing subject dispensable.

Electronic optics and digital systems have paved way for what Virilio calls "the production of sightless vision" (Virilio 1994: 73). Whereas light and darkness are the organizing principles of human vision, the sightless vision of electronic optics, is characterized by its intensification of light and automatic registration of everything that comes within its visual field. The logistics of perception, described by Virilio, can be illustrated by the picture of the two surgeons performing keyhole surgery with stereoscopical devices. The "sightlessness" of the stereoscopical camera inserted into the patient's body, the distribution of images via automatic vision machines, the blending of the present body and the telepresent images, the speed with which distances in time and space are interwoven through television and computers—all these phenomena are effects of the digitization of Western society. Even the sense of three-dimensional space is created with the aid of electro-optical technology.

Surgery as an Expression of Digital Culture

The technology which contemporary medicine is bringing into play is closely linked to the mass media of consumer society. This fact is made all the more obvious when medical doctors refer to their own field as cybermedicine or telemedicine and to doctors, nurses and patients as cybersurgeons, telenurses and virtual patients. Hip terms like these, indicate an awareness among medical professionals of partaking in the making of modern culture. Digital technology does not only provide hospitals and clinics with proper tools, it inscribes medicine in the wider framework of digital culture where the boundaries between entertainment, science and ideology have become difficult to discern. Before computer graphics became a serious option in medicine, producers of computer games like Nintendo, used them to create virtual environments into which players could plunge their avatars and simulate action.

Today, computer aided design is used for a number of reasons, but whether it is a question of playing games, educating doctors or training soldiers, the main purpose is to create an illusion of reality. "A successful virtual environment is one that engages the user, encouraging a willing suspension of disbelief and evoking a feeling of presence and the illusion of reality", Metin Akay and Andy Marsh declare in *Information Technologies in Medicine* (Akay and Marsh 2001: 5). "Presence" and

"illusion" are important features of digital culture. Computer simulations are used precisely for the reason of creating an illusion of being present in a virtual environment. In this sense, medical doctors and players of computer games are governed by the same psychological outlook. In order to achieve a successful user interface, both doctors and players, have to picture the graphical figures on their computer screens as worthy representations of human anatomy or fictitious landscapes. It is for this reason that computer aided design has become such an important aspect of virtual reality. What takes place on the screen has to have the power to wholly capture the user. This is the case when the images displayed there relate to real bodies as well as when they are strictly imaginary.

Digital culture is influencing medicine in various ways. As for surgery, certain skills that hitherto had distinguished the skilful surgeon, are in the midst of being redefined. The coordination of eye and hand, for example, can no longer be executed in the same way as when the surgeon has total access to the body. Dexterity and visual perception have to be adjusted to new technologies and new modes of action. Moreover, changes in the way that surgery is performed, are likely to entail a shift in identification and professionalism. If we are to believe the eager advocates of digital medicine, informatics is becoming just as important in surgery as ever anatomy and physiology. Future surgery may not require knowledge in handling the scalpel but rather familiarity with computers. It has also been suggested that surgeons who often play computer games sharpen their ability to coordinate the senses of vision and touch, when performing keyhole surgery (Satava 1998: 143–144).

Throughout the history of medicine, ideals of how to best gain experience of the marvels of the human body have alternated. Physicians have either stressed the importance of postmortem dissections or clinical studies. Instruments such as the stethoscope and the pulsewatch have either been praised or rejected. Today, with the spread of high-performance computers, yet another paradigm of learning and experience has appeared; the paradigm of interactive learning with the aid of computer simulators and Virtual Reality graphics. Virtual Reality is not only taking place on the computer screen but literally creeping out of cyberspace and rearranging the material appearance of hospitals, clinics and the operating room. Now that computer simulations have become widely recognized, one can wonder how these "suspensions of disbelief" will effect the future pedagogics of medicine. If medical training used to involve too much reality—blood and fainting, the stink of decomposing corpses, vomiting and nausea—we find today a situation where great efforts are made to enforce an experience of the real thing.

References

Akay, Metin & Andy Marsh eds, (2001). *Information Technologies in Medicine. Medical Simulation and Education.* New York: John Wiley & Sons, Inc.

Brown, Nik & Andrew Webster (2004). *New Medical Technologies and Society. Reordering Life.* Cambridge: Polity Press.

Dijck, José van (2005). *The Transparent Body. A Cultural Analysis of Medical Imaging.* Seattle: University of Washington Press.

Johnson, Ericka (2004). *Situating Simulators. The integration of simulations in medical practice.* Lund: Arkiv förlag.

Lenoir, Timothy & Sha Xin Wei (2002). Authorship and Surgery: The Shifting Ontology of the Virtual Surgeon. Bruce Clarke & Linda Dalrymple Hendersson eds, *From Energy to Information. Representation in Science and Technology, Art, and Literature.* Stanford: Stanford University Press, 283–308.

Prentice, Rachel (2005). The Anatomy of a Surgical Simulation: The Mutual Articulation of Bodies in and through the Machine. *Social Studies of Science,* 35:6 (December 2005), 837–66.

Rabinovitz, Lauren & Abraham Geil eds, (2004). *Memory Bytes. History, Technology and Digital Culture.* Durham: Duke University Press.

Satava, Richard M. ed., (1998). *Cybersurgery. Advanced Technologies for Surgical Practice.* New York: John Wiley & Sons, Inc.

Virilio, Paul (1994). *The Vision Machine,* trans. Julie Rose, Indiana: Indiana University Press.

Virilio, Paul (2000). *Polar Inertia,* trans. Patrick Camiller, London: Sage Publications.

−6.9−

In the Service of Ben Comun: Visions of Good and Bad Government in Siena

Timothy Hyman

By the end of the 1330s, when one of Siena's leading painters, Ambrogio Lorenzetti was commissioned to celebrate Siena's system of government in the Palazzo Publico in the city, the Commune was an institution under threat: as Dante has lamented earlier in the century, 'the towns of Italy are full of tyrants' (*Purgatorio* VI: 124–5). There has seen much debate as to the probable sources for the allegory of Good Government, Nicolai Rubinstein proposing Aristotle and Thomas Aquinas, Quentin Skinner suggesting Brunetto Latini, as well as Cicero and Seneca. What now seems clear is that no single author provided the text. It probably emerged out of preliminary discussions, to which several individuals, including Ambrogio himself, would have contributed ideas. (In 1347, the artist is documented as having 'spoken wisely' at one of the main Sienese councils.)

The resulting room was perfectly structured to make its statement. The Nine, the elected "Governors and Defenders of the Commune", entered beneath Justice—the bricked-up arch of the doorway is still visible—and sat below the allegory on a raised platform. The petitioners facing the nine men were able to read off the six female Virtues seated above them: Peace, Fortitude, Prudence, Magnanimity, Temperance and Justice; with Hope, Faith and Charity hovering above. To either side, they say extended a stark choice: the 'Bad' wall on their left, where Tyranny leads to War; the 'Good' on the right, where the Commune creates a world in harmony (Figure 17).

They would have read Good Government from the left, with Justice raising her eyes to Wisdom. Justice rewards and punishes, she gives just measure. From each of her scales a cord leads down, the two cords plaited together by a handsome figure, who bears on her knees a massive carpenter's plane inscribed Concordia. She hands the double cord to a blue-robed man who turns to receive it; and so it is passed along the line of gowned-and-capped (but subtly individuated) citizens, each one laying hold of it; until finally it is tied around the wrist of the noble old greybeard. The letters around him, CSCV, identify him as Commune Senarum Civitas Virginis ('Commune of Siena, City of the Virgin') and he is elsewhere named as Ben Comun. Here is a team of citizens, harnessed in the traces of Justice and Concord and flanked by all the Virtues, serving the common good—or the Good Commune.

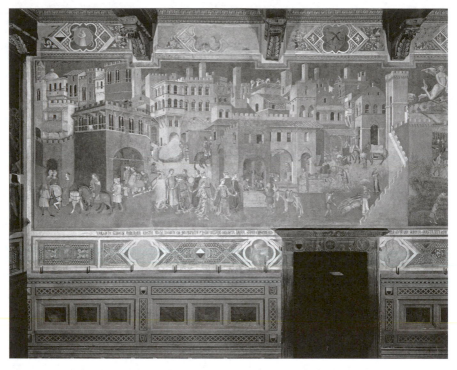

Figure 17 Ambrogio Lorenzetti: *The Well Governed City* (Detail), Palazzo Publico, Siena. Courtesy of PhotoSCALA, Florence.

Allegory of this kind can easily sound laughable, an enormous mixed meta-phor. But in Ambrogio all is realized with a convincing materiality. The angel in Justice's scales gives two kneeling merchants a large black object resembling a hat box, recently identified as a staia or bushel; an instrument of just measure in their commerce. Concord's attribute, the carpenter's plane, is even more practical. Com-mentaries have usually talked of her 'smoothing out discord'; but surely everything we know about the Nine suggests they favoured a more robust action of any 'good government'—to make citizens more equal, to shave the overmighty, by taxation or by other measures. The three Virtues to the left of Ben Comun are finely character-ized. Pax (Peace), lolling on her discarded armour with more piled under her feet, has often been viewed as the room's pivot—and hence its familiar name, the Sala della Pace (Hall of Peace). Yet the vernacular inscriptions in the frame make clear that it is from Justice, not Peace, that all good is said to flow. The same text built into Simone Martini's *Madonna-as-Justice* in the Great Council Hall next door, now reappears some twenty years later in the semicircular inscription above the scales: 'Love Jus-tice, You who Judge the Earth'. Finally, below the panorama of the adjoining wall, it is Justice who is praised: 'Turn your Eyes to Look on Her, You who Govern...':

Guardate quanti ben'vengan da lei
È come e dolce vita e riposata
Quella de la citta du è servato
Questa virtu ke piu d'altro risprendo

[Look how many good things flow from her / And how sweet and reposeful is life / In the city where she is served / That Virtue who outshines any other]

The Image of a Just Society

Ambrogio's famous wall must, at over forty-six feet, be among the widest uncompartmented depictions in all painting prior to the colossal nineteenth-century panoramas. What defines Ambrogio's space as 'panoramic' is its highly extended format, almost five times wider than it is high (twice the ratio of even the widest cinemascope), the culmination of all Siena's bird's-eye imagery. Once again, we are above the city, but we see only the right-hand segment; the city wall must continue far below and to the left, just as the vast tract of countryside under its curving horizon must imply an equally grand vista on the other side of the city. Perhaps the clearest way to conceptualize this would be as two concentric circles—the circuit of the city walls, surrounded by its territory.

The panorama has often been seen as a problematic viewpoint: it gives us a kind of omniscience, but also holds us at a distance. Ambrogio's pre-perspectival space is able to resolve this dilemma. In a manner that might seem almost magical, we are both above and inside the city; we see everything, yet we are also able to participate and move freely about. (We might think of the mystical condition known as 'ambient vision', with its 'circumspatial' or infinite perception; or of the demon Asmodeus lifting the roofs of Madrid in LeSage's *The Devil on Two Sticks*.) Many of the characteristic Sienese building types—the loggias, open fountains, free-standing porticos—assist Ambrogio's in this aesthetic of total disclosure, creating a cityspace that is intrinsically cut away. Could Ambrogio have known some of those passages by classical authors that describe works of art in terms of their comprehensive vision of all terrestrial existence? Homer's 'Shield of Achilles' in the Iliad, for example, with its representations of Peace and War; or the famous text by Pliny the Elder, where the Roman painter Statius paints villas, harbours, landscape gardens, sacred groves, woods, hills, fishponds … figures of people coming up to the country houses either on donkeys or in carriages beside figures of … fowlers, or of hunters.

Yet what makes Ambrogio's space so much more accessible than any of his Renaissance successors, is the way near and far can be simultaneously present; at a single glance, we take in the lecturer in the city classroom together with a glimpse of the sea miles beyond. We recognize a kind of seeing truer to our imaginative experience of space (confirmed in reverie and ream) than single-point perspective can ever be. And

it also takes on a moral dimension—embodying the social diversity and fluidity of the republican ideal.

Ambrogio's masterstroke is the complex construction of gate and wall at the center, triggering powerful spatial cues: the sliver of dark wall that reaches down on the right of the nearest zig-zag plunges us back into space; the pale line of ledge behind the unguarded castellations—out of sight in the foreground, visible half way up, then lost again—leads us compellingly to a little door in the gate. The pigment used is, once more, burnt sienna, with each shifting plane perfectly graded to the most luminous range of tones. It is from the gate that we move left into the city: or outwards, along the road and down to the bridge.

Of course we can also move across the city from the left. The first ten feet or so have been insensitively reworked by a later artist; it is unlikely that Ambrogio would have included the Cathedral in a composition so markedly free of any specific local topography. The campanile is poorly observed (the artist needed only to look out from the other side of the Palazzo to register that the number of arches decreases as the tower descends) and although the wedding procession has its charms, the figures are clearly by a later hand. So Ambrogio's city really begins just to the left of the dancers, under an arch where a falcon perches and two little children are chatting, and where a group of men concentrate on some now obliterated object—perhaps a board game. The nine dancers, much larger than the figures around them, are almost certainly emblematic; a tenth, differentiated by her dark gown, accompanies them with tambourine and song. Perhaps we should call these dancers the 'Daughters of the Nine', even though some commentators have identified them as male, their fantastical gowns suggesting a masquerade. Dancing in the street was, in reality, expressly forbidden in security-conscious and faction-ridden Siena. Yet the significance of their dance here is surely as a kind of distillation of peace. For Ambrogio (as later for Matisse) when human beings move together in a circle they spell out a fundamental image of social well-being—the *dolce vita e riposata,* the *bonheur de vivre,* that follows from communal freedom and justice.

We are invited to pause at each of the activities our eyes alight on: the bookshop behind the dancers with a reader in a carrel; the shoe shop, or hosiery; the rapt audience that lecture; the tavern counter, with its cured hams hanging very much as they do today above Italian bars. Then our eye may travel upward, catching a woman looking out of a side window, a vase of flowers, a birdcage—and high above, the builders at work on the wooden scaffolding, set against the dark sky. This band of very deep metallic blue, applied over a crimson underlayer, unifies all three walls. Outside the tavern a peasant goads his donkey forward; behind, facing the opposite way, another donkey appears in profile, its huge head delicately floated on a golden ochre ground. Everywhere we notice Ambrogio's relish in chance overlappings: the play of partial donkeys, as headless hindquarters disappear behind houses; the incongruous appearance of a sheep's head jutting forward over a young girl's shoulder, as a shepherd and his flock pass her by.

The city itself is conceived as a compressed mass of irregular buildings. Ambrogio's preparations must have involved a great deal of architectural drawing, far more than most modern painters would stoop to. The details of the building types are precise, and they can still be recognized in modern Siena, though today much of the painted stucco has been stripped away. Ambrogio was able to dispose of a varied palette of contrasted greys, pinks and browns; modern Siena is a more uniform brick landscape. But he avoids literal topography—there is no trace, for example, of Siena's most striking feature, the Campo. It is as though Ambrogio picked up his entire city and redistributed it, elided and concertina'd, across the spread of a single wall.

The Space of Vernacular Style

But who is the winged woman flying to the right of the gate? Beside her is inscribed the word 'SECURITAS', yet the cartouche she displays seems also to identify her as sovereign Justice. And why would Security be nude? I believe Ambrogio's figure may represent an echo of a once familiar prophecy—the 'Just Virgin' of Virgil's fourth Eclogue. 'The Golden Age Returns', the most famous throughout the Middle Age of all his poems:

> Time has conceived and the great Sequence of the Ages starts afresh.
> Justice, the Virgin comes back to dwell with us

That conception of a New Age under the sign of the Just Virgin, in which 'the waving corn will slowly flood the plains with gold', and 'Golden Man inherit all the world', was well attuned to Ambrogio's theme. It was also timely: in 1347 Cola di Rienzo would use the same Virgilian imagery to rally all Italy to the cause of liberty; while Dante, both in *De Monarchia* and in his *Purgatorio,* had invoked the same figure of the rule of the Just Virgin to embody his Ghibelline hopes. What makes Ambrogio's imagery unique in all Western art, however, is that he dares to affirm the possibility of a perfected society, a Golden Age, not as a pre-urban pastoral, but within the complexity of a contemporary city-state.

Once we pass through the gate, the whole atmosphere changes. There is less overlap, and space moves more freely around several complete figures: the falconer and his squire, the amazon seated side-saddle in her bright red skirt—the head of her horse perfectly framing the blind beggar, painted with extraordinary economy. The beggar's hat may identify him as Chinese—perhaps a Mongolian slave or prisoner. Ambrogio shows here a 'Franciscan' attention to the unregarded: juxtaposing the rich and the destitute as part of his own canticle 'of all created things'. Across the entire wall, fifty-six humans and as many animals can be counted. There are fewer women than men, but anonymous peasants register vividly as they pass on the road; one, rope in hand, is led by his saddlebacked pig to market; two stumpy contadini lower

down, are deep in conversation, legs fused in amity. When we recall the steep road of Duccio's *Entry into Jerusalem* of thirty years earlier, we marvel at the distance Ambrogio has travelled.

The scale is not constant. The falconers are much bigger than the peasants at work in front of them. As we move down the paved highway, figures diminish in size more or less 'correctly', and distance is powerfully felt between road and field. But when we examine the distant figures more closely, it becomes apparent that the foreground threshers are smaller than the harvesters behind. Such inconsistencies create a sequence of compartments; the effect is of our loosely hovering over the landscape, passing from one focus to another, invited to take a journey through an ideal land of both spring and summer—where sowing and harvesting take place simultaneously.

The landscape is unmistakably Sienese territory, with its villas and vines, its crete and distant towers. This huge vista, so unlike any other known medieval painting, has prompted much speculation. Perhaps the wildest, but too persistent to be ignored, is that Ambrogio may have seen Chinese landscape scrolls. The twentieth-century painter Balthus found 'no difference between Far-Eastern painting and that of the Sienese'. In the fifty years after Marco Polo's return from the East in 1298, trade between Italy and Cathay was at its height. *The Merchants' Handbook* of c. 1340 declared the Silk Road between the Black Sea and Cathay 'perfectly safe, by day or by night'. Chinese brocaded silks and other fabrics became important European commodities, and the fantastical textiles worn by Ambrogio's dancers, patterned with dragonflies and silkworms, are likely to be of Far Eastern origin. In addition, Tuscan cities are known to have had substantial populations of Mongolian slaves. Thus a Chinese connection cannot be ruled out, even if another possible source for fluid atmospheric landscape illusionism did exist nearer to home, in the Late Antique mural cycles of the Christian basilicas in Rome.

Ambrogio's fresco handling is much looser than any of his contemporaries', more intimate and unplanned. No preliminary design could have anticipated the constant play of calligraphic mark across this enormous surface: the wisps of vegetation, the percussion of a cornfield's stubble, the featheriness of a cockerel's multicoloured tail ... Even after so much damage, it survives as one of the greatest 'touch paintings' in European art, an astonishing feat of sustained improvisation. Only one later artist would offer an itinerary quite like this—landscapes of cosmic breadth, crowded cityscapes, executed in a comparable 'drawing/painting'; whenever I see Ambrogio's peasants I think of Pieter Brueghel. The hypothesis first put forward by White—that the young Brueghel, passing through Siena twice on his journey to Rome, Naples and the South in 1552–53, would have encountered Ambrogio's still famous fresco—seems to me persuasive. Early Netherlandish landscape of the fifteenth century had owed much of its spatial idiom—its detailed naturalistic vignettes strung together—to Sienese painting, transmitted by the Limbourg Brothers and other International Gothic miniaturists. Yet as Mark Meadow tells us, the Antwerp that Brueghel returned to was now being invaded by a new landscape conven-

tion. Classicizing, idealized, unified by Albertian perspective, it came with all the prestige of Italian humanist culture, and threatened to sweep away the earlier tradition. Brueghel, in Meadow's phrase, 'defended the space of vernacular style'; his art developed into a new panoramic genre, and his Seasons became the greatest heirs to Ambrogio's landscape vision.

The Winter Wall

The 'Bad' wall, which happens to be by far the most damaged, is also in general the least compelling pictorially: a rare case where the devil does not have all the best tunes. Yet as I read my way into this scheme, I enjoy Ambrogio's intellectual cunning in the placing of ideas—what might be called his 'zoning'. We are now, as the framework tells us, in winter, presided over by unfavourable planets—Saturn, Jupiter, Mars—and by tyrants, including the emperor Nero. Inherent in the structure of this 'sinister' wall is that we must read it from right to left—in other words, against the grain of our customary reading. The throne of tyranny is flanked by Cruelty and Deceit (bearing a sheep with a scorpion's tail): by Fraud, Fury and saw-wielding Division (whose black-and-white livery is inscribed 'Si' and 'No'); by War in black armour. Avarice, Pride and Vainglory are airborne above. At the foot of the throne lies Justice, abject—her hands tied, her scales broken. In the words of the inscription:

> There, where Justice is bound, no-one is ever in accord with Ben Comun, nor pulls the cord straight.

The gate of the Ill-governed City is aligned exactly opposite that of its Well-Governed counterpart. When we pass through the city itself, we enter a world where, as White puts it, 'nothing fits'—where disharmony is a principle, where every overlap jars. Tyranny's city is falling into ruin: windows have lost their colonettes and gape hollow, and at top center, two men are demolishing the house they stand in. The only industry to be seen is an armourer hammering at his forge. In the foreground, a kind of sinister clown in motley pulls at the collar of a civilian, drawing his dagger. Close by, two soldiers lay hold of a red-gowned woman; another lies dead at their feet. To the left, a horseman clatters steeply down the deserted street, towards the gate, to join the armed group just emerging. Above them, there flies out from the city into the countryside a terrible dark-skinned figure, sword in hand, teeth bared in a wolf-like grimace; it is Timor (Fear), and written in Latin on her scroll, we read: 'Because each sees only his own good, in this city Justice is subject to Tyranny; nobody passes along this road without Fear'.

If the 'Good' space is made up of concentric circles, returning us to Ben Comun, the 'Bad' is an endless extension, petering out in a landscape of utter desolation—among the most compelling areas of the entire scheme. This is nature made hideous,

the landscape of those 'dark injuries' listed in the inscription: 'Where there is Tyranny, there are great fear, wars, robberies, treacheries . . .'. The damage this landscape has suffered has only increased its atmospheric power. The two armies advancing towards the green river have been rendered spectral against the blackened vegetation, palely silhouetted close to the burning village. The red flames twist upwards with wisps of grey smoke, towards the hilltop crowned with ruins, under a sky that has lost almost all its blue and is now a mottled crimson. Our nearest modern parallel to this ravaged storm-lit world is in Anselm Kiefer's Holocaust imagery of the 1980s—the burnt heath inscribed with words from Paul Celan's 'Fugue of Death'.

In 1339, as Ambrogio's room neared completion, the Nine embarked on their most ambitious undertaking; the creation of a new cathedral, to whose colossal nave the existing Cathedral was to be merely the transept. As Borsook puts it: 'Siena already possessed the biggest piazza, hospital and altarpiece in all of Italy: why not the biggest cathedral?' Meanwhile in the Campo itself, another massive project was under way: the paving of the entire arena in bricks, cunningly laid in curved section between the nine stone runnels—a solution both decorative, and, on a rainy day, superbly practical. The paving was completed in 1347: the final enterprise of a regime which, in the following year, would be irreversibly crippled by catastrophe.

–6.10–

Intimate Immensity
Gaston Bachelard

Le monde est grand, mais en nous
il est profound comme la mer.

<div align="right">R. M. Rilke</div>

(The world is large, but in us
it is deep as the sea.)

L'espace m'a toujours rendu silencieux.

<div align="right">Jules Vallès, L'enfant, p. 238</div>

(Space has always reduced me to silence.)

I

One might say that immensity is a philosophical category of daydream. Daydream undoubtedly feeds on all kinds of sights, but through a sort of natural inclination, it contemplates grandeur. And this contemplation produces an attitude that is so special, an inner state that is so unlike any other, that the daydream transports the dreamer outside the immediate world to a world that bears the mark of infinity.

Far from the immensities of sea and land, merely through memory, we can re-capture, by means of meditation, the resonances of this contemplation of grandeur. But is this really memory? Isn't imagination alone able to enlarge indefinitely the images of immensity? In point of fact, day-dreaming, from the very first second, is an entirely constituted state. We do not see it start, and yet it always starts the same way, that is, it flees the object nearby and right away it is far off, elsewhere, in the space of *elsewhere*.[1]

When this *elsewhere* is in *natural* surroundings, that is, when it is not lodged in the houses of the past, it is immense. And one might say that daydream is *original contemplation*.

If we could analyze impressions and images of immensity, or what immensity contributes to an image, we should soon enter into a region of the purest sort of

phenomenology—a phenomenology without phenomena; or, stated less paradoxically, one that, in order to know the productive flow of images, need not wait for the phenomena of the imagination to take form and become stabilized in completed images. In other words, since immense is not an object, a phenomenology of immense would refer us directly to our imagining consciousness. In analyzing images of immensity, we would realize within ourselves the pure being of pure imagination. It then becomes clear that works of art are the *by-products* of this existentialism of the imagining being. In this direction of daydreams of immensity, the real *product* is consciousness of enlargement. We feel that we have been promoted to the dignity of the admiring being.

This being the case, in this meditation, we are not "cast into the world," since we open the world, as it were, by transcending the world seen as it is, or as it was, before we started dreaming. And even if we are aware of our own paltry selves—through the effects of harsh dialectics-we become aware of grandeur. We then return to the natural activity of our magnifying being.

Immensity is within ourselves. It is attached to a sort of expansion of being that life curbs and caution arrests, but which starts again when we are alone. As soon as we become motionless, we are elsewhere; we are dreaming in a world that is immense. Indeed, immensity is the movement of motionless man. It is one of the dynamic characteristics of quiet daydreaming.

And since we are learning philosophy from poets, here is a lesson in three lines, by Pierre Albert-Bireau:[2]

Et je me crée d'un trait de plume
Maître du Monde
Homme illimité

(And with a stroke of the pen I name myself
Master of the World
Unlimited man)

II

However paradoxical this may seem, it is often this *inner immensity* that gives their real meaning to certain expressions concerning the visible world. To take a precise example, we might make a detailed examination of what is meant by the *immensity of the forest*. For this "immensity' originates in a body of impressions which, in reality, have little connection with geographical information. We do not have to be long in the woods to experience the always rather anxious impression of "going deeper and deeper" into a limitless world. Soon, if we do not know where we are going, we no longer know where we are. It would be easy to furnish literary documents that

would be so many variations on the theme of this limitless world, which is a primary attribute of the forest. But the following passage, marked with rare psychological depth, from Marcault and Thérèse Brosse's excellent work,[3] will help us to determine the main theme: "Forests, especially, with the mystery of their space prolonged indefinitely beyond the veil of the tree-trunks and leaves, space that is veiled for our eyes, but transparent to action, are veritable psychological transdendents."[4] I myself should have hesitated to use the term psychological transcendents. But at least it is a good indicator for directing phenomenological research towards the transcendencies of present-day psychology. It would be difficult to express better that here the functions of description—psychological as well as objective—are ineffective. One feels that there is *something else* to be expressed besides what is offered for objective expression. What should be expressed is hidden grandeur, depth. And so far from indulging in prolixity of expression, or losing oneself in the detail of light and shade, one feels that one is in the presence of an "essential" impression seeking expression; in short, in line with what our authors call a "psychological transcendent." If one wants to "experience the forest," this is an excellent way of saying that one is in the presence of *immediate immensity,* of the immediate immensity of its depth. Poets feel this immediate immensity of old forests:[5]

Forêt pieuse, forêt brisée où l'on n'enlève pas les morts
Infiniment fermée, serrée de vieilles tiges droites roses
Infiniment resserrée en plus vieux et gris fardés
Sur la courche de mousse énorme et profonde en cri de velours

(Pious forest, shattered forest, where the dead are left lying
Infinitely closed, dense with pinkish straight old stems
Infinitely serried, older and grayed
On the vast, deep, mossy bed, a velvet cry.)

Here the poet does not describe. He knows that his is a greater task. The pious forest is shattered, closed, serried. It accumulates its infinity within its own boundaries. Farther on in the poem he will speak of the symphony of an "eternal" wind that lives in the movement of the tree-tops.

Thus, Pierre-Jean Jouve's "forest" is *immediately sacred,* sacred by virtue of the tradition of its nature far from all history of men. Before the gods existed, the woods were sacred, and the gods came to dwell in these sacred woods. All they did was to add human, all too human, characteristics to the great law of forest reverie.

But even when a poet gives a geographical dimension, he knows instinctively that this dimension can be determined on the spot, for the reason that it is rooted in a particular oneiric value. Thus, when Pierre Guéguen speaks of "the deep forest" (the forest of Broceliande),[6] he adds a dimension; but it is not the dimension that gives the image its intensity. And when he says that the deep forest is also called "the quiet

earth, because of its immense silence curdled in thirty leagues of green," Guéguen bids us participate in transcendent quiet and silence. Because the forest rustles, the "curdled" quiet trembles and shudders, it comes to life with countless lives. But these sounds and these movements do not disturb the silence and quietude of the forest. When we read this passage of Guéguen's book we sense that this poet has calmed all anxiety. Forest peace for him is inner peace. It is an inner state.

Poets know this, and some reveal it in one line as, for instance, Jules Supervielle, who knows that in our peaceful moments we are

Habitants délicats des forêts de nous-mêmes.
(Sensitive inhabitants of the forests of ourselves.)

Others, who are more logical, such as René Ménard, present us with a beautiful album devoted to trees, in which each tree is associated with a poet. Here is Ménard's own *intimate forest:* "Now I am traversed by bridle paths, under the seal of sun and shade ... I live in great density ... Shelter lures me. I slump down into the thick foliage ... In the forest, I am my entire self. Everything is possible in my heart just as it is in the hiding places in ravines. Thickly wooded distance separates me from moral codes and cities."[7] But one should read this whole prose-poem which, as the poet says, is actuated by "reverent apprehension of the Imagination of Creation."

In the domains of the poetic phenomenology under consideration, there is one adjective of which a metaphysician of the imagination must beware, and that is, the adjective *ancestral.* For there is a corresponding valorization to this adjective which is too rapid, often entirely verbal, and never well supervised, with the result that the direct nature of depth imagination and of depth psychology, generally, is lacking. Here the "ancestral" forest becomes a "psychological transcendent" at small cost; it is an image suited to children's books. And if there exists a phenomenological problem with regard to this image, it is to find out for what actual reason, by virtue of what active value of the imagination, such an image charms and speaks to us. The hypothesis, according to which it is due to remote permeation from infinite ages, is a psychologically gratuitous one. Indeed, if it were to be taken into consideration by a phenomenologist, such a hypothesis would be an invitation to lazy thinking. And, for myself, I feel obliged to establish the actuality of archetypes. In any event, the word ancestral, as a value of the imagination, is one that needs explaining; it is not a word that explains.

But who knows the temporal dimensions of the forest? History is not enough. We should have to know how the forest experiences its great age; why, in the reign of the imagination, there are no young forests. I myself can only meditate upon things in my own country, having learned the dialectics of fields and woods from my unforgettable friend, Gaston Roupnel.[8] In the vast world of the non-I, the non-I of fields is not the same as the non-I of forests. The forest is a before-me, before-us, whereas for fields and meadows, my dreams and recollections accompany all the

different phases of tilling and harvesting. When the dialectics of the I and the non-I grow more flexible, I feel that fields and meadows are with me, in the with-me, with-us. But forests reign in the past. I know, for instance, that my grandfather got lost in a certain wood. I was told this, and I have not forgotten it. It happened in a past before I was born. My oldest memories, therefore, are a hundred years old, or perhaps a bit more.

This, then, is my ancestral forest. And all the rest is fiction.

Notes

1. Cf. Supervielle, *L'escalier,* p. 124. 'Distance bears me along in its mobile exile.'
2. Pierre Albert-Bireau, *Les amusements naturels,* p. 192.
3. Marcault and Thérèse Brosse, *L'éducation de demain,* p. 255.
4. 'A characteristic of forests is to be closed and, at the same time, open on every side.' A. Pieyre de Mandiargues, *Le lis de mer,* 1956, p. 57.
5. Pierre-Jean Jouve, *Lyrique,* p. 13. Mercure de France, Paris.
6. Pierre Guéguen, *La Bretagne,* p. 71.
7. René Ménard, *Le Livre des arbres,* pp. 6 and 7. Arts et Métiers Graphiques, Paris, 1956.
8. Gaston Roupnel, *La campagne française,* see the chapter entitled *La Forêt,* p. 75 and after. Club des Libraires de France, Paris.

Hearts perceive only through sight, and the eyes of faces perceive only through sight. Wherever there is sight, perception occurs. Sight in the rational faculty is called the "eye of insight," while sight in the outside world ... is called the "sight of the eye." The eye in the outside world is the locus for sight, while insight in the inside world ... is the locus for that eye which is sight in the eye of the face. Sight's names are diverse, but it is not diverse in itself.

From: W. C. Chittick, *The Sufi Path of Knowledge*

Suggested Readings

The readings suggested here are those that expand the various themes explored in this volume. They come from three sources although they are presented in a unified list. First are general readings in the field. Second are key works cited in the pieces in this volume, brought together here for ease of reference. Third are references to material which is very much in the spirit of the volume, and which the editors may have considered for inclusion but that, for one reason or another—for instance, overall balance, being published too late, or copyright problems—did not make it to the final cut.

Armstrong, Nancy (1999), *Fiction in the Age of Photography: The Legacy of British Realism.* Cambridge, MA: Harvard University Press.

Arnaud, Jean (2005), 'Touching to See', *October,* 114 (Fall): 5–16.

Aumont, Jacques, Bergala, Alain, Marie, Michel and Vernet, Marc (1992), *Aesthetics of Film,* Austin: University of Texas Press.

Babb, Lawrence (1981), 'Glancing: Visual Interaction in Hinduism', *Journal of Anthropological Research,* 32/4: 378–410.

Bal, Mieke (1996), *Double Exposure: The Subject of Cultural Analysis,* London and New York: Routledge.

Bal, Mieke (2003), 'Visual Essentialism and the Object of Visual Culture', *Journal of Visual Culture,* 2(1): 5–32.

André Bazin (1968), *What Is Cinema?,* Vol 1, Berkeley: University of California Press.

Bell, Joshua (2003), 'Looking to See', in L. Peers and A. Brown, eds, *Museums and Source Communities,* London: Routledge.

Belting, Hans (2005), 'Image, Medium, Body: A New Approach to Iconology', *Critical Inquiry,* 31(2): 302–19.

Bottomore, Stephen (1999), 'The Panicking Audience?: Early Cinema and the "Train Effect" ', *Historical Journal of Film, Radio and Television,* 19.2: 177–216.

Brennan, Teresa, and Jay, Martin, eds (1996), *Vision in Context: Historical and Contemporary Perspectives on Sight,* New York: Routledge.

Brodsky, Joyce (2002), 'How to 'See' with the Whole Body', *Visual Studies,* 17(1): 99–112.

Bryson, Norman (1981), *Word and Image. French painting in the ancien regime,* Cambridge: Cambridge University Press.

Bryson, Norman et al. (2003), 'Responses to Mieke Bal's "Visual Essentialism and the Object of Visual Culture"', *Journal of Visual Culture,* 2(2): 229–68.

Buckley, Liam (2001), 'Self and Accessory in Gambian Studio Photography', *Visual Anthropology Review,* 16(1): 71–91.

Burch, Noel (1981), *Theory of Film Practice,* Princeton, NJ: Princeton University Press.

Burgin, Victor (1986), 'Seeing Senses', in *The End of Art Theory: Criticism and Postmodernity,* Basingstoke: Macmillan.

Cahiers du Cinema, Collected Essays, Vols. 1–3, ed. by Jim Hillier et al., Cambridge, MA: Harvard University Press.

Certeau, Michel de (1984), *The Practice of Everyday Life,* Berkeley: University of California Press.

Chion, Michel (1994), *Audio-Vision: Sound on Screen,* New York: Columbia University Press.

Clark, Andy (1997), *Being There: Putting Brain, Body and the World Together Again,* Cambridge, MA: MIT Press.

Classen, Constance (1993), *Worlds of Sense: Exploring the Senses in History and Across Cultures,* London: Routledge.

Classen, Constance (1997), 'Foundations for an Anthropology of the Senses', *International Social Science Journal,* 153: 410–12.

Crary, Jonathan (1990), *Techniques of the Observer,* Cambridge, MA: MIT Press.

Crary, Jonathan (2000), *The Suspension of Perception: Attention, Spectacle and Modern Culture,* Cambridge, MA: MIT Press.

Csordas, Thomas J. (1994), 'Introduction: The Body as Representation and Being-in-the-World', in *Embodiment and Experience,* Cambridge: Cambridge University Press.

Cubitt, Sean (1998), *Digital Aesthetics,* London: Sage.

DeBray, Régis (1996), *Media Manifestos,* trans. Eric Rauth, London: Verso.

Deleuze, Gilles (1986), *Cinema 1: Movement Image,* Minneapolis: University of Minnesota Press.

Deleuze, Gilles (1989), *Cinema 2: The Time Image,* Minneapolis: University of Minnesota Press.

Derrida, Jacques (1993), *Memoirs of the Blind: The Self-Portrait and Other Ruins,* Chicago: University of Chicago Press.

di Bello, Patrizia (2007), *Women's Albums and Photography in Victorian England,* Aldershot: Ashgate (Chapter 6, 'Photography, Vision and Touch').

Dikovitskaya, Margaret (2005), *Visual Culture: The Study of Visual Culture after the Visual Turn,* Cambridge, MA: MIT Press.

Eck, Diana L. (1998), *Darśan: Seeing the Divine Image in India,* 3rd edn, New York: Columbia University Press.

Edwards, Elizabeth (2001), *Raw Histories: Photographs, Anthropology and Museums,* Oxford: Berg.

Edwards, Elizabeth, & Hart, Janice, eds (2004), *Photographs, Objects Histories: On the Materiality of the Image,* London: Routledge.

Edwards, Elizabeth, Gosden, Chris, and Phillips, Ruth, eds (2006), *Sensible Objects: Colonialism, Museums and Material Culture,* Oxford: Berg.

Elkins, James (1996), *The Object Stares Back: On the Nature of Seeing,* New York: Simon & Schuster.

Elkins, James (1999), *The Domain of Images,* Ithaca, NY: Cornell University Press.

Elkins, James (2000), *How to Use your Eyes,* London: Routledge.

Evans, Jessica, and Hall, Stuart, eds (1999), *Visual Culture: The Reader,* London: Sage.

Freedberg, David (1989), *The Power of Images: Studies in the History and Theory of Response,* Chicago: University of Chicago Press.

Gell, Alfred (1998), *Art and Agency: An Anthropological Theory,* Oxford: Clarendon Press.

Geurts, Kathryn L. (2002), *Culture and the Senses: Bodily Ways of Knowing in an African Community,* Berkeley: University of California Press.

Godard, Jean-Luc (1986), *Godard on Godard,* New York: Da Capo Press.

Gunning, Tom (2000), *The Films of Fritz Lang: Allegories of Vision and Modernity,* London: British Film Institute.

Hansen, Miriam (2006), *Babel and Babylon: Spectatorship in American Silent Film,* Cambridge, MA: Harvard University Press.

Haraway, Donna (1989), *Primate Visions: Gender, Race, and Nature in the World of Modern Science,* New York: Routledge.

Helliwell, Christine (2001), *'Never Stand Alone': A Study of Borneo Sociability,* Philips, ME: Borneo Research Council.

Hirsch. Eric (2004), 'Techniques of Vision: Photography, Disco and Renderings of Present Perception in Highland New Guinea', *Journal of the Royal Anthropological Institute,* 10: 19–39.

Holly, Michael Ann (1996), *Past Looking: Historical Imagination and the Rhetoric of the Image,* Ithaca, NY: Cornell University Press.

Howells, Richard (2003), *Visual Culture,* Cambridge: Polity Press.

Howes, David, ed. (1991), *The Varieties of Sensory Experience: A Source Book in the Anthropology of the Senses,* Toronto: University of Toronto Press.

Howes, David (2003), *Sensual Relations: Engaging the Senses in Culture and Social Theory,* Ann Arbor: University of Michigan Press.

Howes, David, ed. (2005), *Empire of the Senses: The Sensual Culture Reader,* Oxford: Berg.

Hulme, Lynne (2007), *Portals: Opening Doorways to Other Realities through the Senses,* Oxford: Berg.

Ingold, Tim (2000), *The Perception of the Environment: Essays on Livelihood, Dwelling and Skill,* London: Routledge.

Jackson, Michael, ed. (1996), *Things as They Are: New Directions in Phenomenological Anthropology,* Bloomington: Indiana University Press.

Jay, Martin (1993), *Downcast Eyes: The Denigration of Sight in Twentieth Century Thought,* Berkeley: University of California Press.

Jay, Martin (2002), 'That Visual Turn: The Advent of Visual Culture', *Journal of Visual Culture,* 1(1): 87–92.

Jenks, Chris, ed. (1995), *Visual Culture,* London: Routledge.

Jones, Amelia, ed. (2003), *The Feminism and Visual Culture Reader,* London: Routledge.

Kristeva, Julia (1982), *Powers of Horror: An Essay in Abjection,* New York: Columbia University Press.

Lacan, Jacques (1977), 'The Mirror Stage as Formative of the Foundation of the I as Revealed in Psychoanalytic Experience', in *Écrits: A Selection,* trans. A. Sheridan, London: Tavistock.

Lalvani, Suren (1996), *Photography, Vision, and the Production of Modern Bodies,* Albany: State University of New York Press.

Latour, Bruno, and Weibel, Peter, eds (2002), *Iconoclash: Beyond the Image Wars in Science, Religion and Art,* Cambridge, MA/Karlsruhe: MIT Press/ZKM.

MacDougall, David (2006), *The Corporeal Image: Film Ethnography and the Senses,* Princeton, NJ: Princeton University Press.

MacDougall, David (2007), 'The Experience of Colour', *Senses and Society,* 2: 5–26.

McQuire, Scott (1998), *Visions of Modernity,* London: Sage.

Marks, Laura U. (1999), *The Skin of the Film: Intercultural Cinema, Embodiment, and the Senses,* Durham, NC: Duke University Press.

Mauss, Marcel (1979) [1950], 'Body Techniques', in *Sociology and Psychology: Essays,* trans. Ben Brewster, London: Routledge & Kegan Paul.

McLuhan, Marshall (1962), *The Gutenberg Galaxy,* Toronto: Toronto University Press.

Merleau-Ponty, M. (1962), *The Phenomenology of Perception,* trans. Colin Smith, London: Routledge & Kegan Paul.

Metz, Christian (1986), *The Imaginary Signifier: Psychoanalysis and the Cinema,* Bloomington: Indiana University Press.

Miller, Toby, and Stam, Robert, eds (2000), *Film and Theory: An Anthology,* Oxford: Blackwell.

Mitchell, W.J.T. (1992), *The Reconfigured Eye: Visual Truth in the Post-Photographic Era,* Cambridge, MA: MIT Press.

Mitchell, W.J.T. (2002), 'Showing Seeing: A Critique of Visual Culture', *Journal of Visual Culture,* 1(2): 165–81.

Mitchell, W.J.T. (2005), *What Do Pictures Want? The Lives and Loves of Images,* Chicago: University of Chicago Press.

Mitchell, W.J.T. (2005), 'There Are No Visual Media', *Journal of Visual Culture,* 4(2): 257–66.

Mitry, Jean (1999), *The Aesthetics and Psychology of the Cinema,* Bloomington: Indiana University Press.

Mirzoeff, Nicholas (1999), *An Introduction to Visual Culture,* London: Routledge.

Mirzoeff, Nicholas, ed. (2002), *Visual Culture Reader,* 2nd edn, London: Routledge.

Morgan, David, and Promey, Sally M., eds (2001), *The Visual Culture of American Religion,.* Berkeley: University of California Press.

Morin, Edgar (2005), *The Cinema, or the Imaginary Man.* Minneapolis: University of Minnesota Press.

Napier, Susan (2006), *Anime from Akira to Howl's Moving Castle: Experiencing Japanese Animation,* New York: Palgrave.

Nichols, Bill, *Movies and Methods,* vols 1 and 2, Berkeley: University of California Press.

Nochlin, Linda (2006), *Bathers, Bodies, Beauty: The Visceral Eye,* Cambridge, MA: Harvard University Press.

Okley, Judith (2001), 'Visualism and Landscape: Looking and Seeing in Normandy', *Ethnos,* 66 (1): 99–120.

Ong, Walter (1991), 'The Shifting Sensorium', In D. Howes, ed., *The Varieties of Sensory Experience,* Toronto: University of Toronto Press.

Pauwels, Luc, ed. (2006), *Visual Cultures of Science: Rethinking Representational Practices in Knowledge Building and Science Communication,* Hanover, NH: University Press of New England.

Pink, Sarah (2006), *Future of Visual Anthropology: Engaging the Senses,* London: Routledge.

Pinney, Christopher (1997), *Camera Indica: The Social Life of Indian Photographs.* London: Reaktion.

Pinney, Christopher (2003), 'Visual Culture', in V. Buchli, ed., *Material Culture Reader,* 81–103, Oxford: Berg.

Pinney, Christopher (2004), *Photos of the Gods,* London: Reaktion.

Pinney, Christopher, and Thomas, Nicholas, eds (2001), *Beyond Aesthetics,* Oxford: Berg.

Pinney, Christopher, and Peterson, Nic, eds (2003), *Photography's Other Histories,* Durham, NC: Duke University Press.

Plate, S. Brent (2002), *Religion, Art and Visual Culture: A Cross-Cultural Reader,* New York: Palgrave.

Poole, Deborah (1997), *Vision, Race and Modernity: A Visual Economy of an Andean Image World,* Princeton, NJ: Princeton University Press.

Prasad, Madhava (2000), *Ideology of the Hindi Film: A Historical Construction,* New York: Oxford University Press.

Reddy, William M. (2001), *The Navigation of Feeling: A Framework for the History of Emotions.* Cambridge: Cambridge University Press.

Rosen, Philip (1986), *Narrative, Apparatus, Ideology,* New York: Columbia University Press.

Schwartz, V. R., and Pryzyblyski, J. M., eds (2004), *The Nineteenth-Century Visual Culture Reader,* New York: Routledge.

Scott, Clive (1999), *The Spoken Image: Photography and Language,* London: Reaktion.

Screen Reader, vols 1 and 2, various editors.

Segall, M. H., Campbell, D. T., & Herskovists, M. J. (1966), *The Influence of Culture on Visual Perception,* New York: Bobbs-Merrill.

Seremetakis, C. Nadia (1993), 'Memory of the Senses: Historical Perception, Commensal Exchange and Modernity', *Visual Anthropology Review,* 9(2): 2–18.

Seremetakis, C. Nadia, ed. (1996), *The Senses Still: Perception and Memory as Material Culture,* Chicago: University of Chicago Press.

Shuzo, Kuki (2007), *Reflections on Japanese Taste: The Structure of Iki,* Sydney: Power Publications.

Sobchack, Vivian (1992), *The Address of the Eye: The Phenomenology of Film Experience,* Princeton, NJ: Princeton University Press.

Stafford, Barbara M. (1991), *Body Criticism: Imaging the Unseen in Enlightenment Art and Medicine,* Cambridge, MA: MIT Press.

Stafford, Barbara M. (1996), *Good Looking: Essays on the Virtue of Images,* Cambridge, MA: MIT Press.

Stoller, Paul (1989), *The Taste of Ethnographic Things: The Senses on Anthropology,* Philadelphia: University of Pennsylvania Press.

Stoller, Paul (1997), *Sensuous Scholarship,* Philadelphia: University of Pennsylvania Press.

Tarkovsky, Andrey (1989), *Sculpting in Time,* Austin: University of Texas Press.

Taussig, Michael (1993), *Mimesis and Alterity: A Particular History of the Senses,* New York: Routledge.

Tsivian, Yuri (1998), *Early Cinema in Russia and Its Cultural Reception,* Chicago: University of Chicago Press.

Wright, Chris (2004), 'Material and Memory: Photography in the Western Solomon Islands', *Journal of Material Culture,* 9 (1): 73–85.

Zizek, Slavoj (1992), *Everything That You Wanted to Know about Lacan, But Were Afraid to Ask Hitchcock,* London: Verso.

Contributors

Marc Augé is an anthropologist based at Centre National de la Recherche Scientifique in Paris.

Gaston Bachelard (1884–1962). French philosopher of science.

Mosche Barasch taught History of Art at The Hebrew University of Jerusalem.

Kaushik Bhaumik is a film historian, previously of the Open University, and is co-ordinator of programming for *Osian's—Connoisseurs of Art,* one of India's premier arts and culture institutions.

Suzannah Biernoff is lecturer in the School of History of Art, Film and Visual Media at Birkbeck College, University of London.

Liam Buckley is Assistant Professor of Anthropology, James Madison University, Virginia.

Patricia Caldwell specialises in Victorian literature and composition and is based at Eastern New Mexico University.

Michel Chion is a composer of experimental Music and Associate Professor at the Université de Paris.

Constance Classen teaches in the Department of Sociology and Anthropology at Loyola International College of Concordia University, Montreal, Canada.

Lorraine Daston is Director of the Max Planck Institut für Wissenschaftsgeschischte, Berlin.

Rachel Dwyer is Professor of Indian Cultures and Cinema at the School of Oriental and African Studies, University of London.

Elizabeth Edwards is Professor in the Cultural History of Photography and Senior Research Fellow, University of the Arts London.

Fernando Felíu is Associate Professor at the International Institute, University of Michigan.

Norma Field is Robert S. Ingersoll Professor in Japanese Studies in East Asian Languages and Civilizations, University of Chicago.

Finbarr Barry Flood is Associate Professor of the Arts of Islam, Institute of Fine Art New York University.

Jane Gaines is Professor of Literature and English at Duke University.

Jean-Luc Godard is a distinguished French filmmaker.

Alain Grosrichard is Professor of French Literature at the University of Geneva.

Tom Gunning is Edwin A. and Betty L. Bergman Distinguished Service Professor, Department of Art History, The University of Chicago.

Clare Harris is Reader in Visual Anthropology, ISCA, and Curator of Asia Collections Pitt Rivers Museum, University of Oxford.

Tim Hyman is an independent art historian, writer and curator.

Tim Ingold is Professor of Anthropology, University of Aberdeen.

Youssef Ishghpour is Professor at the University René Descartes, Paris V.

Alan Klima is Associate Professor, Department of Anthropology, University of California, Davis.

Paul Landau is Associate Professor of History, University of Maryland.

Catherine Lupton is Senior Lecturer in Film Studies at Roehampton University, UK.

Laura U. Marks is Associate Professor in the School for the Contemporary Arts, Simon Fraser University.

Maurice Merleau-Ponty (1908–1961). French phenomenological philosopher.

David Morgan is Professor of Religion at Duke University.

Howard Morphy is Director of the Cross-Cultural Research Centre, Australian National University, Canberra.

Lynda Nead is professor in the School of History of Art, Film and Visual Media at Birkbeck College, University of London.

Annalee Newitz is a writer and activist in the social impact of technology and science at *www.techsploitation.com*.

Linda Nochlin is Lila Acheson Wallace Professor of Modern Art at the Institute of Fine Arts, New York University.

Jan-Eric Olsén is postdoctoral fellow at Medicinsk Museion, University of Copenhagen.

Christopher Pinney is Visiting Crowe Professor, Department of Art History at Northwestern University, and Professor of Anthropology & Visual Culture at University College London.

Elisha Renne is associate professor in the Department of Anthropology and the Center for Afroamerican and African Studies, University of Michigan.

Gulam Mohammed Sheihk is a painter, curator and art historian. Previously he taught art and art history at the MS University, Baroda, India.

Wolfgang Schivelbusch is an historian of culture, based in New York and Berlin.

Isolde Standish is Senior Lecturer in Film and Media Studies at the School of Oriental and African Studies, University of London.

Marla S. Stone is Professor of History, Department of History, Occidental College, Los Angeles.

Karen Strassler is Assistant Professor, Department of Anthropology, Queens College, City University of New York.

Susan Stewart is a poet and professor in the Department of English, Princeton University.

Chantal Thomas is an historian at Centre National de la Recherche Scientifique, Lyon, France.

Robert Faris Thompson is Colonel John Trumbull Professor of the History of Art at Yale University.

Yuri Tsivian is William Colvin Professor in the Humanities, University of Chicago.

Eric G. Wilson is Thomas H. Pritchard Professor in the English Department, Wake Forest University, North Carolina.

Lois Parkinson Zamora is John and Rebecca Moores Distinguished Professor, Departments of English, History, and Art, University of Houston.

Andrew Zimmerman is Associate Professor of History and International Affairs, The Elliott School of International Affairs, The George Washington University, Washington, DC.

Copyright Acknowledgements

We are very grateful to all the publishers, photographers and copyright holders who have given permission for their material to be reprinted in this volume.

Opening Quotes

From *The Visible and the Invisible* by M. Merleau-Ponty. Translated by Alphonso Lingis. Evanston: Northwestern University Press, 1968, p. 3. Reprinted by permission of the publisher.

From 'Ono no Komachi', in *Women Poets of Japan,* editors: Kenneth Rexroth, Ikuko Atsumi, p. 14. Copyright © 1982 New Directions. Reprinted by permission of the publisher.

2. Labyrinth

'The Intertwining—The Chiasm' by M. Merleau-Ponty. From *The Visible and the Invisible.* Translated by Alphonso Lingis. Evanston: Northwestern University Press, 1968. Reprinted by permission of the publisher.

'Labyrinthine Complexities: The Ottoman Harem as Seen by Western Orientalists' by Alain Grosrichard. From *The Sultan's Court: European Fantasies of the East.* Copyright © 1998 Verso Press, London. Reprinted by permission of the publisher.

'The Blind in the Early Christian World' by Mosche Barash. From *Blindness: The History of a Mental Image in Western Thought* by M. Barash. Copyright ©1968 Routledge. Reproduced with permission of Taylor and Francis Group LLC. Abridged.

Sight and Embodiment in the Middle Ages by Suzannah Biernoff. Copyright © 2002 Suzannah Biernoff. Reprinted by permission of Palgrave Macmillan and the author. Revised by the author.

'The Light of Wangarr' by Howard Morphy. From *Ancestral Connections: Art and an Aboriginal System of Knowledge.* Copyright © 1991 University of Chicago Press. 1991. Reprinted with permission of the publisher.

'Corpore Obscuro: Meditation on the Dead in Thailand' by Alan Klima. From *The Funeral Casino* by Alan Klima. Copyright © 2002 Princeton University Press. Reprinted by permission of Princeton University Press. Abridged.

3. Orderings

4. Creating

'A Fascist Theme Park' by Marla Stone. From *The Patron State.* Copyright © 1998 Princeton University Press. Reprinted by permission of Princeton University Press.

5. Ruptures

'The Railway Journey: Panoramic Travel' by Wolfgang Schivelbusch. From *The Railway Journey: The Industrialization and Perception of Time and Space in the Nineteenth Century.* Copyright © 1989 Berg Publishers Oxford. Reprinted by permission of the publishers.

'The Secrets of Gas' by Lynda Nead. From *Victorian Babylon: People, Streets and Images in nineteenth-century London.* Copyright © 2000 Lynda Nead, Yale University Press. Reprinted by permission of the author and publisher.

'Supermodernity: From Places to Non-Places' by Marc Augé. From *Non-Places: An Introduction to an Anthropology of Super-Modernity.* Copyright © 1995 Verso Press, London. Reprinted by permission of the publisher.

'Camille Pissarro: The Unassuming Eye' by Linda Nochlin. From *The Politics of Vision: essays on nineteenth-century art and society.* pp. 60–74. 1991 Thames and Hudson. Copyright © 1989 Linda Nochlin. Reprinted by permission of Westview Press, a member of Perseus Books Group and the author.

'The Wicked Queen' by Chantal Thomas. From *The Wicked Queen: The Origins of the Myth of Marie-Antoinette* by Chantal Thomas. Copyright © 1999 Zone Books. Reprinted by permission of the publishers.

'Between Cult and Culture: Bamiyan, Islamic Iconoclasm, and the Museum' by Finbarr Barry Flood. From 'Between Cult and Culture: Bamiyan, Islamic Iconoclasm, and the Museum', *The Art Bulletin* 84(4). Copyright © Finbarr Barry Flood. Reprinted by permission of the author. Abridged. Revised by the author.

'The Creation of a Tibetan Modernist: The Painting of Gonkar Gyatso' by Clare Harris. From *In the Image of Tibet: Tibetan Painting after 1959.* Copyright © 1999 Reaktion Press. Reprinted by permission of publisher.

'Extraordinary Vision and the Two Sides of Cloth' by Elisha P. Renne. From *Cloth that Does Not Die: The Meaning of Cloth in Bùnú Social Life.* Copyright © 1995 University of Washington Press, Seattle. Reprinted by permission of the publisher.

'The Spiritual History of Ice' by Eric G. Wilson. From *The Spiritual History of Ice: Romanticism, Science and the Imagination.* Copyright © 2002 Eric G. Wilson. Reprinted by permission of Palgrave Macmillan and the author.

6. Extensions

'The Eye of the Storm: Visual Perception and the Weather' by Tim Ingold. From 'The Eye of the Storm: Visual Perception and the Weather', *Visual Studies* October

Final Quote

Picture Acknowledgements

Figure 3 Frames: Producing archaeological knowledge. Reproduced by courtesy of Patrick Sutherland.

Figure 4 *A Representative of the Sicilian Race.* Photographer Baron von Gloedden: Reproduced by courtesy of Berliner Gesellschaft für Anthropologie, Ethnologie und Urgeschichte. (P.11463).

Figure 5 Student protesters: Outdoor exhibition. Reproduced by courtesy of the author and photographer, Karen Strassler.

Figure 6 Created landscape: Rice fields. Reproduced by courtesy of Patrick Sutherland.

Figure 7 Parlour portrait. Reproduced by courtesy of Liam Buckley.

Figure 8 Parlour, Serrekunda, The Gambia, 2000. Reproduced by courtesy of Liam Buckley.

Figure 9 Vice President Lyndon B. Johnson with Sallman's *Head of Christ.* Reproduced by courtesy of the *Durant Daily Democrat.*

Figure 10 School Board president places a shroud over *Head of Christ.* Photographer: Jim Merithew. Reproduced by courtesy of the *Herald-Palladium.*

Figure 11 Frank Gurrmanamana, singing stringray. Reproduced by courtesy of the photographer, Roslyn Poignant.

Figure 12 From *Travels in a New World.* Reproduced by courtesy of the artist, Mohini Chandra.

Figure 13 *Red Buddha.* Reproduced by courtesy of the artist, Gonkar Gyasto.

Figure 14 *Somerset Landscape.* Reproduced by courtesy of Patrick Sutherland.

Figure 15 Balu Bagdi. Reproduced by courtesy of the author and photographer, Christopher Pinney.

Figure 16 Surgeons using head-mounted displays. Photographer: Rolf Hamilton. Reproduced by courtesy of *Uppsala Nya Tiding.*

Figure 17 Ambrogio Lorenzetti: *The Well Governed City* (Detail), Palazzo Publico, Siena. Reproduced by courtesy of Scalachive, Firenze.

Index